D0366665

BREAKING DOWN THE BARRIERS

ART IN THE 1990s

BREAKING DOWN THE BARRIERS:
ART IN THE 1990s

Richard Cork

Yale University Press
New Haven and London

To Katy,
with all my love

Designed by Ruth Applin and Beatrix McIntyre
Set in Bembo
Printed in China through World Print

Library of Congress Cataloging-in-publication data:
Cork, Richard.
 Breaking the barriers : art in the 1990s / Richard Cork.
 p. cm.
Includes index.
 ISBN 0-300-09510-4 (pbk. : alk. paper)
 1. Art, British – 20th century – Themes, motives. 2. Avant-garde (Aesthetics) – Great Britain – History – 20th century. 3. Art – Exhibitions. I. Title: Art in the 1990s. II. Title.
 N6768 .C672 2002
 709'.41'09049 – dc21

 2002153138

Frontispiece: Photograph of Richard Cork, 1999

CONTENTS

All these articles were originally written for *The Times*, apart from 'The Critic's Role', published in the *Royal Society of Arts Journal*; 'Bill Woodrow', 'The 1990 Venice Biennale', 'Edward Ruscha', 'Richard Long', 'The First Tyne International', 'Chillida Outdoors' and 'The End of the Twentieth Century', all written for *The Listener*; 'Tom Phillips', published in *RA* Magazine; and 'Cindy Sherman', written for *The Sunday Times*.

AUTHOR'S BIOGRAPHY

Richard Cork is an art critic, historian, broadcaster and exhibition organiser. He read art history at Cambridge, where he was awarded a Doctorate in 1978. He has been Art Critic of the London *Evening Standard*, Editor of *Studio International*, Art Critic of *The Listener* and Chief Art Critic of *The Times*. In 1989–90 he was the Slade Professor of Fine Art at Cambridge, and from 1992–5 the Henry Moore Senior Fellow at the Courtauld Institute. He then served as Chair of the Visual Arts Panel at the Arts Council of England until 1998. He was recently appointed a Syndic of the Fitzwilliam Museum, Cambridge, and a member of the Advisory Council for the Paul Mellon Centre.

A frequent broadcaster on radio and television, he has organised major contemporary and historical exhibitions at the Tate Gallery, the Royal Academy, the Hayward Gallery and elsewhere in Europe. His international exhibition on Art and the First World War, held in Berlin and London, won a National Art Collections Fund Award in 1995. His books include a two-volume study of Vorticism, awarded the John Llewelyn Rhys Prize in 1976; *Art Beyond the Gallery*, winner of the Banister Fletcher Award for the best art book in 1985; *David Bomberg*, 1987; *A Bitter Truth: Avant-garde Art and the Great War*, 1994; and *Jacob Epstein*, 1999. The present book is part of a four-volume collection of his critical writings on modern art, all published in 2003.

ACKNOWLEDGEMENTS

I am primarily grateful to Simon Jenkins, who made this book possible by appointing me as Chief Art Critic of *The Times* in 1991. I hugely enjoyed my decade in the job, and thank the newspaper for granting me permission to publish material that originally appeared in *The Times*.

I am indebted to all the artists, galleries and museums who so helpfully provided photographs for this book. Thanks are due as well to Greg Dyke, Director-General of the BBC, and the Editors of *The Sunday Times* and the *Royal Society of Arts Journal*, for permission to publish material that originally appeared in their publications.

At Yale, Ruth Applin and Beatrix McIntyre deserve an accolade for handling with such skill and patience all the complexities of publishing four books at once. My thanks also go, as ever, to my publisher John Nicoll. His enthusiasm for this project was invaluable, and I am fortunate indeed to benefit once again from his wisdom.

Each of these books is dedicated to one of my four children. Adam, Polly, Katy and Joe can never know how much they have sustained and delighted me, while my wife Vena has always given me a limitless amount of encouragement, friendship and love.

INTRODUCTION

Anyone approaching the place where Rachel Whiteread's *House* once stood, so briefly and yet unforgettably, will find no trace of its existence. Her monument has been expunged from the East End of London with surgical efficiency, by a local council determined that Whiteread would not be allowed to 'desecrate', on a permanent basis, the park newly created on the site. I went there the other day on a melancholy pilgrimage, wondering all over again why her work was not permitted to stay. For a few months at the end of 1993, *House* gave not only its Bow neighbourhood but the whole of London an outstanding public sculpture. Marooned in an otherwise demolished side of the street and eerily sealed up, this haunting structure amounted to an elegiac memorial.

Its deplorable and wholly unnecessary destruction, in January 1994, suggested that nothing had changed since the equally grotesque mutilation of Jacob Epstein's carvings for the British Medical Association headquarters in the Strand almost sixty years before. They were the victims of a similar readiness to condemn adventurous art and obliterate it as well. When the bulldozers moved in on *House* and brutally erased it, I remember wondering if Britain would ever rid itself of the rabid philistinism that abhorred Epstein's naked figures ever since they were unveiled in 1908. Exploring the shameful fate of his Strand statues, for a book on *Art Beyond The Gallery*, I had been left with a sharpened awareness of the ingrained national mistrust of modernity. So when it resurfaced with Whiteread as the target, I began to fear that the 1990s would deteriorate into a decade when new art became the automatic target for even more rampant vilification and vandalism. As a critic who had started writing fired by the hope that attitudes could be changed, I viewed this melancholy prospect with repugnance.

Against all the odds, though, the next few years witnessed a burgeoning public involvement with the work of emergent artists. The decade started hesitantly, with a widespread reluctance to impose on the emergent art of the period an identity it did not yet possess. There was a sense of hiatus when the 1990 *British Art Show* opened: the vehement neo-expressionist momentum in painting had long since died down, but the

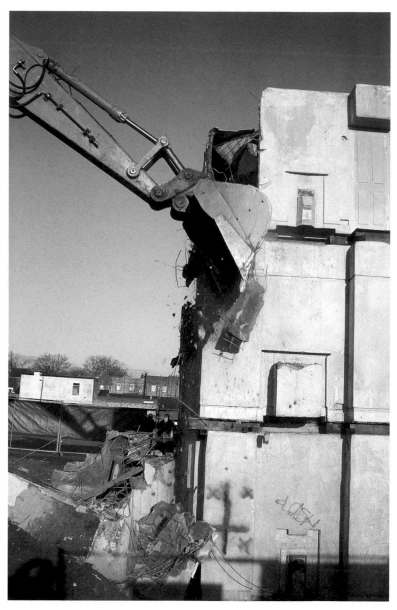

1. Rachel Whiteread's *House*, demolition in progress, 11 January 1994

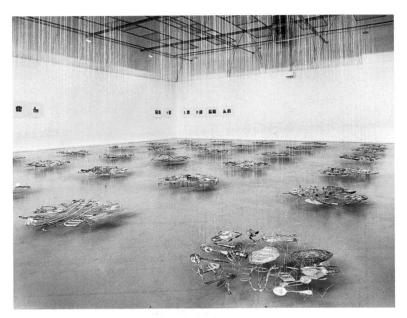

2. Cornelia Parker, *Thirty Pieces of Silver*, 1988–9

show's organisers – Caroline Collier, Andrew Nairne and David Ward – refused to saddle their selection with an alternative, arbitrary character. The prevailing mood was sober and analytical, and they concentrated on the individuality of the artists on display. 'Not surprisingly', they wrote in their catalogue introduction, 'we have found that there is no single, prevalent movement or style, and the much-discussed "pluralism" – in the sense of varied attitudes and approaches to the making and the content of work – is reflected in the diversity of the selection.' Although the apoplectic Director of Glasgow's municipal art gallery loudly denounced the exhibition when it opened in the city, participants as impressive as Cathy de Monchaux, Cornelia Parker, Vong Phaophanit, Fiona Rae and Rachel Whiteread led me to praise the show for defining 'a fascination with the untapped potential of materials which, like Parker's pummelled memorabilia, are only now being appropriated for art.'

Before long, even the most provocative experiments began to be received, not with knee-jerk hostility, but open-minded fascination. By the time Rose Finn-Kelcey, Thomas Lawson and I co-selected the 1995 *British Art Show*, which opened at galleries all over Manchester at the

3. Cover of *The British Art Show* catalogue, 1995, with detail from Damien Hirst's *I Love, Love*, 1994/5

start of a national tour embracing Edinburgh and Cardiff, the young artists' work on display there attracted record-breaking numbers of avid visitors. Sixteen of the twenty-six participants in *The British Art Show* were women, and the fact that they easily outnumbered the men proved how far gender imbalance among artists had altered since the era when women were almost invisible. The sense of excitement about new art was intense. And when *Sensation* opened at the Royal Academy two years later, with many of the same artists on display, the turnstile figures far outstripped the most optimistic predictions. During the same heady period, successive Turner Prize exhibitions at the Tate Gallery were likewise rewarded with increasingly buoyant attendances. New art basked in a boom, and its makers found similar levels of enthusiasm when they accepted more and more invitations to exhibit abroad.

4. Tacita Dean, *Girl Stowaway*, 1994 (detail), exhibited in *The British Art Show*, 1995

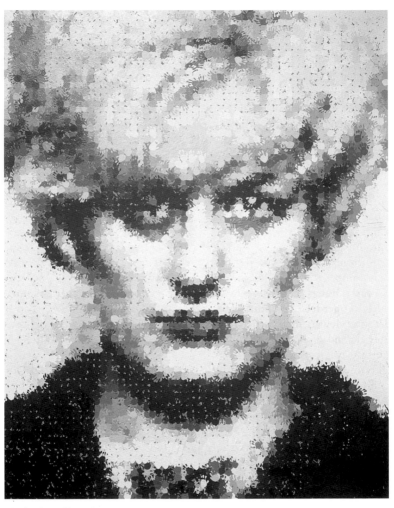

5. Marcus Harvey, *Myra*, 1995

The press, on the other hand, persisted in voicing plenty of the old derision. Many commentators continued to dismiss anything that did not accord with their weary, preconceived notions about what 'art' should be. But they did nothing to dissuade anyone from viewing the work. The more they ranted, the less effective they became. Young people in particular, often from the same generation as the artists on display,

decided that they wanted to see innovative work and assess it for them-selves. An appetite developed for the new, spurred by a public awareness that young artists were often producing accessible work moving, with supple versatility, between painting, sculpture, video, photography, sound, film, light and many other areas. A few disgruntled viewers persisted in attempting to destroy exhibits, most notoriously when Damien Hirst's *Away From the Flock* was discoloured with ink at the Serpentine Gallery and Marcus Harvey's painting of Myra Hindley was assailed at the *Sensation* show.

Some sectors of the media resorted to shameless tactics in their deter-mination to attack *Sensation*. I was asked to appear on ITV's breakfast tel-evision programme and discuss the exhibition on opening day. No men-tion was made of anyone else contributing to the item, so I felt puzzled when a visibly distressed woman accompanied me from the hospitality room to the studio. After sitting down next to me on the sofa, she was introduced as the mother of one of Myra Hindley's victims. She had been brought down specially from the north of England by the televi-sion company, and the interviewers now made sure that they turned to her first. Disregarding the rest of the artists in *Sensation*, they concentrated solely on her feelings about the Hindley painting. She began crying, and the interviewers then turned angrily on me and asked how I could pos-sibly defend such a disgraceful exhibition. It all amounted to a deliber-ate display of ruthless media manipulation, exploiting a mother's deep emotional pain in order to damn a show before anyone else had a chance to discover and assess the diverse array of other work displayed there. But the onslaught on the Hindley portrait succeeded only in igniting greater curiosity, and arousing sympathy among those who instinctively felt that vandalism was indefensible. As for the artists whose work had been dam-aged, they became still more determined in the face of hysterical or vio-lent opposition.

Maintaining such a resolve remains vital if the momentum behind adventurous contemporary art is to avoid ossification. Much of the dynamic driving emergent artists in the 1990s sprang from the urge to break down the barriers that could so easily have prevented them from tackling new subjects, materials, ways of working and exhibiting that had previously been considered out of bounds. The youngest artists discussed in this book have all, in their different ways, pioneered approaches that pushed out the accepted territorial limits, thereby fostering a climate where shibboleths were flouted and definitions of art widened. Writing in *The Times* for most of the decade, after Simon Jenkins appointed me as Chief Art Critic in 1991, I found myself continually challenged and

invigorated by the prevailing spirit of audacity. By no means all these innovative impulses resulted in satisfactory or coherent work, but the gains were as palpable as the burgeoning sense of excitement. Far from being disheartened by the recession-ridden state of the market at the beginning the 1990s, artists emerged from economic blight with a tougher and more focused determination to achieve renewal.

Along with that professional resolve, though, there was a marked absence of optimism. The excitement centred on the energy of artists, but the work they produced was often dark and intensely sceptical. It was concerned with isolation, fragmentation, dislocation and frustration. Writing an essay for the catalogue of *The British Art Show* halfway through the decade, I decided to call it 'Injury Time.' Emergent artists were not, on the whole, conveying any of the exuberance traditionally associated with youth, and its absence reflected the position they found themselves occupying as the century's end approached. There was a lack of belief in big ideas, an inability to be caught up in idealism. Although the young are not conventionally supposed to become fascinated with thoughts of mortality, I kept encountering their powerful and ines- capable engagement with death. Whether overt or implicit, a preoccu- pation with transience and extinction ran through much of the work they produced. Even in Britain, a country so emotionally inhibited that all mention of the grave has often been banished from discourse, artists were no longer afraid of the *memento mori*. Their lack of timidity was in one sense reminiscent of the mood prevailing in Jacobean tragedy, with its elegiac references to blood, bones and human fragility. Their work even recalled, at times, the horror of the images I was writing about in a book on avant-garde art and the First World War. But there was nothing ghoulish about the young artists' approach. Rather than indulging in despair, they explored even the most distressing aspects of existence with a wry, alert, almost forensic precision. Damien Hirst dealt with it most dramatically, but a similar obsession marked many other artists' work as well. Was it part of a *fin-de-siècle* mentality? That is a superficial way of describing, and ultimately belittling, a deeper desire to open up a taboo area. It helps to explain why Francis Bacon, exceptional in his own time for exploring violence and death, was more admired by young British artists during the 1990s than any other painter of his period.

Far from wallowing in morbidity, the new generation was conspicuous for its resilience. Emerging from a period of high unemployment and chronic recession, artists refused to be cowed. They were bloody-minded, and far from demoralised. Even when they dealt with very distressing emotions in their work, they did not allow this despair to erode their belief

in the ability to make art. The public appreciated this sense of defiance, too. It contributed to the wide appeal of their work, and turned some *enfants terrible* into overblown celebrities who became notorious far outside the limits of the art world. There was, inevitably, a danger of turning them and their work into nothing more than a highly publicised spectacle. Whenever media interest in art accelerates, hype raises inflated expectations. If an individual fails to meet those hopes, the subsequent disappointment and condemnation is much greater. But a strong sense of momentum was established, building in particular on possibilities opened up in the late 1960s and 1970s, when so many different ways of working were first explored. Although the mood of the 1990s may have been marked by an absence of the larger hopes prevailing in that earlier, pivotal period, the vitality was astonishing.

Even if new British art dominated so many headlines during the 1990s, I had no wish to discuss it in a narrow, patriotic way. The true strength of the culture lay in its internationalism. England can easily lapse into parochial myopia, exacerbated by its geographical insularity. But London in particular refused to become exclusively preoccupied with homegrown developments. There was a strong feeling of openness, and art no longer seemed in thrall to an overriding obsession with the centralising focus of a supreme centre. The economic power of the West, which at one time threatened to obliterate the national identities of art in other parts of the world, did not prevent us from attempting to gain a less constricted view. London became an increasingly vital place to work, but there were plenty of other centres where contemporary art could thrive. Young artists from the USA and Europe, including Matthew Barney, Tony Oursler and Thomas Struth, held outstanding solo shows in London, while potent work came from Stan Douglas in Canada, Gabriel Orozco from Mexico and Chicano Art on the US border as well. But growing attention was also paid to developments in Africa, China and Japan, ensuring that notions of contemporary art were not bounded by conventional western limits.

A significant number of foreign artists, including Vong Phaophanit, Michael Raedecker, Tomoko Takahashi and Wolfgang Tillmans, decided to make England their home after graduating from art school. The British scene has long been energised by artists who, having grown up elsewhere in the world, settle in London and stay there. Lucian Freud, Frank Auerbach, Paula Rego, Susan Hiller, Gilbert Proesch, Mona Hatoum, Anish Kapoor and Shirazeh Houshiary are among the most notable of older *émigrés*, and art in London is now unimaginable without them. So the city's ability to attract younger artists from abroad should come as no surprise, and their presence has enriched the ever

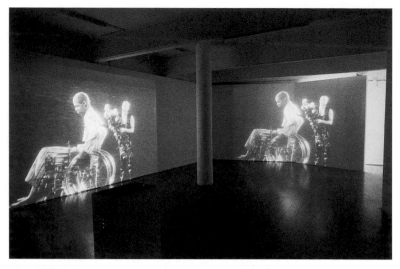

6. Isaac Julien, *Trussed*, 1996

more cosmopolitan character of the metropolis. At the same time young black artists born in England – Isaac Julien, Steve McQueen, Chris Ofili and Yinka Shonibare prominent among them – have made powerful contributions to the vitality of the contemporary scene.

The identity of a decade is not, of course, solely defined by the work of its emergent artists. More senior practitioners, like Marlene Dumas, Rebecca Horn, Annette Messager and Jeff Wall, can further enrich their own achievements, or even redefine themselves by exploring new directions. Their previous work can also take on a new pertinence in the light of interests explored by younger artists, who sometimes generously acknowledge their debt to the example of certain key members from the older generation. Among those octogenarians who acted as particular springboards for new art in the 1990s, Louise Bourgeois stands out along with the ubiquitous Bacon. But several middle-generation artists, of whom Bruce Nauman is perhaps the most influential, provided a formative stimulus for individuals as diverse as Damien Hirst and Rachel Whiteread.

The decade also witnessed spectacular signs of regeneration among galleries and museums. At the onset of the decade, Nicholas Serota inaugurated his superb directorship of the Tate by rehanging and rotating the collection in a more lucid, flexible manner. Norman Foster showed how a new addition can make a potent contribution to a historic building

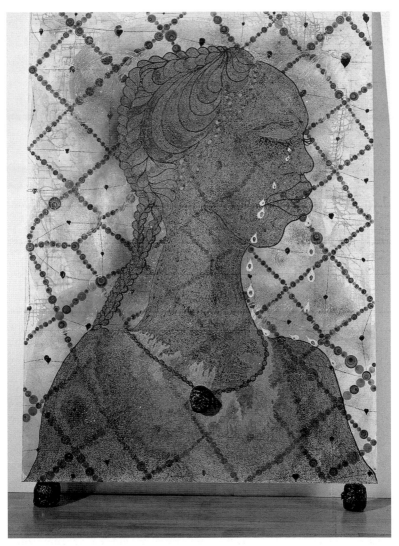

7. Chris Ofili, *No Woman, No Cry*, 1998

with his Sackler Wing at the Royal Academy, an elegant example of a late-modernist architect honouring his context while rejuvenating it. At the National Gallery, Robert Venturi was so bent on respecting the Wilkins facade that his extension lacks character from the outside. But

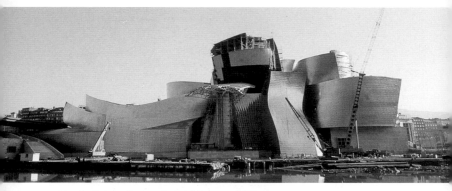

8. Frank Gehry, Guggenheim Museum, Bilbao, 1997

the Soane-influenced spaces he created for the early Renaissance collec-
tion are a limpid delight. So is the Irish Museum of Modern Art in
Dublin, fashioned from the interior of the seventeenth-century Kilmain-
ham Royal Hospital.

But the opportunities for designing a major, untrammelled piece of
modern museum architecture, whether in Britain or elsewhere, proved
rare. In Berlin, the transformation of the Hamburger Bahnhof was ham-
pered by the inevitable difficulties of converting a railway station into a
gallery fit for late twentieth-century work. And in London, the Tate's long-
overdue decision to split the collection and create a museum of modern
art elsewhere in the city ended up focusing, courageously, on the transfor-
mation of a disused power station. While the selected architects tackled the
conversion of Giles Gilbert Scott's Bankside behemoth with sensitivity and
flair, Frank Gehry was fortunate enough to design his own gallery on
another river frontage in Bilbao. The result, when it opened in 1997,
turned out to be a shimmering and convulsive masterpiece. Gehry's *tour de
force* made most other contemporary architecture look unforgiveably timid
and dull. The Guggenheim Bilbao will undoubtedly spur other cities into
commissioning adventurous gallery buildings during the twenty-first cen-
tury. But many artists understandably prefer exhibiting in spaces less
expressive of the architect's own ebullient personality; and the reopening
of the renovated Serpentine Gallery provided London with a modest yet
exquisite sequence of exhibition spaces, where contemporary art is
enhanced by its unfolding relationship with the parkland visible outside.

The successful completion of the Serpentine Gallery's renewal gave
me special pleasure. Chairing the Visual Arts Panel of the Arts Council

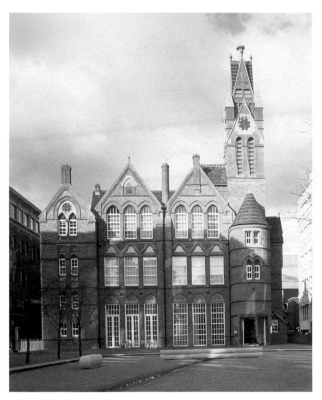

9. The new Ikon Gallery, Birmingham

of England between 1995 and 1998, I witnessed the sudden, momentous advent of Lottery funds and saw how dramatically they transformed the opportunities available to galleries throughout the country. Having started my chairmanship with grave concerns about the crisis in visual arts funding, I soon realised that Lottery money could at last facilitate ambitious building projects that would never, previously, have been able to find the requisite financial backing. The Serpentine Gallery, supported by a Council lottery grant of £3 million, was able triumphantly to rise above the nadir it had experienced only four years before, when a Tory minister threatened it with closure. And the Ikon gallery in Birmingham, armed with a Council lottery grant of £3.7 million, left its inadequate building and reopened in superbly restored Victorian premises at the centre of a rejuvenated city. Sometimes, far smaller grants

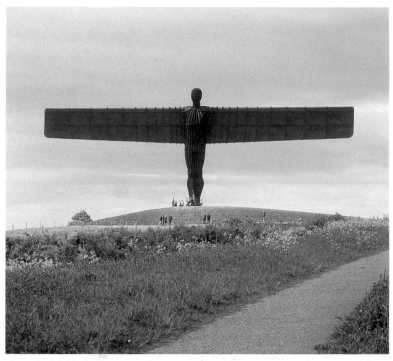

12. Antony Gormley, *Angel of the North*, 1997–8

Claes Oldenburg, whose first proposals for an open-air sculpture in London go back to the 1960s, finally succeeded with Coosje van Bruggen in producing a multi-layered, arresting yet poignant large-scale work for a British location. Its installation coincided with another remarkable monument, this time in the capital: Rachel Whiteread's *House*, which immediately established itself as one of the finest British sculptures of the twentieth century. Taken together, these two ambitious works proved that outstanding art can be produced far beyond the gallery's territorial limits. And later in the decade Antony Gormley's *Angel of the North* offered further cause for hope. Towering on a hilltop near Gateshead, this titanic figure spread his wings as if to bestow benediction on everybody around him. But he could also be seen in a more tragic light, as someone who yearned for the liberty of flight even as he remained frustratingly earthbound. Either way, *Angel of the North* managed in a remarkably brief period to become cherished by most of those who, whether walking past

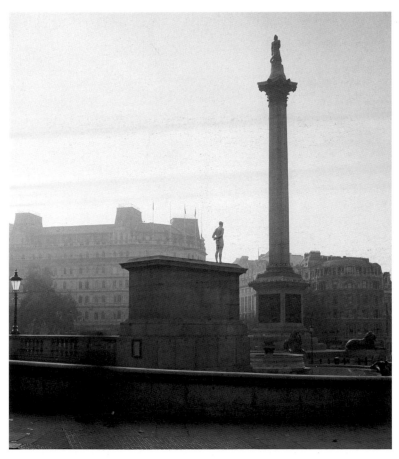

13. Mark Wallinger, *Ecce Homo*, 1999, in Trafalgar Square, London

or driving on the nearby motorway, encountered his gaunt, grave presence.

Since then, an impressive range of projects have been carried out with mounting public acclaim. Some took hallowed architecture from the past as their setting, like Mark Wallinger's vulnerable *Ecce Homo* balanced on the empty plinth in Trafalgar Square, or Bill Viola's haunting video installation *The Messenger* at the west end of Durham Cathedral's great Romanesque nave. Georgian Bath, the city where I grew up, turned out to be a potent setting for Jan Fabre's site-specific works, including a darkened riverside chamber near Pulteney Bridge and a disused mortuary

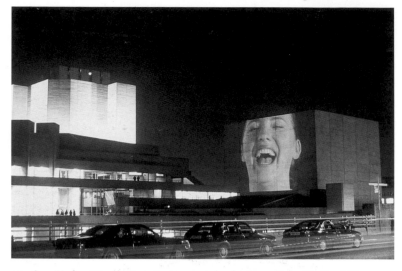

14. Sam Taylor-Wood, *Hysteria*, 1997, on the flytower of the National Theatre, London

chapel in Walcot. As for the indefatigable Public Art Development Trust, they brought a decade of sustained activity to a climax with an ambitious programme of film and video projections on the flytower of the National Theatre. Sam Taylor-Wood's dramatically enlarged, close-up study of a young woman *in extremis* was the most arresting work shown there, illuminating the blackness of a Waterloo night with its forensic yet compassionate exploration of helpless human pain.

My own enthusiasm for extra-gallery initiatives made me willing to sit on advisory panels for several major schemes: Anish Kapoor's visionary new font for St Paul's Cathedral, Alex Hartley's luminous sculpture outside the London Contemporary Art Fair, the graceful Sunderland Gateway Commission by Langlands & Bell, and the North Meadow Art Project near the Millennium Dome involving large-scale, ambitious new work by Tony Cragg, Tacita Dean, Rose Finn-Kelcey, Antony Gormley, Anish Kapoor and Richard Wilson. I was also delighted that *The Times* proved willing to embark on a collaborative venture with Artangel, commissioning two large-scale projects by young artists: Michael Landy and Jeremy Deller. It was the first time a national newspaper had sponsored art works from their inception, and reflected our confidence in Artangel's readiness to take on the most hazardous and controversial schemes if they seem

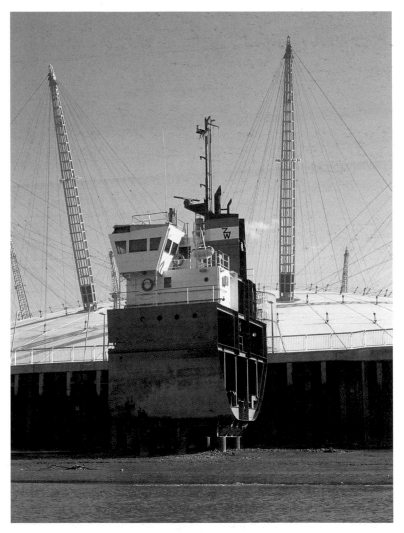

15. Richard Wilson, *Slice of Reality*, 1999, outside Millennium Dome, London

capable of producing unforgettable results. Operating beyond institutional spaces, and keenly responsive to the character of a chosen location, achievements as outstanding as the *Palace of Projects* by Ilya and Emilia Kabakov have been able to astonish, provoke and delight.

16. Tatsuo Miyajima, *Running Time*, 1995, at Queen's House, Greenwich

Artangel proved powerless to prevent its most celebrated project, Whiteread's *House*, from suffering obliteration. But most of its schemes are meant to be temporary, and access to the settings used by the artists is only granted on condition that the work will subsequently be dismantled. Some of the places are as august as Inigo Jones's exquisite Queen's House in Greenwich, where Tatsuo Miyajima installed a hallucinatory network of luminous electronic counters silently gliding through the darkness of the Great Hall. Other locations have a powerful air of dilapidation, like the dank and abandoned underground chambers of the Clink Street Vaults where Robert Wilson and Hans Peter Kuhn installed a mesmeric series of tableaux called *H.G.* But whether the setting is an imposing building in London's clubland, used by Gabriel Orozco for a sequence of strange, dreamlike meditations on Englishness, class, etiquette, snobbery and sport, or a Medical Lecture Theatre in the Royal London Hospital, where Neil Bartlett staged a dramatic monologue inspired by Poussin's great paintings of the Seven Sacraments, the locale is far from arbitrary. It always reinforces the meaning of the work, just as the place once inhabited by Whiteread's *House* enriched her sculpture many times over. Like

all Artangel's finest commissions, the art work and its equally unconventional setting became fused in a rewarding union. Despite *House*'s unforgiveable destruction, no one will ever be able to erase the memories it has left behind.

Painting in the 1990s was by no means as moribund as its detractors often liked to claim. In Britain, practitioners as ebullient as Gary Hume, Chris Ofili, Fiona Rae and Jenny Saville proved that the possibilities of mark-making on canvas or metal were by no means exhausted. And older painters flourished as well, from Lucian Freud, Frank Auerbach, Bridget Riley and Howard Hodgkin to middle-generation individualists like Tony Bevan, Shirazeh Houshiary and Avis Newman. I learned a great deal about the continuing vitality of contemporary painters when serving on judging panels. The NatWest Prize, which boasted a covetable top award of £26,000 and a dozen others of £1,000 each, drew a cascade of submissions. Limited to contenders aged 35 or under, it proved that plenty of young artists still found painting a source of energy, inventiveness and delight. In 1998, we gave the prize to Callum Innes for his exemplary canvas, where the rigour of minimal abstraction was tempered by thinned, flowing paint evocative of water in motion. But the work of other shortlisted artists, ranging from Jason Martin's shimmering experiments with

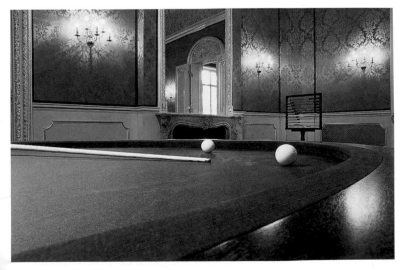

7. Gabriel Orozco, *Empty Club*, 1996, St James's St, London

18. Jason Martin, *Untitled: Gel Loop*, 1998

acrylic gel on copper to Tacita Dean's tumultuous chalk-on-blackboard images of cinematic sea drama, was equally distinguished.

A year later, the vigorously combed surface of a Martin reappeared in the shortlist for John Moores 21, the biennial exhibition of contemporary painting held at the Walker Art Gallery, Liverpool. This time the first prize was £25,000, with ten £1,000 awards again distributed to the runners-up. But the Moores is open to anyone living in Britain, regardless of age, and we were inundated by well over 2,000 entries, well up on recent submissions to the event. Looking at all these anonymously presented paintings, and whittling them down to a tally of fifty for the show, took almost a week. Our jury had vigorous arguments, yet we had no doubts about the overall value of the competition and the way it illuminated the state of painting today. Michael Raedecker, who won the main prize with *Mirage*, exemplifies in his risk-taking employment of acrylic, thread and sequins the distinctive and often heretical strategies developed by artists best able to replenish and extend the language of painting. So does the idea of exploring 'the undiscovered country', the words spoken by Hamlet and adopted as the title of my essay in the John Moores catalogue.

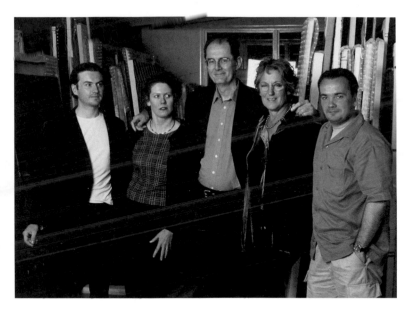

19. Judging the John Moores' Painting Prize, July 1999, from left: Dan Hays, Elizabeth Ann Macgregor, Richard Cork, Germaine Greer and Mark Francis

The notion of an unconfined dream-state can be a central stimulus for painters, and it played a part in some of the shortlisted images. But a strong urge to retain a hold on observable reality was detectable as well, most notably in George Shaw's melancholy return to his boyhood terrain and Kaye Donachie's *Tent*, which might almost have been based on a police flash-picture recording the location of a crime.

If painting sometimes seems threatened by the battery of new visual media available to the artist now, the status of photography is problematic in a different way. Its very ubiquity means that, in British institutions at least, the cultural position of the photograph remains strangely insecure. That is why I welcomed the advent of the Citibank Photography Prize, and joined the selection panel for its first £10,000 award with particular enthusiasm. By the mid-1990s, the cross-over between art and photography had become so fertile that the boundaries dividing them were swiftly eroded. The photographic image played such a potent part in young artists' work that we had no difficulty in assembling a diverse and exceptionally rewarding shortlist. One contender, the eventual prize-winner Richard Billingham, first used the camera as a means of obtaining source material

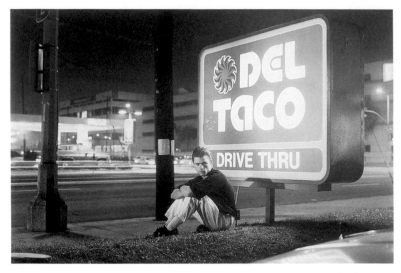

20. Philip-Lorca diCorcia, *Ralph Smith; 21 years old; Ft. Lauderdale, Florida; $25*, from the series *Hollywood*, 1990–2

for his paintings. The imperatives involved in photographing his own family soon took over, although a painter's eye still informs even the most documentary images of harrowing domestic discord. Philip-Lorca diCorcia's studies of Los Angeles street life can be equally disconcerting, and he spares us nothing in his exploration of drug addiction and male prostitution. But the outcome is profoundly affected by the language of cinema, and its dream-like quality recurs in the otherwise very different work of Uta Barth. Misty and elusive, it concentrates on enigmatic interiors and once again discloses an underlying engagement with painting. So do Catherine Yass's luminous transparencies, although her images are driven above all by a determination to meditate on the manifestation of power within institutions as disparate as a hospital, a steel plant and a meat market. Mat Collishaw's fascination with meat extends to wounds in human flesh, and he made a supremely disconcerting series of light-box transparencies from photographs of highly infectious skin diseases. In another mood, however, he roams back to nineteenth-century precedents, and shows himself catching fairies who might have strayed from a Victorian fantasy.

By the end of the decade, the British public's appetite for and involvement with even the most provocative new art had undergone a trans-

formation. In some ways, the escalating renown of the Turner Prize was a barometer of changing attitudes. When the 1990s began, both the award and the exhibition took a mysterious sabbatical and everyone imagined they had vanished for ever. But in 1991 the Turner Prize was back, with the money doubled to £20,000. Sponsored now by Channel 4 Television, the prize had a new upper age-limit of fifty. But the jury interpreted this rule largely as a charter for the under-thirties. Three of the four shortlisted names – Ian Davenport, Fiona Rae and Rachel Whiteread – had left college in recent years. Only Anish Kapoor belonged to an older generation, and at 37 he hardly deserved to be regarded as a Grand Old Man. The fact that he could easily have been humiliated by a younger artist, armed with only a fraction of his sustained output over the past decade, renewed my unease over the strategy of shortlisting for the Turner Prize. True, the event's terms of reference had been narrowed from the mind-boggling grandiosity of the original definition ('the greatest contribution to art in Britain'). Now the award would be given to 'an outstanding exhibition or other presentation'. But I felt that the 1991 shortlisted artists were still being played off against each other, like bewildered animals unwillingly coerced into a muddy and confused scramble for the winning-post.

Even so, Channel 4's involvement did at least guarantee that all four artists would receive prime-time exposure. A serious, hour-long programme about them was televised before live transmission of the prize-giving ceremony. And Nicholas Serota, who chaired the judging panel, declared that he wanted the whole event to 'promote the quality and depth of their work to audiences not necessarily familiar with the twists and turns of contemporary art.' The aim was laudable, and clear efforts were made to improve on the risible inadequacy of previous shortlist exhibitions. Rather than consigning them to the echoing immensity of the Duveen Galleries, where their individual merits usually became lost in a confusing display, the Tate now devoted three rooms to a clearly laid-out Turner Prize show. It was still insufficient, but at least a video and information panels about the contestants prefaced the work itself, thereby helping to introduce them to a wider public.

The strategy paid off. Every year during the 1990s, enemies of the Turner Prize biliously predicted that it would dwindle into tedium and be ignored. But every year, the razzamatazz surrounding the exhibition of shortlisted artists remained as raucous as ever. And one memorable television discussion, broadcast live in 1997 after the announcement of the prize-winner, turned Tracey Emin into the most celebrated British woman artist of her much-publicised generation. As a member of the

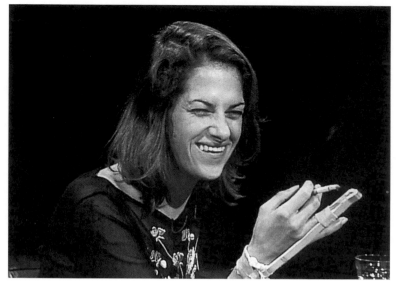

21. Tracey Emin on the notorious Channel 4 programme, 1997

panel who assembled that evening in front of the cameras, I wondered how Emin would cope when she arrived drunk for our debate. But she was shrewd enough to turn to a producer, just before transmission began, and ask: 'can I say fuck on Channel 4?' During the programme she shouted abuse at several panellists, and I remember struggling to make myself heard above her continually interrupting tirade of profanities. Eventually, to my immense relief, Emin announced that she was walking out of the room to 'go home and see my Mum.' It was a moment of supreme bravado, and her outrageous performance on the programme catapulted her into far greater controversy than before.

But in 1999 the *brouhaha* generated by Emin's scandalous bed in the Turner Prize exhibition was, if anything, even more strident. After two Chinese artists invaded her room to trample on the already stained and rumpled sheets, the bed quickly became elevated to the level of national notoriety. When I revisited the show not long afterwards, the throng of viewers made the work almost impossible to see. Irreverent cartoonists, jeering headline writers and splenetic columnists thrived on boundless speculation about Emin's seedy sleeping habits. Compared with the rumpus which erupted during the 1970s over Carl Andre's bricks, however,

22. Steve McQueen, *Deadpan*, 1997

the overriding public response to 'the bed' was far removed from the knee-jerk condemnation which once typified the British attitude to innovative contemporary art.

Focusing so much on one artist might have seemed grotesquely unfair on the other shortlisted contenders. But the truth was that Steve McQueen, Steven Pippin and Jane and Louise Wilson all benefited from the crowds besieging the 1999 Turner Prize show. Thousands who would never normally have encountered these artists' work discovered it, once they had fought a path round the bed and through the second room where Emin's confessional videos exposed the most harrowing aspects of growing up in Margate. Even some diehard opponents of modern art may have found, against all the odds, that unsuspected merit lurked in new art. They could have been seduced by the Wilson twins' dreamlike exploration of Las Vegas, entertained by Pippin's eccentric adventures in laundromat-land, or unsettled by McQueen's death-defying stillness as the facade of a house fell towards him. If they found themselves intrigued by something on show here, it could well have acted as a trigger for a growing involvement with contemporary art in the future.

Most of the hostile commentators never deigned to pay the Turner

Prize exhibition a visit. They preferred to vilify it from afar, without putting their prejudices to the test. Such automatic antagonism quickly grows sterile. It deteriorates into a routine, and its sheer predictability becomes wearisome. Better by far to find out for yourself, and discover if the annual cries of 'rubbish' bear any relation to the specific experiences offered by the work themselves. I was impressed, on my final visit to the 1999 Turner show, by the quality of public response. Plenty of people queuing for a glimpse of Emin's torn and furrowed linen may have come to the Tate on a voyeuristic impulse, spurred by sensationalist abuse. But nobody inside the show was fulminating about her unwashed knickers, or doubling up in satirical mirth at the revelations about her unbridled teenage libido and its disastrous consequences. Rather were they attending, quietly and seriously, to a young woman's frankness about the calamity and mess of her life so far.

The visceral immediacy and directness with which Emin, McQueen and the Wilsons drew viewers into their very different worlds made the 1999 Turner Prize show hugely accessible. That was why it seemed capable of attracting and holding the attention of the most sceptical visitors, who could well have emerged with a new desire to learn more about the art they were previously eager to disparage. It was easy to censure the Turner exhibition for degenerating into a ready-made target for the tabloid press, and view the annual furore as little more than a farce. But since this event managed to widen the audience for adventurous young artists, in a country once so loath to engage with innovative work, the hysteria it excited was a price well worth paying.

NEW BLOOD

HIRST'S SHARK AND WHITEREAD'S GHOST
3 April 1992

Viewed from the entrance of the Saatchi Collection's spartan gallery, Damien Hirst's large steel sculpture looks like a classic minimalist statement. But as you approach this stripped exercise in geometrical purism, the structure's apparent abstraction gives way to a disturbing alternative. For a black swivel chair sits next to a stark office table inside the box. And the only objects on the table's white top are an open packet of Silk Cut, a lighter, a cigarette and an ashtray plentifully supplied with butts. Coolness and austerity are countered, quite unexpectedly, by psychodrama. Nothing distracts attention from the remorseless emphasis on smoking, and Hirst ensures that the container offers no hint of an exit. The outer surface is punctuated with rivets, as openly declared as the bolts on a Richard Deacon but far more oppressive. Within the box, a glass sheet separates the main area from a narrow space beyond. The division, however, only ends up accentuating the prison-like mood. The occupant of this see-through cell is condemned to a life-threatening addiction, and Hirst implies that the habit is irresistibly attractive by entitling his work *The Acquired Inability to Escape*.

The fascination of this promising young artist's work lies in his readiness to organize Kafkaesque nightmares with such clinical clarity. Although the glass structure finally comes to resemble a chamber of extinction, the immaculate order of the work prevents any expressionist paranoia from breaking out. Everything is conveyed in a deadpan manner, allowing room for gallows humour alongside the intimations of mortality.

Even when he deals directly with death, Hirst remains as disciplined as before. Towards the middle of the largest Saatchi room, a tripartite tank rests on the floor. This time, the entire space is filled with green formaldehyde to preserve the fourteen-foot tiger shark suspended within the liquid. Although quite motionless, and therefore clearly dead, the creature retains an uncanny ability to disconcert. Seen from the side, the shark's head appears to hover close to the glass. But when we move round to the front, it suddenly jumps towards the centre of the tank. The illusion of movement continues as we traverse the length of the shark, noticing abrupt shifts in position with each successive sheet of glass. And once the end is reached, the creature's body recedes into a green mist beyond the sharply focused tail. Through the blurring action of the formaldehyde, motion is conjured again. It prevents us from acknowl-

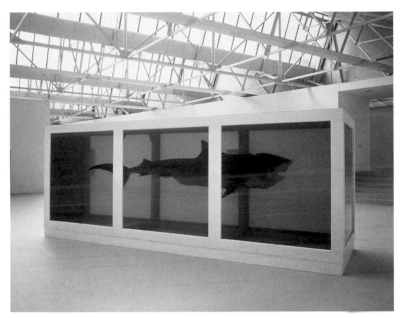

23. Damien Hirst, *The Physical Impossibility of Death in the Mind of Someone Living*, 1991

edging the full reality of the shark's lifeless state, and Hirst's typically intriguing title suggests that we are unable to do so anyway: *The Physical Impossibility of Death in the Mind of Someone Living*.

But that does not prevent him from trying to shock the viewer into confronting the unacceptable brevity of existence. Near the shark tank, a double glass cube contains the most disturbing of his exhibits. In one half, a neat white box provides a hatching-ground for thousands of maggots. When the bluebottles fly out, though, they find themselves confined by the setting Hirst has devised. All they can do is settle on a repellent cow's head with a hypnotic blue eye, lying in the other half of the container. Above this rotting *memento mori* hang the thin tubes of an insectorcutor, attached to a tray littered with dead flies. Plenty more have expired on the floor below, turning the sculpture into a charnel house.

Mesmerized and nauseated in equal measure, we are forced to ask ourselves why the spectacle is so gruesome. After all, the death of a fly does not normally provoke sympathy in humans. Its life-span is brief, and Hirst draws attention to that fact as arrestingly as he can. If we find his

work cruel, should efforts be made to ban insectorcutors from places where they safeguard our health? The sculpture poses these awkward issues, just as the tank piece makes us aware of the alarming ease with which anyone can order a shark for display purposes.

Hirst is the most uncomfortable of artists, and the fact that he presents his murky findings with calm, surgical exactitude only adds to the disquiet. Look at the pseudo-scientific precision with which he marshals thirty-eight species of dour-looking fish in a work ironically called *Isolated Elements Swimming in the Same Direction For the Purpose of Understanding*. Methodically arranged in perspex cases on shelves, they look like laboratory specimens intended to prove some researcher's theory. But their only purpose is to emphasize the unfathomable strangeness of life-in-death, as well as subverting the whole notion of finding solace in a bowlful of goldfish.

Hirst is one of five British artists sharing the Saatchi show. But most of his fellow-exhibitors fail to generate the amount of interest he sustains. Alex Landrum displays minimal paintings in pairs of contrasted eggshell colours. They seem abstract, yet discreetly embedded in each canvas is the name chosen by Dulux to promote this particular hue. Sometimes they are terse: one brilliant blue picture is called *Yacht*, while its rich yellow neighbour carries the title *Goldcoast*. But the sales-pitch soon goes into poetic overdrive, saddling a sickly orange canvas with the name *Exquisite* and dubbing its partner *Extravagance*.

After a while, though, monotony sets in. A similar problem afflicts the ostensibly very different paintings by John Greenwood. An ebullient latter-day Surrealist, he makes no attempt to hide his debts to Duchamp, Tanguy and above all Dalí. Writhing forms, invariably bulbous and sometimes suggestive of ectoplasms, fill the large, meticulously defined images with frenzied movement. Sperms and eggs often appear to play their part in these excitable tableaux, alive with burgeoning incidents which also rely on cartoon sources. The performance is always polished, but the uniform air of frantic activity and complication soon palls.

I turned with relief to the cooler, more analytical offerings by Langlands & Bell. Obsessed by buildings, they concentrate on the plan of a chosen edifice rather than its frontage. Architecture as power-structure is their theme, and they pursue its variations in careful, lucid models culled from a host of countries and historical periods. Despite their white-lacquered purity, these exacting reliefs are sinister, even chilling. Social engineering, whether in the guise of religion, justice or housing, is the underlying leitmotif. And it becomes openly stern in a work called *Maisons de Force*, where seven chairs with models installed in their

seats are lined up on a long white plinth as if waiting to be occupied by a vindictive jury.

But the most powerful of the four artists showing alongside Hirst is Rachel Whiteread. Although her work became widely familiar in the Turner Prize shortlist last year, her grandest sculpture made no appearance at the Tate. Aptly entitled *Ghost*, this colossal apparition in white plaster is the masterpiece of the exhibition. Cast in sections from the interior space of a cramped north London living-room, Whiteread's *tour de force* has a melancholy air. The imprints of a window, panelled door and fireplace complete with scorch-marks appear on successive sides of this glacial block. But for all its magisterial presence, the work seems bound up with memories of a past beyond recall. Thin gaps between the sections disclose the emptiness within, buttressed by a steel frame. Bleached, silent and uninhabited, *Ghost* finally becomes as elusive as a dream.

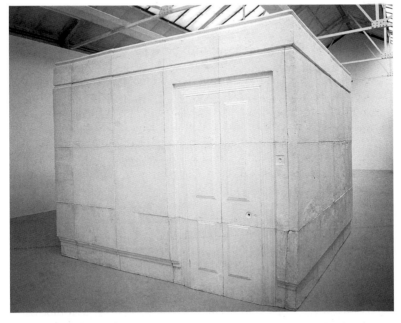

24. Rachel Whiteread, *Ghost*, 1990

DOCUMENTA IX

16 June 1992

Not content with spending £5.5 million to jet in 190 artists from all over the world, Documenta IX has thrown in boxing, jazz and baseball as well. Held in Kassel, this gargantuan jamboree has established itself since the war as the largest and most spectacular of all contemporary art exhibitions. Every five years the entire international art world descends on this sedate German city and overdoses on a cornucopia of discordant contributions from the established, the ascendant and the unknown. In a sequence of galleries spread across the centre of Kassel, and spilling out over acres of parkland as well, Documenta is essential viewing for anyone who wants to diagnose the state of the art.

This summer, the Belgian museum director Jan Hoet has decided to mix art with sport and music. Is his supporting programme of boxing match, baseball tournament and jazz festival a gimmick, or an attempt to say something serious about the nature of art today? Hoet claims that, by making these diverse activities confront each other, he is setting 'a broader challenge to art'. He also argues that they are linked by a shared interest in 'fighting, running around, constructing'. But I worry about pitching artists against the visceral excitement which gladiatorial athletes can arouse. The adrenalin induced by boxing or baseball has no direct counterpart in our slower, quieter and more meditative response to art. And the exhibitors in Documenta IX should certainly not be seen as competitors, struggling to win the aesthetic equivalent of Olympic gold.

In one sense, though, Hoet's emphasis on physical endurance has a point. For visitors to Documenta need stamina as they explore the labyrinthine, endlessly proliferating rooms where most of the art is housed. They could be forgiven for envying the man in Jonathan Borofsky's colossal sculpture outside on the Friedrichsplatz, who marches on a gleaming steel pole towards the sky. Shirt sleeves rolled up, this purposeful adventurer has no trouble in defying gravity with God-like vigour. He gives the lie to the nearby eighteenth-century statue of Frederick II, posturing in imperial mode on a nearby plinth. The monarch looks as earthbound as the rest of us, but maybe Borofsky's heavenly explorer is reminding visitors that Documenta begins high up in the tower of the Fridericianum Museum.

Here, in a former astronomical observatory, eight artists mostly from the past provide the show with its historical compost. But we would be wrong to conclude that images like David's *Death of Marat*, Ensor's self-portrait, Gauguin's Tahitian scene and Giacometti's *The Nose* indicate a

backward lurch into traditionalism. For Hoet sees these secular icons as attempts to 'move out of history' and become 'liberated from constraints'.

Although the messianic arch-liberator Joseph Beuys is included in the tower, Hoet stops well short of proposing that artists can change the world. The collapse of utopian ideologies in recent years has convinced him that, if art can alter anything, it is the individual rather than society. Not that Documenta IX has a cautious air. Hoet wants the show to propose nothing less than 'a completely new structure, itself to be a blueprint for an approach to art in the nineties'. He aims at launching a forceful and even sensual onslaught on the spectators' nerve ends, with an exhibition that 'attacks visitors, seduces them, threatens, confuses, caresses, relaxes'.

This heady ambition takes its most frenetic form in the large and rambling Fridericianum Museum. Step inside the calm classical portico, and Bruce Nauman assails you at once with a loud, rasping, intensely theatrical installation. A vast white box crawling with images of black ants leads into a hell-hole of video monitors filled with pictures of a man's shaven head, spinning as he shouts out indecipherable noises. His relentless features look even more disconcerting when projected onto the surrounding walls. There is no respite inside this clangorous chamber, and even after we have escaped, the sound pursues us throughout the museum.

Hoet, emulating perhaps the syncopated rhythm of jazz, changes the mood dynamically from room to room. Next door to Nauman, Marisa Merz has placed a small, quiet fountain in the centre of an otherwise bare, white room. Her extreme purity contrasts with the sprawling prolixity of Michael Buthe's exotic installation beyond, dedicated to *The Holy Night of a Bride-to-be*. Around a fantastical structure of intertwined candles leading up to a cluster of gilded eggs, copper panels bear incised and freely splattered images of female figures.

By no means all the rooms strive for provocative contrast. The four gigantic white plaster heads by Franz West chime well, in their open anxiety, with the row of small watercolour faces by A. R. Penck ranged opposite. And Francis Bacon, one of only five British artists in the show, is hung next to a suitably ominous and disturbing photo series of shadowy figures by Suzanne Lafont. Bacon's death has turned his canvases into a memorial. They prove that the octogenarian painter was working powerfully to the end. And the triptych in particular takes on an elegiac air. A portrait of the younger Bacon is included in one section, balancing the unidentified face on the other side. The artist appears to be contemplating his life with sadness, and in particular the erotic urge which unites the two naked, writhing figures in the centre.

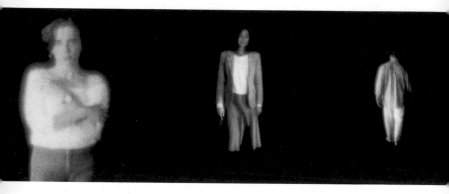

25. Gary Hill, *Tall Ships*, 1992

Mortality becomes even more overt inside the installation called *Precious Liquids* by Louise Bourgeois. Now eighty-one and still irrepressible, she has erected a wooden structure like an upended barrel with the inscription 'Art Is A Guaranty [*sic*] Of Sanity'. Inside, an ancient bed with a lead mattress stands below a cluster of empty, dust-laden glass vessels. Most of the liquid they once held has vanished down the plughole in the mattress, but hope survives as a luminous shell-like form glowing on the floor nearby.

Outside the museum, above the underground car park where the hard-hitting Cady Noland has placed damaged vehicles and photographs of crash victims, Anish Kapoor's exhibit takes the form of a simple cubic building. Inside, he confronts and disorientates the visitor with a large circular floor cavity, coated in limitless blue. The mysterious privacy of the experience he offers could hardly be further removed from Richard Deacon's sculpture, lying in open parkland below. Like a cross between a baseball bat and a juggler's skittle, his bulbous wooden form nestles contentedly within a crisp metal berth.

The show becomes confrontational again in the Neue Galerie, where the permanent collection of eighteenth-century portraits has been partly dismantled to make way for Zoe Leonard's close-up photographs of vaginas. They look startling among the polite, smiling society ladies, but amount to little more than shock tactics. I preferred the corridor where Joseph Kosuth has draped the old master paintings with quotations from, among many others, Wittgenstein ('objects I can only name'), Sartre ('hell is other people'), Artaud ('all writing is pig-shit'), and Auden ('art is our chief means of breaking bread with the dead').

But in the end Documenta is about the living. However partially Hoet has succeeded in arriving at his blueprint for the decade ahead, he does highlight artists who deserve to be better known. One, Bill Viola, presents a stunning video installation within a dark, tall vault at the new Documenta-Halle. Projected on an immense vertical screen, slow-motion images of a figure falling towards water, and then floating underneath, seize the attention with their alarming, mournful yet lyrical power.

Back in the Fridericianum, Gary Hill is equally mesmerising. Walk into his *Tall Ships* video installation, and the darkness prevents you from seeing anything at first. Then, by degrees, a long passage opens out ahead. White figures, all slightly out of focus, appear on the walls, walking towards or away from you. Whether tentative, friendly, puzzled or frail, they all seem at once intimate and remote. The silent frieze terminates on the far wall, with an image of a little girl. She raises her arms slowly in a simple gesture, and then returns them to her sides. Both welcoming and bemused, this vulnerable figure seems to be gently acknowledging the final unfathomability of human experience.

CHICANO ART
29 January 1993

They call the border a wall, an abyss, an umbilical cord, a war-zone and an open wound. The border, that is, between Mexico and the United States – the only territorial line dividing an affluent industrialized nation from the Third World. A border culture springs up there, like a scab struggling to form over a haemorrhage which can never, finally, be stemmed. And the boundary itself nags at the consciousness of American artists trying to make sense of their Mexican descent in the work they produce today. These Chicanos, who acquired their name during the politicized 1960s as a way of defining their troubled identity, have a distinctive presence in the border states of the USA. Almost unknown in Britain until now, eleven of them have been brought over to Manchester's Cornerhouse Gallery from San Diego, Texas and Los Angeles. Together, they blast a hole in our wall of ignorance about a vigorous, but inevitably marginalized movement in modern American art.

Not that they should be seen as a tightly knit group, united by a common manifesto and a shared way of seeing. The exhibition's layout, on

three separate floors of the Cornerhouse, stresses individuality rather than collective harmony. Some rely on traditional means of painting and print-making, others on multi-media installations. Autobiographical references fuel a few of the contributions, while elsewhere a reliance on more reportorial viewpoints gives the show a documentary flavour.

Even at their most removed from private experience, though, the artists are clearly fired by conflict, bewilderment and pain. Take the first room, where Richard Lou and Robert Sanchez have lined a narrow corridor with extracts from the *San Diego Union Tribune*. The clippings concentrate on stories of racism, not only in riot-torn areas of the USA but Europe as well ('The Klan Goes To Germany'). Written on the wall above them, a quotation from the Chicano writer and performance artist Guillermo Gómez-Peña confesses that 'I feel, right now, that we are equidistant from Utopia and Armageddon'.

But the stories recounted below propose a more pessimistic verdict. The corridor leads into a darkened room where newspaper cuttings, always wearisome to read in galleries, mercifully give way to video monitors. Projecting from black walls, where drawings of closed doors frame rubber gloves heavy with sand, the screens relay interviews with unidentified workers about to cross the border.

More disturbingly, they also record a sinister all-white demonstration on the border, where protesting residents of San Diego drove up to the frontier and directed car headlights at the desolate terrain. Their intolerance contrasts ominously with a nearby quotation from a Mexican emigrant, which helps to account for the presence of the gloves: 'We are offering them a hand, work they would not do. We are there to put our grains of sand with theirs.'

If the malaise is laid bare here, by two artists who live on the San Diego–Tijuana border, their work is over-earnest and lacks any feeling of real human engagement. Next door, however, Max Aguilera-Hellweg focuses on the border people themselves. They stare at his camera, half solemn and half defiant. Sometimes they hold attributes, like the outsize box of King o' Hearts lettuces clasped as a talisman by one young man. More often, they appear shorn of all props and possessions. But the most powerful photograph shows a boy in baggy short trousers, posing solemnly with a jumbo-size tyre resting on his head like a secular halo.

Perhaps he has salvaged the tyre from one of the catastrophic car crashes painted by Carlos Almarez. Before his untimely death from AIDs, he lived in Los Angeles – the largest Mexican city after Mexico City itself. But his vision has nothing in common with Hockney's hedonistic celebration of LA swimming-pools, where tanned bodies slump as if

mesmerized by reflections in the flawless blue water. Almarez is closer in style to Edward Hopper, closing in on the bleakness of flyovers and the minuscule cars they carry. Instead of Hopper's stillness, though, Almarez shows the vehicles plummeting from the freeways in flames.

Apocalypse is equally close at hand in Gronk's large, forceful paintings. Reminiscent of Philip Guston at his most sinister, they show corpses heaped below an erupting volcano or flames shooting from a despoiled, soot-black landscape. The outspokenness of the paintings, and their size, suggests that Gronk also owes a debt to the great Mexican muralists. He shares their theatricality, and his work sometimes resembles blustering backdrops for stage productions. But the small, white, free-standing houses placed on the floor in front of the canvases are quiet enough. As chilling as tombstones, they sum up Gronk's obsession with the pervasiveness of death.

Even when living people are depicted, in the paintings and prints of César Martinez, they look dour and defensive. His 'Pachuco' series portrays tough-looking men from the border towns, 'zoot-suiters' armed with sunglasses, swept-back hair and downturned mouths. Drawn from the streetwise characters Martinez grew up with in the 1950s, they all seem to be posing in photo-booths. But their uniform adoption of 'cool' cannot altogether hide a beleaguered weariness.

A similar aura of siege conditions gives Patssi Valdez's canvases their unease. Surrounded by funereal black borders painted directly on the wall, they show interiors where Mexican customs are defiantly preserved in Los Angeles houses. Whenever windows are shown, though, they hint at conflagrations beyond. And within the rooms, dining-tables become transformed into battlegrounds. Candle-flames are blown by winds from an unknown source, while wine-glasses teeter and chairs sway. *What Happened?* asks the title of one painting, without providing an answer. But the air of menace is unmistakable, and when Valdez shows forks skewering a water-melon, blood-coloured juices flow across the dizzily upturned table-cloth.

The domestic altars sometimes glimpsed in the background of her paintings come to the fore elsewhere in the show. For Amalia Mesa-Bains is preoccupied with this feature of the Chicano home, and her melancholy installation uses it to meditate on displacement. Dominated by a battered chest-of-drawers, the work seems stranded in a no-man's-land. The bottom drawers are open, and crammed with earth which spills across the floor nearby. Pot-pourri is scattered there, too, filling the air with unexpected perfume. But its sweetness only accentuates the bitter flavour of a work displayed against a paint-spattered backdrop.

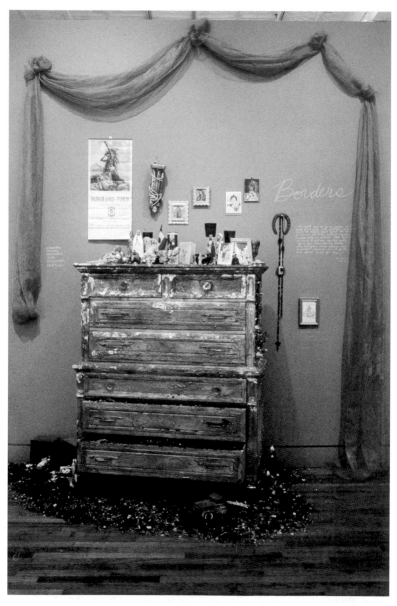

26. Amalia Mesa-Bains, Dresser from *Emblems of a Decade – Borders*, 1990

Superfluously, words like 'psychic destruction' and 'flux' have been inscribed there. The mixture of sacred and secular objects amassed on the chest-of-drawers, where a Madonna figurine stands near family snap-shots and children's shoes, evokes the altar tradition. None of these images can make amends for the prevailing mood of loss, however. Mesa-Bains focuses on the isolation of the migrant, and her lyricism ends up reinforcing the sadness blighting the wanderer without a home.

For Celia Muñoz, who grew up in the border town of El Paso, Texas, survival lies with the unions. Her wall-painting is festooned with the logos of women's unions, and they are contrasted with the images of Carmen Miranda on the opposite wall. With her face removed, this Hollywood stereotype is reduced to a bundle of outrageous costumes and the familiar, fruit-heavy head-dress. Exotic entertainment is over-schematically opposed to workers' solidarity, and Muñoz's contribution lacks the strong undertow of private feeling which gives Mesa-Bains her power.

In the weakest work on view here, the plight of the Chicano is charted, analysed and explained. But in the most memorable exhibits, dispossession is presented as an experience, enabling us to share something, at least, of their makers' insecurity, anguish and ineradicable sense of dread.

MARC QUINN, SARAH LUCAS, MARK WALLINGER AND ROSE FINN-KELCEY
12 February 1993

The most macabre art work in London is impossible to avoid when you enter the Saatchi Collection's latest show. Brazenly positioned opposite the entrance, a porridge-coloured head of a man is becalmed in a case resting on an unusually streamlined plinth. Viewed from the front, he looks calm enough. His eyes are closed, as in a death mask, and he frowns while clenching his mouth. Move round to the side, though, and you realize with a shock that dark red blood has oozed from a fissure in his neck. Running down from his right ear, the liquid gathers in a stickily congealed pool at the base of his head. It makes him look decapitated, like a guillotine victim carefully preserved as a trophy of The Terror.

But the truth is that Marc Quinn, the youngest exhibitor, made this disquieting image from his own features. Although it looks much older,

Self is a portrait of a twenty-seven-year-old artist. And after producing a cast of his head from dental plaster, he took a bizarre step. Nine pints of his blood, removed from Quinn's veins over a five-month period, were poured into the cast. So the plasma-filled effigy now has to be preserved in a refrigeration unit. While I stared at it, the plinth clicked and hummed efficiently. But the cracks running through the face act as a reminder of its vulnerability. If the unit faltered, *Self* would soon begin to dissolve like a blurred wax head by Medardo Rosso and, finally, end up as a puddle.

Quinn's unnerving sculpture might easily have seemed sensationalist, a latter-day exercise in Grand Guignol. The discretion of this oddly meditative image prevents it from degenerating into mere gruesomeness, though. He looks stoical, as if determined to endure his fragile state and survive. The advent of AIDS has made everyone acutely conscious of blood as a death-dealing fluid as well as the sustainer of life. Perhaps Quinn reflects this fear above all else, and tries to exorcise it through the ritual of constructing a talismanic likeness with his own, unpolluted plasma, isolated in an infection-free Arctic box.

Not that Quinn is unaware of the anxiety engendered by such confinement. *I Need an Axe to Break the Ice* is the desperate title he has given another, scarcely less strange self-portrait. This time, the artist's features are imprinted on a latex rubber balloon filled with air. This orange-yellow apparition is trapped inside a globe of glass. And below the vessel's tightly corked neck, three thin tripod legs give the sculpture only the frailest support.

Quinn is preoccupied with fragility: a full-length rubber figure, hanging in space and devoid of substance save for his skin, is as helpless as the emptied-out self-portrait which Michelangelo included in his *Last Judgement* fresco on the Sistine Chapel's altar wall. But there is absurd humour in Quinn's dangling man, too. He calls it *You Take My Breath Away*, as if to mock the figure's wraithlike condition. And in a series of wildly handled busts, baked in dough before being cast in bronze, faces purporting to represent Marie-Antoinette, Louis XVI and Dr Pangloss introduce a vein of caricature similar to Daumier. Although the rising of the dough in the oven has exaggerated their distortions, Quinn clearly relishes these fantastical, heaped-up aggregations of pummelled form. *Character Head*, cast this time in blue-tinged lead, is particularly battered: miserable lengths of dough sag down each side of his beaten-up face like a wig exposed to a rainstorm.

A strain of subversive mockery can also be found in Sarah Lucas's tough-minded work. But her starting-point is lodged far more combatively in the

27. Marc Quinn, *Self*, 1991

present. Outsize photocopies of spreads from titillating tabloids preside over her section of the show. At first glance, they resemble the rawness of early Warhol pictures based on newspaper front pages. But Warhol painted his images, and simplified the raw material. Lucas presents hers unaltered, like a Duchamp ready-made. And her relentless concentration on demeaning stories about women derives from a feminist perspective far removed from either Warhol or the other male Pop artists whose work she appears to cite: Peter Blake and Tom Wesselmann.

Most of her spreads come from the shameless *Sunday Sport*. 'Sod You Gits' runs one headline, 'Men Go Wild For My Body'. The story centres on 'topless midget' Sharon Lewis, 'the half-pint housewife' who unveiled herself as 'Britain's first-ever matchbox-sized SEX SYMBOL'. The tawdriness is intensified by sleazy small-ads for services like Massage Extra surrounding the story. They reappear on the borders of a grotesque work called *Fat, Forty and Fabulous*, where the crowing reporter declares that 'Horrible Hubby Reg Morris is so NAFFED OFF with his marsh-mallow-mound missus, Bet, he's put her up for SALE'. Whatever knockabout humour the story may once have possessed soon palls, leaving a sense of disgust.

I did not, however, find that Lucas's work sustained my attention for long. Sexism in the tabloids may still be rampant, but the target seems too obvious to be handled in such an unmediated way. Mark Wallinger, on the other hand, errs on the side of dissembling. 'Capital', his sequence of sombre, full-length portrait paintings, seems at first to depict homeless figures standing on pavements outside well-buttressed financial institutions. By presenting them in a glutinous, sub-academic and portentous style, normally associated with boardroom portraits, Wallinger hoped that irony would drive home his indictment of homelessness in capitalist society. But the paintings look turgid, and he further undermines them by basing the pictures on his friends, posing as derelicts. There is a patronizing artificiality about their scuffed shoes and baggy cardigans. The way they hold their beer-cans or bottles like symbolic attributes increases the theatrical air, making it impossible for us to take them seriously.

That is why I preferred Wallinger's other series, 'Race, Class, Sex'. Although the four near-identical paintings of racehorses have clear links with Stubbs, they are handled with freshness. Positioned on a blank ground, each stallion is firmly attached to a rein which trails out of the canvas. Their owner is in fact Sheikh Mohammed of Dubai, whose identity Wallinger has revealed (alongside the horses' names) on a caption. The Sheikh's racers look magnificent; and because they are based on photographs in a breeders' reference-book, their images are sleek enough to say a great deal about the glossy, pedigree-obsessed world of the turf.

The other artist in the Saatchi show returns us to the frozen numbness of Marc Quinn's *Self*. In order to maintain the minus-23 degrees centigrade temperature in her wrily named *Royal Box*, Rose Finn-Kelcey makes sure the door is tightly shut. But visitors can go inside the humming white vault for a few chilling moments. Once the door closes fast behind you, claustrophobia threatens within this nine-foot-square space. The U-shaped wall of glistening ice-cubes in the centre is oddly

seductive, though, and offers to enfold anyone hardy enough to linger there.

I did not pause long: the intense cold drove me out of this morgue-like interior very quickly. But Finn-Kelcey provides a beguiling alternative in her other installation. Surrounded by spotlights, an immense aluminium structure inhabits the middle of a darkened room. There is nothing oppressive about Finn-Kelcey's minimalism, though. The main part of her work consists of steam, rising from mesh on the floor and swirling towards dispersal in the hood overhead. Where *Royal Box* encloses the viewer in a rigid, bone-stiffening chamber of death, this installation is open, vaporous and free. Reminiscent of a giant steam-cleaning machine, or warm air escaping into a winter street, her lyrical work replaces sculpture's traditional reliance on solidity with the tantalizing evanescence of mist.

NEW ART FROM CHINA
9 July 1993

Late June in Angel Meadow, Oxford, and Cai Guo-Qiang lights a short fuse. Within seconds, before the artist has retreated to an entirely safe vantage, the fuse ignites the gunpowder he has lodged between a disc and the large paper sheet below it. But after a fierce flash and a profusion of smoke, he wastes no time in lifting the red-hot disc. The circular burn left on the paper satisfies him, and he repeats the explosive process on the edge of the same sheet.

Displayed now in Oxford's Museum of Modern Art, the spectacularly scorched image still reeks of smoke. It has an apocalyptic impact, suggesting a planetary collision. Guo-Qiang seems fascinated by the prospect of a cataclysm engulfing the world, but he is equally intrigued by the notion of creation emerging from devastation. The event in Angel Meadow, documented here by a video relayed on a screen, was staged as a tribute to the Oxford astronomer Edmund Halley. He gave a name to the comets that may have triggered the origins of life by colliding with the earth. And Guo-Qiang announces a determination to continue his own explosive pursuits by laying out heaps of gunpowder on the gallery floor, near a stone altar where herbal medicine, paper and charcoal are placed as if for a sacrificial ritual.

On one level, the result comes close to the installation work produced by so many young Western artists. The Oxford survey is devoted to site-specific pieces specially commissioned by MOMA from Chinese artists, and it proves that some of them have travelled a long way from the old political correctness. Living for the most part outside their native country, they have no hesitation in adopting materials and strategies radically removed from the tradition of ink-wash paintings. Guo-Qiang's gunpowder image could be seen as an all-out attack on accepted Chinese methods of picture-making, blowing them up in order to escape from their irksome constraints for ever.

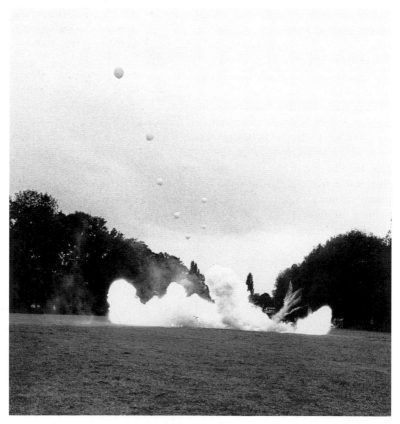

28. Cai Guo-Qiang, The Oxford Comet: Project for Extraterrestrials No. 17, *Silent Energy Energy*, Angel Meadow, Oxford, 26 June, 1993, 3.00 pm

On another level, though, the cultural origins of these exiles still show through. Chen Zhen, now based in Paris, shares Guo-Qiang's partiality for conflagration. Charred wood and newspaper ashes are heaped in a steeply ascending slope from the floor to near the ceiling of his space. But the apparent extremism of Zhen's work turns out to evoke the archetypal terraced fields of a Chinese landscape. Its incinerated furrows suggest that a catastrophe has overwhelmed the country, despoiling centuries of civilization.

Is Zhen concerned with Communism's destructive effect on China, or the threat posed to nature everywhere by technological advances? He leaves the question open, as befits an artist who has made his new home in Europe. Other exhibitors, though, share his pessimistic vision. Wang Luyan, who still lives in Beijing, conveys none of the knee-jerk optimism which used to be a hallmark of Maoist art. He has transformed the whole of his white, low-ceilinged room into a macabre factory where unspecified killings are carried out.

It might be an abattoir, but Luyan ensures that the organic forms defined in his black wall-drawings are impossible to pin down. These swollen, sack-like shapes resemble buttocks or hugely inflated intestines. They may well belong to humans, and the motorized saws dominating the room are undoubtedly slicing through their flesh. Red lines run like ropes on pulleys from one cutting machine to the next, implying that they are all controlled by a single, ruthless intelligence. But the overall purpose of the slaughterhouse is far from clear. Sometimes the saws appear to attack each other, or are left to spin on their own, as though waiting for fresh victims to dismember. The most memorable areas, though, concentrate on metallic teeth tearing their way into plump yet helpless bodies.

By refusing to identify these doomed forms, Luyan evokes a Kafkaesque world. Nothing is certain apart from the inevitability of an immense, remorseless process bent on persecution. The paranoia inherent in such a vision is tempered by the curiously matter-of-fact way in which the cruelty is presented. No anguished rhetoric can be discerned on these walls. Luyan's drawings are closer to diagrams than protests. But their air of deliberation does not detract from their power. They force us to ask questions about the likely source of the oppression outlined here. And Luyan offers no comfort to anyone hoping that the forces responsible for the Tiananmen Square massacre no longer prevail in China today.

Huang Yongping, now based in France, places time-honoured Western suspicions of the Orient at the centre of his provocative installation. Visitors approaching his room are confronted by a collapsed tent, filling

the entire gallery and containing an entrance at either end. One of them leads to an empty space, lined in yellow material and lit by a single naked bulb. But the other interior is far more disquieting. The see-through roof, alarmingly near our heads, turns out to be a breeding-ground for 1,000 locusts and ten scorpions. Most of them dangle from a net some distance above, but occasionally they drop down with an eerie ticking sound. The title of this threatening work, *Yellow Peril*, indicates that Yongping wants to make an ironic comment on European prejudices. But his own exiled status suggests that he harbours considerable misgivings about China himself.

By no means all the exhibitors have cut themselves off from Chinese art of the past. Xi Jianjun, who worked in London for several years, lays out five paintings like prayer-mats on the floor. Using a mixture of wax and coloured pigment, he smothers the surfaces of his wood panels like a cake-maker applying icing and marzipan with gusto. The swirling yellow and pink matter resembles a cosmos in flux. Smoothly worked passages alternate with thickened heaps, and the occasional straggling mark drawn as if with a stick. All the paintings give the impression of a gaseous, liquid substance which has only just cooled and gelled. The sense of spirituality suggests a kinship with Buddhist beliefs. But the indentations puncturing an orange picture on the wall look like bullet-wounds, and their blood-red interiors are reminiscent of stigmata.

Suffering is always present in this survey, whether as intimation or plain statement. The colossal paintings shown by Yang Jiechang in the final, lofty room all contain encrusted black forms. Their cracked surfaces, bordered by white rice-paper, hang down like cliffs of coal. They have a funereal presence, and seem to share Chen Zhen's interest in charred deposits. But Jiechang never allows his paintings to become smeared or messy. Unlike Cai Guo-Qiang's gunpowder pictures, the white surrounds are all left unblemished and immaculate.

This fastidiousness is a hallmark of Chinese brush drawings, and Gu Wenda comes closest to tradition by exhibiting four long scrolls executed in 1986 with ink and wash on paper. The landscape images they contain are, however, combined with heretical red forms sprouting limbs attached to bells. The outcome is deliberately discordant, and since then Wenda has moved away from native propriety altogether. In *The Enigma of Birth*, five wooden cots are ranged in the middle of his floor-space. The white beeswax splashed around them suggests that they are floating on a sea of milk. Dark brown placenta powder is scattered like earth on all but one of the mattresses. The other remains pristine, suggesting that birth has been aborted, yet new life is emerging in the cots nearby. Unaccompanied

by propagandist heroics of any kind, these mysterious powdered forms could celebrate the advent of an invigorated Chinese art, liberated at last from the enfeebling clichés of Communist conformity.

THE TURNER PRIZE 1993
5 November 1993

In recent years, work produced by artists shortlisted for the Turner Prize has often proved frustratingly difficult to find. There is, of course, the special exhibition mounted at the Tate Gallery. But the amount of space allotted to this event is modest — even if the current show is beautifully installed. Contributors are rarely able to display the full range of their abilities, and visitors come away with a limited understanding of the artists' true achievements.

The problem is compounded by the increasingly international nature of their reputations. Ambitious British art today is more likely to be seen outside this country, and the four 1993 contenders for the £20,000 prize are no exception. The oldest, forty-eight-year-old Sean Scully, is hailed by the judges above all for his major retrospective at the Modern Art Museum, Fort Worth. Hannah Collins, an elusive thirty-seven-year-old who now lives in Spain, impressed the jury with her contribution to the Istanbul Biennal and a retrospective at the Centre d'Art Santa Monica, Barcelona. Now thirty-two, Laos-born Vong Phaophanit was one of the younger artists representing Britain at this year's Venice Biennale. And thirty-year-old Rachel Whiteread is praised for her exhibitions in the Van Abbemuseum, Eindhoven, the Sydney Biennale and the Galerie Claire Burrus in Paris.

While congratulating the artists for their ability to gain such cosmopolitan reputations, we are entitled to lament the relative invisibility of their work within Britain. Luckily, though, two of this year's Turner line-up have just completed major works for public locations in London. Like so much adventurous new art, they are sculptures. But the forms they assume are far removed from the bronze monuments found in many of the city's streets and squares. Near the corner of Grove Road and Roman Road in the East End, Rachel Whiteread's *House* now reveals its ghostly presence. Isolated in a small park where a Victorian terrace once stood, it acts as a memorial to the vanished homes which lined the street.

Before the last house was demolished, she managed to make a cast of the interior. With the help of Tarmac Structural Repairs, who co-sponsored this audacious venture with Artangel and Beck's, Whiteread constructed a reinforced sprayed concrete lining inside the walls. The empty house was then sealed off, and left for a curing period to let the mould separate from the outer walls. Finally, over a fortnight in October, the exterior walls and features were dismantled, leaving Whiteread's grey alternative exposed.

It is an unsettling spectacle. Situated across the road from the Kingdom Hall of Jehovah's Witnesses, *House* has a Lazarus-like identity. The blanched structure seems to have returned from the grave, haunting us with its eerie ability to commemorate a house no longer there. The projecting windows at the front are clearly identifiable, but they all look silted up. So do the ascending ranks of fireplaces imprinted on the south side. Memories of Pompeii are stirred, as if the entire building had been engulfed and petrified by an avalanche of lava. Although birds have begun to perch on ledges, human habitation is out of the question.

From the north side, where dark traces of the stairs still zigzag through the pale concrete, *House* looks uncannily like a Brutalist building erected in the 1960s. But this bunker-like structure has an air of vulnerability as well as defensiveness. Occasionally, discreet splashes of pale green and yellow remind us of the wallpaper and paintwork which used to decorate the rooms. They intensify the sense of loss, and make us realize how Whiteread has exposed the private identity of the house to public gaze. Hence the rawness and melancholy of this enormously powerful sculpture, commemorating a century of domestic life even as it insists on the impossibility of ever recovering the lives spent within its solidified spaces.

The *Ash and Silk Wall* made by Vong Phaophanit at the Thames Barrier Gardens also possesses an elegiac aspect. Commissioned by the Borough of Greenwich and realized by the Public Art Development Trust, this profoundly ambiguous monument meditates on the way old walls are being torn down and new ones erected in so many countries. Exiled from Laos since he was eleven, Phaophanit is acutely aware of the barriers dividing different parts of the world. One side of his wall contains a layer of half-disintegrated ash, lit from behind so that its fine network of fissures stand out like meandering rivers traced on a map. Press your eye against one of these cracks, and the deserted chamber inside becomes visible. It looks ominous, but the removal of a central slab allows us to walk through the wall. And there, on the other side, an expanse of dark saffron silk irradiates the entire north façade. The relocation of the slab, which stands on its own nearby, is almost as affirmative as

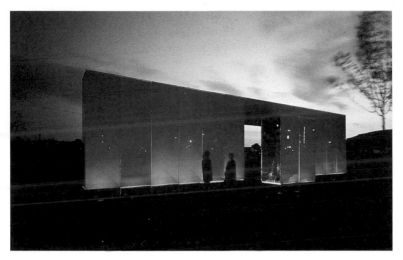

29. Vong Phaophanit, *Ash and Silk Wall*, 1993

the shifting of the stone from the entrance to Christ's tomb. It implies that barriers need not be immutable, and at night the refulgent silk glows like a beacon in the encircling gloom.

Sean Scully, whose three paintings occupy a powerful room of their own at the Tate, is equally monumental. He has long been one of Britain's finest abstract painters, although his decision to live part of the time in New York reflects a strong kinship with American art. Like Barnett Newman and Mark Rothko, he harbours the most elevated ambitions for an abstract language. The broadly applied stripes with which he constructs his images are always imposing. Their *gravitas* demonstrates the high seriousness of Scully's vision, but there is nothing self-satisfied about his paintings. He challenges their finality by lodging smaller panels inside each large picture. They set up a different rhythm, and assert higher-keyed colours among the subdued stripes around them. Often resembling flags or banners, they should have a disruptive effect on the severe architecture of the painting as a whole.

Integration is achieved, though. The disparate parts are brought together in a grand union, half austere and half sensuous. Scully's brushmarks, broadly applied in textured layers, complete the binding process with the help of a resplendent stand-oil pigment. He arrives at an overall richness which dispels any hint of rigidity in the stern disposition of his forms.

Hannah Collins, the least-known of the four, concentrates on black-and-white photographs. But they are blown up to a colossal size, filling the walls with sober images culled from her recent exploration of Istanbul. The most potent is an immense panorama of an empty and dilapidated street. It seems haunted by the people who must have passed through, and sums up Collins's preoccupation with the movement of economic refugees from East to West. Other images are more quirky, most notably a surreal picture of an ex-Russian Army rubber boat for sale in a street market. It looks oddly stranded and obsolete, like the country from which the vessel comes.

Collins herself seems well aware of the difficulties involved in discovering strangeness among such mundane sources. 'In my search for extraordinary places,' she writes, 'there is the mockery of the everyday.' But I prefer her dream-like street scenes to the more obvious theatricality of the other work on view: a studio-based, strongly lit shot of a long-haired young woman viewed from behind. This picture appears to strive for effect, whereas the Istanbul images arise more persuasively from their locations.

Who will win the 1993 Prize, to be presented by Lord Palumbo on 23 November? Predictions are notoriously fallible, but I feel certain that Scully and Whiteread are the most likely rivals this time around. And of the two, the maker of that unforgettable *House* deserves to carry the day.

IN DEFENCE OF NEW ART AND *HOUSE*
23 November 1993

When Lord Palumbo announces the latest Turner Prize-winner at the Tate Gallery tonight, plenty of commentators will be ready to deride the jury's choice. Knocking modern art, as hard and frequently as possible, is fast becoming a national media pastime. Tabloid headlines deplore each new supposed outrage in the most inflammatory language, vying with one another to shout the most virulent abuse and dismiss the entire activity as a preposterous hoax. Focusing on what artists do, they never bother to ask themselves why. It is enough to wax apoplectic over an unpredictable choice of material. This month, the rice in Vong Phaophanit's installation at the Turner Prize exhibition is the latest focus

for those bent on proving that contemporary art suffers from terminal cynicism or idiocy. Many of those who delight in reviling him probably have not even gone to Millbank and seen the work, let alone pondered the multiple meanings it conveys. Kneejerk hostility towards anything out of the ordinary decrees that the offending art must simply be condemned, with the maximum amount of speed and indignation.

Such tactics would not matter very much if tabloid newspapers ever deigned to write about contemporary art in other, less rabid ways. But they never do. Modern art is only mentioned in the popular press when a particular work is treated as an Aunt Sally, fit for brickbats and nothing else. So who can blame the readers if they conclude that galleries are riddled with fraudulent exhibits, fodder merely for those foolish enough to be duped by hollow pretensions?

It is a shame, because anyone who takes the trouble to visit the Tate might well end up with a very different view. Last week, I was invited to give a lunch-time talk about the Turner shortlist in front of the exhibits themselves. A substantial number of people turned up, and they listened with great attentiveness as we moved from room to room discussing the objects on show. Far from sensing antipathy and scorn, I was conscious of a widespread desire to look, learn and assess the work unencumbered by automatic suspicion. Their openness was enormously refreshing. I came away heartened by the realization that an unprejudiced attitude to modern art does exist here, waiting for the opportunity to discover more about work which often seems bewildering at first glance.

All the same, my optimism was tempered by an awareness that the odds are heaped heavily against the hope of fostering such a positive involvement. As the new millennium approaches, Britain seems increasingly determined to lapse into a nostalgia fit for devotees of a Heritage culture alone. While our appetite for the hallowed past swells to addictive proportions, our response to the new is invariably grudging. We mistrust the unfamiliar, preferring instead to reserve our enthusiasm for art already sanctified by time. It is as if the crisis afflicting Britain's post-imperial identity has made us seek reassurance in history, and shun contact with the disconcerting products of our own age. We often feel instinctively uneasy with work which does not provide the consoling toeholds offered by older art. Perhaps this uncertainty reminds us too much of our plight as a nation, forever looking back at an era of far greater confidence rather than coming to terms with the challenges of today.

No good will come of ruminating exclusively on Britain's vanished past, and we should rid ourselves of this disabling tendency to evade the

present. The greatest art produced during the twentieth century has often been profoundly disconcerting at its inception, but its ability to offend was a sign of strength. Take Picasso's prodigious early masterpiece *Les Demoiselles d'Avignon*, a painting so rebarbative that many of his admirers were alienated by its impact. Launching a headlong attack on the Western tradition of figure painting, Picasso envenomed his cluster of harshly simplified female nudes with the brusque, severe distortions he admired in Iberian, African and Oceanic art. The outcome was widely regarded as crude and repellent. Even Shchukine, the great Russian collector who amassed an outstanding array of avant-garde paintings, examined the canvas in Picasso's studio and blurted out an inconsolable verdict: 'What a loss to French art!'

Later on, he and other supporters of experimental work grasped the implications of *Les Demoiselles*, and realised that it opened up a wealth of fresh expressive possibilities. The picture itself, an unfinished battleground where rival ways of revolutionizing the human image struggled for supremacy, remained rolled up and unseen in the perpetrator's studio. Only when acquired by the Museum of Modern Art in New York, over twenty years after Picasso had first shown this pictorial crime to his dismayed friends, did *Les Demoiselles* assume its rightful position as a touchstone for the spirit of audacious, questioning vitality in modern art as a whole.

Plenty of people, especially in our hidebound country, continued to dismiss Picasso's achievements. After the Second World War, the immensely successful horse-painter Sir Alfred Munnings used his eminence as President of the Royal Academy to denounce both Picasso and Matisse. His intemperate and vigorously applauded comments at the RA banquet were similar to the vilification aimed at contemporary artists now. Munnings declared that his targets were irredeemable charlatans. Their work was dismissed out of hand, simply because it did not conform to Munnings' blinkered notions about what a work of art should be.

Even today, nearly ninety years after *Les Demoiselles* was executed, diehard opponents of the innovative impulse in twentieth-century art are still prepared to decry the painting's central importance. They argue that the adventurousness which fired Picasso throughout his career was misconceived, opening the gateway to a succession of increasingly ugly, nihilistic gestures which mock tradition and debase the very word 'artist' at every turn.

The truth is, though, that the makers of the finest and most nourishing art have never been content to rest on the example set by their forerunners. However closely they may study the past – and Picasso's rivalrous scrutiny of art history was second to none – they are determined to

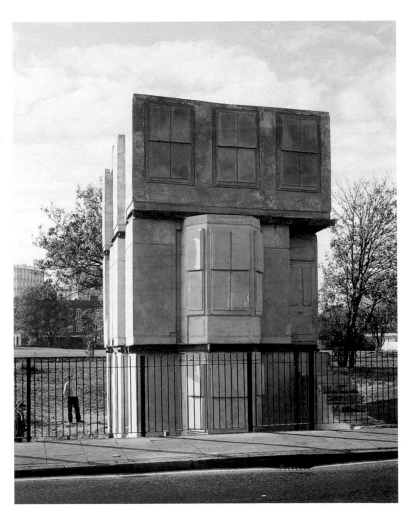

30. Rachel Whiteread, *House*, 1993

contest the solutions arrived at by their predecessors. In his day, Michelangelo was no more ready to reiterate his seniors' work than Picasso. Every great artist has developed a singular vision by departing, often with outright defiance, from the norm. Western art since the Renaissance has never stood still, and during the present century this fundamental dynamic quickened to an unprecedented degree.

The upheaval undergone by modern art is an authentic reflection of larger forces. They have themselves overthrown so many assumptions which the previous century took for granted. If artists had ignored the seismic changes of our own era, the work they produced would soon have ossified. We cannot expect the vital art of today to offer stale panaceas, when the world itself is plagued by so much turbulence and doubt. I expect the best work to stimulate and catch me off-balance, not act as a sedative. If artists want to deploy rice rather than pigment, or dispense with bronze in order to spray a reinforced concrete lining inside the empty walls of an East End house, then their right to experiment should be respected.

An unconventional material is no guarantee of a powerful outcome, of course. It all depends on the intensity of the artist's imagination, and critics must always be prepared to distinguish between the potent and the meretricious. Sometimes, a painter as penetrating as Lucian Freud can renew the language of art by adhering to brush, canvas and the figurative image. But if a new way of working can produce a sculpture as haunting as Rachel Whiteread's *House*, then its departure from precedent is entirely justified. By turning private space into a public memorial, by making emptiness take on an eerie solidity, by transforming a home into a sepulchre and finding expressive form for her preoccupation with the irrecoverable past, Whiteread has made an austere yet melancholy monument which touches on all our lives.

We may not, initially, realize that *House* is a sculpture or feel willing to regard it as a work of art. But if we are prepared to shed our preconceptions, and acknowledge that the modern artist should be allowed to explore new ways of making, then this *memento mori* may well move us with its brave, gaunt and oddly resilient insistence on the finality of human loss.

BILL VIOLA
29 December 1993

While too many video artists numb the viewer with tedious and unbearably protracted images, Bill Viola makes sure that his installations invade our senses on the most visceral level imaginable. I still vividly recall his tall, shadowy vault at last year's Documenta, the mega-survey of contemporary art where 190 exhibitors jetted in to Kassel from all over the world. Among so much meretricious work, Viola's slow-motion images on an immense vertical screen held me enthralled. With alarming yet oddly lyrical power, he showed a figure plummeting towards water and then floating underneath. Suspended between death and life, this elegiac image was enough to convince me that Viola could make video as mesmeric as the most potent painting or sculpture.

My belief is reinforced by his first substantial British exhibition, held at the Whitechapel Art Gallery and augmented by an earlier work at Anthony d'Offay's. The entire barn-like space on the Whitechapel's ground floor has been darkened. Visitors are confronted at once by a colossal three-panel piece projected on a screen almost as wide as the gallery itself. In the centre, the largest image is again focused on an underwater figure. But this time, it is flanked by panels which give the work even greater resonance than its predecessor at Documenta. Like an altarpiece in a penumbral church, where paintings of the nativity and crucifixion are poignantly juxtaposed, Viola's *Nantes Triptych* encompasses birth and extinction with equal directness.

In the left panel, Viola's wife and collaborator Kira Perov is seen bracing herself for the imminent birth of their second child. On the right, Viola's elderly mother approaches her death. The contrast between the two events, separated in reality by a nine-month gap, is stark. Kira crouches, breathing vigorously whenever her contractions resume and supported, from behind, by the naked arms of her husband. From time to time, medical figures move in from the foreground to assist her, and during the climactic moment of birth she is surrounded by helpers. Viola's mother, on the other hand, is for the most part alone. Stretched out motionless in bed, she has nobody to clasp her. Breathing only in feeble spasms, with the aid of a long tube attached to her throat, she is unable either to move or talk. Her mouth hangs open, as if gasping for air, and she occasionally blinks. But she seems unaware of her surroundings, and does not appear to respond even when a man sits beside her.

The silence enveloping her room becomes even sadder when inter-

rupted by Kira's accelerating cries of pain. As the contractions intensify, she begins to sound uncannily like the baby who will soon emerge. Noise also erupts from the central panel, as the anonymous figure crashes through the water and floats, in slow motion, beneath the surface. When Kira lapses into quietness, and waits patiently for the next bout of pain, our eyes travel across to this shrouded presence drifting through the submarine murkiness. Sometimes, the clothes billow outwards in the water and take on a twisting life of their own. The screen is filled with undulations of cloth, stirring memories of the draperies which play such an expressive role in so many Renaissance paintings.

Detached from the figure they once enclosed, these looping and spiralling sheets encourage us to think of a soul rather than a body. They seem to be hovering in limbo, waiting for a resolution of their indeterminate state. Like the old mother on one side and the young wife on the other, the sheets and their wearer have no means of knowing when they might be released from travail. But towards the end of the *Nantes Triptych*'s duration, a mysterious light appears in the central panel. Its radiance coincides with the beginning of birth and with our realization that the dying woman has very little time left. So the advent of brightness appears to symbolize both the baby's emergence from the womb and the departure of the mother's spirit from her body.

The drama of the birth itself, and the safe delivery of a son, inevitably wrench our attention away from the nearby death. Our feelings of relief and satisfaction as the newborn infant is pulled free, and then handed straightaway to his mother, are compounded with guilt when we realize that the woman's final moments have failed to sustain as much of our interest. Dying is unavoidably lonely, even when a hand comes forward to stroke the woman's forehead.

But as the baby nestles into his mother's breast, and stares blearily at his new surroundings, we find ourselves giving an equal amount of attention to both sides of the work once more. Infant and old woman are now seen in close-up. Her face, in death, is resting on the left of the pillow. Her gaping mouth has fallen awkwardly in the same direction. The baby's lips are closed, and the alertness of his gaze contrasts with the sightless shadows beneath his grandmother's loose eyelids. All the same, he looks bemused and weary. His puffy face testifies clearly enough to the arduous journey he has undergone. In this respect, the newborn and the dead are united. They have both reached their destinations after prolonged turmoil, and the shrouded figure between them is finally released from limbo as he rises towards the water's surface before disappearing in a sudden rush of sound and light.

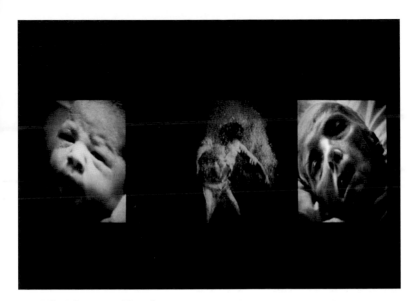

31. Bill Viola, *Nantes Triptych*, 1992

The *Nantes Triptych* amounts to an unforgettable experience. The frankness with which Viola approaches his mother's death arouses a certain amount of unease, just as Monet's decision to paint his wife Camille on her deathbed in 1879 still has the ability to disturb. Many years later, Monet felt mortified when he remembered that picture, and wondered if his willingness to paint it had somehow compromised his feelings as a human being. On balance, though, Viola has no need to regret filming his mother's last moments. However private her death and the baby's birth undoubtedly were, they now have the capacity to help us meditate on the beginning and end of all our lives. During his travels in the South Pacific and Japan nearly twenty years ago, Viola immersed himself in Zen Buddhist philosophy. The experience may well inform the contemplative character of the *Nantes Triptych*, and in particular the unfathomability conveyed by the unknown figure suspended so eloquently at the heart of the work.

Birth and death are brought even closer together in *Heaven and Earth*, where two black-and-white monitors are lodged at eye level in a slender wooden column extending from floor to ceiling. Viola's dying mother reappears on the upper screen, and his new-born son on the one below.

Although they face one another, in apparent confrontation, the two faces soon merge. But this affirmative sense of unity is not sustained elsewhere in the exhibition. Upstairs, in a chilling and darkened room, sleeping heads on video screens are isolated at the bottom of water-filled barrels. We stare down voyeuristically at each face, registering every facial twitch and sudden, involuntary movement of a hand. While sharing the condition of slumber, each one remains trapped and solitary.

Confinement is challenged further on, where a captivating and superbly orchestrated installation called *Slowly Turning Narrative* dramatizes the tension between a monochrome man's face and colour footage of events from the outside world. They are projected on either side of a rotating screen in the middle of the room. The frowning man seems to be struggling to escape from introspection, and engage with the communal activities on the other screen. But he cannot cast off his self-absorption, just as we are continually reminded of our own watchful presence through images reflected in the mirrored surface of the screen.

The alienation becomes stronger still in the final work, where an electronic sign sends illuminated news-flashes travelling round a large white structure. Anyone entering the shadowy chamber within discovers that the walls are dominated by images of sleeping heads. Impervious to the events proclaimed so clamorously on the outside, they confirm the division between private experience and social reality. It is an ominous conclusion, but Viola's mastery at least ensures that the gulf separating video art from its potential audience has been triumphantly and enrichingly bridged.

JENNY SAVILLE, SIMON ENGLISH AND SIMON CALLERY
22 February 1994

In the past, a head of dried blood and a pickled shark have confronted visitors who braved the dizzying whiteness of the Saatchi Gallery. For his third exhibition of young British artists, though, our most voracious contemporary collector confounds all expectations. Painted canvases fill the available space, and the images they contain are, for the most part, unashamedly figurative.

Saatchi is not alone in deciding to focus on new painters: the Hayward Gallery will soon be unveiling, as a companion to its Dalí show, an inter-

national survey called *Unbound: Possibilities in Painting*. So the hallowed business of mark-making on canvas is once again a focus for debate. Having enjoyed a few over-promoted years in the 1980s, when a hectic neo-expressionism became fashionable, painting has in recent years been overshadowed by sculpture, installation art and other alternative media. But what John Golding describes as 'the most aristocratic of the visual arts' will never fade away. Its innate resilience has just been demonstrated in Lucian Freud's success, and at the Saatchi Gallery a twenty-three-year-old called Jenny Saville proves that the Freudian legacy can be a fruitful starting-point for an ambitious painter from the emergent generation.

Nowadays, artists often spend so long at college that they are rarely expected to produce anything significant before the age of thirty. So the overwhelming assurance and finality of Saville's work is quite a surprise. The first image we encounter in the grandest Saatchi space is a titanic triptych entitled *Strategy*. Each panel takes a different view of a mountainous woman, dressed only in unflattering white underwear. Seen from below, her thighs, belly and breasts take on epic proportions. As my eyes travelled up her bulging flesh, I felt like a climber tackling an awesome rocky outcrop. Saville has subtitled her triptych *South Face / Front Face / North Face*, and she probably realizes that the metaphor of woman as mountain has already been explored in British art by Henry Moore. Unlike Moore, however, she makes little attempt to simplify or transform her figures. Far from undergoing a metamorphosis, they remain uncompromisingly real.

But they are far from straightforward. Rather than painting a posed sitter, Saville relies on photographs either of herself or a model. There is a tough element of self-disclosure about these daunting images. If her precocious skill enables Saville to render the lividness of north European flesh, and make all the imperfections of her women uncomfortably persuasive, she never seems to view them with clinical dispassion. Her sense of involvement is paramount, as she closes on these redoubtable, over-life-size bodies and insists that they impress themselves on our vision.

In an age when fashion presents women as waif-like creatures, slim to the point of anorexic, Saville's Amazons act as a meaty corrective. They make no attempt to hide their Rubensian girth, and their faces are the opposite of ingratiating. In *Branded*, the woman grabs a hefty fistful of her own sagging stomach and brandishes it, as if in defiance of anyone who scorns her bulk. There is nothing abashed about these pendulous presences. They thrust their flabbiness towards us, display the stretchmarks on their backs and, in a close-up worthy of Oliver Cromwell, expose the wart protruding from a swollen cheek.

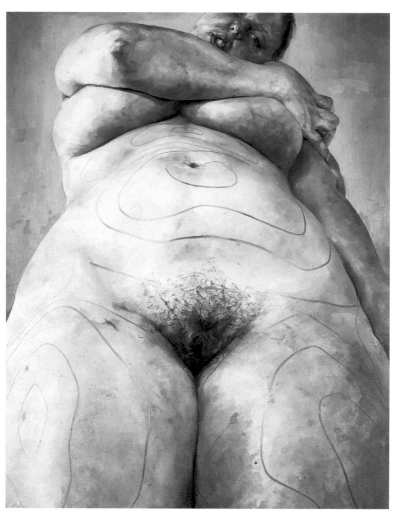

32. Jenny Saville, *Plan*, 1993

All the same, they stop well short of complacency. On the surface of the colossal nude in *Plan*, lines undulate like the contours marking hilly regions on a map. Coursing across ribs, belly and thighs, they reinforce the notion of woman as landscape. And Saville places the body in a more recumbent pose here, so that we seem to look down at her from above

rather than below. But why are the lines there? According to the artist, they represent 'the marks they make before you have liposuction done to you'. So this is woman as target, someone so dissatisfied with amplitude that she is willing to submit herself to the surgeon's knife.

Ultimately, though, the best of these paintings derive their power from ambiguity. There is a hint of regret in the face partially sliced off by the top of the canvas in *Plan*. Lifting both breasts with her right arm to gaze down at her body, she appears to wonder if voluntary violation is the right course to adopt.

Another source of disquiet arises from the words scratched on to some of the figures. 'Svelte' has been incised, in mirror writing, on one woman's distended stomach. It reads like a condemnation, carved in her superfluous flesh by an observer determined to make the errant body conform to current stereotypes. However much Saville's work implies a desire to escape from tyrannical rules about acceptable physiques, the words suggest that she recognizes the potency of fashionable edicts. Hence the anger with which they appear to rip into the women's flesh. These are paintings where the rigour and exactitude of the realist tradition is allied, quite startlingly, with the rawness of street-corner graffiti. That is why they amount to far more than diligent life-class nudes, and why Saville will be a painter to watch if she sustains her present level of achievement in the years ahead.

Simon English, more than a decade older than Saville, is equally prolific. He shares her central commitment to figurative art, devoting each of his canvases to the nude. But there the resemblance ends. While Saville concentrates on women, and lets them stare out at us with sullen obstinacy, English paints men absorbed in their own private world. Her bodies are brazen and alone, whereas his are furtive and congregate in spaces resembling bars or changing-rooms.

The sexual charge in his work is wholly homoerotic, laced with fear and guilt. Although they gather in communal locations, these figures rarely seem to talk. Lined up against a bar, they all look despondent and curiously isolated. Even when they close on each other and begin to couple, there is no sense of relish or fulfilment. Sex is presented here as an impersonal activity, indulged in by people who remain unknown to their partners. They all appear burdened by the impossibility of achieving anything more than hurried, shadowy contact. And English's free, fluent brushwork accentuates their predicament, presenting them as vulnerable beings whose bodies seem far less solid than Saville's palpable women. After a while, his work becomes monotonous and oppressive. If the compositions vary, the mood does not. It remains gloomy and self-pitying, suggesting that English regards homosexuality as a predicament devoid of joy.

It is a relief to turn from this lachrymose vision and encounter Simon Callery's paintings. No emotional wallowing can be detected in his bleached, spartan images. Understated to the point of coolness, they look at first like purist abstractions. But these pictures need time. After a while, their references to urban views grow mistily apparent. He invites us to raise our eyes above the people whom Saville and English might study in the city, and look over the roof-tops towards the polluted, rain-sodden greyness of the sky.

Nothing can be pinned down with certainty, however. Saville's appetite for pictorial fact is replaced, here, by elusiveness. Instead of following English's example and asserting bravura brushwork, Callery restricts himself to spare horizontal lines and diffident curves. His approach is ascetic, linking him with the puritanism of the Euston Road School. But he does not share William Coldstream's insistence on scrutinizing his subject as the painting proceeds. Callery's cityscapes are based more on recollection than observation. They owe a great debt to the most purged and disciplined of abstract artists, even if their veiled reticence also stems from prolonged familiarity with the peculiarities of the vaporous English climate. Within the limits he imposes on himself, Callery ends up achieving a modest lyricism. Quietly devoted to his native London, he finds a muted poetry even in the pallor of a cloud-heavy metropolitan panorama.

UNBOUND
8 March 1994

At many explosive points in the twentieth century, the death of painting has been gleefully announced by artists eager to promote their alternative strategies. But its funeral has never taken place. The act of applying coloured pigment to a flat surface still stubbornly continues. Far from fading into a decline, painters even have a habit of flourishing anew in old age. And younger adherents keep on coming, in defiance of every millennial edict about art's need to harness the dubious resources of computer-land.

In my view, painters today benefit from the lack of a fashionable bandwagon. There was a time, in the early 1980s, when a hectic onrush of neo-expressionism suddenly became promoted. But the hype soon backfired.

The triumphant 'New Spirit in Painting' faltered when rhetorical bluster and grandiosity marred too many mega-canvases. Subsequent attempts to launch a revival of hard-edge abstraction never achieved lift-off: who now remembers so-called 'Neo-Geo'? So I was sceptical when the Hayward Gallery announced its intention to mount an international survey of painting today.

Would we be confronted with yet another puffed-up attempt to maintain, in the teeth of all the evidence, that painters were approaching the century's end with victory glinting in their eyes? Such an inflated notion disregards the fact that art now benefits from an exceptionally catholic range of possible approaches. To exchange this breadth for a narrow adherence to painting alone would indeed be a limiting, dogmatic manœuvre.

Happily, the Hayward's offering suffers from no such delusions. Its main title, *Unbound*, might suggest a clarion-call. But the subtitle, *Possibilities in Painting*, indicates a more modest and open attitude. The painter and critic Adrian Searle, who selected the show with Greg Hilty, declares in his sprightly catalogue essay that people who treat painting 'as an "old-time religion", and they are endemic, especially in Britain, will find little comfort here. This is not a return to order but a breaking of bounds.' Far from heralding the advent of yet another movement or style, Searle shies away from making 'premature claims to greatness'.

He is wise to do so, but the survey does have a loose-limbed coherence of its own. While roaming widely in age, nationality and ways of working, a consistent temper does emerge from this feisty selection. Take Jonathan Lasker, whose jumbo-size *Public Love* shouts out at you across the immensity of the first gallery. Its proportions suggest that the New York-based artist is measuring himself against the Abstract Expressionists. But instead of striving for Rothko's sublime heights, Lasker includes passages based brazenly on doodling and scrawl. By enlarging his preliminary scribbles to titanic dimensions, and using thick ropes of paint, he somehow invests the most inconsequential marks with unexpected grandeur. The scale of skyscrapers is conveyed in slabs of grid-like yellow pigment, and big-city clangour evoked by the rasping orange ground.

Lasker's other exhibits are far less impressive, but the gutsiness of *Public Love* helps prepare us for the most disconcerting work on view. Jessica Stockholder, another ebullient New Yorker, punches through the Hayward's pristine white partitions to disclose the stair-rail hidden behind. She revels in subverting the standardized purity of museum display. For the gash is carried through to the next room, where Stockholder uses it as a doorway to let in a jumble of garish-coloured

materials and found objects. Is it painting, or installation art run riot? Well, Stockholder does use pigment; but she enjoys extending the limits of painting far beyond the canvas. *Fat Form and Hairy* runs the title of her contribution, summing up the belligerence and cheeky humour which gives the work its flamboyant sting.

Unbound knows how to pair its participants, and Stockholder chimes well with Fiona Rae nearby. While adhering to the convention of a canvas-on-a-wall, Rae handles her brushes with much of Stockholder's swinging force. Or rather, she used to. The earliest painting is wilder in handling than Rae's recent purple and orange triptych. Here, the arrival of more sumptuous colour is accompanied by a crisper, neater definition of form. I hope Rae is not losing her admirably un-English lack of inhibition, as she moves towards a more imposing and weighty way of painting.

So far, the show contains scant evidence of an interest in the figurative tradition. Even the oldest artist here, the sixty-four-year-old Belgian Raoul De Keyser, gives only tantalizing hints of his work's origin in observed reality. Sometimes his recurrent oblongs suggest windows, and Matisse's fascination around 1914 with the interplay between outdoor views and interior space. One of De Keyser's deceptively unassuming pictures bears an astonishing resemblance to a 1915 abstract by Vanessa Bell, now in the Tate's collection. In another picture he indicates clouds punctuating a clear sky, only to cancel the illusion with a vertical smear of crimson.

While the tension between extreme abstraction and traces of the visible world is kept alive in De Keyser's quiet work, younger painters often prove more willing to admit representational references. But they reserve the right to deploy irony, as though to underscore the impossibility of using figurative language in a direct, uncomplicated manner. Another Belgian, Luc Tuymans, even mixes a cracking agent with his paint. It gives the pictures a prematurely aged appearance, suggesting a desire to mock his own fondness for the art of the past.

As for the outrageous Juan Davila, a gay Chilean who has unaccountably lived in macho Australia for twenty years, his huge wall-work is riddled with subversive tactics. Noble mountains rear, but then are undermined by an inset panel filled with comic-strip smuttiness. Passages of delicate brushwork alternate with straggling and splashed areas, or images as garish as a kitsch restaurant mural. The whole jarring ensemble is entitled *Utopia*, but it looks more like Hell.

Anyone hung near this brash, grating artist is liable to look tasteful. Michael Krebber almost fades from view, so tentatively does he dab and scribble away at a silhouetted figure and ghostly kitchen crockery. His

33. Luc Tuymans, *Candycontainer*, 1992

work seems scrappy and half-starved, whereas Gary Hume's *Patsy Kensit* and *Tony Blackburn* are too suave for their own good. Only Peter Doig survives his proximity to Davila with robustness. All these paintings contain references to the snowbound immensity of his childhood surroundings in Canada. But Doig's reliance on representation is a complex, eclectic affair. Munch-like trees alternate with freewheeling skeins of Pollockesque paint in the busy, worried surface of *Pond Life*. Even the quietest and most beguiling of his exhibits, *Window Pane*, contains many different kinds of mark-making within its overall winter stillness.

The decision to include Doig, who was awarded a well-deserved First Prize at the last John Moores Liverpool Exhibition, proves that *Unbound* is not afraid of painters who leave abstraction far behind. But the strain

of sadness in Doig's work might partly reflect an awareness of how difficult it is to use representation in a new way. 'Belatedness, the sense of coming after everything has already been done, can lead to a melancholic sense of exhaustion,' writes Searle, before adding: 'but is painting exhausted?'

The answer, according to this welcome show at least, is that the best hope lies in diversity. I share this belief, and understand exactly why one upstairs room juxtaposes Paula Rego with Zebedee Jones. In technique and outlook alike, they could hardly be more removed from each other. The fifty-nine-year-old Rego belongs ever more squarely within the mainstream tradition of European figure painting. Although sometimes cluttered to a fault, compared with the arresting simplicity of her work in the late 1980s, Rego's paintings continue to draw potent stimulus from the wealth of imagery crowding a canvas called *The Artist in her Studio*.

Rego is a dreamer, unafraid to immerse herself in childhood stories. Whereas the twenty-four-year-old Jones obliterates all trace of narrative in his uncompromising work. His acute deafness may help to account for the sensation, within the heaped layers of these thick, grey pictures, of smothering. But their strange luminosity is not despondent; and between the polar extremes of Jones and Rego, painting in the 1990s has plenty of freedom to confound anyone who still insists on consigning it to a premature grave.

BEYOND BELIEF
26 April 1994

At first glance, Stephen Murphy's exhibit at the Lisson Gallery simply looks like a series of family snapshots, strung along the wide, white wall. Their smallness and poor printing, so different from the glamorous sheen of the photos we collect from the chemist today, indicate that they were taken decades ago. But their emptiness soon becomes disconcerting. As our eyes travel along the row, we realize that all the pictures are eerily unpopulated.

A table is laid for a meal, but nobody is there. A pram is prominent in another picture, without any sign of a baby. Toys, scattered on the grass, are unaccompanied by children. And a back garden is occupied only by a coiled hose. The cumulative effect is unsettling. People seem to have been

erased from these images as ruthlessly as the dissidents whom Stalin banished from offical Soviet photographs. And unlike the faulty airbrush elimination employed by Soviet technicians, Murphy's computerized processes are seamless. No trace remains of the figures, whose presence can only be guessed at. Knowing that Murphy has access to state-of-the-art technology, I found myself shuddering at the surgical efficiency with which humanity had been excised from these seemingly harmless little pictures.

On another level, though, these images remain very open-ended in their meaning. Are they a lament for the passing of time – a melancholy acknowledgement that the people who once inhabited these snapshots are either dead or grown virtually beyond recognition? Or is Murphy after an alternative reality, generated by computer know-how to the point where it rivals anything we receive through perceptual experience? Both possibilities are tenable, yet Murphy's other exhibit suggests that the latter is more important to him. Called *Cell*, it consists of a single photograph. Monumental and glossy, it could hardly contrast more strongly with the family pictures.

But the atmosphere in this green interior is disconcertingly similar. We seem to be imprisoned within a windowless space, padded and probably soundproofed as well. A passing resemblance to the bouncy castles in children's playgrounds only reinforces its sinister impact. For nobody jumps up and down in this deserted chamber. It is a sterile, wholly dehumanized environment, and Murphy's ability to conjure such a credible space from computers alone only reinforces the aura of a world outside our control.

Although Murphy's fellow-exhibitors are a disparate bunch, culled from France and the USA as well as Britain, this stimulating Lisson show does have a strong overall mood. *Beyond Belief* is its collective title, and many of the exhibits do possess a threatening aspect. Philippe Ramette's sculpture sounds the clearest alarm of all. *Object with which to be struck by lightning* could be described as a suicide machine. Attached to the wall, its metal headband is connected by conducting rods to a pair of empty sandals resting on a wooden block. As with Murphy, the figure is absent. But the potential effect of this appliance on the human body is readily apparent. A leather chinstrap dangles beneath the helmet, which sprouts a warrior-like spear. Without the title to guide our responses, we could easily mistake this chilling object for an executioner's weapon. Memories are stirred of an electric chair, waiting for the next victim to arrive.

Mercifully, perhaps, Ramette's macabre imagination is seasoned with wit. His most restrained exhibit, a wooden wall-piece, is called *Domestic Scaffold*. Thin, vertical and neatly contained, its capacity for

destruction remains untested. But the whole notion of having a scaffold on hand in the kitchen or living-room has a certain bleak humour, and Ramette's other sculpture pursues the theme of retribution in the home. Described as a 'proposition for urban furniture', the sculpture stands on the floor like a corner sliced out of a room. Although it invites us to think of school dunces, ordered to languish in the corner of the class, the raw wood finish is more akin to a sauna than a schoolroom. But the work's title, *Object for Penitence*, banishes all thought of corporeal pleasure. This is a work apparently intended to stand in its owner's house as a warning, even though Ramette refuses to let us know how vindictive he really is.

If narratives of punishment are suggested in his work, the full story is never revealed. The same policy of deliberate frustration seems to lie behind Doug Aitken's *Autumn*, a three-monitor laser-disc installation which frustrates all our attempts to find out precisely what is going on. The opening moments of the video, simultaneously transmitted from different parts of a darkened room, seem simple enough. A jet flies above the clouds, and shots of the aeroplane are intercut with images of a young woman with blonde, close-cropped hair. Then a man is introduced, playing a record and staring at his reflection in a cluttered bed-sit. But he has no obvious connection with the woman, who reappears driving through urban spaces as well as walking across flat, lonely landscapes.

Sometimes, she seems conscious of the camera's intrusive presence and stares directly into the lens. But the images go in and out of focus, and disconnection is the keynote. Towards the end, a glittering nocturnal panorama of a city from the air reminded me of the opening sequence in *Blade Runner*. Aitken's world does seem close to the alienated dystopia described by Phillip K. Dick. *Autumn* is, apparently, a re-edit of three commercial music videos made by the artist. Accompanied now by a plaintive electronic score, culminating in the scream of a jet, these jaundiced and tantalizing images could be intended as an antidote to the upbeat inanity of most promotional videos pumped out by the music industry.

All the same, quirky humour prevents this show from depressing the spirits. Aitken's work reappears, half-hidden behind the basement stairs, and this time it relies on a pair of crutches. One, propped against the far wall, sprouts a cast of E.T.'s head. The other, grounded in an unidentifiable cast resting on the floor, bears an uncanny resemblance to a hoover. We are back in Ramette's world of domestic dementia, and the electric lights and cables surrounding the crutches add to the air of violence barely withheld.

By no means everything in the show has the power of Murphy, Ramette and Aitken. Don Brown's blown-up colour photograph of a romanticised mountain scene, possibly derived from a backdrop at a fun-fair, fails to sustain attention for long. And Michael Gray's upside-down bicycle, displayed with mock-solemnity on a plinth and coated in white silicone, lacks any potent undertow of feeling. But the big video instal-lation, by Jane and Louise Wilson, does linger in the mind. Framed by a doorway, so that it resembles stage scenery, *Hypnotic Suggestion '505'* has a highly theatrical presence. As the title suggests, it also possesses a built-in ability to mesmerize. Both dressed soberly, against an institutional blue curtain, the artists sit in black leather chairs. They submit to the slow, soothing, almost priestly voice of a hypnotist. And part of the video's fas-cination lies in the spectacle of two young women abandoning them-selves to a calm yet deeply manipulative male authority.

The main drama, though, centres on the artists' reaction to their god-like instructor. They are twins; and having fallen into a trance with aston-ishing rapidity, their movements echo each other throughout. One of them is quicker than her sister, especially when commanded to raise her hand to her face. But on the whole, a sense of uncanny uniformity pre-vails. They are turned from individuals into marionettes, silently obeying their master's lulling injunction to feel 'restful, peaceful'.

34. Jane and Louise Wilson, *Hypnotic Suggestion '505'*, 1993

Ultimately, however, the video leaves us with an enigma. The faithful recording of the hypnotism only deals with the surface of the artists' experiences. We have no inkling of how their minds behave during the session, and at the end the camera zooms in slowly on the curtain until the entire screen is filled with a mysterious, gently pulsating expanse of blue.

SOME WENT MAD . . .
3 May 1994

Suspended in milky green formaldehyde, a dead lamb confronts visitors to the Serpentine Gallery's new exhibition. Although its body has been emptied out and stuffed with canvas, the animal still looks surprisingly frisky. It seems arrested in space, as if poised to leap through the gallery window towards the green delights of Kensington Gardens beyond.

However macabre the lamb may appear, fresh from a knacker's yard in Guildford, it is far milder than much of Damien Hirst's work. Still under thirty, he has rapidly become the most notorious young artist in Britain. His best-known sculptures belong to the Saatchi Collection: a dead shark swimming in a see-through tank, and an even more eerie work involving flies and a rotting cow's head. Here, by contrast, he seems on his best behaviour.

But there is nothing remotely comforting about the international exhibition Hirst has selected for the Serpentine. He calls it *Some Went Mad, Some Ran Away*, and the sense of a world unhinged can be detected in many of the contributions. Perhaps influenced by Hirst's choice of subject, the New York-based Ashley Bickerton hangs a shark upside-down from the centre of the main room. But his is made of black rubber; and instead of formaldehyde, transparent sachets of green mouthwash dangle down from the shark's tail. The coconuts slung alongside them suggest that the trophy-like shark is regarded simply as a source of nutrition for its human captors.

Born in Barbados, Bickerton may be drawing on childhood memories rather than echoing Hirst's interests. The rubber shark certainly looks more despondent than the fish swimming through Angus Fairhurst's large photographic piece nearby. Called *Ultramarine Attachment (Laura Loves Fish)*, this mysterious image shows a diver moving gently through

35. Alexis Rockman, *Concrete Jungle IV*, 1992

a shoal of luminous, boldly striped creatures. Their mutual rapport appears threatened by a prison-like grid of white lines, not to mention the myriad plastic garment attachments sprouting from the picture's surface. But Fairhurst, whose 1989 essay supplied Hirst with this exhibition's provocative title, is one of the least alarming artists on view.

More typical of its ominous, anxious preoccupations is the American painter Alexis Rockman. Using oil paint as illusionistically as Max Ernst, whose apocalyptic visions of the early 1940s must be a major influence, Rockman shares Fairhurst's fascination with an underwater world. But the liquid here seems riddled with toxic waste. Repellent deposits float on the scummy surface, along with a crushed drink-can and a fly riding on a turd. The only creatures capable of surviving in this polluted region are rapacious, snakelike fish. They lunge and wheel through the murkiness, snapping at each other and waiting to seize their prey.

Rockman exhumes a painting technique reminiscent of Bosch in order to convey a rancid vision of late twentieth-century despoliation. In terms of the way he handles oil, Rockman looks wilfully anachronistic compared with the wealth of unconventional media deployed elsewhere in the show. But the emphasis on defilement is followed up, in diverse ways, throughout the survey.

Take Abigail Lane's *Misfit*, an abject wax figure sprawled on the floor. Half naked, the sculpture was cast from Fairhurst's body. But his hair has turned prematurely grey, and Lane seems less concerned with portraying a fellow-artist than with evoking the plight of a down-and-out. The figure might easily be demented, moaning on a city pavement and helplessly in thrall to drugs or booze. Lane's method of making *Misfit* is strangely clinical, though. It looks more like a clean-limbed dummy from

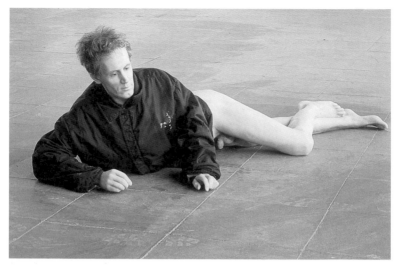

36. Abigail Lane, *Misfit*, 1994

Madame Tussaud's than a messed-up vagrant, and in this respect Lane's work has links with the photographs of Hiroshi Sugimoto.

A native of Tokyo but now based in New York, he displays three exquisitely printed gelatine silver prints. From a distance, they have a documentary air, as if Sugimoto had secretly photographed a series of squalid crimes. Only at close quarters do they reveal themselves as tableaux taken straight from Tussaud's Chamber of Horrors. Whether the subject is the *St Albans Poisoner*, or *The Bride in the Bathtub Murder*, Sugimoto clearly shares the fascination felt by the crowds who visit the chamber every day. Even so, these sombre and immaculate photographs lend the tableaux an unexpected dignity. As a result, they become more threatening than their melodramatic source could ever be.

An involvement with waxworks recurs in different guises throughout the show. It surfaces again in Kiki Smith's *Virgin Mary*, a shaven-headed nude who stands erect and alone on a dark wooden block. Made from an unsettling combination of wax and cheesecloth, this vulnerable figure seems the very antithesis of an unblemished mother of God. She is alarmingly reminiscent of models used in anatomy classes to reveal the sinews and bones beneath the flesh. Perhaps the time Smith spent in New York's Emergency Medical Service played some part in shaping the haggard, defenceless vision of humanity presented here.

Nothing could be further removed from the hand-modelled *Virgin Mary* than Andreas Slominski's *Untitled*. For it consists entirely of found objects: a bicycle, and a motley cluster of bags and other containers slung from its handles, saddle and wheels. Slominski, who lives in Hamburg, has stuffed most of them with old clothes. So the exhibit gradually takes on human associations. The suggestion of homelessness has connections with Lane's sprawling figure, but the fragility of the life led by the bicycle's owner is more akin to Smith's virgin.

Propped casually against a wall, as if Slominski had left it there by accident, *Untitled* goes out of its way to escape from the pretensions of High Art. Like many of the works displayed here, it shares Duchamp's desire to approach the ready-made rawness of everyday life. Art-about-art is rarely glimpsed in this robust show, which seems determined not to put itself forward as the manifestation of a new movement. Hirst wants the exhibition to be accessible, even to people who know nothing of contemporary developments in the cutting-edge galleries of London, New York or Düsseldorf. In fact, I suspect that he would prefer visitors to approach *Some Went Mad* unclouded by any preconceptions about what modern art 'ought' to be.

It is a very open survey, generous in its sympathies. Hirst approves of diversity, and relishes the sudden shifts from one form of expression to another. It is, at times, an eye-wrenching experience. And when a direct reference to art does occur, it turns out to be extremely irreverent. Michael Joaquin Grey's *Apple* uses a heady mixture of urethane, self-skimming foam, fibreglass and aluminium to fashion a recognizable copy of Rodin's scandalously phallic *Balzac* statue. But the aroused novelist is saturated in a lurid orange coating and, like Bickerton's shark, suspended upside-down from the ceiling. The outcome bears more of a resemblance to a dangling three-dimensional map of California than to one of the great icons of late nineteenth-century sculpture.

If Grey's *Apple* represents the exhibition at its most raucous, Hirst does not concentrate exclusively on assaulting the viewer. Shock tactics, in art, can soon become wearisome, and I am glad that the sexual rawness of Marcus Harvey's rasping, brutally painted nude is not repeated elsewhere. Hirst's lamb suggests an obsession with mortality, but its stillness and pathos are far from aggressive. They help to explain why he has also selected Jane Simpson's muted sculpture, where refrigeration units are often used to present images of a mysteriously frozen world. *In Between* juts out from the wall like a rudimentary sink. A layer of frost has accumulated on its surface, countering the gleam of the burnished brass sides. At the centre of all this whiteness, however, is a yellow stain of butter,

melted by a halogen bulb lodged surreptitiously beneath. Warmth and frigidity, sensuous colour and puritanical whiteness, are juxtaposed with quiet assurance in this remarkable sculpture.

Simpson is twenty-nine, and only left the Royal Academy Schools last year. But she is already working with great assurance. By including her work in such a diverse, stimulating show, Hirst proves that he is far more complex and supple than his tabloid reputation as the *enfant terrible* of Grand Guignol might suggest.

THOMAS STRUTH
25 May 1994

An uncanny stillness prevails in Thomas Struth's photographs of city streets. Sternly shot in black and white, they are devoid of people. Although parked cars often testify to human existence, their owners are always somewhere else. Perhaps they are cocooned in offices, or maybe still asleep in the blocks of flats that dominate so many of these troubling images. One thing alone is certain: the buildings, and the empty spaces between them, become the principal actors in Struth's silent urban dramas.

Most of these façades are as anonymous as the industrial structures photographed by Bernd and Hilla Becher, who taught Struth at the Düsseldorf Academy. But the revelation of his first one-person show in England, filling all three of the ICA's exhibition areas, lies in how far he has ranged beyond the Bechers' orbit. They treated objects in series, methodically amassing clusters of images devoted to pit-heads or gaso-meters. Struth, however, soon broke free from their rigid procedures. When he decided to leave the street, exploring instead the interiors of museums, galleries and churches, his work underwent a momentous transformation. The sober, monochromatic purity of the urban views disappeared. In their place, resplendent colour images on the grand scale echoed the sumptuousness of the paintings Struth chose to include. A feeling for magnificence became apparent. Nobody could have guessed, on the strength of his dour street scenes, that he would respond with such sensuous hunger to the Louvre or the Vatican. But Struth has made himself, in recent years, the most potent photographic recorder of these highly charged chambers. And, most unexpectedly of all, the people who

were so eerily absent from his city work now play a vital, often animated role in the museum pictures.

Sometimes, humanity is seen as an unruly threat. In a claustrophobic study of a Raphael room at the Vatican, the space is crammed to bursting-point with blurred, jostling and argumentative viewers. It amounts to a vision of tourist-polluted hell, awakening my direst memories of struggling to see Renaissance frescoes surrounded by hordes of restless, noisy, guide-bullied visitors. Struth's photograph contrasts the dark, turbulent crowd with the brightly lit composure of the figures in the large Raphael painting above. Here, as the enthroned Pontiff raises a hand to bless, his supporters stand in awed concentration on either side. Everything is devoted to the act of benediction, whereas the onlookers below are caught up in the slipstream of their own frenetic, unfocused movements.

Some of them, however, ignore the turmoil and stare up at the frescoes. Struth stops well short of implying that no one actually looks at art or architecture any more. In his superb photograph of the Pantheon, the floor is far from crowded. Everyone scrutinizes the surroundings with hushed reverence. Unlike the throng choking the Raphael *stanza*, they seem minuscule in relation to the building around them. Struth devotes most of the picture-space to the Pantheon itself, and shows enough of the great coffered ceiling to explain why the viewers are looking so overwhelmed.

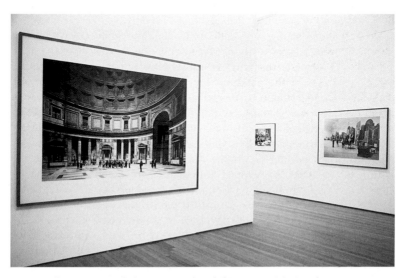

37. Installation view of Thomas Struth exhibition at ICA, London, 1994

When he sets up his tripod in galleries, the results disclose a fascinating range of responses. At the Louvre, a wall covered in David's grandest classical and Napoleonic *tours de force* attracts a crowd almost as large as the congregation witnessing the French emperor's coronation. But they do not share the awe of the Pantheon's visitors. While some acknowledge the presence of David's *grandes machines*, others prefer to sit on benches and talk. The group of young people in the foreground laugh and gesticulate, apparently savouring a private joke rather than attending to the exhibition. Even so, a girl squatting on the floor turns away from her friends and gazes up at a painting with an air of wholehearted wonder.

Struth is clearly intrigued by art's ability to elicit such an intense, spontaneous reaction. He also notices how onlookers' behaviour is influenced by the paintings they examine. In the National Gallery's Sainsbury Wing, his camera is trained on an altarpiece by Cima. Although the Bellinis on either side are greater works of art, the size and drama of Cima's *Incredulity of St Thomas* command most of the viewers' attention. One man is arrested by the painting even as he starts to move on. He turns his head back towards it with an urgency paralleled by the saints staring in astonishment at Christ's wound. Nearer the altarpiece, a woman is so fascinated that she leans over the protective rope in order, presumably, to inspect it as closely as possible. Her eagerness chimes with Cima's impulsive Thomas, who presses forward and places his finger in the gash proffered by his master.

Whether by accident or design, all the figures outside the painting stand in attitudes strangely in tune with Cima's lucidly organized composition. Struth is alive to these correspondences in other photographs as well, and suggests that visitors' movements are continually shaped by the character of the paintings they study. In a quiet corner of the Kunsthistorisches Museum, Vienna, a white-haired man stares at a Rembrandt portrait. He is the only viewer visible, and his isolation is fully in accordance with the solitude of the man depicted by Rembrandt. Although the sitter gestures in the direction of a woman in the companion portrait nearby, he does not look at her. Nor does the visitor, whose hands are clasped behind his back as he devotes all his energy to a single-minded exploration of the image before him.

The cornucopia of paintings in great public collections tempts us to keep perpetually on the move. We may well feel unable to linger, and convince ourselves that glancing will suffice. Struth, however, proves how much we can miss by adopting a hasty approach. At the Art Institute of Chicago, he shows the power exerted by Caillebotte's commanding picture *Rue de Paris; Temps de pluie*. Carefully aligning his camera with the

strong perspectival recession in the painting, he invites us to let ourselves be drawn into the deep, inviting space of an image dominated by a wet road and umbrella-carrying pedestrians. But the woman pushing her baby-buggy through the Art Institute has already become captivated by Caillebotte's canvas. Although we see her from behind and her face is invisible, everything about her stance suggests that she has projected herself into the rainy boulevard stretching out ahead.

I have never seen such a persuasive image of art's ability to exert an imaginative hold on the spectator. All the same, sadness coexists with delight in this complex photograph. For however well the woman has been visually inserted in that gleaming Parisian street, she knows that the transference can never, ultimately, take place. Her body remains obstinately outside the boundaries of Caillebotte's enticing canvas, irrespective of how much she may yearn for a secure position within it.

Of all the people seen near paintings in Struth's work, restorers appear most aware of their separation from the canvases. Standing in a high, luminous room at San Lorenzo Maggiore, Naples, four of them pose near a formidable row of pictures awaiting treatment. Rather than looking at the dirty, torn images, they all direct their eyes towards Struth's lens. It is as if their professional duties oblige them to maintain a distance from the paintings, to diagnose ailments and resist the urge to lose themselves in rapt contemplation.

This coolness seems to affect their personal relationships as well. The restorers stand apart from each other, and no glances travel between them. They appear conscious of maintaining their individual identities, even though Struth photographs them in a collective context. The same emphasis can be found in his impressive portraits of families in domestic surroundings. Although posed *en masse*, parents and children all gaze directly at the camera and do not acknowledge one another's existence. Nor do Giles and Eleonor Robertson, seated on either side of an ample wooden dining-table in their Edinburgh home. They look at ease, quietly relishing the companionship of a long marriage. But the table's expanse seems to act as a reminder that each of them is, in the last analysis, alone. While Eleonor leans forward, staring towards Struth, Giles leans back and gives a stoic smile as he gently accepts the inevitability of the gap even between husband and wife.

PHOTOGRAPHY AND THE FAMILY

31 May 1994

Propped up like a doll on her mother's lap, the little girl looks blanched and listless. Her eyes seem curiously unfocused, and the woman stares down at her daughter with unusual gravity. Something is amiss, and we might suppose that the child is sick. But nothing prepares us for the shock administered by the photograph's caption, which discloses that the girl is already dead.

When Albert J. Beals took this daguerreotype, in early 1850s New York, families often wanted to memorialize infant mortality. The mother who sat with the lifeless body would have seen nothing macabre about the idea, even though she and her daughter adopted a pose borrowed from contemporary paintings of the 'Sick Child'. Far from indulging in wish-fulfilment by pretending that her offspring was still alive, she expected the camera to help her acknowledge the loss she had suffered.

The fact that we are disturbed by this image says more about our squeamishness than nineteenth-century morbidity. Beals and his bereaved client had no hesitation in recognizing that premature death could play a central role in family life. But today, when far fewer children die, we regard the entire subject as taboo. And the presence of this daguerreotype at the Barbican Art Gallery, in an engrossing, poignant and provocative survey largely devoted to contemporary photographs of family life, shows how determined we are to shy away from even a hint of endangered infancy.

The omission seems all the more marked in an exhibition otherwise eager to avoid predictable images of any kind. Rather than choosing cosy pictures of pregnant mothers, calmly contemplating their swollen bellies, Val Williams and her co-selectors start the show with hospital scans. The foetus subsequently named Calum lies there, in the summer of 1993, as nothing more than a grey-and-white blur. The words HEAD, BODY and FEET have been attached to this hazy form, but they serve only to enhance his essential strangeness. Cosseted by the inky womb, he remains unknowable.

The aura of mystery does not evaporate once the child has been born. Linda Duvall, intrigued by the grainy photographs published in American newspapers to celebrate a baby's arrival, began collecting them. She displays a selection here in a Warhol-like series, and they all end up looking the same. Far from rejoicing in their offspring's individuality, the parents who took these snaps seem determined to stress the children's homo-

geneity. The outcome is unintentionally hilarious. Caitlin, Bradley, Megan, Amanda and Cole may all differ in terms of their birth-weights, reverently spelled out in the captions. But they are more or less indistinguishable, and their cloned faces mock the pride with which the births are announced.

Conformism is an overwhelming urge when families submit themselves to studio photographs of the new arrival. But the results are only given room here as sociological specimens. Alexander Honory, with tongue lodged in cheek, assembles rank upon rank of these stiff, well-laundered groups posed in front of garish curtains. They look no more animated than waxwork effigies, and Honory stresses their alien weirdness by giving them the collective title *The Found Image*. They are, perhaps, a lingering vestige of a desire to vie with the grandeur of painted portraits. A number of inter-war photographs have been borrowed from the National Portrait Gallery, to show how sternly sitters like *Mrs Boyle and her Three Children* confronted the lens offered by Lafayette's Manchester studio half a century ago.

In every other respect, though, the Barbican survey breaks the mould. Katrina Lithgow produces glowing and affirmative pictures of motherhood, but she departs from the old madonna-haunted stereotypes. Her mothers are naked, and they expose their pregnant stomachs without embarrassment. In one superb image, the veins on Sarah's forearms stand out as she struggles to clasp her restless son Max, who clearly wants to slide off her ripe belly. Even as we relish the intimacy between woman and child, Lithgow encourages us to notice the physical strain on Sarah – not to mention Max's ambivalent attitude to the unborn sister inside his mother's body.

All the same, Lithgow would never dream of exploring the states of mind revealed in Sally Mann's powerful black-and-white work. Growing up in rural Virginia, her three children are caught in photographs which question the whole notion of innocence again and again. On one level, the girls posing as *The New Mothers* are simply indulging in an archetypal fantasy. But there is something eerie about the brazenness of the daughter who leans on a baby-buggy and, fake cigarette in hand, scowls at the camera. Her little sister, meanwhile, clutches a doll as she stares through heart-shaped sunshades like a miniature version of Lolita.

Mann has no inhibitions as a recorder of pre-pubescent life. She shows one of her children sprawling on a urine-soaked bed, and in *Jessie's Cut* the blood defiles her daughter's face like a gunshot-wound. The most disquieting image of all is called *The Terrible Picture*, and appears to show

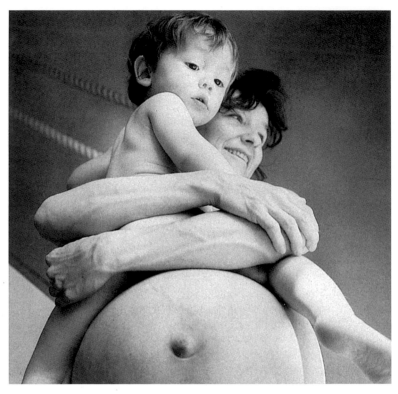

38. Katrina Lithgow, *Sarah pregnant with Lily, and Max, London,* 1992

the same girl hanging by a noose from a tree. Closer inspection dispels the illusion, but her lowered eyelids, bedraggled hair and mud-smeared flesh ensure that she remains alarmingly akin to a victim.

The comic absurdity of domestic life is not forgotten, however. Anna and Bernhard Blume contribute a knockabout sequence of shots entitled *Kitchen Frenzy,* where potatoes take on a maniacal life of their own and fly around the room. More like stills from a zany film than composed photographs, they present food preparation as a form of lunacy. The airborne spuds end up attacking an astonished housewife before she has a chance to slice them up. In a futile attempt to evade the bombardment, she falls off her chair while aiming wild punches at her assailants.

Whether laughable or ominous, most exhibits end up emphasizing the unavoidable chaos of family life. In vain does Robert F. Hammerstiel insist on order when he trains a camera on the meals laid out in his *Mittagsportrats*. We know that the methodical placing of the twinned sausages on the virginal white plate, the mustard tube and the bread hunks will soon give way to messiness. Although the diners are not seen, we can sense their hungry presence and imagine them reducing these spruce table-tops to battlegrounds.

Both Hammerstiel and Thomas Ruff prove that people can be portrayed even when invisible. No figures inhabit the balconies punctuating the regimented block of flats in Ruff's *House No.9, I*. But the grotesquely peeling paintwork, and the rubbish-strewn grass below, prove that life is far from idyllic. When Ruff goes indoors, and moves from room to room, his *Interiors* are equally deserted. Even so, family photographs are sometimes discovered on sideboards, and in one disconcerting work three framed portraits of children seem threatened by the ferociously patterned wallpaper on which they hang.

In the main, though, this exhibition derives its formidable fascination from images of people. Sometimes they are presented too artfully, with pretentious results. Florence Chevallier's *Le Bonheur* series is afflicted by a relentless search for ingenious lighting and clever camera-angles. It compares poorly with the direct, bracing approach of Susan Lipper, who entered the homes of families in the remote Appalachian mountains and caught their most unguarded moments. In one boisterous photograph, a tousled woman struggles to restrain a boy who, brandishing a toy knife, appears to aim a kick at the Holy Bible on a nearby desk.

Nick Waplington defines equally turbulent moments inside a cramped Nottingham council house. Here children scrap, shriek and practise backflips while their parents slump on the sofa. The mayhem is heartening, and infinitely preferable to the wariness of a girl called Ana Quadros. In Ouka Lele's photograph she stands defensively behind a chair, gazing at the camera as if she suspected it of murderous intentions.

But when we reach the police photographs taken by John Heatley, who recorded the family home where Tommy Thompson was killed by his two daughters, intimations of violence give way to brutal fact. Most of the rooms are empty, and an unnerving neatness prevails. For some reason, all the objects stored in a cupboard are labelled with fanatical precision. Suddenly, though, we realize that one interior is inhabited. Thompson's body lies on a bed, still drenched with blood from the fatal bullet. Here is a father who abused his family so callously that they turned against him, transforming his bedroom into a makeshift morgue.

Over the fireplace, a saccharine picture of three fluffy cats hangs in jarring proximity to the corpse stretched out below. Unlike the lifeless girl in the nineteenth-century daguerreotype, Thompson has been left to die alone and, above all, unmourned.

ART FROM AFRICA
7 June 1994

Until now, the blinding white walls and floors of the Saatchi Collection have been placed exclusively at the service of Euro-American art. The work bought in such profusion by Charles Saatchi reflected his preference for reputations formed in Cologne, London and New York. Anywhere more far-flung was regarded, implicitly at least, as beyond the pale. The idea that his purist spaces would one day house contemporary African art would have been regarded as wholly bizarre. But this fanciful hypothesis has suddenly become a reality. Paying host for the first time to another collector's possessions, Saatchi has given over his gallery to a rumbustious array of eleven artists who all live in 'subsaharan' Africa. And according to the show's curator, André Magnin, a thorough search of the area 'has shown sceptics that not only is there a contemporary style of African art, but that it is taking new directions'.

Jean Pigozzi, the man who has purchased these uninhibited works, clearly agrees. But a visit to the show proves that Magnin, who helped to organize the ground-breaking *Magiciens de La Terre* exhibition at the Centre Pompidou in Paris five years ago, is mistaken in seeing them as manifestations of a 'style'. All the artists operate in distinctly individual ways, using languages that have little in common with each other. They range over the gamut, from simplified abstraction to an uncannily lifelike figuration. And while some adhere to painting or sculpture, others plump for voodoo-inspired assemblages of found objects or make multimedia mock-ups called *Models of the Extreme*.

The show starts in the most theatrical manner imaginable. A group of life-size figures in painted wood gesticulate at the end of the first room. They all seem caught up in an exclamatory drama, centring on a kneeling woman and a man whose hands are tied. Bright scarlet blood is already splashed on his back, but he braces himself for further punishment. His 'crime', apparently, is to be married to an adulterous wife – the kneeling

woman, who waits to be slapped by her bare-breasted older sister. The air of expected violence gives the work its tension. Everyone involved in the scene looks strangely spellbound by the knowledge that retribution is about to be exacted. And Emile Yebo Guebehi, the Ivory Coast sculptor responsible for the work, marshals his tableau like the director of an inexorable ritual which must be played out to its gruesome finish.

Part of the sculpture's conviction stems from the knowledge of village life Guebehi gained when he was adopted by the Ebrié community of Songo Dagbé. He has studied their origins, everyday activities and initiation festivities. He occupies a special place among the people who commission his work, but Guebehi may in the end be too limited by their expectations. His approach is rather laborious, as if constrained by a need to fulfil the villagers' requirements rather than his own imperatives,

Not that indulging the artist's fantasies is any guarantee of better art. The Sierra Leone sculptor John Goba broke away from the enclosed Mendé world of women's secret societies and experienced a revelation around the age of thirty. As a result, he feels at liberty to bring together ideas from different ethnic cultures, relying on his own fantasies as much as folk tradition. After conveying an initial explosiveness, though, his sculpture soon becomes predictable. The same mixture of human and animal forms is reiterated, punctured by clusters of porcupine quills which give the work a superficial excitement and quickly degenerate into a tiresome mannerism.

The quills in Goba's work look no more menacing than pick-a-sticks. But the violence endemic in so many African countries is directly reflected in some of the painters' contributions. An obsession with weaponry runs through Cyprien Tokoudagba's large, carefully executed canvases. A restorer at the national museum in Abomey, where he looks after Benin treasures, Tokoudagba displays the same neat, meticulous approach in his own pictures. But they all contain a strain of danger. On the immaculate white ground of one picture, a horned amalgam of animal and man leers as he brandishes a hatchet in one fist and a rifle in the other. He stares at a vessel held up by reverential hands, and probably intends to smash it.

If Tokoudagba confines his misgivings to a mythological, frieze-like realm, where arrows and curved swords float in readiness for conflict, Cheïk Ledy anchors his work firmly in the context of political struggle. *Pillage* is the terse title he gives to one recent, elaborately finished painting. Ledy, who works in Zaire, shows soldiers looting freezers on a trolley and coolly setting fire to shell-battered houses. While the burning

carcass of a car lies abandoned on the ground, civilians crowd into the street with television sets snatched from shattered shop-fronts. They all seem motivated by the same desperate greed as the man in *L'Imprudence*, who rushes towards a cliff-edge pursuing a pink bird carrying banknotes in its claws.

Ledy is an out-and-out moralist, ready to condemn his figures with the aid of preaching messages inscribed on the canvas. But Georges Lilanga di Nyama has a far less judgemental attitude towards the men, women and spirits who writhe their way across his feverish paintings. Drawing inspiration from the celebrated Makonde sculpture produced in his native Mozambique, he concentrates on wild Mapico dances performed by rubber-limbed figures of indeterminate gender. Whether licking the earth with enormously elongated tongues or sprouting leaves from their heads, these fantastical revellers contain good and evil within their undulating forms. Ledy, however, offers no denunciations. He relishes their defects as much as their virtues, and a similar generosity marks the funerary art of the Madagascan sculptor Efiaimbelo.

He has installed an immense bed of stones at the end of one gallery, and planted there a forest of tall wooden poles capped by platforms supporting figurative carvings. The poles are all intended to honour the dead by 'singing' about their lives, and this Whitmanesque celebration derives from funeral rites stretching back to the early sixteenth century. While honouring the forms of the past, Efiaimbelo brings them into the present by introducing to his platforms a mini-van filled with passengers, an aeroplane and even a group of firing soldiers. Their presence helps to ensure that he is revivifying tradition rather than merely reiterating a long-ossified set of conventions.

In their diverse ways, all the most memorable artists in the show do likewise. Take Romuald Hazoumé, whose wide, white wall-full of exhibits reflect his preoccupation with found objects. Nothing is too trashy for Hazoumé, who sees the expressive potential even in a worn-out scrubbing-brush or a humdrum wicker container. But he makes some of his best assemblages out of plastic water-bottles, where the opening becomes a ready-made mouth and a clapped-out portable telephone stands in for a nose. With the help of empty television sets, feathers, skis, Walkman headphones and bent toothbrushes, a quirky assortment of heads is built from urban refuse. In his eye for detritus, Hazoumé recalls Tony Cragg's adroit early work. Unlike Cragg, however, he recycles all these cast-offs in order to give new life to the ancient form of the African mask. Raised as a Catholic in Benin, but still fascinated by voodoo and the cults associated with the god of iron, Hazoumé gives his work a mesmerizing

39. Romuald Hazoumé, *Allo*, 1991

aura. Even as he flouts conventional ways of working, and refuses to employ materials favoured for so long by his native Yoruba culture, this nimble young artist gives new meaning to some of the oldest traditions in African art.

STAN DOUGLAS
6 September 1994

Enter the main gallery in Stan Douglas's ICA show, and you find yourself transported back to the early days of cinema. Not in terms of décor – the space is devoid of period detail, and the piano underneath the big screen looks resolutely modern. But Douglas's black–and white film is based on the conventions of silent movies, complete with melodramatic

plot, dialogue captions, stilted acting and a rip-roaring title: *Pursuit, Fear, Catastrophe.*

A young Canadian artist with a growing international reputation, Douglas came across the film's eerie subject quite by chance. On a boating trip with friends, he discovered a derelict 1930s power station by the Fraser River in British Columbia. It reminded him of 'a vampire's chateau', and his film sometimes strives for a Dracula-like spookiness. But he was also intrigued by the name of the land it inhabited: Ruskin BC, a tribute to the Victorian art critic by the socialist commune founded there in the 1890s. The fact that the venture soon went bankrupt only reinforced Douglas's curiosity. He is as fascinated by 'failed utopias' as he is by 'obsolete technologies'. So the redundant hydro-electric plant became an ideal backdrop for his film, and the story centres on a member of the large Japanese–Canadian community who settled in Ruskin until internment brutally robbed them of their land and property in 1942.

The film's starting-point is an unexplained disappearance, unearthed by Douglas in the British Columbia police archives. He makes no attempt to solve the mystery, though. Half the characters' dialogue remains teasingly unrecorded by the captions, and we are often reduced to bafflement. Even so, the air of suspense carries us forward. Hiro, who works in the power station's control room, has gone missing. The local policeman finds his hat floating in the river, and he is suspected of stabbing a man interviewed in hospital.

At this point, the programmed piano begins to play Schoenberg's *Accompaniment to a Cinematographic Scene.* The increasingly frantic expressionism of the music lends itself well to the plot's air of paranoia. It reminds us that Schoenberg, who settled near Hollywood in 1934, taught film composers and influenced the scores of melodramatic movies. All the same, Douglas does not try to pretend that music and film match. While Schoenberg's atonal score grows more and more agitated, the movie remains stubbornly deadpan. Its refusal to indulge in mayhem becomes tantalizing, and the film breaks off with arbitrary suddenness. We never find out what happened to Hiro, but Douglas does suggest that he may be the victim of a racist attempt to discredit him. The police regard Hiro's Japanese friend with disdain, and he suspects them of a conspiracy.

When the lights go up, we are left with framed colour photographs of the Ruskin area today, displayed on the gallery's walls. The scene looks mournful and decrepit, a landscape stripped of its natural magnificenc by industrial despoilation. But Douglas never hammers home his inte est in such issues. He prefers an enigmatic approach, nowhere m

tersely than in the series of *Television Spots* and *Monodramas* made for Canadian television.

Seen on monitors at the ICA, they appear brusque enough. When broadcast, they must have been baffling. Brief and inconclusive, each video offers a fragment seemingly culled from everyday life. But the truth is that Douglas devised them all, carefully simulating a documentary look. Three young men sit on a city bench, staring at an unidentified arm stretched out on a nearby lawn. 'Get up' says one, 'come on – get up'. But nothing happens, apart from the random twitching of the hand. Another *Spot* is more dramatic, showing a near-collision between a yellow van and a car. Then both vehicles drive on, and we are left with a similar feeling of bathos. Douglas is fascinated by the anonymity, uneventfulness and frustration of urban life. A firework fails to shoot into the sky, petering out on an empty road in the middle of a deserted town. Elsewhere, a man hails a passer-by, calling him Gary; but the latter replies blankly: 'I'm not Gary.'

After a while, the emphasis on alienation becomes oddly mesmeric. One work called *Lit Lot*, concentrating on a car-park attendant marooned in his bright, lonely booth at night, reminded me of Edward Hopper's brooding nocturnes. But the preoccupation with isolation and emptiness has a peculiarly Canadian flavour as well. Many of these *Spots* are bleak, and as aimless as the man in a grey suit who stands on a pavement next to a graffiti-spattered wall. He looks nervous and expectant, but once again nothing happens. The atmosphere is close to Beckett, a writer Douglas clearly admires. And in one confessional *Spot*, a bewildered man wrily tells the camera that 'everything seems to catch my attention. Even though I'm not particularly interested in anything'.

Those words seem applicable to *Evening*, an elaborate installation upstairs where three large screens fill one wall of an otherwise empty room. On each screen, a Chicago newscaster is shown reading a bulletin. But there is no furniture in the room, and Douglas does not encourage us to imagine that we are comfortably watching the news at home. Rather does he promote a more analytical, questioning mood. Although shot in Chicago earlier this year, *Evening* cleverly simulates the broadcasting style fashionable at the end of the 1960s. We notice how cunningly Douglas recreates the period. After a while, a tension develops between the sober, paternal delivery of the old presenter, and the bouncier approach introduced by his younger colleagues. Nicknamed 'Happy Talk News', it swept away dryness and favoured an upbeat, jocular style laced with plenty of 'human interest' items.

As a result, even stories dealing with Vietnam or the Civil Rights movement become trivialized. They are drained of their seriousness,

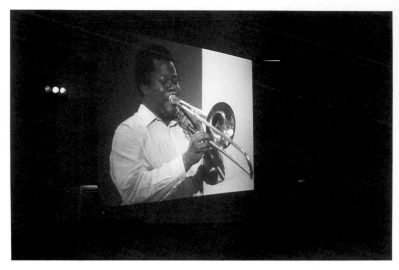

40. Installation view of Stan Douglas's *Hors-Champs*, 1992, at ICA, London, 1994

and softened by the smiling suavity of anchormen who appear wholly detached from the meaning of the sentences they mouth. Douglas exacerbates the malaise by ensuring that all three presenters talk in unison. Silenced only by the insertion of cards bearing the words 'Place Ad Here', their voices merge into a newsspeak drone. After a while, it becomes relentless. And we realize that *Evening*, although set in the past, deals with a problem which has grown even more acute today. How can events retain their proper significance, once the babbling media machine has reduced them to a sequence of sanitized sound-bites? I left *Evening* oppressed by the suspicion that ever-accelerating news proliferation leads, in the end, to a state of chronic listlessness.

Perhaps Douglas feels nostalgic for the 1960s. Born at the beginning of that turbulent decade, he was too young to have experienced the full force of its exhilarating idealism and destructive absurdity. So he brings it back to life now, devoting another installation to a plausible recreation of the style of a mid-1960s television production. Projected on both sides of a screen hanging in the middle of the room, *Hors-Champs* presents a performance of 'free jazz' by four American musicians with direct experience of playing in France. Douglas has researched his subject with typical diligence, and knows that 'free jazz' had a special resonance for th

May 1968 generation. The music played here is based on Albert Ayler's *Spirits Rejoice*, which interweaves the *Marseillaise* and the *Star-Spangled Banner* with gospel melody and a heraldic fanfare. After building to a frenetic, improvisatory climax, the band lapses into quiet, melancholy playing. The rest of the performance alternates between these two states, celebrating and then lamenting.

By evoking the historical period with such conviction, though, Douglas ends up stressing an overall sense of loss. However exuberant the music may be at times, with its black nationalist associations, the large hopes it once aroused have long since faded. Hence the pessimism in Douglas's fractured presentation of present-day life in his *Television Spots*. Nothing adds up, and the only key to even a partial understanding lies in a skilful resurrection of the past.

DOUGLAS GORDON
3 January 1995

Only a decade ago, the new art from Glasgow was dominated by big, hectoring canvases of square-jawed dossers, wild-eyed young men in tweedy suits and heroic Clydeside workers. The emergent names – Howson, Campbell and Currie – were all doughtily committed to figurative painting on the grandest possible scale. Nothing less would suffice. Today, however, young Glaswegian artists are driven by very different concerns. Although pigment on canvas still plays a part, it is more likely to take an abstract form. And a whole host of alternative media, including video, photography, film, texts and ready-made objects, are deployed with zest. If anything, the spirit of community among these resourceful allies is even stronger than it was in the Glasgow of the early 1980s. But many of them are already accustomed to exhibiting abroad, and one of the most internationally successful is now submitting himself to the acid test of his first one-person show in London.

It turns out to be a strange, deeply unsettling event. The first room visitors find at the Lisson Gallery is divided, almost territorially, by the steel cable of a practice tightrope. Stretching in a taut diagonal across the space from one corner to another, this high-tension wire seems both expectant and inviting. It tempts everyone to have a go, despite the notice warning 'danger: do not touch'. Two white metal platforms, placed at either end

of the tightrope, certainly make it easier for would-be performers to try their luck. But a large colour photograph on the wall offers a prospect of Niagara Falls, half-obscured by spray. It carries a reminder of the risks which high-wire walking can involve, especially when the emptiness beneath the cable is deep enough to bring on an attack of vertigo.

A spare and rigorous artist, Gordon stops well short of presenting his tightrope work in nightmarish terms. But there is still a link between this matter-of-fact installation and the main exhibit in the next room. Here, propped with deceptive casualness against a black pole in the middle of the darkened space, leans a screen. It is as large as many of the hefty canvases painted by Gordon's Glaswegian seniors ten years ago, and shares their fascination with a male figure. But there the resemblance between the generations ends. For this screen is the focus of a video projection, and the jerky images flickering here clearly derive from a silent film produced long before Gordon himself was born.

No attempt has been made to hide the ragged, blotchy grain of the original film-stock. It reinforces the desolate mood conveyed, in the opening seconds, by the room where the action takes place. Apart from an iron-frame bed, redolent of a hospital or army barracks, the room is as empty and devoid of decoration as the gallery itself. But to start with, at least, a pair of naked legs occupies the centre of the screen. They move backwards, forwards and then stop. The camera reveals the whole figure, of a young man who looks sturdy and agile enough to have recovered from whatever ailment he once suffered. No sign of a wound or injury can be detected on his pale body.

Just as we are about to conclude that he is fit to leave, though, the man suddenly falls over. It happens so fast that the unseen camera operator is also caught off-guard. The figure falls partially out of sight, to the left. He is still lying there when the camera catches up with him. The man tries sitting up, only to fall back sharply on the floor. Then his head moves from side to side, as if to reassure him that he can still perform a simple feat. By this time, however, a horrible sense of paralysis afflicts this prone form. Well-muscled, he is nevertheless quite unable to make his limbs respond in a normal way.

But he does not lack determination. With an enormous, grating effort, he tries to prop himself up on an elbow. The attempt defeats him, and he flops down once more. Eventually, though, he manages to sit up, turn to one side and place both hands resolutely on the floor. Using all the strength his arms can muster, the figure now tries to get up. But the legs refuse to do his bidding. He nearly succeeds, several times, before crashing back on the floor in a humiliating display of helplessness. The film

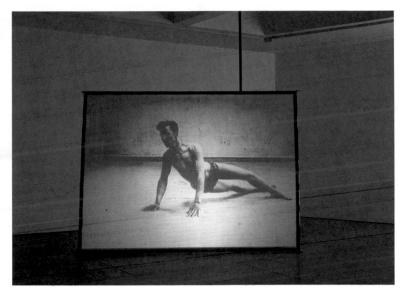

41. Douglas Gordon, *10 ms-1*, 1994

leaves him lying horizontally, his body still twitching with spasmodic, unconvincing attempts to raise head and limbs.

It is, on one level, a gruelling film to watch. Whatever distress I felt, though, was increasingly countered by a sense of absurdity. As the figure's movements become more manic, so he sheds some of his humanity and begins to resemble a dummy. Lacking the strings which might restore co-ordination, the hapless puppet is reduced to a permanent state of oscillation between striving and collapse. He comes to seem merely frantic, a mannequin well-proportioned enough for a shop-window who has, inexplicably, spun out of control.

The fact that the camera lingers on him in such a deadpan, methodical way fosters a voyeuristic mood. The filming has clearly been carried out for medical purposes, and the knowledge that the young man's torment is real only adds to the vicarious fascination. Gordon has edited and manipulated the footage for his own ends, doubtless heightening the patient's air of futility. He must want us to become engrossed in the utter mortification of the figure's strivings. And, as we do so, to feel guilty about the perverse satisfaction involved in watching the man's pathetic manœuvres so closely.

The guilt is compounded by a gathering realization that the falling man may be a victim of the Great War. In another part of the space, a monitor installed half-way up the wall relays a second, far briefer video. Doubtless derived from the same grim archive, it shows an endlessly replaying clip from a film of a hand trapped in the act of firing a gun. Its whiplash restlessness contrasts absolutely with the slower, mournful fumbling of the figure still visible on the large screen beyond. But they share a sense of being locked into repetitive rituals completely beyond their control.

In the case of the hand, the title Gordon has given the work identifies it as a traumatic legacy of war: *Trigger-Finger*. The victim, unable to shake off the memory of shootings, finds himself re-enacting them. Like a recurrent nightmare that poisons each fresh attempt to sleep, the moment of killing refuses to go away. It assails the man's consciousness as remorselessly as the trauma plaguing the figure who cannot keep upright. In his case, the incessant need to duck and dodge hostile fire, whether in the trenches or out on exposed land leading to the enemy's lines, might have led him to acquire a chronic urge to stay on the ground. However much he may wish to stand up, the pain of accumulated memories forces his legs to surrender their strength.

This inability to forget has connections with the main work upstairs at the Lisson, *Kissing with Sodium Pentothal*. A series of black-and-white slides, thrown by a projector on to a white wall, show moments from a performance using the so-called 'truth drug'. The embracing figures, printed in negative so that they are reduced to ghostly presences in a black room, all seem caught up in a muscle-relaxed, dance-like event. But I felt excluded from whatever heightened emotions they were experiencing. Gordon does not involve the viewer in either their mental or physical sensations, and that is why the tumbling man downstairs impressed me far more powerfully.

Oblivion, a state explored by Gordon's earlier text wall-paintings, gives way in this shadowy chamber to a stubborn refusal to let go of the past. The writhing, toppling figure seems doomed to an eternity of remembering, years after the war itself has finished. I have a suspicion that his uncontrollable body will, in turn, haunt my mind for a long time to come.

ABIGAIL LANE AND LUC TUYMANS
21 March 1995

As the 1990s lurch towards their half-way mark, more and more young artists are becoming preoccupied with a sense of damage. Whether mental or physical, individual or social, self-inflicted or perpetrated by an aggressor, injury is a growing obsession. Perhaps the waning of the present century brings with it a gathering awareness of death in general. The additional fact that a millennium is ending may be momentous enough to make us all unusually conscious of our own mortality. But how can this concern be conveyed, especially in a nation so emotionally inhibited that the grave has long been a taboo area? The question is raised in an acute form by *Skin of the Teeth*, Abigail Lane's perturbing installation commissioned for the upper gallery at the ICA. On entering, no sign of distress can be detected. Visitors walking into the high, luminous space designed by John Nash are not immediately alerted to the trouble in store. A small stone dog stands expectant on the otherwise empty floor. Lights shine up at the ceiling, as if to celebrate its impeccably preserved plasterwork. On the opposite wall, a large and imposing red abstract reinforces the aura of resplendent grandeur.

Then, by degrees, the mood shifts. For the spotless severity of this initial room is unsettled by the wallpaper. Lane designed it, in the same colour as her abstract picture. But far from extending the sense of splendour, the marks on this paper resemble hand-prints and splashes of blood. They make us realize, in turn, that the red picture is more like an outsize inkpad than an oil painting.

Nothing, however, is straightforwardly linked in Lane's tantalizing *mise en scène*. She may tempt us to conclude that the wallpaper marks were made by pressing her hands in the giant inkpad, like a criminal suspect recording fingerprints at a police station. But a photograph in Lane's catalogue discloses a far more gruesome starting-point. A murder scene on the fourth storey of an unnamed New York building is reproduced. The floorboards are soaked with blood, suggesting that someone was murdered there. Before death came, though, the victim left a cluster of despairing hand-prints on the wall above, and they dribbled forlornly downwards. These are the marks transposed by Lane, who thereby turns the most distressing evidence imaginable into a form of décor.

The result removes us from the reality of human suffering. It is as though Lane insists on her inability to retain in art the full implications of an atrocity. By changing it into a paradoxically elegant and tasteful

pattern, she dramatizes the gulf between the horror of raw police evidence and the sanitized refinement of art. No wonder the dog looks stranded and purposeless. Like us, he has been thrown off the scent.

Frustration increases in the next room, where the ornamental plasterwork is even more magnificent. The same wallpaper is deployed here, apart from an expanse of whiteness bordering the doorway. This time, however, wax fragments of a figure hang down from the ceiling's centre. They become the macabre equivalent of the chandelier which might once have graced Nash's original interior. An upside-down male head is suspended, with eyes closed and mouth open in a frozen cry. He recalls the yelling and grimacing bronzes of the eighteenth-century sculptor Franz Xaver Messerschmidt, many of whose 'character heads' resemble catatonic patients in an asylum. But the comparison shows how undisturbing Lane's head really is. Although decapitated, he is no more capable of arousing terror than the equally crimson arms dangling below. They appear to be saturated with blood, and yet no attempt is made to convince us that these limbs once belonged to a real corpse.

The slightest draught sets these bodily parts into motion. We share their air of helplessness, and search for more clues to Lane's intentions. In such an enigmatic context, even the surveillance cameras take on a new significance. Although a routine part of the gallery's security equipment, they become now as suspect as the ICA's safety notice by the windows bearing the terse instruction 'In Emergency Pull'.

Only on the way out, though, do we experience genuine disquiet. The sounds might have caught our attention at the beginning, but the need to explore the rooms probably prevented us from lingering. Now, by contrast, our puzzlement makes us more receptive. In the far corner of the room, a curious scratching and scraping can be heard behind a door. It is shut fast, forcing us to stand there feeling shifty and voyeurist as we eavesdrop. The noises are muffled, and they have the same teasing quality as the rest of this maddeningly ironic exhibition. But they also have the capacity to alarm. Although out of sight, these sounds convey a desperation far more persuasive and palpable than anything on view in the galleries themselves.

Is Lane therefore implying that, in our violence-sated age, the artist can only startle us out of detachment by mounting an unexpected, almost stealthy invasion? This, at least, seems to be the underlying belief in Luc Tuymans' show downstairs at the ICA. Wallpaper turns up here as well, providing the source for a painting based on a childlike image of geese waddling down a path. One of the birds opens its beak in a quack, and its visible eye expands into a black, horizontal void. The more we look at this apparently innocent painting, the less playful it becomes.

42. Luc Tuymans, *Body*, 1990

Although the picture is stylistically quite unlike the other exhibits, its final effect typifies Tuymans' approach. For the work produced by this young Belgian painter is slow-burning. Quiet almost to the point of nondescript at first, it gradually yields more perturbing possibilities. Tuymans relies on the power of memory. In the geese canvas, he recalls a nursery wallpaper that frightened him as a child. Most of his art, though, concentrates on fears which only arrive with adulthood.

A woman's breast hangs down in one picture, filling the modest dimensions of the canvas with pale, doughy flesh. Tuymans' habit of cropping an image, so that it is only barely identifiable, turns the breast into an object of near-abstract strangeness. But its flatness and formality also resemble a medical diagnostic photograph, prompting us to search for signs of disease beneath the soft skin. After a while, it looks intensely vulnerable –

like the figure in another impressive painting who seems to be over-shadowed or penetrated by a dark, predatory creature.

Tuymans' handling of paint spurns virtuosity. He would rather appear perfunctory than facile, and often ensures that the pigment begins to crack or even flake off soon after it dries. Conservators must already be having nightmares when they examine the decaying surfaces of his work, but the damage chimes with the meanings he conveys. Take the little picture simply called *Body*, the most memorable image on display. Sliced off at the neck and crotch, it is an anonymous and possibly vio-lated figure. The body's odd lumpishness suggests that it might be a stuffed doll, misshapen after years of use. Two thin black lines half-way down the torso could represent cuts, but nothing is certain. Although a smudge of dark paint on the picture's upper edge hints at hair, Tuymans stops well short of answering the questions in our minds. All we know is that the figure seems fragile, and the cracks running across the picture add to the feeling that disintegration is imminent.

Not all Tuymans' paintings are successful. Sometimes his understated manner looks merely offhand, and too slight to detain us for long. One of his pictures is based on a gas chamber from a concentration camp, but without that knowledge the viewer could be forgiven for seeing it as a dull, scrappily painted interior drained of visual interest. All the same, Tuymans seems prepared to take the risk of boring the spectator. For his best pictures ambush us with the surprise of discovering suppressed fear, aggression and harshness lurking within the apparent banality of every-day life.

YBAS, FROM FRANKLAND, TAYLOR AND LOCHORE TO TURK AND HARVEY
11 April 1995

Visitors to the Saatchi Gallery's invigorating new show might well imag-ine that they had stumbled, by mistake, on the office of a smart advertis-ing agency. The first room, normally no more than a quiet preamble for the epic spaces beyond, has been transformed into a streamlined foyer. An artificial ceiling, low-slung and studded with circular lights, replaces the normal lofty whiteness. And along the entire stretch of the wide left wall, John Frankland has installed a gleaming golden lift.

It is an alluring spectacle. Walking alongside this great burnished expanse, we find ourselves reflected in its sumptuous sheen. Our blurred forms draw us towards the lift, and we move nearer in the hope of sharpening the mirror-image. But Frankland frustrates our desire. Faces stay fuzzy even close-to, and the lift doors remain resolutely shut. By robbing this machine of its function, Frankland invites us to look at the whole shining apparatus in a new way. However hard we may press the moulded buttons flanking the doors, they will never open. The gold surfaces take on a mocking character. They hold out the promise of infinite wealth and glamour, only to underline its unavailability.

When Frankland started planning the work in 1992, Britain was deep in recession. So this teasing exhibit, poised between painting, sculpture and architecture, could be seen as a monument to the betrayal of hopes inflated beyond all reason in the previous decade. The meaning is reinforced by the material, too. Peer at the lustrous lift, and you will soon discover that its air of luxury is superficial. Frankland has made the work by stretching a skin of metalized polyester across the entire surface. It is even cheaper than the supporting wooden frame, and the occasional tiny crease reveals the skin for what it really is.

The tantalizing game continues downstairs, in the main Saatchi space. Here, Frankland displays a far shinier structure. Although untitled, it resembles a garden shed. But a quick tour discloses that it is no more useful than the lift. For this shed has been sealed tight, and its bright polyester coating ensures that walls, door and roof are all invaded by clear reflections of the surroundings. Pictures hung on nearby walls are mirrored as vividly as the gallery's metal ceiling. They make the shed seem even more mysterious and impenetrable. We are left wondering why it is so out-of-bounds. Was toxic waste discovered there, or the victim of a crime? Frankland tempts us to speculate, but provides no answers. All we do know is that something has gone wrong.

In this respect, both lift and shed are typical of the unease running through the whole exhibition. The five young British artists represented here are very individual, but they share a strange sense of misgiving. Take Marcus Taylor, whose perspex sculptures inhabit a neighbouring room. His starting-points are fridges and freezers, so the overall mood should be reassuringly domestic. The more we gaze at these purged white presences, though, the less familiar they become. Taylor has sanded all the perspex surfaces, so that they no longer offer clear views into the sculptures. All we can see is a series of misty, frozen voids, waiting to be filled.

Like Frankland, Taylor ensures that no doors provide a way in to his glacial structures. Although one or two are open at the top, access is difficult.

So they simply stand there, asking to be admired for their bleached, contemplative beauty. And after a while, serenity gives way to a more sinister mood. I found myself recalling the gruesome story, recently reported in *The Times*, of a youth found dead in a shop freezer by his appalled employer. However beguilingly Taylor's sculptures evoke a tranquil world of eternal preservation, they also bear an unnerving resemblance to chambers of extinction.

Brad Lochore's paintings do not share the desire to chill. They have an air of elegant refinement, and considerable pleasure is generated by the spare network of lines travelling across each wide canvas. All based on shadows, they conjure an urban environment filled with grand office windows washed by soft light. The results are ambiguous, caught halfway between celebration and elegy. In one sense, they seize on fugitive patterns and elevate them to the status of monumental paintings. At the same time, though, they remain elusive. The largest canvas, handsomely positioned on the end wall, may look imposing enough. But its linear lattice is surprisingly flimsy, and Lochore never lets us forget that shadows, by their very nature, are bound to slip and fade.

All the same, his fastidious work lacks any willingness to disturb. He seems bland compared with the other two artists on view. Gavin Turk dominates the main gallery with a bizarre sculpture called *Pop*. Its title acknowledges a debt to Warhol's full-length portraits of Elvis as a Hollywood cowboy, included in the very first Saatchi exhibition a decade ago. Turk, however, turns the gun-toting figure into a waxwork and encloses it in a glass box. As for Elvis, who came to champion right-wing values later in life, he is replaced by the face of a far more rebarbative singer: Sid Vicious of the Sex Pistols. The fact that Turk himself looks like Vicious complicates the sculpture still further. If this is fundamentally a self-portrait, the artist is remarkably willing to filter his own identity through the fame of two starkly contrasting but equally self-destructive pop icons.

Turk's other exhibits elaborate on the notion of an artist preoccupied with indirect, ironic presentations of his own existence. One room is inhabited solely by a round, ceramic-blue wall plaque. It announces, GLC-style, that 'Gavin Turk The Sculptor worked here 1989–1991'. Surrounded by so much empty space, the plaque looks more melancholy than it would on the façade of a London house. It commemorates an absence, as if Turk were preoccupied with removing himself and leaving only a trace behind. He deals, in the main, with fragments: his signature, scrawled across the centre of an ample canvas, or his right forearm suspended in a glass cylinder like a pickled laboratory specimen. When Turk finally reveals his 'true' image, he appears with wife and child on a mock

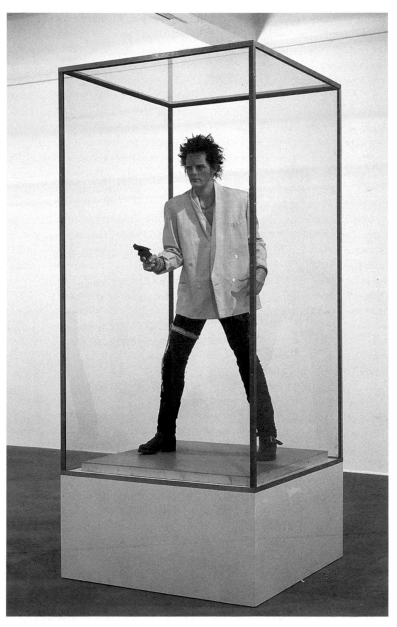

43. Gavin Turk, *Pop*, 1993

cover of *Hello* magazine. The smiling artist gives nothing away as he poses, 'relaxing at home'. Although the headline promises that his 'views on culture and fatherhood' will be revealed inside, this edition of *Hello* contains no pages.

If Turk plays around, Barthes-like, with the notion that he does not exist, Marcus Harvey explores even darker territory. His wildly handled paintings bear an initial resemblance to de Kooning's work. The exuberance of his mark-making suggests that Harvey is trying to revitalize the language of abstraction at its most visceral. But then the black lines running through each picture assert a very different mood. They define the limbs and genitals of female figures, adorned with titillating underwear. Their brazenness is disquieting, partly because these women might be involved in unwilling exposure of some kind.

The tension is increased by the pictorial conflict between the contours and the flamboyant flux of the pigment. They are perpetually at war, and this visual aggression makes the paintings even more troubling. The female nude, in Harvey's work, loses the last of whatever innocence she may once have possessed. Like much of the art in this memorable show, his sprawling figures seduce and alarm in equal measure.

MATTHEW BARNEY
9 May 1995

The smart white room where Matthew Barney's *OTTOshaft* is installed, as the first show in a welcome new Tate Gallery space devoted to Art Now, is utterly unlike the work's original setting. At Millbank, everything is carefully regulated: attendants only allow a modest number of visitors to enter at any given time, and the exhibition is preceded by a printed introduction on the wall. But at Kassel, where I first encountered *OTTOshaft* in the Documenta survey three years ago, it occupied a frankly sinister location. Far removed from the grand galleries and parkland where most of Documenta's art was displayed, Barney's exhibit inhabited a dismal underground car park. There, beneath the curving entry and exit ramps, I felt threatened by all the shadowy, concrete emptiness. And Barney's installation did nothing to alleviate the menace. Odd, unclassifiable yet seemingly functional objects lay on the floor, as if abandoned after some macabre ritual. High on the wall, video images of

figures suspended in a lift-shaft, chasing each other or climbing up to a perilous glass roof reinforced the unease. I remember wondering if I might be mugged – either physically, by a thief lurking in the car park, or mentally by Barney's perturbing art.

Now that *OTTOshaft* has been transplanted to the Tate's sanitized space, much of the threat is removed. In the brightly lit Art Now room, the introductory panel explains that the work is named after Jim Otto, a celebrated American football player of the 1970s. The frenetic activities recorded on video, relayed here by three monitors in the centre of the installation, all take as their springboard Otto's bodybuilding exercises and the manoeuvres of football itself. But if visitors imagine that Barney uses Otto's prowess in a documentary way, they could not be more wrong. The Tate show is still bewildering and bizarre. Three orange containers, open at one end, lie on the floor as you enter. They look discarded, possibly at the end of a highly charged performance, and a black uniform with well-polished buckles has been pushed under an appliance nearby. Our eyes travel up to the monitors in search of an explanation. But Barney is an elusive artist, and his dense, multi-layered work does not yield instant meanings. He presents us instead with obsessive video sequences, half humorous and half gruelling, where a cast of unlikely figures are embroiled in strange, often manic pursuits.

However baffling they may appear, the videos are hypnotic. The first monitor concentrates on Barney himself, naked apart from a swimmer's cap and harness. He embodies one facet of Otto's character, and swings his body up and down a lift-shaft. At times, the effect is exhilarating. This well-muscled figure seems to delight in his ability to scale vertiginous heights. At other moments, though, he appears to be trapped within a claustrophobic ordeal. Crashing against the sides of the narrow shaft, his limbs become bruised and start to bleed.

So Barney is fascinated by the punishing, almost masochistic side of sporting exercise. Even as he admires Otto's determination, he is aware of its inherent absurdity. Hence the weird, dreamlike mood of the second video, where a bearded figure involved in elaborate training procedures is clothed in the 'OO' numbered shirt which Otto himself once wore. We see him motionless, attached to a kind of gymnastic frame. Cylindrical forms reminiscent of bagpipes project from his mouth, and suddenly the screen is alive with figures arrayed in the kilted uniform of the Black Watch. At one point, they plunge their heads into containers identical with those laid out on the gallery floor. But they soon re-emerge, covered in white Vaseline, and then start throwing objects in an underground car park.

Why on earth should these archetypally Scottish performers be

involved with American football? Barney offers no clue. But he is clearly fascinated by the most demanding and stressful aspects of the game. The objects turn out to be pills and cakes variously containing protein and carbohydrate. Both are essential to any sportsman in his drive towards a fully trained athletic physique. Hence the close-ups of orifices, and the increasing sense that Barney is equally concerned with the body's inner processes.

After introducing the harnessed figure, who rushes into a lift in an apparent attempt to escape from his Black Watch pursuers, the second video shows him struggling with the bearded man. In slow motion, they enact a curiously intimate combative sequence. Reminiscent of Muybridge's wrestler photographs as well as the homoerotic couplings in Francis Bacon's paintings, the struggle ends inconclusively. But it frees the harnessed figure to climb up towards a glass dome projecting from the roof of a tall building. Defying dizziness, he walks gingerly across a high beam and stretches up to touch the glass above him. Then the camera reveals that a kilted man is seated on top of the dome, bagpipes raised triumphantly to his mouth.

Unavoidably phallic, they seem to insist on the sexual drive inherent in sporting ambition. But they also point towards *OTTOshaft*'s preoccupation with the body's internal passages. The final video returns, time and again, to images of pipes inserted in orifices. Barney is just as concerned with the inner functioning of the sportsman as with his outer physique. And perhaps he seeks to draw a parallel, above all, between the athlete's and the artist's urges to reshape the body according to their own desires. Hence the unsettling, forceful and often downright maddening vein of fantasy in *OTTOshaft*, where sport becomes the starting-point for a nightmarish investigation of the human figure pushed to its limits.

The same driving purpose, at once aggressive and preposterous, powers its way through Barney's new film *Cremaster 4*. Presented by Artangel all this week at the Metro in Rupert Street, this forty-two-minute barn-stormer focuses on four TT bikers roaring round the Isle of Man in customized sidecars. Brandishing considerable cinematic virtuosity, Barney presents the bikers as anonymous, helmeted gladiators. They seem utterly in thrall to speed, and thrust their way through the narrow, undulating Manx countryside with singleminded virility. But they are no more fanatical than the tap-dancing satyr who, in the film's opening sequence, dances gleefully on a forlorn Victorian pier. Three smirking 'faeries', even more demented than the Black Watch trio in *OTTOshaft*, spur on the satyr and insert balls in his pockets. They are as organic as the white biological forms which gradually ooze out of slits in the biker's uniforms.

44. Matthew Barney, *Cremaster 4*, 1995

Once again, Barney is equally interested in notions of an internal journey through the body. Viewed in this light, the arresting aerial shots make the tiny bikers look like corpuscles circulating through the island's veins.

Barney springs his greatest surprise when, quite suddenly, he forces the satyr to undertake a labyrinthine expedition into the island's bowels. After his dancing feet wear a hole in the pier's floor, the satyr plummets into the water. Instead of drowning, he makes his unflappable way across the sea-bed towards the land-mass. Then, inch by painful inch, he burrows through the island's body. The dandified figure becomes intrepid, forcing himself past excruciating protuberances in tortuous tunnels. By constantly cutting between his efforts and the biker's relentless speeding, Barney builds up the idea of a race between state-of-the-art machines and the godlike satyr. He probably derives from the Phynnodderree, a hairy satyr in Manx mythology who once inhabited the island with other supernatural beings. But he has to undergo an exacting rite of passage below the ground, and there is no guarantee that he will be the first to arrive at the goal: a ram with bright red hair, standing unconcerned in the middle of the race-track.

Any attempt to explain the knotty symbolism of *Cremaster 4* is bound to make this extraordinary work sound impossibly complex. Against all the odds, though, the film is vivid, entertaining and immediate.

Barney's virtuoso direction ensures that we are caught up in the driving dynamism, and made conscious at every stage of the tension between streamlined, mechanical modernity and the primordial, legendary strangeness of the ancient island. That is what matters, not the outcome of a race which remains unresolved even at the end. Wilfully obscure and eccentric he may be, but the originality and panache of Barney's Blake-like paean to energy's 'Eternal Delight' cannot be doubted.

MARK WALLINGER AND THOMAS LAWSON
30 May 1995

No setting could be more appropriate for a Mark Wallinger exhibition. Anyone approaching the Serpentine Gallery becomes aware, quite quickly, of horse-riders in the park. It is a quintessentially English scene, providing a piquant context for Wallinger's engagement with equestrian matters. Strolling into the first room of his show is like entering a top trainer's stable. Impeccably groomed thoroughbreds are lined up against the white walls. Painted with smoothness and precision, these polished images seem custom-designed to hang near eighteenth-century racers by George Stubbs.

But then the mood changes. For these cool, well-mannered pictures turn out, in every case, to depict a divided animal. The front and rear halves come from different stallions, and Wallinger makes no attempt to hide the disjunction. Although they share the same maternal bloodline, these frankly disparate parts are brought into an unsettling union.

Another artist might easily have made them grotesque. To Wallinger's credit, however, these paintings never jar. They retain a streamlined elegance worthy of high-class mounts, and this seductive emphasis on pedigree makes the fault-line running through each canvas even more subversive. If Wallinger did not genuinely savour the gleaming strength of race-horses, his desire to question their origin and purpose could have resulted in heavy-handed work. As it is, the stallion paintings are subtly ambiguous, poised half-way between celebration and scepticism.

Wallinger's attitude to the painting tradition is just as hard to pin down. Fascinated by the eighteenth century, he has no hesitation in see-ing himself as an inheritor of Hogarthian social satire. But he is deter-mined to avoid concentrating, in an antiquarian way, on the media

45. Mark Wallinger, *Half Brother*, 1994–5

Hogarth employed. Hence the presence, in another room, of a four-monitor video installation. Using television coverage of the royal procession at Ascot, the screens deftly edit the event into a smoothly orchestrated display of smiling, hand-waving and hat-doffing. Regal pedigree is brandished here, in a highly theatrical manner reliant on the excitement of the racecourse.

If the Queen and her family are pure-bred products, like the stallions, the continuation of the lineage is in both cases vitally important. Beyond the video piece, a darkened room displays *National Stud*, a wall-size film documenting the elaborate ritual of equine mating. It is a mechanical affair, devoid of sensuality and intimate feeling. The mare looks supremely detached, to the point of outright boredom, as the stallion is guided towards her by patient, expert handlers. Sometimes the mounting operation ends in failure. But even when it succeeds, speed and efficiency are the overriding concerns. After all, an inordinate amount of money has been invested in the preservation and passing-on of the bloodline.

In this sober work, Wallinger's own views remain subservient to the faithful recording of a process. Elsewhere, though, he allows his instinctive humour to erupt in knockabout style. The hilarious *Behind You* takes

the pantomime horse convention and proposes that mating, of a far naughtier and more surreptitious kind, takes place beneath the innocent costume. Its music-hall relish compares well with the *Fountain* nearby, a homage to Duchamp which trains water though a hose. After curling through the gallery, the hose pushes through a window and spurts into the gutter, where the water is then returned to the hose.

This endless recycling seems witless, especially when set beside the ingenious Tommy Cooper video in a small end room. Here visitors are confronted by a mirror-image of the screen. We can watch ourselves watching Cooper, as we realize that his familiar routine is being played backwards. Comedy turns to puzzlement and, ultimately, a sense of sadness, as we watch him mouth garbled jokes and feverishly try on a manic parade of hats. He seems, in the end, caught up in a ritual as bizarre and absurd as the royal miming from ceremonial coaches at Ascot. England is replete with these unlikely cross-connections, and Wallinger probes our sense of national identity with a keen eye for its inherent greed, class-conscious codes and high-flown dottiness.

If Wallinger is obsessed with analysing the phenomenon of Englishness, Thomas Lawson's show at the Anthony Reynolds Gallery offers a far more complex, multinational brew. A Scottish painter of considerable distinction, Lawson has lived for well over a decade in the USA. He is currently dean of the Fine Arts Faculty at CalArts in Los Angeles, but his new exhibition takes Vienna as its springboard.

The paintings on view all seem to be the product of Freudian traumas. Brilliant, often discordant colours charge the rooms with a strong, disquieting energy. Lawson reinforces the unease by joining two images in one queasy hybrid. He makes even less attempt than Wallinger to hide the joins between them. Each panel is separated from its neighbour by a thin strip of wood or plastic, often as brightly coloured as the paintings themselves. Sometimes, Lawson opts for a shrill clarity, and we find a trio of Poe-like crows silhouetted against a blood-red ground. But then, in another mood, he exchanges all this precision and flatness for a more painterly, blurred approach. And more often than not, different styles are brought into troubling conjunction in these strange, tantalizing diptychs. Grimacing masks loom, as if the carvings on ornate Viennese buildings had become detached from their surroundings and started to haunt us. But their demented air belongs more to the madhouse than to a baroque façade.

Time and again in this elusive, teasing exhibition, Lawson returns to the image of an institutional room. As stark as a convict's cell, it never includes the figure who inhabits this forbidding chamber. The occupant's

presence is strongly felt, however. And the strident, bilious colours envenoming door, bed and window accentuate the air of anxiety. Some of these interiors derive from images made by Egon Schiele during his short period of imprisonment. They help to account for the claustrophobic mood, and the feeling that escape is impossible. Here, in this oppressive space, the screaming heads press forward like denizens of dreams endured by the captive. Hence the special significance of the bed, which Lawson may well see as a diabolic cradle for the nightmares he unleashes with such disconcerting relish.

STEVE McQUEEN AND MIRAGE
27 June 1995

Slowly, almost languorously, the camera moves in searching close-up across a black man's face. Then it cuts to another black face, plumper and more anxious. He rubs sweat from his lips, moving nervously from side to side as if limbering up for a fight. But the threatened struggle between the two men never really takes place. Both naked, they grin at each other. They even embrace, and when eventually their bodies lock in a bout of wrestling, it soon gives way to a slow-motion, lyrical dance.

Bear, a ten-minute film by the promising young British artist Steve McQueen, stands out in the ICA's mixed international exhibition called *Mirage: Enigmas of Race, Difference and Desire*. The show takes its cue from the writings of the Martinique-born Frantz Fanon, whose 1952 book *Black Skin, White Masks* proved a widely influential, provocative study of colonialism and its traumatic psychological legacy. Like Fanon, McQueen refuses to accept stereotyped attitudes. 'Look a Negro! . . . Mama, see the Negro! I'm frightened!' wrote Fanon, dissecting the insidious blend of voyeurism and terror which so often fuelled colonial prejudice. *Bear* plays with the notion of a threatening black aggressor, but soon replaces it with a far more stimulating alternative. Time and again, the camera lingers on the faces of the two men, inviting viewers to question their own expectations about how the encounter might develop. Rather than serving up a predictable stew of *macho* violence, McQueen turns the supposed combat on its head. A teasing vein of tenderness and affection runs through this remarkable film, tantalizing us with ambiguities. By staying close to both bodies, encircling them with shadow and

46. Steve McQueen, *Bear*, 1993

selecting dramatic camera angles, *Bear* sustains the aura of mystery throughout. And the final dance, as well as banishing all thoughts of war between the men, seems to rejoice in the film's escape from racial clichés.

Even so, there is nothing complacent about McQueen's vision. His most recent film, the still more impressive *Five Easy Pieces*, begins with an image of unease: a tightrope, viewed in arresting close-up, is flung across the screen and hangs there like a challenge. Sure enough, a foot begins to move across it. But the possibility of danger recedes once the precision of the tightrope-walker's tread has been established. McQueen then cuts to an aerial shot of hula-hooping men. It is a superbly conceived image, at once elegant and dynamic. Figures and hoops both cast shadows on the ground, making up a composition as poised as the aerial vantages explored by Rodchenko and other Russian artists in the post-revolutionary period.

But there is tension here, along with a veiled sense of erotic defiance. One hula-hooper is seen from below, his body caught up in provocative gyrations. Then a man in white shorts is seen from a similar vantage,

standing expectantly with legs apart. A few seconds later, a woman in a sequinned top starts moving up and down. She might be the tightrope-walker, but McQueen's fragmentary style leaves us feeling uncertain. Only the walker's shoes are shown, making their way across the diagonal rope. The camera is now directly below, involving us vividly in sensations of danger. And when the man in shorts starts to urinate, apparently straight down on us, the apprehensive mood grows.

Not for long, though. Water bubbles fill the screen, forming patterns as appealing in their way as the hula-hoop circles. McQueen leaves the camera on them as they slowly burst, and the hint of melancholy is confirmed by a final shot of the hula-hoopers themselves. Their gyrations come to an end, leaving us with a sense of exhaustion and aimlessness. The incessant mood-shifts in *Five Easy Pieces* vary as much as the camera angles, and they add up to an experience rich in ambiguities.

I missed this complexity in some of the artists' contributions to *Mirage*. Glenn Ligon's *Rumble Young Man Rumble* is a punch-bag suspended from the gallery ceiling. The canvas is covered with words written in paint-stick, and anyone trying to read them quickly becomes dizzy from moving round the bag in circles. The words turn out to be a quotation from Muhammad Ali, complaining that 'everything in America that has been made the greatest has been painted and colored white – like Jesus is white, Santa Claus, Tarzan . . .' The denunciation grows in anger as it runs down the canvas, suggesting that Ali might have terminated his mono-logue against oppression by slugging the punch-bag with his fist.

But the work seems simplistic compared with McQueen's films, and a certain wry slickness enters Ligon's art when he fills a tall painting with the repeated sentence 'I feel most colored when I am thrown against a sharp white background.' The words become more and more smudged as they descend the tall panel, ending up almost indecipherable. But that does not prevent the whole picture seeming like a one-liner, quickly absorbed and easily exhausted.

Isaac Julien's contribution takes longer to watch, and it addresses with impeccable seriousness the problem of rabidly right-wing US television talk shows. All the same, Julien scarcely lives up here to his distinguished reputation as an innovative black film-maker. Footage from the show hosted by the notorious Rush Limbaugh is intercut with sober comments, written and performed by Patricia Williams. While offering no bland reassurance, she seems po-faced when set against Limbaugh's grotesque, rabble-rousing energy. A muffled soundtrack makes her difficult to hear in a narrow ICA corridor, so I decided that Julien's film would be far easier and more effective on a television set at home.

Upstairs, visual impact is restored by Sonia Boyce. Her linotronic print of a kissing couple is as colossal as a billboard. It sets up an odd tension between the intimacy of the act and the grandiose public exposure involved in placing this outsize image in a gallery. The fact that the woman is black and the man white indicates that Boyce wants to celebrate the breaking-down of boundaries, and the gentleness of the couple's proffered lips reinforces their mutual affection.

All the same, *Mirage* does not permit us to wallow in optimistic certainty for long. Marc Latamie, who shares Fanon's birthplace, confronts us with a stark wooden hut. It might once have been occupied by a plantation worker. Now, however, its emptiness is alleviated merely by a video screen, relaying an image of a field filled with sugar-cane flowers. They should be as seductive as a shimmering Impressionist landscape, but in this context they look utterly joyless.

Apart from McQueen, only Lyle Ashton Harris seasons his work with humour. He intersperses his own sumptuous photographic images – large, glossy, studio-lit and well-framed – with family snapshots stuck on a green wall with drawing-pins. Selected from albums, these modest little pictures include beach holidays, a wedding and a graduation ceremony, all proudly witnessed and recorded by the artist's grandfather, Albert Sydney Johnson Jr. They could hardly be more conventional, and their touching tributes to the pleasures of married life contrast with Harris's defiant, taboo-breaking work.

A natural chameleon, he poses in lavish make-up and New York police uniform as *Saint Michael Stewart*, named after a young black man who died in police custody several years ago. Possibly inspired by the uninhibited theatricality of Cindy Sherman's recent photographs, Harris subjects his own identity to a bewildering sequence of transformations. At his most flamboyant, he presents himself as the eighteenth-century Haitian liberator Toussaint L'Ouverture, and also uses the occasion as a pretext for dressing up as a drag queen. But then he appears naked in a series of brazen photographs with his brother Thomas Allen, kissing and embracing like a gay couple while aiming toy guns either at each other or the viewer.

Harris is HIV positive, but no bitterness can be detected in this young man's work. It is exuberant, mischievous and, above all, intoxicated by the desire to discredit weary old preconceptions about black males. He must, in the past, have challenged and flouted the family expectations implicit in his grandfather's snapshots. But by combining them with his own work here, Harris proposes that reconciliation becomes possible if love is strong enough. A victory has been won for greater understanding, and it carries a redemptive, liberating force.

GLENN BROWN, KEITH COVENTRY, HADRIAN PIGOTT AND KERRY STEWART

26 September 1995

Like the ageing Howard Hughes before him, young Hadrian Pigott is obsessed with hygiene. But the water pressure in his flat, high up on the twentieth storey of a South London block, is too feeble for a shower. Nor can he muster enough hot water for a bath. So Pigott finds himself crouching in the tub for an old-fashioned hand-wash, a ritual which informs the strangeness of all his exhibits in the Saatchi Gallery's new show.

Neatly laid out along the far wall of the main space, Pigott's clinical art makes the all-white Saatchi interior look even more pristine and purged than ever. His imagination seems to dwell permanently in the bathroom, and he turns one work into a celebration of cleansing. Each of eighteen white soap-bars, nestling blamelessly in an equally spotless dish, is inscribed with the name of a body-part rather than the manufacturer's logo. We move down the row, from 'armpits' and 'chest' to 'belly', 'balls' and 'back', just as Pigott might methodically wash one bit of himself after another.

The whole notion of having a separate piece of soap for each anatomical area is bizarre, suggesting that the artist views his obsession with wry humour. 'Dirt Urgent' are the words pressed into another white bar, as if its owner were driven by a paranoid need to rid his flesh of the slightest contaminating speck. And when Pigott turns his attention to the places where purification occurs, he displays an even more subversive streak. The lavatory is sealed tight, frustrating any desire to lift the seat. A near-by sink has been transformed into a convex mass of snowcrete and plaster, on which two taps, a plug and a metal hole perch ridiculously. As for the bath, nothing is left apart from a solid cast of its interior. Taken together, this perverse ensemble adds up to a hygiene fanatic's nightmare. Perhaps that is why Pigott elsewhere places a fully functional wash-basin in a red velvet case, complete with plumbing accessories. True cleansing zealots can carry it around with them, ready for use whenever the urge to wash becomes overwhelming.

Several of these works are so bleached and simplified that they resemble sculptures by Brancusi, Gabo or Hepworth. But far from sharing a desire to arrive at an abstract purity of form, Pigott's vessels are allied with everyday objects and reek of mental disorder and absurdity. Cleanliness has grown, paradoxically, into a disease.

From a distance, Keith Coventry's paintings also stir memories of modernism's heroic early years. They all look as white and abstract as Malevich's canvases at their most extreme. Like Pigott, however, Coventry evokes the early twentieth-century avant-garde only in order to challenge its revolutionary idealism. Gradually, as we approach his seemingly impeccable surfaces, refinement gives way to frustration.

Seen at close quarters, his pigment is the very opposite of serene. Vigorously brushed figures and buildings can be detected beneath its snowy façade. And although Coventry calls each picture *White Abstract*, his subtitles provide us with a clear idea of the represented scene. *Royal Family* seems to be based on a conventional photograph of the House of Windsor's main members, staring out stiffly in line. But by the time Coventry has spread his whiteness over these ubiquitous figures, they become robbed of substance. Pale and vulnerable, the Queen and her relatives look like spectres attending their own funeral. They hardly exist, and the subjects in the other paintings soon indicate that the artist is concerned throughout the series with Britain at its most hidebound and ceremonial.

The aptly named White's club appears, covered in the all-enveloping hoar-frost which Coventry's brush bestows. The building's dimly perceived frontage shimmers, and threatens at any instant to fade completely from view. So do the Horse Guards parading through central London, their uniforms all drained of colour. They appear to be assailed by a midwinter blizzard, and end up looking more like statues than riders on the move.

The chill grows ever more severe as we walk around Coventry's room. Whitehall, Eton and Ullein Reviesky, 'the last Deb', all become frozen into stasis. Petrification inevitably leads to thoughts of death, and the figures discernible in these Siberian pictures come to resemble corpses smothered by a layer of white ash. If the choice of subjects allies Coventry with Sickert's late work, which ranged across British society and depended openly on photographic sources, the two men's visions are in the end quite different. Sickert savoured the vitality inherent in his chosen images, whereas Coventry sees them all as remote, blanched vestiges of a social order receding into obsolescence. The longer we gaze, the more they fade and hover, in the end, on the very borders of invisibility.

No such danger threatens Glenn Brown's work. In a startling break from the normal Saatchi austerity, the walls of his space have all been painted a rich, ripe red. It looks as luxurious as the plushest of Old Master galleries, but the canvases displayed here take twentieth-century paintings as their starting-point. Brown appropriates the work of other artists, and does so with brazen bravado.

The effect is disconcerting. For he lavishes enormous technical skill on these exercises, and they appear at first to be nothing more than clever, shameless copies. The most arresting exhibit, *Dalí-Christ*, is based in the most blatant manner on one of Salvador Dalí's most familiar works, *Soft Construction with Boiled Beans: Premonition of Civil War*. But it is by no means a simple facsimile. Dalí's painting, which centres on an anguished struggle between two grotesquely distorted figures, is square in format. Brown's version is far taller, and he twists the figures even more drastically in order to fit them in. He uses bright, harsher colours, too, giving Dalí's terracotta flesh a more unhealthy pallor and making the sky's blue patches more garish.

Far from copying Dalí's original, he seems to have based his version on a billboard-size reproduction. So on one level, Brown's painting shows how an artist's work can be misrepresented by the proliferation of cheap, often inaccurate department-store prints. In a wider sense, though, he appears to be questioning the whole notion of an authentic, individual vision. Two of the other artists he appropriates, Karel Appel and Frank Auerbach, both use thick paint and indulge in vigorous, headlong mark-making. But Brown's versions all flatten their work, making them more like reproductions and deadening their vivacity. They become neutralized, neither more nor less important than the large, glossy copies of science-fiction illustrations by the apocalyptic Chris Foss.

It is a relief to escape from this oppressive, mass-produced levelling and encounter the fourth artist in the show, Kerry Stewart. She is shown off with triumphant flair. The whole of one room is given over to a single figure – a plaster *Sleeping Nun*, painted in black and white enamel. Although resting the full length of her body on the grey floor, she appears to be hovering above it. Her loneliness is intensified by the void around her, evoking the solitude and meditative stillness of convent life. Entering this surprisingly potent gallery is akin to finding yourself marooned in a chapel.

Stewart's other figures benefit just as much from the even greater immensity of the space they inhabit. One, a *Ghost* wrapped in a childlike sheet, lumbers forward waving both arms with melodramatic energy. It should be laughable, but the vengeful grey eyes are reminiscent of the mask-like slits in a Ku-Klux-Klan costume. Even a nursery-rhyme phantom has the ability to disturb, and elsewhere Stewart's work becomes more commanding when she abolishes movement altogether. The pregnant schoolgirl, presiding helplessly over the swelling in her regulation pullover, seems paralysed by her predicament. But she remains as upright and defiant as the twins who stand at the distant end of the gallery.

47. Kerry Stewart, *Sleeping Nun*, 1995 (detail)

Modest rather than monumental, these identical boys nevertheless dominate the vastness around them with effortless authority. They have an extraordinary presence, at once beleaguered and accusatory. Capable of arousing our sympathy and discomfort in equal measure, these mesmeric figures prove just how much a young artist stands to gain from a perfectly calculated display in the Saatchi Gallery's cool, clear light.

'AFRICA 95' AND JAMAICAN ART
24 October 1995

Visitors to the Royal Academy's great *Africa* show could be excused for imagining that art, throughout the continent, somehow petered out in our own age. But the 'africa 95' season, now enlivening so many galleries across Britain, demolishes that supposition with delightful aplomb. The major contemporary exhibition is housed at the Whitechapel Art Gallery, where *Seven Stories about Modern Art in Africa* is powered by a disarming vitality. Rather than attempting a comprehensive overview, it pinpoints seven countries and defines their singular achievements since the 1960s. In each case, the selection has been made by an insider – an artist or historian from Africa armed with an eyewitness's grasp of recent developments.

'The Quest' is the open-ended title chosen by Chika Okeke, curator of the first story, for an exploration of different movements in Nigerian art. The section is prefaced by Erhabor Emokpae's painting *Struggle Between Life and Death*. Executed in 1962, its black-and-white geometrical starkness centres on the image of a head and outflung hands. They seem trapped, but at the same time determined to escape. And this urge to overcome even the most daunting constraints runs through the entire exhibition.

In Nigeria, artistic liberation has come by merging indigenous traditions with fruitful Western influences. The tension between them gives much of the work its dynamic, and in the section devoted to Sudan and Ethiopia a further division becomes apparent. For modern Sudanese artists tried to make sense of the gulf between the Arabic and African sides of their country. Kamala Ibrahim Ishaq is inspired by traditional ceremonies, but in *Images in Crystal Cubes* she also shows an awareness of Francis Bacon. Women's faces appear to be imprisoned in the cubes, and female dilemmas are also dramatized by the Ethiopian artist Elizabeth Atnafu. Her *Shrine for Angelica's Dreams* is the most spectacular exhibit, bringing together a cornucopia of religious icons, plastic soldiers, flowers, dolls and much else besides in a tribute to women's fantasies and aspirations.

For sheer theatricality, though, the Senegal section is impossible to resist. Visitors are invited to move through a curtain into an arena where colossal painted canvases dangle freely from the ceiling. A raised platform acts as an outsize plinth for wooden crosses and other, equally emotive props. It looks like a stage-set, and many of these objects were

made for performances at the Laboratoire Agit-Art, an artists' collective in Dakar.

As well as revelling in high spirits, these collaborative images address global issues as urgent as deforestation. But the harshest emotions are found upstairs, where South Africa kicks off with a room dominated by heartfelt paintings of the martyrdom of Steve Biko. Sam Nhlengethwa, Paul Stopforth and Alfred Thoba all make moving images about Biko's death in detention. In the next room Kevin Atkinson's *White African Landscape* seems at first glance like a fierily expressionist response to the heat of the countryside. But part of its turbulence derives from Atkinson's indignant awareness that 87 per cent of the country's land was given to white settlers in a 1913 parliamentary Act.

As we move on to Uganda and Kenya, the mood becomes increasingly tragic. The political regimes of Idi Amin and Milton Obote scarred the imaginations of native artists, and Kega Sempangi uses a lizard as the springboard for a painting where a Yeatsian 'rough beast' ranges the desert like a marauding harbinger of extinction. Nearby, Josephine Alacu's *Mother's Nightmare* dramatizes the anguish of a woman dreaming that her child has been devoured by an insatiable monster.

The emphasis on internecine combat and oppression continues in the final room with Kenyan artists, who are often self-taught. Richard Onyango's immense painting of a catastrophic train crash presides over the space, like a rumbustious painterly equivalent of a widescreen disaster movie. A flooded river has swept away half the carriages, and Onyango reinforces the brutality of the event with the vigour of his muscular brushmarks.

But Sane Wadu's *Waiting* concentrates on another, more ominous kind of transport: a truck filled with terrified prisoners awaiting their fate. The sense of struggle in Africa, announced at the beginning of this overwhelming show, has not lessened over the last thirty-five years. Even so, the Ugandan artist Francis Nnaggenda sums up the strength of the exhibition by declaring: 'Destruction exists but the spirit must survive – amputated but still full of resistance.'

Buoyancy is the overriding temper of the Serpentine Gallery's enjoyable *Big City: Artists from Africa* show. Unlike the Whitechapel survey, it concentrates on individuals and gives each one an abundance of space. Cyprien Tokoudagba, accustomed to decorating shrines and temples with murals in his native Benin, is able to fill all four walls of the largest room with exclamatory paintings. Addicted to gods, especially if branches or triple heads sprout from their necks, he handles the wide white surfaces with seasoned verve. Although grinning animals occasionally make a

predatory entrance, the murals as a whole are infectiously cheerful. Indeed, the Whitechapel's violence and suffering are hard to find anywhere in this effervescent exhibition.

Some of the small drawings in ballpoint and coloured crayon by the prolific Frédéric Bruly Bouabré tackle the savagery of racial conflicts. But his childlike style is more often playful and fantastic, reflecting his own belief in the visionary, God-inspired origins of his talent. Satan appears in one of Johannes Mashego Segogela's carved and painted scenes, clutching a corpse like a sacrificial offering and marketing it as fresh meat. Macabre humour prevails in his work, though, and Bodys Isek Kingelez spirals off into a frankly surreal world.

Based in Zaire, this indefatigable and witty artist builds proliferating cities out of wrapping paper, cardboard, plastic and any other materials he can find. The resourcefulness of his approach is quintessentially African in its improvisation, and the epic construction called *Kimbéville* is the high point of the whole show. Peppered with post-modern buildings whose function escapes definition, this bizarre yet oddly persuasive town bristles with unpredictable energy.

Not everything at the Serpentine is a success. Georges Adéagbo's installations, combining found objects with written messages, are long-winded and hard to decipher. But Seydou Keita's photographs of friends and clients in his native Mali are rich in psychological insight, wry play-acting and a marvellous instinct for the revealing pose.

Caribbean experience is the theme running through the defiantly individual contributions to *New World Imagery: Contemporary Jamaican Art* at the Arnolfini in Bristol. All the same, this lively touring show points out that over 95 per cent of Jamaica's population are the descendants of Africans taken there during the Slave Trade. So issues of race are important; and all the diverse artists on view here owe a profound debt to the sculptor Edna Manley's attempts, after her arrival on the island in the 1920s, to nurture an identifiably Jamaican visual culture.

Most of the painters have a strong expressionist flavour. Milton George sets biblical figures in primordial landscapes, and is unafraid of vehement colour heightened by loose, impassioned brushwork. Leonard Daley is even more impetuous, crowding his surfaces with clamorous clusters of figures and animals who leer, gesticulate, threaten and dance with beguiling gusto. Self-taught, Daley is proud of his intuitive approach. But Raz Dizzy is equally irrepressible, operating half-way between George's expressionism and Daley's untrained impulsiveness. Dizzy's name, inscribed in proud capitals on each of his hectically painted panels, sums up the wild, almost vertiginous excitement generated by his best paintings.

48. Anna Henriques, *Isabella Boxes*, 1995 (detail)

Such headlong work could hardly be further removed from the stillness and secrecy cultivated by Anna Henriques. Of Portuguese Jewish descent, she tries to bring about a fusion of European and indigenous Arawak influences. Often presented in the form of cupboards and dressers, her art ensures that doors and drawers open to disclose trinkets and archeological remains arranged like burial offerings within.

The most polemical images are provided by David Boxer, the Director of the National Gallery in Kingston and a doughty champion of Jamaican art. His haunting collage sequence, *Memories of Colonisation*, shows grandiose European interiors invaded by African masks and photographs of injured bodies. The sense of melancholy and waste is poignantly conveyed, and the paintings by Omari Ra 'African' of hunched figures are equally anguished. But the overall feeling of the show is resilient. After centuries of subservience Jamaica is discovering its independent identity, and artists play a central role in giving this emancipation a zestful, questioning form.

THE VITALITY OF YOUNG BRITISH ARTISTS
7 November 1995

So far this autumn, the art of the past has dominated the blockbuster shows. But now contemporary work at its most challenging moves centre-stage. At the Tate Gallery, the four shortlisted contenders for the Turner Prize limber up for the bestowal of the £20,000 award on 28 November. And next Sunday, *The British Art Show* opens in no less than seven galleries throughout Manchester. By the time its national tour finishes in the summer of 1996, this large survey will have given its twenty-six artists a comprehensive airing in Edinburgh and Cardiff, too.

As one of *The British Art Show*'s selectors, along with Rose Finn-Kelcey and Thomas Lawson, I am in no position to assess its merits. But it could hardly be happening at a better moment. New art in this country enjoys an outstandingly high reputation today. Curators, critics and collectors in many different countries are excited about the vitality of British artists. Their work is galvanized by a strong sense of confidence, inventiveness and subversive humour. Far from lapsing into complacency over burgeoning international success, they continue to lace their images with disconcerting insights.

Take the Turner Prize show, where the Tate has at last given each of the front-runners the ample space they deserve. Despite the kerfuffle last week over the non-appearance of Damien Hirst's principal exhibit, he emerges very powerfully. *Mother and Child, Divided* may be dismissed by the tabloid press as a publicity stunt, but in my view it is one of his most impressive works. I first saw it at the 1993 Biennale in Venice, a city dominated by

49. Mona Hatoum, *Corps étranger*, 1994

Renaissance paintings of sublime madonnas and their offspring. Hirst's sliced cow and calf offer a far bleaker view as we pass between their bodies, each eerily suspended in a formaldehyde tank.

Mona Hatoum's work is almost as disquieting. Her *Corps étranger*, a video projected on to the circular floor of a claustrophobic chamber, was shown at the Tate earlier this year. It has lost none of its visceral impact.

We stare down at the images transmitted by minuscule medical cameras as they travel through the artist's body. Recordings of her heartbeats heighten the tension and air of vulnerability, whereas *Light Sentence* in her other room is utterly silent. A naked bulb, enclosed by stacks of wire-mesh lockers, moves slowly up and down. The complex shadows it casts on surrounding walls heighten the sense of melancholy constriction conveyed by the empty, seemingly abandoned cages.

Mark Wallinger, by contrast, is not afraid to deploy humour in his dissection of national life. At the Tate, his images concentrate on horse-racing, and some of the large canvases seem as still and immaculate as Stubbs's horse paintings. Then we realize, with a shock, that each of Wallinger's stallions is a hybrid image. Two different animals are cut in half, as abruptly as Hirst's sliced mother and child, only to be joined together in an incongruous whole.

For Wallinger, painting is only one medium among the many that he employs. Callum Innes, however, is solely preoccupied with oil on canvas. This Edinburgh-based artist loads his brush with turpentine and washes away the colour already applied to the canvas. The results are arrestingly varied. Sometimes the turpentine trails are left as a series of thin vertical stripes, running from the top of the picture to the base. On other occasions, the washing process begins to generate new forms, suggesting that Innes has no intention of adhering to absolute abstraction.

Innes is a refined and seductive artist, and his presence rounds off the most satisfying Turner Prize survey I have yet seen. Both Hirst and Wallinger are also included in *The British Art Show*, where their willingness to move freely from one medium to another typifies many of the contributors. At Upper Campfield Market, a handsome and freshly converted Victorian building which provides Manchester with a spectacular new exhibition space, an extraordinary variety of work will be displayed alongside Hirst's celebrated floating sheep work, *Away From The Flock*. Gary Hume is committed to painting, but he is heretical enough to employ shiny household gloss in his determination to revitalize the figurative tradition. Kerry Stewart takes liberties with the figure in sculpture, drawing on charity statues as she explores adolescent sexuality and irrational childhood fears.

All the other artists at Upper Campfield Market adopt less orthodox approaches. The possibilities of photography are investigated in widely diverse ways. Gillian Wearing uses her camera in a documentary spirit, inviting people she meets to write down their spontaneous observations on paper and pose beside them. But Jane and Louise Wilson take their camera indoors, using theatrical lighting and illusionism to explore mys-

terious rooms filled with ominous expectancy. As for Hermione Wiltshire, she incorporates photographic images of body parts in wall-works which arouse sensual responses and yet, at the same time, undermine them.

Elsewhere in the Market, visitors will move between extremes of experience. John Frankland's shining sculpture encloses a shed in a silvery, highly reflective coating. However much it attracts us, this beguiling structure cannot be entered. Christine Borland, on the other hand, lets us go into a Portakabin and explore all the bizarre and gruesome contents of her *Black Museum*. To watch Steve McQueen's powerful films, *Bear* and *Five Easy Pieces*, viewers will have to penetrate the darkness of the two rooms where they are projected on large screens. But Tacita Dean's film, of a girl stowaway on a tall ship, is shown in a space otherwise given over to a teasing blend of evidence about her elusive heroine.

Three more artists rely on their ability to transform everyday objects, ranging from Jordan Baseman's hair-clogged shirts and Permindar Kaur's dagger-adorned dress to Lucia Nogueira's rug mysteriously flanked by clusters of broken glass. Chris Ofili, however, does not interfere with the brazen reality of the elephant dung he applies to his meticulously crafted paintings, where William Blake vies with African art as the dominant influence.

Although Upper Campfield Market is by far the largest exhibition space, the other six galleries offer equally thought-provoking installations. At the Chinese Arts Centre, Mat Collishaw will transform the main space with his intricate and deceptive video work. Anya Gallaccio is smothering the walls of the Castlefield Gallery with chocolate. And Douglas Gordon's mesmerizing, large-screen film works will compel attention in the monumental interior of the Metropolitan Galleries, alongside Ceal Floyer's cunningly understated light-projection.

At the City Art Galleries, Georgina Starr is setting up an elaborate video ensemble based on childhood memories of a science-fiction movie. But silence is restored at the Whitworth Art Gallery, where Bridget Smith's sumptuous photographs of cinema interiors share the space with Marcus Taylor's luminous perspex sculptures.

Finally, at Cornerhouse, Wallinger's work on the top floor is followed in the space below by two disturbing sets of images: Catherine Yass's unearthly light-box photographs of hospital corridors, and Julie Roberts's clinical paintings of mortuaries and dentists' chairs. The sense of unease continues on the lowest floor, where Sam Taylor-Wood's video installation combines everyday lassitude with intense, operatic emotion.

By giving each artist a substantial space, *The British Art Show* wants to celebrate the sharply defined individuality of every participant. But the

overall mood of the exhibition, with its emphasis on investigation, memory, dislocation, mortality, loneliness, enigma and fragmented storytelling, ends up saying a great deal about the troubled temper of our time. The provocative new art of the 1990s has no intention of hiding away from the world, and visitors will find that the exhibits impinge on their own lives at every turn.

REFLECTIONS ON THE BRITISH ART SHOW
18 November 1995

Against all the odds, young British artists are now rejoicing in an extraordinary boom. Invitations to show their work arrive from all over Europe, America and beyond. Finding themselves the focus of avid international attention, they respond with energy, wit and resourcefulness. No trace of traditional insularity hampers their buoyancy. Nor do they silently accept the tired old idea that their nation's cultural strength lies principally in its literary and theatrical talents. Defying our supposed bias against the visual, they have proved that Britain is capable of producing a remarkably self-assured and inventive generation busily redefining accepted ideas about what art can be.

That is why I feel fortunate to be involved in selecting *The British Art Show*, a large exhibition of contemporary work which opens its national tour in Manchester next weekend. The timing for such an event is ideal, providing an opportunity for visitors throughout the country to discover some of the most outstanding newcomers of the 1990s. The last *British Art Show* was held five years ago, before the current explosion of international interest began. So this instalment can be seen as a celebration of the boom years, and seven major galleries across central Manchester have united in an unprecedented way to give this survey the space it needs.

Not that the task of selection was easy. *The British Art Show* is a National Touring Exhibition organized by the Hayward Gallery in London; and when they invited me to be a selector, along with Rose Finn-Kelcey and Thomas Lawson, no limits were set on the number or age of the artists who might be chosen to participate. To make matters still more complicated, none of the selectors knew each other. So at our first meeting, well over a year ago, all three of us were conscious of the possibility that we might never find enough common ground. It was a

nervous occasion, overshadowed by our awareness of the daunting problems involved in shaping a coherent show from a potential cast-list stretching from senior figures like Sir Anthony Caro or Lucian Freud to recent art-college graduates.

During the first few months of intensive research, we kept our minds open and examined a cornucopia of contenders. Throughout the country, a network of advisers submitted names, many of whom we had never encountered before. Thousands of slides were inspected, exhibitions visited and catalogues consulted. The process often proved exhausting, but we were sustained by the excitement of making discoveries and realizing, with considerable relief, that we shared enthusiasms about a growing number of the artists under review.

Many of them were young; and after a while we found, quite independently of each other, that our thoughts were focusing more and more on the new generation. Their exceptional vitality ended up dictating the character of the exhibition. The work demanded to be shown in some depth, so we kept the number of artists down to a level where they would all have enough room to assert their own identities. Only then would the emergent artists of the 1990s be able to display their provocative freshness and bold, innovatory edge.

The wonder is that they have flourished at all. Too young to have benefited from the short-lived yet feverish investment mentality of the mid-1980s, when an astonishing amount of money was gambled on art, they arrived at a time of gruesome recession. Few of the dealers who managed to survive the market's collapse were interested in taking on unknown names, and the artists themselves could easily have succumbed to dejection.

To their credit, though, they rejected the prospect of defeat. Since the West End galleries refused to show them, they decided instead to organize their own exhibitions. Buildings left vacant by the property slump were taken over by enterprising groups. With an admirable display of self-reliance, they turned these alternative spaces into showcases for work that seemed surprisingly at home in gaunt, sometimes ramshackle premises. We first encountered several of the contributors to *The British Art Show* in *ad hoc* exhibitions of this kind, and the improvisatory spirit galvanizing such spontaneous events helped to give their work its adroit, quick-thinking verve.

Many of these artists befriended each other, and continue to show together even though adventurous dealers are now signing them up on an individual basis. But they were never united by the desire to form themselves into groups or movements, as so many of their forerunners

50. Sam Taylor-Wood, *Killing Time*, 1994 (detail), in *The British Art Show*, 1995

did in the early years of the century. Such collective endeavours, usually armed with joint manifestos and titles as resounding as Futurism, Suprematism or Vorticism, belong irrevocably to the past. The artists of the 1990s are unmoved by idealism, and lack the visionary fervour that gave so many pioneering avant-garde initiatives their headlong impetus.

The contributors to *The British Art Show* are all firmly independent, and resist any attempt to impose glib generalizations on their work. But the fact is that they have grown up in the century's declining years and found it wanting. Disenchantment is an unavoidable part of their out-look. The death of old illusions has been impossible to ignore over the last decade, and none of these artists has an overriding faith in any fore-seeable amelioration. If young innovators greeted the advent of the twentieth century with optimism and unbounded dynamism, their suc-cessors at the century's end are far more likely to thrive on a bracing diet of irony and scepticism. They also tend to distance themselves from any binding allegiance to a single way of working. Rather than satisfying themselves with loyalty to a single, exclusive medium, they often relish the expanding array of alternatives and move freely between painting, sculpture, video, film, photography and ready-made or found objects.

carpet, like the rest of Gallaccio's work, is bound to fade and rot as the weather assaults its brazen gaudiness. She is fascinated by the slow, relentless process of decay, and the transformations it brings about. Although they are often savage, reducing an outsize daisy chain to a bedraggled ruin, Gallaccio accepts putrefaction as an inescapable part of her art.

Not that the colossus of ice at Wapping will ever fester and stink. Its decomposition is proving far more graceful than Gallaccio's work normally allows. In fact, the melting is happening so slowly in this chilly interior that complete dissolution is difficult to imagine. Discreetly, she has tried to hasten the process by lodging a boulder of rock salt within the ice. A strip-light is also buried there, enhancing the sculpture's seductive bluish glow and, no doubt, contributing to its eventual demise. So far, however, the most noticeable sign of disintegration only occurs at the top, where a sizeable cavity has already appeared.

We notice it at the outset, before walking downstairs to the floor level where the work rests on a wooden pallet. The blanched behemoth rears above us here, so large and cold as to seem indestructible. We cannot peer in very far: the melting process has fused the slabs together, making them appear solid enough to frustrate anyone wanting to gaze through to the middle of this arctic mass. But we do become aware, after a time, of the quiet yet persistent sound made by dripping water. Puddles have spread across the floor, making us tread with care as we move round the sculpture. And runnels wriggle like worm-trails across its shimmering surface, inviting us to prod the ice for as long as our fingers can withstand the cold.

The further we explore, the less stable it appears. What started out resembling an exercise in refrigerated minimalism turns out, in the end, to undermine all the stable, slab-like solidity which Carl Andre, Don Judd and the other pioneers of sturdy Minimal Art did their best to emphasize. Their work is impersonal, reined-in and utterly opposed to emotional onrush. Gallaccio, by contrast, is not afraid of using her art as a vehicle for painful feeling.

In a side room, which visitors pass as they walk to and from the main chamber, a far smaller ice piece waits to be inspected. Low-lying, it lacks the overwhelming grandeur of the principal exhibit. And Gallaccio has left an electric iron on top, seemingly plugged in. It appears to have been abandoned, perhaps by someone fed up with the futility involved in smoothing out slabs of frozen water. Indentations made by the iron spatter the surface of the ice, and the appliance itself seems to be sinking into the block.

This absurd yet mournful tableau offers a clue to the pressure of emotion which brought the large sculpture into being. Even the most imper-

turbable edifices contain within them the seeds of their own disintegration. Eventually, as warmer weather sets in, Gallaccio's glacier may well become a titanic waterfall and turn the Boiler Room into a pool. The pumping station, once a powerhouse of heat which supplied electricity throughout London, will resemble the site of a flash flood. And nothing will remain of the great, glittering apparition which, for a few memorable weeks, charged this echoing interior with a hallucinatory presence.

Georgina Starr, another of the inventive young women who are revitalizing British art, also deals in dreams. But unlike Gallaccio, who stakes everything on a silent, purged simplicity, Starr rejoices in noise, activity and garrulous complication. She has filled the Art Now space at the Tate Gallery with a cornucopia of theatrical set-pieces, and prefaced them with a crowded collage of brashly coloured faces which warn of the greater mayhem to come.

Shamelessness is Starr's forte. She has never been reluctant to feed off even the most feverish fantasies. Part of the large room is transformed into the kind of bedroom inhabited by the teenage girls in *Grease*, a musical Starr performed in at school. We can sit on a fluffy counterpane, flanked by pin-up photographs and an old-fashioned record player, to watch a video where Starr acts all the roles in a scene from the film. But this is only one part of a turbulent, kaleidoscopic work which introduces us to a whirling cast of other characters.

Some, like the four Marys from the *Bunty Annual* who appear with enlarged, staring eyes in a night-club called The Hungry Brain, also seem to derive from Starr's childhood enthusiasms. In this respect, they have links with her last elaborate work, *Visit to a Small Planet*, which wittily explored her own ten-year-old infatuation with a Jerry Lewis science-fiction movie. But the rest of the Tate installation, aptly given the dizzying title *Hypnodreamdruff*, spirals off into less autobiographical realms.

Starr invites us to sit at a breakfast table, dominated by a packet of Kellogg's Sustain, Tropicana fruit drink and a carton of Sainsbury's half-fat organic milk. The yellow formica top is festooned with notes and drawings, and a nearby video shows a woman scribbling them on a similar table as she tries to work out the meaning of her flatmate's perturbing dreams. At one point, they single out Lionel Ritchie's song *Hello (Is It Me You're Looking For?)*. The question seems to sum up the notion of a bewildering search for identity that runs through everything in Starr's multi-media extravaganza.

Answers, however, prove elusive. Sitting at circular tables in The Hungry Brain, we find ourselves bombarded with fractured images on a bank of wall-screens. Starr herself reappears here, this time as a

pouting singer in the night-club. But a cavalcade of other, even more outrageous performers pours through the screens as well, their conversations punched up in subtitles. They talk, with an intensity bordering on the ridiculous, about mind-reading, magic and schizophrenia. Their obsessions are mirrored on the table-tops, where a book called *Practical Self-Hypnosis* lies among a bizarre clutter of objects.

After a while, the gap between the characters' teeming fantasies and the limitations of their surroundings becomes acute. Duck into Dave's caravan, stuffed with the detritus of a lonely life, and you can watch a video documenting his daily routines. When he sings along to Lionel Ritchie with the aid of headphones, hoovering and dressed only in underpants, Dave is at his most risible. But when he prepares a spaghetti meal and eats it alone, his solitary existence suddenly seems sad. No amount of magic tricks can hide the fact that he lives in claustrophobic seediness and works at a dry cleaner's. Like Gallaccio's ice mountain in Wapping, both he and the other characters thronging Starr's frenzied psychodrama are vulnerable, and might at any moment fall apart.

SPELLBOUND
5 March 1996

Ever since Sickert painted an early cinema projection, flickering away in the bowels of the Old Mogul music-hall, adventurous British artists have regularly been bewitched by film. Sickert himself, in risk-taking old age, based a powerful painting on an Edward G. Robinson gangster movie called *Bullets or Ballots*. He was soon followed by Richard Hamilton and Eduardo Paolozzi, whose voracious involvement with Pop culture prompted them to incorporate film references in some of their finest works. And over the last thirty-five years, artists ranging from David Hockney to Damien Hirst have kept on succumbing to the lure of the silver screen.

Now, to mark the centenary of the first film screening in Britain, the Hayward Gallery has mounted *Spellbound*, a lively and stimulating celebration of the love affair between art and film. Specially commissioned works by ten UK-based artists and film-makers loom out from the darkened interior. They testify, in startlingly diverse ways, to a tangled yet mutually enriching crossover dialogue which enables Ridley Scott to

52. Douglas Gordon, *24 Hour Psycho*, 1993

find inspiration in Francis Bacon and, conversely, lets Fiona Banner make a colossal pencil work based on *Apocalypse Now*.

Nowhere do art and film come closer together than in the opening room, where Douglas Gordon slows Hitchcock's *Psycho* down to a twenty-four-hour projection time. Bean bags litter the floor, supporting the weight of viewers mesmerized by the weirdly balletic movements on Gordon's screen. While I was there, Anthony Perkins dragged Janet Leigh's corpse from the shower and sluiced her blood down the plughole with a mop. Hitchcock filmed this macabre scene in a brisk, matter-of-fact manner. But Gordon's soundless version makes Perkins's feline exertions strangely torpid. He lingers over the body like a sleep-walker, and even the simple task of washing his hands is transformed into a ritual fit for a dream. The whole notion of watching *Psycho* for twenty-four hours is at once appalling and fascinating: does the film really run on through the night, ensnaring solitary attendants in an otherwise deserted gallery? But if Gordon's work seems on one level almost sadistic, it also turns *Psycho* into a gravely beautiful, meditative experience filled with choreographed revelations unsuspected by anyone viewing Hitchcock's original.

Balletic images reappear in Paula Rego's room, where around twenty large pastels are riddled with homages to Disney's animation. As so often, Rego draws on obsessions stretching back to her childhood. She turns the dancing ostriches from *Fantasia* into sturdy ballerinas, who flaunt their bodies on armchairs and leather sofas or stand around in poses parodying Degas's far younger, slimmer dancers. Rego's beefy troupe looks oddly thuggish and ready for trouble. But her most menacing pastels concentrate on Snow White, avoiding Disney's sentimental side and exploring the darkest areas of the fairy-tale. The predatory stepmother, sheathed in a tight dress and spiky high heels, seems about to tear Snow White's knickers as she pretends to help the girl dress. And in the most alarming picture of all, Snow White's poisoned body tumbles through space like an inverted martyr from a baroque altarpiece.

Paolozzi's room also bears witness to a lifetime's obsession. He invites us to roam through a silent repository, where tables and plinths are stacked with abandoned props waiting, forlornly, for the chance to be used again. Paolozzi understands the melancholy allure of the film-studio storeroom. He also knows how to move, with unsettling rapidity, from blue movies to Buñuel. His imagination has always been encyclopaedic, but he does not allow his proliferating accumulation of statuettes, weapons, fake jewellery and candles to become stifling. His complementary show at Jason & Rhodes Gallery is called *Obscure Objects of Desire*, and everything he assembles in this heterogeneous display reflects his undying infatuation with movie imagery.

Three artists at the Hayward have made films of their own, with an assurance that proves just how intoxicating the cinematic elixir has become in British art of the mid-1990s. The most effervescent offering, Boyd Webb's *Love Story*, is irresistible. Using animation with his customary deftness and fantastical wit, Webb brings a lowly popcorn kernel to life in the middle of a dark, sweaty cinema. Unnoticed by the hypnotized audience, it jumps out of the carton and begins to sprout leaves on the carpet. But the feet of the departing crowd threaten it with instant extinction, and in a dizzying sequence it becomes stuck to the bottom of a boot. The camera adopts the popcorn's viewpoint as it lurches forward, hitting the pavement and then rising into the air. After an exhilarating escape, the popcorn is sucked into a hoover. But instead of ending the film on a pessimistic note, brooding on the brutishness of chance, Webb allows the popcorn to achieve a soaring resurrection in the cosmos.

Damien Hirst's offering, a twenty-minute film called *Hanging Around*, likewise moves between mortal gloom and brazen fantasy. Several people die in this 'day-in-the-life' story of the depressed Marcus, blearily played

by Keith Allen, and his three wives. One expires in a bath of blood, but elsewhere Hirst's mordant wit helps him to avoid Grand Guignol as he follows the increasingly manic Marcus in and out of workrooms filled with Airfix models. At one point, when Marcus traps a butterfly inside a wine glass, Hirst threatens to turn his film into a meditation on the remorseless passage to oblivion. The insect is finally released, and Marcus achieves a parallel freedom by flying high in the sky, muttering 'I love life'. But the final image shows Hirst at his most stern: a butterfly crashes into an insectocutor and fries its exquisite wings with a nasty sizzle on the soundtrack.

If Hirst uses the naturalism of soap opera as a ready-made language, within which he pursues his central preoccupation with death, Steve McQueen adopts a far more austere approach. His compelling film, *Stage*, is both black-and-white and silent. A plot seems about to unfold at the beginning, as a young white woman walks slowly downstairs towards a corner where a black man waits beyond her vision. Nothing really happens, though. McQueen's powerful use of close-up, and continual cutting from one face to the next, builds up considerable suspense. But like his earlier film *Bear*, now to be seen in *The British Art Show* at Edinburgh, *Stage* raises expectations only in order to frustrate them. The black loiterer, who in a more predictable film would be an assailant, ends up gazing with an expression as lovelorn as the satyr in Piero di Cosimo's *The Death of Procris*. Man and woman remain separate to the end, while McQueen's lingering camera allows us plenty of scope to speculate as he refuses to comply with narrative and racial stereotypes.

Although several distinguished film directors contribute to *Spellbound*, their rooms are less impressive. Ridley Scott offers insights into the making of both *Blade Runner* and *Alien*, but he shows storyboards, photographs and scripts on four cramped monitors suspended from the ceiling. They look rather perfunctory, whereas Terry Gilliam provides a more theatrical and interactive installation. We approach it down a corridor, where a poster seems to promise a viewing of Gilliam's film *Twelve Monkeys*. Inside the room beyond, though, he destroys these expectations with gleeful panache. A noisy and violent film is indeed being projected on a giant screen, but ranks of filing cabinets prevent us from seeing it. So we resort to inspecting the cabinets instead. One, wrily labelled 'The Price of Fame', is stuffed with miniature monitors relaying your own face back to you. Another, 'A Piece of the Action', allows us to see a tantalizing fragment of the film on the screen behind. Gilliam revels in bewilderment, but his teasing ultimately seems half-hearted and lightweight.

Only Peter Greenaway, among the directors, comes up with a substantial work. In recent years he has exhibited in a number of art exhibitions,

and the experience pays off here. For Greenaway assaults us with spectacle, in an immense chamber where noise rises to a thunderous level as lights flash on and off with disturbing abruptness. But Greenaway's shameless showmanship soon becomes hectoring. Props are laid out like an indigestible cornucopia on seemingly limitless tables; the audience section is placed beneath the deafening clatter of passing trains; and, most eerily of all, five glass cases enclose live actors. Although they are replaced every day, these seated performers cannot help looking humiliated. They have nothing to do except endure the rumble and glare of Greenaway's special effects, and they are herded into cattle-market categories like 'A Cast of Actors Over 15 Stone'. I found Greenaway's vision of cinema dispiriting, and hurried back downstairs to find further nourishment in the slow, mysteriously addictive silence of Gordon's *24 Hour Psycho*.

STEPHAN BALKENHOL AND MICHAEL LANDY
16 July 1996

When Stephan Balkenhol's *Figure on a Buoy* was marooned in the Thames during the winter of 1992, a passer-by leaped into the icy water to save him from suicide. Seen from the bank, the distant wood effigy of a man in nondescript clothes appeared uncannily lifelike. But the would-be rescuer must have felt very foolish when he discovered, close-to, just how rough and simplified Balkenhol's carving really was.

As his exhibition at the Saatchi Gallery testifies, Balkenhol has no interest in deceptive illusionism. The marks made by his blade are left exposed on the methodically hewn surface of his sculpture. Although he paints these heads and figures, the colour is brusquely applied and does not hide the rawness of the wood beneath. In this respect, he displays a kinship with the German sculptors who revitalized a distinguished national tradition of wood carving early in the twentieth century. Ernst Ludwig Kirchner and his allies adopted a deliberately 'primitive' approach, cutting with such vehemence that their sculpture still looks rasping.

The wild spirit of Expressionism lingers today, above all in the gouged and daubed figures carved by the uninhibited Georg Baselitz. But Balkenhol, who belongs to a younger generation of German sculptors, distances himself from naked emotionalism. The most distinctive and

tantalizing aspect of his work lies in its refusal to convey strong feeling. Devoid of passion, the men and women he carves are united by their deadpan air. Arms dangling passively by their sides, they seem incapable of indulging in eruptive gestures. They belong to an everyday, matter-of-fact world, where nobody would dream of rebelling against normal codes of behaviour.

Even when Balkenhol produces a colossal head, he does not invest it with heroic significance. Rearing to a height of nearly twelve feet from the middle of the Saatchi's largest space, *Head of a Man* looks utterly impassive. Everyman rather than Superman, he is at the furthest possible remove from the domineering political leaders usually portrayed in such an inflated way. There is something stubborn about his sheer ordinariness, as if Balkenhol was determined to produce an antidote to all those spurious statues of demagogues who once loomed over public spaces in Germany. Today, mercifully, celebratory effigies of both Hitler and Stalin are nowhere to be seen. But they still exist in the memories of those who lived in East and West alike, and Balkenhol has carved a head in honour of the average, unsung person whom tyrants love to control.

Towering size, in his sculpture, offers no guarantee of invincibility. *Large Man* rises almost eleven feet from the floor, and he is chiselled out of the same tree-trunk which provides such an ample base for his feet. He leans at an unstable angle, though, like someone recoiling from a threat. And as we move around this supposed titan, his body becomes thinner. The substance he displays from the front shrinks, at the side, to a far more vulnerable attenuation.

Balkenhol likes to confound our first impressions by exploiting sculpture's capacity for change. *Large Male Head Relief* appears composed enough, sheltering within its unchiselled and projecting poplar surround. Seen from the right, however, the face buckles and contorts, ending up trapped by its wood container rather than nestling there. Nearby, the bland normality of *Man with Green Shirt* suddenly loses its reassuring sense of wholeness: at the back, Balkenhol has sliced off his shoulders in a surprisingly drastic manner. As for *Double Identity Figure*, both he and his 'reflection' turn out to be desperately thin from the side. They look like shooting targets at a fun-fair, and the 'reflected' figure is pierced by a bullet-shaped hole where his navel should be.

The longer I stayed in this exhibition, the more unsettling it became. Three life-size female nudes, standing on tall plinths each painted a contrasting colour, initially seem unexceptional to the point of outright dullness. Unlike most of Balkenhol's figures, they were based on models – a procedure which seems to have inhibited his imagination. But as I

moved among them, deep cracks became noticeable. Dark fissures run down the back of one woman, from her orange hair to her thigh, while another crack travels its jagged path between the breasts of the woman with pale brown hair. Whether or not they are simply faults in the wood, Balkenhol's unwillingness to hide them says a great deal about his interest in the understated exposure of infirmity.

Some of the exhibits are playful, and they show the sculptor at his weakest. One carving, of a doll-size man wrapping his limbs around a giraffe's neck, looks merely whimsical. And the circular convocation of bears perched on tall columns of lignum vitae seem ingratiatingly twee. They are unworthy of the man who is able, in another carving called *Harlequin*, to invest the simplest movement with a surprising amount of disquiet. The man's diamond-patterned shirt may look festive enough, but he gazes upwards and askance like an animal sniffing the air for a scent of danger. In common with most of Balkenhol's figures, he resembles a bystander rather than someone capable of commanding and deserving centre-stage attention. All the same, his innate dignity and poise should not be underestimated.

The first time I saw Michael Landy's ambitious installation, *Scrapheap Services*, it occupied the decaying interior of the derelict Electric Press Building in Leeds. Now it has moved to the hygienic whiteness of the Chisenhale Gallery in East London, where the surroundings emphasize the clinical efficiency of the event he dramatizes. The gallery floor is littered with a multitude of tiny figures, cut out from discarded crisp packets, Burger cartons or beer cans. But the employees of Scrapheap Services, a make-believe cleaning company founded by Landy a couple of years ago, are on hand to clear the mess away.

The red-uniformed mannequins are silent as they spike, shovel or sweep their way through the detritus. A smoothly persuasive video is on hand, however, with a purring voice of welcome and explanation. Scrapheap Services is, apparently, 'the cleaning company that cares because you don't'. Without a trace of genuine concern, the voice observes that 'a prosperous society depends upon a minority of people being discarded'. But his tone becomes principled when he asks: 'Why put up with unsightly people who are such a burden on your resources, when you can turn to the Scrapheap Services people-control range of products?'

With the identical nylon-suited disposers at hand, nobody need fear being overwhelmed by these diminutive victims. However inescapably they may besmirch the Chisenhale's immaculate white floor at the moment, their unwanted bodies will soon be gathered in dust carts, bagged and consigned to the equally red 'purpose-built people shredder'

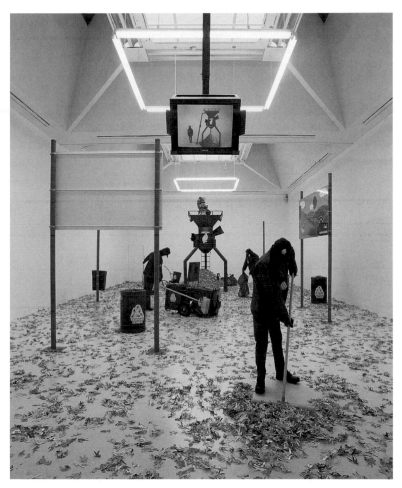

53. Michael Landy, *Scrapheap Services*, 1995

dominating the room like a callous, hideously enlarged predator. The menace inherent in its squatting insect legs gives the lie to the video voice's honeyed tone. Landy calls it *The Vulture*, and ensures that the machine's implacable presence gives the entire tableau a chilling air. The impersonal cleaners, with their corporate clothes and logo-decorated implements, are the anonymous servants of a system whose leaders care more about downsizing than people. Unsightliness is the only fault they

can find in unemployment, and the pulverizing *Vulture* can be relied on to reduce all the redundant figures to a state of invisibility.

But not just yet. Landy opts for the moment before the final sweep-up, when the embarrassing jobless thousands still defile the ground. Their heaped-up proliferation is the most disturbing feature of the installation, largely because each one was snipped out by the artist himself from rubbish he salvaged in nocturnal raids on neighbouring take-aways and recycling centres. The extraordinary patience and devotion that went into the figures' individual shaping became clear when I examined them closely, and it made their disposability far more melancholy. The wastefulness of the whole operation hangs over Landy's elaborate enterprise, making a nonsense of the video's smooth-tongued sales-talk and ensuring that *Scrapheap Services* will remain a glacial parable for our times.

SCREAM AND SCREAM AGAIN
6 August 1996

Judging by its shock-horror title, *Scream and Scream Again*, the latest exhibition at the Museum of Modern Art in Oxford ought to be awash with blood and corpses. After all, the 1969 movie from which this show takes its name was a Vincent Price vehicle, where he created a super-race of vampires who seize control through serial murders. But the six young artists included in the Oxford survey are, for the most part, averse to violence. Fascinated by film, they see no point in mirroring Hollywood's shameless addiction to gore.

Not that their contributions are bland. Isaac Julien, whose *The Young Soul Rebels* won a Cannes award five years ago, has no hesitation in immersing us in grief. AIDS is the spectre lurking within *Trussed*, his double film projection specially commissioned for the show. The soundtrack is plaintive yet restrained, dominated by a single, sustained note drawn out to a painful duration. Lyrical images of homosexual love-making soon give way to more disturbing scenes, focusing on an inverted man suspended in space. Through his eyes, we see the faces of male onlookers, and the swaying rhythm gives the film an increasingly dreamlike flavour. A man in pyjamas, confined to a wheelchair, is visited by a friend bearing flowers. Petals reappear, floating on the surface of water where a face seems to be drowning. And in the most elegiac sequence, a

leather-clad white mourner carries a black man's inert body in a pose immediately reminiscent of a Renaissance *Pietà*. Premature death is inescapable, but Julien constantly reminds us of its links with erotic delight by moving freely between images associated with bereavement and ecstasy alike.

The whole experience is reminiscent of watching an early silent film, where the director lingers on the close-up of a face or a tormented figure in order to generate an intense, meditative mood. Liisa Roberts, the New York-based artist who has made *Trap Door* for this exhibition, shares the desire to slow down the expectations we normally bring to film viewing. But where Julien was openly emotional, Roberts is detached and coldly analytical. The triangular structure of large screens installed in her room has a sculptural presence, and she allows the projectors to occupy a prominent place at its centre. Their mechanical clatter is the only sound we can hear, as three silent 16 mm films are beamed on to the screens. Images of gesturing hands and naked bodies alternate with shots of landscapes, apparently glimpsed from a train or car.

Public and private realms are contrasted, and sometimes interrupted by isolated words like 'Here'. They recall the use of printed dialogue and headings in silent films, but serve only to stress enigma rather than offering any explanations. The effect is fragmented, as if Roberts wants to frustrate any attempt to build up a coherent narrative. And the film projected on to the fourth screen, marooned elsewhere in the room, offers no key to the work's overall meaning. Instead, the camera travels round a bronze statue of three dancing female nudes. Their intimacy, pitched against the backdrop of a park, brings together Roberts's public/ private themes in a single image at last.

In *Black and White (Babylon)*, Douglas Gordon takes a 1950s stripper film as his starting-point, and slows it down on one screen to an almost hallucinatory extent. The generously endowed woman goes through her disrobing ritual with plenty of winks, smirks and wriggles. But she might as well be performing underwater, and her sluggish movements accentuate the absurd artifice of the whole event. On a neighbouring, somewhat larger screen, the same film is projected upside-down. Unlike the inverted man in Isaac Julien's work, this gesticulating figure becomes virtually abstract. She is drained of allure, and for that reason proves far less watchable than the stripper on the other screen. The latter may well be more compelling than she would seem when projected at normal speed. But her slowness here often approaches the condition of painting, and stirs memories of French nineteenth-century nudes from Delacroix's odalisques to Manet's deadpan yet defiant *Olympia*.

If Gordon's stripper is archly aware of the male gaze, the Dutch artist Marijke van Warmerdam turns the tables by confronting us with row after row of staring, motionless men. Placing a 16 mm projector in the middle of her space, she shows a colour film of a crowd gathered round her in a Marrakesh marketplace. Van Warmerdam's camera moves round the circle of faces, largely men and boys who all watch her intently. The motion of her lens is re-enacted in the gallery, for the projector gradually revolves and carries these life-size images of the crowd round the walls of the room. The effect is oddly mesmeric. After a while, the ranks of Moroccans begin to look predatory as they circle endlessly and expectantly. And we, standing near the projector, find ourselves placed in the artist's position as the assembled faces seem to stare at us with voyeuristic fascination.

Sadie Benning, by contrast, trains the lens on herself. She invites us in to a small, enclosed and stuffy space with viewing benches provided. The surroundings seem designed to prepare viewers for a confessional experience, and Benning does not disappoint. Astonishingly, this precocious Illinois-based artist made *It Wasn't Love* with a Fisher Price toy video camera when she was only nineteen. Concentrating for the most part on her own face performing a variety of male and female roles, she produces the equivalent of a diary. It is supposed to record the development of her first lesbian affair, but the incessant play-acting makes clear that the story is only a fantasy.

Benning uses disco and movie soundtrack music with wry and witty briskness, heightening the impact of a work already made urgent by the starkness of the video's raw, bleached-out quality. She also intercuts, without warning, clips from 1950s Hollywood films: family 'problem' pictures and gangster massacres, which blend uneasily with the lyrics of pop songs as cute as *Why Must I Be a Teenager In Love*. Whether brandishing an aggressive cigar or pouting at the lens, Benning is the star of her own show. But a well-developed sense of irony prevents her from descending into an outrageous display of adolescent egotism.

The most powerful contribution of all comes last. In MOMA Oxford's largest gallery, Tony Oursler's *System for Dramatic Feedback* explores the pathetic gulf between cinematic excitement and the frustration of lonely lives. On the end wall, a film of a movie audience presides over the entire space. These faces, alternating between dimly lit obscurity and brilliant illumination exploding from the invisible screen, are enthralled. Ramming popcorn into their mouths, the people in the front row seem to bask in communal enjoyment. The rest of Oursler's installation, though, is bitterly devoid of pleasure. In one corner, a tiny doll-like figure stands behind a

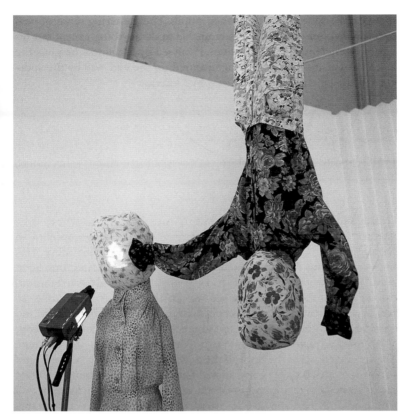

54. Tony Oursler, *System for Dramatic Feedback*, 1996 version (detail)

video projector which beams a screaming head on to the dummy. Towards the centre of the room, another hapless inmate sprawls on the floor with bottom stuck in the air. A video-projected hand spanks it repeatedly, and the same kind of meaningless aggression links two larger dummies nearby. One, suspended upside-down like the dangling man in Julien's film, constantly hits a neighbour's face with a fist.

Each of the people in Oursler's asylum-like arena seems doomed to repeat a futile action. They are all trapped in numbing isolation, and the mood becomes even more desolate when we encounter two white spheres hovering in space. Both of them are animated by projected images of eyes, enlarged so much that minute sequences from a television game

show can be seen mirrored in their pupils. The gathering sense of desperation is summed up by a figure unable to do anything except rest his bloated, twitching face on the floor. Paralysed by loneliness, he gives the lie to the sensation of well-being savoured on the end wall by the audience in the cinema's dark and deceptive interior.

GABRIEL OROZCO
27 August 1996

Unlike his celebrated namesake José Clemente Orozco, whose fiery energies were concentrated on painting revolutionary murals in Mexico's public buildings, Gabriel Orozco is forever on the move. This mercurial young Mexican often returns to his native land, but he is equally familiar with Berlin, Madrid and New York. His ICA exhibition, the largest show he has staged in Britain, seems impossible to pin down. Darting restlessly between countries, from one strategy and medium to another, he is the most unpredictable artist of his generation.

At first, no apparent links can be detected between the disparate objects ranged across the floor of the downstairs gallery. By far the largest of them, *La DS*, is a sliced and altered Citroën car. Its gleaming sleekness might seem to have nothing in common with the ungainly lump of dull plasticine and dust, the swollen rubber spheroid or the crazily intertwined bicycles all displayed nearby. Gradually, though, they turn out to have surprising affinities with each other. All of them share the possibility of movement. From the streamlined speed inherent in the Citroën to the wobbly wanderings of the rubber sculpture, they refuse to settle into the customary role of a static gallery exhibit. Moreover, they have emerged from obsolescence, gaining new life as Orozco transforms their potential. The rubber piece was originally the inner tube of a lorry's tyre. Cut open, sealed with a couple of patches and then re-inflated, it takes on an overblown identity bordering on the comic.

Humour, tinged with absurdity, is never far away in Orozco's work. The old Dutch bicycles joined together with bewildering efficiency look, from a distance, as if they could each be disentangled and ridden out of the room. But closer examination discloses that their fusion would defy any such attempt. Robbed of any function, they become instead a tangled monument to frustration and pointlessness.

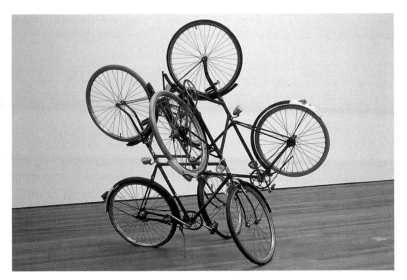

55. Gabriel Orozco, *Four Bicycles (There is Always One Direction)*, 1994

There is, however, no suggestion of despair in Orozco's fascination with futility. The bicycles appear to enjoy the bizarre new life he has given them, and the Citroën gains an extraordinary potency from his meticulous interference with its bodywork. Taking a vintage model from the 1950s, he cut it lengthways into three segments. After the removal of the central piece, the other two portions were fitted together with uncanny skill. The join is invisible, and from the sides this classic icon of post-war car styling still seems beguilingly intact. When viewed from the back or front, though, the loss of sixty-two centimetres in width becomes inescapable. Thin to the point of anorexia, the sharp-prowed machine now possesses a predatory menace. It begins to resemble a car in a nightmare, and anyone fortunate enough to sit at the steering wheel can experience this strangeness at full strength.

After a time, Orozco's love of paradox and ambiguity becomes paramount. On one level, the voracious Citroën sculpture is an exercise in unsettling distortion. But it also appears to increase the car's potential mobility, for the slimmed-down bonnet thrusts forward like a custom-built racer whose owner is bent on breaking the land speed record.

Just at the moment when we think Orozco's intentions are becoming clear, he shows a cunning delight in confounding us. Take *Elevator*, which dominates one of the spaces upstairs. Rusty and redundant, it seems like

an abandoned relic of a nondescript building long since pulverised by the demolition men. Most of us would not accord this battered cabin more than a glance if we came across it lying in a junkyard. But here, restored to a vertical position and exposing the machine parts formerly hidden by the lift-shaft, it oozes all the accumulated melancholy of hum-drum offices, hotels and apartment blocks mouldering in seedy urban locations throughout the world.

Not content with making us feel the intrinsic sadness of an elevator without a function, Orozco leaves the door open and invites us to step inside. Its ceiling has been lowered to the height of the artist, forcing me to stoop. So the claustrophobia latent within any metal container is intensified, just as the sides of the sliced Citroën threaten to close stiflingly on anyone seated at the steering-wheel. At the same time, though, Orozco's ceiling displacement generates a feeling of compression oddly akin to the sensation of shooting up and down a real lift-shaft. So an object that initially appears inert and abject is transformed, by a sly act of manipulation, into a reminder of the prowess it no longer commands.

Perhaps Orozco's Mexican origins help to give him the perspective of a perpetual outsider, viewing the products of other Western societies through a sensibility formed in the 'developing world'. In *Empty Club*, the remarkable Artangel project recently carried out in the grandiose rooms of a former gentlemen's club at 50 St James's Street, he conducted a coolly ironic meditation on Englishness. As ever, his meanings often proved elusive. But in Orozco's extensive photographic work, recording the deft interventions he likes to make in outdoor locations, his satirical streak becomes more overt.

Island on an Island takes as its springboard the twin colossi of the World Trade Centre, soaring amid a cluster of neighbouring Manhattan sky-scrapers. He relegates their phallic bulk to the distance, contrasting it with a forlorn and deserted parking lot. In front of a decaying concrete wall, Orozco assembles in the foreground an improvised model of the towers beyond. Probably made from detritus he has scavenged from the streets of New York, the miniature skyscrapers stand in a puddle that mimics the Manhattan waterfront. The model's scrappiness punctures the overweening pretensions of the buildings behind and, by extension, reflects pithily on the gulf between centres of extreme Western affluence and the desolation so often found outside their limits.

Not that Orozco could ever be described as a polemical artist. *Island on an Island* typifies his ability to make trenchant observations in a playful and ironic manner. A quicksilver wit darts through his other photographic pieces as well. On the whole, he prefers to restrict himself to gestures as

simple yet telling as the lowered ceiling in *Elevator*. Once, confronted by a profusion of tinned green beans in a supermarket, he slipped a small can of cat food into their ranks. This single surreptitious move countered the banality of the beans display, turning them into a forest of burgeoning vegetation crowded round the feline intruder peering from the label in the centre.

Orozco calls this cheeky image *Cat in the Jungle*, and our first reaction is to smile at his wit. But on a deeper level, his insertion of the anomalous tin makes the encircling beans suddenly appear oppressive. They threaten to smother the animal, and by doing so make us aware of how monstrous the endlessly repetitive abundance of supermarket produce really is. Only the cat's steady gaze, unflustered yet alert, provides relief amid this mass-produced orgy of consumerism. Its vigilant eyes could almost belong to Orozco, as he persists in scrutinizing and illuminating the disordered universe around him.

TACITA DEAN

3 September 1996

Pushing open the doors leading to the Tate Gallery's Art Now room, I was assailed at once by a great surge of sound. Waves, wind and seagulls all hurled themselves at me. Embroiled in high-frequency turbulence, I imagined that the space beyond would contain a visual spectacle to match the acoustic blast overwhelming my eardrums.

As I turned into the room housing Tacita Dean's exhibition, though, my expectations were flouted. The gallery is empty, apart from a tall magnetic tape machine and a brilliantly illuminated display box stretching across most of the far wall. In its lustre and epic width, the backlit box is reminiscent of a cinema screen. But it contains words interspersed with diagrams, and close inspection is needed to discover that they are entries written on a dubbing cue sheet.

However legible these notations may be, they only make sense in relation to the footage transmitted by a monitor placed high on another wall. There, the normally unseen makers of the noises filling the gallery are revealed at work. Arrestingly shot and succinctly edited, Dean's film concentrates on two Foley Artists. Beryl Mortimer and Stan Fiferman take their quirky professional name from the original Mr

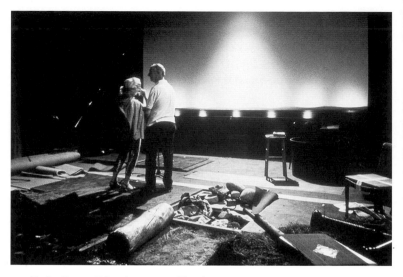

56. Tacita Dean, *Foley Artist*, 1996 (detail)

Foley, who concocted sound effects in the pioneering days of film post-production. The tricks he practised may seem laughably archaic, now that movie-making technology has become so sophisticated. But the skills of the Foley Artists remain indispensable, and Dean shows just how resourceful they are. Both Beryl and Stan go about their bizarre tasks in the most matter-of-fact spirit imaginable. He shakes a colossal sheet to simulate thunder. She jumps up and down in high-heeled shoes on a mess of wet newspaper, evoking the sound of someone hurrying through the rain. The polka-dot umbrella in her hand makes another noise, simultaneously. And while she performs her routine, an apocalyptic storm clashes with church bells in the aural maelstrom around her.

Gradually, as we watch the Foley Artists' weird yet precisely calculated antics, Beryl and Stan come to resemble a vintage music-hall double act. They join forces sometimes, doing what amounts to a soft-shoe shuffle as they simulate mushy footfalls on a beach. They clutch, stroke and pull at their own clothes, writhe like demented patients in an asylum and tear up large sheets of paper with aplomb. They open and shut doors without going through them, stamp on cobbles and, in the most surprising moment of all, give the backs of their wrists careful little kisses.

Their contribution to the impact of the film they enhance with such

cunning should not be underestimated. But they perform in a vast, deserted Delta Sound Studio at Shepperton, invisible to anyone other than the recording engineer and unacknowledged save on the credits in small print at the film's end. By highlighting the activities of these unsung survivors from an earlier, pre-electronic era of movie-making, Dean implies that she would lament their passing. So in one sense, she is determined to celebrate them here before it is too late. A similar nostalgic impulse led her to include, in an earlier work called *Girl Stowaway*, footage of an elderly couple who have perfected the delicate art of putting miniature sailing ships into bottles. Dean relished the sheer strangeness inherent in devoting a lifetime to such an unlikely feat, just as she now admires the oddness of the Foley Artists' dedication to illusionistic trickery.

The near-emptiness of her own space at the Tate echoes the studio used by Beryl and Stan, who seem marooned in the vacant immensity of a room where most of the props are hidden away neatly beneath flaps in the floor. But the studio's bleakness is fitting: it reflects the fact that everything there is dedicated to the ears rather than the eyes. On another level, then, Dean's exhibition deliberately sacrifices visual stimuli in order to let sound play the dominant role. Its eloquence enlivens the whole gallery, making us aware of how much film usually relies on aural effects to enhance and even shape the images on screen.

The noises made by the Foley Artists can have an astonishingly three-dimensional impact, and in this respect their work might be described as a form of sonic sculpture. Dean certainly gives sound its head, and at the beginning of the story dramatized in her show she includes a Shakespearean actor, playing the part of Rumour in *Henry IV Part II*: 'Open your ears; for which of you will stop the vent of hearing when loud Rumour speaks?' As the backlit dubbing cue sheet reveals, Dean's own exploration of 'the vent of hearing' made her devise a tantalizing tale for the Foley Artists to work on. Having started inside a theatre, it then moves to a pub and a beach pursuit worthy of a thriller before returning, finally, to the play. As in *Girl Stowaway*, Dean presents a fragmented narrative, riddled with ambiguity and questions left deliberately unanswered. But the mystery created by the fractured story, which appears to combine scenes from two wholly separate dramas, is subservient to the orchestration of sound.

So the true heroes here are undoubtedly Beryl and Stan, who in their final moments on the monitor quietly pack up and leave the studio. On the powerful speakers installed in the gallery, though, we hear an audience applauding the Shakespearean players. After the actor's last words, 'I

will bid you good night', an ecstatic roar goes up followed by vigorous clapping. Dean ensures that the noise accompanies Beryl and Stan out of the studio, giving them for the first and only time in their careers the rousing public accolade they deserve.

RACHEL WHITEREAD
17 September 1996

The demolition of Rachel Whiteread's *House*, early in 1994, was a shocking and disgraceful blunder. It robbed us of an outstanding public sculpture, a potent memorial rooted in the East End of London and yet able to impinge on all our lives. Anyone passing its former site, a stretch of open ground at Grove Road E3, would have difficulty understanding why the local council insisted on sweeping it away. But at least the memory of *House* can never be obliterated. It haunts Whiteread's beautiful and immensely rewarding exhibition at the Tate Gallery Liverpool, the first substantial retrospective survey she has been given in Britain. Photographs of the lost sculpture are included here, along with a video charting the work's evolution and destruction in fascinating detail.

The sadness and anger provoked by these images are countered, in the same room, by a model for Whiteread's forthcoming *Holocaust Memorial* in Vienna. Commissioned as a monumental sculpture for the Judenplatz, this pale, restrained yet awesome presence evokes the interior of a great library. Like all her finest work, it disconcerts and consoles in equal measure. While the cast books lining the monument's walls offer a reassuring link with the past, they also seem tragically exposed and glacial. I only hope that the current Viennese political infighting does not prevent Whiteread's gravely contemplative work from reaching fruition. The *Holocaust Memorial* promises to be as haunting as *House*, managing simultaneously to celebrate endurance and commemorate loss.

The wonder is that Whiteread can generate such complex responses by following so simple and direct a working procedure. With admirable clarity of purpose, she has pursued a single-minded course ever since leaving the Slade School of Art in 1987. The following year she made the earliest sculpture on view, *Closet*, when still only twenty-five years old. Taking an ordinary wooden wardrobe, she emptied the inside, laid it on its back, drilled several holes in the doors and then filled it to overflowing with

plaster. Finally, the shell of the wardrobe was jettisoned, leaving a bleached cast of the interior in its place. Rather than leaving it naked, she covered the plaster replica with black felt. While this Beuys-like material gives the sculpture a protective layer, its colour is funereal and claustrophobic. It seems to conjure childhood memories of hiding in a wardrobe, and finding that excitement can easily turn to fear once the door has been shut.

The paradox inherent in the whole idea of casting an empty space, of turning voids into solids and making the hidden visible, must have fascinated Whiteread. She was probably aware that, way back in 1965, Bruce Nauman had made a plaster cast of the space under his chair. But Nauman only repeated the experiment twice, before turning his mercurial energies in a dizzying variety of other directions. Whiteread, by contrast, decided to explore the possibilities opened up by *Closet* in all her subsequent work.

In 1990, her *annus mirabilis*, she cast the space around a square sink, transforming the banality of her starting-point into a mysterious, slab-like presence, unknowable and immemorial. The plaster is left bare this time. Whiteread makes no attempt to hide its rawness, just as she leaves the divisions between the sections frankly exposed. Her approach is honest and unprecious, its purity chiming with the idea of washing.

When she turned her attention to a bath in the same year, the outcome was more ominous. Deprived of taps, plug and shiny metal interior, the bath-shaped cavity resting within the plaster blocks takes on a melancholy air. It resembles a sarcophagus unearthed in some primordial tomb. The plaster's corners are chipped, its vacant interior smeared with green and orange stains. Although only cast from the space around the bath, the sculpture seems in an eerie way to bear the marks of continual human use. A body can easily be imagined floating inside, and the thick sheet of glass Whiteread has placed over the top seals it off with the finality of a coffin lid. Satisfying in its chaste simplicity, *Untitled (Bath)* is at the same time freighted with grief. Dark streaks run down from the tap holes, giving them an uncanny resemblance to weeping eyes.

Ghost, the masterpiece of this prodigious early year, is unfortunately too large to be accommodated in the Tate's low-ceilinged gallery. Cast from a room in a house, its sheer bulk emphasizes the strangeness involved in giving vacancy sculptural form. The solidity is illusory, of course: one glance through the slits between *Ghost*'s sections discloses the emptiness within. But the main emotion generated by *Ghost* is frustration. The room itself cannot be entered, and appears either to have been silted up with pale mud or smothered in a flood of lava. However

you choose to interpret this bleached replica of a family heartland, the irrecoverability of the lives led by its inhabitants is beyond argument.

So, too, is Whiteread's ability to invest even the most mundane, over-looked aspects of existence with an unexpected dignity and fascination. Nothing could be more banal than the objects she chooses as her raw material. But by the time she has cast the space under a bed in rubber, and half-propped this burnished amber oblong against a wall, the non-descript is transformed, like the submerged coral-boned skeleton in *The Tempest*, into 'something rich and strange'.

The casual way in which the bed-cast is displayed, gently curved and leaning, shows how informal Whiteread can sometimes be. In another mood, though, she prefers absolute severity. Nothing could be more res-olute than the seven elements comprising *Untitled (Floor)*, a remarkably tough sculpture that deservedly receives the accolade of a room on its own. At first, these dark and powerful oblongs look almost charred, as if they have survived an ordeal by conflagration. Their uneven resin sur-faces seem churned, like the wind-whipped and equally grimy waters of the Mersey visible through a nearby window. But then, quite suddenly, a bar of sunlight appears, striking through the glass and across one cor-ner of the sculpture. Whiteread's brooding resin is set ablaze. It undergoes a magical metamorphosis, alive now with the brilliance of glittering lemon and lime. Its former solidity is ousted, as the sun reveals the oblongs' transparency. While glowing like ingots, they disclose the fact that their maker has created them from airy nothing – the gaps between the floor-boards' underlying supports.

As we approach the most recent work, Whiteread moves away from her former reliance on found objects. She starts making her own forms, specifically for casting, and also indulges a passion for colour which her earlier work had suppressed. The austerity of white plaster gives way to polychromatic splendour, above all in a triumphant multi-part installa-tion called *Untitled (One Hundred Spaces)*. Ranged across the widest sin-gle section of the show, these compact resin units unfold in a muted yet marvellously sensuous array of colours. Although hard enough to touch and defined with clear-cut lucidity, they seem as edible as jellies. They also look more mysterious than most of Whiteread's work, refusing to yield up their origins as quickly as her early sculpture. Derived from the spaces underneath stools, chairs and tables, they transcend their com-monplace origins and assume the four-square magnificence of temples.

All the same, the more disquieting reverberations of Whiteread's art refuse to go away. The objects gathered together in *Untitled (One Hundred Spaces)* also resemble caskets fit for cremated ashes, and we can

walk up and down their ordered rows like visitors to a military graveyard. The memorializing side of her imagination is as insistent as ever, suggesting that she remains steadfastly attached to the idea of giving permanent, ennobling form to the most unexceptional aspects of domestic life.

Like the empty seats encircling *The Table of Silence*, Brancusi's great memorial to the First World War in Romania, the pieces congregated in *Untitled (One Hundred Spaces)* show no sign of human occupation. Somehow, though, the human presence is implicit in everything Whiteread produces. The title of a moving new work, *Untitled (Double Rubber Plinth)*, does nothing to inform us that it derives from the space beneath a mortuary slab. But since the soapy texture and blanched colour of the work both seem intimately allied with embalmment, we can easily imagine that the plinths are bound up with the laying out of corpses. Far from wallowing in morbidity, these luminous forms calmly acknowledge the prospect of death. Accepting that mortal loss is inescapable, they nevertheless confront its certainty with warmth, serenity and redemptive stillness.

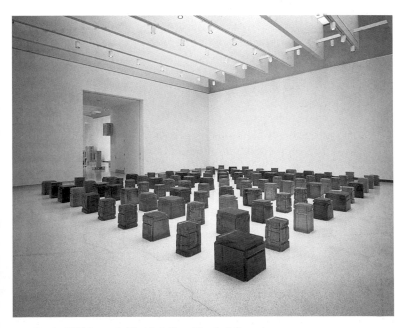

57. Rachel Whiteread, *Untitled (One Hundred Spaces)*, 1995

SAM TAYLOR–WOOD AND JORDAN BASEMAN
1 October 1996

Among the many young women who contribute so powerfully to the vitality of new British art, Sam Taylor-Wood charges her work with a pungent sense of loneliness, dissatisfaction and bewilderment. Entering the darkened immensity of the excellent Chisenhale Gallery, where her ambitious new film installation fills the whole of one wide wall, is like stumbling on a series of wounded, intimate disclosures. We feel intrusive.

Each of the five separate projections, shot on 16 mm, concentrates on an isolated individual. All in distress, they nevertheless range from manic agitation to hunched despondency. The rumpled youth on the far right grimaces and writhes as he paces outside a house, swearing to himself and bellowing up at the windows. The woman next to him is even more voluble, moving restlessly around the counter of a bar. But she is less easy to make out in the subdued lighting, and her boozy recriminations are no more coherent.

As I scanned the wall, trying with difficulty to decide which monologue to settle on, I found myself returning again and again to the young man in the middle. Pacing through his flat in a pair of boxer shorts, he looks unshaven and hung over. He mutters to himself, appraises his body sceptically in the mirror and slumps on a bed, hanging his head upside-down from the side. Although his actions are uneventful, and culminate merely in the act of climbing into a bath, the man's dissatisfaction is convincing. His tense restraint, subtly conveyed by Dexter Fletcher, compares well with the declamatory style of the two figures on his right. In this respect he reinforces the title of the work, *Pent-Up*, and mediates between their theatricality and the less demonstrative behaviour of the people to his left.

One, an older man played by John McVicar, sags in his armchair and admits to a sense of despair. Static, soft-spoken and wearing only a sweatshirt and shorts, he contrasts with the crisply dressed formality of the middle-aged woman on the far left. Walking along a pavement, and hemmed in most of the time by traffic and park railings, she seems at first the most controlled member of Taylor-Wood's cast. But then she breaks the unwritten code of the street by talking to herself, often loudly and with a reined-in vehemence.

Any attempt to describe *Pent-Up* as a sequence of separate monologues falsifies the impact of the whole installation. Taylor-Wood makes sure that it is, at all times, a tantalizing work to absorb. We are constantly wrenched

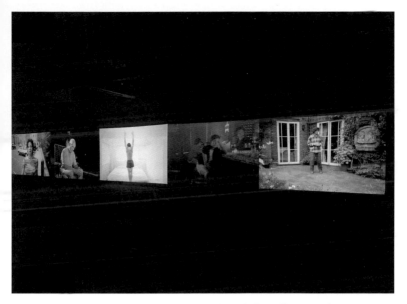

58. Sam Taylor-Wood, *Pent-Up*, 1996, at Chisenhale Gallery, London

from one film over to another, distracted by sudden cries or emphatic gestures. Even on a repeated viewing the cacophony of competing voices rebuffs anyone wanting to grasp precisely what all the people are saying. *Pent-Up* remains fiercely fragmented, even if these solitary figures sometimes appear to be responding to one another in odd, unpredictable exchanges.

This tension between the reality of loneliness and the possibility of shared experience is reminiscent of Taylor-Wood's most outstanding earlier work, *Killing Time*. Projected in video on four separate screens, each containing a single figure in different surroundings, it alerted me to her remarkable talent. Rather than talking, the casually dressed people in *Killing Time* all mime roles in Strauss's stridently emotional opera *Elektra*. But they do not try to match the heightened drama of the parts they have been given. Ill-at-ease and often frankly bored, they lip-synch their way through the impassioned music without any involvement in the drama. The gulf between Strauss's unbridled romanticism and their utter mundanity has a poignancy of its own. However prepared they are to mouth the singers on the soundtrack, often with surprising fidelity, we remain sharply conscious of their lassitude.

The people in *Pent-Up* may be more angry and less puppet-like than their predecessors in *Killing Time*, but the two works are finally united by Taylor-Wood's fascination with an overall mood of helplessness. All her people seem in their various ways to be trapped. They may yearn for alternative lives, and in *Pent-Up* be more ready to protest about their predicaments. But their vulnerability is beyond dispute, and the self-absorbed solitude afflicting everyone in Taylor-Wood's work ends up revealing a great deal about the frustrations of existence in the 1990s.

Stunted life is also an overriding preoccupation in the work of Jordan Baseman, the most impressive contributor to the latest Saatchi Gallery show. Born in Philadelphia but a London resident for the past decade, Baseman often takes found objects as his springboard. By the time he has finished with them, though, they take on an identity alarmingly at odds with their former character. From afar, the colossal words 'I love you' look as if they are simply written or painted on the wide, white wall. Close-to, they turn out to sprout human hair. The dark, thin tendrils dangle down limply, suggesting that all three words have long since become overgrown. At the slightest breath, they tremble like tall grass reacting to a breeze. On one level, they seem to convey an uncontrollable outpouring of emotion with a strong erotic undertow. On another level, though, the hair appears unbearably mournful. The words' unequivocal declaration is countered, indicating that such a headlong commitment is bound to be short-lived. Hair is inescapable in Baseman's perturbing art. More tendrils spring out of a child's conventional white shirt, slung from a wooden hanger on the wall. The violence of this unexplained growth makes the shirt tilt to one side, so that it dangles sadly askew. Both the shirt and, by implication, its young owner appear to have been overwhelmed by some unstoppable growth, as if puberty had arrived in a premature and grotesque rush.

Even when dealing with adulthood, Baseman's work insists that nothing adds up. *Call Me Mister* consists principally of a man's shirt torso, complete with a wholly conformist collar and necktie. But child's sleeves grow out of the shoulders, suggesting that the wearer is in some respects hopelessly immature. And human hair courses down the centre, compounding the imbalance in an almost monstrous way.

Wherever you look, Baseman is preoccupied with bizarre, unchecked disjunction. Two shoes lie on the floor, outrageously extended into brazen, phallic forms. They look like an assertion of masculinity run riot, but anyone attempting to wear these elongated brogues would soon realize how fatuous they really are. Comedy, often of a grisly kind, plays a subversive role in much of Baseman's work. At his most puckish, he is

capable of lodging wisdom teeth in pink mouth braces and transforming them into winged creatures. *Up, Up and Away* is the work's title, and they do certainly appear to be relishing their airborne freedom. At the same time, though, both teeth and braces remain gruesome enough to make the entire sculpture repellent as well as festive. As for *Surrender*, the petals borne upwards by a cluster of winged rococo cherubs turn out to contain, at their heart, an assortment of teeth ranging from the pristine to the decayed. They look like rotting chocolates, gift-wrapped for an undeserved journey to heaven.

The darkest side of Baseman's haunted imagination is more potent, though. On one wall, the skinned pelts of a tabby cat and a collie dog hang next to each other. But their heads are modelled, and the cat seems to gaze disconsolately down through glass eyes at its vanished body. The fact that both animals' paws, legs and tails have been preserved only makes their corporeal loss grimmer still. Their pelts, especially on the luxuriant collie, are resplendent enough to remind us that humans can relish them as trophies. In this context, however, they look forlorn, macabre and far more damaged than the loners who lament their pain in Taylor-Wood's cinematic confessional.

THE TURNER PRIZE 1996
19 October 1996

Inexplicably, the shortlist for this year's Turner Prize turns out to be an all-male affair. None of the many women making such an impressive contribution to British art's current vitality has been judged worthy of inclusion. Instead, the 1996 jury have chosen four members of their own sex. The decision gives the line-up a narrow, retrograde air, stiflingly akin to the bad old days when women artists so often endured a state of near-invisibility.

It is a pity, because in every other respect the current Turner contenders are carefully balanced in terms of vision and working methods alike. They encompass painting at one extreme and video installation at the other, with photography, wall-drawing and multi-media strategies powerfully represented as well. Unlike last year's contest, when Damien Hirst's triumph was almost a foregone conclusion, none of the selected artists basks in a superstar status. It is a wide-open race, and for the first time in years a painter stands a healthy chance of ending up the winner.

Not that Gary Hume could be described as a conventional believer in the virtues of pigment on canvas. For one thing, he uses household paint on aluminium panels. Its brash enamel sheen may appear heretical to devotees of oil paint, allying him more with a DIY store than an art gallery. Then there is the question of Hume's sudden, and for some shocking, change of stylistic direction. Still only thirty-four, he established a precocious reputation in the late 1980s with colossal, severe and seemingly abstract pictures. The squares, circles and rectangles dominating their shiny surfaces may have derived from hospital swing-doors. But they appeared more akin to the stern imperatives of non-representational art than to the work produced by his student contemporaries at Goldsmith's College in London.

With hindsight, we can now see that the starting-point for Hume's early paintings was more important than it once appeared. Those swing-door references announced an involvement with the contemporary world, however purged and aloof they may once have looked. By 1992, he had become dissatisfied with geometric forms. They seemed tasteful and oppressive, shutting him off from life beyond the hospital corridor. So he decided to burst the confining doors open, exploring the kind of images which had only appeared before as accidental reflections in his works' glossy surfaces.

It was a restless, uneasy time for Hume. He began experimenting with video, sculpture and photography, playing the part of King Canute in a quirky video where the artist sits smoking in an overflowing bath placed in his own backyard. But by 1993 he had arrived at a commitment to open-ended, boldly executed figurative paintings. They will dominate his space at the Tate Gallery when the Turner Prize exhibition opens there on 29 October, and their freewheeling variety proves just how far Hume has moved away from the stern geometry of his former work.

He is still capable of highly simplified images, bordering on abstraction: *Snowman* consists of two slightly irregular circles, the former balanced precariously on its scarlet companion. As a rule, though, different styles commingle in one picture. *Kate*, one of his most impressive new paintings, takes as its springboard an image of the model Kate Moss. But her body is transformed into a sequence of fragmented limbs, close in their brittle vivacity to a late Matisse cut-out. As for her face, its features have been obliterated by a brusquely applied layer of grey gloss. Reminiscent of the pigment smothering the young woman's face in his 1995 homage to the Renaissance master Petrus Christus, this strange veil is at once alarming and sensuous. It typifies the teasing ambiguity that enlivens all Hume's finest art.

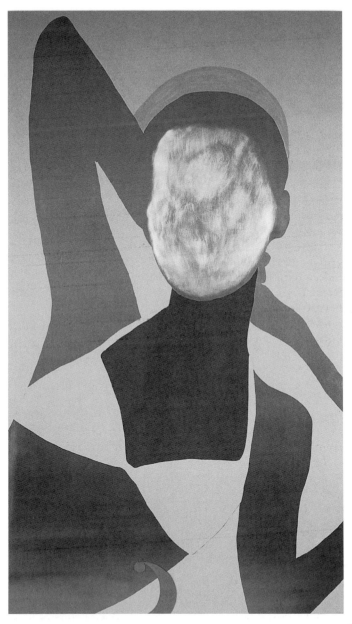

59. Gary Hume, *Kate*, 1996

The human figure also plays a central role in the work of the twenty-nine-year-old Glaswegian artist Douglas Gordon. In his case, however, the images have been increasingly drawn from cinematic sources. Alfred Hitchcock provided the raw material for a 1993 *tour de force* called *24 Hour Psycho*, where the director's macabre masterpiece was slowed down so much that it lasted a whole day. Our memories of the original film were pitched against the eerily balletic and silent alternative provided by Gordon, who enabled viewers to move around the film by rear-projecting it on a screen placed in the centre of the gallery. The slow motion made us feel even more voyeuristic, emphasizing the fascination to be derived from even the most horrific sequences.

Gordon is preoccupied with our psychological response to the moving image. He subsequently unearthed some early, little-known medical demonstration films, among them a distressing exploration of a soldier traumatized by front-line service in the Great War. By slowing down and editing the young man's doomed yet repeated attempts to control his helpless limbs, Gordon subjects us to a gruelling experience. We are made to feel almost sadistic in our fascination with the soldier's suffering; and this unease lingers in a work called *Hysterical*, even when it becomes clear that the film is performed by actors. On one screen, the original 1908 footage is projected. Its clumsily painted scenery and crude melodrama soon give the game away, but the slowed-down version on another screen is still painful to watch. The laughable innocence of the correct-speed film grows darkly sinister, filled with suggestions that the male doctors restraining a masked, female patient take a salacious delight in their power over her.

Despite his minimal approach and apparent air of detachment, Gordon is not afraid to explore the murkiest regions of the human psyche. One of his Tate exhibits, *Confessions of a Justified Sinner*, takes its title from a celebrated nineteenth-century novel by the Scottish writer James Hogg. The book centres on a pious youth who is seduced by the devil. Schizophrenia forces him to murder his own brother, and Gordon explores Hogg's fascination with the conflict between good and evil by taking three clips from an early film version of *Dr Jekyll and Mr Hyde*. The terrible metamorphosis undergone by Fredric March, acting the role of the doctor, provides Gordon with images as ambiguous as Hume's paintings, and a great deal more disturbing.

Although Craigie Horsfield's photographs are likewise rooted in a sense of crisis, he produces images far quieter and more redemptive than anything offered by Gordon. At forty-six the oldest of the Turner Prize contenders, he began his career by studying painting at St Martin's School of Art in London. Rapidly disenchanted by what he saw as modern painting's

removal from reality, Horsfield turned to the camera instead. But the large, square-format photographs he has produced since the early 1970s are still affected by his awareness of the European painting tradition. The seven years he spent in Poland proved a formative experience, furnishing him with a store of negatives which still feed the work he prints today. But his Tate exhibits all derive from a recent project in Barcelona, where he collaborated with Manuel Borja-Villel and Jean-François Chevrier on photographing individual relationships within a community.

Horsfield wants to explore, in everything he makes, the human experience we all share. He is fiercely critical of most contemporary art, deploring its 'separation' from any notion of communal life. Whether he is photographing members of the Catalonian Parliament, clustered and argumentative in their lofty hall, or the stillness of Pau Todo and Marga Moll seated by a window, his engagement with particular people is unmistakable. The monumental size of his photographs, coupled with their imposing compositions, enable him to bestow immense dignity on the figures he portrays. But he never forgets the wider context of the city they inhabit. Barcelona itself is a palpable presence in this series of pictures, helping to shape the character of the men and women framed by Horsfield's ever-vigilant lens.

Images of human figures are nowhere to be found in Simon Patterson's playful and subversive work. Like Hume, he participated while still a Goldsmith's student in *Freeze*, a landmark 1988 group exhibition organized by fellow-student Damien Hirst in a Docklands warehouse. It swiftly became seen as a show that defined the emergence of a new generation in British art, but Patterson's work had little in common with either Hirst or Hume. Obsessed by information systems, he sets out to challenge or undermine the power they hold over our lives.

His funniest and most popular work, a 1992 lithograph called *The Great Bear*, is based on the London Underground 'map' designed by Harry Beck in 1931. Long lauded as a classic of inter-war graphic design at its most lucid, helping commuters to understand and use the tube system with ease, it undergoes a bizarre transformation in Patterson's hands. The familiar station names vanish, and in their place an extraordinary array of saints, singers, philosophers and explorers are inserted. Patterson sees the tube stops as stars arranged in a fantastic constellation, and revels in his anarchic mixture of references. High and low culture meet in entertaining profusion, but Patterson's plan to exhibit *The Great Bear* as a poster on the underground came to nothing. It was thought too bewildering for tube travellers to cope with on their journey through the labyrinthine corridors.

The Tate's visitors will now have a chance to make up their own minds, as well as confronting Patterson's spectacular new work where three tall white sails rear up from aluminium bases. Like a London house bearing a blue plaque, each sail is printed with the name and dates of a novelist: Raymond Chandler, Laurence Sterne and Currer Bell (the pseudonym of Charlotte Brontë). The surnames of this otherwise disparate trio are linked by maritime associations, while Patterson explains that the white sails 'are about the artist contemplating the blank canvas, and about the problems of making art'. Above all, though, the sails seem to evoke the excitement of a yachting race, and sum up the temper of an art event that turns its participants, however reluctantly, into rivals vying for the much-coveted trophy.

THE FIRST CITIBANK PHOTOGRAPHY PRIZE
2 November 1996

The advent of this major new prize could hardly be better timed. It responds to a resurgence of vitality in the contemporary photographic image, and celebrates the resourcefulness of young artists who deploy the camera's manifold possibilities in their work. Deciding on a shortlist for the first award was, therefore, never going to be easy. A lot of exciting work is being made with the camera in the mid-1990s. Over the past year, new photo-based exhibitions held in art and photography galleries alike have been consistently impressive. So have many of the images published in print or electronic form, and the overall standard of nominations for the £10,000 prize was high.

When the judges assembled in the Berkeley Square boardroom of the sponsors, Citibank Private Bank, we were prepared for an arduous and even bitterly divided session. After all, the non-voting chairman and originator of the prize, Ian Dunlop, had ensured that the five selectors were drawn both from the art and photography worlds. Apart from myself, they were Mark Haworth-Booth, Curator of Photography at the Victoria and Albert Museum; Maureen Paley, who runs the East London gallery Interim Art; the former *Vogue* photographer Tessa Traeger; and Paul Wombell, Director of the Photographers' Gallery. In the event, though, our discussions yielded a surprisingly high level of agreement about the most outstanding contenders. Although the debate inevitably

grew more tense as the list was whittled down to just five names, we all felt that their work will make a hugely stimulating and varied exhibition at the Royal College of Art in January.

What made us choose them? In the end, the intensity of their imaginations was the paramount consideration. Each of the shortlisted contenders has a highly singular vision, and is able to use the photographic medium to convey it with arresting power. But they could hardly be more contrasted in their use of the camera's resources. I believe that the participants in this exhibition reflect the exceptional diversity and sharply individual character of lens-based strategies today. Indeed, the differences between the five exhibitors serve to throw their singular identities into illuminating relief. The ways of working encompassed here range from brazen informality at one extreme to elaborately refined deliberation at the other. While a number of the shortlisted contenders clearly believe in the central importance of the human figure, the rest thrive on exploring a world where people have no place. An appetite for raw, alarming disclosure is set against an almost mystical withdrawal elsewhere. The often overwhelming amount of visual information which the camera can provide is at times explored to the full, while at other moments tantalizingly withheld. And the camera's seeming ability to offer a 'faithful record' of visible appearances is upheld by some as vigorously as it is flouted by others.

The approach adopted by Richard Billingham, at twenty-six the youngest artist on display, could hardly be more brazen. All the photographs in his extraordinary book *Ray's A Laugh*, published by Scalo last April, mark the arrival of a forceful new talent. With single-minded persistence, Billingham has spent the last six years photographing his own family in the most intimate manner imaginable. He makes no attempt to hide the fact that his father, Ray, is a seasoned alcoholic. Nor does he turn his camera away from the tensions flaring inside this claustrophobic and chaotic home. Billingham refuses to hide the sadness of their lives. But his images are seasoned with love as well, and redefine the reality of family life in the 1990s. Unsparing and yet deeply affectionate, these candid pictures are brilliantly observed, often painful and farcical at the same time, and above all truthful. They end up saying a great deal about both suffering and survival.

Philip-Lorca diCorcia's work could hardly be more different. There is nothing spontaneous about his superbly composed images. Making no secret of his debt to the cinema, this New York-based artist has turned the street life of Los Angeles into photographs resembling stills from a dream-like film. The results, exhibited at the Photographers' Gallery last

60. Richard Billingham, *Untitled*, 1990

summer, are an outstanding series of pictures called *Hollywood*. But the glamour of Tinseltown plays no part in these muted, melancholy scenes. The young men who appear in them are drawn from areas like Santa Monica Boulevard, notorious as a centre for drug addicts and male prostitutes. DiCorcia's terse captions reveal the names, ages and birthplaces of the men who posed for him, as well as the amount he paid them to appear. These drifters remain anonymous, however, and they seem removed from the twilight world of freeways, diners, gas stations and motel rooms around them.

No people can be discerned in Catherine Yass's light-box images of an old London hospital, where the corridors and stairwells are transformed with hallucinatory colour. But the human presence still appears to haunt these strangely expectant spaces. Yass's portrait work, published by Aspex last year, shows both men and women at their most measured and contemplative. Even so, their ordered air is usually underpinned by a feeling of tension. And the disquiet is accentuated by Yass's almost fluorescent colours – most notably a pulsating electric blue, at once radiant and sinister. This ambiguity characterizes her fascination with deserted, eerie buildings. She finds them a source of dread and fascination, in equal measure. After her unsettling exploration of the rambling Victorian psychiatric institution, she turned her attention to the uninhabited halls of

Smithfield's. The market's stillness focuses our eyes on the meat-hooks instead. They dangle tenaciously, waiting for the carcasses to arrive.

Mat Collishaw is quite prepared to show the dead meat itself. In 1994 he made an acrylic photograph of frozen zebra finches, enclosed in a bed of ice and lit from behind like an X-ray hung up for medical inspection. But Collishaw's range of subjects is as wide, inventive and unpredictable as the materials he employs. In his 1995–6 show at the Camden Arts Centre, he played with the early history of photography by projecting video footage into a wooden frame once used for holding glass-plate negatives. The footage showed a hollow oak, as quintessentially English as the forest glade reflected in the mirror of a nearby 'enchanted wardrobe'. He is just as ready, though, to indulge in a frankly repellent exoticism. His recent computer-aided flower images attract us initially, and then disturb when we realize that the petals are made from manipulated photographs of skin diseases at their most infectious.

No such disgust is allowed to penetrate Uta Barth's serene and enigmatic work. Her ostensible subjects have all but vanished. In the *Ground* series, shown at London Projects last summer, she concentrates on unfocused interiors where nothing is visible apart from blurred hints of corners, window-frames and floors. Like abstract painting at its most lyrical, these quietly seductive images seem to dissolve in the light. For German-born Barth, now based in Los Angeles, turns everything she photographs into a misty, elusive dream. The camera's capacity for precision plays no part in her work. Judging by the Vermeer reproductions hanging in the background of *Ground no. 42*, she is quite prepared to acknowledge a debt to artists from the past. But contemporary painters as diverse as Agnes Martin and Gerhard Richter may also have influenced her, as she searches so coolly for paradoxical ways of making absence appear more potent than presence.

Laminated on to wooden frames and projecting from the wall, Barth's images also exemplify the blurring of the old territorial limits that used to divide photographers from artists. Barriers are being broken down, in a climate where the camera enjoys an increasing ability to play a decisive role in many young artists' work. That is why the advent of this generous prize is so welcome. It enables the judges to celebrate the intensity of five highly singular visions, all proving in their distinctive ways just how vital and innovative photography can be in contemporary image-making at its most powerful.

The eventual winner of the first Citibank Prize was Richard Billingham.

CHRISTINE BORLAND AND TRACEY EMIN
29 April 1997

Like the reincarnation of a figure from the darkest Jacobean tragedy, Christine Borland is obsessed with bones. But her approach is more forensic than ghoulish. In the early stages of her most haunting work, she was astounded to discover that it was possible to order a real human skeleton through the post. Having paid £900 and received her grisly mail-order acquisition, she set about using the methods of crime detection to discover the identity of the corpse. Helped by an osteologist, Borland carefully reassembled the bits and pieces. They revealed that the bones had once been an Asian woman who died at the age of twenty-five after at least one pregnancy. So for an eerie yet compassionate exhibition at the Tramway Gallery in Glasgow, where Borland lives and works, she juxtaposed the bones with a blow-by-blow display of her investigative process. It culminated in a bronze reconstruction by forensic scientists of the dead woman's face – a poignant, posthumous tribute to a victim who may even have been murdered for her skeleton.

Nothing so shocking can be found in Borland's first one-person London exhibition. Throughout the aptly clinical white rooms at the Lisson Gallery, though, the same dedication to a methodical uncovering of the past is detectable. In the most substantial work, *L'Homme Double*, six clay heads by different artists are positioned on plinths. They were commissioned by Borland, who asked each of the sculptors to make a traditional, life-size portrait of the infamous Doctor Joseph Mengele. Photographs and verbal descriptions of the Nazi war criminal were supplied, but they testify only to his maddening elusiveness. For Mengele was never caught, and the supposed discovery of his body on a Brazilian beach is still contested. No wonder that the sculptors, confronted by such an enigma, have produced heads notable for their grey, academic sobriety. Although Borland told them that the information she supplied 'can be interpreted as freely as you wish', the main differences between them centre on the presence or absence of a moustache and a tie. They all look anonymous and remote, proving that no amount of patient research can in this case solve the mystery. The macabre and repulsive nature of Mengele's atrocities are wholly at odds with the conventional decency of the faces on view here.

All the same, there is no doubting Borland's readiness to confront and explore even the most gruesome aspects of life. The emotional commitment behind her seeming coolness erupts in the small room next to *L'Homme Double*, where two battered chairs carry photocopies of The

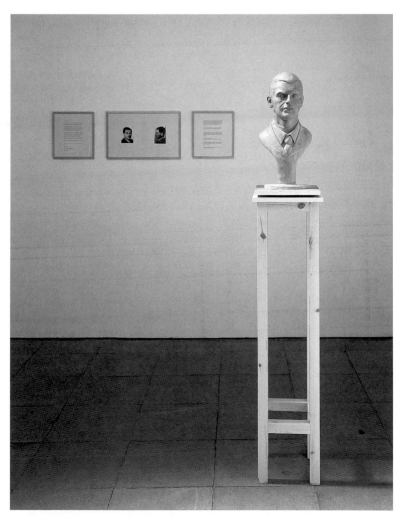

61. Christine Borland, *L'Homme Double*, 1997 (detail, Head by Alison Bell)

Creature's Monologue from Mary Shelley's *Frankenstein or The Modern Prometheus*. We are invited to sit down and read them, and on their covers Borland has printed an impassioned quotation from *Paradise Lost*: 'Did I request thee, Maker, From my clay To mould me man? Did I solicit thee From darkness to promote me?'

Wandering through the rest of the show, we come across fragmented manifestations of Borland's intense, governing concerns. Some might easily be overlooked – like the replica of a .38 Government Colt Automatic visible, as a blurred form in a blue-striped plastic bag, at the bottom of the shadowy basement stairs. Borland prefers understatement to the rhetoric of Milton or Shelley, and the first-floor gallery yields its contents slowly. The room is in darkness, apart from one document spotlit on a wall and a dimly illuminated area by the far window. Here, embedded in the concrete floor, are a dozen brilliant-cut diamonds. They look randomly scattered at first, but then spectral suggestions of a human form become apparent around them. As hard to discern as the body parts outlined by dust in Borland's contribution to *Material Culture*, the Hayward Gallery's current show, it seems on the verge of disappearing. But the diamonds turn out to pinpoint its anatomy with surprising precision. They are also another means of reminding us that our bodies can be bought and sold like jewels or any other commodity on the market.

Borland's awareness of corporeal fragility is conveyed most clearly in *Bison-Bison*, a work that takes as its springboard an experiment described in *Gray's Anatomy*. On the long central table, the animal's astonishingly elongated vertebrae extend from one end to the other. It is an awesome spectacle, but Borland has extracted the bones' organic compounds. As a result, they become as light as paper and look ready to crumble at a touch. Towards the far end they have already turned into blue-tinged powder, whereas the bison ribs on the other two tables are orange and surprisingly supple. Their mineral compounds have been removed, leaving them so soft that the artist was able to twist some of the ribs into knots. This unexpectedly playful gesture highlights the wry, dry humour underlying an exhibition riddled with intimations of mortality.

Tracey Emin, another of the young women who play such a prominent role in the new British art, shares Borland's feeling for vulnerability. But the work in her show at the South London Gallery is focused unabashedly on Emin's own life. Furniture, drawings, photographs, paintings, written texts, found objects and videos are all employed, with freewheeling candour, by an artist who calls her exhibition *I Need Art Like I Need God*. Everything on view here is presented as part of Emin's salvation, her way of exorcizing the traumas of the past. On one of the brazenly revealing videos, her mother admits that she thought the adolescent Tracey 'would have gone to the dogs if you hadn't gone to art school'. Her attempt to become a painter foundered during her student years, but she eventually learned how to make autobiography her central theme. Many of the exhibits focus on the often painful experience of

growing up in Margate. She talks frankly on video about the time she was raped, and concludes that 'for me my childhood was over'. She describes her moments of depression and attempted suicide, how schoolkids taunted her with racist abuse, and the anger she still feels about her abortion.

Nothing, it seems, is excluded from this startling and raw self-exposure. In another artist's hands, the outcome could easily degenerate into an intolerable form of narcissism. Against all the odds, though, this show does not feel self-indulgent. For one thing, Emin never makes the mistake of raising herself above criticism. Her feelings of guilt and envy are freely exposed in a white partitioned room at the centre of the gallery, where she recreates an installation produced in Stockholm last year. The discarded paintings inside, including blue body-imprints uncomfortably close to Yves Klein's work, are often inscribed with messages and exhortations, directed either at friends or herself. Perhaps the most germane is the command boldly telling Emin 'Not To Be Afraid. Most Of My Life Has Been Built On Fear.'

Judging by the uninhibited mood of the exhibition as a whole, Emin succeeds in obeying this injunction. Her often searing book of memoirs has been published under the headlong title *Exploration of the Soul*, and a panoramic colour photograph shows her clutching it in Monument

62. Tracey Emin, *Outside Myself (Monument Valley)*, 1994

Valley during an epic trip across the USA. The text is unsparing in its determination to deal honestly with her past, and words also play a decisive role in many of the objects she has produced. An embroidered chest stuffed with clothes bears an inscription on the front celebrating 'All the love that I have made'. But on the back, a counter-dedication conveys regret for 'All the love I have destroyed'.

There is no suggestion, at any stage in this labyrinthine voyage through Emin's history, that she has reached a plateau of serenity. Bitterness frequently explodes, above all in some accusatory prints scrawled with outbursts like 'You Were Not Men You Were Less Than Human'. On these occasions, Emin's writing becomes as direct and raw as graffiti on a street corner. She admits to scrawling on the sea wall at Margate, where many of her teenage years appear to have been hellish. In another mood, however, she is capable of drawing small, tender images of birds.

Her command of line is impressive, especially in some spidery nudes and street scenes reminiscent of German and Austrian Expressionism. But Emin's work is so dartingly various that it cannot be categorized with ease. She thrives on diversity, moving from the handmade and homely to the language of television documentary without apparent hesitation. Binding all these offerings together is a confessional urge, and Emin shows no sign of exhaustion in her compulsive, versatile attempt to turn the messiness of life into art.

DEATH IN VENICE
17 June 1997

Future, Present, Past: the theme of the 47th Venice Biennale is broad enough to embrace virtually anything submitted by the contributing countries. So the artists chosen for the national pavilions in the Castello Gardens span an unusually wide age range. At one extreme we find Robert Colescott, a senior American painter who studied under Léger way back in 1949. And at the other, Rachel Whiteread, the young sculptor who left art school only a decade ago and is one of three British artists to win a prize at this year's Biennale. With astonishing assurance, she has transformed the British pavilion into the ideal showcase for her single-minded, powerful and continually developing talent.

The outcome is even more impressive than I had expected. In the first room, Whiteread's ability to make a presence out of absence, give emptiness solid form and invest ordinary objects with an unforced grandeur is given imposing form in a large, white plaster sculpture called *Ten Tables*. Scarred, cracked and mottled, it has a stillness that reminded me of Brancusi's *Table of Silence* in Romania. But Whiteread's secular Last Supper, cast from the spaces underneath the furniture, is an unmistakably individual achievement.

The great excitement of her other rooms lies in the gradual unfolding of Whiteread's more sensuous side. A rich, gleaming resin table and chair are juxtaposed with a cream mattress. A deep orange bath occupies a ceremonial chamber of its own, and the main gallery at the back is enlivened by a magisterial floor-piece. The Venetian sun falls straight on to its dark blocks of resin, revealing a surprising range of colours inside them. Although Whiteread's art is elegiac and bound up with memorializing, her preoccupation with death is conveyed with great serenity and warmth. At the age of only thirty-four, she can already be counted among the most formidable artists at work anywhere in the world. The Biennale jury was right to give her a Best Young Artist award.

Her pavilion is surrounded by disappointing neighbours. Fabrice Hybert's French pavilion, decked out like a tent, is filled with irritating videos and arbitrary bric-à-brac. Its deliberate disorder contrasts with the emptiness of the German Pavilion, where Gerhard Merz's light sculpture is installed perversely high on the wall. His fastidious coolness could hardly be further removed from the crowded images installed by Katharina Sieverding in the side rooms, where her enigmatic forms convey a sombre mood. So it is a relief to find in the Canadian Pavilion an entertaining film where Rodney Graham, arrayed in eighteenth-century clothes, finds himself stranded like Robinson Crusoe on an idyllic desert island. Coconuts knock him unconscious and the efforts of a squawking parrot fail to revive him. But for all its gentle wit, the film seems a lightweight affair.

This is a multi-media Biennale, and few pavilions are devoted to painters. Abstraction at its most severe reigns in the Swiss Pavilion, where Helmut Federle fills his main space with brooding, minimal canvases. He strives for a pared-down, almost glacial essence, whereas Robert Colescott's large figurative canvases in the American Pavilion present an angry, hectic and often apocalyptic vision. He sees the US as an emergency room in an overstretched hospital. Racism is his principal concern, and nobody can doubt the sincerity of his moral disquiet. But his paintings, seen *en masse*, become cluttered and repetitive. They suffer from the wearisome stridency also to be found in the Russian pavilion.

It is devoid of the ability to surprise that animates Joan Brossa's work in the lively Spanish pavilion. Insects swarm over one colossal white wall, but his most macabre room is dominated by an instrument of execution. Until Spain abolished the death penalty in 1974, this horrible *garrote vil* was regularly used. The neck-clamped victim was killed from behind by a spine-snapping device, and Brossa compounds our disquiet by laying out an elaborate dinner table with silver candlesticks for the prisoner's final meal.

But at least Brossa seasons his gruesomeness with black humour. In the main pavilion, Marina Abramović provides no such respite. Seated in a darkened room, she is surrounded by a heap of blood-smeared, stinking bones. For several hours each day Abramović stays in this charnel house, moaning and washing a large bone propped like a baby on her lap. She calls this unnerving and repellent performance *Balkan Baroque*. Originally intended for the Yugoslav pavilion, it was rejected by commissioners who found it too strong to stomach. By no means everything in the main pavilion is so mortifying. Agnes Martin shows some surprisingly seductive stripe paintings, and Tony Cragg's three monumental sculptures are typically inventive. Roy Lichtenstein also stands out, with a roomful of bold and witty aluminium sculptures in hard, shiny colours. But even though Gerhard Richter and Annette Messager also make powerful contributions, long-established reputations are celebrated here. For younger artists, we must visit the nearby Arsenale.

The work in its lofty, multi-columned interior starts predictably, with a glistening toylike sculpture by Jeff Koons positioned appropriately near the gallery shop. Some exhibits are merely playful, like Bertrand Lavier's giant yellow Caterpillar truck festooned with Christmas-tree decorations. Others are guilty of grandiosity, like the portentous row of white crosses installed by Robert Longo. But some of the younger participants are far more rewarding. Juan Muñoz arrests attention with his cluster of grey-painted, bald oriental men, smiling despite their leg braces and unaccountable lack of feet.

Two women artists prove outstanding, too. Sam Taylor-Wood's three-screen video installation is set in a smart restaurant, where the diners' pleasure provides an ironic foil for the distress of one young woman. Close-ups concentrate on her anguished face, and the restless hand-gestures of the man who seems to be causing her so much unhappiness. Taylor-Wood ensures that sounds of laughter, clattering cutlery and the generalized din of other people's chatter is heard more clearly than anything this couple say to each other. But the sense of crisis in their relationship is vividly conveyed. So is the vitality and glee of the young woman in Pipilotti Rist's video work. While a contented humming fills the soundtrack, she walks

63. Pipilotti Rist's video *Ever is Over all*, at the Venice Biennale, 1997 (detail)

down a street aiming a red-hot-poker flower at the windows of parked cars. Her improvised weapon must contain a hidden weight, for it smashes the glass every time. She reacts with relish, and nothing can stop her triumphant, ecstatic progress. A passing policewoman simply salutes her and walks on, while the flower-filled fields on a neighbouring screen seem to applaud her attack on the polluting vehicles. If a 'green' message underlies Rist's exhibit, she conveys it with irresistible flair and wit.

Douglas Gordon, another British winner at this year's Biennale, also makes an impact. For thirty seconds his room is completely dark, and then a single light bulb suddenly illuminates a text on the wall. It describes how, in 1905, a French doctor tried to communicate with a condemned man's severed head immediately after a guillotine execution. The face showed definite signs of response for half a minute, the amount of time Gordon allows us before the light is switched off again. We stand there, waiting to finish reading and nervously finding that our own imaginations visualize the doctor's alarming experiment in the gloom. This fascination with mortality, which also unites the otherwise very different work of Joan Brossa and Rachel Whiteread, is the most potent theme running through the entire Biennale.

In Ireland's contribution, superbly displayed in the Galleria Nuova Icona on the Giudecca, Alastair MacLennan has created a chilling, clinical

installation. The papered walls, so reminiscent of white tiles in a mortuary, turn out to be hung with the names of people who have been killed in the recent Irish Troubles. While unseen voices solemnly read them all out, we find ourselves confronting a rough-hewn sculpture of wood and earth, along with an empty wheelchair waiting for its next occupant.

Anselm Kiefer's exhibition ensures that the elegiac mood is sustained. Presented with great theatrical flair at the Museo Correr, it begins with two of his largest recent paintings. While one evokes the crumbling structure of a stepped Mayan temple where sacrificial rituals were once staged, the other fills the sky over an immense furrowed field with sunflower seeds. While symbolizing renewal, they also threaten to choke the picture with their swarming blackness. And upstairs, the rest of Kiefer's powerful show reveals how he has explored this ambiguity for more than twenty years. Burnt landscapes from the 1970s testify to his vision of Germany as a country battered by its own traumatic history. But the strong outlines of a painter's palette are roughly brushed over some of these harrowing scenes. Kiefer's determination to make an eloquent art from the horror of his nation's tragedy cannot be doubted.

In the end, the sense of a profoundly troubled legacy from the past dominates this year's Biennale. The present and the future are both overshadowed, and the predominance of older artists means that we learn disappointingly little about the new, emergent generation.

DOCUMENTA X
24 June 1997

An astonishing cascade of journalists descended on Kassel for Documenta, the jumbo-size global round-up of contemporary art which galvanizes this sleepy German city every five years. In order to accommodate them all, the press conference was shifted at the last minute to a vast auditorium at the Stadthalle. But Catherine David, the oddly defensive French organizer of the exhibition, was in no mood to communicate. She contemptuously dismissed most questions from the floor as 'foolish' or 'ridiculous', and hardly mentioned the artists she had chosen. As a public relations warm-up, the event was a disaster.

But at least she deigned to point out the significance of the show's itinerary, starting at the old railway station and moving in a line through the

centre of Kassel towards the baroque flamboyance of the white-and-gold Orangerie in the elegant park below. Modern urban experience is her governing theme, not only in a Western centre like Kassel but all the 'elsewheres' throughout the world. There is nothing celebratory about David's vision, though. An air of dereliction prevails at the disused station. The Viennese artist Lois Weinberger has planted weeds between the rusting railway tracks, and smashed up tarmac in the nearby car park like a drunken vandal. On the platforms, violence becomes becomes more alarming. Tunga, from Brazil, hangs skulls over giant straw boaters and dangles body parts, severed and trussed, above an equally enormous brown felt hat.

Sigalit Landau's corrugated metal container on a nearby platform is scarcely more reassuring. She calls it *Resident Alien*, and once inside the stifling, green-painted chamber we are forced to stagger across a mountainous, misshapen floor beaten by the hammers Landau has left there. Then, at the far end, a box hangs from the roof. Poke your head up inside it, and you quickly realize that you have passed through the hole in a 'Turkish toilet'. Working in Jerusalem, Landau dramatizes the plight of dispossessed communities with anger and disgust.

Down in the shabbiness of the underground passage leading to Kassel's main pedestrian precinct, the mood becomes more desolate. Mounted in a light box, and gleaming like neon in the gloom, Jeff Wall's large colour photograph shows a man squatting against a brick wall. He looks haggard, and the milk spurting from the paper bag in his hand is as forceful and unexpected as a scream. Respite is provided further along the tunnel, where Christine Hill has set up a 'Volksboutique' in dingy shop premises. Describing herself ironically as an 'Artslut', this young American artist talks to anyone entering her store. Second-hand clothes are available for a few Deutschmarks, and she seems ready to provide a welcoming, sociable space scattered with sweets and balloons. But I saw no reason to linger there, and Hill's shop seemed dull compared with the gritty humour of Peter Friedl's video outside. Making aggressive, high-volume sounds of slamming and beating, an enraged man in a subway attacks a cigarette machine. It refuses to function, and as he stalks away a begging bystander kicks him for refusing to give money.

These subterranean passageways are so uninviting that they will soon be closed down. The city centre built in the 1950s, after British bombs flattened Kassel with lethal accuracy, now looks like a melancholy victim of the German recession. But nobody should be surprised that an event as expensive as Documenta continues to be staged here. The overwhelming crowds it attracts throughout the summer ensure that the exhibition generates much-needed business. The arch-dissenter Hans Haacke, however,

provides a warning for anyone who views the marriage between art and commerce too naïvely. His garish poster, wrapped round an advertising pillar at the base of Kassel's focal 'Stairway Street', is dominated by an image of a Dada-like wooden puppet. It mocks the classic pose of the Renaissance Vitruvian man, and Haacke has adorned his automaton with quotations from business leaders who relish the power of arts sponsorship. 'It is a tool for public opinion' declares one, while Hilmar Kopper of Deutsche Bank bluntly declares that 'whoever pays, controls'.

To her credit, the tough-minded Catherine David has produced a show fiercely opposed to such manipulation. But in her determination to offer something more than spectacular entertainment, she errs on the side of dryness. This is a cerebral Documenta, dominated by rooms filled with small black-and-white photographs and too many texts. It smacks of the schoolroom. David would rather provide a stern, educative experience than anything associated with the suspect enticements of pleasure. She favours a documentary approach, repetitively stressing the harshness of inner-city life. And at the grand eighteenth-century Museum Fridericianum, her stern priorities are made uncompromisingly clear. An immense space is set aside for Gerhard Richter, whose paintings could have given the 1997 Documenta a welcome shot of sensual vitality. But the walls are lined instead with *Atlas*, an archival work-in-progress containing all the family snapshots, press cuttings, sketches and other material he uses as the source of his work. Memorable images lurk among the thousands of pictures assembled here, from concentration-camp pictures and blurred pornography to intimate studies of Richter's wife and children. But they lack the commanding presence of his large canvases, and could be assimilated far more easily in book form.

The emphasis on photography, in room after room, soon becomes relentless. And David's insistence on setting new work in the context of the past often turns the exhibition into a history lesson. The great excitement of Documenta, at its provocative best, has always lain in a stimulating overview of new developments. Here, to my surprise, I found generous spaces devoted to Walker Evans's subway portraits of the late 1930s, and Helen Levitt's camera studies of street life in East Harlem during the Second World War. Both these displays contain remarkable images, and Levitt's keen eye for the poetry of graffiti gives her work a sharp contemporary edge. David probably wants them to enhance our understanding of Jeff Wall's room, where his characteristic light-boxes have largely been replaced by a new commitment to black-and-white photography. Wall's often hallucinatory command of colour gives way, here, to sober images of a cleaner leaving a hotel room, a sleeping cyclist and (best of all) a startling

64. Johan Grimonprez, *Dial H-I-S-T-O-R-Y*, 1997

yet enigmatic encounter between two passers-by in a nocturnal alleyway. But they do not need any help from Evans or Levitt.

Richard Hamilton's contribution is impressive enough to stand on its own as well. Based on an identical reconstruction of the space at the Anthony d'Offay Gallery, where this series of *Seven Rooms* was first shown, Hamilton's cool images offer a tour of his own house. They are computer-assisted paintings, relying on the resources of the camera and the Quantel paintbox to provide a lucid yet mysterious voyage of discovery.

Few other British artists are included. The conceptual group Art & Language has never looked better, with a beguiling two-room display of brilliantly coloured panels each containing a double-page spread from a book. The texts are partially obscured, so the viewer is constantly tugged between reading and looking. The fact that the panels take the form of furniture only adds to the sense of unease. Tension can also be found in *Catch*, a new video installation by the young London artist Steve McQueen. The camera moves between him and a woman who could easily be his sister. Before it comes to rest on their calm faces, the video goes through a startling series of twists and turns. Apart from alerting us

to the mechanics of camera movement, these convulsions seem to hint at some psychological disturbance which both man and woman conceal.

On the whole, though, David ignores the new British art. Rather than including a dead animal by Damien Hirst, she opts for Gabriel Orozco's human skull covered with a finely-drawn chequerboard of black squares. And among the least familiar names in the show, she scores a bull's-eye with a powerful video film by the Trinidad-born, Ghent-based Johan Grimonprez. Primarily reliant on archive footage of aeroplane hijacks throughout the world, he includes sequences so harrowing that they could never have been shown on British television news. The terrifying sincerity of the terrorists is conveyed as pungently as their callous fanaticism. The suffering of relatives and the sweaty claustrophobia of hostages' cabins are both punched home, sometimes with a slickness that made me suspect Grimonprez of exploiting human anguish. But his mastery is incontestable, cutting between documentary shots, science-fiction films and his own reconstructions with the help of ironic music and spoken extracts based on Don DeLillo's wry novels. The whole work had a visceral impact, a sense of urgency and a wrenching emotional attack which so much of Documenta desperately lacked.

SENSATION
16 September 1997

Until now, Charles Saatchi has displayed his extraordinary collection in the dazzling, minimal whiteness of a converted St John's Wood factory building. This week, though, the most munificent patron of young British artists has made a risky move. The bulk of his holdings in the work produced by this feisty new generation is invading the august portals of the Royal Academy. Flaunting its ability to ignite banner-headline controversy, the show has been given the inflammatory title *Sensation*. The rebels have stormed the bastions of conservatism, and howls from outraged Academicians are still bouncing around the walls of Burlington House.

By making an hysterical attempt to ban Marcus Harvey's portrait of Myra Hindley, the crustiest Academicians have revealed just how ugly their censorious hatred can be. If they do fulfil the threat to resign in protest, their departure will be the Academy's gain. It has spent much of the twentieth century condemning the most vital impulses in

modern art, and the advent of the Saatchi Collection was bound to be ferociously resisted by its most diehard members. So I am delighted that the exhibition will open on Thursday with the Hindley painting defiantly in place. The show's arrival is a welcome sign that the Academy has belatedly decided, just before the century's end, to atone for its disgraceful, antiquated intolerance in the past.

How does the art itself look, transferred to these imposing and richly embellished Victorian galleries? Fears that the works might look out of place turn out, on the whole, to be unfounded. Displayed according to the principles of the risibly overcrowded RA summer show, they would have appeared calamitous. But Saatchi and the Exhibitions Secretary Norman Rosenthal have aimed at spareness, and most of the survey is presented with judicious aplomb.

The first room, inevitably, is dominated by Damien Hirst's iconic tiger shark, eerily suspended in its tank of misty green formaldehyde. Now all of six years old, the notorious behemoth is beginning to look rather frayed. Seen from the front, where predatory teeth are bared, it has the looming quality of a nightmare. In the end, though, it seems far less disturbing than Hirst's later sliced animals. Aware of the gallery's historic context, the organizers have cleverly pinpointed new British art's links with tradition. Surrounded here by Mark Wallinger's immaculate, friezelike paintings of thoroughbred racehorses, some reflected in the glass tank, the stillness of the shark shares their kinship with the work of George Stubbs. Even a work as provocative as Marc Quinn's blood-saturated head, severed and refrigerated inside its steel and perspex sepulchre, seems surprisingly at home here. It has been placed, with a feeling for ironic juxtaposition, below classical roundels filled with noble nineteenth-century heads of Renaissance masters. Part of the room's original architecture, they suggest that Quinn is far more conscious of the art of the past than his detractors might suppose.

So is Rachel Whiteread, whose work is superbly represented in the Saatchi Collection. Although she casts most of her sculptures from ordinary household objects, they end up stirring memories of antiquity, Her *Untitled* (*Bath*) resembles a bleached, austere sarcophagus, waiting to receive its corpse. And even her masterpiece, the aptly named *Ghost*, transcends its origins as the cast of a commonplace London living-room. Majestically positioned at the far end of a suite of galleries, this purged and melancholy plaster can already be ranked among the classic British sculptures of the present century.

Scattered across the wall opposite *Ghost*, Richard Billingham's powerful colour photographs remind us of the turbulent lives that might once

have been led inside Whiteread's now-silent living-room. Based on his own dysfunctional family, Billingham's intimate pictures frankly depict the tension, boredom and pathos of existence inside this claustrophobic home. But his painter's eye ensures that some of these images, especially of his mother, possess an unexpected magnificence as well.

Not all the Academy's rooms boast such pertinent pairings of artists. Whiteread's *Untitled (One Hundred Spaces)*, with its glowing blocks of resin ranged in orderly ranks like gravestones in a war cemetery, deserves to be displayed on its own. But paintings by artists like Simon Callery and Keith Coventry have been ranged on the walls above, and their diversity is a distraction. In his St John's Wood gallery, Saatchi never mixes exhibitors together. Although the same principle of segregation clearly could not be maintained in this far larger show, embracing over forty artists, the most impressive moments occur when individuals are seen in near-isolation. Hirst is seen at his toughest in the room containing his bisected pig, its two halves echoing the movement of a slicing machine as they glide slowly past each other on a motorized track. Placed near his earlier *A Thousand Years*, where a decaying cow's head lies in a gruesome smear of blood beset by flies, the pig sculpture sums up Hirst's ability to tackle death with mordant humour. Alain Miller's virtuoso painting *Eye Love Eye*, hung nearby, pursues the same rotting-meat theme in terms of a staring human face.

Those who protest that *Sensation* is a 'conceptual' conspiracy, hatched by malignant 'anti-art' forces, take no account of the painters plentifully on view here. They show how catholic Saatchi's taste really is. At one extreme, he savours the severe, minimalist abstraction of Jason Martin, while at the other Jenny Saville's colossal paintings of mountainous female nudes could hardly be more figurative. She is the most 'academic' artist to be found here, and yet her preoccupation with cosmetic surgery makes her work chime with the darker obsessions pursued by other, less conventional exhibitors.

I cannot share Saatchi's enthusiasm for the work of Glenn Brown, whose slick pastiches of painters as diverse as Auerbach and Dalí amount to little more than flashy displays of technical skill. But the show also devotes generous amounts of space to some of our most exuberant, life-affirming young painters. Fiona Rae continues to beguile and astound with her virtuoso, exclamatory canvases. She is effectively displayed in one of the most flamboyant rooms, where Yinka Shonibare's trio of headless women swathed in clangorous wax-print cotton textiles are as shameless, in their way, as Gary Hume's brazen *Transvestite* nearby. Anyone who accuses the new British art of joylessness should look out

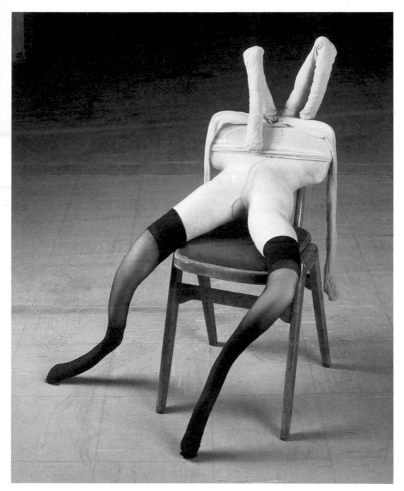

65. Sarah Lucas, *Pauline Bunny*, 1997

for Hume's work, scattered through the show and enlivening it at every turn with instinctive vivacity.

However much Hume may owe to Matisse, though, he is sinister as well as sensuous. And none of the other artists could be described as straightforwardly celebratory. Even Chris Ofili, whose extravagant and orgiastic paintings flaunt glitter and map pins among the swirls of oil and acrylic, rests all his paintings on balls of elephant dung. He belongs to a

generation unaffected by squeamishness and eager to challenge taboos. Mat Collishaw's cibachrome work, mounted on fifteen light boxes, takes a colour photograph of a bullet hole and transforms it into a weirdly flaring, exotic image. As for Mona Hatoum, she invites us to sit down at a table laid for a meal and then confronts us, on an otherwise empty plate, with a surgical camera's exploration of her mouth, throat and stomach.

Tracey Emin is even more willing to indulge in self-exposure, encouraging us to crawl inside a tent embroidered with the names of 'everyone I have ever slept with'. There is nothing discreet or cosily reassuring about new British art. Taking as their springboard a celebrated Goya etching of war's atrocity, Jake and Dinos Chapman produce their own sculptural version peopled with shop-window mannequins. It spares us nothing in terms of gory mutilation, just as Sarah Lucas's *Bunny* twists the female body into a grotesquely deformed figure. Obsessed with violation, her art is fuelled by disgust and private pain.

Lucas refuses to ignore the least palatable aspects of late-twentieth-century life, and this is the grim context in which Marcus Harvey's portrait of Myra Hindley deserves to be placed. Far from cynically exploiting her notoriety, Harvey's grave and monumental canvas succeeds in conveying the enormity of the crime she committed. Seen from afar, through several doorways, Hindley's face looms at us like an inescapable apparition. By the time we get close enough to realize that it is spattered with children's hand-prints, the sense of menace becomes overwhelming.

I can see no reason why such an image should be banned. Some Academicians may choose to shy away from the most alarming aspects of contemporary life, but many of the artists in this show are prepared to confront them. Their right to do so must be defended as vigorously as possible, just as the attempt to suppress them should be resisted and deplored.

MAT COLLISHAW AND ROSE FINN–KELCEY
2 December 1997

New British art is obsessed, to an overwhelming extent, by gritty urban life. When rural references do appear in contemporary work, they are more likely to be troubled than lyrical. In the past, British painters were often at their best when passionately engaged with the landscape at its most sublime. But the romantic ecstasy of Constable or Turner is far

66. Mat Collishaw, *The Awakening of Conscience: Kateline*, 1997

removed from two impressive exhibitions, where the countryside serves only as a starting-point for images filled with tension, unease and a feeling of dislocation. Take Mat Collishaw, whose haunting show at the Lisson Gallery starts with a roomful of woodland photographs. Seen as if through a spyhole, these large circular views lead us into picturesque, sun-dappled glades. In each picture, a uniformed schoolgirl lies among the foliage. They might be mistaken at first for adolescents who, like Lewis Carroll's Alice, simply fell asleep on a country stroll. Or they might be day-dreaming, like Brooke Boothby in Wright of Derby's languorous portrait of an eighteenth-century poet reclining in a sylvan dell.

We soon realize, however, that something has gone wrong. Books are scattered pell-mell among the leaves, along with other, more sinister

tubes and pots. Despite their clean white socks and school ties, these girls might be victims. Suddenly, the photographs' circular format becomes alarmingly reminiscent of a rifle's viewfinder. And the figures' stillness grows more and more ominous, suggesting that they are easy prey for anyone moving through the trees with predatory intentions.

What is going on here? Near the centre of the gallery, Collishaw has placed a tyre festooned with plants and flowers. They ought to evoke the pleasures of a harmless ramble. But among the ferns lurk an old-fashioned camera and, more sinister still, a canister labelled *Purified Butane Lighter*. These girls have been sniffing solvents. They might well be addicts, a condition that would explain their willingness to put themselves at risk. The camera indicates that a voyeur has already been at work. So the lush, enticing locations in the photographs look increasingly like scenes of a crime. A Victorian funerary angel reclines next to one of the girls, increasing the probability that their death is near. And Collishaw makes them appear even more vulnerable by specifying their first names in the titles of the works. Clara, Emily and Kateline: we are able to identify them, just as newspaper reports of woodland murders might distress us by revealing who the anonymous bodies really are.

Before each name, Collishaw has added the words *The Awakening of Conscience*. Devotees of the Pre-Raphaelites will doubtless find themselves remembering Holman Hunt's once-notorious painting *The Awakening Conscience*, where a kept woman in St John's Wood repents of her sinful life and yearns for redemption. But the girls in Collishaw's photographs show no sign of wanting to change their lives. They seem as embroiled in addiction as the video image of a stripper, projected on a large screen next door. Eyed by male onlookers standing in a shadowy circle around her, she revolves and exposes her body to their hungry gaze. Cleverly made from twenty still photographs morphed together, she seems doomed to repeat the same pose for as long as her audience remains ogling. Her features appear masked and expressionless, more like a mannequin than a flesh-and-blood woman.

But at least she remains upright and controlled, unlike the figures in the upstairs gallery. Here, synthetic lotus flowers float on 'lakes' lined with plastic. They look like the décor in a kitsch hotel foyer or brothel, and the naked light bulbs dangling over them add to the melancholy air of seediness. At the heart of the biggest flower in each pond is a small projected video of a prostitute touting for business on the street. Tottering along in thigh-length boots, they eye the cars cruising past. But they are barely able to stand, and one of them collapses in a stupor probably induced by drugs. Once again, Collishaw discloses their identity in his

titles: Carmen, Charlene, Keiko, Leticia and Sandy. The names increase the sense of wretchedness, and the cloying prettiness of the lotuses serves to heighten the women's degradation.

So the rural references in this show end up illuminating the urban reality Collishaw has explored in earlier works on violence and homelessness. In this respect, his work has an unexpected kinship with Rose Finn-Kelcey's absorbing and provocative exhibition at Camden Arts Centre. Immediately we enter the eye-battering brightness of the main gallery, agricultural images seem to confront us. Five plump yellow sacks stand nearby, fit for containing potatoes, earth or corn. And beyond them, an enormous farm gate stretches across the room, its reflected whiteness shimmering in the highly polished floor.

The nearer we approach them, though, the less bucolic these objects become. The 'sacks' turn out to be made of rubber, silicone and foam. Hard and bulging, they look more like blown-up versions of plastic toys than anything found in a field. The gate is, if anything, even more removed from farming reality. Spotless and streamlined under the gallery lights, its clinical surface has been coated with car spray-paint.

All these tantalizing images arise from Finn-Kelcey's own divided experience. Although she has lived in London for the last thirty years, her childhood was spent in the country, It shaped her imagination at a formative stage, and explains why she now attempts to explore the friction in what she calls 'the space between the rural and the urban'. Hence the unclassifiable character of the works on view here. They seem to transcend their agricultural origins and convey another level of reality. But nothing quite prepares us for the titles Finn-Kelcey has given them. The sacks are called *Souls*, and their companion is *The Pearly Gate*. So maybe we are presented here with an ironic vision of heaven – or rather, the tension-ridden place where the deceased finally discover if they have gained access to eternal bliss. The sacks are, after all, still some distance from the daunting, monumental gate. Their entry is by no means guaranteed, but at least the gate stands ajar. The possibility of pushing it further open gives a qualified optimism to the work as a whole.

All the same, Finn-Kelcey's subversiveness should not be underestimated. In the next room, a tufted wool rug lies on a steeply sloping support. Suspended between ground and ceiling, it bears a vastly enlarged image of a 1000-lire Vatican airmail stamp. A heavily bearded God the Father dominates the design, illuminated by a halo and clasping a quill pen. Probably derived from a painting in the Vatican's collection, he appears to float on a cloud. But the franking marks undulating across the stamp resemble waves, and lend him a nautical air. Hence Finn-Kelcey's

mischievous decision to give the deity an eye-patch, transforming him from an imperious patriarch into a jaunty, piratical figure.

The final gallery returns us to the farmyard, but the spiritual dimension refuses to be ousted altogether. Painted white, this long and lofty space could scarcely be more pristine. The entire floor has, however, been covered in deep layers of oat straw. So have the great arched windows, ensuring that the traffic-clotted Finchley Road is sealed from sight. Rich in texture, colour and smell alike, the bristling straw turns the room into a warm, womb-like shelter. It invites us to lie down in it, and forget about gallery-going altogether. We might even fantasize about lolling in a real barn, soothed by its contents' comforting presence.

Finn-Kelcey makes no attempt to disguise the rest of this gallery, with its light-tracks and fire-extinguishers fully exposed. But she is not averse to making our imaginations float away. One end wall is left free of straw, so that the constellation of black dots punctuating its white surface stand out with maximum force. They suggest stars flickering in a sky devoid of city pollution, encouraging us to contemplate an unfathomable cosmos far beyond the fertile and sustaining earth.

GILLIAN WEARING
13 January 1998

Anyone who complains that modern art is obscure, ingrown and detached from everyday life should look at Gillian Wearing's work. Throughout the 1990s, the latest Turner Prize-winner has explored other people's experiences with compassion, humour, patience, courage and irony. The results, whether startling in their intimacy or melancholy in their alienation, generate a profound feeling of unease. But her absorbing new exhibition at the Spacex Gallery in Exeter leaves no doubt about her involvement with the individuals she exposes to steady scrutiny.

Haunted by the memory of a woman with a bandaged face, Wearing decided in 1995 to make a homage. She saw the woman in Walworth Road, south London, lingering by a bus stop and walking down the pedestrian-clotted pavement. Brilliant white, apart from black slits for eyes and mouth, the face of this enigmatic figure 'seduced' Wearing and made her feel strangely 'elated'. So she decided to re-enact the scene, swathing her own face in heavy bandages and taking a video camera to record people's

reactions. The outcome, edited into a seven-minute video, is tantalizing, dreamlike and impossible to forget. We see passers-by puzzled by the apparition, then ogling her or adopting a studied metropolitan indifference. Nobody talks to her until, outside a Kwik-Fit garage, she hears shouts from a gang of lurking fitters. One comes forward, leers and says 'hello'. But he does not stay long enough to talk, and Wearing finally admits that she could not explain her obsession to anyone on the street.

In a second video, she paid tribute to another woman seen dancing wildly in the Royal Festival Hall. The setting is transposed to a busy mall in Peckham. This time, Wearing is not an unseen, bandaged presence holding a camera. She occupies the centre of the screen, flinging her body around to Gloria Gaynor and Nirvana. But no music can be heard: only the distant buzz of traffic is recorded on the soundtrack. Plenty of shoppers walk past, and some pause to look for an instant. However wildly her limbs may gyrate, though, nothing can persuade the inhabitants of Peckham to acknowledge her for long. They keep their distance, just as Wearing herself carries on performing oblivious of her surroundings.

Despite this awareness of urban isolation, she continually attempts to break barriers down. This is the central tension running through all her work, however various the methods and media she employs. Most of the time, Wearing removes herself from the images altogether. Collaboration is her aim, and in an extended early project called *Signs* she invited people in the street to write down their thoughts on paper. The directness of the resulting photographs, where each individual holds up the written message, is remarkable. One smiling and neatly groomed young man, the apparent epitome of sleek success, scrawled 'I'M DESPERATE' on his sheet. A trio of drunken young siblings, emboldened by booze, hold up the defiant collective message 'ME AND MY BROTHERS SAY BOLLOCKS'. But amid all the levity, pathos keeps recurring. Loss of love or home is a constant theme, and one forlorn interviewee claims that 'I HAVE BEEN CERTIFIED AS MILDLY INSANE'.

Although she deals with a notoriously secretive and repressed nation, Wearing manages to pierce our defences. Nowhere more than in a thirty-minute video where a succession of men and women voice their most private, shameful concerns. She found them in a typically straightforward, unpretentious manner, by placing an advertisement in *Time Out* magazine: 'Confess all on video. Don't worry you will be in disguise. Intrigued? Call Gillian.' It was a risky enterprise, meeting disturbed strangers on her own and leading them to a makeshift studio where they gave vent to often alarming anguish. But Wearing carried the project through with self-effacing tact, skill and sympathy.

67. Gillian Wearing, *Signs That Say...*, 1992–3

Her debt to television documentaries, especially the explorations of domestic life she had viewed in childhood, is at its most overt here. But the need to hide the confessors' identities leads her a long way from 'fly on the wall' naturalism. Each face, shot in unvarying close-up, becomes a bizarre spectacle. The pain informing many of their revelations is countered by the absurdity of a burgeoning ginger beard, a Neil Kinnock

rubber mask or a curly, lop-sided wig. We start out wanting to smirk at these muttering gargoyles. After a while, though, they seem sad rather than comic. And their disclosure of stunted or perverted emotions soon prevents us from regarding them as macabre entertainment.

Most of them appear bent on telling the truth with a sober attention to detail. Hidden behind an old man's mask, one thirty-six-year-old discloses that he is still a virgin. Quietly, and with halting thoughtfulness, he tells us about his father's desertion from the family, leaving four children behind. His brother and two sisters were sexually attracted to each other, and their amorous antics made him permanently inhibited about sex. Rather than mocking his words, the haggard mask accentuates the plight of someone grown old before his time. As for the cling-film wrapped around a young woman's face, turning her into a smeared and distorted Francis Bacon grotesque, it mirrors the mental entrapment of someone in thrall to drugging and robbing male victims.

Wearing edits the sequence with aplomb, interweaving the more unsavoury revelations with milder confessions like the youth who stole a computer from school. But there is no let-up. She passes without a pause from one outpouring to the next, and gives a lot of time to an abhorrent man who delights in making dirty phone-calls to unsuspecting females. Hidden behind an outsize moustache and an eruption of hair, he looks suitably repellent. But his manner is jaunty, and he speaks with curious eloquence about his need for 'sex with total strangers'. He sounds proud of his reliance on soft-porn magazines, and claims to have bought the services of over fifty prostitutes. His easy manner signals no shame. Unlike most of the others, he appears unburdened by the need to exorcise guilt. That is why his confession is the most perturbing of all. I found it a relief to listen afterwards to a young man with a golden nose and silver beard, admitting that he was unfaithful to his wife. He ends abruptly by apologizing to her. And then, unable to continue talking, he looks sideways and downwards in an attempt to evade the camera and curtail the filming.

Such an unflinching work proves that Wearing is prepared to probe the most distressed areas of the national psyche. But she makes us conscious, all the time, of the human capacity to distort and dream. On one level, she has inherited the concerns of Mass-Observation, that remarkable inter-war team of artists, anthropologists, photographers and writers who set out to document British working life. On another level, though, she makes no claims to realism. Her most recent work is marked by a Brechtian willingness to emphasize artifice at every turn. *Sacha and Mum*, a harrowing dramatization of an ambivalent yet destructive relationship, is

clearly performed by actors. And Wearing removes them even further from cine-verité by running the video backwards, a device that heightens the disastrous choreography of alternating affection and violence.

The distancing is even more overt in *10–16*, where the voices of children are lip-synched by adults. Some of the revelations, involving addiction and murderous fantasies, are just as unsettling as the earlier confessional video. By transposing them to middle-aged mouths, Wearing alleviates some of the distress with humour. But she also manages to suggest how even the most irrational childhood fears can survive inside adult minds, often in a surprisingly unchanged state that thwarts the development of a more mature outlook.

The artifice in her most celebrated work, *60 Minutes Silence*, is less apparent at first. Arrayed in uniforms, the twenty-six figures assembled in rows look like authentic members of the police force. They are not, and some incensed critics accused Wearing of a 'scandalous' hoax when they discovered that actors were involved. But the furore was irrelevant. What really matters is the slowly unfolding shift of power, from the grand, imposing figures in the video projection to its viewers.

Initially, the uniformed ranks seem to be posing for a group photograph. Then, as the minutes go by and nothing happens, they look increasingly like an oppressive surveillance team monitoring our behaviour. They stare out at us gravely, and we feel resentful of their unrelenting gaze. Eventually, though, a reversal occurs. They begin to look vulnerable, a stranded group struggling to obey the ridiculous order to remain as motionless as statues for a whole hour. Some of them sway, scratch, and glance furtively at their watches. A woman wipes her nose repeatedly, while a man on the front row sinks down into a sulk. Having started out as omnipotent observers, they end up reluctantly as the observed.

We might be tempted to conclude, as the viewing ordeal tests our stamina as well, that Wearing is satirizing the phlegmatic British determination to suffer without complaint. But at the end we realize just how strained and deceptive their air of control really was. When the sixty minutes are complete, they explode into movement. And one figure, who maintained a resolute stillness throughout, thrusts up his arms and gives a cathartic yell. After the eternity of silence, its shocking force bounces round the gallery like a gun-shot.

CORNELIA PARKER
19 May 1998

Ten years ago, in the Hertfordshire countryside, a steamroller thundered towards 1,000 pieces of silverware carefully laid out in a curving line. Goblets, teapots and a host of other gleaming utensils were all flattened. Then Cornelia Parker picked them up and set about making an installation from the squashed remains. As for the steamroller driver, he told Parker that her invitation to run over all that silver plate had been 'a dream come true'.

Now, at the Serpentine Gallery, the installation has been recreated to become the most spectacular exhibit in Parker's largest-ever London exhibition. Visitors to last year's Turner Prize will recall how deftly and poetically she suspended, in a vertical downpour, the scorched fragments of a Texas church struck by lightning. They looked like black arrows falling towards the ground. Here, by contrast, the flattened silver plate has been ordered into a horizontal series of circular clusters, each dangling on metal wires from the ceiling. Shimmering in the sunlight from the row of nearby windows, they stir gently as you move among them.

Parker has long been fascinated by the metamorphosis undergone by objects. She is prepared to inflict an alarming amount of violence on them, most dramatically when the British army blew up a shed whose shattered contents were then transformed into her masterpiece, *Cold Dark Matter*. But aggression is always leavened with dry humour. More aware than anyone of the absurdity inherent in her actions, Parker relishes the irony involved in attacking and rendering useless silver-plated items normally regarded as prized wedding presents. The conventions of middle-class life are mocked, and we are left with a roomful of seemingly weightless shards hovering in space. Suspended on lengths of wire so thin that they seem in danger of snapping, her mysterious lumps of crushed silver hover just above the floor. An epic space has rightly been devoted to this *tour de force*, so that its clusters have room to assert themselves as an ensemble. But closer inspection reveals that each mass of mangled material is made up of spoons, candlesticks and trophies. By reducing them to glittering, flattened fragments, Parker launches a disconcerting assault on objects which would once have been treasured. Her title, *Thirty Pieces of Silver*, suggests that she associates them with greed and betrayal, but the overall mood of the work is far from condemnatory. For the silver achieves an alternative beauty of its own as it floats and spins, like something transformed and resurrected, in the air.

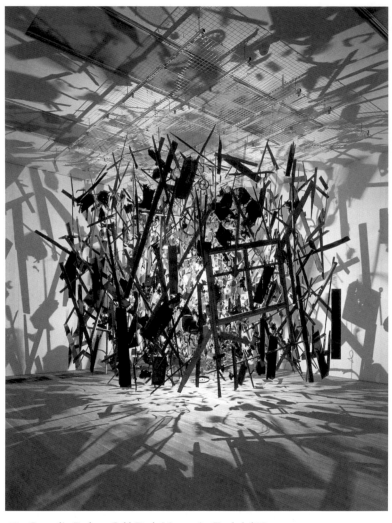

68. Cornelia Parker, *Cold Dark Matter: An Exploded View*, 1991

For all its implicit satire, a strain of lyricism runs through Parker's work. Elsewhere in the Serpentine, two figures also float just above the floor. Further scrutiny discloses that they are made of coins suspended from templates on the ceiling. This time, Parker arranged for them to be run over by a train and defaced. But the coins retain their monetary identity, and their polished glinting suggests that greed was the overriding priority in the lives of these mummy-like figures. More coins are scattered beneath them, as autumnal as fallen leaves. The mournfulness of this installation, *Matter and What it Means*, counteracts Parker's lacerating comment on the values of the dead couple. The coins oscillate silently in the air-conditioned room, suggesting that both they and the corpses are still powered by an eerie source of energy.

Even when Parker's preoccupation with death is at its most overt, she hints at redeeming possibilities. Nothing could be more funereal than the installation called *Another Matter*, dominated by a coffin lid leaning against the far wall. Parker obtained it from an undertaker in Brazil, soon after suffering a serious car accident. She then painstakingly dismantled the coffin's sides with a hammer and chisel. The traditional sculptural act of carving was thereby given a macabre new twist. Splintered pieces of slender wood lie around the lid, some stacked to resemble makeshift bonfires. Their ends have been dipped into match material, so the whole work seems about to ignite. Hence its strong sense of expectancy. Everything seems to be waiting for the end, but the prospect of flaring flames ensures that the destruction will not be a muted, depressing affair.

Although Parker's installations and suspended sculptures are her most impressive achievements, the framed wall-works and showcase objects look better here than they did at the Turner Prize show. There, the room containing them was congested with proliferating exhibits. Here, generous amounts of white space surround them and they are easier to absorb. A rolled copy of *The Times*, dated 22 April 1998, has a prominent position in a new work called *Shared Fate*. Trussed with string, it is gashed by the edge of the guillotine which sliced off Marie Antoinette's head. Similar wounds have been inflicted on the objects ranged beside it, including a loaf, a spotted tie and a shoelace. But the ineffectiveness of the guillotine, usually preserved at Madame Tussaud's Chamber of Horrors, is all too evident. The keen blade has become as blunted as France's own revolutionary fervour, revealing once again the wryness of Parker's questioning attitude on her darting, curious and inventive exploration of our continually disintegrating world.

THE NATWEST ART PRIZE 1998
17 June 1998

Ever since Paul Delaroche declared in the mid-nineteenth century that 'from today painting is dead', similar claims have been made as often as end-of-the-world prophecies. Delaroche made his apocalyptic pronouncement in response to the rise of photography. Today, the increasing use and availability of new technologies in art has triggered further gloom about painting's future.

Its obituaries, however, are premature. Despite the popularity of film, video and heady digital techniques, painting shows no sign of expiring. It may be unfashionable, and fail to produce practitioners who carry off the Turner Prize. But the urge to paint is old and fundamental enough to endure, vying with all the heady new possibilities thrown up by alternative forms of image-making. Hence the avalanche of submissions for the latest NatWest Art Prize, which offers a covetable top prize of £26,000 along with ten other awards of £1,000 each. Open to anyone aged thirty-five or under, it has become established over the last seven years as a national event with the promise of a metropolitan showcase for the eleven finalists. The Lothbury Gallery, positioned at the heart of the City's financial district, offers a monumental space for an exhibition of the shortlisted artists. And this year, the assembled paintings offer a fascinating cross-section of the adventurous work still being produced in the age-old name of painting.

There is nothing timid or reactionary about these young artists. Even though painting is hysterically decried in some quarters as an obsolescent activity, it still permits experiment and innovation. Enormous freedom of manœuvre is possible, and the 1998 finalists explore a remarkably heterogeneous range of directions. This variety doubtless reflects the different standpoints of the judges. Apart from myself, the panel included the artist Stephen Buckley, the dealer Anthony Mould and the Director of Visual Arts at the British Council, Andrea Rose. The Curator of the NatWest Group Art Collection, Rosemary Harris, also joined our deliberations and made sure we did not flounder in a bog of murky disagreements. But our shortlist was assembled without undue dissent. We all responded to the diversity of work on offer, and favoured tough individualists committed to distinct, highly contrasted ways of working.

Some are involved with the language of extreme abstraction, stressing the unconventional processes often employed to make paintings today. Jason Martin uses pieces of paper or plastic rather than a brush. He drags

them through the wet pigment, furrowing the surface into undulating patterns reminiscent of a ploughed field. His recent experiments with acrylic gel on copper gives his work a fierce optical shimmer, contrasting with the scribble technique in Alan Brooks's pictures. His large canvases look like hectic drawings rather than paintings. But his medium is oil, and he carefully copies blown-up projections of his initial small sketches. The outcome of this intriguing and perverse procedure has the forcefulness of graffiti scrawled on a city wall, belying the deliberation of Brooks's method.

Alexis Harding prefers a more spontaneous approach. Fascinated by the effects of chance, he pours gloss paint on to an oil-painted surface of aluminium, canvas or wood. As the painting dries and dangles like stalactites from the pictures' lower edges, it takes on an unpredictable identity suggestive of torn or rumpled curtains. This violence could hardly be further removed from the calm order of Sybille Berger's work. She organizes her heraldic paintings into horizontal bands of colour. Not afraid to set crimson against scarlet, she is the opposite of a dry, geometric artist. Her passion for colour is immensely sensuous, enabling her stripes to burn on the canvases they emblazon.

Sue Arrowsmith is a more subdued artist. With the aid of ink and ruler, she sends thin lines of colour plummeting like waterfalls down the fibreboard. Densely ranked, the vertical downpour seems misty from a distance, like a delicate veil of spray. Callum Innes, by contrast, thrives on setting up oppositions within a painting. A horizontal oblong of sheer black, asserting its presence with an almost sculptural solidity, is juxtaposed with a vertical stream of vaporous pale brown. The outcome is rigorous and yet surprisingly sensual. Like Arrowsmith, Innes evokes the motion of water. But he thins his paint with turpentine and lets it flow, rather than resorting to the control of a ruler. Born in Edinburgh in 1962, Innes has never looked better than he does at Lothbury. The judges' decision to give him the top award hails a young artist at the peak of his powers. Presented with the winner's cheque by Culture Minister Chris Smith last night, Innes is now one of the most widely admired painters of his generation.

But Jeff Gibbons, who hovers teasingly between abstraction and representation, is far less familiar. Fired by locations as disparate as a balcony in Port Grimaud and a staircase outside the National Theatre, he starts depicting a recognizable scene only to break off, splashing the canvas with smears or blots and adding inscriptions in large, sprawling handwriting. He is as quirky, in his stubborn way, as Alexandra Baraitser. Her large, dream-like images take Roman ruins, carvings and fountains as their

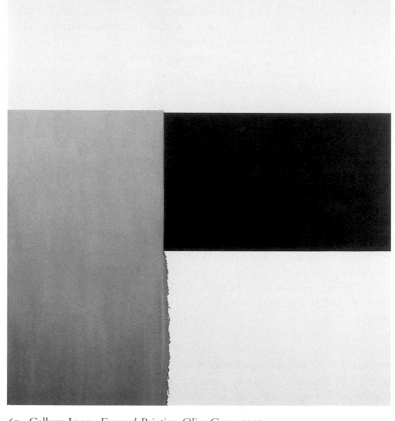

69. Callum Innes, *Exposed Painting, Olive Green*, 1997

starting-point. But they are only a springboard for glistening, fruitful images that surge up, inexplicably, from the base of the canvas.

If Paul Delaroche thought that photography would destroy painting, the other three artists use images derived from the camera's lens. Luke Caulfield is fascinated by family snapshots, but there is nothing cosy or saccharine about his work, A small blonde boy races towards us in one picture, grinning and expectant. The side of his body is torn apart, however, by a ragged vertical rent. Its startling assault destroys the idyll, making the sunlit wood behind him suddenly look as sinister as the scene of crime. Nicky Hoberman's view of childhood is even more disquieting. She takes her own

photographs with a Polaroid camera, employing small girls as her models. They smirk or pout, clutching pet rabbits or turning away from us to slump, perhaps sulkily, on the ground. Technically skilful, Hoberman depicts several of these temperamental sitters in a blatantly photographic style. She conveys a great deal about the emotional seesaw of girlhood, and suggests how easily their poses might be exploited for pornographic purposes.

The final artist, Tacita Dean, is obsessed by film. Although she works with chalk on large blackboards, her tumultuous images of stormy seas are riddled with references to cinematic procedures. Peppered by editing inscriptions like 'establishing shot' and 'opening swell', they resemble storyboards used by Dean in the production of her own 16mm films. But the truth is that these grand, stirring images are sublimely romantic sea-pieces in their own right. Dean deploys chalk with the fluidity of a brush, inviting us to be caught up in the water's turbulent immensity. I have no doubt that her 'Sea Inventory' series is an outstanding achievement, using the conventions of film to revitalize a great maritime tradition in British art.

PETER DOIG
23 June 1998

Viewed from afar, the flaxen-haired woman in the canoe seems to be lost in a contented reverie. Right arm dangling from the vessel, she trails her hand in the milky water. As we approach Peter Doig's canvas, though, the dream seems to go sour. The woman's eye, punched out of a curiously green face, looks like a black cavity. Her head flops forward with the slackness of a corpse, and the dark expanse stretching across the base of the picture has a funereal air. As for the thin trees fringing the lake, they seem to be caught in the glare of a searchlight.

This complex mood, half-way between idyll and nightmare, haunts most of the work in Doig's outstanding exhibition at the Whitechapel Art Gallery. Born in Edinburgh but taken with his family to Canada while still a baby, he only returned here at the age of twenty. Those formative years permeate everything he paints, like memories that refuse to relinquish their grip. He returns, time and again, to a quiet locale where boats, mountains and jetties predominate. Snow often lies on water and land alike, and its imminence is felt even in settings where whiteness cannot be found. At once masking and clarifying the remote locations he prefers,

70. Peter Doig, *Canoe-Lake*, 1997–8

the snow adds to the ambiguity of his work. For even as its coldness accentuates the sense of danger, it enhances the pictures' ability to beguile.

Doig, more than anyone, must know the perils of dwelling on such seductive terrain. But he never makes the mistake of serving up fodder fit for tourist brochures. Nor does he rely on the allure of family snapshots, however much his paintings may seem to take photographs as their springboard. Smiling groups of relatives play no part in his work. The figures they contain are invariably isolated, like the woman marooned in the canoe.

The earliest canvas on show, the 1991 *Young Bean Farmer*, presents the landscape as a place of agoraphobia rather than delight. Leaving the white buildings far behind, the boyish farmer has been reduced to a blurred shadow. The orange earth around him looks scorched, and the crimson strokes smeared across its surface suggest that it will soon be hot enough to catch fire. Perhaps suspecting the conflagration to come, the figure seems on the point of breaking into a run. But heat is not his only concern. The sky is choked with snow-laden cloud, and the branches hanging in the foreground are glittering with hoar-frost.

If Doig takes liberties with his supposed locations, he also indulges in a supple variety of mark-making. Seen close-to, the painting called *Blotter* is alive with flicks, blots, trails and flurries of pigment. Its surface seems to have been treated with the abandon of an abstract artist at his most headlong. But when we move back from the canvas, it turns into a coherent, intently observed image of a boy standing on snow-spattered ice. Like so many other figures in Doig's work, he is alone. The stripped

winter forest beyond is uninhabited, and fresh flakes still drop on the snow piled by the river's bank. They provide the only motion in a scene otherwise notable for its stillness. The boy looks down, through the concentric circles of whiteness around his feet. He seems spellbound by his own reflection shimmering in the ice.

Awestruck and solitary in the natural world, he is a spiritual descendant of the figures who gaze at the sea or mountain-top mists in Caspar David Friedrich's paintings. Doig is a latter-day northern Romantic, and he conveys a sense of the Sublime in a diptych called *Ski Jacket* dominated by towering peaks. Their presence is so magisterial that they reduce the minuscule skiers to insignificant, barely identifiable patches of colour. In this case, though, Doig's broken brushwork is as sensuous as the dappled, patchwork handling in late Bonnard. *Ski Jacket* lacks the brooding quality that allies some of his work so strongly with the nocturnal fearfulness of Munch.

In *Jetty*, an elongated figure stands on the wet, snow-stained planks. Dwarfed by the mountain beyond, he appears to be gazing expectantly at a boat on the lake. Night has arrived, and the only remaining light is provided by the moon. Everything, including the fir trees rearing in the foreground, lacks substance. The whole painting is as vaporous and elusive as a fast-fading dream.

Even in daytime, this feeling of transience remains inescapable. At his most lighthearted, Doig partially obliterates the body of a standing boy with snowballs. As if thrown by an energetic action painter, thick pats of white pigment hit the canvas with playful aplomb. But one of them smashes into the boy's face, obscuring his features so much that he becomes unidentifiable. Doig is fascinated by robbing his people of corporeal solidity. Most of the space in *Reflection* (*What does your soul look like*) is occupied by water containing the silhouettes of trees and, at their centre, the figure whose real feet stand at the top of the picture. It is an enigmatic painting. Is the figure lost in Narcissus-like admiration for his own image? Or could he be dejected, finding in the water's snow-scattered surface a melancholy confirmation of his depression?

Doig has no intention of settling the question, and the aura of mystery intensifies when we encounter *Daytime Astronomy*. Once again, a figure is lost in contemplation of nature. This time, however, no reflections are involved. Lying face-upwards on the grass in an immense expanse of flat countryside, the figure stares at the sky as if to commune with its vastness. Some of the surrounding meadows are lit by the sun and peppered with gaudy flowers. But the more we examine this verdant scene, the less straightforward it becomes. Why is the foreground so shadowy,

and scored with horizontal lines? Its dark, ominous mass threatens to blot out the figure altogether, and several of the trees beyond have turned white and bare. They look spectral up against their amply foliated neighbours, giving the picture as a whole a profound feeling of unease.

To look at this widescreen picture, or the still more panoramic canvas called *Echo-Lake*, is to realize how fascinated Doig must be by cinematic images. A man stands on the bank of a lake, cupping hands round his mouth as he shouts over the water's emptiness. Judging by the painting's title, he is rewarded only by the mocking sound of his own voice. But the police car parked nearby hints at the urgency of his quest. By arresting the narrative at this point, Doig leaves us with a conundrum. We are as baffled as the bellowing figure on the shore, but in no doubt about the artist's eloquent ability to enchant and unsettle in equal measure.

MARIKO MORI
10 July 1998

If Mariko Mori had her way, visitors to the Serpentine Gallery would find themselves levitating in the very first room. A pear-shaped, transparent capsule occupies the centre of the space. It glows with a mysterious luminosity. Iridescent light fills the chamber, making the lotus blossom at its base even more alluring. The overlapping leaves invite us to peer inside, and Mori intends making a version of the capsule large enough to enter. Once inside, she promises that we will float up from the lotus as if reborn.

The gap between the promise of miraculous enlightenment, and the reality of a sculpture at present too small for humans to inhabit, sums up the problem presented by Mori's entire exhibition. It is, without doubt, the most bizarre show of the year so far. For this young Japanese artist requires us all to make an extravagant leap of faith. The old notion of 'suspending disbelief' is too mild a term for the experience on offer here. She challenges viewers to engage with a magical world where Western science fiction meshes with Eastern philosophy. Tokyo-born, Mori studied at Chelsea College of Art and the Whitney Museum in New York. She now divides her life between the USA and Japan, ensuring that her work maintains a carefully calculated balance between rival cultures.

In her earlier work, Mori enjoyed setting up piquant clashes between

everyday reality and futurology. She posed as a gleaming, semi-robotic creature from the cosmos inside a Japanese subway carriage, where none of the passengers noticed her. Now, however, references to Mori's present-day urban surroundings have dropped away. The nearest she approaches to a recognizable setting is in a video called *The Shaman-Girl's Prayer*. Using Kansai Airport as the location, Mori appears in a peroxide wig and chants as she slowly turns a crystal ball. The airport itself is reduced to a blur of high-tech architecture, and might easily be a space station. But Mori's flaring white eyes, their pupils masked by bleached lenses, seem absorbed in her devotions. And teardrop-shaped wings sprout from her shoulders, promising the imminence of flight.

In the main room at the Serpentine, this airborne promise is fulfilled with spectacular stylishness. Four colour photographs on glass, each twenty feet in width, fill the walls. They transport us to a variety of epic panoramas, each reinterpreting in a wide, cinematic sweep one of the elements. Earth takes the form of Arizona's Painted Desert, yet Mori employs digital trickery to transplant a Californian wind-power station on the horizon. With propellors surmounting tall white columns, this forest of instruments could easily give the landscape a surreal menace. But Mori appears to see the terrain in a wholly positive light. For good measure, she includes the egg-like form of the Tucson Biosphere. And the foreground is dominated by a hovering capsule, enclosing the diminutive figures of the artist and her sister wearing traditional Japanese garments.

Mori calls the capsule a 'love shelter', and she means it. Another artist might well have seasoned this kind of star-gazing speculation with a dash of irony. But Mori is an absolute believer. True, she introduces cute humour to her vision of Pure Land, where Disney-like characters nicknamed 'Tunes' float on clouds over the Dead Sea. No trace of self-mockery can, however, be detected in the artist's presentation of herself, gliding over a lotus blossom dressed up as the Japanese goddess Kichijoten. She really is convinced that paradise can be achieved, if only we learn how to fuse the spiritual and the material. 'In a future civilisation of higher dimensions, with the boundary between mind and matter transcended,' she declared in a recent New York lecture, 'a triad may be realised as science and religion are fused through art.'

Heady sentiments indeed, and Mori has the images to back them up. In *Mirror of Water*, she dons a mauve wig and reappears a dozen times in a French cave where stalactites hang over a see-through UFO. The architectural images within this object are likened, by the artist, to a futuristic tea-ceremony. She delights in taking the most time-hallowed rituals of her native country and giving them a new, space-age identity. Nothing

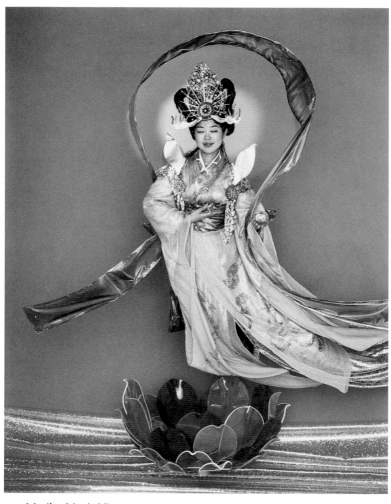

71. Mariko Mori, *Nirvana*, 1997

is too sacrosanct for Mori to transform. Even the Buddha loses his male identity in *Burning Desire*, set this time among the rocks and heat-cracked earth of the Gobi Desert. Arrayed in resplendent Buddhist costume, four images of the artist sit amid flames. They flank a central, circular rainbow, where Mori supplants the Buddha and becomes a multi-limbed alternative god suspended above the land.

In this instance, her gender is left deliberately ambiguous. But in a 3-D video installation called *Nirvana*, she reappears as an unambiguously female deity. Special glasses are provided, enabling us to relish the coloured balls shooting out of the screen like errant planets and invading our space. The 'Tunes' reappear as well, and Mori takes to the air dispensing feathery elements that give off an ethereal, phosphorescent shimmer. By this time, though, the kitschiness has begun to pall. No amount of special effects can hide the sense of glossy repetition. For all the ingenuity of Mori's technical conjuring, and her undoubted ability to concoct a beguiling *mise-en-scène*, I had difficulty entering into the spirit of the proceedings.

In *Kumano*, her most recent exhibit, she becomes more elusive. Flitting like a spectre between tall trees in a Japanese wood, Mori teases us with her infinite capacity to dart behind foliage, re-emerge for an instant and then vanish in a shadow. Ancient ceremonies with vessels are enacted once more, but reality has become wholly virtual by now. A denizen of cyberspace, the artist rejoices in a gravity-defying freedom of manoeuvre not granted to the humans who view her work. By the end of this seductive yet baffling show, I felt left behind. Mori may have attained her digitally manipulated Eden, but the rest of us can only gape, wonder and contemplate our mortal limitations.

LOOSE THREADS

1 September 1998

In the bad old days, when women artists were hard to find and embroidery dismissed as the pastime of 'housewives', the Serpentine Gallery's international show would have been blasted by male derision. After all, its seventeen contributors all employ thread as their principal material. Unlike so many of their contemporaries, who place the latest technological discoveries at the centre of the work they produce, the artists gathered here opt for a defiantly homespun material.

But there is nothing quaint or reactionary about the disparate images in this stimulating survey. Its title, *Loose Threads*, hints at the unpredictability of individuals who delight in confounding our expectations at every turn. Even Elaine Reichek, whose installation of embroidered samplers dominates the main space, escapes from any attempt to pigeon-

hole her activities. She calls the twenty-seven samplers *When This You See ...*, as if her main aim is an old-fashioned act of remembrance. But the barrage of quotations she deploys could hardly be more anarchic. In a single, two-panel work, she juxtaposes the overfamiliar adage 'A fool and his money are soon parted' with Barbara Kruger's caustic 'I shop therefore I am'. They are wrily contrasted, and yet Kruger's feminist satire prompts us to look at the older quotation from a fresh perspective. Reichek refuses to be bound by conventional limits in her array of references, encompassing anything from the Brontës and Moby Dick to Jasper Johns and the worldwide web. Her images are just as free-roaming, and in a witty, cleverly researched video she pinpoints moments from classic Hollywood movies where heroines as lustrous as Greta Gabo, Olivia de Havilland and Audrey Hepburn all turn out to indulge in a surprising amount of needlework during their encounters with men.

But this is no ghettoized, women-only exhibition. Among the male contributors, Michael Raedecker stands out. Concentrating on the interiors of minimal suburban houses, he combines acrylic paint with thread to create an aura of suppressed violence. The rooms are empty, their simplicity impeccable. But Raedecker stresses their desolation by wielding his needle with virtuoso aggression. From a distance, the splashes of light on some glass windows look lyrical. Close-to, though, they reveal themselves as vicious white strands puncturing the linen surface of the painting.

Anna Hunt shares this fascination with architecture, but she prefers to explore the exteriors of celebrated buildings securely lodged in the modernist canon. Le Corbusier's Villa Savoye, Frank Lloyd Wright's Falling Water and Frank Gehry's Guggenheim Bilbao are all painstakingly simulated by her silken, multicoloured threads. She makes even the starkest structure look strangely cosy, using sensuous luminosity to soften the stripped, angular sobriety of the architects she favours. The outcome should look anachronistic, but her work flouts the conventions of handicraft so flagrantly that Hunt ends up with an oddly subversive hybrid.

Not that *Loose Threads* is confined solely to representational exhibits. The liberties enjoyed by abstract artists are embraced as well, and they generate some of the most poignant work on view. Bringing together wire, yarn, thread and artificial flowers, Ava Gerber links them in a looping, relaxed and fragile rhythm. She seems to draw in space, with a melancholy poise reminiscent of Eva Hesse who made a memorable hanging installation with latex over rope, wire and string in 1969–70. Hesse's tragically short-lived exploration of such heretical materials and 'eccentric' forms, at a time when the Minimalists insisted on stern, four-square solidity, proves a cardinal source of inspiration for several artists in this show.

Her interest in unashamed absurdity and lowly, often fugitive materials has links with Lisa Hoke's *Heirloom*, a brazen extravagance of thread, glue and wax spread across several walls. Its gaudy, gaseous colours look like the residue of an explosion. Flattened against the white surfaces, *Heirloom* smears and stains its confined space. It has a toxic, almost nauseating impact, and yet retains an odd feeling of intimacy as well. Hoke uses her own body as an integral part of making the work, rolling across the sticky substances before she attaches them to the wall. Spools are left on the floor at the Serpentine, still joined to the threads like a reminder of their origins.

Pushing her art to the other extreme, Holly Miller shuns spectacle and favours quiet, immaculate refinement. Just as Agnes Martin hones her grid paintings into models of discreet distillation, so Miller uses acrylic and thread in images as soothing as the aptly named *Smooth*. The placid surface is sliced by stitches, but without a hint of violence. Only the unexpected breaks in the stitched lines create tension, and even then Miller minimizes the disturbance by ensuring that the painting as a whole remains a serene, meditative affair.

The presence of such potent objects, here at the Serpentine, compares favourably with other exhibits documenting activities that happened far away from the gallery. In the thoughtful catalogue, Lisa Corrin explains the full, complex significance of Kim Soo-Ja's 'bottari', bundles of festive fabrics tied up with rope. Parting, in her native Korea, is often conveyed by the act of wrapping, especially in funeral rituals. Journeys accentuate the notion of farewell, but Soo-Ja's video of trussed 'bottari' travelling on a pick-up truck through a coastal landscape seems disappointingly humdrum. I felt divorced from the event, and similarly removed from the actions performed in Stockholm by Francis Alÿs. Small photographs, maps and captions are no substitute, in this instance, for the experience undergone by the artist himself. Wearing a woollen jumper which unravelled as he walked, Alÿs traversed the streets and left a wavering line of pale blue yarn behind him. He took a random route, dictated by his own cogitations rather than a preconceived plan. Thoughts about the need for modern-day fables, as necessary for us as Utopias were for Renaissance societies, stimulated his journey. But his documentation largely excludes us from the excitement he must have felt along the way.

Regina Frank, by contrast, gains immediacy by performing in the gallery. At the heart of her installation, *The Glass Bead Game*, hangs the 'magic mantle' produced by spinning the artist's favourite texts into textiles. Dressed in black, she moves like an elegant shaman around her space and invites viewers to join in by sharing poems and stories or

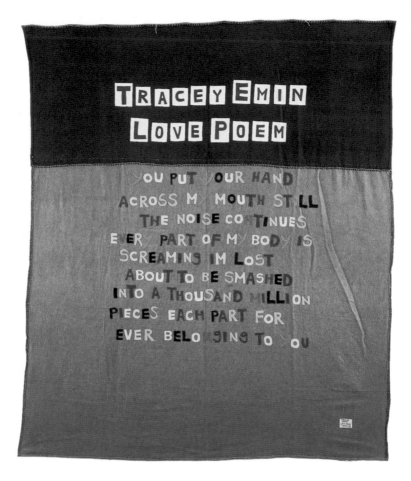

72. Tracey Emin, *Love Poem*, 1996

e-mailing them to her website. Frank regards them as 'thread-sentences', and adds them to a 'virtual' mantle of 'thought-beads' on the computer. But the real mantle provides an arresting visual anchor, and she often kneels before it to draw in the sand like an absorbed, dreamy child on the beach.

The symbolism of the bead, derived in Frank's work from Herman Hesse's novel of the same name, chimes with the plexiglass bubbles in Brigitte Nahon's exhibit. Strung across the window looking onto the

Serpentine's lawn, they are suspended by pins on long, dangling threads. Each bubble contains an inverted reflection of the view, bringing the landscape into the gallery. It smacks, once again, of childlike wonder, but offers in the end a far more vulnerable vision than Frank's slow, measured ritual. The bubbles might easily fall from their precarious perches, dashing any illusions about the safety of the world Nahon has created.

In this respect, she can be related to Tracey Emin, whose appliquéd blanket provides at first a nursery-rhyme air of happiness. The artist's name and the work's title, *Love Poem*, are announced in large pink capitals on a purple ground at the top of the blanket. But the poem itself, in smaller, multicoloured capitals below, soon becomes disturbing. The poet imagines her whole body is screaming, and her lover unable to silence it. She feels fragmented to the point of utter obliteration, and yet the poem concludes by admitting that every smashed particle still belongs to him. The comfort normally associated with a blanket turns out to be useless in the face of such destructive infatuation, as cancerous as the invisible, burrowing worm in William Blake's poem *The Sick Rose*. This time, no amount of patiently applied thread can alleviate the pain.

CHRIS OFILI
6 October 1998

Feeding off William Blake and Blaxploitation movies with equal relish, Chris Ofili is one of the most inventive and original painters of his generation. Notorious for using elephant dung, he is an infinitely more complex, ambitious and engaging artist than his tabloid reputation suggests. Now that Ofili has been shortlisted for this year's Turner Prize, the sneers about muckspreading will doubtless intensify. But the truth is that dried gobbets of excrement are only one element in his multi-layered work. Although their brute presence may offend viewers unaccustomed to confronting animal droppings on canvas, Ofili knows precisely how to incorporate them in paintings where intricacy and finesse count far more than scatological provocation.

Not that there is anything cautious or dogged about his triumphant exhibition at the Serpentine Gallery. Feistiness is the keynote, conveyed above all through a whirling fecundity of lines, flamboyant colours and unconventional materials. Working now on a grander scale than before,

Ofili shows a corresponding increase in assurance. Each canvas continues to be supported by two lumps of dung resting on the floor, but many of his recent paintings fill their allotted wall-space with gusto.

One of the finest, *She*, goes off like the most spectacular firework display imaginable. An African woman, whose face and shoulders dominate the picture-surface, smiles. Her delight seems to ignite an explosion of pictorial devices, radiating out from her sensuous mouth. They make her hair shudder in seismic convulsions, then course across her head-dress and undulate through space towards the very edges of the canvas. Further down, they make her earrings swing, and run like a sudden surge of voltage through the rippling patterns of her dress. Everything in this dithyrambic picture seems to be erupting. And among the concentric circles that give it so much irresistible panache, hundreds of miniature Afro heads spin like planets caught up in a colossal cosmic convulsion.

If this festive image shows Ofili at his most exuberant, the three Captain Shit paintings unleash a more satirical side of his many-faceted personality. He calls the captain 'a superhero', and the full-length figure certainly succeeds in bestriding his canvases with theatrical aplomb. But the captain's showmanship soon topples into absurdity. Contorting his face in a frown as exaggerated as a Samurai warrior, he flaunts his brazenly exposed chest like a swaggering stripper. His costume, alive with jagged lightning bolts, is more shameless still. But nothing, not even his spangled cloak and boots, is quite as ludicrous as the turd projecting from his navel. The captain brandishes it with spunky pride, and map-pins piercing the brown lump make it glitter like a precious stone.

The black stars spattering the air around him all seem to be mocking the captain with their inset, watchful eyes. The more he struts, the more risible his macho groin-posturing becomes. In *Double Captain Shit*, painted a year after the first version, the repeated images are reminiscent at first of Warhol's gun-toting Elvis. The next moment, though, they look more like the result of drunken double vision. The bifurcated captain appears more preposterous than ever, and in the most recent version he allows frenzied white hands to claw greedily at his trouser-belt. Ofili, whose own eyes may well be staring out from each of the dancing black stars, has reduced the 'superhero' to the level of desperate titillation. All the same, the artist probably retains a lingering fondness for the captain. He cuts a phantasmagoric figure, flaring with the peacock allure of a man bent on dramatizing the stereotype of black virility with as much tacky bravado as he can muster.

Ever since Ofili moved his studio from Chelsea Harbour to King's Cross, he has increasingly peopled his work with figures who exploit

73. Chris Ofili, *She*, 1997

their own sexuality. The surrounding streets have long been a haunt of prostitutes, and in *Pimpin' ain't Easy* he allows the canvas to be dominated by a cartoon-like phallic erection. Probably based on graffiti, the penis is capped by the grinning features of a clown. But there is nothing laughable about the collaged images of diminutive, sneering men who circulate in the eddy of acrylic, oil and resin flowing round the central form. Their limbs sprout female legs, parted in crablike positions. They resemble predatory insects, waiting to ensnare the women whose lives they end up controlling with such ruthlessness.

When Ofili turns his attention to the prostitutes themselves, he has no qualms about making them macabre. *Foxy Roxy* is a sad and repellent creature, her face smeared with gaudy lipstick and partially obscured by a ridiculously garish peroxide wig. A pair of pneumatic pink breasts jut out from her black body, as if they were the outcome of some gruesome genetic experiment. More breasts, pale white this time, peep out from the whorls of scarlet paint glowing around her like the rings on an electric cooker. They look hot enough to scald the hapless Foxy Roxy, who struggles to retain some semblance of poise even though the strain is becoming unendurable.

Beneath the surface exhilaration of this skilful young painter's work, then, a remarkable amount of pain can be detected. In a wall-full of water-colours, Ofili relaxes and enjoys his ability to summarize, with confident swiftness and economy, the simplified forms of black faces. Devoid of incidentals, often to the point of silhouette, these beguiling studies show how instinctively he can jettison detail and arrive at the essence. Even here, though, traces of preliminary pencil lines are still visible, suggesting that his use of watercolour is not as effortless as it might appear. And in the paintings, an ostensible brashness should not fool anyone into ignoring the sophistication, subtlety and deliberation Ofili can deploy.

In *Blossom*, among the most commanding of his recent pictures, he spells out the title on a row of seven descending turds. The clash between the fragrance of the word, and the crude mounds of matter supporting it, announces the bitter-sweet mood of the painting as a whole. For the name belongs to the woman seated in the centre, gazing out at us with a large tropical flower in her hair. Branches, leaves and petals coil behind her, in lines as sinuous and extravagantly composed as an art-nouveau decoration. But the woman's hands rest knowingly on her bared right breast, falling out of Blossom's dress and declaring her availability at the right price. So the pastoral lyricism of the background clashes with the melancholy, pornographic reality of a woman whose flesh is for hire.

This jarring picture warns us not to take any of the nature images

elsewhere in the show at face value. However attractive they may initially appear, with their intertwined foliage and lush, proliferating blooms, these paeans to fertility turn out to harbour references to disease and mortality. Blobs of elephant dung lodge themselves like malignant tumours among the yellow ecstasy of burgeoning plants in *Two Doo Voodoo*. A mass of writhing, luxuriant vegetation ends up threatening to choke the entire surface of *Black Flowerheads*, a particularly menacing canvas. As for the flame-like painting called *Satan*, Ofili allows a crazed, diabolic face to emerge from the turbulent growth thrashing all over this angry, incandescent canvas.

However apocalyptic his visions may be, he seldom succumbs to despondency. *Black Paranoia* is the most subdued painting on view, its severely striped ground interrupted by the multiple contours of skulls. One seems to be enclosed, perhaps even trapped, by another. A pair of lips parts in a leer redolent of the Grim Reaper at his most merciless, and no amount of glitter, resin pools or multicoloured map-pins can ameliorate, this time, a sense of gathering despair.

It remains a rare moment. On the whole, Ofili's innate high spirits give his work an enormous, often overpowering, effervescence. He treats these paintings as fields of energy, where all his intoxicating responses to the world can be conjoined and flare into fiery, agitated life. Manchester-born, he thrives on the adrenalin rush of hectic, big-city dynamism. But Africa, where his parents lived before they settled in England, also provided him with a crucial stimulus when he visited Zimbabwe six years ago. Finding an ancient cave festooned with coloured dots alerted him to alternative forms of mark-making. Ofili fuses them, now, with western brushstrokes in the same all-embracing way that he absorbs so many diverse stimuli and transforms them into coherent art. Whether he finds nourishment in the Bible or Notting Hill Carnival, Hip Hop or Wu-Tang Clan, Francis Picabia or Muhammed Ali, this supremely alert pictorial juggler throws them all high in the air and never lets them drop.

THE TURNER PRIZE 1998
3 November 1998

Last year, the all-women Turner Prize shortlist led to hysterical accusations of rampant feminist tokenism. This year, attacks on the contenders have been dominated by endless jibes about elephant dung. I suppose this annual razzamatazz is inevitable, now that commenting on the Turner line-up has been elevated to the status of a national sport. But with the arrival of the 1998 instalment at the Tate Gallery, visitors no longer have any excuse for resorting to Britain's time-honoured, knee-jerk mockery of contemporary art. The truth is that four serious individuals are displaying their work here, and the tenor of the show is far removed from slick, attention-seeking charlatanism. Although the artists are very diverse, both in their choice and use of materials, a common preoccupation gives them an unexpected unity. Whether they take the form of painting, sculpture, blackboard drawings, photographs or film, the images on view return, time and again, to an emphasis on pain and isolation. A powerful undertow of melancholy runs through the show, amounting to an end-of-the-century obsession with loss. But each exhibitor tackles the source of this distress in a sharply distinctive way.

Cathy de Monchaux, whose works are exposed like festering wounds on the walls and floor of the first room, is the most openly anguished. She mounts a visceral assault on the senses, concentrating on organic fragments that seem to originate deep inside the human body. Manipulating leather like flesh, she encases her defenceless forms in cruel metal structures. Brass, copper and rusted steel are used to entrap, twist or pull orifices apart. It is a disconcerting spectacle, and the anguish receives confirmation in titles as alarming as *Making a Day for the Dead Ones*.

A fascination with torture becomes apparent. De Monchaux returns incessantly to the suffering endured by so many victims, even if the agony may often be inflicted in the name of pleasure. Sometimes she deals with these beleaguered figures from the outside, assembling a long row of diminutive bodies imprisoned and baring amputated limbs. More often, though, the forms appear to issue from a more private, even erotic exploration. They become frankly sexual, and so disturbing that we flinch from close investigation.

Rawness is tempered, to a certain extent, by the layer of chalk dust coating many of the sculptures. But it does not detract from the unease they generate. The whiteness might easily signify death, and in the largest work a funereal mood prevails. Called *Never Forget The Power of Tears*, it

contains a dozen slabs of lead laid out on the floor like tomb-covers in a graveyard. Since their surfaces are devoid of inscriptions, anonymity reigns. Even so, their grey blankness is set against dusted leather forms stretching like a spine through the centre. Steel vices clamp them viciously on both sides. The cemetery-like stillness of the slabs is challenged, at the sculpture's heart, by the persistence of grief.

Chalk reappears in Tacita Dean's section, where seven blackboards are covered in a sequence of swift, confident drawings called *The Roaring Forties*. Fascinated by film, she treats them as cinematic story-boards. The images so deftly outlined here, with luminous white contours, suggest an epic adventure in the south Atlantic at its most tempest-tossed. Full-sailed vessels list in the waves, sailors strain at the oars, and a struggle for survival appears to be fought out. Dean's handling of chalk is economical, resisting the temptation to indulge in melodramatic flourishes. And she punctures her heroic tale with humour. The main images are accompanied by written comments, ostensibly as an aid to the film's director. But they show a leaning towards irony as well. A particularly turbulent scene bears the inscription 'she's still afloat (just)', indicating that Dean has no desire to take her subject too portentously.

74. Cathy de Monchaux, *Never Forget The Power of Tears*, 1997

There is a sprightliness about *The Roaring Forties*, reflecting an instinctive love of maritime themes that originated during her student period at Falmouth School of Art. She regards the oceans as an immense, enigmatic force, and in a 16mm film the mysterious tragedy of Donald Crowhurst becomes the springboard for a more elegiac work. *Disappearance at Sea* commences with a lingering close-up, shot through an anamorphic lens, of the bulbs glowing inside St Abbs lighthouse in Berwickshire. Slowly revolving, they establish a sense of loneliness. Dean accentuates the desolation by swinging her camera out to sea, as if following the direction of the beacon's beam. Seagulls screech, and yet nothing can be detected on the nocturnal water. The illumination takes on the character of a searchlight, scanning the sea for signs of life. But the film terminates in an engulfing blackness, just as Crowhurst's own ambitions as a round-the-world yachtsman terminated in a void.

Not everything in this year's show is as bleak. Dean's other film *Gellert*, named after a Budapest hotel with thermal baths in its basement, offers a quietly optimistic experience. She focuses here on middle-aged and elderly women savouring the restorative water. Communal delight is affirmed rather than solitary despair. The bathers enjoy each other's company and, when standing in a frieze for a shower, stir memories of Renaissance paintings where the comeliness of The Three Graces is celebrated.

Chris Ofili also knows how to be joyful. His room is by far the most exuberant, and paintings as headlong as *Afrodizzia (2nd Version)* erupt like an orgiastic firework display. His energy is infectious, and I marvel at Ofili's ability to combine seeming spontaneity with a fanatical amount of elaborate calculation. Images that explode in front of us turn out, finally, to be the outcome of complex organization. The elephant dung is only one element among many in these fantastically inventive and beguiling pictures. Like Dean, he is capable of poking fun at his obsessions, most notably in the knockabout comedy of *The Adoration of Captain Shit and the Legend of the Black Stars*.

Even the ebullient Ofili, however, is conscious of tragedy. In *The Shadow of Captain Shit*, the spangled superhero loses his glitter and becomes surprisingly sombre, as though suddenly unable to hide the sadness lurking beneath his garish façade. The grinning face now seems little more than a grotesque mask, and the black stars take on a menacing aspect. It encourages us to look again at the apparent exhilaration of *Afrodizzia*, and discover an underlying malaise within its multicoloured maelstrom of acrylic, resin, map-pins and collaged photographs of black celebrities. Their overwhelming impact grows ominous as well as festive. They are caught up in an apocalyptic frenzy wholly beyond their control,

and Ofili hints at the danger involved in succumbing to such combustible excitement.

His most impressive painting here, *No Woman No Cry*, confirms his willingness to confront calamity. An outsize head of a black woman fills most of the picture-surface. She looks dignified rather than openly anguished. But tears tumble from her eyes in a loose necklace of drops, and they enclose miniature photographs of the murdered teenager Stephen Lawrence. So the entire painting is transformed into a lamentation, made all the more moving by Ofili's refusal to indulge in an outspoken display of emotion.

Disquiet predominates in Sam Taylor-Wood's space as well. Three photographic pieces, each as wide as an oriental scroll, present 360-degree views of three rooms and their inhabitants. Since they are as stylish and well-heeled as their surroundings, the people initially appear at ease with their comfortable world. Gradually, though, Taylor-Wood alerts us to discord and alienation. Most of these figures are as marooned as sailors abandoned on a remote island. They look listless and dissatisfied, and even when talking or making love their faces register no enjoyment.

Coolness is seen, in these theatrical surveys of contemporary urban life, as an affliction rather than an asset. One ample woman in a red dress gazes out at us with as much disconcerting starkness as a sitter in a Lucian Freud interior. Both she and the rest of Taylor-Wood's cast of characters seem jaded, unable to experience anything more animated than a half-hearted stare from a window or a brief, flaring argument that signifies little.

The emotions registered by the young woman in *Atlantic*, a three-screen laser-disc projection in the final room, are more heartfelt. Taylor-Wood trains a camera on her face, while simultaneously showing close-up foot-age of her male companion's hands on the opposite screen. In between, spanning the width of the far wall, she provides a panoramic projection of the fashionable restaurant where the couple are seated, and from which the work takes its name. The other diners are unaware of the emotions wrenching the woman, and we are prevented from hearing anything more than tantalizing fragments of what she is saying to the largely silent man.

But her face is expressive enough. Like Ofili's mourner, she cannot stop tears pouring from her eyes at first. Although she later stiffens into a more accusatory stance, her sense of hurt remains palpable throughout. Her companion's hands look guilty, fiddling with cigarettes and a wine bottle as he listens to her remonstrations. Taylor-Wood's refusal to show his face in close-up gives him an air of detachment. The motion of his

hands seems almost callous compared with her vulnerability. And the chatter of the oblivious diners around her intensifies the woman's plight. In common with Crowhurst, adrift in the ocean's vastness, she finds the Atlantic a lonely place to confront her distress.

DIE YOUNG STAY PRETTY
17 November 1998

Just over a year from the century's end, the latest wave of British artists are flirting with suicide. *Die Young Stay Pretty* urges the title of their show at the ICA. The first image confronting visitors, Dexter Dalwood's garish painting of Sharon Tate's house, might seem in thrall to violent, premature extinction. But no trace of blood or bodies can be found in this glossy room. It is empty, and the American flag draped over the white sofa sounds an unexpectedly festive note. In his avoidance of openly disturbing imagery, Dalwood typifies the mood of the entire exhibition. If death is supposed to be a common preoccupation here, it remains hard to detect. A nostalgic love of retro glamour is more noticeable, not only in Dalwood's love affair with kitsch Hollywood interiors but in other artists' longing for an idealized past. Japanese-born, Goldsmiths-trained Jun Hasegawa moons over the young Paul Weller in her gloss-painted, cut-out colossus. Like Dalwood, who owes a debt to Richard Hamilton's cinematic interiors from the 1960s, Hasegawa adopts a clean, comic-book style dreamily dependent on Roy Lichtenstein and Alex Katz.

Alongside these knowing references to the past, *Die Young Stay Pretty* reasserts the old hierarchy of painting and sculpture. Installations are nowhere to be seen, and the only video is confined to a screen no larger than a small television set. The Duchampian interest in ready-made objects, so important to Damien Hirst and his friends, is replaced here by a defiant involvement with the hand-made. Impersonality is out, giving way to renewed fascination with private lives and domestic surroundings.

Such concerns chime with the way Martin Maloney, the show's curator, first displayed the work of like-minded artists a few years ago. Using his own house in Brixton as an unpretentious showcase called *Lost in Space*, he made a virtue of informality. Even now, transposed to the ICA's Regency grandeur, much of the art still seems suited to a home rather than a museum. Jane Brennan's irritatingly cute panel paintings, of pearls,

75. Martin Maloney, *Hey Good Looking* (after Poussin's *The Choice of Hercules*), 1998

beads, lotus flowers or mistletoe, lend themselves to intimate spaces. But they seem devoid of any impulse other than a vapid desire to indulge in *faux-naïf* prettiness. Her nightingale, perched on a branch against a pale green ground, seems at first to have strayed from the backdrop of a Holbein portrait. Brennan's perfunctory brushwork, however, would not have passed muster in a Renaissance painting.

Nor does she have the feistiness shown by Maloney himself, who dares to brandish his childlike handling of oil paint on a canvas of monumental proportions. Taking his cue from Poussin's *The Choice of Hercules*, he updates the mythological scene by showing three figures partying to the blare of a ghetto-blaster. Stripped down to a pair of bulging trunks, with a towel flung racily over one tanned shoulder, the man in the centre grins at the blonde beside him. She looks as rapacious as the brunette with the bare midriff on the other side, who grabs the man's wrist. The friezelike design still possesses a Poussinesque classicism, but Maloney deliberately cultivates gaucheness. He enjoys being blatant and affects a manner as insouciant as the nearby baby in a push-chair, who brandishes a milk-bottle with tipsy bravado.

The only other artist with Maloney's chutzpah is Steven Gontarski, an American who shares this desire to vie with tradition. His *Lying Active (Dying Captive)* pays homage to Michelangelo's carving of a languorous male nude in the Louvre. Gontarski retains the preening pose, but his figure is far more slender and delicate. He needs support, and his PVC skin is stuffed with polyester wadding to give him the air of a floppy, homoerotic doll. Hans Bellmer's surrealist distortions are echoed, particularly in Gontarski's other, more rampant copulation sculpture called *Wife*. Even here, though, the overtly sexual content seems calculated to discourage arousal in the viewer. Imprisoned in their glistening straitjackets, these disconsolate lovers are akin to Sarah Lucas's *Bunny*, the kapok-stuffed figure who was the most forlorn exhibit in last year's *Sensation* survey at the Royal Academy.

Far from presenting an outright alternative to the *Sensation* show, *Die Young Stay Pretty* intersects with the earlier exhibition at various points. Charles Saatchi has already acquired work by several of the artists displayed here, and he included in *Sensation* two of the strongest artists now at the ICA: Maloney and Peter Davies. *The Hot One Hundred*, Davies' wittiest exhibit at the Royal Academy, relied for its impact on a chart-topping written list of Davies' favourite artists. Here, by contrast, his most recent paintings leave words behind. Working on an expansive scale with conspicuous assurance, he manipulates multicoloured stripes, cubes or white spirals on a black ground. The mood is as assertive as early Bridget Riley at her most militant, and Davies rejoices in exuberant perspectival trickery. But it would be a mistake to associate him too closely with the eye-smarting aggression of Op Art.

In his fascination with stridently decorative abstraction, Davies stands apart from his fellow exhibitors. For the overriding thrust of this show is allied with representation, even if the images are filtered through the mass-market culture of television, newspaper photographs and fanzine illustrations. David Thorpe's art-shop paper pictures look like period record covers, with a hint of old-fashioned psychedelia in their heightened colour oppositions. *Dare to Thrill* is the misleading title of one utterly bland landscape, its sky enlivened only by the minuscule white arc of an ascending plane. Thorpe's choice of names promises more than he delivers: the apocalyptic-sounding *Ready to Burn* turns out to be no more incendiary than three skyscrapers glowing orange against a pale pink sunset.

Judging by his catalogue interview, Thorpe would like to invest the contemporary world with the twilit intensity of Claude and Friedrich. But Michael Raedecker, who makes no such inflated claims for his work, commands a more substantial level of conviction. He first

impressed me with his contributions to *Loose Threads* at the Serpentine Gallery, where minimal interiors took on a stark, alienated emptiness. Now, Raedecker aligns himself more clearly with his native Dutch tradition by moving out into the landscape. But there is nothing consolatory about his vision of the natural world. *Haze* explores a bleak panorama, its glacial desolation punctuated only by a few rocks, some perfunctory bushes and an isolated tree. It extends to the top of the picture with the lean melancholy of the bare, shattered trunks in Paul Nash's paintings of the shell-ravaged countryside at Passchendaele. Like Nash's images of hell, Raedecker's wintry scenes appear unable to sustain any form of new life other than some diminutive, windblown shoots already blighted by frost. An expanse of water appears in a painting called *Spot*, but its surface is covered in taut threads. They seal the pool off as effectively as a thick layer of ice, and their harshness accentuates the aridity of the surrounding terrain.

Here, if anywhere, is an artist whose bleakness begins to justify the exhibition's injunction to die. Raedecker's despondent locations would provide an apt setting for suicide. Caroline Warde's severed head of a mule might be stumbled upon in a similarly benighted place. Her modelling of this painted resin sculpture is, however, more tender than harsh. Even her blackened *Peach Branch*, its oil surface gleaming in the light as it grows from the gallery wall, lacks the capacity to arouse an authentic sense of dread. But she does command a quiet strangeness that compares favourably with the other sculptor in the show, Gary Webb. Intoxicated by combining perspex, glass, plastic fruit, paper and acrylic paint, in order to make a form reminiscent of a Christmas candle with streamers, he succeeds merely in producing a concoction as wearisome as its title: *God Knows*.

It is left to the solitary video to sum up the show's dual obsession with morbidity and narcissism. The young gay man in *Teeth, Toes and Contact Lenses*, by Shaun Roberts and Gilbert McCarragher, swings feverishly between manic anxiety and prolonged self-absorption. His careful ablutions are a drawn-out ritual, centring repeatedly on extensive scrutiny in the mirror. Bent on expunging all trace of dirt from his body, he seems unbearably pressurized by the need to make himself as alluring as possible. Conscious of his inability to compete with the looking-glass fantasy projected by certain aspects of the gay press, he appears on the verge of succumbing to bulimia. Even at its most retching, though, the video remains visually seductive. Towards the end, the man sinks grimly beneath the surface of his bathwater. But the tub is lined with redemptive candles, and the threatened suicide turns out to be an illusion. Prettiness triumphs in his beguilingly lit world; and death, for the moment at least, is put on hold.

NEUROTIC REALISM
12 January 1999

Despite his prodigious appetite for the latest art, Charles Saatchi has until now stopped short of naming a new movement. When Damien Hirst, Rachel Whiteread and their contemporaries first appeared at his gallery in the early 1990s, their show was given the non-committal title *Young British Artists*. Its studied neutrality acknowledged that the heyday of 'isms' belonged to a distant era. Before the First World War, Fauvism, Expressionism, Cubism and Futurism were only the most notorious of the revolutionary groups that erupted during modernism's most turbulent years. But artists in recent decades have shied away from labels, so the arrival of the freshly coined 'Neurotic Realism' at the Saatchi Gallery is a great surprise.

Equally unusual is the fact that this movement was invented by a collector. From Impressionism onwards, many avant-garde upheavals in the past derived from terms of abuse, hurled by enraged critics or gallery visitors. Only a few groups, like Vorticism in England or Suprematism in Russia, were named by the artists themselves. None was the brainchild of a patron who purchased their work, and in that respect Saatchi's launching of Neurotic Realism breaks with historical precedent. It seems to inaugurate a bolder, more open and partisan approach on his part, a remarkable move for someone who has always shunned interviews and guarded his privacy as tightly as possible.

Neurotic Realism is not, however, completely divorced from the artists he displayed in the *Sensation* exhibition. Martin Maloney, the only painter in this new show, was included in the Royal Academy survey. The overlap also extends to the ICA's *Die Young Stay Pretty*, organized by Maloney last year. Among its most prominent participants was Steven Gontarski, whose sculpture now reappears at the Saatchi Gallery. *Die Young Stay Pretty* turned out to be a disappointingly slight event. But Neurotic Realism, in this first instalment at least, is a far more substantial affair, and all five of its participants gain enormously from the epic spaces they occupy with such assurance.

No one displays more apocalyptic relish than Tomoko Takahashi, the only woman in the show. Tokyo-born but now based in London, she has been given by far the largest area and handles it with gusto. Viewed from the top of the steps, her mammoth installation looks like a nightmarish prophecy of chronic millennial malfunction. The entire floor is strewn with detritus, scavenged with obsessive zeal from skips, dumps and friends'

attics. Initially, the room resembles a technological graveyard, a wasteland of instant obsolescence. But as I scanned the piles of junk, deposited seemingly pell-mell by a manic artist who could not help accumulating an embarrassment of refuse, signs of activity began to assert themselves.

The bars of a small heater glow orange inside an office drawer. The deck of a record-player spins round, carrying watch mechanisms rather than LPs and relaying no sound at all. It is as futile as the television sets scattered around the room, flickering and buzzing but failing to transmit any coherent images. Although clocks tick on crazily chaotic tabletops, they are incapable of telling the correct time. A globe atlas is lit from within, and yet most of its coloured map has peeled off to leave a surface punctured with knives. A glass water-jug bubbles pointlessly on a hot plate, while a nearby electric fan swivels inside a metal box. The sense of absurdity is reinforced by a grumbling spin-drier, vigorously rotating with its door open and nothing inside. Reminiscent of Bill Woodrow's early work, it exists here only as one of a thousand similarly redundant objects.

Encountered on the pavement of a blighted street, they would all be dismissed as rubbish. Reassembled in this installation, though, they finally take on an unlikely order of their own. Takahashi, who spent

76. Tomoko Takahashi, *Line-Out*, 1998

a month working and sleeping on site, even lays out some of her material with the care and respect that Tony Cragg accorded his floor-based plastic cast-offs in the early 1980s. She has carved out narrow pathways between the heaps, enabling us to pick a path gingerly through the bedlam. At the same time, though, she conveys an overwhelming sense of pulverized breakdown. Like the crash-helmet resting upside-down on an abandoned case, or the corner crammed with fragments from half-crushed bicycles, the entire space resembles the scene of a cataclysmic accident caused by forces beyond human control.

If Takahashi's contribution manages to sound an end-of-the-century warning, Brian C. Griffiths' roomfull of equipment reduces dysfunction to a childlike level. The control consoles lining the walls should be streamlined, gleaming and state-of-the-art, fit for a set in a multimillion-dollar science-fiction movie. In reality, though, they are made of cardboard boxes joined together with ungainly strips of brown tape. This is Star Trek's flagship reconstructed by a cack-handed, and quite possibly deranged, DIY devotee. The clocks and monitors turn out to be made of pencils or burnt matchsticks glued onto cheap plastic plates. Chipped, smeared and stained, these redundant space-age monoliths are at once laughable and forlorn. Long since discarded, they have lapsed into melancholy inertia. And their air of preposterous solemnity is punctuated, in places, by accretions as outlandish as the umbrella suspended at the centre of a work called *Osaka*. An egg whisk has unaccountably been taped to the brolly's broken handle, thereby delivering the final *coup de grace* to an object already steeped in irreversible uselessness.

So far, although the presence of humans has been implied in the exhibition, they remain impossible to detect. But Paul Smith's powerful photographic images focus, with relentless regularity, on people. In *Artist Rifle Series*, uniformed figures carry out manœuvres informed, no doubt, by Smith's own army experiences. Moving between beach, woodland and swamp, they appear at first to have a documentary veracity. Soon enough, however, we realize that the young men's faces are oddly similar. Using digital techniques, Smith has inserted himself in all of them. Like a demented, egotistical actor, bent on taking every part in the drama, he plays the three soldiers grimly shovelling sand as well as the corpse half-buried below them. Armed with a Sten gun, he emerges from a forest tottering under the weight of his own injured body slumped across his shoulders. And he is each one of the silhouetted figures advancing with their backpacks into a morning mist.

Sometimes, it is possible to ignore his pervasive presence and simply admire these images as arresting, even alarming recreations of death-

haunted military exercises. But Smith does not allow us to forget him for long. When he appears ten times over as a crowd of victorious soldiers cheering their conquest of a burnt-out tank, his sheer recognizability makes the celebrations look like a charade. The play-acting involved in training exercises is here pushed to the point of outright ridicule, and yet the underlying coldness of these lethal rituals is, in a strange way, intensified by Smith's tireless interventions.

Both here, and in another series of lager-lout partying called *Make My Night*, his insistence on posing for every figure gives the pictures a demented mood. Whether waving V-signs while pissing in the Gents, kissing a phallic cucumber or pouring booze on a mate in the pub, Smith's identical drunken lads eventually take on the guise of crazed automatons. In this sense, they have unexpected links with the bodies in Steven Gontarski's sculpture. Made of PVC stuffed with polyester wadding, most of his figures are involved in orgiastic coupling. Although their faces are so blank that they verge on the robotic, Gontarski takes a perverse delight in adding human details to their shimmering limbs. Matted hair can be detected, along with transfer tattoos and kinky socks hanging off projecting leg-stumps.

But even the synthetic clothing serves only to stress their creepiness. Whether lunging lustfully at one another, or intertwining so closely that their separate forms are impossible to identify, these libidinous performers are all repellent. One pair, copulating on a see-through perspex plinth, seem to be sucking their faces into a single, hideously distorted, glutinous mass. For all their voracious concentration on sex, their bodies look so prosthetic that a feeling of futility hangs over even their most acrobatic feats.

Martin Maloney, at thirty-seven the oldest exhibitor, operates as an *éminence grise* in neurotic realist circles. Here, however, he seems most closely allied with Gontarski's macabre pleasure-hunting. His paintings have grown larger, darker and far more erotically explicit over the last few months. In the press release for the show, his work is described as 'fresh and enjoyable'. To my eyes, though, he seems to be pushing his work in an ever harsher and more garish direction. Walking into Maloney's main room is akin to entering a gay club where everyone is hooked on unsafe sex. Tongues hang out, buttocks are brandished and fingers grab hungrily at dangling genitals.

But there is no sign of joy. One energetic pair copulate as they watch another couple having sex on television. The emphasis throughout these deliberately crude, daubed canvases is on impersonal gratification, pursued automatically by people devoid of love. Nor is there any escape.

One pallid young man sits ruminating on a bar stool, but he is already being approached by a whispering seducer with predatory teeth and a lascivious leer. Rave culture may be regarded by its participants as heaven, but in Maloney's feverish panoramas it looks more like hell.

JANE AND LOUISE WILSON: GAMMA
17 March 1999

Once a well-publicized target for women campaigning against the nightmare of nuclear annihilation, Greenham Common has now lapsed into disuse. The US military's English base served as an arsenal for cruise missiles, ready to be launched whenever the Cold War went on red alert. Greenham became a symbol of apocalyptic menace, and its placid rural setting only threw into relief the horrifying prospect of a planet laid waste by irreversible conflagration. Jane and Louise Wilson are young enough never to have witnessed Greenham's former notoriety. But they insist, in their haunting exhibition at the Lisson Gallery, on bringing the dormant base back to an eerie semblance of life. By calling their video projection *Gamma*, the Wilson twins imply that Greenham's radioactive past is not forgotten. And in order to show how disquieting the abandoned buildings remain, the two artists take us on a journey to the heart of places where missiles used to lie in permanent expectation.

Long before we reach *Gamma*, our ears are alerted to the alarming images it contains. Amplified sounds of rising and descending lifts, the ominous hum emitted by machines and the snapping-shut of mighty metal doors assail visitors at the gallery entrance. They prepare us for the experience ahead, and walking along a dark corridor towards the video room is uncomfortably like groping our way through the gloom of the deserted base itself. Once inside, we find large, engulfing screens positioned on opposite walls. Anyone wanting a comprehensive viewing is obliged to stand between them, and turn continually from one set of images to the other. Even here, though, it is impossible to catch everything. The perpetual swivelling makes us feel disorientated, and incapable of absorbing all the sensations conveyed on the screens competing for our attention.

The sense of bewilderment and frustration generated here is surely akin to the Wilsons' own reaction when they penetrated the arsenal for

the first time. They must have felt that only fragments of Greenham's former reality lingered there, leaving the artists to wonder about the true significance of the interiors they explored. In this respect, they operate in *Gamma* like detectives struggling to assess evidence at a locale long since abandoned. Their cameras change speed in response to the scenes in front of the lens. When scrutinizing an enormous hangar-like structure, they slow down and loiter. Seen through mirrors that gradually shift and unsettle the viewer, this desolate space seems to be frozen in a state of suspense. Although its personnel and equipment have long since departed, the suggestion that they may return hangs oppressively in the air. The Wilsons' willingness to remain there appears motivated by the suspicion that something may be about to happen.

But they are not prepared to stay in the hangar indefinitely. Before long, the camera starts to travel briskly down narrow concrete passageways, claustrophobic and redolent of the need for secrecy. No sooner have we become accustomed to a fast pace than it slows once again, gingerly moving towards a door opening on to a bare, uninhabited room. Two blue plastic chairs sit there, as if recently vacated. The sound of ticking adds to the unease, a mood heightened when we find ourselves confronted by a close-up of an official form headed 'Soviet Inspection'. The words may well refer to the Greenham base's current status, defunct and yet subject to an INF treaty that permits scrutiny by Russian military at any time until the year 2001.

No sign of such a visit can be detected in *Gamma*. Occasionally, though, the Wilsons compound the mysterious atmosphere by registering an unexplained human presence. At one point, after travelling very fast over a sequence of arrows set into the floor, the camera settles on a flashing, electric-blue control panel. An instruction issues a warning in urgent capitals: 'DO NOT TOUCH UNLESS DIRECTED BY THE LAUNCH CENTRE'. But an enigmatic finger appears to flout the order by pressing a button, and soon stockinged legs strut across a mirrored floor whose reflections only add to the perceptual confusion.

More figures appear outside the building, hooded this time and moving along the top of grimy, defensive walls at night. They look like soldiers on patrol, but we are not allowed to look at them properly before *Gamma* sets off on another expedition to the interior. We travel deep inside the structure, descending to the bowels of the building and a space lined with containers. The hum on the soundtrack grows especially threatening, and the mood is not alleviated by the brief, tantalizing appearance of a female official striding past. The strangest sector of the base is located down here, in a chamber where long plastic strips dangle

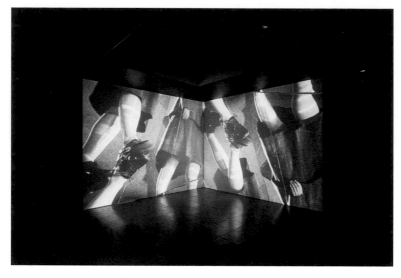

77. Jane and Louise Wilson, *Gamma*, 1999 (detail)

from the ceiling. They partially hide a cartoon-style image of a snarling, running dog newly freed from a broken neck-chain. In the absence of any other pictures on walls elsewhere, this graffiti-like hound transmits a powerful force. It resembles the canine equivalent of a cruise missile, released from its moorings in order to pulverise the enemy.

Everything in *Gamma*, regardless of its ostensible purpose, takes on a similarly sinister import. On one screen, an anonymous hand is seen loading a message cylinder and sending it, with a thunderous noise, to another part of the labyrinth. It arrives, appropriately, on the opposite screen, causing us to swing round if we want to witness the event. No explosion occurs, and yet the velocity of the journey combines with the container's rocket-like shape to give the whole episode an aggressive force. By focusing on the quiescent objects still lurking in the Greenham base's gloom, the Wilsons succeed in reactivating its past. They scrutinize the Decontamination Chamber, focus on a door studded with a disconcerting array of levers, and track past a sequence of directional arrows that might have strayed from a Francis Bacon painting. Indeed, many of the bleak spaces investigated by *Gamma*'s camera are reminiscent of the rooms where Bacon's figures assert their isolated, convulsive presence. The

Wilsons, who admire his work, must realize that it cannot be disentangled from the existential anxiety generated by the Cold War era as a whole.

Nor can Greenham, despite the waning of hostility between the nuclear superpowers. Wherever we are taken in the building, its echoing emptiness fails to offer reassurance. However irrefutable the closure of the base may be, its redundant interior still seems freighted with burdensome, worrying memories of former use. The dangers and fears that brought this arsenal into existence will never entirely go away. They remain in an arrested state, just as the Wilsons themselves appeared in an earlier video sitting side by side in a hypnotic trance. But even if they remain fascinated by suspension in *Gamma*, its mood is markedly different from the hypnosis video. The latter work was shown at the Lisson a few years ago, and an altar-like flight of steps leading up to the screen enhanced its dream-laden serenity. Now, however, the very same space is occupied by a disturbing presence. Moving out of *Gamma*, we walk up identical steps towards a white metal doorway. It looks grubby from years of use, as if taken from the Greenham base and transferred, unchanged, to the gallery. The door is open, and bears a painted inscription in commanding capitals: 'TWO MAN POLICY NO LONE ZONE'.

Nothing prevents us from stepping through to the darkness beyond, a space as empty and enigmatic as the rooms in the arsenal. Standing there, we hear sounds from the nearby *Gamma* video puncturing the silence and adding to the feeling of unease. Another open doorway, dramatically spotlit, stands ahead of us, offering a chance to leave. But the EXIT sign glowing above it conveys no sense of welcome escape. After everything the Wilsons have done in their deeply troubling show, this four-letter word reads instead like a final warning that the post-Greenham world will never be truly free from the threat of imminent obliteration.

DOUGLAS GORDON'S FEATURE FILM
7 April 1999

Stumbling through the darkness of the Atlantis Gallery, we suddenly discover that a precipitous drop separates us from the screen where Douglas Gordon's *Feature Film* is projected. Halted by a barrier, we stare down into the shadows and realize the aptness of the void below. For Gordon has decided to tackle Hitchcock's *Vertigo* in this, his first London exhibition

since winning the Turner Prize three years ago. And the dizzying fear suffered by James Stewart, as he climbs a bell-tower in pursuit of the elusive Kim Novak, is echoed by the unease we feel on this lofty platform.

Our disorientation is increased by the images on the screen. Unlike his previous homage to Hitchcock, a 1993 *tour de force* called *24 Hour Psycho*, Gordon's new film contains no visible trace of *Vertigo* itself. He concentrates instead on James Conlon, the charismatic *chef d'orchestre* of the Paris Opera, conducting a performance of Bernard Herrmann's score for *Vertigo*. Gordon does not even offer a glimpse of the 100 musicians under Conlon's control. The face, arms and hands of the conductor are all we see, and they prove mesmerizing in their own right.

Conlon responds to the heightened emotions animating Herrmann's score with athletic sensitivity. The sounds seem to run through his body with the force of an electrical discharge, reaching a climax in the quicksilver motion of fingers alert to every musical nuance. Even when the orchestra lapses into silence, during the periods when *Vertigo*'s manic story develops without Herrmann's aid, Conlon does not allow his involvement to lessen. Gordon's camera lingers on his face for a while, and the tears in the conductor's eyes show the depth of his engagement with the unfolding narrative. He knows how powerfully Herrmann contributed to the film's hypnotic mood, and his orchestra's members perform the score with all the formidable eloquence at their command.

As a result, Gordon succeeds in presenting an audacious alternative to the experience normally offered by *Vertigo*. In a conventional cinematic presentation, Herrmann's contribution is always subservient to the overall impact of Hitchcock's directorial vision. Audiences are bound to be affected by the impassioned music, but they cannot disentangle it from the movie as a whole. They may even remain unaware of its exceptional potency, and give Hitchcock unqualified credit for *Vertigo*'s ability to sear the imagination. By slicing off Herrmann's work and holding it up for inspection, Gordon enables us to assess it with far greater clarity. And by showing how ardently Conlon responds to the score, the full extent of its capacity to ensnare us in *Vertigo*'s nightmarish convolutions is revealed.

Anyone familiar with Gordon's previous work will appreciate how his fascination with Conlon's movements relates to earlier concerns. Soon after he emerged as an artist, Gordon unearthed and edited some medical demonstration films. Although they ranged from the hysteria of a masked, female patient to the helplessness of a young soldier traumatized by the Great War, Gordon ensured that they shared a central preoccupation with the body. Conlon's exclamatory manual gestures reminded me in particular of a short, disturbing work that Gordon based on a film

78. Douglas Gordon, *Feature Film*, 1999 (detail)

showing a hand endlessly repeating the act of firing a gun. He called it *Trigger-Finger*, and the neurosis exposed on the film is far removed from Conlon's infinitely supple responses. All the same, Gordon uses hands in both these contrasted works to disclose a surprising amount about the emotional condition of the men themselves.

Nor does he stop there. As we gaze down at the screen enlivened by Conlon's exertions, our eyes gradually notice another film flickering at the far end of the vast Atlantis hall. The urge to investigate proves irresistible, and a staircase half-hidden in the gloom enables us to descend. The distant film turns out to be *Vertigo* itself, far smaller in size and projected modestly on to a wall by equipment resting on the floor. The almost offhand presentation suggests that Gordon intends it as a footnote to the principal offering, still fully visible on the large screen. But once I started watching *Vertigo*, it would not let me go. My eyes kept moving between the two rival images, eager to follow Hitchcock's narrative and yet determined to see how Conlon dealt with the music filling the entire gallery with its Mahlerian disquiet.

Gordon makes the experience still more complex by robbing *Vertigo* of its dialogue. The actors mouth soundlessly at each other, just as they did in the films Hitchcock would have seen during his youth. Growing up in the great era of silent cinema, he was bound to have been influenced at a formative stage by their emphasis on forceful emotion. But there is scant reliance on the melodramatic acting that so often fuelled

silent movies. The absence of dialogue made me aware of Hitchcock's restraint as a director, his insistence that actors adopt a statuesque approach rather than indulging in ostentatious performances. Stewart and, supremely, Novak are for the most part reined-in. Apart from scenes of high anxiety, like the dream sequence where Stewart is tortured by neurotic memory-flashes, the actors are notable for their stillness, their reluctance to rely on rhetorical flourishes of any kind.

In such a hushed context, where a substantial court scene reduces all its players to a notably undemonstrative level, the return of the music has an extraordinary impact. At one point, after a bout of soundless conversation, Stewart re-enters a room in distress. Herrmann's score ambushes our senses, lending the actor's anguish an intensity it would not otherwise have attained. Hitchcock may well have found his composer too emotionally effusive: there is undoubtedly a clash between Herrmann's unabashed late romanticism and the understatement dictating so much of Hitchcock's visual style. Against the odds, though, an unlikely chemistry is established between the two men's approaches. Without Herrmann, Hitchcock might well look stilted at times. And shorn of Hitchcock's rigour, Herrmann could easily sound embarrassingly lush. When they come together, the fusion goes a long way towards explaining why *Vertigo* exerts such a compulsive, lingering hold over us.

Ultimately, however, Gordon's installation sustains our attention through the interplay between *Vertigo* and the film he has made. The longer I looked at Conlon conducting, the more I realized that he seemed to inhabit a Hitchcockian world. There is, for one thing, a strange resemblance sometimes between details of Conlon's frowning face and Anthony Perkins in *Psycho*. Although he is manifestly in charge of an orchestra, Conlon becomes one of the characters in the complex, multi-layered drama played out here. When Stewart's haunted face is caught in close-up, enmeshed within a spider's web at the height of the nightmare sequence, he looks utterly alone. Conlon likewise seems marooned in a nocturnal void during the moments when the camera rests on his features for a while. He appears overcome by the same autumnal melancholy that afflicts Stewart in his futile search for the unattainable Novak. And Conlon's ability to identify so strongly with this sadness helps him to locate it in Herrmann's score, ensuring that the music is sometimes as overwhelmingly insistent as the Mahler sound-track deployed by Visconti throughout *Death in Venice* – another film dominated by the doomed pursuit of a destructive infatuation.

Gordon does not make it easy to absorb the richness of the relationship between Hitchcock, Herrmann, Conlon and his own equally obsessive art.

Only repeated viewings would disclose everything worth extracting from their interaction; and the absence of seating in this austere hall obliged me to end up squatting on the floor, swivelling from one screen to the next and back again in an attempt to absorb the array of competing images on offer. It is a strenuous experience, and yet the inordinate demands made by Gordon end up tallying with the ordeal Stewart forces himself to undergo during the film.

All the disparate elements combine most arrestingly in the final minutes, when Stewart bullies Novak into ascending the tower of the Mission of San Juan Bautista one more time. The brutality of his struggle with her is surprising and then alarming, all the more so in view of Stewart's subdued demeanour in many of *Vertigo*'s earlier moments. Herrmann's music responds to the challenge with hectic conviction, while Conlon attains a frenzy of gestures on the other screen. As Stewart goads Novak up the stairwell, the conductor's hands stab, claw, thrust and swoop through the inkiness in blurred white arcs of agitation. Conlon drives his orchestra onwards with the single-minded vehemence Hitchcock unleashed on his actors as they stagger to the top. They are all caught up in the same demented trajectory. And nothing, not even the swift intervention of the nun who sounds the bell, can prevent the tragedy from terminating in free fall.

GAUTIER DEBLONDE
1 May 1999

Talk of British art in the 1990s invariably centres on the emergent generation, the highly-publicized young pack whose vitality has earned them the high international profile they enjoy today. But the truth about a decade is far more complex. Even the most rebellious *enfant terrible* turns out to have been influenced by more senior artists. And the best members of older generations continue to develop, often producing their finest work and setting an example of sustained energy that the young would do well to emulate.

The strength of Gautier Deblonde's photographs, taken over the last five years and now published together for the first time, lies in his acknowledgement of the British art scene's extraordinary diversity. Since he is close in age to the youngest artists in this collection, Deblonde

might have been expected to concentrate on them alone. Instead, he has set no arbitrary limits on the men and women defined by his lens. They range from the seventy-five-year-old Anthony Caro, still spry enough to be caught balancing like a tight-rope walker on an edge of steel, to the baby-faced Simon Patterson, only a precocious twenty-nine when short-listed for the Turner Prize in 1996.

Older artists often influence the young through teaching. Michael Craig-Martin's impact on the outstanding generation of Goldsmith's students would be hard to overestimate, and in Deblonde's photograph he looks suitably professorial next to an open book suspended in the picture behind him. But the prominent presence of that painting is also significant in a different way. For Craig-Martin's teaching has always been rooted in his activities as a hard-working, highly professional artist. He instilled that attitude in many of his students, and their success testifies to his effectiveness.

Not that the young have allowed the pursuit of reputations to impair their sense of playfulness. Jake and Dinos Chapman, incorrigible brothers who specialize in provocative tableaux, are seen in front of a studio wall spattered with childlike graffiti. As for the notoriously irreverent Tracey Emin, she raises a sceptical eyebrow at the camera while kids on the street outside gawp and giggle at her. Deblonde indulges in wry

79. Gautier Deblonde, Jake and Dinos Chapman

humour of his own when dealing with the ubiquitous Damien Hirst. Rather than taking yet another photograph of Hirst himself, he trains his lens on two masked and goggled technicians pouring formaldehyde into tanks containing a sliced cow. Their anonymity could not be further removed from Hirst's instantly familiar face, and a serious point is also made about the dangers of the preservative liquid he employs.

Antony Gormley likewise seems at risk as he sits in his studio, steadfastly waiting for a cast of his head to be set. He looks like an Egyptian potentate preserved for posterity, while the severed heads and limbs heaped on the shelves above hint disconcertingly at human sacrifice. But his wife Vicken, disappearing through a door with plaster-mixing bowl in hand, introduces a more practical note. Artists know how their chosen materials should be handled. And judging by the photograph of Marc Quinn, his overalls spectacularly smeared as he peels the outer layer off a cast figure, some of them do not mind getting mucky in the process.

Deblonde is very open about how to obtain the image he wants. Sometimes, his lens ignores the artist's surroundings and moves in very close to the face alone. The strategy pays off best with his senior subjects: the septuagenarian Eduardo Paolozzi, eyes deeply shadowed, stares forward with a frowning, defensive expression like an old pugilist who still refuses to let his guard down. Frank Auerbach, head cocked on one side, looks gentler, but he eyes the camera with a distinct wariness. The older artists become, the more unwilling they are to 'act up' for a photographer. An outstanding portrait of Howard Hodgkin, looking sidelong at the lens, catches his vigilance. Hodgkin's eyes remain supremely watchful, missing nothing, and even the cloudy reflection in his mirror reinforces the image of a man forever on the alert.

Some artists, of course, cannot help staying camera-friendly. Deblonde cleverly catches the gregariousness of David Hockney by photographing him while he poses for another photographer. Hockney's mood seems as buoyant as the sunflowers in his painting on the wall beyond: he welcomes the exposure, and basks in public attention. But his geniality seems, in the end, curiously unrevealing. It discloses little, just as Gilbert & George adopt expressions of studied politeness as they sit with teacups in their local café. Their emotions are held in reserve, and will only be unleashed in the outspoken images of themselves deployed so frequently in their own photo-works.

All the same, showing artists in the surroundings they like to inhabit can be revealing. Helen Chadwick, whose death at the age of forty-three robbed British art of a stubborn individualist, sits barefoot on the

doorstep of her East End home. This plain terraced house, in Beck Road, was as unpretentious as Chadwick's approach to art. But it did not feed her work in the same way that urban architecture is reflected in Julian Opie's art. He is blurred in Deblonde's portrait, whereas the tower block beyond him is in focus. And Opie stands to one side, as if to acknowledge that impersonal big-city buildings of this kind occupy a central position in the work he produces.

Ultimately, though, the most illuminating of Deblonde's portraits show artists interacting with their work. Gary Hume takes his cue from the gesticulating woman in one of the paintings stacked behind him. He adopts a self-consciously preening attitude, parodying the peacock assurance of a model posing on the catwalk. Hume discloses a great deal about his own fascination with stylishness, and at the same time maintains a fastidious distance from the painting itself.

Other artists appear more intimately involved with their work-in-progress. Chris Ofili allows powerful lighting to project his own shadow on to the wall next to his painting. His hand invades the picture, appearing to juggle with the spades dancing across its surface. This is the artist as conjuror, playing with ironic references to his black identity. Paula Rego, on the other hand, appears to be dreaming about the bizarre incident depicted behind her. With upturned eyes, she seems in thrall to the mood of a painting where a half-dressed woman lies helpless on the floor, violated by a smaller figure brandishing a weapon. The violence of the image contrasts with Rego's ruminative face, suggesting that she is herself surprised by the fertile workings of her own imagination.

Peter Blake looks positively conspiratorial as he looks back at us from his painting of a boxer. He appears to be warning us that the fighter's menacing gloves might suddenly burst out and deliver a blow to anyone who finds fault with the picture. Perhaps, in his fantasy, Blake would like to be the boxer. Deblonde certainly suggests a close identification between artist and subject in his photograph of Mark Wallinger. While one painting of a faceless jockey rests against the wall, Wallinger grasps a similar picture and places himself over the blank, anonymous rider. For an instant, he almost becomes the jockey.

In several photographs, Deblonde proves himself adept at conveying the artists' ability to become absorbed in their work. Bruce McLean, caught in a typically robust action-man pose, seems to be enmeshed in the gauze-like surface of the screen he grasps. Its fuzziness robs his body of its solidity, and there is an intriguing suggestion that McLean might end up as a figure trapped inside his own picture. Bill Woodrow still clearly stands outside his monumental drawing. But he appears arrested

by the forms wriggling across it, while the floating spoon looks colossal enough to scoop Woodrow up and drop him into the maelstrom of swarming organisms.

Such notions could easily be dismissed as fanciful. But Deblonde knows how intensely artists can project themselves into their work as it develops. Tony Cragg, dwarfed by the titanic, undulating sculpture in front of him, appears oblivious of anything except the forms consuming his attention. Fiona Rae, arms akimbo, seems to be caught wondering how best to proceed with the painting beside her. But the most magical photograph shows Cornelia Parker, engrossed in the act of installing one of her Turner Prize exhibits at the Tate Gallery in 1997. Called *Colder Darker Matter*, it suspends the charred remains from a baptist church struck by lightning in Texas. Parker gazes upwards, her attention perhaps focused on how best to hang them on their wires. But her arms rise up like an orchestra conductor's in response to the charcoal fragments dangling before her. She appears as spellbound as we may feel when, confronted by an especially potent work of art, we end up lost in wonder.

CITIES ON THE MOVE
19 May 1999

Brace yourself for a roller-coaster of a show at the Hayward Gallery. Taking as its cue the 'urban chaos' of fast-expanding East Asian cities, this headlong exhibition assails us with images of rampant, overwhelming anarchy. 'You Are Here' announces a deceptively reassuring sign just inside the entrance. But we soon become lost in the labyrinth of tangled, wildly conflicting exhibits, all reinforcing a frenzied vision of a world delirious with its own burgeoning excess. The breathless tempo is set up at once, in a frantic opening section that plunges us into life on the street. To the left, pale bricks stacked in the shape of towering buildings are stuffed with banknotes. On the right, we peer through a torn plastic sheet to discover a construction workers' makeshift shelter, where flashing yellow lights and sounds of relentless hammering provide no respite for its occupants.

From the outset, then, speculative greed is set against its human cost. As we advance warily into the gallery, ambushed on every side by visual and verbal clamour, a disorienting picture emerges. Sleek colour photographs

of Tokyo suburbia show a desolate, drive-in cityscape, dominated by the ubiquitous McDonald's and Kentucky Fried Chicken. No wonder the trainer-clad youth in Takashi Homma's print looks so dazed and forlorn. The identity of his surroundings is bewildering. And Zhang Peili, a Chinese artist based in his native Hangzhou, accelerates the confusion in an eight-monitor video installation where street scenes become blurred and indecipherable.

Other artists prefer journeys into completely unfamiliar territory. Yutaka Sone gave video cameras to several friends and asked them to film nocturnal bus trips in cities he did not know. The results are alienating, and no comfort can be found in a lacquered milk-box projecting from a dark, half-hidden wall. It looks defiantly hand-made among all the technology, but the objects on its shelves carry melancholy typed messages: 'it is easier to make friends than to keep them'.

No permanence seems possible in this incessantly changing metropolitan mayhem. Liew Kung Yu is based in Kuala Lumpur, the Malaysian city boasting (for the moment, at least) the world's tallest building. All he can offer is a nightmarish vision of the future, in the shape of a garish superhero called Wira symbolizing the year 2020. By then, the government of Malaysia predicts that its nation will head the developed world. But Wira is no more than a kitschy funfair extravaganza, gesticulating on stage at the end of a red carpet flanked by constantly winking lights. 'Feel free to stand on the platform and have your photo taken with your head on his body', announces an effusive caption, adding that disposable cameras are available in the exhibition's Commerce section.

Escape seems possible nearby in 2 Tuk Tuks, a motorized three-wheeler taxi from Thailand. Climb aboard, and you find yourself confronted by a three-screen film about a Bangkok driver falling in love with a Viennese girl. They travel to all the cities explored in the exhibition. But the accessibility of the taxi, with its gaudy decorative accessories and user-friendly cassette players, is countered elsewhere by rooms with padlocked doors, forcing the viewer to gaze voyeur-like through openings at private, tantalizing interiors. They seem the inevitable outcome of East Asia's obsessive hunger for fast-build, high-rise developments. The ever-proliferating population finds itself crammed into densely packed accommodation, where the only relief is provided by bizarre urban golf-courses. Cai Guo-Qiang, born in China and now working in New York, presents a gently satirical installation called *Red Golf*. A flag representing all the region's Communist regimes stands proud on the immaculate green baize floor-covering, while clubs wait at the ready in a bag enticingly labelled 'PING'.

It provides a moment of pristine calm, but at the top of a nearby stair-case the onslaught continues with Zhu Jia's dizzying video of a tricycle ride round Beijing. While an amplifier emits sounds of gross snoring by an invisible sleeper behind us, we find ourselves caught up in the vortex of images shot by Jia's camera as it spins round on the tricy-cle's wheel. Everything seems about to collapse in a nauseous blur, and out on the terrace beyond stands a reminder of real seismic catastrophe. Tokyo-based Shigeru Ban developed his *Paper Log House* as an emer-gency structure after the devastating Kobe earthquake of 1995. Made from cardboard tubes and resting on blue beer crates, it looks surprisingly sturdy on the Hayward's rain-sodden paving.

If the prospect of further tremors proves too frightening, a cinema sec-tion offers respite. But no idylls are provided in a programme with movies like *Chungking Express* and *Kids Return*. The prevailing emphasis seems to be urban anxiety, and the dispiriting mood is hardly lifted when we encounter the bargain basement goods by Thai artist Surasi Kusolwong in the neighbouring street-market installation. An ironic title is inscribed on the wall above this cornucopia of cheap plastic: *Freedom of Choice* (£1 *each*).

True freedom, however, is hard to find in much of East Asia, and the exhibition soon moves into a protesting vein. Jakarta-born Heri Dono shows a macabre armless mannequin, spouting a speech by President Suharto of Indonesia. A notice alongside this lipstick-smeared figure, whose hands are attached to shoulder-straps, explains that 'to see footage of the speech, please look up the mannequin's penis'. Sure enough, if you kneel down and obey the instructions, miniature images are visible inside the hole. But I preferred the more robust attack of *Home Body Home* by Marintan Sirait and Andar Manik, whose mud-spattered wall-map of Indonesia becomes a backdrop for an old iron-frame bed suspended at a tipsy angle. Film of Indonesian riots is projected on bed-base and mud-map alike, creating a sense of widespread unrest that dominates Shen Yuan's installation as well. A Chinese artist now based in France, she places a row of five bicycles in front of a screen filled with footage of street demonstrations across the world. As police attempt to suppress the agita-ted crowds, eggs are fired from cannons mounted on the bikes. The screen ends up as splattered as the surface of an action painting, and plenty more eggs are piled in the bikes' baskets to provide ammunition for further onslaughts.

The show is most effective when taking a subversive look at the urban malaise. But it lapses into dullness in the architecture section, where models of colossal developments by Renzo Piano, Richard Rogers and

80. Chen Zhen, *Precipitous Parturition*, 1999 (detail)

other international stars are displayed with conventional reverence. The exhibition's previous rooms lead us to expect a critical edge here as well, and its absence generates disappointment.

Chen Zhen, however, makes marvellous amends with his outrageous installation *Precipitous Parturition*. Slung in the air on one side of the architecture section, it undulates like some cancerous, serpentine growth over the mezzanine ramp. Zhen, born in Shanghai, takes as his springboard the Chinese government's promise to upgrade every citizen's bicycle to a car. Horrified by visions of the ensuing bedlam, he has made his floating dragon from a tangled mass of inner tubes. At the centre, the apparition's distended stomach erupts in a gruesome torrent of toy cars.

They hurtle down with apocalyptic force, giving the lie to the Utopian calm of the ordered architectural models below.

Zhen's bilious, uninhibited imagination has produced, here, the most impressive single exhibit in the show. And it prepares us for the final arena where full-blown urban decay is investigated. A peroxide-tinted Western prostitute becomes the running image, reappearing at intervals to leer and bare her overblown breasts. But she is overshadowed by Lee Bul's monstrous *Hydra*, an inflatable mass of vinyl surging like a bloated whale towards the ceiling. Bul, who lives in Seoul, has photoprinted an image of herself on Hydra's side. Half goddess and half stripper, she embodies the ambiguity of a monument poised between denunciation and homage. The myth of The Orient is her target, and visitors are urged to keep Hydra inflated. 'Please feel free to help pump her up' says a notice, trusting that we will enter into the spirit of this irreverent, caustic entertainment. But the jaunty invitation cannot disguise the underlying fear that, without constant maintenance, the crazily ballooning Orient will sag and collapse.

THE VENICE BIENNALE 1999
16 June 1999

An end-of-the-century thunderstorm heralded the advent of the 1999 Venice Biennale. As the sky blackened and lightning stabbed at the rain-lashed city, I wondered if the art on show here would be equally apocalyptic. Further bouts of angry weather interrupted the preview days, battering visitors with downpours of monsoon-like ferocity. But the Biennale itself, a massive multinational jamboree sprawling across the Castello Gardens and the dramatically expanded Arsenale buildings nearby, proved a surprisingly light-headed affair, high on callow showmanship and low on authentic millennial torment. Take the knockabout atmosphere in the Russian pavilion, where the gleeful duo Komar and Melamid display blurred, tilting photographs of Moscow taken by a seven-year-old chimpanzee called Mikki. In the next room, Thai elephants are shown on a video screen painting at an Elephant Art Academy. Curling their trunks around dripping brushes, they swipe at giant sheets of paper with a gusto worthy of a drunken Jackson Pollock. The results are displayed, with apparent seriousness, around the walls.

They look like blown-up samples of mediocre children's art, and I am glad that Komar and Melamid were banned from implementing their plan to bring the elephants over to Venice.

But at least the animals' swipes of paint have a hectic energy. Not so Lee Bul's offering at the Korean pavilion. Walking in, I found a colossal video of schoolgirls feebly chanting Abba's *Dancing Queen* in a woodland location. At either side, visitors are invited to enter padded boxes, choose a disc and sing along to it, karaoke-style. The box I entered rapidly became claustrophobic and appallingly hot. Maybe the artist meant it to be unendurable, but I have my doubts.

Participation is even more of a keynote at the Czech pavilion, where we can select a tattoo from hundreds of designs papering the walls. The title of the event, *Slovak Art For Free*, holds out a promise: make an appointment, lie down on a bed and have the tattoo of your choice incised in your flesh. The designs, however, were dominated by female genitalia, copulating lovers, bandaged limbs or slogans like 'I've definitely tried it before'. Adolescent jokiness reigned. And the blood leaking from the arm of a visitor, as he rashly submitted to the tattooist's buzzing needle, was enough to drive me from the room.

More beds could be found in the German pavilion, but this time they occupied a darkened room where two exhausted Biennale viewers were already resting. Perhaps recovering from traumatic tattoos, they looked grateful for the chance to relax. But they may also have been conditioned by a double-screen video called *Sleeping Pill* in the adjoining room, where Rosemarie Trockel shows men, women and children falling asleep or hanging in suspended bubble-suits. The dazzling white chamber they inhabit is reminiscent of a spaceship, but as the figures wake up and calmly walk off, they do not seem part of a Kubrickian nightmare from 2001. Instead, they appear refreshed by their experience, as if energized by Trockel to take on the daunting amount of art on offer elsewhere in the Biennale.

Anyone trying to account for its oddly childlike mood will find little help from this year's director, the distinguished Swiss curator Harald Szeemann. A veteran organizer of avant-garde exhibitions, he shuns all talk of any overriding theme. Now in his late sixties, Szeemann has tried to highlight young artists, commenting that 'grandfathers tend to get on better with their grandsons than with their sons'. But the artists in the Castello Gardens' national pavilions are all chosen by their respective countries, so Szeemann cannot be blamed for their most gruesome contributions. One of the most juvenile is Canada's representative Tom Dean. Lining his curved space with dot-pattern screenprints of the Ten

Commandments, he has punctuated the floor with bronze dogs sniffing and shitting. Bronze turds appear to be scattered on every side, but they turn out to be male genitals. It all seems pathetically gratuitous, and Dean does not redeem himself by placing piles of tied-up newspapers with Kosovo headlines at the far end of the room.

Relief is at hand in the British pavilion, where Gary Hume's paintings charge the galleries with clean, refreshing colour. His most recent work, assured images of young women seen as if through rippling water, seem lyrical and sensuous at first. Even here, though, tragedy is hinted at in an Ophelia-like painting tangled with streaming flowers and leaves. The side rooms are too closely hung, and suffer from the misplaced urge to provide a mini-retrospective. But the large gallery at the back, devoted to only three large paintings of monumental, highly simplified faces, is magnificent. At the age of thirty-seven, Hume has developed into one of our finest and most supple painters. Always likely to catch us off-balance, this unpredictable artist beguiles and disconcerts in equal measure. Heraldic hues have always been his forte, intensified by his habitual use of gloss paint on aluminium panels. But here, in the Venetian light, his ability to make colour sing takes on a new eloquence.

Quite unexpectedly, Ann Hamilton also relies on the potency of colour in the US pavilion. Moving through her rooms, we find deep pink powder falling like blood-tinged soot from the ceilings. Long vertical trails are continually discharged from hidden containers near the roof, sliding softly down the walls to gather in heaps on the floor. Our feet tread through the powder, leaving imprints and encouraging some visitors to make their own marks. While I was there, one woman knelt and, with her fingers, drew intricate calligraphic patterns in the accumulated pinkness. For Hamilton, a resourceful artist who has in the past used photography, video and objects, the reliance on colour comes as a great surprise. But she risks overloading these quietly sensuous spaces with her oblique, confusing references to poetry in braille, Lincoln's speeches and Jefferson's architecture.

Ann Veronica Janssens, on the other hand, resorts to whiteness in the Belgian pavilion. The interior is filled with a dense mist, making us wander from room to room like travellers lost in a winter landscape. We hear a child's voice, and suddenly encounter suspended flowers or a large cluster of bulging water-bags waiting to burst. Fragility seems paramount, and yet the mistiness has a strangely soothing effect. Although striving to find our way, we are slowed down to a calm, meditative pace.

On the whole, though, the overwhelming quantity of exhibits at the Biennale forces us to journey briskly. The emphasis on national identities

in the Castello Pavilions, a legacy from the late nineteenth century when this Venetian spectacular began, seems overbearing today. I sympathized with Dan Perjovschi, who covers the entire floor of the Romanian pavilion with thousands of jaundiced, cartoonish drawings. In one wry little sketch, he asks a question that reads like a *cri de coeur*. 'I represent Romania: what about Romania representing me?'

To his credit, Szeemann has attempted to break down patriotic barriers in the central pavilion. The traditional emphasis on Italian artists gives way to a freewheeling, multiracial approach. China, ignored for so long in successive Biennales, is here represented by a multitude of artists unfamiliar in the West. But they seem adrift, and their prominence in the Arsenale section appears scarcely less arbitrary. Szeemann has enlarged the space available in this historic area, using not only the Ropeworks but the magnificent Ordnance and Tese buildings as well. Along with the derelict dockland setting, the Arsenale's colossal columns, crumbling arches and epic timber-vaulted roofs often dwarf the art they contain. Or else the vastness of these interiors tempts exhibitors to be grandiose, over-extending work that looks even more puny when spread over such immense distances.

Jason Rhoades and Paul McCarthy, with their tedious infantilism and titillating film of lesbian sex projected furtively on to a staircase, are among the worst offenders. But several contributors stand out precisely because they resist this gigantism. Maurizio Cattelan confines himself to a corner, where we peer through mouldering brick windows and find the praying hands of a kafir projecting from a bed of sand smothering the rest of his body. For two hours at a stretch, several times a day, he holds this clasped position with uncanny stillness. The image of endurance has stayed in my mind far more clearly than many of the clamorous exhibits.

So has Pipilotti Rist's witty offering, a strange metal structure that emits, every three minutes, a flurry of plump bubbles in an explosion of dry ice. Above all, though, I was impressed by Doug Aitken, a young Los Angeles artist whose video installation *Electric Earth* has a rare sense of economy, style and single-minded coherence. Tracking the nocturnal wanderings of a young black man, Aitken catches his vitality, aimlessness, impatience and frustration in deserted, eerily lit streets reminiscent of Edward Hopper's paintings. Exceptionally accomplished, it made me eager to see more of Aitken's freewheeling, poetic and yet precisely calculated art.

To find work as thunderous as the weather, though, I caught a boat to the Ancient Grain Store at the Zitelle. This superb timber-beamed building

81. Doug Aitken, *Electric Earth*, 1999

provides an ideal setting for Anthony Caro's new sculpture, a twenty-eight-piece *tour de force* called *The Last Judgement*. Walking through the Bell Tower, a façade of weathered railway sleepers surmounted by a terracotta bell, we are brought to a halt by the uncompromising stoneware Door of Death. Beyond it, however, Caro has transformed the Grain Store's brick interior into a secular nave, lined on either side by tall containers reminiscent of confessional boxes. Each one frames anguished images drawn from mythology and the Bible, encompassing Charon and The Furies as well as Judas and Salome.

But the overriding emphasis is on brutality, suffering and the grave. The horrific 'ethnic cleansing' of the 1990s helped to prompt the work, which adds up to a brave, ambitious and risk-taking transformation of Caro's sculptural language. But underlying it all is an old man's private confrontation with mortality. At the end of the nave, on a stark platform, four trumpets project from hideously misshapen body-stumps, the victims of some barbaric massacre. Here, finally, is a sculpture for the millennium's end, blowing the Last Trump high into the turbulent Venetian sky.

ABRACADABRA

14 July 1999

Abracadabra is being promoted as a user-friendly show, a light-hearted soufflé ideal for summer consumption. But do not expect any bland reassurance from the feverish cauldron of international art awaiting you at the Tate. It is an exhibition fit for the fiercest heatwave, and the macabre mood shared by the fifteen young artists is triggered at the outset. Puce and fleshy, two monstrous waterlilies by Keith Edmier rear high above us. Monet would have banished them at once from his Giverny pond, but these triffid-like creatures seem creepily at home here. A two-way mirror behind their writhing forms makes us feel even more off-balance, gazing at ourselves as we stare up apprehensively at Edmier's apparitions. And the hallucinatory feeling increases when we turn to a nearby notice-board, festooned with press cuttings pinned there by Vik Muniz. Some, like a recent article from the Arts pages of *The Times*, are genuine. But most are dubious, inviting us to believe in headlines as startling as 'Henry Moore Took Drugs'.

Tall stories turn out to be a feature of this unashamedly far-fetched show. They crop up again in Patrick Corillon's two-sided painting of a man and a woman. With oval holes where their faces should be, it looks like an end-of-the-pier entertainment encouraging us to put our heads through. But the text hanging on the side tells a melancholy tale about one Oskar Serti, a fictional poet and composer partly based on Bela Bartók. He seems to serve as an alter ego for Corillon himself, who describes how Serti tried to meet Catherine de Selys at Maastricht railway station in 1915. The attempt is abortive and ends in profound frustration, which may help to explain why both their faces are missing. But at least they do not suffer the fate of the 'middle-class family' inhabiting Fernando Sanchez Castillo's *Violent House*. It looks innocent enough, a toytown structure for children to play with. A tangle of wires is attached to the walls, however. They ensure that, every three minutes, the interior explodes in a deafening maelstrom of hurtling furniture and smoke.

The more you explore this unpredictable show, the less like a harmless playground it appears to be. True, the Tate's entire exhibition area has been opened up into a single barn-like space, peppered by exhibits so quirky and bizarre that they have a carnival air. The boisterousness is deceptive, though. Beneath the fizzy surface, an aching sense of pain and loss can soon be detected. In Sanchez Castillo's case, the viciously erupting house relates to his boyhood memories of Spain in

the aftermath of General Franco's tyranny. When we confront Patrick van Caeckenbergh, a less specific yet still more distressing malaise afflicts his work. In one sculpture, frying pans ascend in diminishing sizes from an old-fashioned stove. Each pan is peopled with miniature cardboard cut-outs of the artist himself in a Balzacian dressing-gown. Leaping, crouching and crazily gesticulating, these figures seem to enjoy their unlikely confinement. But the ashes heaped in each of the pans are ominous, and the stove's open door discloses an interior strewn with charred remains. The contrast between this murderous incinerator and the antics of the cut-outs above is as jarring as in the film *Life Is Beautiful*, where a Nazi concentration camp is placed, very riskily, in the context of knock-about Italian comedy.

Humour abounds in *Abracadabra*, and some of it is slapstick rather than than unsettling. The irrepressible Pierrick Sorin uses video with delightful ingenuity, deploying mirrors so that his tiny figures look as three-dimensional as holography. In *Pierrick is Cutting Wood*, one character dressed in drag films a male companion cavorting at the opposite end of a long white pole. Making the column appear to jut like an erect penis from his shorts, the man slices it off with a chainsaw. Benny Hill is crossed here with Buster Keaton, and we never really feel threatened by this absurd emasculation.

Sorin's frothiness, however, is untypical of the show. In Katy Schimert's work, playful references to ancient mythology are harnessed to more troubling emotions. On one wall, a gleaming circular relief sculpture in blown glass is called *The Sun*, and it blazes out with a warmth that appears, at first, overwhelmingly optimistic. But the life-nourishing heat turns menacing elsewhere in Schimert's section. On her large astronomical wall-drawing, three words spell out a menacing title: *Oedipal Blind Spot*. And her most powerful work, a super-8 mm film transferred to video, shows a handsome Icarus-like figure gradually sinking to the ocean bed. Weighed down with giant love-hearts, he is sometimes barely visible through the subaqueous murk. At other moments, though, the camera closes mournfully on the young man's singed, sightless eyes.

For me, despite its indebtedness to Bill Viola's underwater videos, Schimert's *The Drowned Man* is among the show's most deeply affecting works. It seems far more resonant than the cluster of mannequins by Maire-Ange Guilleminot, each one swathed in dresses she has worn in performances. Without her animating presence, the *Perspirator Dress*, the *Navel Dress* and even the *Dress with One Cut and One Hidden Breast* appear incommunicative. They compare poorly with the more disturbing shop-window models produced by the Surrealists sixty years ago, and

only one of Guilleminot's works goes beyond decorousness. In *The Rotary Machine*, a gummy resin body shorn of head and arms suddenly starts spinning violently. Resembling a flayed carcass on a spit, this severed stump introduces a gruesomeness that provides *Abracadabra* with many of its arresting moments.

Take Brigitte Zieger, whose two contributions are among the most impressive on view. In a video piece called *Venus*, the artist looks absorbed in a narcissistic infatuation with her own mirror-image. Staring solemnly at the glass, she smears her hair with tendril-clogging radiator paint. Then, without a pause, Zieger reappears wearing an exposed plaster brain on her skull. She treats it like a fashion accessory, parting the cells into a trendily severe hair-style. In doing so, she appears to destroy her mind, and the relentless cicadas ticking on the soundtrack add to the mood of obsessive frenzy. Zieger herself remains grim-faced throughout, even when the video speeds up like a jerky silent movie. She ends up resembling a demented android, strayed from a B-movie about a Creature from Another Planet.

The strength of Zieger's art, however, lies in its everyday roots. Her preoccupation with weird, deviant behaviour seems to stem from observation rather than untrammelled fantasy, and in *Playtime* we find ourselves cast as voyeurs scrutinizing a video of a big, clumsy American man holed up in a Parisian room. He seems merely doltish to begin with, lurching around as his hands fiddle with jumbo-size pieces of cardboard. Then, whistling tunelessly, he forms the fragments into an outsized rifle and fires through the window at an unseen target. The plump simpleton undergoes a sinister metamorphosis, turning into a hitman driven by some lethal grudge. And Zieger, who lays out the same gun parts on a groundsheet around the video set, implicitly invites us to assemble our own weapons as well. Maybe we are all, in her view, potential killers.

Several other exhibits encourage audience participation. Maurizio Cattelan, whose *Stadium* occupies a place of honour on a central platform, blows up an ordinary table-football game to a colossal size. The rows of red and blue players waiting to be manipulated look, in their stillness, like diminutive figures by Antony Gormley. But *Stadium* can only be properly assessed when visitors seize the chance to play a delirious match on it. Without them, at a quiet press view, I found its physical presence far less intriguing than Cattelan's unpronounceable *Bidibidobidiboo* tucked away in a far corner. It dramatizes the outcome of a squirrel's suicide. The taxidermic animal is shown slumped on a yellow table-top, with the discarded gun lying nearby. We might easily overlook the tiny sink attached to a neighbouring wall, stuffed with dirty crockery

82. Maurizio Cattelan, *Bidibidobidiboo*, 1996

waiting to be washed up. Although its wry humour prevents the squirrel's pathos from becoming sentimental, I preferred Cattelan's *Charlie Don't Surf* precisely because it avoids whimsy altogether. Seated at a school desk, a hooded boy is pinioned by pencils skewering both his hands. He seems initially to be alive, like an updated secular version of the crucified Christ. Peering round the hood, though, I discovered that his blackened eye-sockets were as empty as Schimert's drowned Icarus.

Death appears inescapable here, just as it is in the work of so many young British artists of the 1990s. But *Abracadabra*'s two contributors from Britain, Emma Kay and Paul Noble, seem disappointingly laboured when compared with the show's finest, most hard-hitting participants. Kay's wordy memory-feats and Noble's meandering cartoons lack the concentrated impact of Momoyo Torimitsu's robotic Japanese businessman scuttling across the floor. Bearing an eerie resemblance to Michael Howard, the grinning and bespectacled automaton appears blithely unaware of his body's futility. But one of the accompanying videos shows Torimitsu herself attending him as a nurse, continually recharging his batteries with the aid of a swift spinal jab. However jaunty he seems in another video, accompanied by a soaring James Bond theme-tune, this abject creature is as pitiful as any of the other victims in this unsettling, deceptively festive jamboree.

HITCHCOCK AND CONTEMPORARY ART
4 August 1999

Even the most chilling of Hitchcock's films are so familiar that they can easily be taken for granted. Now, 100 years after his birth, he needs to be seen afresh. And the required tonic is provided in abundance at Oxford's Museum of Modern Art, where a diverse range of contemporary artists respond to the paranoia, desire, terror and mystery embedded in his work. They assail us on every side with nightmarish images, cutting through predictability to give more direct, unsettling access to the director's turbulent psyche.

Hitchcock was incurably obsessive, returning time and again to a set of compelling concerns. Two young Germans, Christoph Girardet and Matthias Müller, have cleverly trawled the immense corpus of his work. Their findings are distilled into a sharp, witty series called the *Phoenix*

Tapes, which punctuate the show and ambush us with quick-fire extracts highlighting themes as loaded as 'Bedroom', 'Burden of Proof', and 'Why Don't You Love Me?' I found them all irresistible, reaching down to the depths of Hitchcock's darkest preoccupations. Hands are foregrounded in the first tape on show, all seen in mesmeric close-up. They fiddle with keys, fend off pecking birds, tear open letters, hover above door-handles, smash wine-glasses, cram cash in envelopes, fire guns and, sickeningly, claw at blood-smeared tiles in the *Psycho* shower scene. Narrative expectations are constantly being aroused and then, quite brutally, frustrated. But we are kick-started into a fresh awareness of Hitchcock's power as a film-maker, and left eager for more insights.

Other artists approach him in still more fragmented ways. John Baldessari's *Tetrad Series* is at once teasing and opaque. He juxtaposes shots of Cary Grant's partially cut-off head, or a shoe pressed down on fingers clutching a cliff's edge, with images from Goya and other, less identifiable sources. They seem wilfully arcane, and far less haunting than Victor Burgin's multi-panelled photo-text work called *The Bridge*. His starting-point is *Vertigo*, with James Stewart pursuing Kim Novak through San Francisco. But by the time Burgin has introduced his own obsessions, the elusive blonde is transformed into a shop-window mannequin drifting, like Millais's Ophelia, on a water-borne bed of flowers and cellophane.

Hitchcock's weirdest moments seem able, in their turn, to bring artists out in a rash of their own peculiar fixations. David Reed stages a three-dimensional reconstruction of Scottie's bedroom in *Vertigo*. Rumpled by recent use, the bed itself is placed in the gallery with a strangely hectic abstract painting on the wall above. It is a canvas by Reed himself, who confesses his ambition to be 'a bedroom painter' on a nearby videotape. Then, using digital manipulation, he inserts the same painting into a clip from *Vertigo*, hanging over the pillows where Kim Novak lies exhausted and apprehensive.

This desire to invade Hitchcock's films, alter them and come up with a different source of anxiety recurs throughout the show. Cindy Bernard, in thrall to the forest scene from *Vertigo*, projects slide images of tall, shadowy trees on to three screens suspended in the darkness. We wander among them, gazing up at their ancient trunks and searching for traces of human presence. But the forest, lit by hallucinatory colours, is empty. We are left with disappointingly bland landscapes, too far removed from the hypnotic world of pursuit and suspense explored by Hitchcock himself.

Upstairs, in the otherwise deserted vastness of the Piper Gallery, Stan Douglas redresses the balance. On the far wall his weird, soundless homage

to *Marnie* is projected. Shot in fuzzy black-and-white and stripped of dia-logue, it reminded me of the silent films that must have nourished Hitchcock's cinema-going in his London boyhood. Many of his finest sequences are purely visual, freed from dependence on speech of any kind. Douglas subjects us only to a loud, oppressive hiss on the soundtrack, as he recreates Tippi Hedren's robbing of the office safe. It adds up to a desolate experience, shot in such an ominous way that I half-expected Douglas's camera to find corpses behind each of the desks it roams around. Endless repeated on a loop, his film is like an insistent dream that refuses to let go of your feverish mind.

From then on, the Oxford survey penetrates even further into the most bizarre recesses of Hitchcock's imagination. Girardet and Müller return, this time with a crisply edited compilation focusing on his treatment of women. It starts quietly, concentrating on lonely figures marooned in rooms. But soon, after a flurry of hungry embraces with men, their melancholy moods turn into tears, hysteria and a final salvo of struggles, screams and stranglings. The last shot, a woman's lifeless arm flopping from the bed as bracelets clatter on her wrist, is among the most rasping images in the show. This is Hitchcock in the raw, freed from over-exposure and presented to our startled eyes as if for the very first time.

The dangling arm also prepares us for Cindy Sherman, whose early *Untitled Film Stills* are saturated with unforced references to 1950s Hollywood and Hitchcock in particular. Small, black-and-white and fea-turing the young Sherman in a variety of subtly dramatized guises, they are devoid of violence. But her later colour photographs are saturated with death. The most alarming settle on close-ups of hands or feet lying inert and muddy in woodland locations. Reminiscent of Géricault's grisly painting of severed limbs, they also show Sherman's determination to vie with Hitchcock at his most gruesome.

The final barn-like room, divided into a series of dim chambers, restores the primacy of the moving image. Wandering through these interlinked spaces is like being assaulted by Hitchcockian images at every turn. Judith Barry focuses on the most voyeuristic side of his work, in a quirky colour video called *Casual Shopper*. A man and a woman stalk each other, with mounting erotic intensity, through malls where fruit is heaped in orgiastic abundance and sex magazines are waiting to be savoured. Even though the man sports an oddly repellent moustache, the woman finds him magnetic. They make love, but in a desultory manner far removed from Hitchcock's usual insistence on voracious desire.

Pierre Huyghe goes much closer to the movie he admires, producing a 16mm film version of *Rear Window* called, bluntly, *Remake*. The 100-

83. Judith Barry, *Casual Shopper*, 1980–1 (detail)

minute outcome is as matter-of-fact as its title, turning the chairbound James Stewart character into a younger, scruffier man with stubble and tousled hair. In terms of age, he is more suited to the role than the silver-haired Stewart. But he looks strangely stoned, and the equally amateur woman playing Grace Kelly's part is as stilted as the English subtitles. I see little point in such an elaborate exercise. It has the air of Hitchcock seen through Godard's viewfinder, and compares poorly with the sustained tension generated by *Rear Window* itself.

Hitchcock is such a consummate image-maker that he remains hard, if not impossible, to compete with in a full-length feature. Better by far to adopt Atom Egoyan's approach, and direct an independent thriller with Hitchcockian references. That, at least, is what he intends with his yet-to-be-released *Felicia's Journey*. Egoyan made extracts from this film into a nineteen-minute video installation for the Oxford exhibition. Based on outspoken taped interviews with a serial killer's potential victims, it is sufficiently distant from Hitchcock to assert a documentary-style identity of its own. Once we realize that all these young women are being filmed by a murderous voyeur, though, their outpourings take on a macabre dimension.

When Douglas Gordon decided to make his classic *24 Hour Psycho*, installed here on a giant, walk-around screen hanging in the centre of its space, he had the good sense not to tamper with the film itself. Slowing *Psycho* down to such an arduous length, so that even the shower scene lasts an agonizing three hours, is transformation enough. It demands patience, of course, and the drawn-out unfolding may well seem unbearable. But if you resist the longing to blast it with a fast-forward button, this astounding work gradually exerts its fascination.

Gordon makes us realize how austere Hitchcock was, for all his love of occasional, shock-horror showmanship. Moment after slow-burning moment is defined on the screen with stark, disciplined authority. And when the pace suddenly quickens, as Anthony Perkins stops his seemingly endless close-up monologue and runs through a doorway towards the staircase, we find ourselves pitched into a sequence as saturated with dread as the original. *Psycho* emerges from this exacting ordeal with its allure intact. Like all the shrewdest artists in this inexhaustible show, Gordon cleanses our vision and enables us to wonder at Hitchcock's spellbinding menace all over again.

VISITING MICHAEL RAEDECKER
20 September 1999

Two large hooks hang down from the rafters of Michael Raedecker's white-walled London studio. They look disconcerting at first, and give his room the air of an abattoir. But no carcasses dangle in this luminous space. Instead, Raedecker suspends his paintings from the hooks, so that he can work on them with needle and thread. Embroidery, for this highly individual artist, is an integral part of the paintings he makes. And the results are so impressive that Raedecker has just won the coveted John Moores Prize, a £25,000 award to be handed over on Thursday at the Walker Art Gallery in Liverpool. As a judge of the 1999 Prize, I am delighted with the painting Raedecker submitted. The largest he has yet produced, *Mirage* was the outcome of 'a very intense period, when I worked long hours, every single day, for about four weeks. I saw it as a challenge to finish that painting for the John Moores deadline.' Raedecker's strenuous commitment paid off. *Mirage* had to compete in open competition with well over 2,000 other paintings sent in for the Moores this year, but it

84. Michael Raedecker, *Mirage*, 1999

stood out at once. Both I and my fellow judges – Germaine Greer, for-
mer Moores prize-winners Mark Francis and Dan Hays, and the new
Director of Sydney's Museum of Contemporary Art, Elizabeth Ann
Macgregor – were overwhelmed by the avalanche of entries. Painting,
far from being dead, seems to enjoy boisterous health at the century's
end. But our exhaustion was offset by the excitement of encountering
submissions as outstanding as *Mirage*.

Raedecker invites us to roam across the panoramic width of this
painting, as if we were travellers undertaking an epic journey. But the
landscape unfolding in *Mirage* is a desolate locale. No one seems to
inhabit this parched country, and there are few signs of vegetation. Plants
are limited to the base of the two main trees, while their trunks and
branches are as stripped as the bare, stricken woods in Paul Nash's paint-
ings of First World War battlefields. Strange, glittering deposits, where
Raedecker has applied sequins, counter the bleakness and even make this
empty terrain seem beguiling. But the longer we gaze at *Mirage*, the less
anything makes sense. Take the thin shadows cast along the ground by
both trees. They are contradicted by two more shadows, running up the
trunks and destroying the illusion of perspective. Raedecker appears to
be suggesting that the entire landscape is as flat as a piece of painted stage
scenery. He puzzles us even more on the right, where the ground curves
like a wave and, as though shaken by a seismic tremor, turns upside-
down. The violence of this upheaval is ominous, indicating that the
world has suffered a catastrophic convulsion.

Raedecker, for his part, is buoyant and 'really surprised' that he won the prize. He may put the money towards buying a house: 'I'd like to find something much bigger than my flat in Vauxhall – a warehouse or an old, empty pub which I could work on myself.' Although he grew up in his native Holland, training initially as a fashion designer, Raedecker has lived in London for the last three years. He came here to take an MA in Fine Art at Goldsmiths College. 'London was at the centre of all the media attention about art,' he recalls, 'and Goldsmiths made me more self-assured – I wasn't fully grown-up before then.' He still enjoys London enormously: 'So many things are happening here, it's so huge and overwhelming. I don't miss Amsterdam – when I go back there, it seems like a combination of Walt Disney and Club Med.'

His great-grandfather, John Raedecker, was the sculptor responsible for the prominent National Monument in the centre of Amsterdam. It was a prestige commission at the time, and Michael's work, in turn, is beginning to receive official recognition in Holland. He has already won a Royal Painting Prize in Amsterdam, and Queen Beatrix has bought two of his paintings. Other Dutch collectors have acquired his work as well, but none matches the enthusiasm of Charles Saatchi, who now owns 'at least 13 of my paintings'.

Raedecker is a restless, energetic thirty-six-year-old. Tall, slim and constantly making dramatic hand-gestures to back up his remarks, he never once sat down during the afternoon I spent in his studio near Tower Bridge. Several haunting images hang on his walls: a lonely rural house half-submerged in floodwater, an eerily deserted white bedroom, and a few small heads of old men lost in contemplation. Their faces all seem melancholy, but Raedecker himself is the very opposite of uneasy. Open and confident, he has no time for Charles Saatchi's insistence on calling him a Neurotic Realist. 'I hope that Saatchi will give my work another name,' he says. 'Nobody knows what Neurotic Realism is. It's fabricated. I don't think it's the title of a real group of artists – it's like Pepsi-Cola, it doesn't mean a thing.'

What, then, is the springboard for images as bewitching as *Mirage*? 'I like seventeenth-century Dutch landscapes, the ones with mountains,' he explains with an ironic smile. 'But my own work starts like a dream. I'm fascinated by the fact that landscapes were there long before we came along. *Mirage* is about seeing something that's an optical illusion. It's all fake, and I make my art ambiguous so that viewers can complete the paintings in their own minds. But people often tell me that my images derive from Australia or locations they've seen in films. I was on holiday in Spain recently, and my girlfriend kept saying: "Look, there's one of your landscapes."'

The thread plays a paradoxical role in his work. It emphasizes the artificiality of a painting and, at the same time, 'makes certain details stand out. To me, using thread seems such a natural thing to do. After all, there's a very old tradition of artists designing tapestries.' But Raedecker is also aware of the risks involved in giving thread such prominence in his work. While hovering dangerously near the borders of craft and folk art, he knows precisely where to stop and how to play off the thickness of embroidery against the thinness of his acrylic paint. 'If I used any more thread in a picture', he says, 'it might become kitschy.'

Raedecker also stops short of introducing figures to any of his landscapes or interiors. 'If I put one of my sad old men into a painting of a room, it would leave the viewer out,' he explains. 'When a room is empty, the viewer can step into it. But when someone's already there, the painting becomes too close to narrative.' Raedecker wants his work to retain a vital sense of mystery, and he seems completely absorbed by the tantalizing images conjured in his work. 'I cherish being in my own private space,' he admits. 'I really like going to the studio every day, and feeling that I can do whatever I want. But I always have music on, and I make it myself, sampling modern and old, rock'n'roll, classical, hip hop. When you're in the studio, you must be careful not to shut off the rest of the world completely.'

THE TURNER PRIZE 1999
20 October 1999

Never shy about exposing her own messy life, Tracey Emin now invites us into her bedroom. At the centre of the opening space in the Tate's new Turner Prize show, her double bed is displayed in a shamelessly rumpled state. Unlike Emin's notorious tent, which visitors could enter to inspect the embroidered names of 'everyone I have ever slept with', the bed cannot be climbed into. But once we have walked round it, any urge to lie down there quickly evaporates. The sheets are discoloured by murky spillages, while the torn pillows ooze feathers. As for the heap of belongings dumped on the floor alongside, they are frankly repellent. No knickers could be more darkly stained, no ashtray more befouled with cigarette butts. Even the slippers look squalid, and the fluffy dog seems defiled by the scattered pills and mouldy toothbrush nearby. The entire

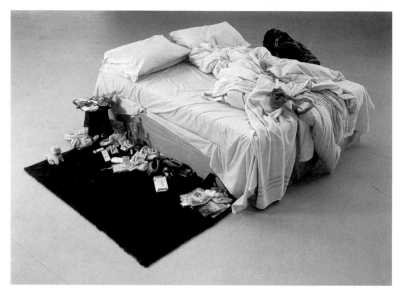

85. Tracey Emin, *My Bed*, 1998

deposit appears to be festering, but Emin has no qualms about revealing its manginess. In her work, all English inhibitions are flung away. With a frankness she may well have inherited from her errant Cypriot father, Emin has already described in mortifying detail her 1990 abortion and the rape she suffered at the age of thirteen. Memories of her gruelling girlhood in Margate continue to feed the appliqué blankets and spidery, expressionist drawings she produces today.

Such a confessional approach could easily be mawkish or self-pitying. But Emin, even as she discloses her vulnerability, toughens her work with a welcome strain of defiance. In the second room, a video called *Why I Never Became a Dancer* makes powerful use of traumatic spoken memories accompanying blurred, hand-held footage of Margate revisited. While we glimpse sand, sea and the Lido Leisure Centre, Emin's voice-over recalls how her attempt to win a dance contest was wrecked by 'a gang of blokes, most of whom I'd had sex with at some time or another'. When they all started shouting 'slag' at her, she ran off the dance floor and escaped to the beach. But instead of ending on a tearful note, Emin tells us that she left Margate and the video shows her dancing alone with wicked delight on her face.

It would be a pity if Emin's notoriety prevented the other shortlisted Turner artists from receiving the attention they merit. Jane and Louise Wilson are showing the latest of their highly impressive installations, and it repays close scrutiny. A single viewing of this carefully structured four-screen work, shot on 16 mm film and then transferred to video, cannot yield up its full, multi-layered complexity. Once again, the twins take us on a disconcerting journey through a sequence of interiors. This time, the location is Las Vegas rather than the disused Stasi head-quarters or the echoing redundancy of Greenham missile base. But the kitsch extravagance of Desert Inn and Caesar's Palace turns out to be equally macabre. Filmed in the early morning at so-called 'graveyard time', before even the most addicted gambler is able to penetrate the premises, these garish temples have an eerie stillness. Precisely because everything they contain is aimed at enticing the customer, the deserted casinos seem futile. Their strident patterned carpets look preposterous, and the gleaming machinery has a melancholy air. The Wilsons' cameras glide seductively over the stacked gaming chips and immaculate baize tables. They show hands expertly shuffling and fanning cards out, thereby promoting a momentary illusion of business as usual.

But then, without warning, they cut to the gloomy underworld of the Hoover Dam. Its claustrophobic tunnels reminded me of the subterranean spaces in their exploration of Parliament earlier this year. This time, however, their cameras travel on to the very heart of the dam, housed in an interior as lofty and awesome as the old Bankside Power Station. The forbidding immensity of the architecture, no less than the machinery housed there, reflects the life-or-death importance of the Hoover complex. For Las Vegas relies on the dam's water supply. Without it, the city would quickly perish. So when the Wilsons return to the casino at the end, the silent emptiness takes on a more ominous character. However many lights flash from the unmanned slot machines, their inactivity seems to issue a warning that catastrophe might one day overwhelm this citadel of rampant excess.

The laundromats in Steven Pippin's exhibits are equally moribund. Only one figure can be detected moving through each sequence of circular images, as if on a nocturnal security patrol. There, however, any resemblance to the Wilsons' work stops. While they take advantage of the latest sophisticated developments in multi-screen video transmission, he returns with single-minded eccentricity to the origins of photography. His equipment is rudimentary, and he takes a perverse pleasure in turning washing-machines into cameras. Pippin recaptures the pioneering spirit of early photographers who, like Fox Talbot in rural Lacock, struggled with the technical deficiencies inherent in a new-born medium.

He is a curious artist, who thrives on setting up unnecessary obstacles for himself. Conquering them presumably gives him enormous satisfaction. But the wry humour in the title of an early work, *The Continued Saga of an Amateur Photographer*, hints at self-mockery, too. He persists nevertheless, and his Turner exhibits consist of four elaborate works produced in 1997 with a New Jersey laundromat as his unprepossessing location. Each contains a sequence of twelve black-and-white photographs. We see him walking past the scratched machines dressed only in underpants, as pale and indistinct as a wraith who haunts the building at night. Then he appears clothed in a formal suit, but now his body is moving backwards. His coolness masks the calculation involved in executing this manœuvre, for Pippin triggered each of the twelve machines by activating trip-wires as he passed. The same feat was performed running, but on this occasion he looks more like the uneasy target of riflemen who use the laundromats' glass doors as ready-made viewfinders. The analytical detachment of these images promotes the idea that Peppin may be a victim watched by an unseen killers. But they also pay overt homage to another great photographic pioneer: Eadweard Muybridge, whose seminal stop-action studies of *Animal Locomotion* have stimulated artists in so many ways throughout the present century.

Although the admirable Steve McQueen has recently started experimenting with still photography, his first allegiance lies with film. Like the Wilson twins, whose debts to Hitchcock and Kubrick are openly declared, he takes as his starting-point in *Deadpan* a Buster Keaton stunt from a 1928 film called *Steamboat Bill Jr*. And like Pippin, he uses himself as the absurd yet resilient figure who makes no attempt to escape from a falling house. McQueen fills the end wall with *Deadpan*, making viewers feel that the house is descending on them as well. It pitches forward with frightening speed and heaviness, accentuated by McQueen's decision to film the event from several different vantages. Repeating the fall serves to increase our respect for the man who defies it. He knows that the blank window will save him, by passing neatly over his head and crashing at his feet. But his refusal to do anything except blink still seems laudable, and the film terminates with McQueen's steady, impassive face staring out stoically from the screen. Without indulging in Hollywood heroics, he seems braced to endure adversity with calm, stubborn resolve.

The relentless downward movement of *Deadpan* is reversed in his new film, *Prey*. It looks earthbound at first, as an anonymous hand switches on a two-spool tape machine resting in the grass. After *Deadpan's* arresting silence, the sound of tap dancing comes as a shock. And just as we begin to wonder why McQueen fastens up the tape, the entire machine

is suddenly hoisted into the air by a white balloon. With dizzying speed the grass becomes open fields, and then we find ourselves surrounded by sky as the balloon takes its strange cargo higher and higher. The unlikely sound of airborne tap dancing grows faint, as the machine threatens to vanish in the void. But it never quite disappears, and in the end plummets back to the ground with an inconsequential bump. We should be left with a feeling of bathos. Against the odds, though, *Prey* generates a lasting sense of suspended exhilaration. Just as Emin asserts her undaunted determination to keep on dancing, McQueen affirms the artist's insistence on letting the imagination take flight.

GARY HUME
8 December 1999

Walking into Gary Hume's new exhibition is like entering a sublime, luminous cathedral. The traffic-crammed mayhem of Whitechapel High Street is banished at once. In its place, we find ourselves moving through a lofty, nave-like space flanked by colossal paintings of angels. Their size could easily make them ponderous and overbearing. But Hume's angels, each confined to a head alone, seem weightless. They hover on the surface of their aluminium panels with an almost disembodied poise. And the shimmer of the household gloss paint, bouncing at every turn with reflected light, adds to their airborne *élan*.

Having first ignited our interest a decade ago with severe abstractions, based on the forbidding geometry of hospital doors, Hume might appear to have escaped from the sickbed and glided up to heaven. These new paintings seem to rejoice in their buoyancy, their release from all gravitational constraints. The progression through the 'nave' reaches its climax in an exclamatory painting called *Yellow Angels*, suspended from the ceiling in front of us. Hume's decision to detach the panel from any wall-support accentuates its free-floating brio. A host of angels cluster here in ecstatic profusion, merging with one another at the centre of this clamorous panel.

Its springboard was an encounter with Oscar Niemeyer's modernist cathedral in Brasilia, where angels fling themselves across the raw concrete ceiling. But Hume is an artist far removed from catholicism at its most triumphal. The longer we spend with his paintings, the less straightforwardly they relate to the notion of a blissful afterlife. The figures in *Yellow*

Angels are reduced to contours alone, and depend for their vitality on the restlessness of purple lines flowing over a sun-saturated ground. As they converge in the middle, their bodies become enmeshed in a tangle that has little to do with a believer's view of Christian heaven. The lines detach themselves from the angels' contours and acquire an aggressive life of their own. They appear to be tied around several bodies, imprisoning them rather than defining their ability to glide, swoop and soar through space. At the very centre, Hume's linear play grows chaotic, suggesting furious conflict rather than divine bliss. Individual angels are impossible to make out in the blizzard of contours, where *joie de vivre* gives way to an irksome feeling of entrapment.

A harder look at the paintings on the side walls reveals a similar malaise. Despite the sensuality of their liquid handling, these blown-up heads are far from blithe. One, entitled *She*, is smothered in blackness, from which her features slowly emerge like an impassive mask with blank, unfocused eyes. It is a suffocating image, and the *Large Angel Head* paintings nearby are no less disquieting. One of them is stretched and distorted to the point of unrecognizability. Her face has been pulled and twisted with alarming violence. She could never be accused of blandness, and none of the angels assembled here promotes the ideal of heavenly equilibrium. Rather do they resemble the denizens of Purgatory or Hell. Even their freedom from corporeal substance begins to look oppressive. They could almost have been inspired by the title of Milan Kundera's *The Unbearable Lightness of Being*, and one *Large Angel Head* allows a dark blue mouth to swell like a grotesque bruise across her pale puce flesh.

Hume's detractors, who accuse him of being a mere purveyor of prettiness, have never looked at his paintings properly. He may be fascinated with the idea of surface, where the shiny DIY paint is allowed to spread like a thin layer of skin. But his exploration of emptiness should not be confused with vacuity. It arises instead from an acute awareness of vulnerability, along with a realization that hollowness may lurk behind the most decorative and beguiling façade. Hume can be guilty of superficiality: a painting called *Blackbird* has been inserted very oddly among all the angelic images, and it amounts to nothing more than an inflated, simplified version of an illustration in a nursery-rhyme book. For the most part, though, the images with the sweetest initial appeal turn out to harbour a bitter aftertaste.

At the top of the Whitechapel staircase, a painting of a boy gazes eagerly down at us. He leans forward, peering with blue eyes beneath a crop of fair hair. Like many of Hume's images, he derives from a newspaper photograph. The boy in the original picture was deaf, and must

have aroused compassion when seen on the page. Hume, however, forces him to undergo a disturbing transformation. His face has turned pale blue, as though the colour had somehow run over his flesh from the striped pullover he is wearing. His cutely shaped lips are black, and a gash of scarlet opens like a wound beside his right ear. Still more weird is the area of silver gloss formed into a shining halo around his head. *Messiah* is the name given to this deceptively innocent apparition, but he looks more like a sulphurous messenger from Satan.

By no means all the paintings upstairs are as disconcerting as *Messiah*. A frankly ornamental work called *Birdsong* has the exuberance of the stained-glass windows in Matisse's sublime Chapelle du Rosaire at Vence. And a notably purged portrait of *Lady Parker (After Holbein)* sounds a rare note of absolute serenity. On the whole, though, unease continues to prevail. Two small angel paintings are even more discordant than their monumental counterparts downstairs. Their mouths part in Bacon-like screams, envenomed by the rasping colours deployed in *Angel Fuchsia World*. Hume restricts himself to black, white and pale brown in the other Angel picture, giving her a funereal air. She looks inconsolable, and a fissure running down from forehead to jaw suggests that her entire face may be about to crack open.

Much of the upstairs space is devoted to the *Water Painting* series executed earlier this year. They provided Hume's show at the Venice Biennale's British pavilion last summer with a compelling first room, at once seductive and perplexing. Here they seem at first the most idyllic works on view. Images of young, naked women, reduced to their most refined linear essence, multiply and overlap until they bewilder the viewer. They look like reflections undulating in a river where cross-currents frustrate all attempts to form coherent images on the water's surface. In one sense, the perceptual confusion only adds to their allure. With faces as expressionless as models on a catwalk, these shimmering goddesses are delectable enough. Hume makes sure, in several of the paintings, that the reiteration of nipples is as mesmeric as ever-multiplying eyes. These sirens are bewitching as they beckon us into their liquid world. But their passivity is disturbing as well. They could easily be inert, sinking beneath the water like drowning bodies. When Hume interweaves them with long, straggling foliage, it clings to their limbs. Memories are stirred of the demented Ophelia drifting, flower-strewn, towards her grave.

The melancholy undertow is unmistakable, the work of an artist who once painted an image of Kate Moss with obliterated features. However irresistible Hume may be, he is ultimately as death-haunted as Damien Hirst, Rachel Whiteread and other young British artists whose concerns are

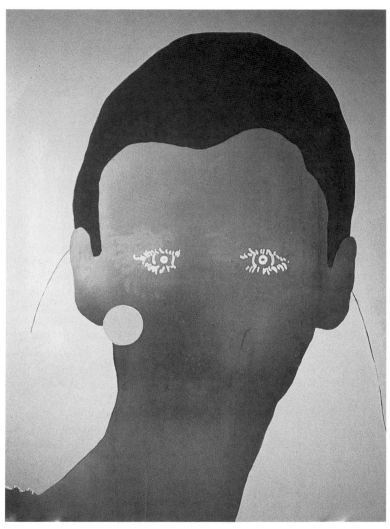

86. Gary Hume, *Cerith*, 1997

supposed to be far darker than his. Do not be deceived by the captivating sheen of these images. Although they are a tonic to behold, their fundamental preoccupation is with frailty and loss. Look at the portrait of *Cerith* on the end wall upstairs. It seems jaunty to begin with, set against a brilliant yellow ground. Both eyes are flecked with the same zestful colour, and the hair above is an enticing rush of blue. But the face itself has been reduced to an all-over grey, and Cerith's nose, mouth and chin are all missing. For all its vivacity, this is a painting of a spectre already fading from sight.

HEAVEN

15 December 1999

Lamented by the Bishop of Liverpool even before it opened, *Heaven* has got off to a thoroughly sacrilegious start. No trace of angels can be detected in an exhibition that promises, in its provocative subtitle, to 'break your heart'. As for God, he has been banished from the Tate building and marooned outside in Albert Dock. Here, buffeted by rain and formidable winds, he extends white-robed arms in benediction. But there is no suggestion that he is walking on water. Instead, the fibreglass figure relies for support on a sturdy, matter-of-fact pontoon.

Inside the gallery, this spirited international show brings heaven right down to earth. Naomi Campbell, Kate Moss and Marilyn Monroe enjoy prominent positions, but the traditional saints are nowhere to be found. At first glance, Olga Tobreluts seems to display a reproduction of a Renaissance St Sebastian. But she has used computer techniques to replace Sebastian's head with Leonardo DiCaprio's. Although arrows still pierce his flesh, the Hollywood actor looks unperturbed by martyrdom. And his loincloth has been turned into crotch-hugging briefs signed, very prominently, by the fashion designer Thierry Mugler.

All the old divinities are ousted from this profane paradise. In their place, a gaggle of rock stars, movie idols and supermodels enjoy a secular apotheosis. Far and away the most gaudy is Michael Jackson, transformed by Jeff Koons into an all-white, red-lipped ceramic statue with gilded hair. Hugging an equally white-skinned ape called Bubbles, he is the gleaming embodiment of kitsch. The result looks so shamelessly garish that it becomes risible, but Jackson's cult following is real enough. Elsewhere a glittering rhinestone stage glove, 'thought to be worn by

him at 1984 Grammy Award Ceremonies', is isolated in a showcase like a saint's precious relic.

No wonder Ron Mueck's *Big Baby 3* appears so aghast. Crouching on the floor in a thick nappy, the pudgy infant stares up at the other exhibits with an air of dismay. His mouth drops open and eyes widen in astonishment. For the world he has so recently entered is filled with adoration bordering on madness. Ralph Burns defines the hysteria in *How Great Thou Art*, a series of black-and-white photographs taken between 1978 and 1998. Focusing on the Elvis Presley Memorial Day, held each year at Graceland, he shows a middle-aged woman kneeling and weeping by the heaped floral tributes. Ardent fans thrust candles into the air at a nocturnal service. But the most macabre image reveals a bloated woman sitting in melancholy vigil beside a bed, where an Elvis mannequin has been lovingly covered in a blanket.

So far, Presley mania shows no sign of diminishing. But other current idols represented here, including Linda Evangelista and Claudia Schiffer, are unlikely to last as long in the popular memory as their biblical counterparts. Diana, Princess of Wales has already lost the intense level of public emotion aroused by her untimely death. She appears here as a full-length limewood madonna, dressed in flowing draperies fit for a devotional statue. But she looks strangely pallid, wholly lacking the charisma exerted by Diana herself. Hands clasped limply in front of her, she gazes upwards with a hesitant expression. The figure has been carved by Art Studio Demetz from the Dolomites, who produce religious images for Catholic cathedrals across the world. However professional the Diana sculpture may be in execution, though, it lacks any inner conviction. The statue amounts to nothing more than a stunt, demeaning the woman it is supposed to elevate.

The show becomes more convincing when it moves away from mawkish attempts to deify celebrities. The Princess of Wales reappears in Karen Kilimnick's little painting called *Princess Di, That Dress*. But the modesty of this swiftly brushed canvas works in its favour. Kilimnick does not disguise her indebtedness to a newspaper photograph, taken from above to emphasize the subject's cleavage. Diana is no more exalted by Kilimnick than the omnipresent Leonardo DiCaprio, seen in another of her paintings as a fresh-faced teenage heart-throb grinning in a fanzine. So far as millions of hormonal girls are concerned, he is indeed a denizen of heaven. But in this instance, the word carries no religious connotations at all.

Nor does the word beauty, at least when it is applied to Kirsten Geisler's outsized, computer-animated face of a virtual woman. She stares straight at us, albeit in a completely impersonal way. Her head is shaven,

her features idealized, her skin blemish-free. Geisler calls her *Dream of Beauty 2.0*, and a nearby caption encourages us to clasp a dangling microphone and ask her 'a short question'. I did so, inviting the enigmatic presence to tell me who she was. After a pause, she raised her perfectly formed eyes to the ceiling, nodded, laughed and said: 'talk with me' in a robotic, speech-processed voice. There was clearly no point in persisting with the conversation.

Dreams, nevertheless, refuse to go away. They resurface in Mariko Mori's epic cibachrome print, unfolding a Japanese beach panorama as impeccable, in its way, as Geisler's tantalizing personification of beauty. The pale sand could not be more spotless, and the sea offers a miraculously unpolluted idyll for the swimmers floating there under a flawless sky. Mori herself uses digital editing to appear as a mermaid no less than four times. She arouses remarkably little interest among the sunbathers. Nothing disturbs the holiday Eden, yet the entire scene is artificial. The sky turns out to be a colossal photographic backdrop, and the beach is illuminated by an even larger skylight. Mori calls the image *Empty Dream*, summing up the deceptiveness of a world where simulation can be more alluring than nature.

Because we live in an age of rampant technological fantasy, it is increasingly difficult to tell where dreams end and reality begins. Anneke in't Veld explores this slippage in her handsome photographs, where male and female bodybuilders brandish swollen biceps and transvestites mingle with transsexuals in gender-bending tableaux. Whether strutting in leotards or posing piously against ecclesiastical architecture, these well-honed specimens evade any attempt to pin down their defiant identity.

But at least their bodies are still visible. Justen Ladda taunts us further by presenting four exquisitely crafted dresses in a glade of ferns. They look, initially, as if people inhabit them. Then we realize that they are all headless, and that nobody lurks inside the scintillating surfaces where steel, oil paint and acrylic are so cleverly blended. A similar sense of vacancy pervades Jean-Michel Othoniel's versions of a titanic necklace. All made of glass, they hang expectantly from ceilings at various points in the show, as though waiting for a giant owner to claim them. One is called *Le Collier Infini*, but it failed to stretch my imagination in a limitless way. So did *Le Collier Sein*, where each fat white bead sprouts several pink nipples.

Othoniel's necklace-wearing super-race is the product of simple-minded indulgence, whereas Yinka Shonibare's *Alien Obsessives* turn out to be rewardingly complex. In one work, Mum, Dad and the kids all stand swathed in African-style fabrics made in England. Sprouting antennae, their distorted bodies look utterly bizarre. Against the odds, though, they seem harmless rather than menacing. Their status as a family is reassuring.

87. Yinka Shonibare, *Alien Obsessives, Mum, Dad and the Kids,* 1998

And the ironic African reference suggests that the word 'alien', for Shonibare, does not apply solely to science-fiction scenarios. It also indicates an awareness of people who find themselves marginalized and victimized by societies where they can easily become targets for persecution.

Such multi-layered work is infinitely preferable to exhibits that wallow in a saccharine notion of heaven. Wang Fu's *Under the Stars* is intolerably cute, laying a dozen prettified babies on beds across the floor. There they sleep, beneath duvets spattered with cockatoos, flowers and butterflies. It is a cloying spectacle, and my sceptical mind responded far more to Tony Oursler's *Separation.* Isolated in a tank of clear liquid, a wooden ovoid lies on its side. Video projection then transforms it into a man's face, frowning and muttering like a perplexed character in a Beckett play. On the walls behind, a headless male nude stretches and struts before going into manic, speeded-up motion. The absurdity of *Separation* is much nearer my jaundiced attitude to heaven than any amount of sanitized superstars or muscle-bound exercise freaks. Oursler's decapitated man looks frightened, baffled, helpless and above all astounded, as he ponders his mortal fate in a godless universe.

STAYING POWER

BILL WOODROW
18 January 1990

A bronze soldier sprawls near the entrance of Bill Woodrow's hard-hitting new exhibition at the Imperial War Museum. From one side, the red bullet-hole which ended the figure's life seems neat enough. But a walk round the sculpture discloses a far messier sight. For the seemingly innocuous bullet has smashed his stomach open, making his black entrails tumble out and undulate across the floor. There they form themselves into the words 'Mum & Dad', as if the dying man's thoughts of family had left a yearning farewell behind.

Point of Entry, the sculpture's sardonic title, is also the name Woodrow has chosen for the show as a whole. It implies that his own starting-point was an awareness of war's human cost, and everything else displayed here reinforces that fundamental priority. Like Paul Nash before him, he uses amputated trees as symbols of the people felled in battle. One sculpture concentrates on the bandaged stumps of a trunk and branches, with a glass axe propped against them. Green leaves sprout from the uppermost limb, giving momentary cause for hope. But a closer look reveals a caterpillar wriggling towards these juicy shoots. They will be devoured as summarily as the cripple in *For Queen and Country*, who leans on his crutches beside a discarded sword. Instead of a face, he exposes a blood-red gash, and neither of his arms terminates in a hand. The gold letters lined up alongside the blade spell 'reminder', a word which could well define Woodrow's overall intentions. For sculpture is here turned into a warning, and his reference to the Queen indicates that war poses as much of a threat now as it did in 1914.

Invited by the museum to respond to the collections it contains, Woodrow refused to see war as something safely sealed away in history. The wounds it has inflicted during the present century have not healed, and he deliberately reopens them in a section devoted to his choice of pictures from the collection. Hung in pairs, these largely unfamiliar images often work by ironic contrast. Gaudier-Brzeska's poignant drawing of St Sebastian, martyred by a modern firing squad, is juxtaposed with a bland picture of women smiling as they tend a military graveyard. Time and again, artists' attempts to anaesthetise violence or pain are undermined by Woodrow's selection. Sandys Williamson's absurdly mystical drawing of a surgical operation is displayed next to a little painting of a hospital interior, where soldiers' fearful mutilations are undisguised. Nearby a sleek portrait of an impeccably tailored general is paired with

88. Bill Woodrow, *Point of Entry*, 1989

Nevinson's *A Taube*, dominated by the broken body of a child lying in a bombed-out street.

But perhaps the most disturbing reflections are prompted by Frank Brangwyn, who in May 1915 drew a design for the Kitchener Appeal. Sold by auction at the Red Cross Gift House, it shows working men volunteering for the army in response to a handwritten letter by Kitchener himself, framed at the centre of the drawing. 'The time has come,' it announces, 'and I now call for 300,000 recruits to form new armies.' Next to this ominous message, which reflected the dramatically rising death-toll at the Front, Woodrow has hung a crisp Lutyens drawing for the Cenotaph inscribed 'The Glorious Dead'.

There is nothing glorious about the view of war presented in Woodrow's own work. His use of bronze marks a startling new departure for a sculptor whose reputation is based on the resourceful transformation of found objects, from discarded washing-machines to battered car bonnets. Far from seeking to dignify his exhibits with a time-hallowed material, though, Woodrow employs bronze ironically. It is, after all, associated with war memorials, and he attempts throughout the show to question the vision of war promoted in the majority of those reverential monuments. *Refugee* includes a miniature reference to just such a memorial, nestling in a handcart along with an equally diminutive tank.

But they are both menaced by the gleaming Zeppelin overhead, bearing the words 'Good Year' as it hovers to take aim. Down below, the cart has been abandoned by its owners. Their fate is signified by the blood pouring from an axle on to the detached wheel lying nearby. Its rim serves as a container for the coagulating liquid, whereas the blood rushing from one of the cart's handles spreads more freely into a palette-shaped configuration.

Refugees never feature in conventional war memorials, which restrict their attention to soldiers alone. But Woodrow implies that civilians, whose homes and lives were often destroyed, deserve to be remembered just as much as members of the armed forces. In England, where the savagery of military occupation has not been experienced for centuries, the refugees' plight is often overlooked. Woodrow's decision to mourn them here is refreshing, and emphasises his desire to move beyond an insular view of war. Although the title of *For Queen and Country* suggests a specific reference to the Falklands campaign, the rest of the exhibits could apply to any nation embroiled in conflict. The ravages inflicted on countries by invasion or internecine disputes all end up taking a horribly similar form, and an outstanding sculpture called *Un Till The Land* concentrates on their inevitable outcome.

The skeleton of Death, who appears in so many traditional denunciations of war, is here ingeniously transformed into a plough. His wiry body hangs over the ground like a hovering agent of destruction. The tipsy tilting of his wheels does nothing to detract from the single-mindedness of this apparition. They reinforce the frenzied zeal with which he carves into the earth, gripping the sculpture's title like an emblem of ferocity between his teeth. As its words indicate, no crops are being nurtured by this skeletal intervention. Death is ensuring that the natural cycle of growth is disrupted by the weapon he slices through the fields. The fractured terrain is reminiscent at first of the shell-blasted landscapes familiar from elegiac images of the Great War. But then the furrows seem to form themselves into an outflung soldier's cloak – as though its owner's body beneath had already been pressed deep into the soil.

The Imperial War Museum's Keeper of Art, Angela Weight, should be congratulated for initiating this bold and imaginative show, which has stimulated Woodrow into extending his sculptural range with compassion, anger and alert inventiveness. He challenges every visitor to appreciate how, behind all the awesome weapons and trophies displayed elsewhere in the collection, there lies a suffering so vast that it only becomes finally comprehensible through art.

THE 1990 VENICE BIENNALE

7 June 1990

From the moment you take a *vaporetto* trip in Venice this summer, Jenny Holzer fiercely demands your attention. The wall-piece she had installed in my water-bus presented her work at once at its weakest and most compelling. One flanking panel of the triptych, repeated in German on the other side, declared in red capitals that 'TORTURE IS BARBAROUS'. It seemed no more than a statement of the obvious, but the central panel's black capitals issued a more complex and disturbing plea: 'PROTECT ME FROM WHAT I WANT'. Not content with displaying her work in the Biennale's American pavilion, the tireless Holzer has spread similar messages all over town. Whether travelling by taxi or watching television, there is no escape from her peculiar blend of indignation, wit, anxiety and dissent. 'ABUSE OF POWER COMES AS NO SURPRISE' proclaims Holzer's disenchanted slogan on a T-shirt for sale at most Venetian kiosks. The words look unsettling among the plastic gondolas and cuddly toys, and she clearly intends them to act as a verbal emetic. Since tourist trivia has been the curse of Venice for too long, her messages can, at their best, counter the saccharine souvenir industry with wry precision.

Holzer established her initial reputation by making an impact even in public locations as clamorous as Times Square and Caesar's Palace, Las Vegas. Using billboards, metal plaques, electronic signboards and other devices, she punched her warnings, criticisms, truisms and confessions home with an accelerating mastery of spectacle. Her recent Guggenheim installation in New York set a 535-foot-long signboard into flashing life on the sides of Frank Lloyd Wright's spiralling ramps. The linguistic torrents she unleashed there have their counterpart inside the American pavilion at Venice, where Holzer proves equally adept at transforming the interior spaces at her disposal. The rooms nearest the entrance are the quietest, in visual terms at least. Many of the gleaming diamond-shaped panels set into the dimly lit floor reveal Holzer at her most preacherish – a tendency no doubt traceable, ultimately, to her Methodist upbringing. But statements like 'ANY SURPLUS IS IMMORAL' seem perverse when inscribed on the finest-quality Rosso Magnaboschi and Biancone marble. Holzer's exhibition, the first site-specific installation produced for the pavilion, is conspicuously lavish in its materials. The twenty-one three-colour LED signs ranged horizontally on the walls of another room must have been expensive as well. Here, however, state-of-the-art technology is allied with Holzer's most powerful work. The flickering

multilingual messages pulsate across the penumbral chamber like a neon-lit stream of consciousness. They switch, with virtuoso assurance, from aggression at one extreme to panic at another. And in a second darkened interior, her first text relies on autobiographical revelation to explore the guilt, protective ferocity and lacerating apprehensiveness of a mother's attitude towards her child.

For all its lapses into stridency, Holzer's contribution stands out in a Biennale otherwise notable for its numbing imaginative poverty. The theme this year is supposed to celebrate youth, but the half-heartedness of so many pavilions seemed more akin to senility. I could not believe, wandering from one national offering to another in the Biennale gardens, that the selected artists really represented the most vital work produced by their countries today. The banality and ineptitude was so widespread that it approached the proportions of an epidemic. Even the main exhibition, devoted to artists working in Berlin, degenerated into a hectoring, clumsy display of over-heated neo-expressionist emotion. Homage was duly paid to the tearing-down of The Wall, but this great liberating event does not, as yet, appear to have generated an artistic Renaissance. The East German pavilion seems locked in past traumas rather than looking forward to a new beginning. Hubertus Giebe, in particular, is obsessed by a nightmare world of murdering soldiers and naked, haunted drummer-boys. Despite his skill, the style and symbolism he employs in these over-wrought images seem stale and predictable.

In the West German pavilion, by contrast, coolness presides. Bernd and Hilla Becher, who have been taking systematic photographs of industrial monuments since the 1960s, are given a mini-retrospective here. The fascination of their assembled smelting-furnaces and other structures compares well with the enigmatic coldness of their co-exhibitor, Reinhard Mucha. With a material lavishness reminiscent of Holzer, he has installed a marble-panelled chamber in the pavilion's central hall. Precision-finish showcases line the walls, filled with planks from the floor of his studio – a building which used to house the main plant of the Düsseldorfer Waggonfabrik. Mucha meditates on Germany's industrial past with exactitude, but the weird sterility of his work robbed it of any real power.

Unlike Mucha's depressed and glacial geometry, France offers an unashamedly patriotic vision. Its pavilion was designed years ago by an Italian architect, so Jean Nouvel, Christian de Portzamparc and Phillipe Starck have been invited to submit proposals for a new, irreproachably Gallic structure. Their models fill a building which ought, by rights, to be housing art. But France puts architecture first, as the proliferating cultural

monuments of Paris continue to testify. The Biennale catalogue insists, revealingly, that 'the construction of the new pavilion is an affirmation of the modernity France vindicates, a modernity that it would like to apply in the field of economic endeavour'.

Such rampant nationalism does not, mercifully, disfigure the other pavilions. In the Soviet building a group of young artists are staging a boisterous show called *Rauschenberg to Us, We to Rauschenberg* – a display of Russo-American collaboration unthinkable in pre-*Glasnost* days. But a more abrasive spirit erupts in the *Aperto* section, where younger artists exhibit outside the main pavilion area. An eleven-artist American group aptly called Gran Fury launch a no-holds-barred attack on Catholicism and AIDS. One panel is dominated by a photograph of the Pope, who smilingly declares that 'the truth is not in condoms or clean needles'. Another panel boasts a photograph of an erect penis, accompanied by the baleful caption 'Sexism rears its unprotected head . . . AIDS KILLS WOMEN'. As they must have hoped, Gran Fury provoked a storm in the Italian press, and their exhibit narrowly escaped official banning. Another American contributor, the notorious Jeff Koons, shows no sign of using condoms in his outrageously kitsch photographs of the naked artist embracing the Italian MP and ex-porn queen La Cicciolina. Gauze butterflies and billowing boudoir curtains fail to disguise Koons's complete lack of sexual arousal – his own solution to the AIDS dilemma, perhaps?

It's a relief to escape from Koons's knowing, hothouse vulgarity and enter the British pavilion. By general consent, it amounts to a triumph for the young sculptor Anish Kapoor. With poise and inventiveness, he meditates on the contrast between presence and absence, the quantifiable and the unknown. Filling the main room with the red sandstone boulders of *Void Field*, he counters their megalithic bulk by piercing each lump with an aperture. Close examination of these small black circles reveals an immense emptiness in the blocks, and similar dualities are explored in other works. From a distance, a black rectangle appears to have been painted on the rough-hewn stone surface of *It Is Man*. But the 'paint' turns out to be a dark opening, inviting us to peer inside and ruminate on a mysterious hollowed-out region which refuses, ultimately, to disclose its true dimensions. Kapoor asserts volume with monumental grandeur only to subvert it, by meditating on the vacuum within. Being and non-being coexist with absolute assurance in these poetic works, which mark the advent of a resounding new maturity for Kapoor. While much of the Biennale was dismaying to anyone looking for signs of a fresh impetus in the 1990s, his contribution was a salutary affirmation of the transforming power of art.

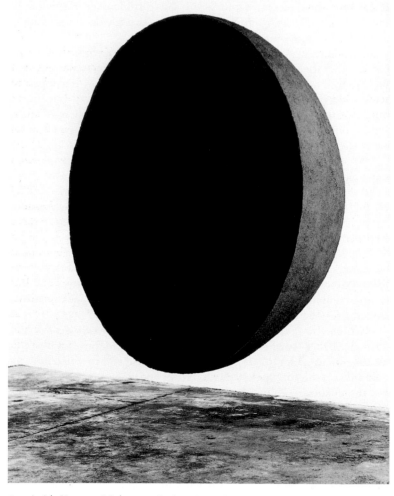

89. Anish Kapoor, *Madonna*, 1989/90

EDWARD RUSCHA

11 October 1990

Just over a decade ago, in a gesture of impatience with historical assessment, Edward Ruscha inscribed a large pastel with the fractious words 'I DONT WANT / NO RETRO / SPECTIVE.' But here he is, an older and more accommodating man, with a touring exhibition which surveys his career from 1959 to the present. Having already been staged in Paris, Rotterdam and Barcelona, it is now at the Serpentine Gallery before going on to his home city, Los Angeles. For an artist who once spurned the whole notion of looking back and summing up, his decision to mount such a show signifies a fairly surprising change of heart.

All the same, the work itself reveals the consistency of Ruscha's interests, right back to the time when he studied at the Chouinard Art Institute in the late fifties. He had recently moved to LA from Oklahoma, where the landscape gave him an enduring love of the wide spaces which came to dominate his art. The Abstract Expressionists were at the height of their influence, and the reckless, splashy handling of the earliest exhibit suggests that the young Ruscha was impressed by their impetuous brushwork. But it also demonstrates a far more independent fascination with the pictorial potential of words. Instead of confining his name to a modest signature at the base of the canvas, he painted 'E. RUSCHA' in brash capitals across the surface of the picture. The letters are split up in a *faux-naïf* way, so that the 'HA' terminating his name is isolated like a defiant laugh.

In one sense, this quirky painting pokes fun at the hard-sell idea of art as a vehicle for promoting its maker's celebrity. Ruscha was fascinated for a time with commercial art and sign-writing, and the books he produced in the early sixties owe a great deal to advertising techniques. The images in *Twenty-Six Gasoline Stations* might have come from promotional brochures. Their blatancy linked Ruscha with Pop Art, as well as hinting at a kinship with Edward Hopper's inter-war paintings of equally mundane roadside subjects. At this point, Ruscha might have developed into a full-blown photo-realist. But his infatuation with words led him to take a more laconic path. In several modestly sized canvases from the mid-sixties, a single word is spread across the centre of each picture. They float on nebulous colour-fields which evoke skies or deserts, but the strangely metallic greens and oranges hint at a more urban presence. The words themselves – CHEMICAL, AUTOMATIC, VASELINE – confirm the sense of advanced industrialization stamping its identity on the natural world.

Even so, Ruscha offers no comment of his own. He leaves a generous

90. Edward Ruscha, *Large Trademark with Eight Spotlights*, 1962, Whitney Museum of American Art

gap between each letter, ensuring that the words are partially robbed of meaning. They seem as dislocated as the verbal fragments opticians use in eye-tests, and Ruscha subsequently decided to push these isolating devices even further. In *Sea of Desire*, the first word stands out forcefully from a deep blue ground. But the second begins to merge with the lighter colours behind, and 'DESIRE' below has almost melted into an encroaching mist. Moreover, Ruscha enlarges the first letter of each word, detaching them from their ostensible context and inviting us to read them as 'SOD'. Whether interpreted as a term of abuse or a joky reference to the grave, it subverts the mood of hedonism which the painting initially appeared to celebrate.

The closer the exhibition approaches to the most recent work, the darker Ruscha's mood becomes. Even the ubiquitous word 'HOLLYWOOD', the focus of a million tourist advertisements, takes on an ominous power in a painting where the giant capitals are marooned on a bleak, grey plain. A panoramic canvas from 1981, which looks at first like a sublime expanse of remote countryside, turns out to contain the word 'MURDER' in three separate places. The epic landscape is thereby transformed, with the utmost economy, into a police map for a multiple homicide investigation. A similar technique is employed in *Industrial Village and its Hill*, where an equally wide painting is dominated by the grimness of a black incline pitched against an oppressive white sky.

Even when Ruscha indulges in the kind of colour associated with Californian sunsets at their most Technicolor, the outcome is garish rather than uplifting. In one canvas, the words 'A CERTAIN FORM OF HELL' descend

implacably through blood-tinged clouds, while another flaring sky acts as the backdrop for a strange warning: 'THE ACT OF LETTING A PERSON INTO YOUR HOME'. The words imply that anyone rash enough to extend such a welcome risks a disastrous disruption of privacy. Safer by far to regard your home as a fortress, like the two defensive houses savouring their nocturnal fastness in a painting called *Strong, Healthy*.

The older Ruscha grows, however, the more he realises that impregnability is an illusion. A malaise has infected the land he once defined as streamlined, Drive-in America. Now the phosphorescent form of a neon woman glows in the night like a radiation warning in *Pacific Coast Highway*. Still more disconcerting is a canvas dominated by a gallows-like structure, from which dangle a cluster of empty boards. In his earlier work, Ruscha would have inscribed them with the words he now confines to the title alone: *Drugs, Hardware, Barber, Video*. The four white oblongs gaze out from the dark with a cheerlessness suggestive of closure, redundancy and death.

By no means all the recent pictures concentrate so overtly on this *fin de siècle* malaise. An immense canvas called *17th Century* places a diminutive galleon on the horizon of an otherwise empty ocean and peppers the sky with exclamations like 'war!', 'taxes!', 'plague!' and 'melancholia!' – all painted in a gothic script. After a while, though, it becomes clear that Ruscha is drawing a parallel between these ills and our own. The fundamental problems besieging human life never really alter, and an almost confessional note breaks through the former impersonality in some of his latest paintings. Take *Five Past Eleven*, an exquisitely handled image of an outsize clock-face. The hand pointing at XI has the sharpness of a needle, and an even more punitive bamboo whip curves over the timepiece as if to echo its circular contour. With a pictorial finesse which fails to disguise his underlying anxiety, Ruscha gives vent to the idea of time as an elegant yet relentless scourge.

Existence takes on a Sisyphean dimension in *Uphill Driver*, where the silhouette of an archetypal gas-guzzling car addresses itself to an awesome slope. The angle of the road is so steep that the vehicle might well be sliding down rather than ascending. Is Ruscha referring to his own middle-aged condition or the state of the nation? It is difficult to disentangle the one from the other, but in 1989 he painted an untitled picture of a gas-station with the same 'STANDARD' sign he singled out in his book nearly thirty years ago. At that time, the gleaming structure with its expectant pumps typified sunlit affluence, and a board on the forecourt advertised the benefits of a 'TONE-UP'. Now, by contrast, the shadowy station looks forlorn and deserted as night closes on its funereal façade.

RICHARD LONG AND ANISH KAPOOR

18 October 1990

Confronted with the challenge of displaying their work in the Tate's awesome Duveen galleries, many artists might well feel intimidated. This high, austere sequence of spaces runs through the centre of the Tate like an echoing temple interior. It could easily dwarf the exhibits displayed there, and the temptation to react by crowding the rooms with an embarrassment of objects must be hard to resist.

Richard Long makes no such mistake. In an exhibition marking his Turner Prize award last year, he handles the Duveen with unerring aplomb. The walls are left empty throughout, but there is no sense of excessive bareness. Our attention is seized from the outset by the sculpture Long has installed on the floor, and the initial piece is ideally attuned to the immensity of the surrounding space. A line of Cornish slate fragments stretches ahead of us, leading our eyes like a primordial causeway towards the rotunda beyond. The slate's upper surface is so fresh that it seems wet with rain. Each piece is defined with immense clarity by the contrast between this lightness and the deep shadows beneath. It helps to accentuate the rhythms which give this colossal oblong its internal vitality.

Within the rigour of its overall form, which Long has established so crisply, the slate components are driven by a perpetual restlessness. They impel us to walk round the sculpture, thereby participating in the act of journeying which lies at the heart of Long's work outdoors. His expeditions to remote regions of the world are fired by the need to explore a landscape, not appraise it from a convenient distance. The walks he undertakes through deserts, mountains and moors enable him to establish a close relationship with the natural world. Making a work out of the materials found in the terrain, he fuses his sculpture with the place it inhabits. That is why Long can arrive at such a satisfying sense of rightness when he exhibits in galleries. Although Millbank is many miles from the locations which feed his imagination, the Duveen galleries have been successfully charged with his feeling for the epic grandeur of nature. He thrives on vastness, and the absolute inevitability of his work at the Tate means that it enhances the strength and dignity of the surrounding architecture.

The rapport between sculpture and place is at its most engaging in the rotunda. Here Long has assembled a circle of Norfolk flint which appears to fizz and bubble beneath the chaste walls curving round its circumference. In colour and form alike, the flint segments bear an inescapable resemblance to popcorn. They seem to bulge and ripen even as we look

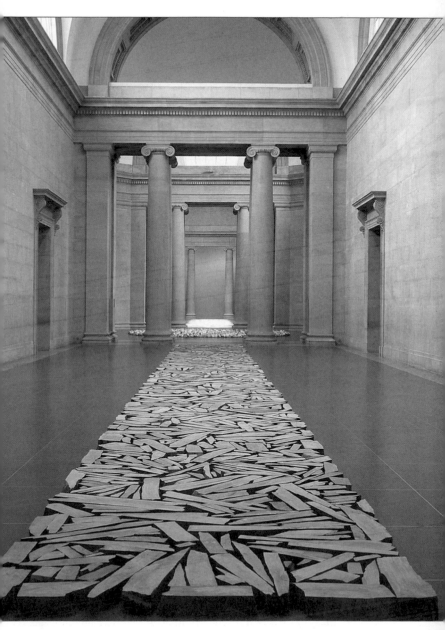

91. Richard Long, *Cornish Slate Line*, 1990, in the Tate's Duveen galleries

at them, like a field heavy with crops waiting to be harvested. By deploying his materials in their raw state, Long invites us to look at a substance like flint as if for the first time. It proves enormously rewarding. My eyes savoured every dip and swell in this tightly bunched congregation of stones. At times their broken sides are dark enough to stress solidity, but elsewhere the flint becomes so pale that it is almost robbed of substance. Although Long has done nothing to shape them himself, they bear an extraordinary resemblance to the Henry Moore carvings where he concentrated most intently on merging the human figure with the form of the landscape. Moore might easily have found one of these flints in the country and taken it back to his studio as inspiration for his sculpture. So might Paul Nash, whose later paintings often cherish the surrealist strangeness of the configurations flint can assume.

In the final room, palpable form gives way to the flat, flowing rhythm of a *White Water Line*. Relying now on china clay diluted with water, Long has poured a meandering river of thick liquid directly on to the floor. Its snakelike progress through the gallery seems the antithesis of the tight packing in *Norfolk Flint Circle* and the formal geometry of *Cornish Slate Line*. Long is here at his most loose-limbed. We become keenly conscious of his own bodily exertions as he moved through the room, letting the stream of clay course down from the spout of a watering-can. The edges of the wriggling line, snowy and opaque against the polished darkness of the floor, erupt into hundreds of small splashes. They are reminiscent of the marks made by Long outdoors, when he flings water against a rock, or pours his water-bottle along the walking line of a 560-mile journey across Portugal and Spain. His involvement with the interaction between water and land must derive ultimately from his experience of growing up near the Avon Gorge, which provided him with his first experience of nature's vastness as the river carves its way through the titanic cliffs. Mud from the Avon has often provided Long with material for his indoor works, and in this instance the china clay undulates over the gallery like a lazily expansive waterway spreading itself over a fertile plain.

Downstairs at the Tate, in a suite of newly refurbished rooms, another outstanding British sculptor reveals the importance of drawing. Anish Kapoor has always made colour play a sensuous role in his work, and many of these images deploy reds, mustard yellows and deep blues which sound from the wall like a gong. Some of the exhibits engulf the viewer with a field of colour, like the immense midnight-blue *Madonna* in Kapoor's memorable pavilion at the Venice Biennale this summer. Others alleviate this enveloping cloud with a tiny aperture at its centre, which appears to lead through to a mysterious void. Kapoor is fascinated by such a duality

in his sculpture, where he undermines the seeming bulk of a stone boulder with a hole disclosing the unexplained emptiness inside.

As well as evoking the interior of a body or vessel, these images are sufficiently open in meaning to suggest events in the cosmos. Whiteness explodes in space like nebulae, and elsewhere a purple spiral hovers over forms redolent of a lunar landscape. In the end, though, Kapoor ensures that everything returns to the idea of space within rather than without. Many of the drawings are preoccupied with the idea of penetration. Orifices gape, not erotically but as invitations to meditate on the unknowable world inside the body. Inverted branches hang down in an almost infra-red light, signifying a Leonardo-like fascination with the correspondence between tree forms and arterial structures. Seeds fructify, and in one gouache the paper swells at the centre to produce a cluster of pods ready to germinate.

Fear seems the dominant emotion in the darkest works, where an undefined immensity threatens to overwhelm and even extinguish everything around it. The prevailing mood, however, is meditative and instinct with wonder. In a world where so much store is set by the instantly quantifiable, Kapoor turns away from calculation in favour of an art which reveals how little we really know. He confronts us time and again with the unfathomable, in the hope of arriving at a more spiritual apprehension of the enigma at the heart of existence.

CINDY SHERMAN
4 August 1991

She might be Tuesday Weld, this young blonde hitch-hiker in the check skirt standing with her suitcase by the roadside. Her air of innocence certainly belongs to the Fifties rather than today, and she gazes over the darkening countryside with expectancy. She looks like a woman who has just left home, setting off on the decisive journey that will define her adult life.

Cindy Sherman, the American artist who places this photograph at the beginning of her Whitechapel Art Gallery retrospective, offers no clue to the identity of the traveller. Like the rest of the extended series to which it belongs, the picture is simply called *Untitled Film Still*. The name makes limited sense, confirming the mood of Hitchcockian suspense

which Sherman so cleverly evokes. But she leaves visitors to discover, as they make their way through the show, that the hitch-hiker is in reality the artist herself. Throughout this early series of small, black-and-white images, Sherman takes a bewildering delight in changing her persona from picture to picture. Tuesday Weld becomes fragmented into a cast of alternative roles, mostly far more knowing and self-conscious. Even in the kitchen, standing beside a cooker bristling with pan handles, she looks beckoningly over her bared shoulder. Sometimes she pretends to be caught unawares, hosing her lawn in sunhat and shades while staring at the camera with seeming surprise.

She is not meant to fool anyone for long, though. After a while we learn to see through each pose, and relish its irony. Kitted out in apron and headscarf, an archetypal housewife stands in a ramshackle room. But her sulky stance, hand on hip, suggests that she has no intention of clearing the scuffmarks off a nearby door. Nor does the woman taking a tome off the densely packed bookshelf pass muster as a bibliophile. Her peroxide wig and carefully projected bosom give the game away – just as the crucifix dangling from the neck of another figure is undermined by the ample cleavage exposed below it. The wealth of variations in this proliferating sequence seems to sabotage the whole notion of a one-off portrait. Sherman implies that there is no such thing, and that she herself is a multi-faceted personality who runs the gamut from *ingénue* to slut. It is a bravura performance, all the more impressive for being so understated.

After the series ended in 1980, she moved into colour photography and dramatically enlarged her scale. The results looked, for a time, as if they might come nearer to the 'real' Cindy Sherman. Using close-up shots more often than not, she cultivates an intimacy that promises honesty at last. But the illusion is not sustained. The tears on the face of the blonde under a bedsheet are patently glycerine, and in one picture she sports a billowing fancy-dress outfit which prophesies the costume-pieces to come.

Then, around 1985, the mood suddenly darkens. All the appealing wistfulness vanishes, and Sherman fills one panoramic picture with a pair of swollen, luridly lit buttocks covered in boils. They look false enough, like the prosthetic appliances used in surgery. But that does not prevent them from being as repellent as the sores afflicting the foreground figure in Grünewald's great painting of *The Temptation of St Anthony*. The subsequent photographs of dolls are even more disturbing. One of them lies discarded on a darkened floor strewn with broken typewriter keys, smashed electronic gadgetry and ribbons of film wound round its body.

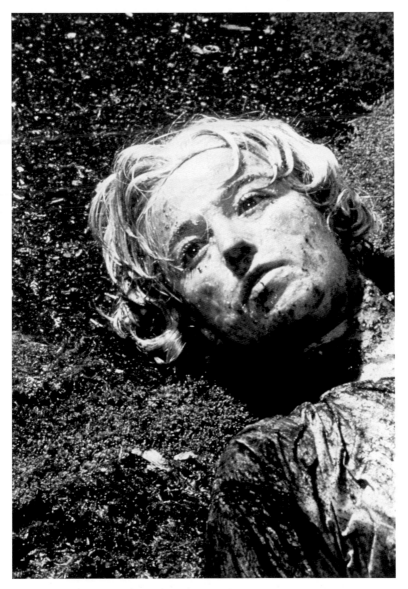

92. Cindy Sherman, *Untitled # 153*, 1985

The room looks like the scene of an inexplicable atrocity, a Hollywood version of the doll images which Hans Bellmer produced in Surrealism's heyday.

The violence becomes more explicit in a later group of pictures, all employing garishly painted rubber faces. One of them dominates a colossal diptych showing eerily flattened features. Blood, caked in a nostril and oozing from a corner of the mouth, indicates that an assault has taken place. But another picture concentrates on the moment when a man's face is wrenched upwards, forcing the nose to collide with the eyes and baring broken teeth in a mouth reminiscent of Bacon's screaming popes.

Despite Sherman's attempts to distance the aggression, by using masks rather than flesh-and-blood models, these images still have a nauseating impact. It is a relief to move away from them and explore a more satirical group of Old Master photographs framed in gold. Although Sherman reappears in these elaborate tableaux, and apes everything from a Holbein merchant to a Leonardo madonna, she exposes the cosmetics at every turn. Sometimes it is laughable: a hooded man in an oval frame sprouts a Cyrano-like nose, and Sherman does not bother to disguise the join. Elsewhere, though, her charades become more eerie. Posing as Raphael's mistress Fornarina, she places prosthetic breasts and belly over her own body. The outcome is grotesque, transforming a Renaissance nude into a shrewish caricature who reveals her pregnancy beneath a semi-transparent shawl.

But I find Sherman's mockery of art history less compelling, in the end, than her engagement with brutality and death. Upstairs at the Whitechapel, four new works hang in a small white room. The darkest pictures she has so far produced, they show inert hands and feet strewn across mossy ground. Tufts of earth are wedged between toes, and in one picture spent cartridges litter the scene. Indebted to the paintings of severed limbs which Géricault produced as studies for *The Raft of the Medusa*, the four photographs inhabit a chamber as chilling as a mortuary. Little more than a decade separates these *memento mori* from the blonde hitch-hiker on the road to a new life. But now the American dream has turned into nightmare. However stage-managed her work may still be, it freezes the blood with a relentless emphasis on putrefaction and the grave.

DAN GRAHAM
29 November 1991

Constrained by colossal overheads and lack of available land nearby, most West End dealers never have the chance to transform their exhibition space with a new, specially commissioned building. But the Lisson Gallery's unusual location, in the area between Marylebone Station and Edgware Road, means that expansion is possible. On an astonishingly grand scale, too. The handsome £1 million extension to the existing gallery in Lisson Street doubles its displaying capacity, allowing shows to be mounted on a far more ambitious scale than before. The new building's façade on Bell Street announces its distinctive identity at once. Sandwiched between the Brazen Head pub and R. J. Sutton's bric-à-brac shop, its pared-down purism looks forceful. Designed by the young architect Tony Fretton, the frontage is a clean-cut, uncompromisingly modernist exercise in steel, concrete and glass. The enormous windows dominating the first two storeys give generous views of the work displayed within. They offer an open invitation to enter, but the ground-floor room is sunk slightly below the level of the pavement. The gallery is thereby removed from too direct a relationship with the street, and the strange lowering of the floor adds an enticing air of surprise.

Inside, the mystery intensifies with the very first of Dan Graham's exhibits. Thrusting forward like a ship's prow, the aluminium and glass model on a black-topped table looks straightforward enough. Move around it, however, and the entire gleaming structure immediately becomes a thing of infinite, teasing ambiguity. The glass sides, so unequivocal from a distance, turn out to dissolve all certainty in a haze of bewildering reflections. Graham ensures that the confusion extends to the nature of the work he produces. He calls these models Pavilion Sculptures, a term which suggests that they hover provocatively between the condition of art and architecture. Several have already been realised on a monumental scale for permanent sites in Europe, Japan and his native America, where they become even more unclassifiable. The more functional they appear, as places of shelter or display, the less they resemble sculpture in any accepted sense.

But Graham, with increasingly subtle stealth, has always enjoyed challenging notions about what art should be. By far the largest piece on show is, in one sense, the most utilitarian: a five-sided, walk-in structure called *Gift Shop/Coffee Shop*. Intended for Munich International Airport, this deceptively simple object is based on a ground plan of two equilateral

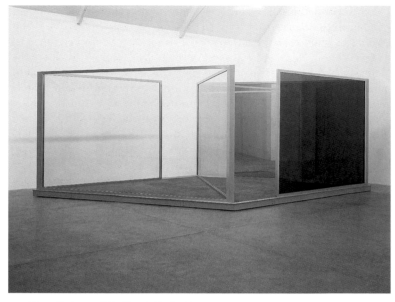

93. Dan Graham, *Gift Shop/ Coffee Shop*, 1989

triangles butted together. They form a pair of rooms separated by a single sheet of glass, and each space can be entered through a narrow opening. When viewed from the outside, however, the whole idea of a container is undermined by the reflective surface of the glass. As I approached, the rest of the gallery behind me appeared mistily on the structure's wall. Once inside, the same melting of conventional distinctions between exterior and interior occurred. The rooms are transparent, and the multiple grey reflections of my own peering figure only added to the general sense of disorientation.

Graham has long been fascinated by the segregation of public and private spaces, just as he is preoccupied with a mirror's ability to disclose and conceal. He aims at stimulating us into questioning their role, rather than continuing to take them for granted. In his own cool, understated way, he also wants to make spectators aware of their own presence. By confronting them again and again with sudden reminders of their gazing and appraising, as they attempt to explore his perpetually puzzling work, he encourages a greater awareness of the active, participatory nature of looking. Encountering a Graham structure soon involves them

in a perceptual drama, punctuated by interrogation, doubt and moments of heightened self-consciousness. At once perplexing and revelatory, his exhibition amounts to a continual fight against the complacent eye.

Take the model for a *Triangular Pavilion with Shoji Screen*, built for the Yamaguchi Prefectural Museum of Art in Japan. At a distance, the combination of two-way mirrored sides and open wood grid seems direct and clear. But when I began circling this modest yet hallucinatory object, my expectations were subverted at every turn. The screen floated out at assertive angles, threatening to create barriers. But they all turned out to be illusory. Once a corner had been negotiated, the grid vanished, leaving me instead with a maze of treacherous glass walls. Their reflections bemused me even as they offered tantalizing glimpses of the space inside the pavilion. However elusive it proved, the traditional screen serves as a reminder of the wooden temples which the Japanese placed in gardens for rest and contemplation. By juxtaposing it with glass redolent of high-rise offices, Graham creates a hybrid form directly expressive of Japan's fierce attachment to history and modernity alike.

This dual involvement with both present and past feeds the rest of the exhibition as well. In the basement room of the new building, an austere white space lit artificially from the ceiling alone, a series of colour photographs chart Graham's early studies of contemporary housing developments. The images are linked with an article called 'Homes for America', which he published in *Arts Magazine* twenty-five years ago. Intrigued by the eerily rootless standardization of these dwelling units, as they proliferated in 'dead' land areas across the nation regardless of regional differences, Graham was already acutely receptive to aspects of modern urban architecture which most other artists would have shunned.

Today, however, he is equally well-versed in historical precedents for his structures, from the east as well as the west. The model for *Pavilion Influenced by Moon Windows* is one of his most elegant and enigmatic works. The circular openings in its half-transparent and half-mirrored walls breed confusion even as they convey serenity. But they derive from the moon windows or gates in Chinese garden pavilions. Symbolizing heaven, they enabled the visitor to view the next section of the walled garden through their iris-shaped apertures. The stripped forms employed in this model are also akin to the most purged kind of modernist architecture, particularly the projects undertaken in India and Pakistan by Louis Kahn. Graham continues to be nourished by his contemporary surroundings, and colour photographs show that his interests range from a Los Angeles reflective skyscraper to a Family Restaurant playground on

the outskirts of London. Hung on the walls of the two wide, white rooms above the basement gallery, they provide a backdrop for the models throughout spaces lit by Tony Fretton's spectacular expanses of window.

No gallery setting could chime more satisfyingly with Graham's work. One of his most seductive exhibits is a purged, graceful piece called *Model for Bob Mangold*. Its poised geometry pays tribute to the purity of Mangold's minimalist paintings, whereas the nearby Heart Pavilion derives its curves from the popular symbol for Valentine's Day. Built in a full-size version for this year's Carnegie International at Pittsburgh, its role as a romantic rendezvous shows Graham at his most genial. But since distorted reflections confront anyone standing inside, his characteristic sense of unease still lurks here. It can even be found in the playful Skateboard Pavilion, where a four-sided canopy of mirror glass stands protectively over an ample cement bowl. The sides are festooned with exclamatory graffiti, evoking the high spirits which skateboarding engenders. Among the scrawled messages, though, are a skull and cross-bones, and the words 'SUICIDAL TENDANCIES' (*sic*). Their jokiness cannot disguise the underlying air of danger, just as the seeming placidity of Graham's other pavilion sculptures is countered, more often than not, by a troubled and alienating mood.

TOSHIKATSU ENDO AND CALLUM INNES
15 May 1992

Entering Toshikatsu Endo's exhibition at the ICA is like stumbling across the battered, uninhabited remains of a prehistoric settlement. At one end, the gallery's white walls are obliterated by the colossal bulk of a cylin-drical form in charred wood. Iron staples, punched into the stacked blocks both horizontally and vertically, help to keep them together. But slits between the upper row of blocks disclose a void within, and their scorched, coal-black surfaces bear witness to the flames which once assailed them.

Now that the fire has died down, Endo presents us with the aftermath. He calls the sculpture *Epitaph*, and a funereal air hangs over the entire work. At the same time, though, its defensiveness remains formidable. Intact enough to resemble a fortress, this great tarred presence looms over the rest of the show like a testament to endurance. So maybe the fire was

a purging event rather than a catastrophe. Endo favours minimal forms stripped of all extraneous detail, and the use of flames would certainly ensure that his sculpture ends up reduced to essence. But the paradox is that the burnt offering does not seem in a terminal state. On the contrary: *Epitaph* has taken on a new identity by passing through the ordeal by fire. And the other exhibits also appear pregnant with possibilities.

Take the large bronze ring occupying the central floorspace. Cracked in five places, this gleaming sculpture seems to have suffered from a different kind of onslaught. The circle described on the floor is still complete, though. Empty for the moment, it might nevertheless be marking out the territory for a ritual of some kind. Intensely energetic activity could one day erupt within the ring, if a nearby drawing called *Milestone* offers any guide. For here, dynamic lines whirl outwards from a pair of brass discs. Their generative power seems inexhaustible, like torrential water endlessly cascading through a primordial landscape. That is why Endo's other prominent sculpture is charged with such a sense of expectancy. Ranged in a circle, tall columns of wood form a palisade. Tar has darkened their texture almost as dramatically as in *Epitaph*, and they seem to be prepared for an onslaught. Although they are separated from each other, the gaps between them are not wide enough to let anyone through. And the mood of suspense is heightened by the water lying in their hollowed-out tops. The liquid quivers as you move near, threatening to spill on to the floor. But no splashing occurs.

The same eerie preoccupation with stillness and violence, water and fire, runs through the slide show in the final room. Photographic sequences chart successive stages in the development of Endo's spectacular performance works. Enacted for the most part outdoors, either in the countryside of his native Japan or elsewhere, they invariably move towards a climax of burning. Circles reminiscent of Richard Long's work, laid out in woods or open fields, are suddenly set alight. They blaze ferociously, but the most powerful conflagration of all bursts from a primitive wooden boat moving slowly through the sea. Memories are stirred of ancient burial ceremonies, even though no corpse is lowered into the deep. A distinct aura of melancholy enveloped the burned boat when it was exhibited, charred and heavy with water, in a gallery. Like *Epitaph*, however, the boat has survived. Endo made sure of that, for he is fascinated above all by the transforming agency of change. Apparent destruction pervades his work, and slides reveal how the burning of *Epitaph* resembled some great funeral pyre devoured by apocalyptic flames. But when the smoke finally cleared, the sturdy wooden cylinder emerged whole and resilient. An unlikely renewal has occurred, defying

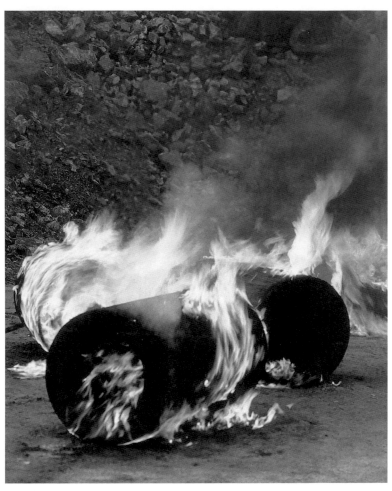

94. Toshikatsu Endo, *Fountain – composed of nine pieces*, 1989 (detail)

the ashes and affirming a cyclical progression in nature that stretches back to the very beginning of history.

One of the first paintings in Callum Innes's show, occupying the ICA's other galleries, looks surprisingly like an Endo drawing. There is the same emphasis on a vertical expanse of darkness, dramatically alleviated by a splash of gold-coloured paint near the centre. Innes, however, allows

his turpentine-thinned oil to dribble some way down the picture-surface. He is a less theatrical artist than Endo, and stands equally apart from the boisterous Glasgow-based figurative painters of his native Scotland. Quiet, ruminative and abstract, the thirty-year-old Innes pursues a relatively isolated path in his Edinburgh studio.

He nevertheless encompasses an unexpectedly broad range of images. Some could hardly be more spare: *Exposed Vertical on White* depends for its effect on leaving a thin line of bare, brown canvas meandering like a crack down the centre of a white painting. Just as Innes hopes in his catalogue interview, the result 'looks like it has developed by itself'.

Even in works enlivened by more pictorial incident, Innes makes them seem indebted to natural processes rather than the action of an artist's hand. In *Monologue Three*, paint runs down the canvas with a gently undulating motion, like ribbed sand left behind by the retreating sea. And an untitled work executed this year uses oil and shellac to let a pale orange stain spread across the picture, flecked with tiny deposits of thick pigment. In this case, I was reminded of staring closely at the surface of a weathered rock, pitted and discoloured by the incessant action of water and wind. But *Formed Painting No.2*, a sumptuous red and bronze canvas streaked with vertical rivulets of paint, offers an experience akin to peering through a frieze of bulrushes by the river's edge.

As his titles indicate, Innes has no desire to make overt references to nature. After exploring the potential of figurative painting in his early work, he now relates to the American minimalist tradition. At times, his work is too reminiscent of the artists he reveres. *Exposed Vertical*, a black and shiny painting divided down the centre by a line of bare canvas, looks like a 'zip' picture by Barnett Newman. And *Exposed Olive Painting No.2* is, for all its qualities, uncomfortably close to early Brice Marden.

At his most independent, though, Innes moves away from these severely pared-down canvases. Without betraying his respect for the inherent processes of painting, which play such a large part in shaping the pictures, he allows his feeling for the world beyond the studio to penetrate the images as well. When changing from figurative to abstract work, he was impressed by an earlier drawing of a leaf in his sketchpad. Without tempting him to introduce literal plant-forms to his painting, the leaf pointed him towards a deeper engagement with organic life. The consistent gentleness running through his work implies an ecological awareness, a need to respect and savour nature rather than shut art off inside a hermetic cell.

The most memorable outcome is a 1991 painting called, with characteristic reserve, *Six Identified Forms*. Phosphorescent eruptions of pale

gold glow in a predominantly black canvas. They look like flares climbing a nocturnal sky, even though Innes does nothing to disguise the pouring, staining and streaking processes which enabled him to arrive at this understated yet stirring image. Suspended in space, the points of light seem transient enough. But their brilliance is reassuring, as though vigilance and understanding were being stubbornly upheld in the otherwise impenetrable gloom.

ANNETTE MESSAGER
31 July 1992

Unlike most artists, who insist on stamping their work with a single, clearly defined identity, Annette Messager thrives on images of a contradictory and fragmented self. Her multi-faceted show at the Camden Arts Centre is impossible to pin down, and challenges us to locate a style, medium or meaning which reveals the 'real' Messager. As early as 1972, this elusive Paris-based artist dramatised her search for a definable persona. Or rather, she revealed how easily her individuality fractured even when experimenting with writing her own name. Like an eager yet tormented adolescent, she set out on a quest to find 'my best signature'. The venture ended up covering 2,000 obsessive pages, a selection of which is ranged across one of the exhibition's white walls. A definitive autograph failed to emerge. But Messager discovered a prodigious array of alternatives as she toyed so inventively with ever more fanciful combinations of the same two words. Sometimes, the name sags down the paper, as if exhausted by the effort involved in devising all these options. She soon revives, though, trying out a sharp, aggressive series of pincer-like lines and then encircling her signature in a flamboyant flourish. Her favourite turned out to be a distinctly phallic form, made from the initials 'AM'. At once erotic and ironic, it sums up the edgy sense of humour which runs through this diverting yet unsettling show.

Messager constantly confounds lazy expectations and throws us off balance with her half-beguiling, half-disconcerting manœuvres. Take the extraordinary photo-work called *Voluntary Tortures*, which helped to establish her early reputation in 1972. She assembles a comprehensive collection of magazine cuttings, all revealing the rituals to which women submit themselves in search of smooth, slimmed-down flesh. A naked

body reclines under a fearsome battery of lamps, like a humiliated victim undergoing some ghoulish examination. Another figure stares down at the repellent metallic device clamped to her breast, while elsewhere a towel-turbaned woman lies in a bath attached to a macabre bank of electronic dials and monitors. Perhaps the weirdest aspect of the entire work rests in the unconvincing efforts made to persuade the viewer that these processes are pleasurable. One face grins rigidly through the bandages swathing her features, and a haughty woman poses in triumph with an encrusted, plaster substance smeared over her skin. All the figures enjoy ideal proportions, of course: the thighs enclosed in a vibrating strap could hardly be more shapely. So even as Messager questions the discomfort undergone by the smiling goddesses, she exposes the titillation informing these craftily composed images.

Not that she exempts herself from erotic motives. In *My Advances*, Messager plays the role of a voyeur shooting unknown men in the street with a telephoto lens. The handwritten captions beneath the pictures are prim and quaint, commenting on the clothes they wear. But the photographs tell a different story, closing in so brazenly on the crotch level that the trousers all grow blurred. The final image in each sequence contains mysterious outlines reminiscent of a bird in flight or a fishbone, as Messager allows herself to play around with the folds in these almost indecipherable garments.

Just as we imagine that the elusive artist has disclosed her most private longings, however, she changes direction altogether. Neatly framed, attractively coloured pictures fill a wall with irreproachable images of blissful tourist scenes. An ideal couple gaze at one another before a lurid sunset, while around them a cornucopia of equally kitsch images pay homage to clichés like the ocean liner, the Red Indian chieftain and the inevitable pyramids. The ultimate effect is nauseating, as Messager forces us to overdose on the packaged unreality of holiday brochures.

But she does not linger in this saccharine realm for long. The largest gallery, where Messager is able to display some elaborate work with theatrical panache, contains at its centre a constellation of photographs called *My Wishes*. Suspended on strings pinned to the top of the room-divider, they appear to be plummeting towards the floor like a burned-out meteor hurtling earthwards. There is nothing terminal about the images clustering inside this apparition, though. Piled on top of and around each other, the small black-and-white photographs contain parts of the human body. Wrinkled foreheads, thinning scalps and crinkled buttocks show that Messager – unlike the photographers responsible for the pictures in *Voluntary Tortures* – is unafraid to acknowledge physical

imperfection. She had, after all, become middle-aged by the time this spectacular work was produced in 1989. But the cumulative effect is unmistakeably erogenous. Tongues project from mouths, nipples vie for attention with ears, penises and stubbly chins. They all seem to clamour for admiration, turning us into voyeurs and at the same time bearing out Messager's realization that 'I always perceive the body in fragments . . . when you make love you only see parts of the body of the other, vague close-ups, you don't see everything.'

Nothing in Messager's work is ever straightforward, however. Just as we are about to conclude that the bundle of corporeal desires in *My Wishes* is celebratory, she makes us aware of a darker side to the work. The sheer proliferation of images becomes oppressive, even threatening. They crowd in on us, implying a *horror vacui* on Messager's part and also a suspicion that the fantasies they embody might easily run out of control.

In the ceaselessly deceptive world she creates, the most innocent object turns out to convey an unexpected sting. One exhibit relies for much of its impact on a series of woollen gloves spread along a wide wall. But they are all impaled on pikes, as if placed there like decapitated heads by some gory executioner. And each glove turns out to contain holes, through which the eyes and noses of unidentifiable animals peer mysteriously. Creatures associated with the nursery take on, here, a significance more akin to adult anxieties. Messager is fascinated by the interplay between childhood and later life. She refuses to regard them as wholly separate areas of experience, and their relationship provides her work with some of its most startling moments. In *Attack of the Coloured Crayons*, a battalion of pencils thrust aggressively from holes puncturing the wall. They aim themselves at us like rifles at a public execution, and over in a corner a heap of children's toy animals look as inert and humiliated as corpses abandoned after a massacre. The glass boxes ranged above them contain dolls' clothes, but each one is accompanied by a photograph of a finger painted with a clownish figure, a bed or a boat.

Playfulness and melancholy run hand in hand, as Messager defies us to sort out the dominant emotion. The answer is that she thrives on a constant oscillation between contrasting poles of feeling, nowhere more ambiguously than in a work called *Stories and Narratives*. As the title suggests, books play an important part here. Underneath an ample recessed window area in the last gallery, stacks of English paperbacks alternate with piles of discarded teddy-bears and other remnants from the playpen. The juxtaposition appears light-hearted enough, until we realise that the stuffed rabbit, hen, duck, squirrel and mouse perched on top are all blindfolded.

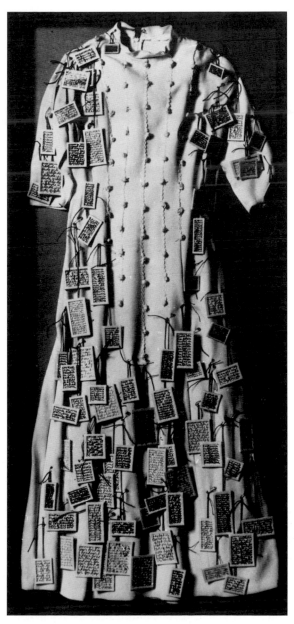

95. Annette Messager, *Histoire des Robes*, 1990

They act as a reminder that even the blithest of fables tends to terminate in arbitrary cruelty, and in the most elaborate exhibit Messager makes her preoccupation with mortality explicit. Glass boxes cover the whole of one large wall, resembling see-through coffins lodged in a cemetery chapel. They all contain clothes, laid out with fetishistic reverence as though by a mourning relative desperate to retain a souvenir of the lost one's presence. A black dress is festooned with little framed drawings of skeletal remains, while a neighbouring garment provides a backdrop for photographs of couples kissing and hugging. Words are used in a similar way, covering one pink dress with letters spelling out 'INNO-CENCE' and another with 'DOUBTS'. Between these two Blake-like alternatives, Messager nourishes her work with a perpetually questioning awareness of ecstasy and suffering, optimism and disillusion, sensuality and the tomb.

TOM PHILLIPS
December 1992

Artists who write copiously and exhaustively about their own work do so at their peril. Critics can easily bristle when they find their interpretative ambitions pre-empted by a first-hand account of a work's origin and development. As for the viewing public, they may well feel suspicious of artists who constantly seek to explain themselves. Painters, after all, are supposed to produce their work and, only very occasionally, mutter incomprehensible comments on their mysterious intentions.

But Phillips, like Richard Hamilton, defies these unwritten rules at every turn. His verbal facility means that he cannot resist giving articulate, detailed, wrily humorous accounts of how a particular project came into being. And given the nature of his work, such testimonies are at once appropriate and inevitable. For Phillips' art is so multi-faceted that a Bluffer's Guide provided by the artist can be helpful. Besides, how could a painter so adept at words be expected to refrain from writing down his thoughts on paper? Reynolds showed no hesitation when composing his *Discourses*, and we are all the richer for finding out how the first President of the Royal Academy saw the purpose and context of his art.

Difficulties, nevertheless, persist. Confronted by a 'selective retrospective' of Phillips' work, the first show by a Royal Academician in the new

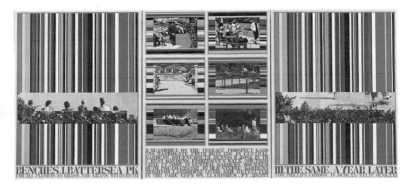

96. Tom Phillips, *Benches*, 1970–1

Sackler Galleries, the problem is where to begin. Perhaps the easiest solution would be to consult the catalogue, a substantial volume of *Works and Texts* written (of course) by the artist himself. But that would run the risk of seeing everything through Phillips' own eyes, rather than forming an independent view of his prolific and labyrinthine activities. Better, surely, to carve a more personal pathway through the ever-burgeoning thicket of Phillips' tireless inventions.

I first came across his work in 1971, at a one-man show held by Angela Flowers in her old Portland Mews gallery. He was presented, there, fundamentally as an ambitious young figurative painter, capable of taking postcard scenes and using them as the basis for a monumental canvas. *Benches*, now owned by the Tate Gallery, was the most imposing image on view. It exemplified Phillips' readiness to take his cue from the distortions of the postcard, organising his complex picture-surface as a schematic demonstration of the painter's ability to transform a documentary motif into a private reverie.

The slices of figurative imagery, concentrating on people seated and half-hidden by civic flower-displays, were surrounded by borders of abstract stripes – each one standing for a colour used in Phillips' reconstruction of the postcard. Then, as a border for the painting, bold lettering was introduced around the edges of the stripes to reinforce their stern pictorial architecture. The letters alternated between spelling out the location of the benches, in a matter-of-fact, caption-like manner, and quoting phrases as emotive as 'for all flesh is as grass. The grass withereth.' The clash between these two series of messages, the literal and the biblical, was unsettling. And Phillips intended it to be. Over and above the

stylistic variety deployed in the handling of each postcard, and the 'alienation' device of the stripes and lettering, a profound melancholy seeped out of his painting. The staring, contemplating and waiting figures all seemed to be conscious of their own mortality.

There were, admittedly, other pictures on view in that early show which indicated rather different concerns. I remember that some images made use of tantalising, almost teasing extracts from W. H. Mallock's *A Human Document*, the once-obscure Victorian novel which Phillips has continued to raid for his own idiosyncratic reworking, *A Humument*. But I could never have guessed, from the evidence of that exhibition alone, how extraordinarily diverse Phillips' subsequent development would be.

He has become a portrait painter, most notably of Iris Murdoch looking like the heroine of a Leonardesque enigma. He has turned himself into a one-man translator and illustrator of Dante, whose poetry also became the springboard for Phillips' collaboration with the film director Peter Greenaway on *A TV Dante*. He has composed music and operas, as well as painting an elaborate sequence of abstract pictures which recycle left-over pigment into *Farbenverzeichnis* (colour-catalogue) stripe compositions. He has made a monumental series of tapestries for St Catherine's College in Oxford, where he read Anglo-Saxon and English Literature as an undergraduate in the late 1950s. And every year, in May, he photographs the same twenty locations in his South London neighbourhood, revealing both how much and how little appearances have changed in an area he has continually inhabited for the fifty-five years of his life.

Phillips' reluctance to move from the locality where he was born contrasts absolutely with the restlessness endemic in his work. His refusal to remain satisfied with one means of expression has aroused hostility, in the main from critics who accuse him of rampant eclecticism and being 'too clever by half.' But Phillips himself rejoices in his prodigious versatility, and clearly sees no reason why the Italian Renaissance should be the only period when artists were allowed to try their hand at a diverse array of activities.

So the Sackler Galleries exhibition should prove an important moment in the attempt to assess his achievement. For it brings together many of the often bewilderingly disparate strands which make up Phillips' kaleidoscopic personality. Here, at last, the full range of his interests will be laid out under one roof. Devotees should find much to savour, and sceptics will finally be able to test their prejudices against the incontrovertible reality of the work produced in such profusion by this unwearying dreamer.

TIM HEAD
18 December 1992

Entering the Whitechapel Art Gallery is like finding yourself transported, for a second, from the traffic-choked winter city to an empty stretch of countryside in high summer. The immense floor is covered entirely with cricket-pitch green, and the far wall has become a clear expanse of sky blue. Untroubled to the point of blandness, this seemingly idyllic locale promises an exhibition filled with innocent delight. But Tim Head, whose mini-retrospective takes up both floors of the gallery, ensures that the placidity is short-lived. As our feet crunch jarringly on the hard Astroturf carpeting, the illusion of nature's lushness gives way to a nasty synthetic alternative. And the blue side-walls turn out to be an ironic backdrop for two-tiered ranks of billboard-size images, presiding over the space like vast, implacable sentinels.

The change of mood is disquieting. Suddenly, the whole ground-floor space with its sturdy white pillars resembles the nave of a temple. So which alien gods are protected by the forms gazing out from the walls? Head does not reveal their identity. But whether they resemble scimitars, goggles or shields, their speckled, metallic sheen suggests armoured surveillance. They lurk in their canvases like helmeted presences, silently dedicated to monitoring every move we make. The scanned ink-jet process employed to print these enigmatic images adds to their eeriness. Neither convex nor concave, they hover on their grey half-tone grounds as spectres from another world. The fact that Head based them on shapes used in packaging and presentation does nothing to detract from their ominous impact. By the time he had transformed them with the aid of photocopying, collage and enlargement, their familiarity was masked by mystery. They look like mutants, serving the indefinable purpose of a Big Brother whose passion for control is boundless. Head has grouped the whole series under the collective title *Thirteen Most Wanted*, and their impersonal air of menace might well signify criminal intent.

In the end, though, these hybrids frustrate any attempt to limit them to a single meaning. And Head himself shares their elusiveness. Now in his mid-forties, he first gained a reputation during the 1970s for his intriguing yet tantalizing installations with projected light and a minimum of props. Spare, delicately calculated and almost hallucinatory in their effect, they confounded expectations but stopped well short of the sinister implications envenoming his recent work. Although they questioned the camera's supposed objectivity, and left the viewer with an

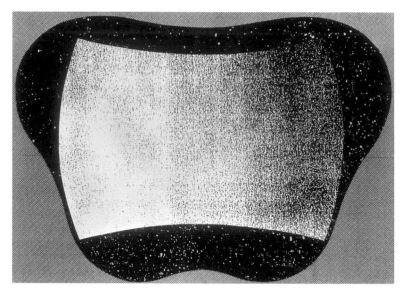

97. Tim Head, *Thirteen Most Wanted, No. 7*, 1992

awareness of conundrum, Head was not yet ready to spike them with Kafkaesque unease.

In the Whitechapel's small audio-visual room, a slide presentation smoothly documents many of these early installations. While conveying very little of their former power, the slide piece does at least prove how much Head has changed since then. For the audio-visual room is opposite the gallery's café, where one wall has been lined with a recent, banner-like frieze of identical, voracious faces all bent on devouring each other. His starting-point here was the smiling head motif used in the Happy Eater motorway restaurants. By removing the hand and enlarging the open mouth to a grotesque extent, he ends up with a consumerist nightmare of cannibalistic proportions. Its cartoon brashness could hardly be further removed from the cool, almost rarefied understatement of his early installations.

Even so, the café piece is in no sense typical of Head's work today. The stairs to the upper galleries terminate in a darkened chamber, lit only by two dimly glowing ultra-violet tubes lodged in the ceiling. They ensure that hundreds of self-adhesive labels festooning the walls stand out against the blackness like a myriad multicoloured stars. Spattered with orange, scarlet and green particles, which shine more vividly than their

blue companions, this seductive room shows how much unexpected poetry can be conjured from banal, ready-made stationer's ware. Head gives the installation a sting in the tail by calling it *Made on Earth*, thereby emphasizing that the entire heavenly vision is based on nothing more uplifting than ephemeral, secular products. But the room remains remarkably beguiling, and far softer in mood than the images displayed in the larger of the upper galleries.

Emerging from the womb-like prettiness of *Made on Earth*, we are confronted with a harsher diagnosis of contemporary life. In the Orwellian year of 1984, Head decided to become a studio-based photographer for a while. He assembled a gruesome array of the sleaziest objects on sale in the shops, and built them up into a monstrous metropolis where pink dildos become skyscrapers and scale models of nuclear bombers glide through the streets. Saturated with images of commercialised sex, Nazi insignia, computer war-games and garish cosmetics, *State of the Art* amounts to a lurid indictment of the late twentieth century at its most squalid. Head stresses the saleability of this tawdry merchandise by photographing his tableau as glossily as the most hard-hitting advertisement. But despite the horrible opulence of this large Cibrachrome photograph, everything seems to be veiled in dimness – as if Vaseline had been smeared over the lens.

State of the Art shows the most denunciatory side of Head's multi-faceted outlook, and it spawned a whole sequence of equally disturbing images. The skulls which played a minor role in this photograph dominate *Still Life (Erasers)* where, heaped up like the contents of a shadowy charnel house, they lose their original playfulness and become macabre. Head's obsession with updating the *vanitas* tradition led him in a melancholy direction. Dwelling so heavily on extinction threatened to rob his art of its subtlety. The stealthy complexity of the installations was exchanged for an openly polemical stance, fired by gloomy warnings of decadence and the grave.

Once Head turned his attention to despoiled landscapes, though, revulsion was tempered by a paradoxical, and less predictable, sense of attraction. The glutinous substances floating in *Toxic Lagoon* stir our appalled fascination as they seem to grow like funghi in the dyed blue water. As for the puce plastic detritus bobbing in *Petrochemicaland III*, they pollute a location akin to Monet's water-lily pond: Giverny after the fall.

The feeling of loss becomes clearer still when Head's attitude to food is compared to the Pop artists, whose interests he often shares. They celebrated the consumerist abundance of supermarket shelves, whereas he views the same subject with anxiety and nausea. Taking a high-spirited

design from Sainsbury's milk cartons, Head distorted the merry cows so violently that they ended up as Dubuffet-like biological monstrosities. The other surprise about *Cow Mutations*, which won the John Moores First Prize in 1987, is that Head painted it by hand on canvas – something he had not done since his student days.

Deep Freeze is even more disconcerting. Like many of Head's pictures, it seems pale, inoffensive, almost tasteful at first. But gradually, the fragments of food hovering in a glacial vacuum come to look repellent, like bones, brains, offal, or some appallingly misshapen, contaminated substance. The abstraction inherent in the mutation of images allows Head to escape from the over-literal emphasis of photographic works like *Still Life (Erasers)*.

It also allows him to roam more freely through the image-bank opened up by technological advances. Satellite radar recordings provided him with a new map of the world, and he uses it in *Dark Planet* to produce a writhing, seething vision of a world convulsed with unnamed tremors. Acid-green forms flicker and swirl against blackness, as if struggling to retain their coherence. They look vulnerable, and Head is in no mood to hold out facile hopes about their long-term survival. Downstairs, by contrast, *Thirteen Most Wanted* loom down from their walls, waiting for the moment to assume full, dehumanised control.

ROBERT RYMAN

5 March 1993

No captions are permitted to disturb the impeccable white walls in Robert Ryman's Tate retrospective. All the picture-titles are confined to a simple list near the door of each room. And the implication to visitors is clear: concentrate on the paintings, rather than anything that might distract you from the visual sensation they offer. Such a purist priority hardly comes as a surprise. Ryman's high reputation in American painting is based, after all, on his devotion to whiteness. For over thirty years of steadily sustained achievement, he has remained fascinated by this one neutral colour. Its possibilities absorb his energies as much today as they did when he first defined his mature identity.

Not that Ryman arrived at this singular commitment without hesitation. As his Nashville childhood might suggest, he first became enthralled

by music. At Tennessee Polytechnic, Ryman was a passionate saxophon-ist, and in the early 1950s his appetite for Charlie Parker and bebop led him to New York. But gradually he became intrigued by the far quieter satisfactions of oil paint, brushes and canvas. In order to support his new obsession, Ryman obtained a job as a gallery guard at Manhattan's mod-ernist temple, the Museum of Modern Art. He stayed there for seven years, until the age of thirty, avidly scrutinizing the great paintings wait-ing to be savoured in such abundance. The stimulus they gave him would be difficult to exaggerate. Ryman learned to look very hard at paint-sur-faces during the long hours of invigilation at MoMA. The job must have suited his contemplative nature, for the Tate exhibition cannot be appre-ciated by visitors impatient with the notion of lingering. These undemonstrative images need time, and their meditative serenity demands an unprejudiced mind to be relished as much as they deserve.

The young Ryman also needed time, as the first room discloses. His earliest painting, started in 1955, is covered in a heavily worked, hot orange. Resembling a segment from an especially sumptuous Rothko, this vehement picture looks almost sacriligeous among its reticent neigh-bours. But it already announces Ryman's preference for an all-embrac-ing veil of colour. And in that respect, the orange intrusion is more prophetic than some of the later paintings in the room. Sometimes, strag-gling lines run through them, as in Roger Hilton's abstractions from the same period. Unruly black rectangles disrupt the prevailing calm in sev-eral images, and one small painting contains the phrase 'The Paradoxical Absolute'. Inscribed in rough white capitals on a black ground, the words suggest that Ryman knew, even at this early stage, that his search for purity and perfection would never reach a definitive goal.

He was, however, already sure enough of his work to sign it with pride. One small 1958 painting leaves a generous amount of tan paper free for the artist's name, written in startlingly large, loping pencil lines across a third of the surface. Capped by the last two numbers of the date, crimson against a cloud of floating white pigment, the whole picture seems to rejoice in the proclamation of an artist's identity.

The dealers did not share Ryman's delight. Related neither to the Abstract Expressionists nor the emergent Pop painters, his work found scant favour until a gallery finally gave him a one-man show in 1967. Nothing was sold, but the steady rise of Minimalism soon ensured that international interest began to focus on his work. Although the extreme austerity of Ryman's abstraction allowed his work to chime with Judd, LeWitt and Andre, he never really belonged in their company. One tiny picture from 1961 anticipates the kind of titles LeWitt would give his

own work: *A painting of twelve strokes measuring 11¼″ × 11¼″ signed at the bottom right-hand corner.* All the same, Ryman cannot be associated with the more conceptual side of the minimalist movement. Despite his commitment to whiteness, he seems the least programmatic of artists. Intuition is central to his way of working, and some of his most delectable images are charged with spontaneous sensuality.

Wedding Picture is particularly seductive. The white paint is handled in patches so loose and broken that the warm brown Bristol board shows through in many places. At the upper-right corner, the whiteness fades away, leaving a patch of green flecked with yellow to assert itself. The outcome has the immediate attraction of a landscape transformed by a fresh, uneven fall of snow. And in another 1961 canvas, a small brown triangle has been left in the lower-right corner – as if Ryman had peeled back the white coating to reveal a mysterious dark layer beneath. There is an impulsiveness about such a strategy which links up with his early enthusiasm for bebop. However resolved and refined the pictures may look, they rely on improvisation in the same way, perhaps, that their maker once played his jazz saxophone. And sometimes, as in a small painting on unstretched linen canvas from 1961, the pigment achieves a surprising lushness. Fat white strokes are spread like the palest butter over areas of blue, green and black, which still glimmer in fragments through the creamy deposits.

During the 1960s, though, Ryman felt the need to discipline his intuitive play with procedural rigour. After completing some spectacularly large, busy pictures, where plump white squiggles dance all over a ground of red, ochre and purple strokes clearly exposed in many places, he moved towards more regulated rhythms. 1965 seems to have been a decisive year. One consummate little untitled picture is covered in a single coat of white enamel. The paint appears to have been floated on to the canvas rather than applied with brushstrokes, for they are barely noticeable. But the pigment stops short of the edges all the way round, leaving an irregular line of hair's-breadth brown to act as a foil for the imperturbable milkiness within.

Ryman, who shares Matisse's desire to aim at an art of supreme well-being and fulfilment, must have realised that he wanted to retain this quietness of surface. For he then proceeds, in subsequent pictures, to drag his brush across the canvas in a series of parallel, horizontal bands. Without sacrificing the sensuousness of his previous work, or the touch of an individual mark-maker, he now asserts the principle of order. The outcome should be even more abstract than before, but associations with the visible world will not entirely go away. The thin lines of dark canvas

98. Robert Ryman, *Versions VII*, 1991

between each stripe resemble faint tremors in an otherwise placid, infinite sea. Mondrian's *Pier and Ocean* series is recalled, even though Ryman does his best to banish all representational references by emphasizing exactly how the painting is executed.

Another, more pervasive association is with the potency of light. In *Lugano*, painted on twelve sheets of handmade paper hung together, the linear grid formed by their edges divides up the image like panes in a window. But even when the window reference is absent, luminosity persists. In an unusually agitated sequence called *VII*, the enamelac is splashed onto corrugated paper squares with the vivacity of sunlight dancing on wind-ruffled water.

Such boisterousness is rare, all the same. As the show proceeds, Ryman gradually eliminates gesture and opts for the smoothest, least inflected surfaces possible. He brings the wall into play, too, securing *Advance* with Plexiglass fasteners which travel down the painting like a pair of braces. Steel, bolts and anodised aluminium become evident, introducing in the penultimate room an air of mechanised aridity. Since it compares so

disappointingly with the earlier sensuous engagement, I was relieved to find that his most recent paintings return to a direct, tactile and enlivening involvement with the stuff of pigment. One work in particular, *Versions VII*, builds up a delicate cloud of vigorously applied white paint on the thinnest of wax-paper grounds. The result is wonderfully diaphanous, and near the centre a V-shaped form hovers like the memory of a bird in flight. It is a fugitive image, indicating that beneath Ryman's long preoccupation with paint as a material substance lies an awareness of life's fundamental transience, conveyed with all the elusiveness of a dream.

SUSANA SOLANO AND MELANIE COUNSELL
2 April 1993

Born at the end of the Second World War, Susana Solano is the most out-standing Spanish sculptor of the generation who came to maturity after Franco's death. But if the waning of his regime led to an extraordinary upsurge of vitality among artists throughout Spain, Solano's work shows no sign of euphoria. On the contrary: the governing mood of her first British retrospective at the Whitechapel Art Gallery is stern, rigorous and devoid of facile optimism. None of the adjectives too often glibly applied to women's art – decorative, sensuous, beguiling, etc. – can be associated with the work displayed here. It could hardly be tougher, and the first sculpture confronts visitors with an utterly uncompromising presence. Grimly entitled *The End of the 90s*, this bulky iron box rests on the floor like a bunker left over from some distant battle. Two glass sheets are inserted in the top, hinting for a moment at the possibility of access to the structure's interior. But they remain shut firmly together, and their thick, indented surfaces rule out any possibility of peering through. Defensive and implacable, the whole work presents a cheerless vision of how belea-guered life may have become by the time our century expires.

True, this forbidding stasis is immediately challenged by *The Bridge*, where lead cascades in curving, overlapping sheets until it reaches the ground and spreads into a flat, pool-like stillness. Even so, Solano makes no attempt to pretend that a waterfall is represented here. The slabs of lead remain undisguised, their welding marks openly exposed. And the network of iron struts supporting the 'cascade' is rusted and bent, sug-gesting that the bridge may well be on the point of collapse.

Like Julio González, the most renowned of modern Catalonian sculptors, Solano relishes the rawness of the materials she employs. Her studio is in St Just, the industrial quarter of her native Barcelona. And the commitment she displays to riveting, cutting and welding allies her powerfully with a great local ironwork tradition. All the same, González's preference for attenuated delicacy plays no part in Solano's sculpture. He would often handle iron like an exhilarated draughtsman, making his thin, supple lines soar through space in order to rejoice in the agility of a dancing figure. She, by contrast, opts for severe primary structures which owe a debt to the American Minimalists. But there is nothing derivative about the feelings engendered by her objects. In *Twice Times No*, the sculpture lives up to its ominous name by rearing up in front of us, as implacable as a prison. A transparent pvc sheet is installed on one part, allowing us to look inside. But grilles guard the space within, ruling out all possibility of escape. The sculpture's oppressiveness is quite different from the work by Judd, Andre or LeWitt which may originally have impressed Solano. She explores far more gruelling emotional territory than the Americans, and after a while I began to wonder if the harshness of the Franco years still lingered in her imagination like memories that refuse to go away.

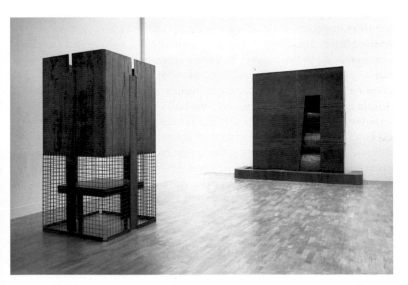

99. Installation view of Susana Solano exhibition at Whitechapel Art Gallery, London, 1993 (left, *Aqui yace la paradoja*, 1990–1; right, *Pervigiles pepinae*, 1986)

Just as Anselm Kiefer is obsessed with the most traumatic aspects of Germany's past, Solano seems unable to escape from images of incarceration and aridity. The title of one sculpture, *Spa*, arouses the hope that it might be as refreshing as the trough of water where the young Solano once splashed with her brother and sister. In a snapshot reproduced as the catalogue's frontispiece, all three children are shown grinning as they crouch in the trough. But *Spa* itself contains no water. Only stains and smears of dirt can be found inside these two iron containers. Their dried-up desolation is a measure of the apparent gulf between the woman who made *Spa* and the blithe little girl in the family photograph.

Judging by some autobiographical notes Solano has published, her childhood nevertheless feeds the work she produces today. While Franco's repression provides one possible source of her disquiet, the sculptor's own father clearly played his part too. 'I never had a conversation with my father,' she wrote, 'neither did he speak. Authoritarian, categorical and hot-tempered.' The silence which enclosed him seems to have contributed to the lack of communication dramatised in a work like *Here Rests the Paradox*. For the cage structure this time contains a table, unaccompanied by chairs and surmounted by a tall, four-sided barrier which shuts us off from all further exploration of the interior.

Solano is often preoccupied with the impossibility of penetrating the mysterious privacy of the spaces she creates. The final exhibit upstairs is the most impregnable of all. An especially large iron box capped by corrugated sheets like a roof, it is more reminiscent of a house than anything else in the show. But a walk round the sculpture discloses no doors or windows punctuating its dark, uniform sides. It resembles instead a condemned building, closed off against the threat of vandals until the demolition gang arrives.

Besieged and unrevealing, this ominous presence shows how stillness easily takes on the aura of death in Solano's work. She recalls, in her writings, the time when 'my father is dying. I suggest they shave him.' But the work itself cannot be pinned down to such a specific source. Instead, a strong and consistent determination to strive for a sense of ancient ritual gives the entire exhibition a mythic quality. *Surly* looks like a sacrificial altar. Covered by a pvc cloth but far too high to dine on, this colossal table seems to be waiting for the slaughter to begin. And round its base run dark gutters, ready to channel the victim's blood.

A lesser artist dealing with such concerns might easily have descended into Grand Guignol. Solano, however, knows where to stop. *Effect and Cause* may bear an unsettling resemblance to an iron bedstead containing two sealed coffins, lying side by side. But it is abstract enough to resist

being tied to a single interpretation. Even when she takes the unusual decision to incorporate a photographic image, in a sculpture called *Act 1 Scene 1*, Solano fights shy of a specific meaning. For the figure floating in water at the base of this glass and iron container is shadowy and enigmatic. Swimming, drowning or already dead, she deliberately frustrates identification. But there is no mistaking Solano's high seriousness, and the undertow of dour emotion running like an elegy through everything she produces.

Melancholy persists at the installation Melanie Counsell has made for the Coronet Cinema on the Mile End Road. Commissioned by the enterprising Artangel, who present new art in unconventional locations, Counsell could hardly have chosen a more dilapidated setting. The Coronet has long since outlived its glory days as a streamlined art-deco picture palace. Positioned next door to Blockbusters Video, who must have played a part in hastening its demise, the cinema has been left derelict by squatters. The darkened foyer leads up to a once-resplendent room where torn ceiling paper hangs down like stalactites and graffiti festoon the red walls.

Entering the cold, musty auditorium is an even spookier experience. Lit only by floor-level lamps, the empty and often broken seats stretch up ahead in intimidating ranks. A bright rectangle on the screen proves that something is being projected, yet a barrier of thick, ribbed glass blocks the view. Only from the topmost row of seats does the screen become fully visible. But rather than alleviating the gloom, Counsell's black-and-white film intensifies it. A glass beaker brimming with dark, unidentifiable liquid is shown, and over the course of half an hour the contents gradually evaporate. The effect is stupefying. Counsell must have wanted the emptying vessel to reinforce the mournful sense of loss she found at the Coronet. But the decrepit auditorium is more potent by far than her muted film, which ends up seeming superfluous in such a desolate locale.

TONY BEVAN

21 May 1993

Who, among the younger generation, are most likely to succeed Lucian Freud and Frank Auerbach, now presiding so magisterially over figurative painting in Britain? Some would answer by pointing towards Glasgow, where Steven Campbell and his ebullient contemporaries were lionised in the 1980s. But I suspect that they peaked too soon, whereas the really impressive figurative painters know how to pace themselves and steadily develop over the decades. Take Tony Bevan, whose rewarding retrospective has just opened at the Whitechapel Art Gallery. Although his emergence was not hyped as ecstatically as the Glasgow Boys, Bevan has quietly continued to hone his singular vision long after they ran out of breath. Rarely seen in London, where no dealer represents him, he is now working more cogently than ever. So the Whitechapel survey is a timely event, bringing us into sustained contact with one of the most unsettling painters at work in Britain today.

A confrontational mood becomes apparent from the outset. Hanging opposite the entrance, a large canvas is dominated by a man leaning forwards and staring out at us. He rests his oddly distorted, upturned hands on the table in front, as if to present them for inspection. Covered in thin, stabbing strokes of the brush, they seem to be wounded. And the man's expression compounds the sense of injury. His features look tense, almost aggrieved, as he gazes questioningly and maybe challengingly at his viewers.

The intensity of the image arouses curiosity, but Bevan's work refuses to be pinned down. His directness is matched by ambiguity, nowhere more than in the self-portraits on show here. The most disturbing of them focus on his head and neck, wrenched upwards in an awkward, straining pose. The deep red marks so evident in the painting of his upturned hands are now far more prominent. They are slashed across the neck like incisions left by a knife-attack, and must in some way reflect Bevan's preoccupation with the scars of a serious neck operation he underwent in 1977. But on a less macabre level they could also define muscle and bone structures, and Bevan keeps their meaning as open as he can. In *Self-Portrait with Door*, his naked back is turned away to reveal a crimson fissure running down its centre. It might be a cut, or alternatively his violently lit spine. Either way, the temper of the painting is ominous. Bevan's body looks lumbering and unsteady, with his right arm dangling down vulnerably from a hunched shoulder. No trace of vanity

can be detected in this ungainly figure, and the artist's brush spares nothing as it defines all the blemishes peppering the battleground of his skin.

Although debts to Van Gogh and Munch are discernible in this quietly forceful show, the main influence is surely Francis Bacon. Bevan, who sometimes starts by drawing straight on to the wet canvas with charcoal, shares Bacon's partiality for linear painting. He also likes to contrast densely worked areas of flesh with flat expanses of saturated colour, where tables or windows are simplified as ruthlessly as in a Bacon painting. Both men are preoccupied, for the most part, with the male figure, and the least satisfying paintings at the Whitechapel are two rare images of women. Above all, Bevan and Bacon are painters of humanity in isolation, with a disconcerting emphasis on the carcass-like quality of bare flesh.

The most unnerving image in the show is a colossal canvas of a hand clutching a fork. Fingers and thumb close round the handle with resolute precision, preparing to jab at an unseen target. It may simply be some food on a household plate. But the blood-red table below has a sacrifical aura; and by marooning the hand in an immense, dark-purple void, Bevan gives the entire image a menacing air. Only a glimpse of forearm is allowed to emerge from the gloom. He paints its skin with a rawness nearly as disquieting as Géricault's studies of decapitated limbs, or Goya's paintings of slaughtered animals.

Compared with Bacon, though, Bevan seems restrained. His handling of paint is more cautious and controlled, relying far less on chance and writhing impulsiveness. Unlike Bacon, he prepares himself by making drawings on paper before the painting begins. And his favoured subjects are less overtly disturbing than Bacon's recurrent themes. Many of the paintings in this exhibition contain images of men with open mouths – a classic Baconian obsession. But Bevan's men are not screaming. They appear to be singing, and the artist's starting-point was a blurred newspaper photograph of a Chilean choir illustrating a report on a community or sect founded in the 1960s.

By the time he had worked on the image, the source was transformed. Several paintings of single heads show men who could be shouting rather than singing. Dressed in open-neck shirts and usually set against neutral grounds, they part their mouths to reveal vermilion tongues and predatory teeth. The stiffness with which they perform jarringly contrasts with the informality of their clothes. And as the series proceeds, their strangeness grows more disturbing. One man, wearing a shirt crisscrossed with red lines almost as harsh as the incisions Bevan seems to make in bare flesh, only opens one eye. The other is closed, and the lid covering it looks scratched and puffy. He reappears in an even more

100. Tony Bevan, *Portrait Boy*, 1991

unsettling picture, juxtaposed now with a man in a dark blue shirt standing close behind him. His face, so similar in construction and only slightly less open at the mouth, almost seems to merge with the other. Their identical outward gazes take on, through repetition, a remorseless feeling. They look programmed, like a pair of mindless performers in a ritual manipulated by some unknown authority.

Bevan is subtle enough to make us question the likelihood of such a sinister interpretation. The two men could, after all, be simply and innocently engaged in a community sing-song. If the activity were as straightforward as that, however, he would hardly have been prepared to devote so much thought and energy to its exploration.

The grand culmination of all these images is *The Meeting*, a multi-part painting of nine singers which must be his largest and most ambitious picture to date. Here, at first glance, Bevan seems to have escaped from images of isolation and embraced an assembly. But the more closely this painting is examined, the less harmonious it becomes. Although the seven men ranged across the back row are unified by their strident vermilion background, they remain divided into four canvases. No attempt has been made to hide the borders between them, and none of the singers seems to have any real connection with his neighbours. They remain eerily dislocated, staring in different directions while retaining the same frontal position.

Before them, hanging down like displaced panels from a quattrocento altarpiece, two orange-ground paintings of adolescent singers have been placed. They partially obscure the men behind, but their youthfulness is undermined by the few sparse strands of hair lying limply over otherwise bare scalps. They resemble patients stoically enduring chemotherapy treatment for a life-threatening disease. So although *The Meeting* stirs initial memories of angelic choirs in Renaissance polyptychs, it ends up as a far more troubling image. These glazed performers could be as brainwashed as the members of some demented religious cult, and their open mouths have a joyless, mechanical character. There they stand, singing out the century's final years like automatons devoid of emotion. No wonder the solitary boy in another Bevan painting looks wizened before his time, and gazes at the future with misgivings scored deep in his pale, ascetic features.

THE 1993 VENICE BIENNALE
16 June 1993

The year is 1934, and Adolf Hitler made sure a photograph was taken when he strutted into the Venice Biennale with a dour, self-righteous air. While a Mussolini henchman gives a fawning smile nearby, the Führer satisfies himself that all the exhibits are politically correct. The Biennale, after all, was conceived as the Olympics of contemporary art, a contest between the national pavilions ranged around the public gardens. And the Nazi leader wanted his country's honour to be upheld without a hint of degenerate deviation.

If Hitler were alive today, and visited Hans Haacke's installation for the German pavilion at the 1993 Biennale, he would be gratified to find this photograph confronting visitors as they step inside the entrance. But pride would quickly turn to outrage if he walked round this hoarding and surveyed the pavilion's monumental interior. For the space is empty, apart from the word GERMANIA inscribed in large capitals on the far wall. And the marble floor which Hitler installed over half a century ago has been uprooted and smashed, like the fragments projecting from the frozen water in Caspar David Friedrich's masterpiece of German Romanticism, *The Sea of Ice*. Visitors who pick their way across this broken, treacherously unstable terrain make a clattering sound, which reinforces the echoing desolation. With great boldness, Haacke presents a brutal image of the wasteland left behind by Hitler after his death. But the pulverised pavilion also forces us to ask questions about present-day Germany, where so-called unification has led to dissent, recession and an alarming renewal of the savage racism fostered by Fascist bullies sixty years ago.

By subverting the whole notion of a patriotic shrine, Haacke's room chimes with the aim of the Biennale as a whole. For this year's organiser, the Italian critic Achille Bonito Oliva, stresses the need for 'cultural nomadism'. He maintains that contemporary artists must leave narrow definitions of nationalism behind, undertaking 'voyages' to other cultures in order 'to rediscover energy and expressive strength'. The meaning behind the resounding title he has chosen for the Biennale, *The Cardinal Points of Art*, remains irritatingly vague. But some pavilions have entered into the nomad spirit by breaking away, quite literally, from the hallowed idea that the Biennale should be the Fine Art equivalent of the Eurovision Song Contest.

Haacke, although German, has lived in the USA for thirty years, and his co-exhibitor is the Korean-born video artist Nam June Paik. Over at

the otherwise confused and disappointing Italian pavilion, the presence of invited artists from Africa strikes a blow for a continent usually unrepresented at the Biennale. New York–based Joseph Kosuth occupies the main space at the Hungarian pavilion, where his dense collage of wall-texts contrasts coolly with the clanking, jerky, participatory junk-machines installed by the Tinguely-influenced Viktor Lois in the basement. And the former Yugoslavian pavilion has turned national tragedy to poignant account by inviting seven artists from other countries, including Tony Cragg, Shirazeh Houshiary and Julian Opie, to fill the 'evacuated' building with 'works regarding peace'. Opie comes nearest to defining the insanity of internecine butchery, displaying an ironic *Fortified Area* as childish as the castle walls in a nursery game.

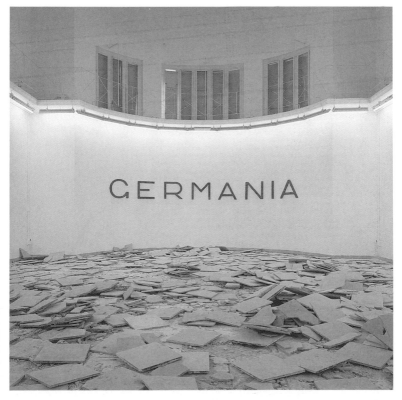

101. Hans Haacke, *Germania*, German Pavilion, Venice Biennale, 1993

Plenty of pavilions refuse to flout patriotic tradition, staying loyal to home-grown artists instead. But they are often the dullest contributions. The Swiss contender, Jean-Frédéric Schnyder, offers three stupefying rooms lined with dogged little paintings of traffic on motorways. The Venezuelan pavilion, devoted to Miguel von Dangel's melodramatic and gory images apparently inspired by Uccello's San Romano battle paintings, looks as if someone has vomited all over the walls. As for the French, they have allowed Jean-Pierre Raynaud to smother the entire sequence of rooms with a repetitive sequence of white tiles, each bearing the same banal image of a human skull. Far from adding up to a remorseless *memento mori*, this stunningly tedious pavilion reduces the idea of mortality to a chic and overblown exercise in bathroom décor.

It is a relief to report, after these pathetic antics, that the British pavilion restores dignity to the name of art. Richard Hamilton, awarded the top Golden Lion Painting prize by the Biennale jury, has never looked better than in this lucid selection of paintings and installations from the past decade, displayed with a crispness lacking in his Tate retrospective last year. If the British have decided against selecting a foreign artist for their pavilion, Hamilton does at least devote his first and finest room to a series of paintings about Northern Ireland. Begun in the 1970s with a melancholy picture of a 'dirty protest' prisoner, and continued ten years later with the harsher image of an equally unyielding Orangeman in full ceremonial regalia, the sequence is now concluded with a new painting of a British soldier in camouflage uniform. Walking backwards down a street, this wary figure is juxtaposed with a damp, dismal landscape reminiscent of Gerhard Richter's work at its most blurred. Taken together, the three pictures amount to the most sustained meditation on the Irish troubles made by any living English artist. Still as fascinated by photographic and film sources as he was in his heyday as a pioneer Pop artist, Hamilton has widened his range and addresses this complex theme with a new sense of gravity.

In his willingness to tackle social and political issues, the septuagenarian Hamilton has links with the young artists selected for the *Aperto* section of the Biennale. Under the urgent title *Emergenza/ Emergency*, this vast and often hectoring survey sets out to explore five categories: entropy, violence, survival, social marginalization and difference. The outcome is too often marred by a desire to sensationalise. As if determined to outdo shock-horror tabloid journalism and the television soundbite, artists from many different countries indulge in attention-grabbing tactics. Oliviero Toscani sets the tone early on, smothering an immense room from floor to ceiling with outsize colour photographs of genitalia. It is a dispiriting

spectacle, and just as easily exhausted as Rudolf Stingel's colossal orange carpet stuck on the wall or Carter Kustera's callow list of racist stereotypes: 'All British Are Snobs/All Canadians Are Nice/All Germans Are Nazis/All Italians Are Horny', etc., etc.

Sex and death predominate, with special lingering emphases on masturbation and the morgue. Andres Serrano photographs the decaying victims of pneumonia and knife-attacks, revealing no emotion save a cold curiosity. Mat Collishaw displays a photographic image of a corpse in a copse, heartlessly accompanied by a dawn-chorus soundtrack. Compassion is conspicuous by its absence, but Damien Hirst generates a palpable mournfulness with *Mother and Child Divided* – a cow and calf each sliced in two and displayed, pathetically suspended, in boxes of formaldehyde. Everywhere you look, a gloomy and often fascinated emphasis on extinction prevails, perhaps reflecting the new generation's obsession with mortality as the century nears its close in a plethora of global epidemics.

In such a context, Yukinori Yanagi's ingenious exhibit seemed almost optimistic. He showed a series of perspex boxes containing world flags made of coloured sugar. They are all interlinked by hollow tubes, enabling ants to crawl from one to another, busily destroying and rearranging these images of nationhood. As well as offering a timely comment on the current dissolution of territorial boundaries, the ants' irrepressible energy contrasts favourably with the morbidity so evident elsewhere. According to this doleful *Aperto*, young artists are more preoccupied with the fluff in their own navels than with the broader issues they are supposed to be exploring.

Much of their work looks anaemic compared with the indomitable Louise Bourgeois, who at eighty-two is magisterially fêted in the American pavilion. French by birth and upbringing, and therefore an appropriate choice for a 'nomadic' Biennale, she fills her rooms with sculpture and dimly lit installations where desire, loss, memory and the grave are powerfully intermingled. The outcome could easily have been as cheerless as so many of the *Aperto*'s offerings. But Bourgeois, who appears to be at the peak of her considerable abilities, succeeds in tackling these sombre themes with zest, inventiveness and a surrealist wit. Without betraying the tragic import of her concerns, she seasons them with a beguiling strangeness which makes her pavilion stand out in a generally despondent Biennale. If only Bourgeois's juniors possessed half her vitality and the capacity, time and again, to spring a well-staged ambush on the unsuspecting viewer.

SHIRAZEH HOUSHIARY
6 August 1993

Among the deserving artists unaccountably excluded from this year's Turner Prize shortlist, Shirazeh Houshiary should have been a front-runner. Many visitors to the Venice Biennale this summer will be arrested by her exhibits, not only at the former Yugoslavian pavilion poignantly dedicated to 'works regarding peace', but in a mixed show on the enchanting Island of San Lazzaro. There, amid exhibits distributed throughout the ancient Armenian monastery, Houshiary's copper and steel polygonal floor-sculpture is quietly enhanced by its position in the ante-chapel, glowing near a cluster of the monks' candles burning in their holders nearby.

Now, in a survey with the intriguing title *Dancing Around My Ghost*, the Camden Arts Centre is presenting an extensive selection of her new work. Houshiary's largest London exhibition to date, it confirms her prominent place among the outstanding generation of sculptors who emerged in Britain during the 1980s. Born in 1955, she only settled here to study at the Chelsea School of Art after growing up in Iran. So her work brings about a fascinating fusion of her Iranian background and her involvement with late-twentieth-century Western art. Everything she produces is fuelled by a fruitful tension between these two traditions; and within the show there is a parallel tension between sculptural solidity and far more ethereal concerns. Although the Camden show is full of objects, they are informed by an awareness of something intangible, to do with the spirit rather than the flesh. For Houshiary, the work itself acts as an intermediary between body and soul. She uses art to help her search for the true self – a quest bound up with her interest in the mystical Sufi idea that you must withdraw from the world in order to arrive at your essential being. Only by gradually annihilating your conventional self can you experience a reawakening, and these notions inform the set of drawings displayed in the first room like votive offerings on a chapel's walls.

From a distance, the five brooding images seem reminiscent of the black squares painted by minimal abstractionists like Malevich and Ad Reinhardt. Closer-to, though, you realise that the dominant forms within the squares are in fact circles. Apparently vaporous and cloudlike, they turn out from even closer examination to be defined in an astonishingly precise way. For each circle is made from a multitude of minute graphite marks. They take the form of Arabic words and, as in a chant, repeat a word or phrase like 'truth', 'I am breath' or even 'I am God'.

A Western agnostic might well find such dicta hard to appreciate. But no religious knowledge is needed to savour the extraordinarily controlled and delicate way in which Houshiary has drawn these words. They must have taken an enormous amount of time, starting from the centre and working outwards with a freehand lack of reliance on preliminary geometric outlines. An unusual level of concentration was required to perform such a feat. It arises from a state of mind dependent on emptying yourself out, refusing to be distracted by any extraneous considerations. Looking at these minuscule marks, we become conscious of Houshiary's patient ability to purge herself of habitual, everyday thoughts and arrive, hour after hour, at a heightened level of intensity.

Not that the five images are identical. Even though their reliance on calligraphy shows the strength of her links with Islamic art and architecture, strange forms variously suggesting the motion of sea or radar scanners run through them like waves. In this sense, they are akin to the seemingly very different work displayed next door. The modest proportions and subdued lighting of the first room now give way, dramatically, to a dazzling alternative. Here, in a grand and luminous chamber transformed by recent restoration into one of the finest gallery spaces in London, six lead sculptures are ranged in a circle on the wide, white floor. They appear to be floating in an ocean of boundless light. Although physically separated from one another, they all seem caught up in the same chain of being. The six components cannot be understood in isolation, or treated as independent forms. They belong together, united by the enigmatic title *Licit Shadow*, and trace a steady progression underpinned by Houshiary's interest in number. Like the Sufis, she believes that mathematics can help to define the path pointing towards spiritual essence.

The nearest of these low-lying boxes is the most austere. Lead is its only material, and the cell-like structure within sinks down to a low point at the centre. Concave and unadorned, it borders on bleakness. But even as we stare down at the sculpture, our eyes make us aware of other forms hovering on the edge of our vision. These neighbouring objects are enriched with burnished copper linings. Sparingly applied at first, they gradually fill more of the inner cells as the boxes complete the circle. The result is a gathering sensuousness, which counteracts the initial impression of grid-like severity. These sculptures appear to be on the move; and as we walk around them, the increasing splendour of their copper infill is matched by a progressive swelling of their inner structure. They seem to be gently rising, and geometrical rigour is replaced by a yeasty feeling of organic growth.

102. Shirazeh Houshiary, *Licit Shadow*, 1993

The whole momentum reaches its zenith in the most sumptuous box, where copper is exchanged for gold leaf. The cells all strive upwards now, like a mountain rejoicing in the sun. They look fulfilled, even triumphant. But the rest of the sculptures do not seem subordinate to this majestic presence. It belongs to the ensemble, and Houshiary appears to insist that they must be grasped as a totality rather than a miscellany of unrelated fragments.

The same impulse to see things whole, and appreciate how interdependent they really are, governs the work installed in the final room. Unlike *Licit Shadow*, which gains hugely from its epic surroundings, this multi-part sculpture is constrained by the room it occupies. The space should, ideally, be ten times larger. For each of these five elements is a looming, bulky object, and they all appear to have been crammed into an uncomfortably limited arena. As a result, they seem surprisingly defensive. The low-slung lightness of *Licit Shadow* is exchanged for dour, high-walled cubes of lead.

At first glance, they resemble classic minimal sculpture from the 1960s. But Don Judd would have left these cubes either covered or empty, and

utterly simplified. In Houshiary's hands, they become receptacles for an inner richness. The entire ensemble is called *The Enclosure of Sanctity*, which points towards the idea of providing protection for something sacred and inviolate. Each piece, however, represents a planet as well. Peering into the recesses of the 'Moon' form is like looking down a deep, dark well, and finding a silver reflection glimmering at the bottom. It is a poetic image, ostensibly at odds with the mathematics which brought the sculpture into being.

Houshiary's dependence on numbers, derived this time from a medieval system, gives the work its coherence. But *The Enclosure of Sanctity* can be enjoyed without a detailed knowledge of the calculations behind it. The labyrinthine complexity of the structures inside each form, with their descending ramps and uninhabited apertures, have a fascination of their own. Whether representing Venus, Mercury or Mars, they appear to explore the limitless mysteries of the human soul. Even the climactic form, where the Sun is celebrated with the aid of resplendent gold-leaf lining, points away from material magnificence. For all their redoubtable substance, these tantalizing sculptures are poised between palpable, here-and-now certainty and the unknowable regions beyond.

MARLENE DUMAS
27 August 1993

When painting enjoyed a flamboyant international revival in the early 1980s, outspoken emotions and agitated brushmarks spread like an epidemic across acres of splattered canvas. A decade later, in cooler times, much of the work generated by this excitable resurgence now looks overblown and merely melodramatic. But some of the artists who emerged in that hectoring period have proved durable. Although neo-expressionism no longer basks in the fashionable approval of ten years ago, Marlene Dumas still possesses the integrity and stamina to merit widespread respect. While so many of the other, loudly touted 'new painters' of the time have slipped into rhetorical showmanship, she has quietly grown in stature.

This summer, at the age of forty, Dumas's achievement is being surveyed by the ICA in her first solo London exhibition. Having lived in

Holland for almost twenty years, she is often regarded as a Dutch artist. But she spent the first half of her life in South Africa, and memories of growing up in Cape Town may help to account for the tense, awkward strangeness which gives this show its unsettling power. Dumas is a difficult painter to pin down. 'At the moment,' she wrote in 1986, 'my art is situated between the pornographic tendency to reveal everything and the erotic inclination to hide what it's all about.' The statement still holds true. At first, she appears to declare an open debt to the pioneer generation of German Expressionists. The impulsive harshness of Kirchner and Nolde seems to lie behind many of her graphic works, and she certainly shares their willingness to explore distressing regions of the psyche. Her preoccupation with women and children also recalls Kollwitz's obsessive concentration on the same subjects. Dumas and Kollwitz are united by their determination to avoid a cloying, complacent view of their chosen themes, which usually end up unnerving the viewer rather than providing even a hint of comfort.

On another level, though, this exhibition lacks the Expressionists' headlong, raspingly confessional urge. Dumas may not have been born in Holland, but she shares with the Dutch a certain coolness and detachment. Little of Kirchner's neurasthenic ferocity, Nolde's abandon or Kollwitz's relentless morbidity can be detected here. Dumas is neither anguished, ecstatic nor possessed by death. She stays at one remove, taking photographs from newspapers, family albums and art books as the springboard for ruminative pictures which drain the original images of their colour and detail alike.

Take the array of drawings called *Female*, completed just before the exhibition opened. Unframed, and as informal as snapshots, these rapidly executed studies in grey wash cover an enormous wall with a multitude of wan, introspective faces. Some look down, others glance warily to the side. One raises an arm to shield her eyes, as if weary of observing or being observed. But most of these anonymous heads look tired and defensive – a mood accentuated by the blotchy, stained handling of the wash.

Here humanity is at its most vulnerable, and a sense of universal despondency threatens to deprive Dumas's art of pictorial energy. Upstairs, though, she shows just how arresting her work can be. Four large paintings called *The First People* leap off the end wall. Presumably based on photographs of naked, reclining babies seen from above, they could have been saccharine images regurgitating generalised notions about the wonder of infancy. Instead, they seem raw and disconcerting. Dumas knows exactly how babies writhe and thrust out impetuous

103. Marlene Dumas, *Faceless*, 1993

limbs when lying on their backs. Each swollen face looks dazed, even startled by the world as it struggles to scrutinise the surroundings.

The flesh is either painfully pink, as if suffering from sunburn, or alarmingly blanched. Their tight, swollen bellies contrast with the spindliness of the inert legs dangling below. But the babies' arms are hyperactive, raised with muscular obstinacy to terminate in bunched fists or extended, claw-like fingers. The helplessness of infants is vividly conveyed, and so is their latent dynamism. Some of their glances seem cunning rather than bewildered, and Dumas's supremely uningratiating way with paint ensures that they assert a pugnacious wilfulness as well.

There is nothing innocent about *The First People*. They live up to the paintings' collective title by seeming to contain, in essence, their adult characteristics. In a sinister canvas called *Snow White and the Broken Arm*, a row of boys' faces stare down at the woman resting on a table. Naked apart from the bandage swathing her arm, she resembles a pale victim laid out on a sacrificial altar. The radio in her hand appears incapable of providing reassurance as she helplessly submits to this furtive yet threatening surveillance. Although the boys may be unwilling to inflict any bodily harm, their prying presence is enough to reduce her to a state of near-paralysis.

Not that children are always seen as precociously in control. *The Dance* should be a joyful picture, celebrating the high spirits of four girls – two black and two white – as they all hold hands. Dumas, however, subverts any cosy expectations we may bring to the scene. Viewed from behind, the girls look oddly downcast as they stand erect and gaze into the shadowy bleakness of the yard ahead of them. Far from giving themselves over to the pleasures of dance, they remain cowed by the ominous emptiness beyond. And Dumas's handling reinforces the melancholy mood, stripping the scene of incidentals in order to stress the children's frailty.

Growing up in South Africa may well have made her especially wary of indulging in optimism about the future. Even when she produces an ostensibly cheerful image of *The Turkish Schoolgirls*, anxiety cannot be dispelled. They look happy enough, standing in a row and smiling as if for an invisible photographer. But Dumas's insistence on depriving the pictures of everything except subdued blues, greys and blacks gives it a funereal air. The girls begin to resemble refugees, lined up in readiness for a journey to a destination which could easily rob them of their composure.

In recent years, the plight of the children inhabiting her work has intensified. *The Window*, tersely painted with thin, vertical strokes of the brush, focuses on the simplified figure of a long-haired girl in a nightdress. Leaning her thin arms on the window's sides, she stares out into a darkness as complete as the nocturnal view in Matisse's haunting *Open*

Window, Collioure of 1914. Unlike Matisse, though, Dumas never allows herself to convey unqualified delight. She is closer to Munch in her feeling for the isolation of the individual, nowhere more strikingly than in a large, horizontal canvas entitled *The Particularity of Nakedness*. Instead of showing a female odalisque recumbent in the foreground, she turns the tables on convention by painting a male nude lying next to a stretch of water. With one armpit brazenly exposed, he turns to smile at us like a lover proffering an invitation. But the starkness of his surroundings conveys a Munch-like chill even here. While Dumas relishes the sensual promise inherent in the man's waiting body, she cannot prevent herself from making us conscious of loneliness.

The unease is at its most overt in some small paintings of children. Painted over the past year, some of them show naked girls symbolizing Justice or Liberty. Savagely ironic, they suggest that Dumas is growing more indignant as she approaches middle age. The figure in *Liberty* looks more like a slave than an embodiment of emancipation, while in *Straitjacket*, another girl stands trussed and powerless before a chillingly institutional curtain. She is the quintessence of captivity, and nothing in the rest of this disenchanted exhibition indicates that adulthood will bring freedom in its wake.

RICHARD DEACON IN HANOVER
16 November 1993

Visiting Hanover for the first time, I was astonished and ashamed to discover how enthusiastically art is treated throughout the city. Although the capital of Lower Saxony, Hanover is not very large. Its equivalent in Britain, with a population of just over half a million, would usually be content with a ramshackle, under-funded municipal collection. Here, by contrast, a cornucopia of excellent galleries seize the attention. Foremost among them, the Landesmuseum and the custom-built Sprengel Museum are devoted to historic and twentieth-century art respectively. But Hanover is just as committed to the liveliest contemporary developments. At the moment, the entire Kunstverein is housing a major, superbly installed survey of Richard Deacon's sculpture. And for good measure, the Orangerie in the Herrenhäuser Gärten displays two more works which he has made specially for this monumental space.

Would the Welsh-born Deacon be granted a similar exhibition in, say, Swansea? I doubt it. Like so many of our leading artists, he seems far more generously appreciated on the continent. Since the late 1980s, when he won the Turner Prize and then staged a retrospective at the Whitechapel Art Gallery, Deacon has produced an impressively sustained and inventive body of work. But only a fraction has been shown in London, and Hanover's double venture demonstrates just how much we have been missing. If the Kunstverein provides a well-selected array of his most important sculpture from the past five years, the Orangerie offers a potentially daunting challenge to any artist. This hangar-like interior, set in formal gardens embellished with baroque statuary, might easily lead to disaster. The exhibitor could either be overwhelmed by immensity, or tempted to indulge in grandiloquence. Deacon has solved the problem with resourcefulness and sly wit. In one half of this echo-ing, eighty-metre-long chamber he mocks the vastness by laying a mod-est expanse of steel flat on the floor. Although reflecting light from the tall windows nearby, it is the very opposite of assertive. Rippling out-wards, and punctuated by shallow cavities, this unassuming object seems to be melting. It defiantly refuses to strain for the bravado which the Orangerie would seem to demand.

In the other half of the space, though, Deacon shows how gloriously flamboyant he can be. *What Could Make Me Feel This Way* asks the title, as if in wonderment at his readiness to produce such a colossus. Made of wood, its writhing forms stir memories of the serpents assailing the fig-ures in the great classical *Laocoön* carving. But there is no violence in Deacon's *tour de force*. The cylindrical forms dip and swell like a roller-coaster, making no attempt to crush the calmer forms running back through this labyrinthine ensemble. Despite its undulating complexity, this is a harmonious and exuberant work. Looking through the central tube, we are invited to savour the intricate receding structure of the slats within. They are as precisely ordered, in their way, as the long avenue of trees stretching outside the Orangerie. Walking round the sculpture, we become aware of how well its burgeoning parts fit together. There is nothing sealed-off about these tubes. They are all open and responsive to each other. Nor are they simply suggestive of mechanical parts. More organic than industrial, they might easily refer to the inside of a human body. Deacon does not strive for this biological reference. The work is abstract, and it openly declares the screws and splashes of white glue which bind the elements together. But it operates on a metaphorical level as well, showing how even the most tortuous cluster of forms can interact with deftness and dancing aplomb.

104. Richard Deacon, *What Could Make Me Feel This Way*, 1993

By contrasting these two works in the Orangerie, Deacon reveals the tension that nourishes his art. Part of him is attracted to severity, and part to swaggering lyricism. Both of them are vividly apparent in the sculptures assembled at the Kunstverein, where each white room gives plenty of space to the exhibits it contains. In the largest gallery, *Struck Dumb* lives up to its name by establishing a sullen presence at one end. Bulging like an over-ripe fruit, and yet as ominous as an unexploded mine dredged from the sea, it looks both fecund and defensive. Most of the black steel surface rebuffs anyone trying to discover what might be lurking inside. Only at the front, where a deep red metal plate has been pinned like a bow-tie, does an opening disclose itself. And even here, the viewer must crouch in order to peer at the dark, ribbed underbelly of the form within.

This squat, boorish hulk retains its enigma to the end, whereas the whole of the next room is alive with the extravagant, space-hungry gesticulation of *Doubletalk*. Deacon is here at his most swooping and unfettered. Bulkiness is replaced by line. He uses laminated wood to

draw freely in space. Such a large sculpture could easily have become grandiose, but an athletic poise is retained throughout. Having pressed the wooden strips together until his yellow glue spills out in gobbets, Deacon whirls his material like a lasso. The tense yet graceful arcs invade our space, breaking down the usual division between spectator and exhibit. You are invited to step through the sculpture, puzzle over the russet material swathing one curve like a leather arm-glove, or walk down its centre watching the lean wood soar above your head. It is an exhilarating sensation, akin to watching an aeroplane looping the loop.

All the same, this unabashed theatricality may not have satisfied Deacon in the end. For *Doubletalk* is the earliest piece on view, and its effervescence gives way in later works to a greater emphasis on sternness and substance. *Body of Thought No. 2*, made the following year, is a more reined-in work. While relishing its convoluted knot of forms, he no longer allows them to indulge in such expansive flourishes. The steel and aluminium are tightly coiled, and a pair of upright lozenge forms linked by a dark, horizontal bar give a greater sense of solidity. Judging by a subsequent series called *The Back of My Hand*, Deacon may have wanted to dispense with virtuosity altogether. Three of them are shown here in a room of their own, and they arrive at the same rigorous simplicity which he explores in the Orangerie floor-piece. Hung on the wall at eye-level, they could hardly be more spare. But such extreme conciseness did not satisfy Deacon for long. He thrives on reacting against recently completed work, treating it as a springboard for alternative directions. Hence the continual suppleness of the Kunstverein show, where his exceptional versatility is exposed.

Unlike some artists, who become trapped inside an arid formula. Deacon abhors the idea of repeating himself. Each new sculpture has a sense of fresh adventure, and his use of materials is unpredictable. Take *Distance No Object No. 2*, where aluminium, fibreglass and polyester are conjoined. All glinting, riveted metal on one side, it changes on the other to a dull, rubbery smoothness. And the neighbouring sculpture in the room, *Dummy*, is content with pale wood throughout. This swollen, well-sanded form offers itself like a low-lying seat. Its sense of comfort is appealing, but in another mood Deacon offers no reassurance at all. *Under My Skin* suddenly erupts, rearing into the air with sharp edges and screws exposed to snag the unwary visitor.

Violence goes hand in hand with eroticism in *Breed*, where two linear forms warily confront each other from a distance. Half mating ritual and half gladiatorial combat, it amounts to a richly ambiguous sculpture. And Deacon's mood grows still more implacable in the steel *Skirt*, which

transforms a flowing garment into an armour-plated alternative. As hard and martial as a fortification, *Skirt* discloses the most ominous side of Deacon's imagination. But this unyielding vision is countered in other works by boundless exuberance and, taken together, they prove that he can now be ranked among the most impressive sculptors at work anywhere in the world.

ANTONY GORMLEY

11 January 1994

Unlike most of the other leading British sculptors who emerged in the early 1980s, Antony Gormley is preoccupied with the human form. But his approach does not mark him out as a conventional artist. By concentrating on casting, he distanced himself from the traditions of carving or modelling. Gormley's way of working has more in common with Rachel Whiteread than Jacob Epstein, even if his decision to use his own body means that he upholds Epstein's belief in the central importance of the figure.

The first exhibit in Gormley's most impressive show to date, at the Tate Gallery Liverpool, reaffirms this overriding priority. *Close I* lies spreadeagled before us, its greyness coldly contrasting with the warm wood floorboards beneath. The body might simply be resting, in order to regain physical or spiritual strength and reaffirm a kinship with the ground supporting him. He could, however, be the stripped and defenceless victim of an assailant, who has commanded him to stretch out as a prelude to violation or death. Both interpretations are equally valid, and they give the sculpture an ambiguity which wars with the apparent straightforwardness of its form. Cast from Gormley himself, who adopted this pose for the purpose, *Close I* is more of an Everyman than a self-portrait. Rather than reflecting the sculptor's narcissistic fascination with his own body, it uses the personal simply as a springboard for the universal. Fingers, toes and other distinguishing features have been smoothed away, by an artist whose passion for simplification is reinforced in the white soldering lines running across the figure without regard for anatomical realism.

Close I's title implies that the body draws sustenance from its proximity to the earth. And Gormley does attach great importance to 'a kind of

objective appraisal of my relationship to the world'. Having been brought up as a Catholic in a Benedictine boarding-school, he escaped from its doctrinal framework of moral judgements and searched for another world view. 'I want to start with things that just are,' he says, and in this respect his concentration on the figure is a means of arriving at an incontrovertible reality. But the ambiguity of meaning in *Close I* proves that Gormley's vision is far from simple. The spreadeagled form may well be frustrated with his bodily limitations, and he might even have flung himself on the ground in despair.

At any rate, the next space is devoted to a lead colossus called *Vehicle*, which looks like the cast of a glider unaccountably grounded in an art gallery. The last time I saw this piece, seven years ago, it was displayed on the Serpentine Gallery's lawn and lacked mystery. But *Vehicle* seems more powerful here, constrained by its indoor setting and the sentinel-like iron columns of the original warehouse. The marked absence of a cockpit, let alone the pilot who might occupy it, encourages us to see the whole sculpture as a metaphor for the human body and our desire to fly. *Vehicle* is in this sense thwarted, and escape through the nearby window is out of the question.

Frustration reaches a climax with *Testing a World View*, where five casts of the same bent figure are placed in different ways throughout the room. Gormley himself has likened the ensemble to Cubism's fascination with multiple viewpoints, but this sculpture has a far more violent and alarming impact. Although the figures are identical, they look jarringly disparate. One lies on the floor with straight legs projecting stiffly in the air, while another is jammed horizontally into a corner. The figure who has been allowed to stand on his feet is the most disturbing of all, butting his head against a wall. Nearby, the fourth man assumes a pyramidal shape, rising up only in order to jacknife and fall head-first to the ground. As for the fifth figure, he lies with his back to the wall, as if thrown there by the force of an explosion. The entire sculpture could represent the aftermath of a bomb attack, with each of its victims frozen by *rigor mortis* into a grievously contorted position. Even if they are seen as living, all these figures are in a state of crisis. Perhaps to emphasise their perturbation, Gormley has cast them in iron. Streaks of rust disrupt their grey surfaces, where granular deposits have gathered like soot. The result looks far rougher than his earlier lead figures, whose gleaming, smoothed-out limbs reflected his determination to choose a neutral material distanced from the sensuality of naked form. But this denial of desire, influenced by his youthful interest in Buddhism, has now given way to a more seductive and in my view welcome involvement with alternative materials.

Even concrete, used in six pieces which inhabit a space of their own, is beguilingly used. At first sight, they resemble minimal slabs. And in one respect Gormley does owe a debt to artists like Andre and Judd, whose ruthless simplifications purged sculpture of everything other than its fundamental form. But he uses Minimalism here as a foil, to frame his exploration of the human presence. Each of the slabs turns out to bear a figurative imprint. The indentation of a hand appears on two sides of the tallest block, *Immersion*. And the cruciform piece, *Flesh*, has been punctured by fingers, thumbs and feet in the appropriate places. They have the unsettling effect of suggesting that a body is encased within the concrete cross. But entombment is replaced by a more affirmative notion in *Sense*, where the cubic form is pierced by hands and circular cavities which enable us to peer into the hollowed-out interior. This time, the entire block seems on the point of overcoming its chilled severity and achieving regeneration in human form.

It is only a possibility: Gormley's agnosticism will not allow him to entertain the comforting certainties of his childhood faith. The idea of quickening and stirring nevertheless plays an even more important part in the grandest, most spectacular work he has so far produced. *Field for the British Isles* fills the floor of a vast, barnlike space with around 40,000 figures. Modelled in clay, a far more sensuous material than anything he has used before, they have been made by families contacted through local schools in the Sutton district. Working together for a week in a school annexe, up to 100 people contributed to the epic venture. Gormley encouraged them to find their own ways of making, and only offered the guideline that the figures should be upright, hand-sized and easy to hold, with the proportion of head to body roughly correct. But pencils were provided to make the prominent eyeholes, which he wanted 'deep and close'.

In view of the licence they were given, the outcome's uniformity is astonishing. Although each figure subtly differs from its neighbours, they merge in a homogeneous crowd of standing people who all appear to strain upwards. Their fertile warmth covers the room's immense floor like a burnished carpet, its predominant terracotta richness interrupted by the occasional, irregular streak of a darker colour. At one moment, I found myself thinking of the ancient Chinese warriors clustered so neatly in their emperors' graves. But these watchful figures seem more vulnerable. Even if some rise above the mass, like a group of taller trees suddenly asserting themselves in a forest, they all remain minuscule compared with the viewers gazing in at them. Framed like a painting by the doorway, they prevent us from entering their space. They look apprehensive, as if fearful that their sanctuary might be invaded by a force that could crush

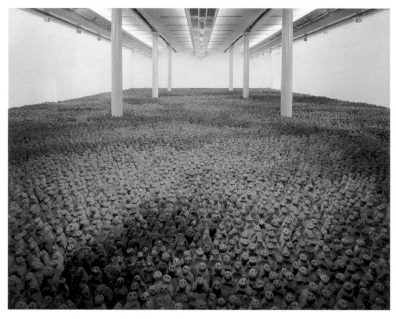

105. Antony Gormley, *Field for the British Isles*, 1993

them. There is obstinacy in their defensiveness, however. And their over-whelming sense of community gives the sculpture an optimistic air as well. Gormley's ambiguity is at its most potent here, balanced between trepidation and reassuring solidarity. But the knowledge that so many untrained adults and children were responsible for making the work adds to the sense of wonder. *Field for the British Isles* bridges the divide sepa-rating so much contemporary art from its potential audience, encourag-ing the hope that a new understanding may spring from this harvest of transfixed yet quietly expectant form.

SEBASTIÃO SALGADO
4 January 1994

Sebastião Salgado is, quite simply, the most impressive living photographer I have encountered for a very long time. His large and revelatory exhibition at the Royal Festival Hall should be visited at once by anyone who still doubts that the camera can rival painting in expressive power. For Salgado, working within the highest tradition of photojournalism, continually transcends the supposed limits of a documentary approach and offers profoundly affecting images of human stoicism, energy, suffering and grace throughout the world.

Exiled from his native Brazil in the late 1960s and now a Parisian by adoption, he occupies a pivotal position in his attempt to apprehend the different realities of work in farming and industrial communities alike. Fired by an impassioned awareness that many of those who labour the hardest fail to receive what they deserve, Salgado never allows moral indignation to lead him down the path of predictable propaganda. Far from resembling a polemical crusade, his work derives its strength and subtlety from a desire to avoid sloganizing and move as close as possible to the particular lives he studies. Salgado thinks nothing of staying with his subjects for months or even years at a time. He is the very opposite of fly-by-night, voyeuristic photographers, who hurriedly train their lens on the most superficial aspects of a given scene and then depart. Salgado lingers, talks and drinks with the people he scrutinises. Reluctant to use a zoom lens because it distances him from wholehearted empathy, this remarkably persistent man aims above all at getting inside his subjects' experience. Detachment plays no part in Salgado's purpose, and within seconds his images begin to involve us magnetically with the lives they depict.

Take the Cuban sugar-cutters whose strenuous activities give the exhibition's opening bay the visual equivalent of a kick-start. He plunges into the fields and seizes, close-to, the whiplash dynamism of sinewy harvesters slicing the cane with their machetes. But if the cutters resemble imperious warriors in one picture, they seem almost overwhelmed by their task further on. The cascading leaves appear to engulf them; and when Salgado shows a group of cutters resting in a makeshift shelter, their weariness is palpable. Aware of the camera, some gaze straight at the lens. There is no sense of posing, however. Salgado wants to record life as he finds it, without pretence.

Given his insistence on travelling to remote areas where labourers often struggle with meagre wages, the work he produces could easily be

depressing. The hardship is never minimised, and the exhaustion of child workers waiting for their leaves to be weighed at a tea plantation is numbingly conveyed. All the same, Salgado does not hammer privation home like a preacher hell-bent on arousing his congregation's pity. If he did, we might soon find his work manipulative. Rather does he emphasize the extraordinary resilience of the people who endure appalling conditions. A small, delicately built girl, far too young to be employed on a tea plantation, directs her wide eyes at the camera and grins. The ample wicker basket slung from her head radiates outwards like a luminous halo in a gold-ground trecento altarpiece. Its shafts ennoble her, lending the face a spiritual aura which has nothing to do with bogus religiosity.

On the whole, though, the workers in Salgado's photographs do not smile. They may well respect his desire to perceive them as individuals rather than a generalised mass, and they show no reluctance to stare at his camera for a close-up. But they also see no reason to assume a family-snapshot jollity they do not feel. While the most distant of three Indian coalminers does indeed offer a shy smile, the other two fix the lens with sober expressions. The young man in the foreground, with his high, firmly wrapped turban and pickaxe resting on a resolute shoulder, possesses an innate air of self-respect. No complacency can be detected in his features, however. His eyes are utterly direct and steady, almost challenging Salgado to treat him with respect.

He has no need to fear the photographer's motives. Salgado is incapable of patronizing his subjects, let alone implying that they lack the will to survive. While never letting us forget the grinding physical effort behind the processes he records, his images often come to rest on moments of unexpected poise. In a superb sequence devoted to women irrigation workers in Rajasthan, he focuses at one moment on the carrying of pipes. Veiled to the point of expressionless anonymity, the figures nevertheless handle their burdens with astonishingly lyrical composure. Bearing the long cylinders on their shoulders, they appear to be performing an intricate dance on the banks of the canal. Rigorous labour in the Indian sun takes on a choreographic beauty of its own, even though nobody can doubt the strain involved in handling the pipes. This series turns into a sustained celebration of women's dignity, most emphatically in an arresting study of a digger. Arrayed in bangles, bracelets and beads, she defies any stereotypes we may harbour about ornamented female passivity by aiming her upraised shovel with a tough, single-minded resolve.

In regions where mothers are invariably obliged to take their offspring along to work, several images show how they reconcile the rival claims

of wage-labour and maternity. One woman bends over the crop in a tea plantation, with arms stretched wide enough to protect the baby perched so precariously on her back. The gesture also seems to acknowledge the fecundity of the countryside beyond, hinting at an instinctive rapport between the mother and the landscape she inhabits. However gruelling and poorly rewarded the job may be, Salgado is alert to its sensuous dimensions as well. In a near-surreal picture, a worker is shown on Réunion Island half-buried in the geraniums he is transporting to the perfume distillery. At first startling, this image of an apparently smothered man becomes in the end an affirmation of the kinship he enjoys with the flowers.

By no means all the labour takes place in beguiling locales. Sometimes Salgado swings his lens away from his primary preoccupation with people and surveys their surroundings instead. One powerful panorama is punctuated by the skeletal forms of densely crowded drilling-rigs near the Caspian Sea city of Baku. They bear an unsettling resemblance to the stripped, broken trees which Paul Nash painted after visiting the cratered terrain of Passchendaele in 1917. Similar memories arise when studying a picture taken in Kuwait soon after the Gulf War. Knocked unconscious by a blast of gas from a wellhead, the helmeted oil-worker looks like a dead soldier sprawling in the mud-churned, water-logged battlefields of the Somme. The men employed to clear up oil installations left flaring by the Iraqi invader are, of course, far better-paid than their counterparts in the Third World. But Salgado makes clear that their duties can be no less arduous, and one photograph is dominated by the collapsed bulk of a hefty figure left stunned, besmirched and despondent after a severe bout of fire-fighting.

Apart from a disappointingly humdrum series on the digging of the Channel Tunnel, the European pictures are just as intense as the images shot elsewhere. A man soldering on the hull of an aircraft-carrier in Brest shipyard has become as visored and ominous as Epstein's *Rock Drill*. Mechanical implements threaten to overwhelm the humanity of those who wield them, but Salgado is not blind to the magnificence of the steel foundries. A mystical awe pervades his images of the robed figures who gesture with priestly authority in these industrial cathedrals awash with their rivers of fire.

Even so, the biblical undertow running through his work grows especially eloquent in his Brazilian homeland. Visiting the gold mine of Serra Pelada, he unearths an Old Testament realm replete with sack-carriers who scale the quarry's heights on rickety wooden ladders. When Salgado concentrates on a few of the sweating, haggard figures, he discloses a

106. Sebastião Salgado, *The Serra Pelada Goldmine, Brazil,*
1987

fight breaking out between gangs hungry for the same meagre profits.
But the most moving pictures survey the mine as a whole, a
Bruegelesque scene alive with pullulating, insect-like activity. Although
it seems to belong to a remote era, Salgado's other work makes us realise
that the pain, danger and monotony endured by these stubborn toilers
are still a reality in far too many regions of our gravely imbalanced
world.

BOYD WEBB
11 May 1994

Do not be deceived by the alluring deftness and sheen of Boyd Webb's exhibition, the compulsive art event in this year's Brighton Festival. Once the initial *frisson* of his scintillating colours and bizarre imagery has been absorbed, a darker undertow becomes apparent. Like Cassandra, Webb has always been adept at sounding the alarm. And in this perturbing show, he takes us on a voyage deep into the recesses of our own bodies.

Whether naked or clothed, figures used to play a prominent role in Webb's work. They would appear in godlike guises, hurling globes through the cosmos or crouching under the earth in order to cause havoc above. By turns well-meaning, malevolent and just plain stupid, they careered through a universe constantly threatened by mishap or full-blown catastrophe. Webb's devotion to Sufi teaching stories, where Islamic mysticism is tempered by a wry sense of absurdity, ensured that he leavened his warnings with wit. He performed an agile balancing-act, poised between the rival pitfalls of solemnity and farce. Now, however, Webb has turned inwards. Doris Lessing, reviewing a new book on the Sufis in *The Times* last week, emphasised their belief that, when social conditioning has been stripped away, 'what is real in us is very small'. As if acting on this conviction, Webb penetrates our inner space in order to meditate on the microscopic origins of things. But that does not mean he has become ponderously philosophical. On the contrary: his work continues to present life as a battleground, alternately frustrating, deadly, hilarious and macabre.

The human body makes only rare and marginal appearances in these new tableaux. It is reduced to fragments, most arrestingly in a work called *Tutelar*. Here, a bare arm thrusts into the upper part of the image. Although young and innocent-seeming, this anonymous limb belongs to a calculating mind. For the arm terminates in a fist, clutching a net bag which might normally be expected to contain fruit on a supermarket shelf. This time, however, it holds an egg rather than oranges. The yolk is dangled inches above a crowd of eager sperms. They undulate and jostle, striving to reach the egg and impregnate its glistening substance. But Webb leaves the outcome of their struggle entirely open. Is the arm lowering the egg, or keeping it just out of reach? We cannot tell. Only the sperms' ambition is beyond doubt, and their desperate scrambling contrasts comically with the yolk's complacent stillness.

Webb's medium is photography, and the Cibachrome colour printing could hardly be more polished. All the same, he does not want the camera

to give his images a spurious air of reality. The arm belongs to a flesh-and-blood model, certainly, and the egg may well be genuine. But close examination discloses that the sperms are all made of plasticine. As for the pale green ground on which they writhe, it is clearly a sheet of embossed wallpaper. Webb does not attempt to disguise his props. He openly declares their origins, confident that we will enjoy discovering how even the most unpromising raw material can be given a mysterious new identity.

The ingenuity with which Webb sets up his theatrical tableaux in the studio is immensely pleasurable. Luminous, unpredictable and dextrously composed, these images possess a singular imaginative force. Even so, Webb never allows us to bask in his agility and resourcefulness. However playful he may seem, a stab of disquiet soon asserts itself. And what may have seemed dominant in one work suddenly grows vulnerable in another. Eggs reappear in *Ebb*, hanging this time in seventeen separate nets from the upper reaches of some sickly puce wallpaper. But no controlling arm holds them now. The *deus ex machina* has disappeared; and without the sperms clamouring below, the eggs look curiously unwanted. Left to themselves, they have begun dribbling through the nets and smearing the wall beneath. Although the yolk-splashes are hard to distinguish from the yellow streaks on the embossed paper, the sense of neglect and futility is inescapable.

The more Webb's latest work is explored, in fact, the more despondent it becomes. The eggs lined up in *Ebb* bear a disconcerting resemblance to rifle-range targets at a fun-fair, waiting to be picked off, one by one. The pathos becomes abject in *Sob*, where an expanse of white wallpaper is pierced by a roll of plastic. It droops down, inert and useless, like an abandoned condom or an elephant's exhausted trunk. The odd curvature in the paper adds to the mood of disorientation. Something has gone awry, and in other images Webb intensifies the anxiety.

Germ is among the most powerful of these works. At first, we are seduced by the shimmering path which stretches up towards an invisible horizon. The light grows fiercer near the top, suggesting that a revelatory radiance is about to flood the whole picture. But the heavenly intimations make a bitter contrast with the objects scattered on the path. A pink balloon lies crumpled, deprived of the breath which once gave it buoyancy. The sprinkling of tiny organic forms nearby, all intricately modelled from plasticine, seem to have escaped by accident. Reminiscent of tadpoles and sea-creatures, they have a viral air. And the balloon is clearly incapable of stopping them as they move towards the blazing source of light.

Defilement menaces wherever you look in this exhibition. *Donor* sounds like an optimistic name for a work, and Webb makes sure that the

107. Boyd Webb, *Stool*, 1993

transparent tubes snaking across the image's pristine white surface are alive with wriggling seeds. But we do not know whether they are beneficent, and the tubes' colour alters as they gather in a convoluted mass. Pale yellow and pink give way to darker, more ominous purples once the twisting begins in earnest. At the centre of the tangle, a hue reminiscent of deep bruising spreads like a stain. What was surely intended as a fertilizing operation ends up looking throttled. We seem to be inspecting an abortive manœuvre, and Webb implies that too much internal tampering is bound to court unknown dangers.

Not all the exhibits carry such a sinister charge. At his weakest, Webb can seem flippant. His more light-hearted inventions, like *Entrechat* or *Stool*, appear superficial compared with the other, more worrying images. On the whole, though, he goes far beyond callow displays of cleverness. Some of the most pervasive anxieties of our time are probed here. Spent balloons litter the cloudy blue surface of *Salvo*, memorializing the limp aftermath of festivities. The party is over, and for Webb's generation this autumnal mood could hardly be further removed from

the hopes harboured by so many who, like him, grew to adulthood in the 1960s. Now, as the century totters to a disillusioned close, nothing seems to work. The attempt at fertilization dramatised in *Zygote*, seen as if through a microscope, terminates once again in frustration and failure. The balloons in *Miasma & Ampoule* may look swollen, but they seem to be stuffed with pins. Sources of delight have turned into receptacles of pain, and in a diptych called *Palliasse* the crumpled bedding has capitulated to a host of worm-like invaders. The people who may once have inhabited this mattress are no longer visible – defeated, perhaps, by the pestilential army now establishing their alien presence.

This is, at heart, an elegiac show. The lamentation grows inconsolable in *Smother*, where the bedding has been folded up and threatens to crush a nosegay of orchids trapped inside. They look like a discarded tribute from the bereaved, and the sumptuous red and gold backdrop seems fiery enough to engulf both flowers and mattress in a final, apocalyptic blaze.

REBECCA HORN
4 October 1994

Nobody could guess, from Rebecca Horn's astonishingly dynamic, fecund and flamboyant work today, that art once made her gravely ill. While studying at the Hamburg Academy in the late 1960s, she was poisoned by the toxic fumes from sculpting with polyester and fibreglass. Her lungs were so badly damaged that she spent a year in a sanatorium, and found herself confined by chronic sickness for a long time afterwards. But the struggle to survive, both physically and as an artist, proved the making of her. Trapped inside the isolation of illness, this resilient young woman began to forge a private world of images to counter her alienation and debility.

In order to find the initial fruits of her hard-won victory, you must enter a side-room in the Tate Gallery's boisterous survey of her career. Here, away from the jolting movements and sudden, startling noises triggered by her more recent work, are the body extensions she made in the early 1970s. Some, nestling now in coffin-like boxes, are redolent of straps and band-ages. They conjure a sense of wounding and restriction, but also the possibility of healing. A similar ambiguity enriches the often bizarre body sculptures hung like trophies on the walls. Once used in early perform-

ances or 'actions', they speak of restriction and freedom in equal measure. The extension once worn by a woman in *Unicorn* is attached to body-straps reminiscent of a strait-jacket. But the horn rising from the head-piece is so elongated and erect that it seems to celebrate recovery, vigilance and spiritual resolve. The feathered wing and fan forms displayed nearby are just as complex in meaning. Even as they threaten to hide the bodies that once inhabited them, these expansive attachments hold out the prospect of flight. Although the promise proves as illusory as in Leonardo's doomed flying machine five centuries before, this liberating fantasy must have sustained the artist at a time when her own mobility was irksomely circumscribed.

Eventually, Horn recovered so well that she went on to gain a high, and still widening, international reputation. But everything she produces with such apparent aplomb today has grown out of those early pieces, with their peculiar freight of pain and yearning countered by a feisty determination to unleash and savour the full energy of life. In the lofty Duveen Gallery at the Tate, she has responded to the immensity of space by taking us on an emotional roller-coaster. The journey is punctuated by unashamedly theatrical surprises, as Horn switches with exhilarating speed between widely different scales, moods and materials.

She may have long since stopped performing, but the fascination with movement and *coups de théâtre* continues in her use of motorised machines. Unlike Tinguely's frantic assemblages, they are not bent on delirious self-destruction. Their eruptions are more calculated, even when violence is involved. In *The Trial (after Kafka)*, motion is restricted to the book perched on a glass case. Silently opening and closing, it stops well short of taking too much attention away from the case's contents. Spattered with red and black paint, they are dominated by an old, jet-black telephone capped by an equally black feather. The receiver has been removed, and dangles from the right side of the case like the similarly forlorn, useless appliance in Dalí's eerie painting *Mountain Lake*.

Horn never spells out the meaning of her intensely metaphorical art. She prefers us to feel our way towards its import, rather like the sightless person whose stick becomes a baton in a work called *Blind Conductor*. Hanging over a rectangular steel plate on the floor, the white cane occasionally starts probing the air as if moved by an invisible hand. Tapping the plate in erratic prods or outlining fluent arcs, the motorised instrument alternates between hesitancy and assurance. Perhaps it symbolises the way Horn herself goes about making art, as well as inviting us to counter any rush to judgement with the aid of thought, care and the open admission of doubt.

She certainly likes to emphasise flux rather than relying on sculpture's traditional involvement with stillness and solidity. Horn has always kicked against received ideas about what 'art' is supposed to be. Just as she glides with ease from performance to object-making, and from film to kinetic installations, so she injects even her grandest work with a strain of volatility. In one of her most baroque exhibits, an iron bed swathed in a sheet is suspended from a bridge high up near the Duveen's roof. But it is not allowed to rest there undisturbed. Thoughts of sleep are disrupted by the chaos of beds beneath, plummeting downwards and intertwined, near the ground, with a riot of lead piping. This onrush, as headlong and demented as the Gadarene swine, has been arrested for our amazed inspection. But the stasis only seems momentary. Rods near the base of the sculpture sporadically begin to move, and the entire unwieldy structure might at any second be shaken by a seizure that changes its identity.

Throughout the Tate show, Horn plays games with the neo-classical architecture at her subversive disposal. The imposing columns leading to the octagon become the resting-place for full-length mirrors at either side. As we pass by them, two pistols become visible. They swivel soundlessly, like security cameras on the move. And once their apparent target has been located, the crack of gunshot assails anyone unwary enough to linger there.

All the same, the noise of the firing weapons only acts as a prelude to the cataclysm ahead. Slung on steel cables from the octagon's ceiling, an upside-down grand piano dangles above our heads. Silent and motionless for a while, its ominous presence gradually generates a mood of unbearable expectancy. Knowing Horn's innate theatricality, we wait for an eruption to occur. But when it comes, the spasm still has the power to shock. Without any warning, the keyboard surreptitiously emerges and thrusts out into space. Then it plunges downwards, splaying out into separate strips of wood like a tree-trunk riven by shrapnel. A group of schoolboys, who happened to be walking directly underneath, ran away as if threatened by an explosion. And then the piano's mighty lid fell open, sending out a discordant hum from the strings jangling within.

Horn calls this cacophanous work *Concert for Anarchy*, and an irrepressible urge to ambush the viewer with disorientating assaults runs through much of her work. At the Tate, she brandishes all the most unsettling weapons in her imaginative armoury. Binoculars attached to poles stare at each other and swivel, like spies engaged in a silent conversation riddled with mutual suspicion. They also make us feel under surveillance, and in a climactic *tour de force* entitled *River of the Moon* we

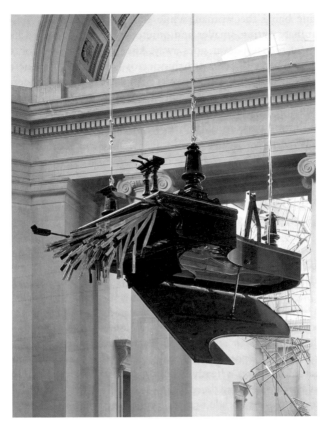

108. Rebecca Horn, *Concert for Anarchy*, 1990

find ourselves threatened by a writhing onrush of twisted lead tubes. They all emanate from a machine-like presence at the far end of the Duveen Gallery, armed with pistons that appear to pump mercury into the piping. Like the serpents crushing their victims in the great classical *Laocöon* carving, the wriggling, weaving tubes course across the floor with impetuous force. Arriving at the other end of the vast room, they either bore into the foundations of the columns or encircle them in a sinister embrace. Horn, like Samson before her, seems bent on bringing the pillars of art's temple crashing to the ground.

Another, more gentle side of her work is disclosed at the Serpentine Gallery. Speaking in typically erotic terms, Horn thought of 'the

painted in the Swiss Alps. So were the subsequent images of deluge. Pouring the paint directly on to the canvas, Barceló achieves a fluidity of method that matches his theme. Then he sharpens it with a fusillade of short, stabbing strokes, evoking the relentless force of the rain assailing the flooded ground.

Because these desolate pictures bear no identifiable relation to the country where they were painted, we can only conclude that they are mystical rather than dependent on an observed setting. Barceló, however, sets great store by drawing and painting from nature. He insists that 'my work is linked to my immediate environment', and the big bull-ring picture of 1990 manifestly derives from a scene in his homeland. Even here, though, there is a feeling of removal. Barceló adopts an aerial vantage, so that the entire circular structure of the ring can be encompassed by the painting. The figures and riders ranged in a procession are on display, and doubtless revel in their costumed magnificence. But they look marooned within the great dusty orb. Its parched immensity dwarfs them, inducing a sense of vulnerability which undermines their strutting assurance.

Seen in the context of his other work, the bullring image soon appears less reliant on Barceló's scrutiny of a particular subject. After all, the form of the ring is close to the structure favoured in his 'soup' pictures. And in *Ad Marginem* he closes on the arena itself, determined to present it as a swirling mass where bull and matador play only an incidental role.

However closely they may purport to be based on specific scenes, Barceló's paintings usually spiral off into a world of his own ordering. *Studio with Green Shelves*, among the more restrained of the recent pictures, may derive from sculpture-in-progress seen in his own *atelier*. But the plaster heads clustered on a foreground table take on a life of their own. They resemble decapitated victims, yearning to become whole again. The studio is turned into a morgue, eerily akin to the abattoir where Barceló must have studied the carcasses dominating other pictures. Blackened and strung ignominiously from ropes, the dead animals are as repellent as he can make them. One is matted with whorls of paint-clogged hair, and its head rests on a skull. The latter's presence typifies the weak side of Barceló's art. He is too eager to overstate his fascination with decay. A perverse sense of relish invades his preoccupation with mortality, especially when making small images inspired by village life in Mali.

Although he knows his subject well, these wispy little pictures have more in common with prehistoric cave-paintings than on-the-spot observation of Africa today. Sometimes, he is direct enough to show an abandoned horse, its legs splayed in the contortion of death. But most of

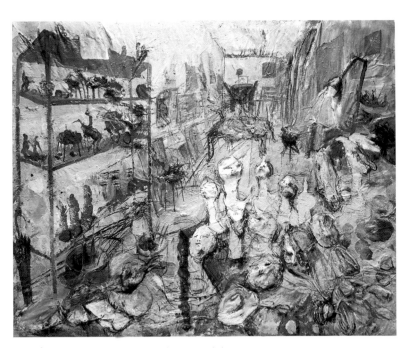

109. Miquel Barceló, *Studio with Green Shelves*, 1994

these works look self-consciously archaic, reducing the inhabitants of Mali to the condition of feeble, hapless spectres. The result is patronizing and sentimental. Barceló reinforces the theme of decay by allowing termites to tear holes in the paper he uses. It is an over-emphatic strategy, manipulative enough to prevent viewers from responding as whole-heartedly as the artist himself would like.

110. Sigmar Polke, *Paganini*, 1981–3

For a while, during the 1970s, Polke was unable to furnish painting with just such a new role. He collaborated heavily with others, suppressing his own initiative to an alarming extent. Then he concentrated on photography, film and video for the rest of the decade. Hallucinogenic drugs increasingly dictated his interests, and long before 1980 he seemed to have abandoned painting for ever. With hindsight, though, we can now see how this difficult, uneven period, scarcely represented at Liverpool, served as the springboard for an astonishing renewal. The advent of another decade was heralded by one of his largest and most impressive paintings: *Paganini*. In one sense, it is an elegiac work. The composer himself occupies the middle of the picture, expiring on his deathbed in faint outlines reminiscent of a nineteenth-century engraving. But his hands are still raised, as though waving to the rhythm of the violin played by the devil crouching on the end of his bed. This horned apparition, freely brushed in near-silhouette, is the most prominent figure in the painting. Macabre yet irresistible, he presides over the entire panorama, lending a diabolic energy even to the grinning clown on the far side of this unusually wide composition. Below the jester, a row of figures recall the people in Polke's work from the early 1960s. They seem absurdly innocent and helpless here, however. For the clown is juggling with skulls which gradually become radioactive and besmirched with swastikas as they tumble from his grasp. Everything in this half of the picture is caught up in a vortex, suggesting that Paganini's death somehow ushered in the engulfing advance of evil.

The mood of this powerful painting is far darker and more agitated than his earlier exhibits. It also inaugurates a decisive shift away from the obsession with consumerism and art-about-art. Now Polke stares deep

into history, and is not at all reassured by the forces he discovers there. As if to stress the hazardous, at times apocalyptic currents at work, he starts using highly volatile and toxic substances that accentuate the paint's instability. And he reminds us, at every turn, of art's capacity to deceive. Diagrammatic projections are set up in *Measuring Clothes*, only to be flouted by the introduction of real shirts and trousers. Wooden stretchers normally hidden from the front of paintings suddenly become visible, as Polke begins to paint on transparent surfaces.

In a monumental recent work called *The Three Lies of Painting* all these strategies come into play, along with his familiar use of fabric and a sense of absurdity akin to Surrealism. Max Ernst seems to be invoked in some paintings, especially when Polke deploys figures based on engravings from the past. Fundamentally, though, he is out on his own. The variety of styles continues to disconcert, just as Polke leaps with dizzying speed from the French Revolution to grainy news photographs of refugee camps. The freedom with which he roams through time is as exhilarating as his refusal to cultivate a tight, narrow identity. Now in his mid-fifties, Polke is working with as much zest and resourcefulness as ever. The Liverpool Tate should be congratulated on being the first British gallery to reveal the full extent of his mercurial, audacious and ceaselessly questioning achievement.

KIKI SMITH AND RITA DONAGH

14 March 1995

Walking into Kiki Smith's show at the Whitechapel Art Gallery is like encountering the aftermath of an atrocity. Ahead, dominating the centre of the high, white space, four plaster limbs dangle from a hammock-like stretch of burlap. Two arms, two legs. All apparently severed, and hanging as forlornly as blood-drained trophies left behind by some marauding murderer. From the outset, then, Smith warns us that her work offers nought for our comfort. The rest of the show, her first one-person exhibition at a British public gallery, may not contain any more references to butchery. But this New York-based sculptor puts forward a vision as grim and disconcerting as the toughest aspects of the city she inhabits.

Smith turns the Whitechapel's big downstairs arena into a secular cathedral. The nave is empty, apart from the suspended white limbs. As

for the aisles, they are occupied by figures whose states of distress echo the anguish that martyred saints convey in ecclesiastical statuary. Nor is this a fanciful connection. Although Smith enjoys a high reputation, as one of the most powerful artists to have emerged from the USA in recent years, she has more in common with the past than the present. Her bronze *Mary Magdalene*, with head thrown back in agony and one leg trapped by a chain, looks like a homage to Donatello's carving of the same penitent. The hair courses down Mary's naked body like a swollen river of tears. She epitomises Smith's belief that artists should not be inhibited about conveying dejection, and that the female form in particular is often a vessel for suffering.

Until now, Smith's most widely debated sculpture was *Virgin Mary*, a life-size flayed madonna in coloured wax. The raw exposure of her insides summed up a determination on the artist's part to show women at their most visceral and vulnerable. In this exhibition, though, her emphasis is mainly on bodies viewed from without. The nearest Smith gets to dissection is in a painted bronze called *Blood Pool*, where the woman lies on the floor in a semi-foetal position. She seems oddly paralysed, like the lava-smothered victims unearthed at Pompeii. But the most alarming part of the sculpture is her spine, an exposed white bone projecting painfully from the red flesh.

Even when the figures are intact, they appear worn and despondent. One woman lies hunched on a steel scaffold, in retreat from the world and oblivious of the dead sunflowers dangling from her resting-place. Another sits wanly on the floor, arms wound tight around her knees. From her eyes, papier-mâché streamers run in thin lines towards the wall, where they are joined to careful, detailed drawings of vaginas. Exposure of female sexuality does not, in Smith's dour world, lead to anything except more anguish.

After a while, the relentless emphasis on misery and pathos becomes oppressive. Even when Smith calls a sculpture *Siren*, and thereby hints that the woman might possess some positive power, the work itself turns out to be a decapitated torso with a blue bird emerging from the neck. The relationship between humanity and birds is also explored in Smith's smaller show at the Anthony d'Offay Gallery, where female plaster heads are brought into swooning proximity with claws, wings and beaks. But no discernible pleasure arises from their union. At the Whitechapel, a sculpture called *Girl with Bird* contains the least beleaguered figure in the show. The bird, however, is attached to a chain held by the girl, who stares down at the captive pet with both arms hanging helplessly at her sides.

Only at the far end of the gallery's nave, in a place where an altarpiece

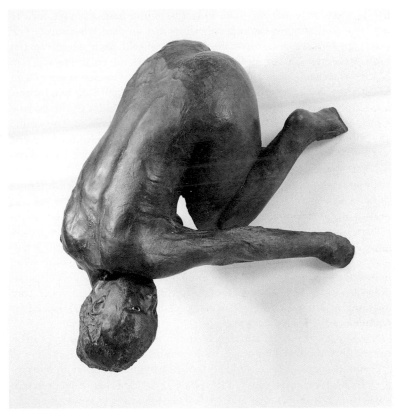

III. Kiki Smith, *Lilith*, 1994

might be displayed, does Smith allow herself to break free from this passivity and depression. Instead of drooping, *Lilith* has crawled half-way up the wall and crouches there, upside-down. According to the Bible, she refused to obey her husband Adam and escaped from his imperious demands. But Smith refuses to celebrate her independence. Instead, Lilith seems traumatised and defensive as she gazes through blue glass eyes in search of danger. Her papier-mâché body looks desperately fragile, confirming once again that the women in Smith's gruesome world have no grounds for hope, joy or redemption.

Why are all these figures marooned in such a desolating way? Smith offers no clue, apart from declaring in the catalogue that 'I grew up in a

family with lots of illness'. Rita Donagh, by contrast, accounts for the elegiac strain running through her show at Camden Arts Centre. The paintings, drawings and watercolours displayed with such aplomb on the brilliant white walls are dominated by her response to the troubles in Northern Ireland. And the images' quiet eloquence has in no sense been lessened by the advent of a ceasefire. On the contrary: the cumulative impact of Donagh's show adds up to a salutary reminder of the malaise which the peace negotiations are now striving to eliminate. The country explored in her art seems stunned by an excess of death, grief, fear and repression. She proposes, time and again, that Northern Ireland has become a strangely glacial region. Universal whiteness descends, especially in her paintings of the 1970s, and it threatens to extinguish everything in sight.

Although her family was Irish, Donagh has spent much of her life in England. So she views Ulster as an outsider, and openly relies on newspaper photographs as the starting-point for her meditations on violence and loss. But nobody could accuse Donagh of sensationalizing her subject. The yellowed press pictures are confined to modest portions of her paintings, and juxtaposed with large areas where oil and pencil are deployed in an elusive way. As a result, plain statement is countered by complexity. Far from producing a partisan commentary on 'the troubles', Donagh brings a refined and deeply contemplative sensibility to bear on matters that another artist might well turn into polemics.

Such an approach is reinforced by her persistent interest in abstraction. Donagh's commitment to the plight of Ireland cannot be doubted, but it does not lead her to adopt a heavily figurative style. Looking at a painting as impressive as *Bystander*, we soon realise that large areas cannot be pinned down to a representational role at all. A small portion is devoted to a photograph of children playing in an urban wasteland. The energy of their near-silhouetted figures contrasts with the dereliction around them. They may even be acting out, as games, the conflicts which have turned their neighbourhood into a battleground. Donagh, however, refuses to fill the rest of her picture with similar manifestations of unrest. She paints a horizontal bar near the base of the canvas. It has no descriptive function, but contributes instead to a feeling of constriction.

So do the thinly brushed passages of murky grey above the photograph. Loosely evoking an overcast sky, they give way to a central area of lightness where diagonal lines lance through the composition like wind-driven rain. Although there is nothing expressionist about the precise, controlled definition of these lines, Donagh conveys a desolate mood. And it prepares us for the most prominent presence in *Bystander* – a black

form, ominously resembling a coat or sheet flung over a corpse. During the 1970s Donagh was preoccupied with this image. It originated in a *Sunday Times* photograph of a body on a pavement, covered by the evening newspapers after a bombing massacre. In her work, these damp, creased sheets take on the pathos of a shroud, while reinforcing the notion of inaccessibility. The victim is hidden, and we are invited to share the artist's sense of removal from the scene. Even as she arouses our compassion, Donagh never lets us forget that we are shielded from the full horror and incapable of preventing its recurrence.

The sense of distance intensifies as her exhibition proceeds. But the adoption of an aerial view in the 1980s led directly to *Long Meadow*, the most impressive painting in the Camden show. By 1982, Donagh's work had centred on the turmoil in the H Block prison. Her husband, Richard Hamilton, painted a full-length figure of a bearded inmate, and coupled it with a close-up image of the wall where he had smeared his 'dirty protest'. Donagh, by contrast, was less direct. In *Long Meadow* she looks down on the H Block as if from the sky. The clouds are darker and more turbulent than before, even though the pigment remains as thin as ever. But they cannot stop the insistent, diagonal shapes of the repeated capital letter H emerging from the gloom. Mainly white, they look like phantoms plaguing the dreams of an artist whose work warns us of what will return if the unthinkable happens, and the current peace talks fail to achieve their goal.

THE 1995 VENICE BIENNALE
14 June 1995

Wherever I went on my travels around Venice's enormous centenary Biennale, a silent man wearing a gold jacket kept gliding mysteriously into view. His face was devoid of expression, but the words printed in black on his burnished garment spelled out a defiant message: 'This Is No Art'. Was it an angry comment on the general standard of work at the Biennale, or a warning against mistaking him for a Living Sculpture? The impassive man never explained, but his earnest attempt to be provocative stood out in a jamboree otherwise starved of surprises.

This is the most sedate and backward-looking Biennale I can remember. Determined to mark its 100th birthday with a history lesson, the

steering committee chose a director well known for his unsympathetic attitude to most contemporary art. Jean Clair, director of the Musée Picasso in Paris, is the Biennale's first foreign supremo. To everyone's dismay, he has abolished the *Aperto* section devoted to the cutting edge of young, emergent art. And his main contribution is a colossal survey, housed in three separate buildings, exploring the theme of art and the human body in the modern world.

Called *Identity and Otherness*, this rambling epic encompasses 700 works by around 200 artists. It starts at the Palazzo Grassi, in the year that the Biennale's first exhibition was held. And after an introductory nod at artists' groups, from Post-Impressionism to Vorticism, Clair soon leads us deep into crime, alienation, disease, madness and death. The vulnerability of the human body, not its beauty, is emphasised at every turn. The Futurists make it explode into machine-age energy, and damage becomes horribly literal once we reach the Great War. After Dix's images of putrescent soldiers, the post-war attempt to revive a serene classicism looks like wishful thinking.

The most haunting sections of the show are devoted to artists' self-portraits. One after another, Beckmann, Bonnard and the little-known but powerful Finnish artist Helene Schjerfbeck explore the gradual disintegration of their features. Bonnard in particular, old and attenuated, looks distraught as he paints his reflection in the bathroom mirror.

Clair discovers equally memorable images of frailty in the post-1945 period. One large room confronts a wall of Bacon at his most wounded with a row of erect and emaciated Giacometti women. British artists emerge strongly at this stage. Kossoff is exceptionally well-presented, while Freud contributes some overwhelming paintings of naked figures at their most raw and vulnerable.

Painting, however, gives way to other strategies as Clair's saga continues at the Museo Correr. Photographs record the lacerating performances staged by Austrian artists in the 1960s. And their emphasis on mutilation is taken up later by Magdalena Abramović, with her willingness to endure self-inflicted pain. Nearing the present day, artists show an accelerating urge to probe the body's interior. Helen Chadwick's brightly lit images of red meat have a clinical directness, and Mona Hatoum goes further still in the exhibition's final section at the Italian Pavilion. She invites us to stare down at the floor of a circular chamber, and watch a tiny camera voyaging through every orifice in her body. The whole notion of self-exposure is taken to its queasy limits as we roam up Hatoum's nostrils, down her throat and through a labyrinth of pulsating, pink and glistening passages.

The rest of the Italian pavilion, though, is lamentable. Complying with Clair's priorities, a clutch of contemporary figurative artists have been rounded up. But Ruggero Savinio, Lorenzo Bonechi and the rest are feeble. Only in the British pavilion is a mature figurative painter displayed at full stretch. Leon Kossoff, our official representative this year, looks very impressive in the Venetian light – paler and more ethereal than he does at home. Each room is devoted to a different London-based theme, so we move from beleaguered tube travellers and shuddering diesel trains to the awesome vertigo of Hawksmoor's great Spitalfields church. Kossoff invests each of his subjects with a freight of feeling, and the emotional charge is heightened by the densely layered, vigorously manipulated pigment. One of the finest rooms is at the back, where four unframed paintings of heads are hung opposite a wide window. They seem to emerge from the darkness of Kossoff's studio and grow towards the luminosity of the Venetian parkland outside.

If all the pavilions were as moving as Kossoff's, the centenary Biennale would be outstanding. But I was shocked by the overall standard of national contributions. César, in the French pavilion, thinks it sufficient merely to instal bigger and more overbearing versions of the compressed metal sculptures he has been producing, ad nauseam, for thirty-five years. César is the epitome of the ageing artist who, having hit on a successful formula early in his career, has repeated it with numbing predictability ever since.

No such accusation could be levelled at Bill Viola's excellent installation in the US pavilion. Plenty of prejudice still surrounds video as a medium for art, but he shows just how eloquent it can be. Viola calls his five-room installation *Buried Secrets*, and makes each space convey distinct, often unsettling emotional states. Having entered the darkened pavilion, we find ourselves moving through a long chamber lined with faces on screens. This is the hall of whispers, where everyone struggles in vain to speak through gags. Their garbled noise fills the room with frustration, and Viola further assaults us in the second room with close-up, hand-held images of fire and water on one wall. On the other side, though, a quiet video of a naked man carefully washing his body provides respite. Viola chops from chaos over to stillness with increasing speed, battering us with oppositions.

In the third room, however, intimacy prevails. Relying on Viola's mastery of sound alone, heartbeats mingle with muttered voices from different generations in the empty rotunda. Their words are hard to make out, and in the next space veils of translucent material diffuse images of advancing figures projected from the far end. In the final room, though,

frustration disappears and clarity is restored. Two women dressed in luminous, flowing clothes converse in an ancient street. They glow like an altarpiece, and Viola confirms a reference to one of Pontormo's finest paintings when he introduces a third woman. She greets the other two, while Viola reveals every nuance of their warm interaction by stretching his original forty-five-second film to a twelve-minute duration. Super-slow motion lends their gestures and expressions an astonishing lyricism. We are able to savour the women's pleasure, and realise how Viola finds in their everyday salutation an almost ceremonial splendour.

Douglas Gordon, a Scottish participant in the British Council's lively fringe show devoted to young artists, echoes Viola's fascination with slowing images down. On two large screens, an old medical film record-ing an attack of hysteria is juxtaposed with a slow-motion version. The effect, this time, is deeply disquieting. It suggests all kinds of sadistic and even sexual manipulation by the doctors wrestling with their masked female patient. Gordon's compelling new work shares the upper level of the Scuola di San Pasquale with a teasing, melancholy video of thumb-twiddling by Ceal Floyer. Her concise deftness could hardly be more contrasted with the shimmering immensity of the swimming-pool installation by Matthew Dalziel and Louise Scullion. Downstairs, the mood darkens with Dinos and Jake Chapman's *Great Deeds Against the Dead*, which transforms the butchered figures from a wartime Goya etching into mutilated shop-window marionettes. The sculpture's cos-metic artificiality drains it of horror, and yet a macabre fascination lingers as we survey these smooth, elegantly dismembered limbs.

With arresting paintings in glossy enamel by Gary Hume, including a tensely expectant image of an encounter between four pairs of feet in a garden, the young British artists' show provides the Biennale with a much-needed injection of energy. So do similar fringe shows of the emergent generation organised by other countries. But the abolished *Aperto* section is still greatly missed. It must, whatever happens, be resurrected in time for 1997. Otherwise, the Biennale will be in no shape to take the pulse of modern art over the next 100 years.

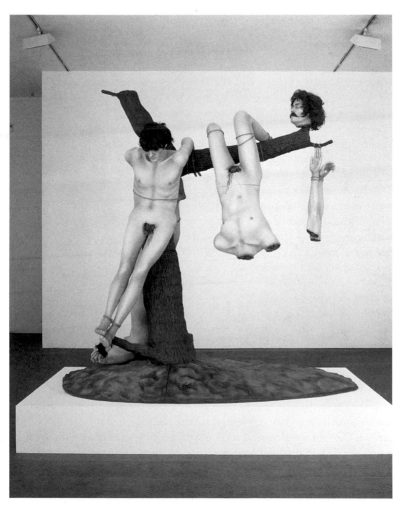

112. Chapman Brothers, *Great Deeds Against the Dead*, 1994

RITES OF PASSAGE
20 June 1995

Although the Tate Gallery's challenging new exhibition is called *Rites of Passage*, it could equally well be entitled *Memento Mori*. Rather than roaming widely over life's landmark experiences, it closes again and again on the brute fact of death. The inevitability of extinction hangs over this survey like a shroud, and the knowledge that two of its youngest artists died recently from Aids-related illnesses accentuates the sense of a funeral ceremony. But that does not mean it is a morbid exhibition. Looking at John Coplans' photographs of his naked septuagenarian body may make us conscious of physical disintegration. Their very frankness, however, is resilient rather than depressing. By exposing every wrinkle, sag and bulge in his elderly flesh, Coplans conveys a defiant attitude towards old age. There is a clenched energy in the stances he adopts, and the exclusion of his face helps to widen them out from the private to the universal. Ranged round the room in clusters, these tall, tripartite images end up surprisingly frisky.

If Coplans focuses intently on his body's exterior, and comes up with images akin to the hardness of a sculptural frieze, Mona Hatoum probes the softness within. Although the body is her own, she emphasises the work's eeriness by calling it *Corps étranger*. Visitors enter a constricted circular chamber, intimate enough to make them uncomfortably aware of their neighbours' proximity. They gaze down at the floor, where a video records the journey of a tiny medical camera through all Hatoum's orifices. Anyone who has submitted to the intrusiveness of endoscopy or coloscopy in hospital will recognise the technique. But patients are not normally shown the visual evidence of these miraculous investigations. Hatoum reveals everything. The whole notion of self-exposure is taken to its queasy limits as we find ourselves roaming up her nostrils, down her throat and through a labyrinth of even more private passages. Pink and glistening, they pulsate with visceral sensations. And the feeling of being enclosed in a mysterious organism is heightened by the soundtrack, which uses ecographic recordings of every beat and splash made by Hatoum's noisy innards.

By turns bizarre, perplexing and uncomfortably invasive, *Corps étranger* also raises fundamental fears about the possibility of discovering disease. And the spectre of imminent fatality becomes more acute in Hamad Butt's room. Pakistan-born but London-educated, he died at the age of thirty-two only a year ago. The knowledge that his life would soon terminate

must have affected Butt's final work. In its most spectacular form, a row of large, bulbous vessels dangle from the ceiling. They invite you to play with them, like an executive idly flicking the Newton's Cradle on an office desk. But the idea of a harmless toy fades when we realise, with a shock, that these vessels are glass. If we did set them in motion, their collision might lead to breakage and the release of the yellow chloric gas inside.

If Butt uses glass containers as metaphors for human frailty, Bill Viola removes any doubt as to the subject of his concern. Having taken viewers through a Hatoum-like tunnel, he confronts them with an arena of darkness. The effect is disorientating. We stand there, wondering what might happen. And our apprehensiveness is not allayed by the shadowy forms which gradually become visible on the walls. They seem to struggle, painfully, towards a visible state. But when, one by one, they do fully reveal themselves, their presence is snuffed out after a few seconds. Although they flare briefly before fading, this brilliant exposure only makes the subsequent obliteration more distressing. And the tantalizing, semi-audible sound of muttering voices adds to the overall air of helplessness. Each figure, young or old, appears marooned in loneliness. They seem unattainable, beyond all assistance, and their bodies submit to a lifespan as puny as a firefly.

Louise Bourgeois can hardly complain about the brevity of existence. Born in 1911 and still wonderfully inventive, she offers triumphant proof of some artists' ability to produce their best work in old age. Primarily a sculptor, Bourgeois now channels her most sustained energies into cell-like installations. They resemble, at first, fortresses which refuse to disclose their secrets. But as we negotiate entry, either through an open window or a winding, maze-like passage, the contents of these enigmatic chambers gradually become apparent. In one, dismembered hands clasp each other on a stone block, as if determined never to be parted. But in the interlinked *Red Rooms*, a bleaker and more claustrophobic world is disclosed. Drawing on memories of her childhood home, Bourgeois presents an ominously hard bed in one cell. And the other is filled with a stifling array of yarn reels, as if to memorialise her parents' activities as tapestry restorers.

Shadowy, cluttered and replete with mirrors, which sometimes offer us disconcerting glimpses of ourselves, Bourgeois's installations are all elegiac in mood. They use memory as a springboard for meditations on domestic oppression. But they also combat transience by erecting monuments to a past otherwise beyond recall. Her cells seem far sturdier than Joseph Beuys's *Earthquake in the Palace*, a room-size work produced after

a devastating tremor hit southern Italy in 1980. Everything, here, seems broken or about to collapse. One table is supported only by glass containers, and most of the floor is strewn with fragments from similar vessels. It is as if the danger of destruction implicit in Butt's contribution had been replaced by the aftermath of cataclysm.

All the same, the palace setting makes Beuys's work ambiguous. He may even welcome the downfall of an old, tyrannical order, whereas Susan Hiller's ironically entitled *An Entertainment* conveys no hint of approval on the artist's part. Taking her cue from the traditional Punch and Judy show, Hiller fills her space with four interlocking video screenings of fighting, shrieking, demented puppets. We feel trapped inside this savage activity, condemned to watch a vastly enlarged Punch as he beats his wife to the point of apparent death. The violence is unstoppable, inescapable. Watching this relentless twenty-six-minute exposé of the sadism inherent in a 'harmless' sideshow, I wondered how many generations of children may have been brutalised by regular exposure to the Punch and Judy ritual.

After mayhem, silence. Robert Gober's contribution consists, too sparingly, of a closed door surmounted by a red light. It illuminates the newspapers stacked below, and enables us to see how Gober has altered them. Stories of racist venom and homophobia abound on their pages, along with a photograph of the artist in a white wedding dress. But the work lacks the impact of Gober's dismembered human limbs, and compares poorly with the neighbouring installation by Pepe Espaliú. His most arresting work, made only a year before his untimely death in 1993, suspends a trio of empty birdcages high above the floor. Their bottoms are left open, allowing the wire strands to dangle down and curve out like the tendrils from Rapunzel's hair. Are we meant to mourn the loss of the cage's occupants, or feel exhilarated by the birds' escape? The question is left open, but a dying fall afflicts the wires as they come to rest, with a melancholy listlessness, on the bare floorboards.

Perhaps the most blatant work in the show is Jana Sterback's tailor's dummy dressed in flank steak. Stitched together, the crinkled meat pieces cling to the figure like a horrible reminder of the body's vulnerability to decay. But the dummy is fast becoming a cliché in current art, and Sterback's involvement with abbatoir imagery lacks the subtlety of Miroslaw Balka, whose sculpture brings the survey to a haunting close. At first glance, his *Shepherdess* seems to offer sustenance: a comforting light shines from her right sleeve. But the oval cavity in her hood leads to a void within, and emptiness also gives *Fire Place* its desolate mood. Although the lamp inside the rudimentary hearth may seem to heat its

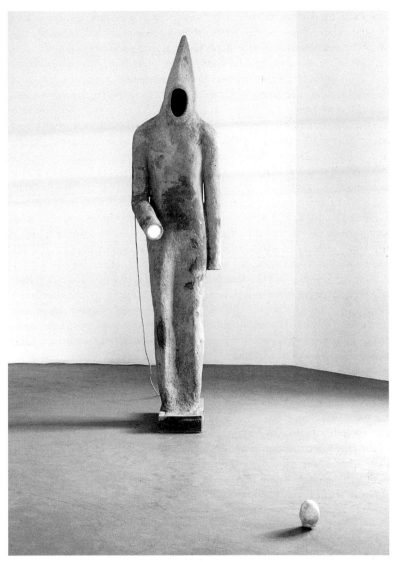

113. Miroslaw Balka, *Shepherdess*, 1988–9

walls, the shaven-headed man on top appears ice-bound. His tilted face suggests a wry acceptance of fate, and the abandoned white shoes are too far away to help him break out of his paralysed predicament.

Rites of Passage adds up to a tough, flinty experience. Its co-curators, Stuart Morgan and Frances Morris, offer nothing for our comfort. But the realization that artists are tackling the frailty of human life with vigour, compassion and courage is ultimately heartening. I welcome this elegiac show, and hope that its commitment to contemporary work will be further developed in the Tate's future exhibition programme.

GERHARD RICHTER

25 July 1995

Confronted by the boldness of Gerhard Richter's recent abstract paintings, we might be tempted to imagine that they were all produced in a rush of spontaneous activity. Their sheer flamboyance has an immediate impact on the white walls of the Anthony d'Offay Gallery. They transform the space with the startling sensuousness of their colour, their visionary breadth and, above all, the spirit of attack enlivening their execution.

The more we study these images, though, the less headlong they appear. After all, Richter continues to paint figurative images as well, carefully simulating the precision and sheen of a photograph. They are not included in the present show, which concentrates on abstraction alone. But the patience they require, amounting at times to doggedness, also informs the far more freewheeling canvases displayed here. For Richter is an inveterate worrier. He may be widely regarded as the foremost German painter of his generation, but his high reputation has not made him complacent. Quite the reverse: the exhibits at d'Offay's testify to the drastic changes they have undergone during their often protracted development. Their surfaces are pitted, and fissures in the pigment disclose patches of colour belonging to earlier stages in their troubled evolution. For all their sweeping grandeur, these paintings only came into being through a complex process of accumulation and obliteration.

Richter's warehouse-like studio in Cologne is a battleground, stalked by an artist who wages perpetual war on his own facility and capacity to beguile. He starts his abstractions with a brush, making a series of impulsive

114. Gerhard Richter, *Red (821)*, 1994

strokes on a cloudy ground. But he quickly grows dissatisfied with any-
thing that threatens to become too alluring. Richter's aggression grows as
the painting proceeds, and his willingness to destroy intensifies when he
starts wielding a tall plastic spatula. Dragging it in a variety of ways across
the canvas, he scores the paint with striations. Another, more timid artist
might then try to hide this brusque evidence of the urge to deface.
Richter, however, leaves the scars he has inflicted on his pictures brazenly
exposed. They testify to a constant state of dissatisfaction, and guard against
any tendency to opt for blandness. At the same time, though, the culmi-
nating act of spatula-pulling often ends up bringing the picture to a state
of resolution. Even if paint-layers left over from previous phases of the
work still show through, a hard-won finality has been achieved.

It is, of course, a strategy fraught with risks. In the handsome catalogue
produced for the current show, no less than thirty-three stages in the
progress of a painting called *Red* are reproduced in colour. They chart a
series of metamorphoses far more dramatic and thoroughgoing than
anyone might imagine. Richter's discontent is exposed as he moves, rest-
lessly, from his initial girder-like bars to far more blurred and melting
alternatives. Red itself, having made a prominent appearance at the out-
set, vanishes until the twelfth stage is reached. Then, after a while, it dis-
appears again, and the preponderance of red in the finished picture

comes as a surprise. It spreads across the canvas in a sequence of wide horizontal stripes, failing to hide plentiful evidence of the painting's previous states. The awesome simplicity of this final image makes some of the earlier stages illustrated in the catalogue look fussy. But others seem just as impressive as the completed picture, and I could not help wishing that Richter had found some way of preserving them.

Perhaps in his eyes they are still there, embedded in the final painting and contributing to the fruitful tension between overall harmony and underlying anxiety. Richter must relish their ability to press through, obstinate reminders of the struggle that led to their rejection. It accords with his refusal to believe in the desirability of ideal solutions, either in art or life. Growing up in an East German village made him balk at the repressive rigidity of Soviet Communism. Once he had moved to Düsseldorf, and decided to settle in West Germany for good, he relished living in a country no longer hostile to the most adventurous aspects of modern art.

Even so, his innate scepticism prevented him from lapsing into an uncritical attitude to his new home. He still fears the German tendency to embrace extremes, whether of Marxism or Fascism. And in 1987 he embarked on an ambitious series of paintings devoted to the Baader-Meinhof gang. These melancholy photo-based images testified eloquently enough to his involvement with the fate of the terrorists, found shot in their cells ten years before. He did not take sides in a partisan way. But his mistrust of ideological excess still made him worry about the State's attitude to anyone who protested against West Germany's post-war reconstruction. Richter once confessed that the death of the gang's members in Stammheim prison was 'something monstrous which affected me, and – even though I may have repressed it – has haunted me ever since'.

The outstanding sequence of images he painted in 1987 appeared to have exorcised the tragedy for him. This year, however, he returned to the subject, and the outcome is included in the current show. Unlike the earlier pictures, these images are small and abstract. They are all executed on pages torn from a book on Stammheim by Pieter H. Baaker Schut. Although pigment spreads across a substantial part of each page, it never smothers the text completely. Certain words, and in some cases whole sentences, remain visible. They reminded me of the evidence left in Richter's large canvases of a painting's earlier stages, but the Stammheim series is animated by an extra tension between pigment and prose.

The results have a rich ambiguity. On one level, the scraped paint seems to be hiding Schut's history behind a tantalizing veil. In the final

sheet of the series, the horizontal direction of Richter's strokes even seems to mimic the brusque black lines of an official censor, determined to eradicate all record of the gang's untimely end. On other pages, though, the artist's intervention has a more visceral impact. The paint, applied at times with vehement thickness, surges across the paper like an incoming tide. It appears to drench the words, as if a factual account of the events at Stammheim had somehow been engulfed by a wave of overwhelming emotion. Whatever their particular colours and directional emphases, the prevailing mood is elegiac. Richter seems to be involved in a process of mourning, and his smothering pigment implies that grief is a far more appropriate response than Schut's measured words. Moreover, the paint's obliteration of the text suggests that nobody can ever know what really happened inside the prison on that terrible day.

The Stammheim pictures may seem modest compared with the monumental canvases elsewhere, but they alter our perception of the entire exhibition. Although Richter regards these paintings as abstract, they do not seem shut off from the observable world. Sometimes the action of the paint suggests curtains, falling in folds from the top of a canvas to its base. In other images, an overall whiteness evokes a blizzard covering the world with snow. This is Richter at his most sublime, and points to his distinguished place within the German landscape tradition. *Schein* is an irresistible example of this purged, glacial vision, and stands out as the most beautiful painting on view.

Some of the exhibits, however, convey a sense of defilement. In a trio of panoramic paintings all entitled *River*, Monet's water-lily images are recalled in the shimmering, deliquescent surfaces. But instead of bearing idyllic flowers, Richter's water appears to be streaked with pollution. This is a late-twentieth-century urban river, like the one running through the centre of Cologne. And compared with Monet's blissful vision of Giverny, it bears an unmistakable resemblance to paradise lost.

LOUISE BOURGEOIS
21 November 1995

Why has Louise Bourgeois taken so long to achieve her present eminence? Now, at the grand old age of eighty-four, she is holding her first British retrospective at Oxford's Museum of Modern Art. It is a major event, but a decade ago Bourgeois was scarcely known in this country. Even the USA, where she has lived since 1938, was slow to recognise her. Only in 1982 did the Museum of Modern Art in New York stage a large survey and begin, finally, to establish her outstanding stature.

Part of the problem probably lies in her gender. Bourgeois was fortunate enough to arrive in New York at an exciting moment, when the city superseded Paris as the foremost capital for Western art. But the painters and sculptors who flourished there did not take female artists very seriously. In the macho spirit of the period, men played the heroic role in the studio. Women were expected to be subordinate, and none of them gained the towering reputations enjoyed by Pollock, de Kooning, Rothko and the rest.

Bourgeois left her native France for an excellent reason: she married the distinguished American art historian Robert Goldwater. The onset of world war, a year after she settled in New York, must have made her feel grateful to escape the Nazi invasion. Many of the artists she had admired in Paris, including her teacher Léger, fled across the Atlantic as well. So Bourgeois should ideally have been at home in New York, stimulated by the exceptional vitality and cosmopolitanism of the city's burgeoning avant-garde circles. All the evidence suggests, however, that she felt marooned. The earliest work on view at Oxford was produced in the late 1940s, and it conveys a powerful sense of isolation. The tall, emaciated figures, displayed at her first one-person show in New York, speak of frailty and loss. Made from rough poles and planks, they seem scarcely able to stay upright.

Bourgeois's readiness to arrive at extreme simplification, and her respect for the innate character of her materials, suggest that Brancusi had been a key influence during her years in Paris. Giacometti's etiolated figures may also have impressed Bourgeois at a formative stage in her development. All the same, a singular vision is already apparent. Her totemic figures lack arms, and their absence increases the air of helplessness. But alongside this inability to defend themselves, they show signs of surprising resilience. Even the most stripped and flattened figure is enlivened by pale blue striations, which offset the blankness of the face

above them. And in the other figures, the overall emphasis on elongation is alleviated, in places, by unexpected protuberances. Although far less generous than the swellings which Bourgeois would explore later, they already proclaim her interest in the obstinacy of sensual, organic growth.

The tension between these two extremes – fearful attenuation and stubborn ripeness – went on to nourish all her finest work. At this early stage, however, the sense of confinement prevails. In a small yet immensely potent ink drawing of 1947, *Femme Maison*, Bourgeois gave vent to a feeling of unbearable entrapment. The naked woman who dominates the image is only visible below her waist. For the upper half of her body is enclosed in a large, many-windowed house. Two arms protrude from its sides, one waving and the other dangling. They both reinforce the mood of repression, stifling enough to border on panic. No eyes can be discerned in the apertures punctuating the house's façade. The building shuts the woman away from the world outside, and no amount of arm-gesturing can restore her lost contact. The very neatness with which the house fits her shows how insidious it really is. The woman's identity has been swallowed up in a domesticity that seems tailor-made. Confining it may be, but she cannot do without her claustrophobic home.

Later on, especially after Bourgeois produced a print version of *Femme Maison* in 1984, it became a feminist icon. And in one respect, it does reflect the artist's perception of the conflict in her adult mind between the rival demands of married life and a more independent existence. But her interest in the house also stems from a deeper obsession with childhood memories. The size of the building in *Femme Maison* reflects the amplitude of Bourgeois' family home at Choisy-le-Roi. She has continued to ruminate on its significance throughout her career, and even in 1947 the artist began to explore its interior spaces as well.

In an outstanding print called *He Disappeared into Complete Silence*, Bourgeois leads us into a bare room. Four rudimentary ladders hang from the raftered ceiling, and one of them seems to rest on the equally austere floorboards. They offer the promise of ascent, but lead nowhere. Once again Bourgeois presents the home as a site of imprisonment, and her harshly scored lines emphasise its oppressiveness. Although a window at the side holds out the promise of escape, the likelihood that the room is an attic suggests that exit would be perilous.

Bourgeois managed to leave Choisy-le-Roi, but not before she had been seared by her life there. Although her mother provided a stable foundation, she was often ill and died in 1932. Long before then, her philandering husband kept as his mistress an English tutor, Sadie, who lived

with the family for a decade. Bourgeois was profoundly unsettled by his betrayal. The emotional complications involved in having three parental figures were bewildering, and help to explain why her work has returned incessantly to rooms redolent of childhood anxieties. At Oxford, the image of a lair takes many different forms. The house appears, at its most minimal, as a severely smooth and simplified *Maison* in austere white plaster. An entrance is visible but no exit, and the entire structure has a forbidding air. Then, in a small bronze, the lair becomes a pyramid punctured by a large hole at the front. Windows are included this time, along with a far smaller hole at the back. But it still looks ominous, and Bourgeois' decision to model the sculpture in a rough, almost pummelled

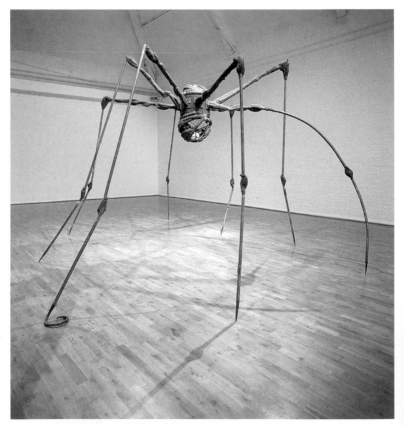

115. Louise Bourgeois' spider at Museum of Modern Art, Oxford, 1995

way hints at brutality within. Violence is finally given open expression in *Labyrinthine Tower*, which uncoils in the air like a predatory creature. It terminates in a fist-like form, ready to hit.

A similar sense of aggression envenoms the large *Structure IV – Boat House*. Balanced on a vertical support seemingly too slender to bear its weight, the building has now been split in two. The upper section rises free of the house's base, leaving a gap between them. So the idea of an enclosed, prison-like home gives way, here, to a more liberating alternative. All the same, fragments from the house project from both sections like broken teeth. They suggest that the building might at any instant snap shut again, crushing anyone unfortunate enough to be making an escape.

A mood of danger energises all Bourgeois' finest work. At its most spectacular, the Oxford show boasts a colossal spider presiding over the largest upstairs gallery like an apparition from an *Alien* movie. The white egg lodged in the spider's belly cage implies that Bourgeois believes in the creature's capacity to spawn an infinite progeny. But the most moving exhibit is found at the other end of the upstairs floor. Walking past a relief in pink rubber crammed with female breasts, and a rough-hewn slab where penile forms thrust upwards in polished profusion, we eventually arrive at *The Age of Anxiety*. Swaying slightly in space, the headless body of a woman hangs from the roof. Her back is arched as if in acute pain, and her splayed fingers stretch towards the exposed soles of her feet. The gleaming surface of the sculpture is deceptive at first, lulling us into imagining that such a lustrous figure could not be suffering too much. But then we realise that Bourgeois forces us to see our own reflections in the body she has made. We stare at ourselves, feeling like voyeurs guiltily implicated in the dangling woman's plight.

JANA STERBAK AND SUSAN HILLER
23 January 1996

Few of the artists in *Rites of Passage*, the elegiac exhibition held at the Tate last summer, let us escape from the prospect of death. Jana Sterbak, Prague-born but living now in Montreal, presented mortality in all its rawness with her most notorious work: *Vanitas, Flesh Dress for an Albino Anorectic*. True to her provocative title, Sterbak clothed a metallic tailor's dummy in a dress made from fast-withering slices of flank steak. No

image of bodily decay could have been more carnal and brutally direct.

Now Sterbak has returned, with a mini-retrospective at the Serpentine Gallery. But the willingness to shock is confined, this time, to a work at the far end of the final room. From a distance, *Seduction Couch* looks alluring enough. To anyone versed in European painting it recalls the *chaise-longue* where Madame Récamier reclines in David's great portrait. But the nearer we approach, the more disconcerting the couch becomes. No smiling society woman in neo-classical robes occupies its curving surface. The couch is empty, and Sterbak's decision to construct it from perforated steel abolishes the notion of comfort. A powerful spotlight beams on to it, casting a cage-like pattern on the wall behind. And the electrostatic energy pulsing through the work gives out a regular crack. Anyone who ignores its warning and touches the couch will receive a sharp discharge – harmless, no doubt, yet stinging enough to obliterate all thought of the pleasures of the flesh.

Knowing that Sterbak spent her first thirteen years in Czechoslovakia, before her family emigrated to Canada in 1968, we may be tempted to wonder if this disrupted life has affected the art she produces. The Soviet invasion of her native country prompted the move, and the tyranny of a Communist regime would have given Sterbak an unforgettable insight into the fragility of human life. But she has lived sufficiently long in Canada to know the shortcomings of capitalism, too. The cynicism souring her work shows that she has no faith in systems, and every expectation that individual liberty is threatened by rules on every side. Nowhere is this more apparent than in the Serpentine's first room. A man on a video screen tries to read out all seventeen articles of *The Declaration of the Rights of Man*, the cornerstone of the French Revolution. He soon begins to stammer, and his struggle to enunciate words as important as 'power' or 'citizen' gradually militate against the text's conviction. By the end of his performance, the effort involved has become excruciating. The confident idealism of the words is undermined by the reader's writhings.

Throughout the show, Sterbak arouses expectations only in order to confound them. Hair sprouts at chest-level from the *Chemise de Nuit* dangling so seductively from its hangar. The back of a man's head establishes an imposing presence but then, at the top of his neck, discloses the bar-code stamped like a convict's mark on his skin. In a screen projection called *Sisyphus III*, a powerfully built male figure finds himself encased in an aluminium and chrome structure. He expends all his energies reacting to the incessant, queasy lurch of the metallic object confining his limbs. Sterbak reinforces its dominance by displaying the structure, empty and waiting for its next occupant, on the gallery floor.

Against the odds, the exhibition does not seem unendurably gloomy. Even the macabre dress of raw steak suggests that Sterbak has a well-developed sense of absurdity, and the endless strivings in *Sisyphus III* are leavened by the humour inherent in their futility. The man is athletic and poised enough to earn our respect as well. On some level, Sterbak admires his agile persistence, his absorption in the task of coping with all the unsteadiness and confinement.

In a recent video work, *Condition*, she even raises the hope of escape. Tracked by an incessantly moving camera, a man staggers round a deserted airport filmed in bleak, grey monochrome. His body is attached to a wire-mesh object on wheels, curving away behind him and hampering his movements. We hear his breath on the sound system, increasingly harsh and beleaguered. The swirling mobility of the filming contrasts ironically with his burdened figure, and at one point he dwindles into invisibility as the camera races away on a joy-ride. Near the end, though, he manages to throw off his appendage. Abandoned on the empty track, it suggests that Sterbak is moving towards a rather more optimistic view of the human predicament.

Susan Hiller, whose contribution to *Rites of Passage* launched a rasping assault on the senses, is also staging a retrospective. At the London Tate last year, she used four video projectors, quadrophonic sound and interlocking video programmes to bombard the viewer with the violence of Punch and Judy shows. Now, at the Tate Liverpool, she reveals the full extent of her range in a very substantial, beautifully installed survey that deserves wide attention. The continuity of Hiller's interests, conveyed in such a striking variety of ways, is revealed here more clearly than before. For over twenty years, this American-born artist has lived in London and dedicated herself to reclaiming overlooked aspects of our culture. Having trained as an anthropologist, she was familiar with the fascination of unearthing hidden material. Early on, she amassed an astonishing collection of seaside postcards showing apocalyptic waves crashing against the shore. Typically, Hiller called the series *Dedicated to the Unknown Artists*. And she later made one of her largest, most commanding works from plaques memorializing forgotten deeds of heroism.

Found in a London park, the plaques have been photographed and arranged on the wall in an imposing cruciform sequence. An ordinary bench stands in front of them, inviting us to sit down and listen to a headphone tape where Hiller talks of memory and death. But the most moving parts of *Monument* are the inscriptions on the plaques themselves, many recounting with grave simplicity the deaths of children drowned while attempting to save a sibling or friend. The plaques are

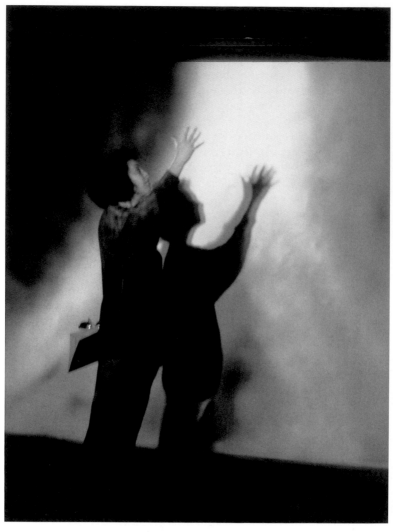

116. Susan Hiller in front of *Belshazzar's Feast* (bonfire version), 1983–4

elegantly designed, and flanked by floral borders in a sinuous Art Nouveau style. But Hiller, who sets no limits on her interest in found material, lodges among the plaques a photograph of graffiti exhorting its readers in smudgy capitals: 'STRIVE TO BE YOUR OWN HERO'.

The act of uncovering the images in *Monument*, and giving them new, suitably elegiac form, lies at the centre of Hiller's concerns. But the Liverpool show proves that her method of manifesting those interests has always been admirably unpredictable. Her most powerful and mysterious works are presented in darkened rooms, where she asks the viewer to suspend disbelief in surprisingly demanding ways. Large circles of coloured light, in red, yellow and blue, are projected on to a wall in *Magic Lantern*. As they intersect, swell, shrink and separate, the after-images are spookily matched by sounds. Hiller chants some of the time, creating an hallucinatory mood. But the strangest passages come from voices recorded by the Latvian psychologist Konstantin Raudive, who insisted that he was able to tape the disembodied mutterings of dead people.

While she is alive to the implausibility inherent in such claims, Hiller refuses to discount them altogether. Obsessed by the way culture so easily leads to curtailment and 'a form of partial picturing', she is prepared to entertain a belief in phenomena which others often impatiently dismiss. The most spellbinding work on view, *Belshazzar's Feast, The Writing on your Wall*, starts with the simple flickering of video-projected flames. A child's voice can be heard, trying to describe the activity in Rembrandt's explosive painting of Belshazzar. Encouraged by the words, we find ourselves reading figures into the flames. And then the focus shifts to apparitions appearing on television screens late at night, after programme transmission has finished.

Whispering on the soundtrack, Hiller reads out testimony from people who insist that they saw such phantasms. As if in response to their words, the flames in the video take on larger and ever more ghostlike forms. Are they manifestations of the dead, or warnings of an apocalypse as terrible as the one confronting Belshazzar? Leaping up the wall like proverbial tongues of fire, these irrepressible images rejoice in Hiller's willingness to give them the benefit of the doubt.

BRIDGET RILEY
6 February 1996

Nobody could accuse Bridget Riley of pallid English reticence. Ever since she launched her first headlong assault on our retinas, her work has never been afraid to dazzle and overwhelm. Riley is a fierce painter, flounting the stereotype of the 'gentle' female artist with eye-bending verve. The toughness of her work has become legendary, and in her sixty-fifth year she has no intention of dropping her guard.

Walk into her exhibition of recent paintings at Waddington's Galleries, and the visual barrage hits you at once. Hung at a disconcertingly low level, these high-keyed canvases pulsate with intense colour contrasts. Their surfaces are immaculate. Flat, orderly and calculated to a hair's breadth, they betray no sign of the artist's own mark-making. The paint is applied with impersonal precision. Sensuous brushwork is not permitted to seduce the viewer, or impede the clean, hard-hitting energy generated by Riley's particles of form. They demand an alert response, and have no patience with the notion of a faint-hearted viewer.

Not that the Riley of the mid-1990s is quite as combative as the young artist who emerged thirty-five years ago. She restricted herself, in that eruptive early period, to black and white. Once viewers became ambushed and ensnared, they found themselves crushed by converging walls of rectangles or pulled into fierce whirlpools. In the Tate Gallery's *Fall*, painted in 1963, undulating lines rush down the canvas like an unstoppable flood. Riley ensures that our eyes struggle to cope with the optical vibrations. Most of these precocious, single-minded paintings are painful to look at, and they demand a formidable amount of commitment from anyone who stares at them for an extended period.

The Rileys at Waddington's do not require quite so much perceptual stamina. The harshness of black and white has been replaced, here, by an almost profligate richness of colour. If her early work was cold, the new paintings are hot. Riley is unafraid to allow puce, orange, scarlet and maroon to play prominent roles. They blaze in the air, kindling the gallery with a warmth defiantly opposed to the February chill outside. Even though Riley counters them with the moderation of light green, deep blue and bleached yellow, the overriding mood is one of Mediterranean radiance.

So how dependent is Riley on the stimulus of luminous surroundings? At Karsten Schubert, where her recent gouaches are on show, many of the exhibits are inscribed with the name Bassacs, where she stays in

France. Executed between April and July last year, they are all paler than the paintings and less busy in their congregation of forms. Strong uprights dominate each image, albeit sliced by diagonal intruders. They are reminiscent of trees, but Riley is enough of a thorough-going abstractionist to make me wary of reading indisputable landscape references into her work. The light-suffused planes floating in these gouaches insist on a life of their own, independent of anything they might represent.

Like many abstract artists before her, in the High Modernist tradition to which she still proudly adheres, Riley is fascinated by the parallel between painting and music. She particularly admires *The Poetics of Music*, the lectures Stravinsky delivered at Harvard where he lauded the benefits to be derived from moving within the limits of a narrow frame. The idea that 'music provides a sensual experience by the organisation of a limited range of formal means – notes, scales, intervals and their possible relationships' has, Riley believes, a direct bearing on her own hopes and ways of working.

But that does not mean she shuts herself away in a hermetic world, refusing to be aware of visual stimuli outside the studio. Robert Kudielka, who has written extensively on her work, recalled visiting Munich with Riley on a bright March day in 1972. Leaving the great collection of Rubens in the Alte Pinakothek, they wandered across to the Hofgarten and sat at a tree-sheltered table laid with a white cloth. 'It was about midday', he remembered. 'A waitress brought us glasses of wine which sparkled yellow and green. The light grew brighter and stronger every minute…Bridget stopped and exclaimed "Look at it! Just look at it!"' There was, Kudielka went on, 'nothing to look at in the proper sense of the word, no particular incident or object to be observed. It was rather as though we were sitting in the middle of an all-enveloping event.'

Those final words apply very well to the experience now on offer at Waddington's. Standing in the gallery, I found myself surrounded by the vibrancy of the colours marshalled so exactingly on the wide canvases. The titles Riley has chosen for these pictures – *In Attendance*, *From Here*, *Reflection* and *August* – are free from any dependence on a specific, observed location. They do not, however, rule out the notion of an artist responding to, and meditating on, a more general apprehension of time and place. Looking is for her a central activity and she can trace it back to childhood years spent in Cornwall during the war. While Barbara Hepworth was nourished by the intensity of her reaction to the landscape around St Ives, the young Riley went on clifftop walks with her mother and discovered the intoxication of looking. She was lucky: Cornwall has a special ability to both sharpen and cleanse the perceptions of the artists

117. Bridget Riley, *Reflection*, 1994

who live there. But she also knew how to learn from that formative experience, and apply it consistently to her work as a painter.

More, perhaps, than the majority of artists, Riley has always been highly disciplined. Just as Stravinsky recommended in his lectures, she imposes rigorous constraints on herself. In the Waddington exhibition, they are most apparent in the meticulous organisation of the images on display. Each picture is broken up into a patchwork of angular segments, systematic enough to rule out the inclusion of a single renegade curve. The proliferation of these segments generates a powerful sense of restless dynamism across all the surfaces. They hover on the edge of shimmering. But despite her admiration for Seurat, whose exquisite *Le Pont de Courbevoie* she once carefully copied, they never become broken or blurred. Riley retains her long-held passion for hard definition. Her recent work is as crisply structured as ever, and within its spangled complexity she ensures that every unit of form retains a clear-cut identity.

The longer we look at her paintings, though, the less confident we become about finding our bearings within their bristling facets. The diagonal movements, which seem so dominant at first, are counter-balanced increasingly by the strength of upright, pillar-like presences. However

forcefully they seem to be pierced by the diagonal shafts, they stay erect. And then we notice how ambiguous they really are. Riley never lets us decide which forms are solid. She plays with possibilities continuously, in an almost teasing manner. What starts out resembling a tree may well become, after a second or third look, a slice of sky.

The airiness of these new paintings is very striking. It suggests that Riley wants, more and more, to break up the rigidity of her pictures and let them breathe. Sometimes, in her earlier canvases, she used to pack them so tightly that a distinct feeling of claustrophobia ensued. Riley made it hard for our eyes to move around freely within her taut, highly controlled images. They were confining rather than liberating, and insisted on leading us in the direction she wanted to go.

Now, by contrast, the overall mood is more expansive. Hedonism has become a potent force, and Riley seems more prepared to let us establish our own relationship with her work. She is, perhaps, entering into a greater state of relaxation. The play of dappled light is omnipresent, encouraging us to feel blessed by its capacity to soothe. Riley is an admirer of Matisse, and what she describes as his great 'shout of joy'. These new paintings seem suffused with the heat and luminosity of the south, and invite us to discover within their fractured complexity an awareness of well-being.

Even so, I cannot imagine Riley ever likening her art, in Matisse's words, to 'a good armchair in which to rest from physical fatigue'. However many changes her art may undergo in the future, it will always insist on the ability to be bracing. A good Riley does its best to invigorate. It purges lazy ways of seeing, and invites us to scrutinise the world with a renewed sense of clarity, wonder and zest.

JEFF WALL
19 March 1996

Stepping into Jeff Wall's show at the Whitechapel Art Gallery is like finding yourself confronted by a glowing cinema screen. The image straight ahead resembles an epic scene from a no-holds-barred war film, replete with special effects so gorily convincing that they make you flinch. But none of the soldiers moves or makes a sound. For Wall's tableau is an immense colour transparency backlit in an aluminium light-box. It

freezes the dead bodies of a Soviet army patrol into an unearthly stillness, and allows us to discover just how macabre they really are.

Despite its documentary trappings, *Dead Troops Talk* turns out to be more like a grotesque hallucination. Although the thirteen corpses were ambushed in a stony Afghanistan wasteland by the Mujahideen, most of them have come back to life. But they are not basking in a redemptive resurrection worthy of Stanley Spencer. One soldier, whose skull has been half blown away leaving his jellied brain nauseatingly exposed, barks at a blood-smeared companion. Another, grinning in apparent ignorance of his severed thigh, looks across at the central group. There, a snarling soldier points with a Christ-like finger at his own putrescent wound. And he straddles a sprawling figure who leers as he extends his tongue towards the entrail dangling from a third soldier's proffered hand.

Wall makes no attempt to disguise the invented nature of the scene. It is, self-evidently, a posed work relying on actors to project heightened emotions. Even so, the overt theatricality does not impair the work's baleful power. Nor is our ability to suspend disbelief affected by the seam-line running through the image – a technical necessity which Wall welcomes as a way of accepting the inherent properties of his photographic medium. The line brings our eyes back to the physical surface of the transparency, reminding us of Wall's kinship with modernist painting. Although he owes a debt in *Dead Troops Talk* to war movies and photojournalism, Wall composed his tableau like an artist and shot it on an artificially constructed indoor set. The result can be seen as an impressive restatement of the disgust that prompted Otto Dix to paint his great, gruesome *War Triptych* over sixty years before. Hideously butchered bodies likewise dominate Dix's corrosive vision of the killing fields, but Wall filters his image through an ironic awareness of artifice. While he uses computerised digital manipulation to give his scene the maximum amount of realism, Wall never lets us forget that it is a product of his own complex imagination.

The rest of this engrossing show proves how adroitly he moves between the interconnected worlds of film, photography and painting. For all his originality, no contemporary artist is more immersed in tradition than Wall, who studied at the University of British Columbia in his native Vancouver before reading art history at the Courtauld Institute in London. Now a Professor of Fine Arts back in Vancouver, he is keenly conscious of the historical precedents for everything he produces. French art of the nineteenth century provides him with a particular stimulus. It extends from the corpses stretched across the foreground of Géricault's *The Raft of the Medusa* to Manet's cool, analytical engagement with so many aspects of modern life.

Wall's ambitions are scarcely less panoramic than Manet's. If *Dead Troops Talk* shows his most theatrical and gruelling side, the landscapes on display here are often pure photography unalloyed by stagecraft of any kind. In *Coastal Motifs*, he scrutinises an epic locale near Vancouver. The distant view is terminated by the ethereal yet awesome forms of pale blue mountains. Their untarnished magnificence is contrasted with the industrial scene in the centre, where mounds of white minerals ape the mountains' forms in miniature. Wall does not declare himself, here, as an impassioned protester against the destruction of Canada's countryside. Even so, the clash between nature and industry is quietly exposed. For the moment, the landscape's overall serenity is retained. But *Coastal Motifs* implies a concern, on Wall's part, about the future of a haven which could so easily end up despoiled.

Elsewhere, Wall shows how alive he is to the uneasy consequences of urban development. In *A Hunting Scene*, two riflemen stalk their quarry in an area of scrubby growth bounded by a nondescript housing estate. The bleakness of the setting, intensified by the amount of picture-space devoted to an empty Canadian sky, gives the whole image a desultory air. The hunters seem to derive scant enjoyment from their activity. It is hard to believe that anything worth pursuing could possibly be found in such terrain. So the suspicion grows that the riflemen might be bent on something more sinister than the shooting of game. Might we be witnessing the tracking of a human target, either by plain-clothes policemen or assassins? Wall refuses to say, but he allows us to ask the question by leaving the precise meaning of his image unresolved.

In several other works, he certainly encourages us to speculate about what might happen next. At first, his interior of a shabby block of flats in Prague looks uneventful enough. A girl makes her way down the battered staircase, absorbed in thought and oblivious of any threat. But the shadows around her create a sense of expectancy, and the dereliction sharpens the tension. Along a dark and narrow passage beyond the soiled sink in the hall, a discarded parasol is just discernible. Lying on a dirty floor, it assumes the significance of a potential clue to a crime.

Wall has a consummate ability to let inanimate objects, and the surroundings they occupy, convey surprisingly potent emotions. The title of *Diagonal Composition* may suggest that he is concentrating, in this unusually small work, on the formal qualities of his rigorous design. But the stains on the decrepit ledge, combined with the decaying bar of soap abandoned on the edge of a cut-off sink or bath, hint at a narrative involving human misery. Although we will never know who the inhabitants of this desolate room were, ignorance does not prevent us from imagining how wretched their lives may have been.

Most of the time, though, Wall's interiors are peopled. *Insomnia* presents a relentlessly lit nocturnal kitchen, where green gloss-painted cupboards glare down on a cheap formica table and, underneath it, a sprawling man. Sweat-drenched and tousled, he gazes out at us as if aware of being observed. But that does nothing to lessen his isolation. The salt-pot and glass dish on the table seem to mock him, suggesting that they are the only companions he can count on during the long hours of sleeplessness. And a similar feeling of domestic ennui invades *Jello*, where a far more streamlined and soothingly lit kitchen fails to alleviate the listlessness of the two forlorn girls marking time within.

The understatement of both these works adds to their fascination, and compares favourably with *A Fight on the Sidewalk*. Wall presents the struggle between two weirdly interlocked figures, obscured by Carravaggio-like shadows, without his customary command of mystery. The presence of an unshaven spectator, standing next to a graffiti-spattered building, looks merely contrived. We become too conscious of Wall's attempt to arouse curiosity, and the staginess of this street-life incident seems misjudged.

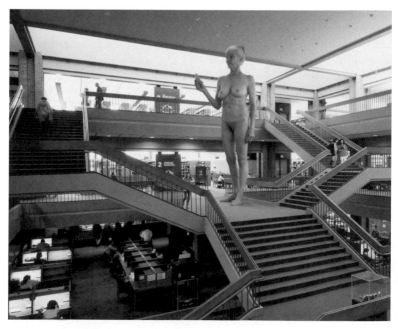

118. Jeff Wall, *The Giant*, 1992

It lacks the depth of engagement which gives Wall's best work its multi-layered resonance. *A Ventriloquist at a Birthday Party in October 1947* is just such an image. For once, the brilliance of the backlit transparency is dimmed. Children dressed in impeccably correct post-war party clothes gather in a subdued living-room where two lampshades flank an entertainer. Balloons float towards the ceiling, where they come to rest in a glowing expanse of brightness. Even so, they fail to distract the guests, who all stare in wonder at the dummy on the ventriloquist's lap. With his sharply upturned nose, mirthless smile and jutting, voracious lower lip, he has a demonic aura. But he is capable of entrancing the children, just as we in turn are transfixed by the spellbinding power of a master story-teller, a magician with light.

AVIS NEWMAN AND ALISON WILDING
9 April 1996

Some artists thrive on constant visibility, moving from one show to the next with an insatiable thirst for exposure. Others prefer a more reclusive approach. They exhibit sparingly, and never push themselves into headline-hogging manœuvres. Their work shuns boisterous spectacle, opting instead for subtle, slow-burning strategies which can easily be overlooked by anyone in search of a quick visual fix. But they often turn out to be immensely rewarding, and provide experiences more satisfying than the work of their high-profile contemporaries.

Two of the finest of these deceptively quiet artists, Avis Newman and Alison Wilding, happen to be showing in London at the moment. Their work does not disappoint. Newman, holding her first exhibition in Britain for five years, fills the Camden Arts Centre with large paintings and small objects that make no attempt to seize the viewer's attention. Seen from a distance, as you enter the grand, handsome gallery where most of them are displayed, the paintings look like monochrome abstractions. Only after closer inspection do these seemingly all-black or all-white images disclose the marks Newman has left on their surfaces. She thinks of them as spiders' webs, and they certainly have the fragility of thin, delicate tracery discovered dangling in a hedge or a neglected doorway. But if the word 'web' implies something intact, then it is misleading. For the faint linear trails in Newman's pictures all seem broken. The

however, *Echo* proves as elusive as one of Newman's feathery paintings. For its interlocking stainless steel slats tease the eye with their geometrical complexity. Highly reflective, they are broken up by the light. And as we explore their glinting, fractured segments, so we realise how bewildering the structure will remain.

Like Narcissus, I found my own face mirrored when I crouched down to peer into the sculpture. But it was a fragmented reflection, and I grew simultaneously aware of my ability to see deep inside the work. There, the fantastic intricacy of the slats creates labyrinthine spaces as frustrating as the interior of a Piranesi prison. Gradually, though, I became conscious of a presence lodged inside. Difficult to see from the sides, it is clearer from above. Made of polished brass, this mysterious sphere may refer to Echo's head. But Wilding ensures that it evades any clear-cut identification, even if the sharpness of the slats might well evoke Echo's body as it changed, according to the myth, from bones to rocks.

Metamorphosis is surely the governing idea at work in the sculpture. The initial impression of a coffin gives way to a more transparent alternative, inviting us to lose ourselves in its maze-like interior. As ever in Wilding's work, considerable tension is generated by the bringing together of two contrasted elements: the brittle interplay of countless steel units, and the rounded solidity of a single brass form. Ultimately, though, the sphere proves impossible to pin down: whenever we look at it from a different angle, the brass appears to have changed position within its resting-place. Instead of remaining solitary, it jumps around the sculpture like the voice of Echo herself, who could only speak when repeating someone else's words.

So we are left with a stimulating conundrum. If Wilding's exhibit is indeed concerned with a nymph's death, it can be seen as a sombre memorial. At the same time, however, the restlessness created by its reflections and baffling interstices is at odds with the whole notion of a sarcophagus. The artist herself has written that, when she was working on the model for *Echo*, it exuded 'a concentrated stare, of brass at steel and steel at brass. It's an intense, obsessional stare and mirrors mine at it.' Those words help to explain why the entire sculpture seems far too alive to be confined by the negation of the grave. Suspended within its metal prison, the sphere may still be animated by the nymph's unrequited passion. The brass quivers in the light, waiting for the chance to escape from the tomb's embrace and leap back into life.

RICHARD WILSON

20 August 1996

Within a few weeks, the parkland tranquillity of the Serpentine Gallery will give way to mayhem. Funded by a £3 million lottery grant from the Arts Council, along with a further £1 million raised by its own enterprising campaign, an ambitious renovation scheme aims to expand and enhance the building even as its essential character is honoured. When it reopens in September 1997, the Serpentine will at last be equipped with facilities worthy of an outstanding gallery now enjoying its liveliest and most popular phase.

Turning a much-loved institution into a muddy building site is bound to upset its regular visitors. But Richard Wilson, staging the last show in the present gallery, helps to prepare us for the imminent upheavals. Nothing on view here is as breathtaking as his masterpiece *20:50*, that oceanic expanse of sump oil flooding its space at the Saatchi Gallery with an ominous, eerily reflective blackness. Nor is there anything as hallucinatory as *She Came In Through The Bathroom Window*, where Wilson removed an entire wall-wide expanse of windows from Matt's Gallery and suspended it, at a disorientating angle, within the space. All the same, he reinforces his reputation as an agent of uncanny disruption before we enter the Serpentine. The normally inviolate windows overlooking the front lawn have been punctured, at their centre, by the corner of a builder's cabin lodged inside the gallery. This jutting triangle forces its way out between the classical columns, directly beneath a lintel where the Serpentine's name is decorously announced in elegant gilt letters. The intrusion heralds the collisions to come within the gallery, as well as signalling Wilson's healthy refusal to let his adventurous imagination be limited by rigid architectural constraints.

Over the last decade, as an ingenious mini-retrospective of his drawings and models at Gimpel Fils reveals, Wilson has thrived on confounding the expectations we bring to particular spaces. He wants to shake us free from a lazy acceptance of the gallery's seemingly unshakeable authority. At Gimpel Fils, the impeccable white purity of a 1970s interior has been disrupted by a diagonally positioned twenty-five-metre-long wall where Wilson's exhibits are lodged in irregular niches. And at the Serpentine, a Grade II-listed former tea-room occupying a fiercely protected landscape in Kensington Gardens, he has staged a heretical series of spatial invasions.

Although the show is called *Jamming Gears*, a title borrowed from the lyrics of a rock song Wilson plays on one of his truck-driving tapes, it

begins cautiously. We enter the largest room first, where he has paradoxically restricted himself to a single modest intervention. The space is deserted, and the only sign of his presence is a neat circular hole cut out of the floor. Although earth lies exposed and unruly at the bottom, flouting the smoothness of the floor-covering elsewhere, the hole does not disturb the gallery's placidity.

But it serves as a portent of the destruction in the room beyond. Here, an epidemic of holes spreads across the available surfaces. One is gouged out of the junction between floor and wall, while another punches its path right through the wall to disclose its surprising hollowness. What once seemed so solid and immovable now stands exposed in all its makeshift flimsiness. A further hole, drilled higher up on a different wall, provides us with a voyeur-like view of the tiled Ladies lavatory next door. But the most disconcerting hole is found in the ceiling, where Wilson has bored through to the sky and left the aperture open. Usually, the prospect of a leaking roof is a nightmare for any gallery director. But with typical chutzpah, Julia Peyton-Jones has allowed Wilson to leave her building vulnerable to a sudden downpour.

So we become increasingly aware of the Serpentine as an institution whose apparent immutability can be undermined with ease. In the middle of the room, a far greater disorder is caused by the tilted cabin dumped there without explanation. Circular lumps of matter from the nearby holes have attached themselves to its walls, disfiguring the otherwise pristine paintwork. Coloured a bilious lime-green, this anonymous shed could hardly be further removed from the conventional notion of a sculpture. It is a boorish intrusion, and the tipsy angle of its steeply inclined floor only accentuates the general expectation of impending collapse.

Wilson's appetite for subversiveness extends beyond the exhibition spaces. In the bookshop next door, soon to be enlarged in the renovation scheme, another hole has been sliced out of the main shelf. Showing an equal lack of respect for critics, historians and philosophers, it carves through volumes by Fry, Gombrich, Gramsci and Hegel. Gazing past their scythed covers, we find a frail expanse of chipboard lurking in the cavity behind. As for the missing chunk of bookshelf, it has mysteriously ended up protruding from the tilted cabin's wall like a builder's trophy plucked at random from wholesale devastation.

Similar sheds will doubtless be erected outside the Serpentine next month, when the real work of alteration begins. By bringing them inside, Wilson invites us to realise that the gallery will soon find itself completely overtaken by forces from another world. At the same time, though, he is mischievous enough to suggest that the heavy-weight

strength of the construction industry can suffer from unforeseen calamities. In the next gallery, a large proportion of the floor has been cut away, enabling his hired machinery to dig down to a considerable depth. If it had been left empty, the excavated area would have looked shockingly raw. But just as Wilson once inserted a green billiard table in the floor of an installation called *Watertable*, so he fills this new pit with the bulk of another lime-green cabin.

Here, however, we seem to witness a bizarre funeral. Hanging upside-down from chains held by a tomato-red fork-lift truck, the cabin looks as if it is being lowered into a grave. Or maybe a macabre resurrection is in progress, whereby the builder's shed emerges from its subterranean lair to take over the gallery. Either way, Wilson has produced a thoughtful and suitably ambiguous image of the changes soon to transform the Serpentine as a whole. Above the truck, the glass in the ceiling dome is cracked, as if responding to some advance warning of the seismic disturbances planned for the coming year. And the cabin's open door tempts us to jump down into the half-buried room, like rescuers helping passengers stranded in a broken lift. Anxious notices festoon the gallery walls, advising visitors to restrain their children and forbidding everyone to 'touch or attempt to enter the cabin'. Visually irritating, they nevertheless manage to stress that an element of real danger remains an important part of the work.

120. Richard Wilson, *Jamming Gears*, at Serpentine Gallery, London, 1996

Nobody will know, until the renovation is finished, quite how successful it has been. In that respect, Wilson's installation mirrors the uncertainty and sense of risk accompanying any such venture. In the final room, we come full circle by encountering the cabin whose prow crashes through the gallery's façade. From the outside it had looked ominous, promising further violence. Inside, however, an air of stillness prevails. Held above the floor by iron girders, the cabin seems to be floating in the otherwise empty space. A circular lump of masonry has, apparently, hurtled like a missile from another room and embedded itself in a wall. It fails to shatter the overall feeling of calm, though. Even the piece of displaced gallery window incorporated in the cabin, like an echo of Wilson's earlier *She Came In Through The Bathroom Window*, does little to ruffle the placidity.

All the same, the mood in this room is tinged with a potent sense of expectancy. It seems, in the end, to pose a question. Will the Serpentine of the future break through its boundaries and engage with the world outside, or will it retreat inwards, like the window now suspended so strangely near the centre of the room? Only the gallery's staff can provide an answer, in the programme they pursue after the reopening. Their admirable determination to give the Serpentine a vigorous continuing identity will be demonstrated, throughout the next twelve months, by a series of major sculptural commissions on the lawn. But the true test of the reborn gallery comes later, and Wilson's coolly unsettling installation shows how alive he is to the challenges posed by the convulsions ahead.

DAVID NASH
29 October 1996

Among the young British sculptors who turned to the land for inspiration in the late 1960s, David Nash has always been distinguished by his consuming passion for wood. While Nash's exact contemporary Richard Long used anything he could find on his epic walks through the countryside, Nash the carver remained faithful to unseasoned fallen timber. He also stayed put in the remote mining town of Blaenau Ffestiniog, where a Victorian non-conformist chapel has served as his lofty studio ever since he bought it in 1968 for just over £200. Here, in an airy and luminous space dominated by a Welsh wall inscription calling on the congregation to 'sanctify this house with prayer', Nash's love affair with elm, oak, pine, beech and ash still flourishes today.

His own roots in the area go back to childhood, when Nash's family spent the school holidays in the Vale of Ffestiniog. Its beauty was instrumental in persuading him to move there at the age of twenty-one. But Blaenau is startlingly at odds with the sublime allure of the Snowdonia National Park surrounding it. Visitors making their way to Nash's studio are often disconcerted to discover the starkness of the setting. Julian Andrews, in his handsome new book on the sculptor, describes it as 'a black moonscape of abandoned quarries and slate tips'. After a while, though, Nash's involvement with such a wounded locale makes redemptive sense. For his healing imagination is governed by the need to honour the wood he carves. Its innate character plays a vital role in helping to shape the sculpture. Everything he produces is charged with a keen awareness of the material's fundamental identity, and draws strength from his desire to give dead timber new life.

In defiance of the post-industrial obsolescence around him, then, Nash insists on rebirth. Indeed, he is perhaps best-known for the open-air projects carried out near his home. The *Ash Dome* is still growing in the thirty-foot-diameter circle he planted at Cae'n-y-Coed in 1977, on a woodland site inherited from his father. Every ten years the twenty-two trees are cut and bent over, so that they will eventually meet in a canopy. Nash relishes the long-term nature of such an enterprise, and accommodates himself to the slow, seasonal rhythm of a nurturing process that would infuriate other, more impatient artists.

How can these concerns be conveyed in a gallery setting? The question is prompted by a flurry of substantial shows devoted to Nash's work this autumn. The largest, a two-part survey of his sculpture and drawings

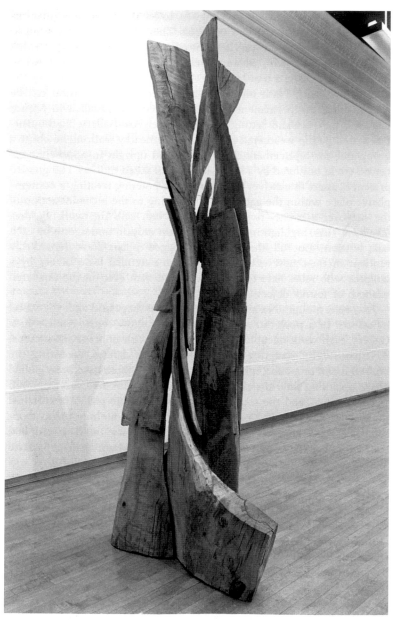

121. David Nash, *Spiral Sheaves*, 1990

War. Ultimately, though, the poise and gracefulness of *Spiral Sheaves* overcome any sense of melancholy. Like so many of his finest carvings, they seem to be caught in the process of growing as they stretch upwards, striving for the source of the sunlight.

VIJA CELMINS
3 December 1996

Given the high reputation she has long enjoyed in the United States, Vija Celmins' lack of recognition elsewhere seems astonishing. Over three decades of sustained and utterly singular work are surveyed in her major ICA exhibition. But this is the first retrospective she has been given any-where in Europe, and none of her paintings, drawings or sculptures is owned by public collections either in Britain or on the continent.

How to account for such neglect? One reason may be that Celmins has never produced a great deal of work. Quiet, painstaking and medi-tative, she takes her time. Naturally reclusive, she has always shunned the celebrity exposure that other artists, especially in the US, are often adept at courting. Even now, at the age of fifty-eight and at the start of a European tour, she only emerges from her carefully cultivated privacy with caution. Above all, though, the work itself is the very opposite of attention-seeking. At the outset of her career she worked in oils, and sometimes pro-duced canvases of substantial dimensions. But after a few years Celmins stopped painting and concentrated on drawing instead. As the size of her images shrank, so she removed any trace of spectacular impact from her chosen subjects. If one or two of these pencil studies were included in a large, mixed exhibition, they might very easily be overlooked. In an age of clamorous self-expression, Celmins remains content to whisper rather than shout.

Just how much her reticence may have autobiographical origins is impossible to tell. But it could be significant that Celmins, born in Latvia, then lived in Germany before emigrating with her family to the US. A sharp sense of dislocation, of surviving in a foreign land, can cer-tainly be detected in the earliest paintings on view. They were executed in a studio she occupied on Venice Boulevard, Los Angeles. The lumi-nous immensity of the Californian coast was on hand, and we might have expected the young artist to have succumbed to its sensuous allure.

Celmins, however, behaved as if the world beyond her studio simply did not exist. As if in renunciation of everything except her immediate surroundings, she focused on the stillness of a few ordinary objects. An electric fan, marooned on an empty floor, stands expectant. But the flex trailing from its base peters out in the encircling darkness. Soon, we feel, the fan itself will no longer be discernible in the gloom.

Even the most banal implements take on an ominous meaning in these remarkable canvases. A double-headed lamp springs upwards like antennae, with both bulbs poised in readiness to be switched on and assail the viewer's eyes. Once again, though, they remain dormant. And Celmins limits herself to a palette dominated by white, black, grey and the palest of browns, as restrained as the colours displayed in the Velázquez paintings she admired so much on a visit to the Prado.

Insofar as Celmins rejected the bravado and muscular mark-making of the Abstract Expressionists, who had dominated American art in the previous decade, her work is akin to certain other painters of her generation. She wanted to dispense with gesture, distortion and the egotistical airing of angst, replacing emotional rhetoric with a deadpan alternative. But that does not mean her early paintings lack tension. The longer we look at them, the more unsettling they become. A hot plate, isolated near the lower edge of an otherwise deserted interior, glows with electric warmth. Its orange rings serve no apparent purpose, though. They merely burn, raising the temperature and accentuating the aridity of the featureless room around them. We are made to feel like detectives staring at the scene of a crime, and wondering why the hot plate was so hurriedly abandoned by its user.

When violence erupts, therefore, it almost comes as a relief. The flat, dimly lit calmness of a typical Celmins space is suddenly invaded by a hand firing a pistol. Even here, however, fundamental information is withheld. As smoke seeps out of the gun-barrel and hangs in the air, it symbolises the mystery of an aggressive act with no visible target. We stay removed from the incident, sealed off from its consequences by an artist who herself seems to feel profoundly estranged.

As the decade develops, her awareness of menace increases. The hand holding a gun reappears in 1965 on the detachable roof of a painted sculpture called *House 1*. Smoke fuses with clouds, and the furry interior of the building appears to offer claustrophobic protection. But in *House 2* a similar home is on fire, and the ferocity of the flames flaring from the windows suggests that its destruction cannot be prevented. Does this obsession with danger, all the more disconcerting for being so coolly conveyed, stem from her response to contemporary life? Or can its origins be traced

to a more distant period? When images of grey war-planes begin to appear, falling through the sky on an equally grey television screen, I began thinking about the East–West nuclear tensions of the time. Once Celmins starts painting close-up images of a German plane and a 'flying fortress' in 1966, though, her preoccupation with the past becomes clear. Based on grainy photographs, like so much of her work, these spectral fighters and bombers seem to issue from childhood fears still haunting her twenty years after the Second World War ended. Blurred and faded, the planes threaten to crack and disintegrate even when airborne. And in paintings like *Explosion at Sea*, the promised obliteration finally occurs.

Any therapeutic release it may have given Celmins did not last long. Soon after painting a burning man as he struggles to escape from a vehicle consumed by flames, she abandoned painting altogether. The vehemence of this 1966 canvas, where greyness gives way to the rasping attack of orange and flaring yellow, seems to have precipitated a crisis. Like a witness recoiling from the visceral horror of an event, Celmins decided to distance herself all over again.

This time she turned to drawing, and used her formidable skill with the pencil to make illusionistic images of torn newspaper cuttings isolated on a plain acrylic ground. The subjects she chose – a mushroom cloud spreading over Bikini Atoll, or the aftermath of Hiroshima – proved that her imagination was still possessed by apocalyptic visions. But they did not last long. By the end of the 1960s, Celmins had decided to take one step further back. Nuclear extinction vanished, and in its place she began exploring the surface of the moon. Fired by newly released images from space explorations of the period, she used her ever more sophisticated handling of graphite to produce exquisite, beguiling simulations of the pitted and encrusted landscapes revealed by lunar probes.

Although the moon studies were only confined to 1969, they had a lasting significance. For Celmins never lost her fascination with vastness. Since then, all her work has centred on the task of reconciling the immensity of the sea, the desert or the sky with the overall flatness of her picture-surface. Some large drawings of oceanic expanses are among her most accomplished performances. The technique she employs for the rendering of the water's choppy infinitude seems almost photographic in its accuracy. But the sea drawings have an other-worldly strangeness as well. After a while they begin to resemble mountain ranges seen from far above. They are not, in the end, dissimilar to Celmins' equally meticulous and faultless drawings of a stone-strewn desert floor.

Her abiding theme in recent years appears to be the interconnectedness of everything. The pallor and hardness of the desert drawings may

portrait photographs, he wore a Nazi uniform and gave the *Heil Hitler* salute to mark the victorious occupation of prized locations across Europe. Today, however, this guilty identification with the murderous lust for war has been replaced by a healing alternative. Instead of ironically glorying in aggression, Kiefer represents himself as a semi-naked figure lying in a field of outsize sunflowers. With bare arms placed calmly at his sides and legs together, he adopts the pose known in yoga as the shavasana. In one picture, where acrylic has been combined with the more rasping attack of a woodcut, flowers spring straight from his groin. Elsewhere, the same prone man is showered with seeds by the sunflower hanging over him as if in sorrowful benediction. The uninhabited countryside and equally desolate halls in Kiefer's previous work have given way, here, to a more nurturing region where humanity can once again become visible.

There is nothing triumphal about this radically altered vision. Kiefer left Germany in the year of reunification, a momentous event that must have made him realise that his harrowing preoccupation with war was over. But the widespread elation that accompanied the dismantling of the Berlin Wall cannot be detected in his new paintings. Their optimism is qualified and hard-won. Compared with Van Gogh's sunflowers, emanating the heat of a Provençal summer, Kiefer's look ominously black. However protectively they bend their heavy heads above the inert figure, they remain redolent of death as well as life. And the man himself, while drawing undoubted consolation from feeling at one with the earth, could well be mistaken for a corpse.

So despite Kiefer's passionate belief in the prospect of renewal, he cannot escape from the past. Fresh life only seems possible if it springs from a sacrificial source. The man in a yogic trance appears to be offering himself, defencelessly, to the sunflowers. Nearby, in a book filled with pages where oil and emulsion have been applied to photo-collages sprinkled with ash, grass and wild plants grow over the remains of obliterated cities. The book's title, taken from the prophet Isaiah, refers in the Bible to the destroyed city of the Philistines. But Kiefer's involvement with the subject stems from his awareness that bombed German cities after the Second World War often ended up covered with natural growth.

This fascination finds its most gruesome expression in a large painting called *The Golden Bull*, where a ruined pyramid from Central America fills much of the surface with its crumbling bulk. It is a melancholy spectacle, proving that Kiefer has not yet ousted the elegiac strain which ran like a festering wound through much of his previous work. Just as the fields in his earlier paintings appeared to be caked and choked

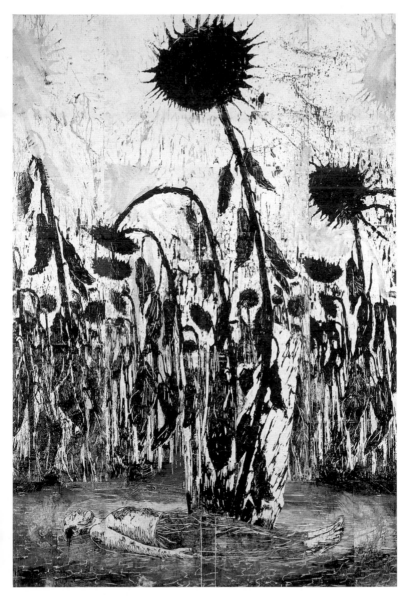

123. Anselm Kiefer, *Untitled*, 1996

with the dried blood of the war dead, so the ramshackle pyramid seems to have collapsed under the accumulated weight of those killed in rituals at its apex. After they were slaughtered and their still-beating hearts offered to the sun, the victims were tipped all the way down raised steps. In *The Golden Bull*, the steep path taken by their bodies is highlighted with gold leaf. Its glow pays tribute to their sacrifice and, at the same time, redeems their fall by implying that the lustrous steps lead up to heaven as well.

This tough-minded duality lies at the centre of Kiefer's vision. It means that his new work, for all its emergent sense of promise, never lapses into wishful thinking. The sunflower seeds can still be seen as a cloud of locusts. Without retaining a suggestion of their baleful presence, he finds a positive future impossible to imagine. In some pictures, the corpse-like meditator is replaced by a vertical man. According to the title of one tall, narrow image, this balding and wispily bearded figure is Robert Fludd, the sixteenth-century physician and mystic philosopher best-known for his influential *History of Both Worlds*. Unlike the trousered man lying amid the sunflowers, he is naked. And the connection with Fludd indicates that Kiefer is exploring ideas about the microcosm of the individual nourished by the macrocosm of the universe.

Even here, though, at the height of his striving for an interconnected wholeness, he stops well short of bliss. Fludd, who can also be seen as a self-portrait of the artist, looks haggard as he hangs upside-down among the drooping flowers. The figure's inversion gives the picture a feeling of instability, preventing us from viewing him as a Lazarus liberated from the grave. He appears to have risen from the earth with difficulty, and when the same male nude is placed the right way up among the continents of the world, he looks no less gaunt than before. This time, the image takes its name from a line by the seventeenth-century Spanish poet Francesco de Quevedo. In his lyrical sonnet, *Portrait of Lisi which was Brought in a Ring*, the writer finds himself entranced by the burnished miniature and concludes ecstatically that 'I hold all Indias in my hand'. None of the shining, seductive colours in Quevedo's enchanting ring can be found in Kiefer's dour picture. Restricted to umber, sepia and pale grey, it has the chilled sobriety of winter. But the lines dangling like loose reins from the man's hands eventually curl upwards, undulating into contours embracing all the land masses. Global harmony is achieved, even if the figure's haunted eyes still belong to someone who once stared straight into the heart of darkness.

TONY CRAGG
14 January 1997

Now in his late forties, and enjoying an extensive international reputation, Tony Cragg might have been tempted to slip into complacent, bovine repetition. He did, after all, play a prolific and inventive part in revitalizing British sculpture throughout the 1980s. Working first with plastic and other discarded materials, scavenged from beaches or the streets of Wuppertal where he settled twenty years ago, Cragg discovered how to turn even the most ordinary and unregarded objects into powerful, often provocative forms. Now, in his first exhibition for an English public gallery since 1989, he is displaying work of the 1990s at the Whitechapel. And although his preoccupations remain consistent with the young artist whose emergence excited so much interest, there is no sense here of standing still. Quite the opposite: Cragg seems incessantly on the move.

The hefty dimensions of several pieces in the Whitechapel's main, nave-like space might tempt us to suspect him of succumbing to middle-aged monumentalism. Sculptors are, after all, particularly prone to inflating their work with the advent of successful maturity and the resources to indulge their most extravagant ambitions. But the size of Cragg's largest recent works is deceptive. Rather than degenerating into grandiosity, they can be ranked among his most unpredictable, deft and mysterious inventions. As we walk around them, wondering at every swell, dip, swerve and thrust in these defiantly unclassifiable images, they keep us forever on our toes.

Take the brazen form careering across the floor of the street-level gallery. It bulges as wantonly as a series of newly inflated, interconnected balloons. But there is nothing overblown about its invasion of space. Sprouting an outsize nipple at one end and curling up like a plump tail at the other, this engorged apparition seems quite capable of undergoing a transformation. The title of the work has already been altered. Originally called *Buoy*, it is now listed as *Boy*. Although such a change may seem merely capricious, it underlines the density of meanings which Cragg's sculpture can harbour. Despite its apparent bulk, this work is made from lightweight styrofoam and keplar. It therefore appears eminently fit for floating in the most turbulent sea, but its swellings are at the same time organic and erotic enough to evoke the human body.

Viewed in this light, the shifting title makes sense. Cragg's devouring curiosity about the interplay between himself and his surroundings

ensures that he never sees anything in isolation. No sooner has a shape manifested itself in his mind than it starts to shed one identity and become something else. That is why his mercurial drawings, displayed upstairs as the fruit of a productive recent period at the Henry Moore Studio in Dean Clough, Halifax, are so enlivening. They show Cragg's ceaselessly metamorphic mind in action. At once flowing and wiry, his defining line seizes on the essence of a form with ease. But just as the contours of a vessel become clear on the paper, we realise that it is changing into a land-mass. Or rather, the two possibilities coexist in the same image. Cragg's restless intelligence as a draughtsman is reminiscent of Leonardo's. An instinctive fascination with science unites both men, and so does a refusal to regard scientific issues as separate from other concerns in their enquiring minds. Cragg refuses to compartmentalise the knowledge he acquires. In this respect, the time he spent working as a laboratory technician before going to art school must have been illuminating, and probably ignited his enduring involvement with beakers and condensers of all kinds.

At the outset of his career, Cragg's vessels were usually found objects made of plastic. Now he is more likely to make them himself, but his ability to persuade us of their surprising expressiveness is undiminished. Sandblasted glass bottles of different sizes and shapes bristle as they project from every side of *Spyrogyra*, where a whirling steel frame seems on the point of setting them in ecstatic motion. Their subdued colours, ranging from soft blue and green to rich brown and a dusty plum redolent of long storage in wine-cellars, are seductive. But the bottles also threaten to spiral out of control, and a neighbouring cornucopia has already descended to the floor.

For all his exuberance, Cragg is fully aware of the darker side of existence. In a Kafkaesque work entitled *Subcommittee*, he takes the form of the clerk's rubber stamp and, after enlarging, multiplying and casting in bronze, stacks the results around a central pole. With their swollen handles resembling featureless heads, they take on the forlorn appearance of mannequins. Once symbolic of bureaucracy, the stamps now look more like the human victims of an obsolete system. More recently, Cragg used the same starting-point for a multi-part work called *Administered Landscape*. The tight clustering of *Subcommittee* has given way here to a looser and more fragmented arrangement, spreading across the floor. Cast this time in pale wax, the drooping handle-heads now appear to be subsiding into the blocks beneath. They are reminiscent of ruins slowly disappearing in desert sands, and an elegiac strain does inform several of Cragg's recent works.

Even the grandest ensembles turn out to be vulnerable. Both versions of *Forminifera* present us with bleached plaster forms, some lying like broken pieces of classical architecture and others balanced on steel holders that resemble precarious trestles. These white presences may derive from containers, but they end up looking other-worldly and tantalizing. Moreover, their surfaces are punctured with holes, like porous rock worn away by the action of water. Similar references to the man-made and the natural can be found in many of Cragg's works. At his most bizarre, he smothers a green piano and several nearby chairs in a glinting, menacing blizzard of small metal hooks. But the same implements also spring out of timber pieces lodged inexplicably among the furniture, suggesting that nothing can escape the hooks' rapacious advance.

Cragg, however, is not a pessimist. Sardonic humour erupts in his most macabre work, most notably when he exposes the plaster teeth of a primordial skeleton in a sculpture called *Complete Omnivore*. Redoubtable in size, they are on one level grotesque manifestations of grinding power. They are also wrily funny, and acknowledge that humanity's survival has depended on its capacity to feed off matter of all kinds. Cragg could himself be described as omnivorous in his attitude to materials. If plastic cannot be found in this exhibition, he is still prepared to go far beyond the sculptor's traditional preference for wood, stone and bronze. Indeed, he has always been able to persuade us that late twentieth-century materials are just as beguiling as their hallowed predecessors.

From a distance, *Nautilus* may seem to be hewn from white marble. The fact that it is made of styrofoam and fibreglass may alter our perception of the work, but does not impair its ability to delight. The five bulbous yet elegant forms congregating so deftly on a circular ledge are complemented, like a reflection, by five more below. The title suggests that Cragg may have taken the wriggling bodies of cuttlefish or octopi as his springboard. By the time he finished with them, though, their resemblance to molluscs was no longer dominant. Over the last few years, as his sculpture grew more audacious in formal terms, Cragg has resisted any attempt to identify a particular work as a single, nameable object. If molluscs did indeed nourish him at the start of *Nautilus*, its forms are now equally suggestive of stones, jugs, pillars and a host of different organisms.

Everything, in Cragg's encompassing vision of the world, is interrelated. He appears as fascinated by molecules as by mountains, and in an outstanding two-piece work called *Secretions* the minuscule and the majestic are both kept at the forefront of our attention. In the lower of the two parts, vessels seem once again the starting-point for these enigmatic

124. Tony Cragg, *Secretions*, 1996

forms. But they are soon overtaken by a rush of other possibilities, and the higher, more baroque part rears into the air like some fantastic, twisted outcrop marooned in a wild landscape. Inspection discloses that the whole of *Secretions'* surface is studded with hundreds of dice. They are a marvellously poetic way of showing how even the most awesome structures are built up, and how chance plays its unguessable part in determining the shape of the world. Cragg's work is replete with such insights, and this triumphant exhibition proves that he is an artist of formidable, invigorating stature.

AVTARJEET DHANJAL

September 1997

Adjoining Pitshanger Manor, the sprightly Regency villa designed by Sir John Soane as his 'country' home in Ealing, a Victorian wing now houses an excellent art gallery. Lit from above by sun filtered through spectacular stained-glass domes, and open at the back to the lawns of Walpole Park, it provides an ideal setting for the sculpture and drawings of Avtarjeet Dhanjal.

Although he has lived in Britain ever since entering St Martin's School of Art as a postgraduate in 1974, Dhanjal is not as widely known here as he deserves to be. A highly selective survey of his career, this well-judged exhibition should serve as a corrective. It cannot, inevitably, do justice to his work as a maker of large-scale public sculpture. But it does show how subtly he has managed to straddle two cultures, nourished by the formative experience of growing up in the Punjab as well as the stimulus he received from Western sources later on. The division between them was not as clear-cut as Dhanjal's life might suggest. In 1965, well before leaving India, he was exposed to the impact of Le Corbusier's architecture while studying Fine Art in the recently erected city of Chandigarh. He also spent several years in Africa, exploring widely before settling down to a spell of teaching in Nairobi. So a complex brew of influences lies behind the present show, and they are reflected in the striking diversity of forms and materials Dhanjal has explored since 1970.

The earliest works on view are all made of aluminium, and might superficially identify him as a sculptor wedded to industrial, urban images. To the extent that they benefited from his artist's residency at Alcan Ltd., these purged exercises in minimal geometry do indeed reflect a fascination with the machine age. But Dhanjal makes the aluminium convey his own poetic vision as well. Each sculpture is simply displayed on a white wooden plinth, and the thin spools of metal curve outwards from cylindrical centres. When I came across them, someone had just been touching these tensely sprung coils. They were all vibrating gently in the air, like slender branches responding to a sudden gust of wind. However sensitively Dhanjal had responded to the innate character of aluminium, he ended up expressing movement redolent of the natural world.

This duality lies at the heart of everything he produces. Dhanjal now lives at Ironbridge in the Midlands, the crucible of the Industrial Revolution. But the town is surrounded by the rural grandeur of the Severn Gorge, and he thrives on the fruitful tension between these two

125. Avtarjeet Dhanjal, *Slate and Flames*, 1984–7

contrasting sources of inspiration. In sculptural terms, they are brought together most overtly in a satisfying group of aluminum and stone works, all executed during the early 1980s. Sometimes the lump of stone is allowed to nestle comfortably within metal rectangles, even though the disparity between the two materials is so marked. More often, though, the aluminium elements dig into their stone neighbours, or clamp down oppressively on them.

In these works, the stone seems imprisoned and almost stifled. Even when Dhanjal uses the base of a real tree, he lets six aluminium segments sink themselves into its bark like predatory teeth. So although the contrasting materials are combined with great deftness in this remarkable group of sculptures, the possibility of arriving at a harmonious coexistence between industrial and natural elements is never taken for granted.

If his involvement with aluminium brought Dhanjal close to other British exponents of abstract metal sculpture, he has always retained a singular vision. A strain of mysticism runs through his work as well, nowhere more clearly than in the slate pieces he has been producing for more than a decade. These boulder-like forms rest directly on the ground, suggesting a kinship with outcrops of rock in a rugged landscape. But minuscule flights of steps are often cut into their sides, suggesting that diminutive figures might clamber up them to participate in ceremonial events.

The rows of lit candles embedded in the upper surfaces of the sculptures give them a votive character. They remind us that Indian art has always been profoundly religious, and the flames flickering above the candles' dark slate enclosures intensify the works' spirituality. One of the finest pieces contains no candles, but the lines incised like a sunburst on the top make it resemble the site of a communal ritual. As for the large slate sculpture positioned at the beginning of the show, it revives Dhanjal's long-term preoccupation with geometry and nature. For the row of candles lead off in a straight line from a circle of water, whose unbroken perimeter contrasts with the rough-hewn edges of the slate block.

The roundness of the pool also chimes with the images in many of the nearby charcoal and ink drawings. Here, with great economy and an instinctive sense of drama, Dhanjal explores motion reminiscent of whirling gyrations, often receding into cave-like apertures. In some drawings, the spiralling energy resolves itself into more static forms resembling suns in a state of eclipse. Natural forces seem increasingly to dominate the artist's imagination, just as they do in the darkened room where his light-box photographs celebrate woodland scenes in autumnal close-up.

The seasonal mood is carried over to the monumental cube of perspex elsewhere in this space. Filled with dried leaves, some of them painted in surprisingly brilliant colours, they ought to sound a mournful note. But Dhanjal's meditative imagination is not tragic. However elegiac this room may be, it is enlivened by a fluorescent light trained on to the leaves fallen from a gash in the cube. Although they seem ready to be consumed in a bonfire, Dhanjal ensures that their festive hues might equally well predict a phoenix-like renewal.

THOMAS SCHÜTTE
3 February 1998

In 1981, at the outset of his career, Thomas Schütte painted a picture of his own grave. The blood-red tombstone bears only the artist's name and the stark dates of his birth and death. They announced he would die in March 1996, at the age of forty-one. Two small, spectre-white figures gaze up at the forbidding inscription, emphasizing by their size just how colossal the house-shaped monument really is.

Schütte has lived long enough to confound his youthful prediction. Now one of the most outstanding middle-generation German artists, he is staging his first substantial British exhibition at the Whitechapel Art Gallery. But the mordant humour that led him to depict his own grave has not gone away. It informs everything he produces, even if the work on show here is so bewilderingly various that several different artists might be on display. Schütte is hydra-headed, and takes subversive pleasure in contradicting any neat, all-encompassing attempt to define his identity.

The first persona he presents at the Whitechapel is Schütte the caricaturist. Marooned on tall, pillar-like plinths, pairs of grotesque figurines writhe, scowl and leer at each other. Their columnar supports look classical, and Schütte started making them after studying antique sculpture in Rome. The figurines themselves, though, have nothing to do with Praxiteles. More akin to Daumier's feverishly distorted models of politicians, they are trussed tightly together. The glass containing them accentuates their sense of imprisonment. Impaled on sticks that serve as makeshift armatures, the heads have a severed air. But they are unable to free themselves from the clothes binding them so unwillingly to their companions.

The sticks protrude lower down, like the artificial limbs jutting out of wounded ex-soldiers' bodies in macabre post-1918 paintings by Otto Dix and George Grosz. I am sure Schütte has no intention of making a direct reference to Germany's plight after the Great War. All the same, his conjoined figurines might reflect a sardonic awareness of his country's state in the 1990s, ostensibly unified and yet unable to achieve a satisfactory fusion of the nation's long-sundered halves. Schütte calls these vigorously modelled fimo sculptures *United Enemies*. But apart from acknowledging that they might have been influenced by political corruption in Rome, he is loathe to speculate about their larger meaning. Absurd instead of tragic, they look more like demented puppets than disgruntled inhabitants of modern Germany.

Schütte's most celebrated earlier work, a group sculpture called *The Strangers*, had a similarly tangential relationship with political reality. He placed these glazed ceramic figures and their belongings on the roof of a department store in Kassel. Commissioned for the 1992 Documenta survey, they stood there as though newly arrived or waiting to depart. Their eyes were cast down, like people who felt ashamed. And the German press saw them as a timely comment on 'the foreigners' – workers from the East or Africa whose hostels were being torched by racist protestors. Schütte's intentions had been less specific, but he does not now

object to such a direct link with the refugee problem. During an interview with James Lingwood in an illuminating new book on the artist, he reveals that the luggage included in his Kassel sculpture reflects 'the feeling that people who come from elsewhere are taking things away; that they are thieves'. The presence of luggage, much of it looking more like vases than suitcases, also helped Schütte develop a new approach to figurative sculpture. The strangers themselves had vases instead of legs; their upper bodies were severely simplified; and their faces were modelled with realistic features beneath expressionistic hair. Several contrasting approaches were brought together, without attempting to disguise their differences, by an artist who thrives on defying our expectations.

Just as Schütte challenges the whole notion of a single style, so he is fascinated by the fragment. Upstairs at the Whitechapel, Alain Colas, the solitary yachtsman who disappeared in the Atlantic, becomes the subject of a clay head. Far larger than the *United Enemies*, he is nevertheless dismembered. Only one shoulder remains, and the rest of his body has been sliced off at the chest. The surviving bust is battered, the head swathed in a white, bandage-like material. With stunned and protruding eyes, Colas sits on rough wooden pallets as if adrift in the ocean. His boat is nowhere to be seen, and in a nearby watercolour Colas's even more pitiful head is perched on a pillar submerged in dark water. He cannot stay above the surface for long, and Schütte uses the form of a public monument merely to drive home the mariner's predicament.

But the desire to work on a grand scale still fires Schütte's imagination as much as it did when he painted his tombstone in 1981. Walk through the Whitechapel's downstairs space and you will suddenly encounter, behind the central screen, a group of aluminium titans. Highly polished and riddled with reflections, their bodies bulge chaotically like Michelin men gone awry. They resemble even more a lumbering gang of automata. Four are grouped in pairs, reminiscent of the *United Enemies*. But they are not tied together, and no glass cases limit their movement. They stand on the floor, superhuman enough in size to suggest that they might threaten the world.

Schütte does not, however, allow them to become all-conquering. An air of pointlessness hangs over their movements. One giant leans forward, as if reeling from a blow. Another flings arms in the air, reacting with dismay to some unguessable catastrophe. If these gleaming robots are indeed invaders, capable of establishing themselves as a master race on earth, they seem remarkably uncertain about their purpose. Perhaps they have just happened on our planet by accident, and now blunder around in stupefaction wondering how best to proceed. Or maybe they are unable

126. Thomas Schütte's *Alain Colas* at Whitechapel Gallery, London, 1998

to co-operate with each other and, like the irascible *United Enemies*, are condemned to internecine quarrels rather than achieving more worthwhile ends. Schütte calls them *Big Spirits*, an enigmatic title indicating that they might be apparitions. Their solidity is certainly countered by the polished surfaces, for the myriad reflections prevent us from seeing them properly. They are more like fantasies than substantial statues. And their shimmering metal suggests that they might suddenly vanish, like special-effect phantasms in a digitally manipulated Hollywood sci-fi extravaganza.

Sure enough, figures disappear altogether in the main upstairs gallery. Here, Schütte assumes the identity of an architect *manqué*, forever constructing elaborate models of ambitious buildings. They seem rational at first, laid out in a long avenue of spartan chipboard tables. The more we explore them, however, the odder they become. Three structures entitled *For the Birds*, painted yellow and orange, are punctured by rows of unvarying rounded apertures. They bear an inescapable resemblance to those silent, expectant façades bordering the piazzas in de Chirico's paintings. They seem melancholy, and the suspicion that they might have been abandoned is strengthened by the *Basement* models nearby. Stairs plummet downwards into a Piranesian labyrinth, their complexity soon lost in the gloom. Dust hangs in cobwebs so intricate and plentiful as to rule out the likelihood of any human presence.

If Schütte's other models are sprucer than the mouldering cellars, they fail to offer reassurance. A toy-sized Mercedes Benz eases its silver snout from a garage. But no chauffeur sits at the wheel, and the adjoining house appears equally deserted. Some of the models boast a civic grandeur, recalling the Utopian architectural optimism of the early twentieth century. Peer inside the windows, though, and you will find that the towers and mansions are devoid of stairs and floors. Hollowness prevails, and when an interior does contain a structure, it turns out to be a mystifying bridge spanning the void all around.

Even the cluster of buildings called *Collector's Complex* courts futility. Their grid-like façades are open, suggesting that the owner might welcome visitors eager to sample the art housed inside. Nothing is visible, however, and the whole complex is overshadowed by the rudimentary bulk of a transport crate in one corner. Most of the works are probably stored inside, the victims of a world where the size and quantity of art production far outstrips the space available to display them. So they remain snuffed out in the crate, its riveted wooden sides coldly reminiscent of an up-ended coffin. Although Schütte has defied the early death forecast on his tombstone, the imagery of the graveyard haunts him still.

CHRISTIAN BOLTANSKI AND JOHAN GRIMONPREZ
17 February 1998

Walking through the first room of *Nightfall*, Christian Boltanski's powerful show at the Anthony d'Offay Gallery, is like visiting a stricken hospital ward for children. Nobody inhabits the small beds lining the white walls. Pillows, sheets and blankets are neatly arranged there, suggesting that they were recently occupied. Now, however, thick plastic sheets cover most of them, and one is sealed off beneath frosted glass. They all look contaminated. Strange handles project from some of their sides, giving them a portable air. Perhaps they are ready for removal, by medical authorities anxious to eradicate anything infected by the epidemic.

Boltanski, true to form, offers no answers to the host of questions aroused by his work. Over the last twenty years this single-minded French artist has established a formidable reputation as a restrained yet melancholy memorialist. We often have no idea who the faces are, staring out from the ranks of photographs in his twilit installations. But there is no mistaking the mournfulness, and the anonymity of these people makes its own point. For Boltanski sees the present century as an era of overwhelming human loss, and millions of those who died were buried in unmarked graves. Hence the enigma of the beds in this, his first one-person London exhibition for more than five years. We are reduced to moving up and down the room searching for clues, like relatives vainly trying to locate a patient they have lost. Boltanski frustrates our efforts even further by shrouding most of the installation in gloom. Each bed is illuminated only by a single upright neon tube. The soft, fuzzy light it gives off adds to the aura of mystery. In one unusually high bed, the neon tube is muffled still more, lodged under the plastic sheet. It hangs directly over the pillow, emphasizing the absence of the head we might have hoped to find sleeping there.

No attempt has been made to hide the tangle of wires attached to the lights. Coiling across the floor in profusion, they make one of the beds resemble an incubator waiting to hatch. Swathed on all sides by plastic coverings, it is the most secretive and ominous structure on view. If new life is being generated within this tantalizing container, the outcome seems likely to be genetically manipulated. On the whole, though, suspicions of sinister scientific experimentation give way to thoughts of mortality. Two of the beds have high sides, and the linen is laid out deep inside them. They both look like sarcophagi, fit only for carrying corpses to the cemetery.

Although the second room contains a separate installation, it could easily be an extension of the first. Five free-standing hospital screens occupy the darkened space, forcing us to negotiate a tortuous path around them. Dimly illuminated from within, each one shows on both front and back a blurred photograph of a person unknown. Enlarged from newspapers or magazines, the images are grainy and hard to decipher. Several are of young women's faces, smiling from the shadows. But one closes her lids and another, more disquietingly, has a black band laid across both eyes. They are all reminiscent of evidence used in police investigations. Boltanski, however, stops short of telling us whether they are victims or perpetrators. The forlorn baby gazing with startled eyes from one photograph could hardly be a criminal. And the laughing woman who kneels so blithely at the entrance of a tent seems an unlikely candidate for villainy. Elsewhere, though, ambiguity reigns. The faces rebuff facile speculation and call to mind Duncan's bewildered complaint, in *Macbeth*, that 'there's no art to find the mind's construction in the face'.

Darkness intensifies in the final room, where the brick walls are hung with over 200 framed pictures of different sizes. This time, no faces tantalise us. The images are uniformly black, and they chime in colour with

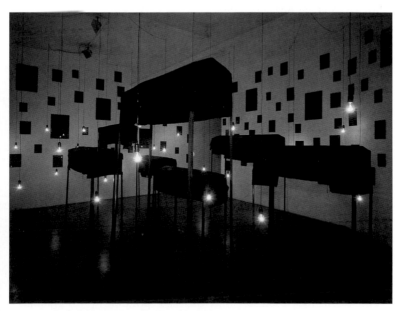

127. Christian Boltanski, *The Tombs*, 1996

the material swathing the seven coffins that fill most of the space with their funereal bulk. All supported on thin metallic legs, the coffins vary considerably in length. But they are strangely narrow, as if the bodies inside were attenuated to the point of outright emaciation. Naked bulbs dangle from the ceiling on long wires, providing the only source of illumination. The atmosphere is as hushed and rapt as in a candlelit painting by Boltanski's fellow-countryman Georges de La Tour.

Moving among the coffins, I accidentally nudged one of the bulbs. It swung like a censer, casting macabre shadows and heightening the ecclesiastical atmosphere throughout the chamber. The spirituality of the installation helps to explain why it appears, in the end, serene rather than morbid. The anonymity of the empty pictures induces pathos, and so does the grim possibility that they stand for a mass of unidentifiable body fragments heaped inside the coffins. But Boltanski ensures that their resting-place is a secular chapel fit for meditation. He invites viewers to project their own private bereavements onto the blankness confronting them at every turn.

No such licence is granted in the other d'Offay space further along Dering Street, where Johan Grimonprez's film *Dial H-I-S-T-O-R-Y* is being screened several times a day. I first encountered this extraordinary work in a small, suffocating room at Documenta X last year. In a generally disappointing survey, where too many exhibits seemed dry and didactic, Grimonprez's film stood out as a headlong assault on the senses. Now, in its British première, *Dial H-I-S-T-O-R-Y* still has a visceral impact. It starts in a deceptively lyrical way with a plane coming in to land from a cloudy sky. But Grimonprez, a young Belgian artist adept at mixing news footage, silent movies, cartoons, amateur video sequences and much else besides, cuts swiftly and brutally to horrifying shots of a jumbo jet erupting in flames on the runway. It is an apocalyptic sight, and the rest of the film spares us nothing in its relentless exploration of hijacking in the air.

The film is interwoven with readings from Don DeLillo's *White Noise* and *Mao II*. They lend it a wry, ruminative quality, set apart from the often harrowing scenes recorded by news cameramen. Some of the worst moments are fast, barely in focus. The lifeless body of an executed pilot is dropped like refuse on to the airport tarmac. Three captive jets, marooned in a distant heat-haze, are blown up with sickening efficiency, one after another. A hamburger stand, blitzed at Rome airport along with its customers, lies in a glistening mess of blood and debris.

Grimonprez never lets us forget the voracious presence of photographers, reporters and the rest of the international media scrum. They jostle

dazed hostages emerging at last from a protracted ordeal, and keep cameras running on a howling mother as she hugs her desperately wounded son on a concourse floor. The creepiness of airport interiors – their sinister tunnels and desolate escalators – is chillingly conveyed. So are the games played by politicians, especially the leaders of revolutionary causes espoused by so many hijackers themselves. Lenin lays on a shameless display of cat-stroking, Castro and Kruschev fraternise on a snowbound shooting trip in the forest, and a colossal photograph of the avuncular Stalin floats with balloons above a Soviet parade.

After a while, everything becomes weirdly theatrical. Officers from the Japanese Red Army seize a plane armed only with Samurai swords, providing millions of viewers with their first televised hijack. 'Nothing happens until it's consumed', comments DeLillo, and everyone here seems embroiled in a murderous form of showbusiness. One bespectacled schoolboy released by guerillas admits, grinning, that they were 'real nice – I loved it, I had a good time'. And a psychologist studying the terrorist mentality analyses the erotic pleasure a young hijacker derives from prodding an air-hostess with his gun and shouting: 'Honey, we're going all the way.'

In the end, Grimonprez's film induces a feeling of nausea – partly caused by the incessant bloodshed, partly by the ruthless media clamour, and partly by the feeling that, as a voice on the soundtrack observes, 'there's too much of everything – only the terrorist stands outside'. Maybe Dial H-I-S-T-O-R-Y is itself guilty of overkill. But Grimonprez counters rawness with mordant humour, and provides an ideal contrast to the stillness of Boltanski's haunting elegies.

ANISH KAPOOR
5 May 1998

Anyone familiar with Anish Kapoor's work might have guessed that his Hayward show would be an uncluttered, limpid affair. After all, he makes objects only in order to undermine their solidity, using sculptural bulk as a means of exploring the void beyond. But the first room of this outstanding exhibition still surprises with its spareness, offering only three works and leaving most of this large, long gallery quite empty. Kapoor ensures, though, that the room does not feel undernourished. He knows

precisely how much space should surround each of his pieces. They invite exploration of a highly contemplative kind. An impatient scrutiny will disclose little. We need to be unhurried, and the generous expanse of whiteness between the two wall-works encourages us to slow down, linger and concentrate.

From a distance, the tall oblong called *My Body, Your Body* looks like a monochrome abstract painting. Kapoor has always been determined to infuse his sculpture with colour, and the sensuousness of deep blue pigment gives this work its initial impact. The flatness, however, is only an illusion. Moving closer, we discover that the apparent surface is in fact concave. We find ourselves impelled to peer into the darkness behind. It is an unsettling experience. For one thing, gallery guards usually prevent us from going too near the exhibits, let alone push our faces inside them. But here, we cannot hope to understand Kapoor's work without exploring this cave-like opening. Although nothing is visible in the gloom at first, our eyes gradually make out a shadowy, central aperture far within. Then, by moving our heads to the left or right, we find that the rounded sides of a tunnel leading to this orifice suddenly swell out in front of us.

The more willing we are to shed inhibitions, the more rewarding Kapoor's work becomes. But we must be prepared to lose ourselves, and discover that our sense of self is threatened or even obliterated. The highly polished, stainless steel tondo on the other wall pulls us towards its concentric circles like an irresistible vortex. We become caught up in a snare of shimmering mirror-images. As I walked towards it, my reflection turned upside-down. But any suspicion of fairground amusement gave way to disquiet once I peered inside. Like Alice stepping through the looking glass, I felt uncertain about how far I could roam around this disorientating chamber. My eyes finally focused on the smallest and most distant circle. Instead of reflecting my face, it offered a gleaming, enigmatic blankness.

Not that Kapoor seeks solely to terrify us with intimations of extinction. Fascinated by the world's awesome immensity and the fear it can induce, he remains at the same time a gentle artist. His work invites us to meditate rather than recoil, and in this sense he has inherited from his Indian childhood a strong sense of art's spiritual power. But Kapoor's decision to settle in London more than two decades ago has enabled him to develop a unique fusion of East and West. He is not afraid to identify himself as an inheritor of the eighteenth-century involvement with the Sublime. Just as British painters and theorists of the period were prepared to explore nature's most disquieting aspects, so Kapoor challenges us to negotiate the whirling danger of a circular floor sculpture called *Suck*.

This time, it rests on the floor. Far from rising up to assert its sculptural

presence, *Suck* is low-lying and sinks into the room's boundaries as discreetly as the two wall-works. I circled its circumference with mounting fascination. For the whole metal surface starts to surge and flow as you walk, setting the reflected blackness of the ceiling above into a powerful, eddying motion. I saw myself mirrored within its spirals, a miniature figure who seemed perilously near the edge of the central cavity. This hole plunges through the floor to an unmeasurable depth. We stare gingerly downwards, trying to guess how far the heart of the whirlpool descends and wondering, too, how easily we might topple in to it.

Kapoor appears to be increasingly conscious of the immensity around us, its capacity to overwhelm with visions of cosmic limitlessness. The first sculpture in the next room resembles a space capsule, inexplicably beached on the Hayward's floor. Shaped like a lozenge, its white fibreglass shell is flawlessly smooth, and almost seems to emit a glow. The oblong embedded within promises to provide a clue to its identity. But once I looked inside, my eyes were engulfed in a pale grey haze. The veil of colour reminded me of looking at a Mark Rothko painting close-to, or staring into a mist of light by James Turrell. Kapoor, however, clearly aims at setting up an extreme contrast between the fuzziness within and the clarity without. The exterior of this remarkable work is as purged and clinical as an egg-like marble by Barbara Hepworth, carved in the classic inter-war years of English modernism at its most purged.

In other words, Kapoor offers the viewer a choice. We can either scrutinise his work from afar, appraising its clean geometric precision and wholeness. Or we move in, immersing ourselves in an ever more mysterious sense of infinity. Seen at a distance, *Yellow* asserts itself on the wall like a solar disc. Pulsating warmly rather than assailing the retina with sun-dazzle, it invites more intimate inspection. When we look inside, though, form dissolves and yellowness suffuses our vision so completely that we might be gazing at a boundless desert.

Once the interior of a Kapoor has been explored, our attitude to the exterior changes as well. For we know, now, that its wholeness and solidity are deceptive. On a sculpture court outside the gallery, a steel globe called *Turning the World Upside Down* flares and flashes in the sunlight. I walked round it, aware that the object's substance was already invaded by reflections of the South Bank's stained concrete architecture. But its rounded bulk was still evident, and this material presence only melted when I looked inside. Trains clattered past on Charing Cross Bridge, and a rainwater puddle at the base of the sculpture's hollow threatened to distract me. But I was soon lost in the glinting, endlessly perplexing tunnel Kapoor has created within this planetary form.

By no means all his exhibits envelop us in such an all-embracing way. Most of the white structures in the first upstairs room are less inviting, and their rectilinear minimalism lacks the sensual charge of Kapoor's more organic work. But one rectangular colossus in fibreglass and wood seems, while you stare at its bleached vastness, to recede as far as the imagination can stretch. To look into it for a long time is akin to being lost in an expanse of deep, freshly fallen snow.

Sometimes, he confounds all expectations by allowing a form to project from the wall. *When I am Pregnant* bulges out towards us in a corridor, swollen like a belly approaching full term. More typical, though, is another corridor work called *Double Mirror*, where the viewer is confronted on both sides by stainless-steel dishes. They throw your reflection around with abandon, inverting, shrinking, spinning and finally, as you push your head further forward, marooning you within a glacial vacancy. Such moments of extreme isolation prove that there is a strain of terror in Kapoor's vision. More often, though, he quells anxiety with an overriding sense of wonder. In *Dragon*, the only work cordoned off from the onlooker, eight limestone fragments are ranged across the floor, saturated in a blue as luminous as Yves Klein's favourite pigment. Craggy and fantastic in shape, they resemble inexplicably frozen clouds, or boulders scattered over a lunar landscape.

The most transporting moment in this exemplary show is reserved for the final gallery downstairs. In the anteroom, Kapoor has positioned a hulking slab of limestone called *Ghost*, its rough-cut sides contrasted with the gleaming smoothness of the nocturnal space inside the aperture. Through the doorway beyond, a line of deep red can already be glimpsed. It seems to be painted high on the far wall. As we move into the room, however, the same rich colour suddenly burgeons and floods our vision with its engulfing, velvet warmth. Seen from the sides, its bell-like form becomes clear. Suspended between floor and ceiling, and surmounted by a dark fibreglass helmet, it resembles a hovering spacecraft from another universe. But when we walk to the centre of the room and gaze upwards, our awareness of the shape evaporates. We are left instead with an infinity of amorphous crimson, extending to all four walls and immersing us in rapt contemplation of a trance-like, unfathomable strangeness. Poised half-way between absence and presence, *At the Edge of the World II* immediately takes its mesmeric place among the defining sculptures of our time.

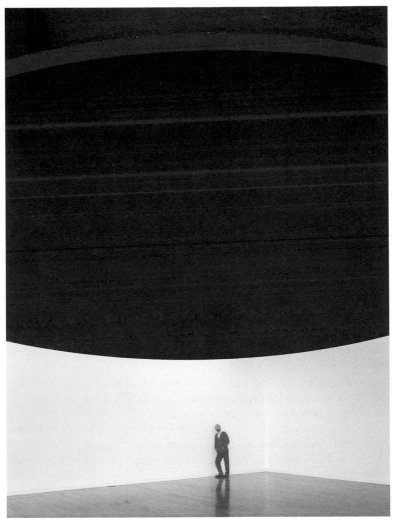

128. Anish Kapoor, *At the Edge of the World II*, 1998

PAUL HUXLEY
19 May 1998

Paul Huxley retires this summer from the Royal College of Art, where he has been a notably open-minded Professor of Painting for the last twelve years. But he gives no sign, in his effervescent show at Jason & Rhodes, of slowing down. On the contrary: the freshness and audacity of his large new canvases could easily be the work of a far younger artist.

One of our most distinguished abstract painters, Huxley has been pre-occupied for the last two decades with setting up oppositions inside his pictures. He divides each of them into halves, and revels in the startling contrast between ordered geometry and whirling exhilaration. The sections on the right are restricted to cool, clear-cut oblongs, squares and other rectilinear forms. They could hardly be more at variance with their neighbours on the left, where Huxley indulges in a love of spiralling exuberance.

The differences are accentuated by his handling of acrylic paint. All the forms on the right are flat and impersonal, revealing scant trace of the artist's own mark-making. But their impetuous rivals on the left are enlivened by excited brushwork, coursing around the black lines that give them their fundamental rhythm. Huxley allows himself to be wilder, here, than he has ever been. The restless, interlocking undulations are made even more turbulent by the splashed-down pigment. It surges so spontaneously that the vertical divisions between the two halves are constantly violated. The expansive forms on the left often spill over the central boundary line, invading the calmness of the other section.

The forms on the right are not discomfited, however. They retain their poise, and Huxley often delights in balancing one on top of the other like acrobatic performers leaping on each other's shoulders at a circus. While clearly the product of hair's-breadth calculation, these geometric forms have the joyfulness of Matisse's painted paper cut-outs. They are playful to the point of outright teasing. Huxley sets up perceptual games with them, challenging us to speculate about how far they might be receding or, conversely, projecting into our space. Windows are some-times hinted at, and so are columns or doorways. But the flatness of the paint returns our eyes to the surface of the canvas. We are aware, at all times, of Huxley's insistence on rigorous control.

In the left half of each picture, though, he gives vent to another, far more headlong side of his complex temperament. These vortex-like convolu-tions, reminiscent of labyrinthine motorways, flashing advertisements and

129. Paul Huxley, *Anima Animus IV,* 1998

other sensations of urban life at its most frenetic, disclose a new appetite
for clangour. The high-keyed colours are often deliberately heated. They
give a sensual, festive air to the paintings. Their optimism reminds me of
Delaunay and Léger celebrating the dynamism and fast-changing specta-
cle of the modern city.

In the end, the central fascination of these assured canvases lies in the
interplay between their vibrantly opposed parts. Despite the over-
whelming energy of the forms on the left, they do not dominate the pic-
tures. The distinctive halves of each painting remain surprisingly well-
matched, making us realise that the tension between them lies at the
heart of their significance. Just as Cornelia Parker often invites us to
complete the meaning of her work by making connections for ourselves,

so Huxley encourages us to make sense of his confrontations in our own minds.

The Jason & Rhodes show reveals a seasoned abstractionist at the peak of his powers, refusing to settle for predictable solutions. Huxley is a painter on the move, far more eager to explore and challenge than rest on his reputation. No hint of complacency can be detected in these invigorating canvases. Huxley wants to ambush himself as well as the viewer, and I left his exhibition eagerly looking forward to the work he produces after his professorial duties have finally been cast off. On the evidence of this brave show, Huxley has the energy, flair and ambition to surpass all expectations in the years ahead.

LUCIAN FREUD
9 June 1998

Unlike Francis Bacon, who was granted two large Tate retrospectives during his lifetime, Lucian Freud has never been given an exhibition of any kind at Millbank. Now, in his mid-70s, partial amends are at last being made for this astonishing omission. A show of his new paintings and graphic work salutes the sustained, adventurous gusto of Freud's late period, and makes me eager to see the Tate acknowledge his stature with a full-length survey of his entire career. Hanging in the room normally occupied by Mark Rothko's mural-size canvases, his exhibits could not be more at variance with the work they have supplanted. Where Rothko was committed to cloudy abstraction, Freud is set on hard, tenacious observation of the figures who are prepared to withstand his prolonged scrutiny. Many of his pictures are smaller than the grand, engulfing images favoured by Rothko. And the moods explored in Freud's show are more diverse than the brooding melancholy that finally drove Rothko, in a fit of unbearable depression, to take his own life.

The range of emotions in this concise, engrossing exhibition should confound those who habitually accuse Freud of unrelenting coldness. All the evidence indicates that the artist, seen here at the peak of his formidable abilities, is able to move at will from tenderness to mordant humour. The first painting we encounter even shows a young man grinning. Sporting a cowboy hat tilted back on his head, he could hardly look more spontaneous and relaxed. Only later do we realise that his

exposed teeth hint at a more predatory nature. But the infectiousness of his smile still succeeds in discouraging further speculation about the sitter's darker side.

After vivacity comes the stillness of incipient death. Leigh Bowery, nearing the end of his struggle with AIDS-related illness, is portrayed in two unusually small canvases. Their intimate size chimes with the compassion Freud bestows on his ailing friend. In one, Bowery sprawls on the sofa in a despondent position utterly removed from the proud resilience he displays in Freud's earlier portraits. In the other, a close-up of Bowery's head alone, the exhaustion is all too palpable. Propped against a pillow and no longer able to revel in his own outrageous fleshiness, he seems on the verge of dissolution. It was the last portrait Freud ever painted of his once-extrovert sitter, and distils all the sadness of a final farewell.

The blurred, elegiac lassitude of the Bowery paintings remains untypical, though. Elsewhere, Freud's command of mark-making is especially impressive when he tackles human flesh. His granular pigment seizes the essence of skin, sinew and bone. Whenever his sitters expose their raw bodies to his stare, they become arrestingly alive. In one tiny painting, a baby suckling at the mother's nipple seems about to melt into her breast. Freud is adept at summoning up the pink vulnerability of young flesh, and he proves even more consummate when painting a large, magisterial portrait of a woman in a dark grey dress. Resting a book on her lap, she places her bare legs on a button armchair. Knees, calves and toes are handled with conspicuous aplomb. They end up disclosing more about the sitter than her meditative face, and their rude vigour counters the decay evident in the stained wall beyond.

Sometimes, the stark rooms inhabited by Freud's figures take on a startling force of their own. In one incisive portrait of his daughter Bella, the bare floorboards are tilted at such a steep angle that they become vertiginous. Rushing past her to the wall behind, they threaten to send Bella and her deep, protective chair plummeting downwards in a free fall. Freud has always been fascinated by instability. The opposite of a bland painter, he often paints people off-balance or slightly askew. Look at the large picture of a naked woman on the far wall, sprawling with legs splayed across the sofa in a bizarre, crab-like posture. Her long hair rushes in Medusa-like tendrils towards the floor, stopping just before they reach it. She seems in danger of falling off, and only her left hand resting on the boards ensures that she stays secure.

Although female sitters outnumber men in this exhibition, the grandest picture on view proves that Freud is equally stimulated by the

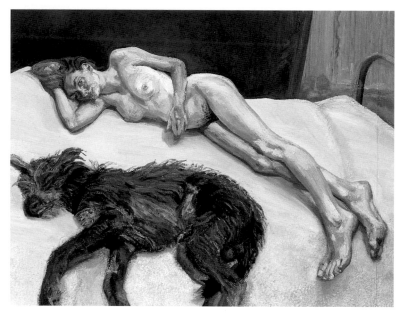

130. Lucian Freud, *Annabel and Rattler*, 1998

challenge of the male nude. Lying back on a bed, the figure shows no qualms about exposing his genitals to the painter. But there is nothing exhibitionist about his pose. He seems entirely unselfconscious, and absorbed in a reverie that makes him unaware of Freud's presence. At the same time, though, he cradles the artist's dog Pluto with his protective left arm. The animal feels so secure that he relaxes in a limp sleep. But the man seems tense, and the pair of unknown male knees emerging so inexplicably underneath the bed adds to the sense of expectancy. Are they alive or dead? Do they belong to a hidden assailant, or a friend indulging in a game?

In most of his paintings, Freud refrains from indulging in such mysteries. The longer we interrogate his images, however, the less straightforward any of them appear. In *Annabel and Rattler*, a naked woman lies on a bed next to an Irish wolf-hound. The painting seems, at first, like a celebration of their companionship. But Annabel is not looking at the dog slumped beside her. Rattler's flaring tufts of hair erupt on the white sheet, and the heaviness of his slack body could hardly be more at odds with the lithe elongation of the woman beside him. He could be seen as

a protective presence, a sentinel whose doziness might easily be replaced by a growling urge to ward off danger. However devoted he may seem to his mistress, though, the distance between them gives the painting some of its tension. There is no suggestion that Annabel wants to touch or cuddle her hound. She leaves her left hand hanging in space and pointing in Rattler's direction. But the rest of the arm remains resting on her body, and her right hand is thrust into her own hair.

Just as her left hand stays suspended above the bed, so her entire body seems stiffened by a state of alertness. Watchful rather than supine, she thrusts her legs towards the edge of the sheet. One lying on top of the other, they indicate a desire to remain in control. But her feet, assuming great prominence at the forefront of the picture, seem less inhibited. They are poised in an ambiguous area, where the pale shadow beneath them suggests that the side of the bed has been reached. Freud does not, however, make clear whether they still rest on the sheet or dangle freely in space. His masterly handling of both these feet gives them a remarkable air of vitality, indicating her readiness to slide down the bed and stride away. The unusually thick layers of paint lend great tactile conviction to the sole of her right foot, and accentuate the vitality running through the rest of her body. The bed's iron frame nearby, combined with the closed-in darkness beyond, ought to make the whole image more claustrophobic. Annabel certainly seems contained by her surroundings, but she is far from imprisoned. Her freedom of movement remains unimpaired, even if a certain turbulence is hinted at in the fierce entanglement of her right hand and hair on the pillow.

Compared with the ambition and complexity of such an outstanding picture, the head-and-shoulders portrait of Freud's son Ali may seem unexceptional. It is, ostensibly, a more formal image than the painting of Annabel and her dog. Far from posing naked on a bed, Ali sits upright in a plain blue shirt and shiny emerald tie. But clothes play only an incidental role in a gentle, intimate work where attention is overwhelmingly focused on the face. Ali looks down, reflective rather than assertive − a man given to day-dreaming and, perhaps, ruminative by temperament. Even so, the intensity of his portrayal means that we, the viewers, cannot forget the power of the gaze Freud trains on his son.

As we leave the show, a troubled self-portrait etching shows the artist's gaunt face and neck invaded by shadows so deep that they seem about to extinguish him. But he remains taut with vigilance and, above all, intent on scrutinising the world for as long as his prodigious energy continues.

BRUCE NAUMAN
21 July 1998

'You are evil' shouts a disembodied voice, floating out of the Hayward Gallery and over the puddle-strewn concrete walkway beyond. The words serve as an apt warning for the experiences on offer within. For Bruce Nauman, whose thirty-year career is surveyed there, has no intention of shielding us from the bleakest aspects of the human predicament. By the time we emerge from this emotion-wrenching show, assaulted through eyes and ears alike, Nauman ensures that we have been exposed to a gamut of powerful, unpredictable and often raw feelings about ourselves.

A multi-faceted individual, who leaps nimbly from one manner of working to another, Nauman has influenced younger artists in all kinds of ways. Damien Hirst and Rachel Whiteread are only the most prominent of the British practitioners to owe him debts, and yet he remains a tantalizing, enigmatic figure who protects his privacy. Indiana-born, California-educated and now living on a 600-acre ranch in New Mexico, Nauman evades facile definition. Roaming with ease from sculpture to photography, from neon to video and much else besides, he is defiantly unclassifiable. And therein lies his appeal for members of a 1990s generation who also thrive on open-ended attitudes.

Not that he is admired simply for blurring the boundaries. Whatever medium he employs, Nauman commands respect above all for the potency of images at once uncompromisingly direct and difficult to pin down. Part of his elusiveness stems from his unexpected, highly un-American, ironic humour. 'Run from Fear' declares a neon work, confronting us as we move into the first large room. Like several of the phrases used elsewhere in Nauman's work, these three words were taken from a graffiti he came across by chance. But the note of urgency they sound here is undercut, immediately, by the wry variation he has added beneath: 'Fun from Rear'. We find ourselves smiling at the laconic mixture of anxiety and playfulness summed up in this simple, apparently straightforward exhibit. Nauman's use of neon-lit messages recalls advertising slogans, but the messages he conveys are so paradoxical that they could never be deployed in the hard-selling of a commercial product.

We are not allowed to linger there for long. Sounds of a bellowing man pull our attention away, and images of the artist's own head confront us in a darkened room. Some are small, relayed either inverted or the right way up on stacked monitors. Others are colossal, projected on to walls from machines casually supported by manufacturers' packing

cases marked 'laserdisc'. Nauman makes no attempt to disguise the technology he deploys. Its mechanics are openly displayed, as if we were witnessing a trial demonstration in the artist's own studio. Nothing prevents us from wandering around the space, or blocking the passage of light from the projector with our own bodies. This freedom of manœuvre draws us into the work, almost to the point where we become part of it. But there are limits to this involvement. Staring at the artist's upside-down yellow face on the end wall, as monumental as a dictator's head yet emitting nothing more sinister than a low hum, we realise that the work stays at a remove and retains its aura of strangeness.

The longer we stay in Nauman's show, the more disconcerting it becomes. One small white room is empty, save for a light bulb lodged at the centre of the ceiling. Then we hear breathing – spasmodic, urgent, and at times reminiscent of puking. The man making the noise must be alone, muttering or even chanting to himself. According to the work's title, he is saying: 'Get Out of My Mind, Get Out of This Room.' But the words are inaudible, and after a while he sounds alarmingly deranged. Standing in the room is akin to being locked up with a lunatic, or a recluse unhinged by booze, drugs and the lack of anyone to talk to.

Nauman likes heightening our response to a work by channelling our bodies into spaces he has shaped. The most threatening is the *Live-Taped Video Corridor*, where we are invited to walk towards two monitors positioned at the far end. So narrow that the walls brushed my shoulders on either side, the corridor only allows one visitor to make the journey at a time. I found it intensely claustrophobic, and on the top monitor my own shadowy image was seen, from behind, moving towards the screen. On the monitor below, however, I was absent. Only the empty passage is visible here. I suddenly felt as if I did not exist, and when I turned round to go out, the surveillance camera above the corridor entrance seemed to mock me.

Not that Nauman excludes himself from these ordeals. Opposite the corridor, a giant close-up image of the artist's face is projected on a wall. The camera travels in slow motion around his features, pausing as he thrusts a finger hard into his ear, his nose and, most disquietingly of all, his eye. He seems perilously near to injuring himself, but his expression remains deadpan throughout. Nauman cultivates a stoical expression whenever he appears in his own work. Nearby, some early black-and-white videos are relayed on monitors, showing the young artist in a T-shirt pacing a room, walking a circle or standing on one leg and gradually swivelling himself round. His movements are as minimal as the sculpture he admired at the time, by Richard Serra and other American

contemporaries. The deftness of Nauman's gestures also reflects his involvement with experimental dance and music. Above all, though, he presents himself in these simple exercises as a lonely figure from a Beckett play, forever condemned to enact a series of rituals that seem both trance-like and inherently pointless.

Nauman is fascinated by absurdity. In one slow-motion piece, a man is seen slipping up on a banana skin to fall, with jarring impact, on his back. Over and over again he tumbles, as though weirdly addicted to the silliness and humiliation involved. But he is not as childish as the clown who, in another projection work, sits on the lavatory sighing, burping, leafing through a magazine, grabbing toilet paper and stuffing it between the pages, weeping, snoozing and picking at his teeth with a white gloved finger. Afflicted by a curious combination of tedium and acute anxiety, he seems to be undergoing a nervous crisis. But the monitors nearby show him performing aggressively, yelling 'no, no, no' at an unseen audience as he flails his arms, legs and ludicrous, outsize shoes.

All this bottled-up frustration finally explodes in a multi-screen work called *Violent Incident*. Our eyes are tugged from one monitor to the next, each presenting a different moment from the struggle between a man and a woman. Initially polite, they degenerate with gruesome speed into murderous hatred. The whole conflict is, simultaneously, puerile and sickening. Fascinated by yoking together contradictory extremes, Nauman can convey his complex meanings as effectively with actors as he does with words.

But the most impressive work relies on the potency of colour and verbal elements. We encounter *One Hundred Live and Die* while approaching a short flight of stairs. Ahead of us, filling the wall below, are four vertical columns each containing twenty-five three-word phrases. At first, they remain dark apart from an isolated component, lit up in dazzling neon. 'Suck and Die' says one, to be followed by 'Rage and Live'. On and on they go, bouncing us from one end of existence to another. The spectrum of glowing hues is orchestrated with seductive flair, and when all 100 phrases are eventually illuminated they emblazon their surroundings with an incandescent richness. A desperate awareness of mortality is pitched, here, against a hunger for sensuous delight. Destruction and elation are held in a precarious balance, but the climactic eruption of luminosity ensures that the work ends in a resplendent state.

Upstairs, another outstanding installation projects the titanic shaven head of a man on to three walls of a blacked-out room. Although the words he shouts are hard to make out, a fundamental opposition between 'feed me' and 'eat me' does become clear. Individual words are,

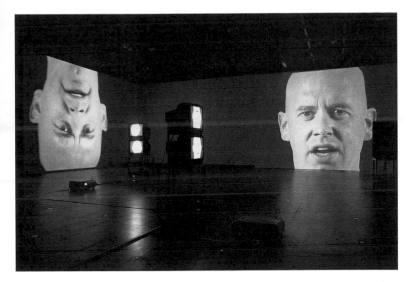

131. Installation view of Bruce Nauman exhibition at Hayward Gallery, London, with *ANTHRO/SOCIO (Rinde Facing Camera)*, 1991

however, soon subsumed within a mesmeric chant. Demanding, fierce and stubbornly optimistic, this relentless yet energising mantra sums up Nauman's ability to stave off the perpetual advance of darkness.

ROSEMARIE TROCKEL
8 December 1998

In one of Rosemarie Trockel's shortest and most arresting videos, a naked woman stands with her back to the camera. The top of her body is out of shot, and we soon discover why attention is focused below. For an egg suddenly drops from her parted legs and smashes on the floor. Liquid spills out, so dark and viscous that it looks like blood. But before we have a chance to find out, Trockel terminates the work in a vanishing circle of light. Brief though it may be, *Out of the Kitchen Into the Fire* encapsulates some of Trockel's governing concerns. Ever since establishing

herself as a provocative young German artist in the early 1980s, she has returned time and again to the themes of frailty, fecundity and feminity. The fascination takes many forms: like many women artists of her generation, Trockel has never limited herself to a particular medium or way of working. Nor does she imprison herself within a particular mood. Whether cool or high-spirited, investigative or irreverent, she can be relied on only to be unpredictable,

Eggs, nevertheless, provide a way in. They reappear so often in the early stages of her Whitechapel exhibition that I found myself moving gingerly, fearing a breakage. In their most monumental form, they fill an expanse of wallpaper stretching across a wide wall. Photographed there in severely regimented rows, like the most austere of minimalist reliefs, they are almost robbed of reality. In the centre, though, purged abstraction gives way to a quite different order of feeling. Like a white beaded curtain, hundreds of real blown eggs dangle in front of the wallpaper. They are the quintessence of vulnerability, and their emptiness has a pathos of its own.

Trockel does not associate eggs solely with humans. A homely wooden structure nearby, called *Chicken Coop*, opens into the kind of cosy, reassuring interior where eggs used to be hatched before battery farming turned the whole activity into such an arid, mechanical exercise. But women are not forgotten, even here. On the open door of *Chicken Coop* hangs a black dress festooned with egg beads and, to mark the breasts, two isolated eggs – one whole, one smashed. Trockel always seems to oscillate between these two extremes. On the floor beside the coop, a bronze egg big enough to have been laid by a Jurassic monster defies anyone to break it open. Ranged across the wall behind, however, are five black-and-white photographs called *Negative Egg-Whites*, vaporous fragments close to disintegration as they float in the void.

In Trockel's fertile imagination, no rigid distinction separates fowls from humans. Eggs are slung like grenades beside the thighs of a young woman who stares, with a secret intensity, at photographs of eggs from a whole array of sources. She could personify the artist herself, for Trockel appraises the world with an anthropologist's gaze. There is nothing drily academic about her stance, though. The clinical style she seems to adopt in her images of *Couples* at the start of the show should not be confused with coldness. At first, the seven large black-and-white prints of naked men and women may appear akin to the studied photographs found in sex manuals. But these bodies offer no how-to-do-it information about positions in love-making. Many of them sit or lie next to each other, and one couple does not even touch. Even when the bodies are most closely intertwined, penetration does not seem to be happening.

Instead, these lovers are savouring one another's company. They hold hands, nuzzle affectionately and let their legs overlap. Trockel makes us conscious of their sculptural form by using computer technology to extract them from their surroundings, placing them on pristine, bleached grounds. Isolating and exposing the couples in emptiness does not impair their intimacy, however. Oblivious of the blank space around them, they concentrate on relishing the proximity of bodies they cherish. Without becoming programmatic, Trockel enjoys the contrast between a shaven-headed man and the flourishing tresses of the woman lounging on his shoulder. She also relishes the interplay of pale and dark skins, or the balding middle-aged man and his younger, curly haired male lover. Roaming well beyond heterosexual limits, Trockel nonetheless refuses to make her choice of couples conform to politically correct dogma. The accent is on personal encounters, between healthy people whose pleasure is manifest yet never presented in a titillating, exploitative way.

Just how much Trockel wants to avoid a keyhole, pornographic approach is evident in *Of Good Nature*, a video where two naked couples are viewed from above. Another artist might well have used such a vantage to signify detachment – laced, no doubt, with a voyeuristic frisson. But as soon as we start watching, the video leaves us in no doubt about Trockel's intentions. Unlike the *Couples* photographs, where she used friends genuinely in love with each other, *Of Good Nature* relies largely on actors. And the dialogue they murmur, in between caresses, is quoted from the writings of Freud, Duras, Warhol and the Austrian poet

132. Rosemarie Trockel, *Untitled*, 1998 (detail from the *Couples* series)

Ingeborg Bachmann. Since the words are spoken in German, I had difficulty in deciding how formal they might sound to an audience fully at ease with the language. In terms of body movement, though, both couples give a convincing performance.

The younger pair, who are in reality married, fondle one another's bodies in a more demonstrative, even ostentatious way. Their erotic involvement is beyond question, and yet Trockel only shows the top half of the couples' bodies. Her emphasis always lies on the lovers as individuals, not anonymous sex-objects or spouters of script. The senior pair seems especially affectionate. More than a decade older than his partner, the grey-haired man takes manifest delight in the woman's personality as well as her beauty. Trockel accentuates the warmth of their mutual respect throughout, and her video provides a corrective to the near-automatic notion that love-making today is bound to founder in a wasteland of alienated, *fin-de-siècle* frustration.

The broken-egg side of her imagination does not remain dormant for long, however. Upstairs, a bleaker vision asserts itself in a new work called *Seaworld*. The title suggests a bland, tourist-themed experience, manipulated to ensure that only the most palatable aspects of marine life are presented for consumption. But Trockel scotches any such nonsense from the outset. A small sailing boat almost blocks our path, its emptiness accentuated by the clothes, gym shoes and other signs of recent occupancy strewn across the vessel. It looks forlorn, and the images beamed on to the creased sail by an automatic slide projector only increase the disquiet. Based on Hamburg, they flick restlessly from dour views of the industrialised docks to the water and back again.

The polluted murkiness of the sea shots, even when sun dances on its surface, subverts any sentimental notions about a marine paradise. As for the nocturnal images, where the water is almost engulfed in blackness, they recall the dying moments of Tacita Dean's film inspired by Donald Crowhurst's disappearance. But Trockel, despite her early training as a painter, is here more allied than the romantic Dean to a documentary tradition. She photographs the Filipino sailors who work for low wages on the big ships moored in Hamburg harbour. They frown at her camera, as if wondering why the lens has been trained on them. The tiredness in their faces undermines the lyrical caption on one man's T-shirt, which boasts that 'we've discovered the pleasure of . . . Island Sailing'. The jauntiness of local broadcasters, whose chatter and music can be heard on a radio beneath the projector, cannot disguise the cheerlessness of a world summed up by the unwelcoming, banal bulk of the International Seamen's Club building.

No consolation can be found in the family portraits near the end of the show. *Mother* is reduced to a grim, wizened mask in alabaster plaster, surrounded on the same wall by charcoal drawings where her face sprouts grotesque protuberances. *Father* is still more unnerving, his features literally defaced to the point of outright obliteration. We are close, here, to the emotional territory explored between the wars by Käthe Kollwitz, whose drawing of a stunned, elderly figure was photocopied and then given new meaning in Trockel's revision. A vein of gruesome, fairy-tale humour erupts in some of these portraits, particularly when blindfolded men sprout phallic noses and a woman is compared with a primped-up poodle. On the whole, though, Trockel reveals herself here as a surgical observer of humanity. There is an iciness lodged at the centre of her art, and no amount of loving bodily contact can thaw it away.

ANDREAS GURSKY

2 February 1999

Opposite the entrance to Andreas Gursky's spellbinding exhibition at the Serpentine Gallery, a large photograph shows six coolly luminous rows of trainers glowing on a wide, white wall. They almost transform the opening room into a state-of-the-art shoe shop, where designer style can be savoured in all its consumerist guile. But the phosphorescent niches containing the trainers also make them aspire to the condition of art. The floor beneath, where their milky reflection seems to hover in a void, is as pristine as the most immaculate museum interior. And the installation of the trainers looks reverential enough to be mistaken for a shrine, filled with intensely desirable objects demanding worship from their devotees. No viewers are visible in this hallowed chamber, so any Serpentine visitors standing in front of the picture look as if they inhabit the same space as the trainers. Gursky makes us acutely aware of ourselves as gazers, and of how our reactions are shaped by the presentation of the spectacle we survey. He also ensures, even in images devoid of people, that the human presence is seldom forgotten. Trainers, after all, are intended for feet, and in his mesmeric photograph they appear to be marooned inside confines denying them any possibility of escape.

Although an impressive range of other subjects is encompassed by Gursky's show, they mostly elicit the same complex response. Initially,

these large and sumptuously printed colour photographs generate a sense of awe. We respond to their grandeur with wonder, just as eighteenth-century onlookers found pleasure in 'sublime' encounters with nature at its most engulfing. At the same time, though, we shudder at the insights Gursky offers into the late twentieth-century world, where so many aspects of life are framed within structures as rigid as the trainers' display shelves.

The most powerful images usually deal with urban life rather than the natural panoramas so prized by lovers of the 'sublime'. In a 1994 print called *Ofenpass*, the snowy Alpine landscape peppered with half-submerged fir trees fails to provide anything more than an over-familiar frisson of vastness. But the exception is *Engadin*, where an even wider view of distant mountains is juxtaposed, in the foreground, with a long, straggling line of minuscule figures who skate and ski across an immensity of whiteness. At first, we are overcome by the sheer breadth of this epic scene. But the feeling of release is short-lived. The more we scrutinise these people, the more circumscribed their movements become. Instead of roaming at will across this expanse of snow, they all obediently confine themselves to a narrow, well-used track. Its limits seem absurd when set against the potential exhilaration of the boundlessness around them.

This severely regulated world becomes still more oppressive when Gursky turns his camera towards cities. He roams freely, from his native Germany to Brazil, Singapore and Happy Valley. But wherever he ends

133. Andreas Gursky, *Hong Kong Stock Exchange (Diptych)*, 1994 (detail)

up, images of ordered, relentless conformity crowd into his viewfinder. In a stunning diptych of the Hong Kong Stock Exchange, both panels are dominated by stern diagonal rows of identical desks, rammed tightly against each other. Passageways covered in wine-red carpet slide through their ranks, but remain deserted. Everyone's attention is consumed by the computer screens on the desks, and their scarlet-coated operatives seem as indistinguishable as the machines they gaze at. Towards the centre of the right panel, a bespectacled old man in black stands out with his strange, priest-like demeanour. But he serves only to underline the uniformity of the figures around him, caged inside a structure so impeccably spotless that it takes on a hellish aspect.

When Gursky turns his attention to the Board of Trade in Chicago, he appears to find a more anarchic scene. The floor and pathways are littered with discarded paper, apparently flung down by officials who seem to have abandoned their desks and rushed into the central arena. Here they gesticulate and jostle in an ostensible frenzy, dramatically at odds with the well-drilled serenity of their counterparts in Hong Kong. But the differences between East and West may well be more superficial than they appear. The waving Chicagoans are indulging in behaviour as ritualised, in its boisterous way, as the undemonstrative occupants of the Hong Kong Stock Exchange. Gursky views them both from a distance, appraising their communal activities with the objectivity that his teachers at the Düsseldorf Academy, Bernd and Hilla Becher, devote to their impressive photographs of ageing industrial structures.

Even so, Gursky is committed to scrutinizing people rather than gasometers. And unlike the Bechers, with their puritanical devotion to black and white, he is not afraid of colour printing at its most sensuous. It reaches seductive heights in his images of dance clubs, where ecstatic kids brandish their limbs with frenzied delight. Raking, tinted spotlights add to the aura of orgiastic release, and Gursky seems to have hit on a subject where humanity succeeds, at last, in flouting the irksome codes that govern office life by day. Even here, though, conformity prevails. For all their seeming spontaneity, the hundreds of upflung arms respond to the music in precisely the same way. They resemble salutes, creating echoes of the equally fervent arms thrusting into the air at Nazi rallies. And in place of a Fascist demagogue, a DJ manipulates the kids' body movements with cunning, practised authority.

Losing inhibitions in the psychedelic maelstrom of a club is not, therefore, as liberating as the ravers might imagine. They still fail to cast off the regimental habits governing the lives of so many during the working week. That is why Gursky remains so preoccupied with the codes of discipline

found in offices and factories alike. Some of his most disconcerting photographs define cheerless spaces whose occupants seem in thrall to the compartmentalised severity of their surroundings. Even a building as glamorous as Norman Foster's icon-like Hong Kong and Shanghai Bank is seen as a sequence of cells. Setting up his camera outside, and choosing a moment in late afternoon when the windows look brilliant against the encircling darkness, Gursky invites us to stare with voyeuristic fascination at the rooms within. Most of them are lit by a cold, bleached glare. It relentlessly picks out the geometrical formations asserted behind the glass façade, where the apparent freedom of open-plan space is countered, at every turn, by identical clusters of furniture. Here the employees sit, in floor after illuminated floor, like automata crowding an updated version of Fritz Lang's *Metropolis*. By removing himself so far from the building, Gursky emphasises the repetitive tyranny of the layout inside. The fact that the ranks of white rooms are contrasted, every so often, with a loftier and more warmly lit area only underlines their numbing sameness. Individual expression has no place within this chilly monolith. We can see in, but the bank's show of architectural transparency provides no real access to an institution as impenetrable as a stone-clad fortress.

Part of Gursky's power, as an observer of ever-spreading millennial impersonality, derives from his unwillingness to protest or condemn. He retains a clinical detachment, even if his reliance on digital technology to erase unwanted elements sometimes results in excessive artifice. *Times Square* is the title of a disorienting image, where Gursky trains his camera on the bland interior of a Portman hotel courtyard. Near the bottom, entrances to the 'Marquis Ballroom' and the 'Cantor Room' supply clues to the building's identity. Most of the picture-space, however, is taken up with lozenges of white and yellow ranged in stern, eye-baffling formations. Gursky has digitally removed so much detail that they look like a minimalist relief. Vestiges of dangling plants help us to realise that the lozenges are balcony walkways, but the few figures detectable on these radiant passages have been drained of colour. Reduced to near-disembodiment, they resemble phantoms rather than guests, waiters or cleaners. Gursky makes us so conscious of his interference with the hotel's overbearing reality that the image is not as persuasive as his less doctored works. It strives too hard to attain an abstracted state.

Maybe Gursky's love of painting and sculpture drove him to push *Times Square* too far. But most of his pictures are enriched by their references to artists as disparate as Caspar David Friedrich and Dan Flavin. He shows, with a high-wire combination of rigour and verve, how the camera's ever-expanding resources can convey a vision as singular, unsettling

and eloquent as any to be found in the art of our time. When Gursky photographs Jackson Pollock's *One: Number 31*, enclosed in horizontal bands of purifying light on its customary wall in New York's Museum of Modern Art, he aims not simply at showing how a modernist masterpiece is displayed with quasi-religious zeal. He also wants to celebrate a transcendent moment in Pollock's work, and imply that his own hopes for a powerful lens-based art are no less ambitious.

WILLIAM KENTRIDGE
28 April 1999

Isolated on a black wall, three swiftly drawn lamps dangle in the darkness. They look fragile, and could easily be torn down from their slender cords. But for the moment they manage to function, spreading white splinters of light through the gloom. Positioned in the opening room of William Kentridge's exhibition at the Serpentine Gallery, the lamps seem to act as a symbol of his hopes for art. He wants to tell the truth, not only about the traumatic history of his native South Africa but the human condition as a whole. At the same time, though, Kentridge is acutely aware of the difficulties hampering such an aim. This dual ability, to bear witness and yet concede that the ambition is thwarted, gives his work its jarring, anguished conviction.

If he had lived a couple of centuries ago, Kentridge might well have channelled his protesting and intensely theatrical imagination into printmaking. Both Hogarth and Goya, impelled by the urge to dissect the follies of their age, became masters of graphic art. Line is the basis of Kentridge's work, too, but he employs cinematic techniques to give his draughtsmanship a leaping, constantly changing dynamism. By filming his charcoal and pastel drawings, then reworking or erasing them and recording the alterations at every stage, he has developed his own style of animation. Although the influence of Beckmann, Grosz and Kollwitz gives Kentridge's films a pronounced expressionist flavour, they end up as the inimitable product of a conscience scarred since childhood by the abomination of apartheid.

The son of a lawyer who represented victims' families after the Sharpeville massacre, when seventy-two black South Africans were killed by police at a demonstration, Kentridge undoubtedly welcomed the tri-

umph of the ANC in 1994. But the films he has produced since that decisive general election are as haunted by the past as his earlier work. At the century's end, he is in no mood to regard South Africa with complacency. The exhibition never stops battering us with baleful images of greed, hatred and violence so limitless that they seem impossible to comprehend.

Kentridge knows he can never define the full extent of the barbarity. But that does not stop him arraigning it with all the linear power he can muster. Avoiding the pitfall of making his targets too diffuse, he concentrates on the corrosive figure of Soho Eckstein. In the earliest film shown here, the pin-striped Soho is a property developer who builds with rampant ferocity all over a convulsive Johannesburg. Kentridge calls it the '2nd Greatest City After Paris', but the urban panorama presented here is a nightmarish vision. It certainly unsettles Felix Teitlebaum, a dreamer whose dazed nakedness contrasts with Soho's malevolence. The two men end up fighting each other in the city's sewage pools, but there is no sign of goodness triumphing.

Felix, who resembles Kentridge himself, succeeds only in bringing love to Soho's neglected wife, and two years later she returns to her husband in another film. Called *Sobriety, Obesity & Growing Old*, this autumnal work does not allow Soho to triumph. He watches his Babylonian empire crumble, and Kentridge invades the film with apocalyptic images of disintegrating office-blocks. The world is laid waste, but Felix is unable to benefit from the obliteration of wealth. He finds himself alone in the wilderness, stunned by the spectacle of a country condemned to destruction without end.

The wrenching power of these short films is cumulative. At first, Kentridge's relentless transformations may seem frenetic and hard to absorb. After a time, however, the underlying pathos becomes clear. Far from simply indulging in an orgy of annihilation, the films show how the incessant turmoil impedes any attempt to keep hold of history. Nothing retains its identity for long in Kentridge's animation. Everything is continually undergoing a metamorphosis, and the ensuing confusion means that the past rapidly becomes obscured.

Felix in Exile is the film where the problem is addressed most disturbingly. Although he has fled to a room in a foreign country, Felix cannot escape his burdensome memories of the nation he left behind. The walls around him, and even his suitcase, turn into the East Rand countryside clogged with corpses. However unavoidable they may seem, though, the bodies soon dissolve into the earth. So Felix, having been tortured by their presence, now finds himself bewildered by their absence. Even a purposeful woman called Nandi, who appears on the

134. William Kentridge, *History of the Main Complaint: Title Page*, 1996

other side of his bathroom mirror surveying the landscape of death with an instrument, eventually succumbs to the same melting process.

The danger of forgetting apartheid's victims came more painfully into focus when the Truth and Reconciliation Commission began its public sessions in 1996. Kentridge must have believed that South Africa could only find a way forward by admitting to the horrors of racist hysteria. Placing Soho Eckstein in a hospital bed, still dressed in impeccable pinstripes but suffering from a coma, he made an outstanding film called *History of the Main Complaint*. Breathing through an oxygen mask, the prostrate Soho is attached to a CAT scan where the inside of his body is juxtaposed with memories of atrocities he once witnessed. We are confronted by his eyes, caught in the rear-view mirror of his car as he drives along a bleak highway past silhouetted figures beating and killing. Soho's condition appears to deteriorate as he revisits the carnage he once avoided. Only when a corpse hits his windscreen and shatters the glass does he emerge from the coma with a start. The shock of finally confronting the reality of internecine strife restores him to health, but Kentridge refuses to present Soho's recovery in a wholly positive light. He soon reverts to his customary profit-grabbing role, as if nothing had caused him to question his old priorities after all.

This oscillation, between a crusading desire for the facts and a fear that they will not change anything, gives Kentridge's work its central bite. He persists in pursuing the grimmest aspects of his country's history, and in 1997 resurrected Alfred Jarry's bloated Ubu Roi for a harrowing film collage where, for the first time, drawn animation is deployed alongside

documentary footage of South African upheavals. The archive material reflects the fact that Kentridge took as his starting-point evidence given to the Truth and Reconciliation Commission. But the most excoriating moments in the film still come from his own drawings.

With swift, confident strokes, he defines a torture room, where a bound figure is dumped upside-down in a bath, hauled out to hang in mid-air and dropped on his head. Individual pain then becomes a collective cry of torment, as the camera widens out to disclose a whole building filled with similar chambers. Ubu, who starts off looking merely puffed-up and absurd, sheds his clothes to reveal a robotic body beneath. Resembling a camera on a tripod, it soon becomes a lethal instrument of terror. In the film's most mortifying scene, the tripod blows up a helpless body – not once nor twice, but three times. The ever more fragmented limbs end up dispersed in the night sky, useless as evidence in any investigation. Then they vanish altogether, and only a giant eye in the clouds appears as a silent reminder of the enduring need to observe and testify.

In the most recent exhibit, a video projection occupying the whole North Gallery, Kentridge's mood seems, if anything, more pessimistic. Its springboard is Monteverdi's opera *The Return of Ulysses to his Homeland*, and music plays an often alarming role in this installation. We find ourselves in a darkened arena lit only by three laser-disc screens flickering on a curved wall. At the centre, a bottle of liquid rises and falls to the sound of someone's laboured breathing, in and out with equal slowness. But the stream of images on the flanking screens become torrential. Ulysses is dying in a Johannesburg hospital, and physical infirmity seems to have quickened his mental agility. We see the surgeon's scalpel at work, in blood-saturated footage that makes Monteverdi's score sound like music played in an operating theatre. Kentridge returns to the body-scanning he explored in *History of the Main Complaint*, and he moves dizzyingly from sonar-blurred embryos in the womb to video snatches of a hurricane lashing and demolishing everything in its path.

Both the beginning and the end of the world are thereby evoked, but the most affecting sequences are, as ever, animated by Kentridge himself. Idyllic Greek landscapes familiar to Ulysses dissolve into a grim South African highway. Hunted figures dart in and out of the tree-lined route, their bodies made spectral by the glare of headlights at night. They arouse feelings of dread; but Kentridge insists that the beams stay full on, regardless of any distress they may cause.

ALIGHIERO BOETTI
6 October 1999

Even before entering the Alighiero Boetti retrospective, we find ourselves teased by this maddeningly elusive artist. In the foyer of the Whitechapel Art Gallery, a 1970 photograph shows him smiling as he pushes the skin around his eyes until they widen into slits. It looks like the gesture of a born conjuror, determined to evade recognition. And throughout the mysterious survey beyond, he delights in confounding all our attempts to pin him down. Boetti was fascinated by the question of identity. As early as 1968, a year after his first solo show in his home city of Turin, he made a photomontage of himself holding hands with another young man. Calling the image *Twins*, he sent it out as a postcard to friends and associates. One of the first manifestations of mail art, it prophesies his decision to adopt a double identity in 1972. Signing all his subsequent work 'Alighiero and Boetti', he explained that 'Alighiero is the more infantile side', whereas 'Boetti is more abstract, precisely because a surname is a category'.

In practice, though, the Turin chameleon assumed as many guises as he wished. His lack of any formal art training probably helped. The freedom of manoeuvre he enjoyed, right up until his untimely death in 1994, might well have been impaired by oppressive teachers at art school. But nothing stopped Boetti's love of diversity from flowering. He was, from the outset, an artist perpetually on the move. And he dramatised that restlessness in one of his earliest works, a pair of wooden boxes powered by an electrical mechanism flashing up the words 'Ping' and 'Pong'. They are placed far apart at the Whitechapel. And as our eyes race from one over to the other, the darting spirit of the artist behind them goes into airborne action.

Ping Pong was one of the exhibits in his first one-man show, along with an assortment of equally tantalizing works. By far the most provocative is *Yearly Lamp*, a nondescript container placed on the floor with a large light bulb nestling inside it. Boetti insisted that it lit up for precisely eleven seconds each year. But his claim will remain unprovable, unless someone is prepared to subject the bulb to 365 days' non-stop scrutiny. Boetti added to the enigma by describing Yearly Lamp as 'a fundamentally literary work'. The truth, however, is that he loved to disguise his real intentions, and the title of another 1966 work sums up his evasive tactics: *Camouflage*.

Not that Boetti hid his materials from view. He rejoiced in openly declaring them, and claiming the right to use as many different components as he wished. In one untitled 1967 work, he clustered together

plexiglass, wood, polystyrene, iron, plastic, Kapok, chipboard and cork. All of them, in his view, deserved to be counted among the legitimate concerns of an artist. Nothing was too ordinary, and he took a huge delight in searching the most unlikely sites for stimulus. Describing a visit to a building yard in 1967, he recalled how 'I couldn't believe my eyes when I saw the amazing things to be found there!' He made a work called *Castata* from asbestos lumber tubes, and assembled firebricks ('very beautiful') into a small floorpiece that mocked, in its careless asymmetry, the formal grandeur of Minimal Art.

Boetti was part of a new momentum in the Italian avant-garde, and before long the critic Germano Celant enlisted him in the highly influential Arte Povera movement. Bent on bringing contemporary art into more direct contact with real life, unencumbered by history or ideology, Celant declared that in Arte Povera 'the hard facts and the physical presence of an object, or the behaviour of a subject, is emphasised'. Boetti had sympathy with such an aim, focusing as he did on 'the elementary and non-signifying action.' At the same time, though, he wanted to retain his own idiosyncratic independence. Nothing was able to constrain his commitment to suppleness and blithe unpredictability. Alongside frankness, he continued to relish mystification, producing a strange Manifesto where the surnames of fifteen artist-friends, among them Luciano Fabro, Jannis Kounellis and Mario Merz, are listed in red capitals. Alongside them, coded symbols convey a private commentary on each artist. Boetti asserted that he had placed the key to the symbols' meaning with a notary, who was instructed to divulge it in return for a suitable fee. But nobody has ever been able to discover who was entrusted with the 'key', and Boetti may well have invented the whole story to amuse himself.

He was certainly adept at keeping secrets, and this love of discretion coexisted oddly with his strong desire to astonish. In one mood, he could produce a lime-painted board restricted to three words: *Stiff Upper Lip*. Ostensibly an Italian's joke at the expense of the English, it may in fact have been referring to his own need for reserve. But when he became more expansive, Boetti could broadcast his talents as ostentatiously as an unrepentant egotist. In order to publicise his 1968 solo show in Milan, he produced a poster of himself locked in a semi-naked, meditative pose with an inverted figure. Called *Shaman Showman*, the image was taken from Eliphas Lévi's *Histoire de la Magie* published in 1860. When flyposted on walls throughout the city, it alerted knowledgeable viewers to Boetti's interest in alchemy and the Cabala. As for the rest of his widening audience, the title of the poster was enough to alert them to the curious duality lurking at the centre of his character.

If it had been more boastful and pretentious, Boetti's art could easily have become intolerable. But the prevailing temper of this exhibition is unexpectedly modest. Most of the early works do not call undue attention to themselves. Concise and compact, they amuse or bemuse without any sense of strain. When he props an expanse of iron and glass casually against the wall, and calls it *Nothing to See Nothing to Hide*, we can relish the irony even as we acknowledge the open way he handles his materials.

All the same, there are occasional hints of a darker and more frustrated outlook. In 1966, he made a triangular *Ladder* from wood and blocked any access to its steps with long planks. On one level, Boetti may have been emphasizing his impatience with anyone wanting art to climb into the realms of mysticism. But *Ladder* also looks thwarted, pointing to a vein of melancholy and even anger in the artist himself. It re-emerges, more disturbingly, three years later. *Me Sunbathing in Turin* is the typically offhand title of a figure sprawled on the floor. Legs parted wide, he is made entirely from lumps of quick-setting cement. The body seems to have been flattened, by a truck or a fall from a high building. Either way, his individuality is obliterated. And the cabbage butterfly perched on his shoulder reinforces the notion that Boetti is here exploring his own mortality, with a directness strikingly reminiscent of young British artists in the 1990s.

The prospect of his own death recurs, more specifically, in a pair of 1971 embroidered squares. On the left, the date '16 December 2040' records the centenary of Boetti's birth. On the right, the date '11 July 2023' speculates about the day he will die. The floral patterns surrounding them look simply decorative at first, but they could be about to engulf the writing altogether. The fact that he is so optimistically mistaken about the date of his death only adds to the work's poignancy.

By the time these embroidered pieces were made, Boetti had entered a different phase. Rather than making the squares himself, he commissioned them from artisans in Kabul. His first visit to Afghanistan had taken place in March 1971, and the following year he opened the One Hotel in Kabul. Boetti stayed there regularly until the Soviet invasion in 1979, leaving behind the Utopian mood of the previous decade and developing a more solitary, introspective vision. 'I was most attracted to a sort of cancelling out, to desert civilisation,' he admitted of his love affair with Afghanistan. It was an intriguing attempt by a European artist to become thoroughly immersed in a non-Western culture.

In my view, though, Boetti's subsequent work suffered. Relying on local Kabul craftworkers to embroider a sequence of large, atlas-scale

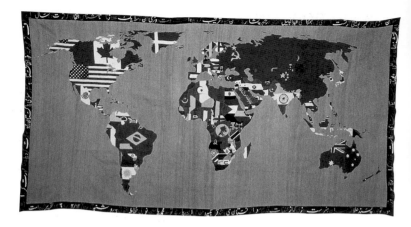

135. Alighiero Boetti, *Map*, 1988

maps, where each country is marked by its national flag, he drifted into a more nebulous state of mind. His work often appears inconsequential, and the disparate impulses that gave his previous art its multiple tensions evaporate in a haze of ornamental prettiness. The old disquiet makes a rare appearance in 1984, when he signs a work entitled *Adding Up* and then describes himself as an 'insecure nonchalant'. The most revealing late work, however, is a tumultuous embroidery called *Everything*, crammed with fragmented figures and other clamorous forms. As wide as a cinema screen, it seems initially to be powered by a headlong, almost childlike enthusiasm. But then its very congestion grows unbearable to behold, as if Boetti's search for an all-encompassing vision of the world had, in the end, overwhelmed him.

HOWARD HODGKIN

19 November 1999

Isolated on a wall in a small, subterranean room, Howard Hodgkin's *End of the Day* sounds a note of mortal conflict. At the centre of the wooden panel, luminosity flares in overlapping bursts of green, yellow and red. But they are enclosed by a border of terminal black, spreading outwards until it smothers the thick, wide frame as well. The darkness is so implacable that it seems bound, at any instant, to snuff out the radiance at the painting's heart. If we take its title at face value, *End of the Day* would seem to be a landscape. But the other paintings in Hodgkin's unmissable new show at the Anthony d'Offay Gallery prove, soon enough, that they are concerned above all with human emotion at a sustained pitch of intensity. So *End of the Day* cannot be reduced to the notion of a sunset, observed from a suitable distance by an artist with a

136. Howard Hodgkin, *End of the Day*, 1999

painting in mind. Instead, it is bound up with the most private feelings of someone in his late sixties, confronting the inescapable realization that time is running out.

Not that the exhibition is at all morbid. Hodgkin savours life far too keenly to make depressing art. If anything, his sharpened awareness of transience makes him more determined than ever to relish life while it lasts. *Learning About Russian Music*, begun and completed with unusual dispatch in 1999, seems quickened by the discovery of a new-found pleasure. Dominated by a yellow-orange rectangle as hot as the bars glowing on an electric fire, it is among Hodgkin's most ardent images. It also made me realise how his work sometimes appears close in spirit to Kandinsky at his most exuberant, prophesying the apocalypse of 1914 and yet revelling in his exploration of an unfettered, abstract 'colour music'.

However far Hodgkin himself may seem to depart from representation, he has never been an abstract painter. His images are always attached with umbilical firmness to particular memories, but he does not try to reconstruct them in a literal way. The occasions are summoned back to life freighted with retrospective emotion, as all acts of remembrance must inevitably be. Experience, not diary-like description, is what counts. So when Hodgkin calls one of his most incandescent paintings *Kathy at La Heuze*, he does not provide an identifiable portrait of the recollected woman. In its place, auburn fieriness bursts upon a surface rough enough to conjure the flinty grey wall of a house in the country. The woman's warmth appears to transform her austere surroundings, and blaze there with the magnetism of a Turner sun.

At the same time, though, *Kathy at La Heuze* seems evanescent. For all its joyfulness, it is in this respect surprisingly close to a more melancholy painting called *Autumn Foliage*. A burning orange-brown ascends here in widening arcs, but they cannot impose order on the more unruly brushmarks presaging disintegration. Some are already breaking up into particles, and a few dark, branch-like lines appear on the point of snapping. Hodgkin's supple strokes seem to shudder as they chart the onset of these convulsions, and yet the painting as a whole still flames with the magnificence of the departing season.

Some of the finest exhibits prefer to deal with times of the day. In *Good Morning*, a thickly handled oblong of dark paint is brushed, with great vehemence, around the central image. We feel like voyeurs peering in through an aperture on an intimate event. A phallic form, erect and pale in the light, gives the painting a jubilant sensuality. It makes *Good Morning* look more alert and defiant than another, wider painting entitled *Afternoon*. This time, long and loosely applied strokes of scarlet

pigment enclose the middle area. The horizontal format, redolent of resting, accentuates the mood of relaxation. So do the marks meandering around the edges of the picture-space. But *Afternoon* does not lapse into laziness. It refuses to settle, and the brushstrokes at the centre appear almost molten. They become convulsive, as if threatened by the advent of the thunderous blue looming on the right.

In a few of the paintings, obliteration becomes a reality rather than a threat. *Small Chez Max*, a circular panel commenced in 1989 and only completed eight years later, still shows traces of pink and white forms that have been largely cancelled by a broad, summary brown bar, sweeping across the entire width of the painting in an imperious diagonal rush. Vestiges of the brushwork beneath it are still detectable, but impossible to decipher. Hodgkin leaves us with an enigma, tantalizing his viewers with the suspicion that he decided, in the end, to let a state of near-extinction prevail.

Dark Mirror is more unsettling still. The modest dimensions of its oval surface are caught up in a cataclysm. At one side, fiery colours continue to flash. But they are engulfed by the shaft of a storm coursing towards them, and a far darker, more menacing cloud hangs down over the centre of turbulence. The drama is intense, and its vehemence undeniably exciting. Perhaps Hodgkin is attracted to despondency at times: it would help to explain why he calls one overcast little painting *Come Back Dull Care*. In the main, however, he banishes dejection and ensures that any turmoil encounters formidable resistance.

In *Pourville*, a threatening mass of darkness on one side is balanced on the other by a lighter, fresher alternative. And in between these two opposed forces, horizontal paint-swipes evoking sunlit sand and water are allowed to assert themselves without interruption. The maritime concerns hinted at here become more overt in *Evening Sea*, justly accorded a room of its own in the d'Offay show. Unusually panoramic in scale, this grand oval panel is lapped at the edges by soft, sensuous strokes of green. They suggest that we are looking through a haze of wild grass towards the water far beyond. All incidentals have been jettisoned and we are left, as in late Turner watercolours, with the essence alone. But there is nothing neatly definitive about Hodgkin's urge to simplify. *Evening Sea* is broken and loose, hinting at storminess to come while accepting that the light's waning power makes any confident forecast impossible. We are left with a sense of fitful, flickering immensity, grand enough to generate awe and yet on the verge of fading from sight.

Paintings as impressive as *Evening Sea* convince me that Hodgkin has embarked on a new phase in his long, enormously rewarding career. In

THE NEHRU GALLERY OF INDIAN ART

17 November 1990

When the Queen opens the resplendent Nehru Gallery at the Victoria and Albert Museum next Thursday, the acrid controversy surrounding its Indian holdings might finally be silenced. Although the V & A owns the largest and most comprehensive collection of Indian art outside that sub-continent, it has never been displayed with sufficient flair and sympa-thetic conviction. In recent years, accusations of flagrant bias began to be hurled at the museum, especially by Indian-born residents of this coun-try who suspected that their native land's culture was being slighted and hidden from view.

In historical terms, they were accurate enough. Even after India became part of the Empire in the mid-nineteenth century, Britain's respect for Indian artistic prowess was restricted to the applied arts alone. The majority of Victorian critics and historians spurned India's immense achievements in painting and sculpture, regarding them as too paltry even to be counted among the fine arts. Such ignorance and prejudice was inexcusable, especially in view of the burgeoning Indian collection amassed by the East India Company. Established at the company's Leadenhall Street headquarters as early as 1801, the 'repository' grew at an immense rate. By the time it was taken over by the V & A in 1879, the collection embraced an extraordinary array of agricultural models, stuffed birds and mineral products alongside jewellery, textiles and a remarkable range of sculpture. Not until the present century, however, did enlightened scholars like the celebrated Ananda Coomaraswamy per-suade Britain to re-examine its bias against Indian art.

A new generation of inventive sculptors, Jacob Epstein and Eric Gill prominent among them, now became profoundly excited by Indian art's uninhibited emphasis on sensual delight. At the height of his infat-uation with India, Gill exclaimed in 1911 that 'the best route to Heaven is via Elephanta, and Elura [sic] and Ajanta'. But the national collection of Indian art was displayed unsatisfactorily, in former exhibition build-ings situated at a significant distance from the V & A's premises. This geo-graphical removal symbolised a continuing unwillingness to accord India's artistic achievement the position and respect it deserved, and worse was to come. When the buildings housing the collection were demolished in 1955, the V & A failed to find it an adequate home. Most of it was consigned to storage, emerging only in sections for temporary displays at the museum.

No wonder its critics suspected that Britain did not, fundamentally, care about Indian art. In 1946, Nehru insisted that the country he led into independence 'has the right to reclaim in universal history the rank that ignorance has refused her for a long time'. We were in no hurry to heed his argument, and only in 1988 did a new gallery open within the V & A to display the arts of India from 200 BC to AD 1500. The overdue process of reparation had begun, but the bulk of the 35,000 Indian objects owned by the museum still languished in the cellars.

Although the museum's financial crisis militated against solving the problem, its recently appointed director appreciated the overriding importance of the Indian artefacts in her care. 'With a community of nearly one million people of South Asian origin living in Britain', says Elizabeth Esteve-Coll, 'it is not only time to display more of that collection, but actively to use it to explain the richness and diversity of our multicultural heritage'. Rightly concerned about the museum's failure to attract this Asian audience, Esteve-Coll launched a £2.2 million appeal for a Nehru Gallery of Indian Art within the V & A's premises. Intended to honour the centenary of Nehru's birth, and bolstered by the joint patronage of Mrs Thatcher and the Indian prime minister, the venture has so far raised £1.7 million. Many of the donations came either from India or companies linked with that country, and work soon began on a display which would at last be worthy of the objects in the collection produced between 1550 and 1900.

Devised by Brian Griggs, the V & A's Head of Design, the Nehru Gallery aims above all to delight the eye. Determined that it 'should make the sort of aesthetic impact on visitors which travellers in India experience even today', Griggs has used a seventeenth-century colonnade from Ajmer in Rajasthan to provide a magnificent approach to the central raised pavilion. At its heart, enclosed by traditional sandstone and marble window screens, the inner treasury will house the superb inscribed jades and jewellery made for the Mughal Court.

Although this focal section includes some of the museum's most precious possessions, the Nehru Gallery takes the broadest possible view of its subject. Dr Deborah Swallow, curator of the Indian and South-East Asian Collection, emphasises that 'we certainly don't want to imply that the Mughals came along and created art in India'. Much of its essential character had been developed in earlier periods, and the changes introduced by the Mughal dynasty and subsequent British domination were counterbalanced by the continuing strength of indigenous traditions.

When the Mughals established their rule in the mid-sixteenth century, India already boasted enormously prosperous cities whose trading power

gave them a cosmopolitan outlook. Several exquisite objects in the early sections of the display derive from the era when the Portuguese founded the first European presence on the subcontinent. Using Goa as their principal entrepôt, Portuguese traders gathered in goods from all over India and sent them to the West. Among the earliest and most outstanding examples of Indo-Portuguese art is the so-called *Robinson Casket*, made from solid ivory panels and secured by a gold-fitted lock studded with sapphires. The virtuoso carvings depict biblical subjects like the Nativity and the Tree of Jesse. Charged with a sinuous vitality which animates humans and animals alike, they announce the conversion to Christianity of King Dharmapala of Kotte. He probably commissioned the casket in 1558 as a present to the Portuguese court, for the 'conversion' symbolised the king's dependence on Portugal's protection rather than reflecting a genuine change in his personal faith.

The politically fragmented India discovered by the Portuguese soon gave way, after the advent of the Mughals, to a more unified alternative. Babur, the founder of the dynasty, combined military expertise with a highly educated appreciation of the arts. His writings often refer to the poets, artists and architects of the Islamic world, and his love of nature inspired him to write poetry. A consummate gouache and gold miniature commissioned by his grandson depicts Babur supervising the laying-out of the Garden of Fidelity. Eager workmen are shown digging, tending and planting the fragrant trees and flowers with which he liked to surround himself. Channelled water flows into a pool, and high walls shut out the 'hundred disgusts and repulsions' that upset Babur when he first explored the countryside around the newly conquered Agra.

The artistic flowering initiated during his reign was interrupted after his eldest son, Humayun, succeeded him. Bitter fratricidal disputes ensued, forcing the new ruler into temporary exile. He was obliged to buy help from the Shah of Iran with the Koh-i-Noor diamond and equally priceless rubies. Eventually the Shah raised the forces needed to regain Humayun's empire, and he was now able to fortify his father's cultural innovations. The master artists he brought back with him from Iran established an imperial studio in India, as well as instructing the young prince Akbar.

Once Akbar began his reign, the arts in India blossomed. Under his enlightened patronage, the imperial painting studio produced fourteen volumes, each containing 100 densely detailed illustrations, devoted to the epic adventures of the legendary Hamza. Their style fuses Iranian and Indian influences, and the enthusiastic Akbar promptly commissioned a

profusely illustrated history of the Mughal dynasty called the *Akbarnama*. No less than 117 miniatures from the royal copy of this prodigious work belong to the V & A. Paintings like *Akbar's triumphant entry into Surat* may be propagandist, but they are also enchantingly beautiful. Akbar's artists were by now copying Western art, as a *Deposition from the Cross* after a lost painting by Raphael proves. The cascade of artistic production was governed by highly sophisticated standards, and the next emperor, Jahangir, was proud of his connoisseurship. 'If there be a picture containing many portraits, and each face be the work of a different master, I can discover which face is the work of each of them,' he claimed, adding: 'If any other person has put in the eye and eyebrow of a face, I can perceive whose work the original face is, and who has painted the eye and eyebrows.'

Although most Indian miniatures revelled in fantastic elaboration, their makers could restrict themselves to a refined simplicity as well. The superb portrait of Jahangir's son, *Shah Jahan as a prince*, isolates the orange-robed figure on a flower-spattered, deep green ground. Festooned with precious stones, he holds a gold turban aigrette set with a particularly sumptuous emerald and diamond. Sir Thomas Roe, James I's ambassador, was astounded by the richness of the jewel-encrusted court ceremonial, and under Shah Jahan the image of a Golden Age took hold. The ruler responsible for the Taj Mahal, he favoured the theme of a flowering plant – whether decorating wall-hangings, beakers, tiles or bowls. The outcome evoked a heavenly garden, and an inscription in his seductive palace complex at Delhi resoundingly declares: 'If there be Paradise on the face of the earth, it is this, it is this, it is this.'

But the Mughal Eden could not last for ever. Shah Jahan's reign ended in appalling internecine butchery, and under his successors the court art gradually lost its vitality. Greater dynamism can often be found in the court art of the Rajput Kings, who ruled territories to the west of Delhi and mounted militant opposition to the Mughals. A marvellously lively gouache shows *Raja Umed Singh of Kota hunting lion*, and the cover of the V & A's handsome Nehru Gallery catalogue is emblazoned with a fiery painting produced in the Punjab Hills. Depicting *A lady in a pavilion conversing with her lover*, it deploys deeper colours and a more audaciously severe composition than Mughal art would have done. Its brazen strength compares favourably with the increasing stiffness of the Mughal court during its final disintegration.

The time had come for the British to assume control. Their rapid and inexorable expansion inspired the making of the most entertaining and popular object in the collection: 'Tipoo's Tiger'. It was produced for Tipu

137. The Nehru Gallery of Indian Art, with 'Tipoo's Tiger', Victoria & Albert Museum, London

Sultan of Mysore, whose determination to resist the British infidels became legendary. He saw himself as a tiger, and commissioned a large wooden model of the animal mauling a helpless European. Bellows inside the tiger make the victim emit groans, while growls are produced by turning the handle of a miniature organ keyboard on the animal's shoulder.

Tipu died a hero in battle, as he had wanted, but his mantle was quickly inherited by Maharaj Ranjit Singh – the 'lion of the Punjab'. Although small, pockmarked and partially paralysed, he excelled as a swordsman and dazzled visitors with the magnificence of his court. Covered with sheets of embossed gold, the lion's throne was especially splendid. Replete with tassles and gleaming gold cushions, it eventually passed into British hands after the annexation of the Punjab in 1846. This empty, conquered throne could easily be seen as a symbol of the booty which flowed to this country while the Raj consolidated its imperial authority. Even at the zenith of Empire, the British never amounted to more than a half per cent of India's population. But the schools of art they intro-

duced to the subcontinent imposed Victorian taste on the students. Dismissing India's own fine-art traditions, the policy had a disastrous effect. When current Indian art was shown at the Paris Universal Exhibition of 1878, one critic deplored the 'mongrel articles' which resulted when the British insisted on 'getting the natives all over Western India to imitate the hardware jugs of Messrs Doulton'.

Ultimately, though, the Raj's influence could not destroy the resilience of indigenous tradition. And the errors committed by British paternalism are now being handsomely atoned for at the V & A. The achievements of Indian art will be disclosed by the Nehru Gallery with a splendour which should prove a revelation to many visitors. Moreover, an ambitious educational initiative has been launched alongside it, to ensure that the museum becomes a lively national centre for the study of Indian culture as a whole. Colonialist scorn is here being replaced by open-minded enthusiasm, and it deserves support from anyone who cares about the enhancement of interracial understanding in Britain today.

NORMAN FOSTER'S SACKLER WING
29 April 1991

When the Royal Academy broke the inflammatory news that Sir Norman Foster would be redesigning part of Burlington House, many conservationists were aghast. What would Foster, the High Priest of High Technology, perpetrate within a building that owes its identity to the previous three centuries? The Victorian Society was particularly upset about the demolition of the staircase leading up to the old Diploma Galleries. Why did the Academy, with Prince Charles prominent among its trustees, let such destruction mar these hallowed premises? The full answer will only become clear on June 10, when the Queen opens the new Sackler Galleries and the accompanying redevelopment. But after donning a hard hat and crawling my way cautiously up half-finished flights of steps, I had a sneak preview of Foster's controversial design.

My tour began right at the top, where the old Diploma Galleries used to be. Despite the cacophony and dust generated by building work, the transformation is already spectacular. With typical audacity, Foster has created an entirely new reception area where once there was open sky.

By opening up the light-wells to public use, Foster has enabled the classical garden front of Old Burlington House to become visible again. Lost windows have been reinstated, along with the rusticated finish to the ground floor. Visitors using both lift and staircase will be treated to delightful glimpses of Lord Burlington's mansion, while fourteen feet away the richly decorative brickwork, blind arcading and 'oeil-de-boeuf' niches of Smirke's façade have also been revealed. In this highly charged space, three very distinctive architectural styles therefore confront one another. Foster's late modernism holds its own with innate grace in such distinguished company, proving that contemporary architecture can indeed live congenially with the styles of the past. Piers Rodgers, the Academy's Secretary, points out with satisfaction that 'when you go into the space between the two buildings, with its lightness and transparency, you realise that you are outdoors'. Foster's ability to preserve this essential airiness is a measure of his quality as an architect, and I predict that his agile blending of ancient and modern will win converts even among the most disgruntled and zealous guardians of tradition.

A MUSEUM OF MODERN ART FOR IRELAND
25 May 1991

A gnarled wooden beam runs up the side of the white, sloping ceiling in Declan McGonagle's office. But it is countered by the clean horizontal thrust of a steel girder, painted an unabashed scarlet. The juxtaposition is startling, and sums up the extraordinary challenge confronting the man who occupies this room. For McGonagle has been charged with creating the Irish Museum of Modern Art in a seventeenth-century Dublin building, erected at Charles II's behest as the Kilmainham Royal Hospital for retired and infirm soldiers.

This ambitious venture has already aroused vigorous controversy. Architectural purists are worried about the propriety of converting the most important Irish building of its period into a showcase for the shock of the new. Devotees of art, accustomed to visiting Dublin's other museums and galleries in the city centre, fear that the Royal Hospital's location on the outskirts may prove a handicap. Other sceptics wonder how on earth a Museum of Modern Art can build up a substantial collection, saddled with a niggardly annual purchasing grant of £250,000 for its first

139. Irish Museum of Modern Art, Dublin

year and only £100,000 per annum after that. Since the world auction record for a twentieth-century painting stands at $51,895,000 (paid in 1989 for Picasso's *Les Noces de Pierette*), McGonagle's powers of acquisition seem desperately limited.

He refuses, however, to be downcast about financial constraints. A quick-thinking and famously voluble thirty-eight-year-old, who always relishes the opportunity to put his case with conviction, McGonagle remains unshaken in his instinctive optimism. When I pointed out that the Irish government has only given a £3½ million grant to celebrate Dublin's current status as the European City of Culture, he argued that it would have been wrong to compete with the £32 million spent last year by Glasgow. 'In the long term,' he said, 'Glasgow's lavishness might come to be regarded as the end of a process rather than a beginning. But we still have a sense of unfinished business here in Dublin, and it doesn't follow that you can only do interesting things with loads of money.'

As if to prove that an exciting programme can be produced on a shoe-string budget, McGonagle has lined up some impressive attractions for the museum's opening. The lack of a historical collection will be temporarily solved by the loan, from the Van Abbe Museum in Eindhoven and The Hague's Gemeentemuseum, of classic paintings by Picasso,

Mondrian, Braque, Delaunay and Miró. Contemporary masters like Ellsworth Kelly, Sol LeWitt and Richard Serra are included in a group of works borrowed from Klaus Lafrenz's collection in Hamburg. And an array of younger artists, including Richard Deacon, Pat Steir, Antony Gormley and Magdalena Jetelová, will be displaying recent work or new projects made specifically for the museum.

Although the selection of current art is broad in its sympathies, embracing the serene rigour of Richard Long as well as A. R. Penck's hectic neo-expressionism, McGonagle maintains that it is 'unified by the idea of questioning either the art work itself or what a museum is'. His conspicuous energy is fuelled by a continual sense of restlessness, and he bluntly declares that 'I'm not interested in running a museum in the old sense of the word'. That is why, paradoxically, the Royal Hospital suits his purposes far better than custom-built contemporary architecture would have done. 'Lots of people have said that a classical building like this is completely inappropriate for a modern museum,' he admits, 'but I think we have to engage with all the historical meanings here. It's better than housing art in the redundant idea of the clean white gallery box, which removes all social references from the work on display.' McGonagle abhors the tendency to sanitise modern art within a sealed-off sanctum, and he believes that 'the question on the agenda now is this: are artists able to deal with social meaning? My job is to lay their ideas in front of a public that can engage with them.'

Such a stance is radically distanced from the traditional, genteel notion of displaying art in a select area of town. McGonagle likes the geographical remove of his new domain, far away from the Georgian elegance of Merrion Square where the National Gallery of Ireland is situated. 'This is a privileged building in an underprivileged part of the city,' he explains. 'Much of the housing round here was built for the railway workers. If we don't make the museum appeal to this local community, as well as to the gallery-goers of central Dublin, we won't deserve public resources at all. The minute that government money becomes involved, we have to accept the widest possible responsibilities.'

So McGonagle refuses to see the magnificence of the hospital architecture, and the forty-eight acres of parkland surrounding it, as a retreat from the world beyond. 'This museum is a function rather than a building' he insists, describing it as 'a porous structure where energy flows in and out continually'. While acknowledging that an opportunity was lost for ever when Dublin failed to build up a representative collection of modern art earlier in the century, he regards the flexibility of the sprawling hospital site as an enormous advantage. 'If a modernist temple had

been built in the middle of Dublin five years ago, it would be obsolescent by now,' he maintains. 'Here we've got room to manœuvre, to be supple and reinterpret what curatorship can be.'

Looking round the building and its environs with McGonagle, I could see precisely why he felt so positive. The hospital's original architect, William Robinson, was inspired by the Invalides in Paris and based his design on a grand, harmoniously arcaded courtyard. The main galleries run round three sides on the first-floor level, providing a continuous flow of high and surprisingly wide corridor space where even the most monumental images could be displayed with ease. Leading off this exceptionally handsome thoroughfare, doorways give access to pairs of rooms which once served as living and sleeping quarters for the hospital's occupants. Fireplaces have been removed and floorboards covered with grey cushion vinyl, but the attractive human scale of the rooms has been retained. When the heritage lobby accused him of destroying the building's character, McGonagle's reply was firm. 'This hospital has been through considerable vicissitudes since its completion in the 1680s,' he explains, 'and so there was no question of restoring it to the original interior anyway. I agreed with the architect of the conversion, Shay Cleary, that the job was to open the building up while respecting its identity.'

On the ground floor, where some rooms will serve as bookshops and video areas alongside the galleries, more of the fittings have been retained. As for the hospital's two grandest spaces, the chapel and the dining hall, their interiors are far too important to be altered at all. Original full-length portraits of Charles II and his court still line the dining hall, and conferences will be held here to supply the museum with a substantial revenue. Since the ornamental plasterwork and wood-carving in the adjoining chapel is even more resplendent, McGonagle admits that artists could not compete with the lavishness of the existing decoration. All the same, he might allow temporary drawings to be executed on the limited amount of bare wall-surface. Otherwise, seminars and lectures will be held here as often as possible, for McGonagle believes the campus atmosphere of the hospital will make it an ideal setting for educational and artist-in-residence schemes of many different kinds.

He is convinced that no arbitrary limits should be set on the museum's potential audience. As well as continuing the concert programme already held in both chapel and dining hall for some years, McGonagle wants to introduce contemporary music and invite composers, theatre directors and writers to work here. He is also determined to make the museum a place for the entire Irish nation. Although heartened by Peter Brooke's current negotiating initiative with all the political rivals fighting

over the country's future, he argues that 'culture is now more important than politics. Seen in the context of European unification, our border division won't mean anything. Very few people now believe that violence has a role, and the killing is just a reflex action.'

McGonagle's views on the troubles carry the conviction of a man who, until now, has lived in Derry for most of his life. The son of a plumber who later became President of the Irish Congress of Trades Unions and a Senator in Irish Parliament, he grew up at a time of accelerating sectarian tension. During his student days at Belfast College of Art in the early 1970s, 'there were horrific bombings going on. I remember painting incredibly violent images as a reaction to the troubles.' He abandoned his own ambitions as an artist soon after becoming Director of the Orchard Gallery in his native city. But McGonagle has never forgotten how artists see the world, and he remains the least bureaucratic of museum men. His extraordinary success in establishing Derry as an international centre for adventurous art led to his nomination for the Turner Prize in 1987, the directorship of the first Tyne International Exhibition last year, and ultimately to his present job.

The move to Dublin has been a wrench for his two young children, who miss 'our huge extended family in Derry. But it's not strange for me to come down here, because Derry is a Catholic city and has always looked southwards for its allegiance.' At the moment, McGonagle is getting up at 5.30 or 6 o'clock every morning, simply in order to ensure that everything is finished in time for the opening. Although his fingernails are deeply bitten, he seems utterly confident. 'I hope that the sheer speed of the thing means we can hit the ground running', he says, 'and build up such a head of steam in the early period that people won't ever want to do without it.' He aims to establish nothing less than a museum of world class here. 'There's always been a feeling in Ireland that we see life at second-hand, and operate on the periphery,' he points out. 'I want this place to be at the centre of something, providing first-hand experience. The potential is there for a broad public involvement with contemporary art. I would like this institution, and the work it houses, to become a part of people's lives. We'll discover the means to achieve that end as we go along.'

THE SAINSBURY WING

22 June 1991

As I entered the National Gallery's Sainsbury Wing for the first time, my excitement was countered by an inescapable sense of dread. Would the interior of Robert Venturi's building turn out to be as dismal as the last extension, an anonymous concoction by government architects who enclosed the German and Flemish pictures in a stultifying sequence of narrow, tomb-like rooms? Adverse surroundings can gravely impair our response to even the greatest paintings, and the Sainsbury Wing provides a new home for the rarest and most sensitive of all the gallery's possessions: the Early Renaissance collection. So were Van Eyck, Uccello, Bellini and Leonardo doomed to be incarcerated in yet another charnel-house, fit only for snuffing out the masterpieces it was intended to enhance?

Since the tour began with a descent to the lower floor, where the architect gave an introductory address in the Lecture Theatre, my forebodings about dungeons intensified. Venturi himself stressed the complexity involved in accommodating a variety of functions ('one-third galleries, two-thirds services') within a structure which 'had to fit an awkward, medieval-shaped site'. It sounded like a daunting brief, but he went on to talk reassuring good sense about the importance of an unslavish respect for context. Referring with reverence to the challenge posed by the rest of Trafalgar Square, he described his building as 'the last family moving into the block, and it was inspiring. All the elevations on the Sainsbury Wing are different because they relate to the different areas around them.' Hence the extraordinary stylistic fragmentation of a design which would not make much sense without the generating presence of the buildings around it. Above all, of course, Venturi saw his façade as 'a coda to Wilkins' – the architect of the original gallery next door. So I hoped that he had adopted an equally responsive attitude towards the paintings he had been commissioned to rehouse.

My optimism was not buoyed up by the next stop on the tour. Down in the basement, a suite of Temporary Exhibition Galleries has been installed to facilitate the staging of larger loan shows than the old building permitted. The varying sizes of the six rooms give flexibility, catering for the very different demands of the paintings it will display. These windowless spaces are, however, chilling in their clinical severity. The plain, off-white walls seem as dispiriting as the grey skirtings, and will surely provide an unsympathetic background for the first loan show: a

predictable-sounding survey of the Queen's Pictures scheduled to open in October.

Why was the chance to build a far bigger space not seized? Then the National Gallery would at long last have been equipped to stage temporary shows on the grand scale, vying with the premises boasted by the Royal Academy. London is short of fully modernised galleries capable of handling ambitious, blockbuster surveys. So the modesty of these six rooms is a lost opportunity, and the miniature dimensions of the nearby cinema positively eccentric. At peak viewing hours the National Gallery attracts enormous, sports-stadium crowds. How will their needs be met by this toytown auditorium, with its eight spartan benches ranged in front of a little screen? The possibilities opened up by video, film and audio-visual presentations are bound to expand hugely in future, but they have not been anticipated here.

The failure seems all the more unaccountable when compared with the accelerating monumentality of the building above ground level. A surprising cluster of blue-painted pillars in the Egyptian style, apparently inspired by Venturi's regard for the work of Wilkins's contemporary 'Greek' Thomson, give one side of the entrance foyer a quirky character. But the main impact of the space is supplied by a row of conspicuously fat stone columns. Along with the magisterial rustication on the east wall, they prepare visitors for greater amplitude in the Grand Stair above. As I began to mount its charcoal-black granite steps, the full spectacular scope of Venturi's design suddenly became clear. For the steps curve round to the left, confronting climbers with the colossal height of the main stairwell. It is an unashamedly theatrical experience. Light from an immense wall of glass irradiates the whole of the right side, through which the old National Gallery is revealed in all its classical stateliness. Venturi's concern for context is put into full-blooded practice with the advent of this gigantic panorama. Another architect might well have wanted to block out all awareness of the Wilkins building, and concentrate on asserting the uninterrupted identity of the new. Here, by contrast, Venturi revels in juxtaposing the past with his own, deliberately heterodox alternative.

The ceiling of the Grand Stair is embellished with eight steel trusses, each weighing around three tons. They are redolent of the great age of Victorian railway-station vaulting, and yet the gap separating them from the walls and roof declares their purely ornamental role. These capricious trusses raise functional expectations only in order to deny them, thereby revealing the strain of Mannerism which runs through Venturi's work. But even as he revels in flouting the rules imposed by stylistic consistency,

this unpredictable architect finds room to honour the true heroes of his building. As if to propel us on our journey up the wide steps, a resounding roll-call of Renaissance masters is incised in the limestone wall opposite the glass expanse. The frieze flows majestically forward in a twenty-five-metre-long sequence, sharpening our expectations as it spells out the promise inherent in names as irresistible as Duccio, Masaccio, Mantegna and Piero.

Half-way up the staircase, any visitors prematurely tired by their ascent are invited to pause, turn left and enter an area containing a coffee bar and brasserie. Seating only thirty-five, either on stools or at granite-topped tables, the coffee bar seems perversely small. Queues are guaranteed to form for the service it provides, whereas the 150-seater brasserie is more sensibly related to potential demand. Its low ceiling offers an intimate ambience after the overwhelming immensity of the Grand Stair. But anyone who penetrates the interior will soon discover that the black-framed windows offer widescreen views of Trafalgar Square beyond. In the National Gallery's old restaurant, which will continue to offer its familiar self-service meals, no such use is made of the city outside. Only from Wilkins's columned portico can the visitor savour one of the most inexhaustible prospects London affords, from the fountains and Landseer's lions right down Whitehall to the towers of Parliament. Now, finally, the multifarious pleasures of Trafalgar Square are made visible within the gallery as well. It is an invigorating spectacle, and Venturi celebrates it at the far end of the brasserie by suddenly raising the ceiling to a giddy height.

The ability of windows to combat claustrophobia, and connect the rarefied museum atmosphere with the exterior world, is exploited in the picture galleries themselves. As we climb the upper reaches of the staircase, several tall windows, echoing the elegant proportions of their counterparts in Wilkins' building, punctuate the limestone wall. They give enticing glimpses of the paintings displayed inside, and show how readily Venturi complied with the National Gallery's desire to avoid sterility by admitting a generous amount of natural light.

Just how well he succeeded is disclosed at the top of the stairs, where a bridge joins the new wing to the old gallery. On the left, the first long vista of the Renaissance rooms unfolds in front of us. It is a magical sight. Although Venturi indulges in some Mannerist trickery, by breaking the elongated archways in the first two rooms with horizontal intrusions, it does not detract from the overall mood of cool, airy clarity. The vista is brought to a breathtaking conclusion, on the end wall of the fourth room, by Cima's great altarpiece *The Incredulity of St Thomas*. It looks uncannily lucid in this setting, and the round-arched windows of the

chamber inside the painting chime to perfection with Venturi's curved archways. Art and architecture fuse in an unforced yet sublime union. Unlike so many modern galleries, the spaces here really do look as if they have been designed expressly for the images they contain.

Although most of the rooms are very high, they never threaten to dwarf their exhibits. Towards the top, the walls slope inwards before rising to clerestory windows filled with the glow of indirect daylight. This ingenious device prevents the gallery-height from becoming oppressively awesome, for Venturi realises that it would be unacceptable to upstage the paintings with an excess of drama. The emphasis throughout is on limpidity and absolute concentration. While providing spaces capacious enough to accommodate throngs of people, the entire suite of galleries acknowledges that many of these pictures were meant to be seen in relative intimacy. Their richness of detail could only be properly appreciated close-to, and the smaller panels were often intended for private devotion. So the grandeur of a Tuscan palace had to be combined with the intensity of an area set aside for private prayer.

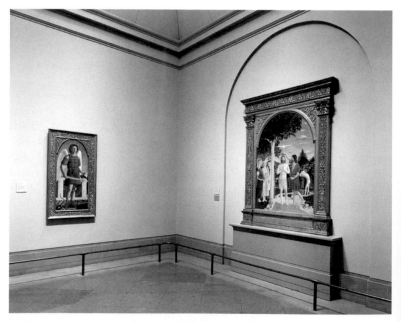

140. Robert Venturi's Sainsbury Wing: The Piero Room, National Gallery, London

The wonder of the galleries springs directly from Venturi's capacity to achieve both these aims without any undue sense of strain. They might well have conflicted, but he performs the balancing-act with the deftness of a seasoned performer. Utter imperturbability is the prevailing mood, aided by a colour-scheme refreshingly removed from the florid backdrops favoured by our more ostentatious gallery directors. The pale grey emulsion used on the walls, and specially mixed for the purpose, could easily have seemed chilling or dour. Its austerity is unalleviated by the *Pietra Serena* (Italian grey sandstone) deployed in the skirtings, margins and door surrounds, but this chaste environment turns out to be an ideal foil for the chromatic splendour of the pictures themselves. In room after room, I seemed to be seeing even the most familiar of quattrocento images as if for the very first time. Well-preserved paintings from that period are notable for the embossed magnificence of their gold grounds, upon which the carefully prepared pigments sing out with unparalleled resonance. Sassetta's series of panels depicting the life of St Francis look particularly piquant, while the orchestration of Lorenzo Monaco's great altarpiece of *The Coronation of the Virgin* is as refulgent as a rainbow.

Time and again, the walls appear to be tailor-made for the paintings they bear. The frozen pageantry of Uccello's *Battle of San Romano* has been given the ideal amount of space to breathe in, and the smaller polygonal room beyond is subtly attuned to the quieter, cabinet-size delights provided by Campin, van der Weyden and the incomparable Arnolfini marriage portrait. I welcome the decision to integrate the early Netherlandish masters with Italian art of the same century. Shared connections between schools of painting are more rewarding to study than conventional divisions dictated by nationality alone. The new wing dispenses with such boundaries, and it also gives painters from Ferrara and the Marches a more prominent place in the mainstream story of Renaissance art. They always seemed unfairly tucked away in the old gallery, whereas here Crivelli, Cossa and Cosimo Tura now prove beyond question that they deserve to occupy a major room. Their wirily defined work looks authoritative, and the space they inhabit inaugurates the central run of galleries where graceful round arches lead through to Raphael's tall, climactic crucifixion altarpiece on the end wall. Although it was painted for the chapel of a church in Città di Castello, it looks absolutely at home in Venturi's felicitous surroundings.

This time, he appears to have been inspired by Soane's arched openings at the Dulwich College Picture Gallery, and the result is a triumph. For me, however, the greatest revelation came in one of the smallest rooms. It contains just three pictures. But since they were all painted by

Piero della Francesca, this modest space becomes more momentous than a hundred larger galleries elsewhere in the world. Never before have the National Gallery's Pieros been given a chamber of their own, with one painting nobly presiding over each of the main walls. Their unwavering serenity charges Venturi's architecture with a trance-like stillness. It is the most potent roomful of paintings in London, and the memory of relishing its contemplative calm makes me impatient to return.

MILLBANK MUDDLE
7 September 1992

Imagine, for a moment, that you are paying your first visit to London from abroad. Having heard about the exceptional range and quality of the city's museums and galleries, you naturally expect to find a Museum of Modern Art worthy of a great metropolis. But a trip to Millbank ends in disappointment and incredulity. Instead of a landmark building custom-designed for twentieth-century work, you find a Victorian structure originally intended as the National Gallery of British Art. And inside the ornate portals, Picasso and the other icons of modernism are expected to fight for display-space with Tudor portraits, Georgian sporting scenes and the Pre-Raphaelites.

How on earth did we arrive at this preposterous state of affairs? The answer can be traced back to 1897, when the sugar magnate Henry Tate presented the building and his own collection of paintings to the nation. He dedicated the gift to 'the encouragement and development of British art, and as a thank offering for a prosperous business career'. Over the next twenty years, the Tate Gallery served the donor's purpose: the collection only encompassed British painters born after 1790. But in 1917 the gallery expanded in two directions, enlarging its coverage of British art to embrace all periods and, with sublime illogicality, becoming the National Gallery of Modern Foreign Art as well.

At that stage, when the twentieth century was still young, this role-confusion may have seemed excusable as a temporary, wartime measure. As the two collections mushroomed, however, the inherent madness of its double identity grew embarrassing. No gallery should be expected to pursue such divergent aims under a single roof, and by the 1930s their incompatibility was clear enough. By rights, the decision should then

141. Henry Tate reading his dedicatory address at the Tate Gallery, London (from *Daily Graphic*, 22 July 1897)

have been taken to split the collections into two separate institutions – each with its own building, staff, exhibition policy and purchase grant. But governmental inertia, combined with a niggardly and philistine reluctance to spend taxpayers' money on visual art, ensured that nothing was done. Starved of funds and grotesquely overcrowded with acquisitions, the Tate limped into the second half of the century pathetically ill-equipped to fulfil its burdensome responsibilities.

We are still suffering from the consequences of that mistake today. Extra space has been added to the original structure – most notably, a suite of rooms for loan exhibitions, and a gallery which tried at last to honour Turner's bequest well over a century after he left his pictures to the nation. But no attempt has been made to seize the initiative and acknowledge that the Tate's dual function is no longer tenable. Instead,

the two collections have grown to the point where only a small fraction of the works can be displayed at any one time.

The present energetic director, Nicholas Serota, decided to make the best of his congested inheritance by adopting a policy of regular rehanging – thereby guaranteeing that some, at least, of the riches languishing in store received a temporary airing. Combined with a much-needed redecoration of the principal rooms, and an insistence on giving every exhibit apart from the Victorian paintings more space to breathe in, Serota's ingenious rotational scheme has proved both refreshing and intelligent. By now, however, it is beginning to offer a painful reminder of how unacceptable the Tate's role has become. With each new rehang, vitally important aspects of the collection are taken off the walls and sent, once again, to the ignominy of the storage-room.

Unlike the National Gallery, where the so-called reserve collection is on permanent display, the Tate is obliged to shut the banished works away from everyone except the diligent enquirer. Anything can be viewed if you are prepared to make an appointment well in advance. But do not imagine that the work is necessarily housed in the Millbank basement. The Tate's unseen holdings are now so immense that many of them have spilled over into stores elsewhere in London – including a melancholy structure at North Acton, where I once found rack upon rack of pictures stretching away in a vista of nightmarish proportions.

By denying all these possessions public visibility, the Tate is failing to carry out its fundamental duty to the artists who produced them. Nobody making a painting or sculpture would want the result to end up incarcerated in darkness, unable to give pleasure to anyone. Enterprising attempts have been made to release some of the captives, and send them off to exhibitions at the Tate's dockland gallery in Liverpool. Further consignments will be sent, next year, to another new outpost at St Ives, and there is talk of a Tate for East Anglia as well. But none of these welcome strategies can hope to rectify the overall imbalance between the seen and unseen elements of the collection. Only one measure can overcome the crisis. The Tate should be cut in two. While the collection of historic British art is left in the present building, the modern collection must be installed in new premises with its own director and a wholehearted commitment to the finest achievements in twentieth-century art alone.

Objections will, no doubt, be raised to such a proposal. Some Tate *habitués* relish the proximity of Hogarth and George Grosz, or Dante Gabriel Rossetti and Stanley Spencer. They savour the unexpected connections between one collection and the other, speculating about a possible kinship linking (say) Turner and Rothko. Other devotees may

well question the Tate's ability to find a site for a new Museum of Modern Art, let alone the money to fund the building in these recession-harried times.

But I am convinced that there is no viable alternative to dividing the collections completely. The longer we allow the Millbank Muddle to continue, the more we will be guilty of betraying the works of art amassed there. None of the gallery's directors made their acquisitions in order to give them a life-sentence of imprisonment in the vaults. No benefactors would wish to see their gifts undergo a similar humiliation. When art becomes invisible, it ceases to have any effect. Well over 20,000 images are condemned to obscurity by the Tate at the moment, and they do not deserve such appalling treatment.

As long as the present nonsense is allowed to prevail, everything suffers. The Tate owns an unrivalled collection of twentieth-century British art, but never has the room to place the full range of this home-grown achievement on view. Although the representation of foreign art during the same period is far less comprehensive, it would likewise benefit hugely from transferral to a special building which proclaims Britain's unequivocal involvement with the present rather than the past. In this new context, the collection's many gaps will no doubt appear more glaring. But a fully fledged Museum of Modern Art would at least have a greater incentive to fill those gaps before it is too late. And the staff would be able to devote their entire exhibition programme to the twentieth century – instead of leaping feverishly from Constable at one moment to Gerhard Richter the next. The Tate is far too wedded to retrospectives, and the new gallery would be able to stage more shows of recent work by younger artists whose contribution is at its most vital today.

While so many major continental cities regard a Museum of Modern Art as a cultural necessity and a source of excited pride, we lag far behind. Paris has been benefiting from the runaway popularity of the Pompidou Centre for well over a decade, and countless German cities boast distinguished buildings devoted single-mindedly to the art of the present century. London's failure to provide a stunning counterpart, designed by one of the many British architects who now enjoy international reputations, amounts to nothing less than a national disgrace. The Tate's trustees should procrastinate no longer. They must take the bold decision to end the insanity and liberate their shackled collections forthwith.

THE HENRY MOORE INSTITUTE
16 April 1993

During the twentieth century, British sculpture has enjoyed a flowering of vitality unparalleled since the Middle Ages. But the sculptors who played a leading role in this latter-day renaissance often suffered from a dispiriting amount of hostility. Jacob Epstein was continually vilified, and some of his finest works were vandalised beyond repair. Even Henry Moore, despite extraordinary fame and wealth in later life, received greater acclaim abroad than in his own country. Surprisingly few of Moore's major sculptures were commissioned for public spaces in Britain, and detractors were always ready to mock and minimise his formidable achievements.

Realizing that a gulf of understanding separated modern sculpture from its potential audience, Moore decided in 1977 to establish a Foundation. The aim was 'to advance the education of the public by the promotion of their appreciation of the fine arts, and in particular the works of Henry Moore'. Since then, the practice and study of sculpture in Britain has benefited hugely from donations made possible by the Foundation's capital fund of around £50 million. Under the energetic guidance of the Foundation's Director Sir Alan Bowness, artists' fellowships, postgraduate bursaries, exhibitions, museum purchases, university lectureships and gallery extensions have been made possible throughout the country. At a time when government funding has become so derisory, the Foundation's support is more vital than ever. And on 22 April a particularly promising initiative will open in the centre of Leeds: the Henry Moore Institute, a £5 million custom-built international centre for sculpture designed by Jeremy Dixon and Edward Jones.

Positioned in the city where the Yorkshire-born Moore produced his first student works, the building occupies space formerly inhabited by three Victorian wool merchants' houses. They have been adapted, with admirable sensitivity, to the needs of an Institute where world-class exhibitions and the scholarly study of sculpture are both important priorities. Conscious of the need to arrive at a balance between preserving the original structure and creating an independent character for the new building, Dixon and Jones honoured the context even as they introduced bold forms of their own. No attempt has been made to hide the cut in the terrace at the end of Cookridge Street, made years ago when the city's central square was enlarged. But the raw, unsightly party wall has now been largely covered by a large, vertical slab of dark, polished granite.

As pared-down as a minimalist sculpture, the wall is fronted by an equally unadorned sequence of rough-textured, granite steps. They lead up from street-level to a dramatically high, thin door set in the polished wall. Described by the architects as 'a tall, eccentrically placed slot', this arresting entrance provides the exhibition galleries with a shallow, stepped passage which acts as a foil for the sudden expansion of space within.

At the heart of the white, well-proportioned rooms where the loan shows will be held, Dixon and Jones have created a chamber which deserves to be ranked among the most beautiful exhibition rooms in the country. By filling in an open-air courtyard, once used as a car park, they have produced a top-lit, two-storey gallery capable of housing even the most imposing objects with ease. Artists, I suspect, will relish the chance to show here. Flooded with daylight and unusually serene, it is bound to enhance whatever is placed on display. The American pioneer of Minimalism, Sol LeWitt, plans to make a grand cinder-block piece specially for the space in August.

Before then, though, the Institute will inaugurate its exhibition programme with a survey of Romanesque stone sculpture. The idea of devoting the first show to medieval carvings may surprise those who associate the Henry Moore Foundation only with twentieth-century enterprises. But the Henry Moore Sculpture Trust, set up by the Foundation in 1988 as its northern base, has a far wider brief. Robert Hopper, Director of the Trust and now operating from headquarters at the Institute, explains that 'the choice of a Romanesque show makes the point that we're about sculpture of all periods, not just the contemporary'. Although the Trust has staged an imaginative and even audacious series of one-person shows at Dean Clough in Halifax, its Deputy Director Ben Heywood is a graduate in Medieval Studies from the Courtauld Institute. 'Ben knew about the 13 figures from the west front of York Minster,' Hopper says. 'They were removed in the 1960s and stored unseen in the crypt. So the Foundation gave some money to restore them, and they will now form the focus of a public exhibition for the first time in our new gallery'. A man well able to convey infectious enthusiasm for the venture, Hopper is enormously excited by the prospect of placing these full-length carvings in the main room. 'It'll be like walking into a forest of Giacometti figures,' he predicts. 'They'll be standing there, establishing a one-to-one relationship with you in a very inspiring way. Moore himself was equally enthralled when he encountered the great Giovanni Pisano carvings, after they had been taken down from Pisa Cathedral and displayed very simply in the Baptistery'.

142. Robert Hopper at the Henry Moore Institute, Leeds, by Dixon Jones

Together with some outstanding panels from a frieze once installed on Lincoln Cathedral's façade, and similarly never exhibited since, the York carvings will demonstrate the richness of twelfth-century sculpture in this area of the country. 'We want to remind people that there are wonderful pieces of work out there,' explains Hopper, 'and that they're at the mercy of the elements and budget cuts. Lots of church memorial carvings are in a perilous state, and neither the museums nor English Heritage will get involved. So what can the cathedrals do? Where can they put them? This show will emphasise that they must be saved and made visible.'

But the Trust's crusading concern for the plight of our great medieval carvings will not lessen its commitment to living sculptors. When the Romanesque show opens in Leeds, the distinguished German sculptor Ulrich Rückriem will be displaying a sequence of new carvings within the ruins of nearby Kirkstall Abbey – a building normally closed to the public. Hopper is also eager to point out that, at the same time, an Eric Gill retrospective opens in the Henry Moore Sculpture Galleries at Leeds City Art Gallery, now linked with the new Institute by a bridge. And only a short journey away, at the Yorkshire Sculpture Park near Wakefield, a large exhibition of carvings by the contemporary Danish sculptor Jorgen Haugen will be presented in the extensive grounds.

Hopper is keen to work with these neighbours on future projects, and rejoices in the fact that the Institute gives the Trust's headquarters a catchment of fourteen million people within a one-and-a-half-hour drive. But he also points out that 'we're not looking for overnight success and immediate returns. Everyone wants to be liked, of course, but we're interested in serious, long-term goals rather than staging razzle-dazzle, blockbuster entertainments. The Institute isn't monolithic: we've got a very small staff and a relatively modest building. We want to go out into Europe and link up with other, equally independent institutions.'

Defining international as well as local objectives, Hopper hopes that anyone interested in the exhibitions held at the Institute will go upstairs and consult, free of charge, the Henry Moore Centre for the Study of Sculpture on the first floor. Moved from the City Art Gallery next door, it boasts major archive, book and laserdisc facilities which amount to one of the best-equipped specialist art libraries in Britain. Moore himself would have been delighted to see how public appreciation of sculpture can now be furthered at the Institute, and Hopper is looking forward enormously to next week's opening. 'But I'm very superstitious', he adds, 'and I'm clutching every piece of wood I can find – sculptural or otherwise.'

ANDY GOLDSWORTHY AT HAREWOOD'S NEW GALLERY
28 May 1993

Trying to find contemporary art in stately homes is usually a futile exercise. Most of their owners seem content to display hallowed collections formed centuries ago, as if the making of painting and sculpture had long since become defunct. Occasionally, an involvement with a living artist's work disrupts the somnolent calm: at Chatsworth, the Duke and Duchess of Devonshire are enthusiastic patrons of Lucian Freud. But on the whole, a John Piper watercolour of the house and grounds is the most we can expect in these shrines to a hushed, imperturbable past.

At Harewood House, though, an adventurous spirit prevails. Right from the outset, in Robert Adam's resplendent Entrance Hall, a shock awaits the visitors. Standing in otherwise empty floor-space, Epstein's doughty alabaster carving of *Adam* flaunts his pendulous genitals on a

plinth sturdy enough to support his titanic weight. Half brazen and half apprehensive, the primordial figure presses his bunched hands hard against his chest and stares upwards. Epstein must have wanted him to commune with God, but here the muscle-bound progenitor seems transfixed by the neo-classical plasterwork ceiling. The first Adam is brought into direct, provocative contact with the work of his eighteenth-century namesake, and the encounter is alive with an almost surrealist incongruity. The Earl of Harewood rescued Epstein's colossus from a humiliating display at Blackpool, where *Adam* had been exhibited in a waxworks peep-show as a pornographic freak. By giving the sculpture such a prominent position, the Earl implies that twentieth-century art of the most unbridled kind deserves just as much respect as the Renaissance paintings on view elsewhere in the house. It is a bold and salutary gesture, proving that a resplendent mansion can become even more stimulating if its historic collections are augmented by modern acquisitions.

The greatest surprise at Harewood, however, is the Terrace Gallery, devoted to loan exhibitions. Recently converted from a gloomy interior, this sequence of white-walled spaces is ideally attuned to contemporary art. And that is precisely what the gallery's young director, Liz Smith, enjoys showing. Rather than playing safe, and only choosing artists guaranteed to chime with the old masters in the main part of the House, she has taken her cue from the challenge offered by the Epstein upstairs. If he broke robustly with the conventions of his day, Andy Goldsworthy extends the boundaries of sculpture in our time. Like Richard Long before him, Goldsworthy goes out into the landscape and works directly with the natural materials he finds there. By a coincidence, one of the first works he ever made in the countryside was sited on the Harewood estate. Goldsworthy remembers wondering if he might be arrested for his temerity. But now, over a decade later, he finds himself welcomed back and honoured in fine style as the Terrace Gallery's summer attraction.

The result is enormously heartening. A visit to Harewood House might easily be a museum experience, one more sampling of past glories to reinforce the image of Britain as a heritage theme park. But this gallery's commitment to new art makes the house part of living culture as well. The audiences streaming through stately homes guarantee that Goldsworthy's work will be seen, here, by a public far wider than his normal gallery following. Since some of the work is for sale, he might find fresh sources of patronage among the visitors. Nothing could be more congenial than the setting he has been given, in rooms leading out to an extensive view of Capability Brown's landscaping at its irresistible best. If

other great houses were to learn from the Harewood initiative, contemporary artists would benefit hugely from the exposure they received.

Not that the work displayed by Goldsworthy has anything to do with the English countryside. He made it all on a trip to Australia in July 1991, as artist-in-residence at Adelaide Botanical Gardens. The appointment probably arose from the realization that he handles leaves, feathers, petals, willowherb and fronds with intricate ease. But Goldsworthy had no desire to repeat himself, nor to linger in his host city. Writing in a diary of his journey, he observed that 'Adelaide in Winter with rain, heavy clouds, mist and green grass has a strong quality of Britain.' Seeking a different challenge, he headed for the bush. Driving to the Mount Victor sheep-shearing station, where he stayed for the rest of his trip, Goldsworthy was confronted by visual sensations wholly unlike anything he had encountered at home. The burnished intensity of the colours give the Harewood exhibition an immediate air of richness. Large, handsomely printed photographs burn on the walls with a hallucinatory force. And they demonstrate that Goldsworthy was prompted, on his lone expeditions into the bush, to place the action of light at the centre of the sculpture he produced.

Unlike Long, who often charts the day-by-day progress of epic walks in his photographic pieces, Goldsworthy never stresses the notion of journeying. But he shares Long's desire to work in harmony with particular locations, and time takes on a particular significance in his Australian work. The incandescence of sunset made him assemble a sculpture from Mulga branches, placing them end to end on the ground and edging them with sand. As he must have hoped, the sun seizes on this thin yellow line and allows it to curve and wriggle across the deeply shadowed earth. It resembles a glinting seam of gold, transforming the broken, discarded branches into objects charged with unexpected vitality.

The most impressive works on show, though, reduce manipulation to a minimum. Sand is used again in a piece involving a Mulga tree, but this time Goldsworthy had no desire to reshape its branches. Instead, he took his cue from a sudden burst of overnight rain. The sand was damp enough to be spread all over the tree's north side, making it stand out in the sun like a fiery apparition against the water-swollen darkness of the clouds massed beyond. The outcome is pungent and refreshing, especially in the photograph where Goldsworthy's lens closes on the tree and shows it leaping from the ground like a flame. To the left, a grey tree seems to reel sideways, as if startled by this explosive growth.

Most of the time, however, the bush light remained unhampered by rainstorms. It led Goldsworthy to make several photographs of a stone

cairn he had assembled in a rocky locale, proceeding from a purple-brown base through red and orange to a bleached apex. Cool in the morning, it turned by sunset into a glowing furnace before emitting an eerie yellow-whiteness in the moonlight.

Goldsworthy had no need to rely on different times of day and night for the strangest of all his Australian sculptures. On an empty expanse of baked earth, he laid clusters of Mulga branches in two contrasting directions. Alternating in a long path towards the horizon, they lie first in shadow and then reflecting the sun. The metamorphosis is uncanny. In the photograph, they look like two wholly different types of branch – one coal-black, the other off-white. But the same branches are used throughout, and the dramatic change in colour is brought about solely

143. Andy Goldsworthy, *Mount Victor, South Australia 92*, at Harewood's new gallery

by the action of light. The sense of wonder in this work augurs well for Goldsworthy's future development. In Australia the stimulus of discovery never left him, and the revelation of working there runs like an excited tremor through everything he made in this deserted, awesome terrain.

THE TATE OPENS AT ST IVES
23 June 1993

Until now, the prodigious amount of art produced in St Ives has been almost invisible to the town's visitors. True, Barbara Hepworth is celebrated in her superbly preserved home and sculpture garden. But to find the work of Ben Nicholson, Alfred Wallis, Peter Lanyon or any of the other artists who made St Ives such a powerhouse of modern British art, a trip to the Tate in London was necessary. And even then, the chronic space shortage at Millbank ensured that nobody could feel certain the St Ives school had not been temporarily confined to the basement.

This shameful state of affairs has been rectified at last. The new £3.3 million Tate Gallery St Ives, formally unveiled by the Prince of Wales today, opens its doors to the public on Saturday. Many of the paintings and sculpture created in this extraordinary Cornish centre have made the return journey from London, to be housed in a purpose-built showcase on the most delectable and dramatic site imaginable. Perched on a sheer cliff wall, the building commands spectacular views of the expansive Porthmeor Beach. So the architects, Eldred Evans and David Shalev, began with a huge advantage. But they also ran the danger of coming up with an anticlimax, a structure that failed to fulfil the grand expectations aroused by the location.

In the event, Tate Gallery St Ives meets the challenge with aplomb. While the beach curves in towards the place where the building now stands, Evans and Shalev's façade curves out to greet us with an irresistible welcome. Far too many museums are bunker-like buildings, determined to depress the visitors' spirits and shut out all nourishing contact with the world beyond. But this white, triple-tiered structure is hugely inviting. And its outward-looking mood is reinforced the moment we walk up the steps from beach level. Instead of finding ourselves enclosed by a forbidding interior, we enter a circular arena wide open at the front to the sea. People can easily congregate here, and

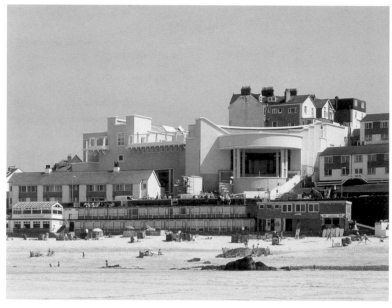

144. Tate, St Ives, by Eldred Evans and David Shalev

lounge on the stone seating ranged around it as in an amphitheatre. Performances, events and sculpture displays will doubtless be held here by the gallery. But the rest of the time, it can easily serve as a meeting place, or even a momentary shelter from the wind and rain.

The enfolding walls soon encourage you to go inside the building. Immediately after the small white pay-desk room, Evans and Shalev spring their first great surprise. In an otherwise empty chamber, saturated with a strange violet light, Patrick Heron's colossal glass window stages an ambush on the left wall. Over sixteen feet high, this exuberant colour-burst hits the retina like a shaft of Mediterranean sun. By using a new lamination technique, Heron dispenses with traditional leading and achieves an all-over intensity with pink, yellow and green dancing on a luminous blue ground. He is at his decorative best here, paying flamboyant homage to Matisse's late painted paper cut-outs. Evans and Shalev provide him with an ideal foil, restricting themselves to a purged simplicity on the rough-textured walls and plain stone floor.

Restraint prevails in the next room, where a solitary Hepworth carving in polished Connemara marble is lit by a large plain-glass window

on the left. Above, three circular windows repeat the curving form of the façade. They look like portholes, and suggest that the entire building is really an art-deco ocean liner waiting to be pushed down a slipway and launched on the Atlantic waves. Evans and Shalev certainly seem to be in love with modernist architecture of the inter-war years. Their gallery is riddled with forms reminiscent of Lubetkin's Penguin Pool at London Zoo, Odeon cinemas and the streamlined seaside pavilion at Bexhill in Sussex. But the unexpectedly narrow staircase leading up to the exhibition rooms introduces another source of inspiration: Charles Rennie Mackintosh, whose elongated ladder structures must have inspired the pale wood banisters. Once again, the purity of the building's bleached surfaces is contrasted with a work commissioned from a painter. Terry Frost's tall banner filled with whirling sun discs runs up through the stairwell, but it looks clumsy compared with the Heron window below.

At the top of the stairs, behind the information desk, another window provides a seductive prospect of the sand and sky beyond. It makes you appreciate how alive Evans and Shalev are to their location, how their adroit interweaving of narrow spaces and sudden, show-stopping views chimes with the character of St Ives itself. A steep double staircase leads up to the restaurant on roof level, where the entire bay unfolds from a wide outdoor vantage-point. But if you choose to enter the first picture gallery on the floor below instead, a low-ceilinged room establishes an intimate space for the earliest St Ives paintings. They transport us to the late 1920s, when Ben Nicholson and his friend Christopher Wood discovered the retired seaman Alfred Wallis on a day trip to the town. Captivated by the freshness of his untutored painting, on scraps of cardboard or even a pair of bellows, they acquired some examples and showed them to friends. Wallis's images of the harbour and sailing ships seemed childish to many, but Nicholson and Wood cherished his originality. They tried to arrive at a similar directness and simplicity in their own work – an ambition shared by Bernard Leach when he returned from Japan and set up a pottery in St Ives. Although the Tate does not collect ceramics, a range of work by Leach and his friends fills an immense glass case in the next space. Their limpid, oriental subtlety amounted to a revolution in English pottery.

But our attention is wrenched away from them by the most resplendent part of the gallery's interior: a curved concourse wrapped around the frontage, where sculpture by Naum Gabo, Hepworth and Dennis Mitchell is displayed on a handsome terrace. Visitors can either look down at them from the viewing balcony or descend to the concourse level. But the problem is that the glass walls give on to a stunning

panorama of the beach and water outside. Nature provides heady competition for art, and threatens to ruin our concentration on the gleaming bronzes and stone carvings within. Because these views are so compelling, the gallery will probably become very popular. After a while, though, Evans and Shalev's ability to provide such beguiling panoramas threatens to overwhelm the exhibits. We linger so long by the circular windows, waylaid by the generous space and seating, that the story of the St Ives school is broken. Finding our way back to the galleries proves surprisingly complicated, and some of the pictures look muted after the breathtaking views.

A roomful of quiet, gentle Hepworth studies of surgical operations leads on to a more ebullient gallery where Alan Davie, Heron and Nicholson stand out. The 1950s was the most confident decade for St Ives painting, and all three men reached their peak then. Heron is at his most tropical and sensuous in the broken brushwork of *Azalea Garden* while Davie's *Image of the Fish God* is a splendidly powerful canvas. As for Nicholson, he had by then fortified the spare geometry of his pre-war abstractions with a more robust feeling for the world outside the studio. The most impressive of the St Ives painters, he is under-represented here. All too soon, we reach the final room where Peter Lanyon and Roger Hilton represent the last, flaring brilliance of a school that failed to survive their deaths.

Karl Weschke's *Body on a Beach*, painted in 1977 after he had been saved from drowning, sounds an elegiac note. The body looks more like a corpse, and most of the colour has been drained from the surrounding landscape. The result resembles a lament for the passing of the town's artistic vitality, but at least St Ives can now celebrate its vanished golden age in style.

RICHARD WENTWORTH AND THE SERPENTINE GALLERY'S PLIGHT

14 December 1993

Everyone who cares about the survival of contemporary art in Britain will be shocked by the sinister machinations of Iain Sproat, the malevolent Junior Minister at the National Heritage Department. Until now, the Serpentine Gallery in Kensington Gardens has enjoyed a rent-free

existence. But Sproat is insisting that it should pay an annual levy of £60,000, index-linked to soar to £90,000 in five years' time. Such a Draconian imposition would threaten the gallery's very existence, but Sproat is implacable. He wants, unbelievably, to 'raze it to the ground and put in horse-riding facilities instead'. This disgraceful remark, which brazenly flouts the 'arm's-length' policy separating government from the arts it subsidises, could hardly have been aimed at a more inappropriate target. For the Serpentine, ever since its transformation from a genteel teahouse in 1970, has been cherished as a uniquely pleasurable showcase for art.

Most London galleries inhabit wholly urban settings, and display their exhibits in windowless rooms where nature cannot be glimpsed. Even at the Hayward on the South Bank, where extensive views are provided upstairs, prospects of the Thames are largely blocked by forbidding concrete hulks. But the Serpentine rejoices in its parkland location, offering limpid panoramas of the surrounding landscape at every turn. Walking past trees, lawns and water to reach the gallery removes us from the metropolitan frenzy, quickens the senses and induces a contemplative mood. No wonder the artists who show there find it such a refreshing experience, generating unexpected relationships between their work and the green idyll beyond.

The serenity, though, is deceptive. Soon after she became the Serpentine's Director in 1991, Julia Peyton-Jones realised that repairs were a pressing priority. The building had not been touched since it opened as a gallery, and the roof needed especially urgent attention. She decided to act, spurred on by her awareness that renovation ought also to improve facilities for visitors. The Serpentine's delectable position in a Royal Park means that the character of J. G. West's original 1934 design must be preserved. But John Miller and Partners, architects of the Whitechapel Art Gallery's successful renewal and the recently opened suite of rooms at the National Portrait Gallery, have produced a plan that combines conservation with an exciting expansion of the interior. If their proposals are implemented, three interior staircases will be removed. Space is thereby made available for an enlarged bookshop and a café opening on to the lawn. For the first time in a quarter of a century, tea will once again be served at the Serpentine. So will food, turning the gallery into a still more congenial place where visitors can meet, talk and rest themselves after viewing the exhibition.

At the moment, the Serpentine closes whenever a new show is being installed. But the renovation will ensure that it stays open all the year round. Miller wants to transfer the entrance from the north to the south

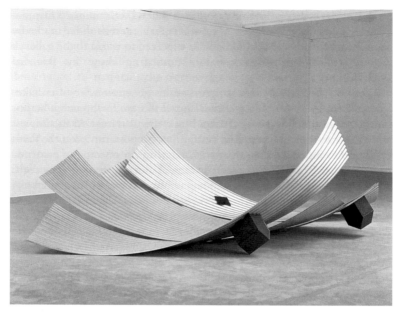

145. Richard Wentworth, *Mercator*, at the Serpentine Gallery, London, 1993

sheets resist any attempt to see them as parts of a globe, and the houses soldered on to them are overwhelmed by the surging motion of the sheets themselves.

Like so many artists before him, Wentworth is seen at his best in this lucid survey. It would be a tragedy if his intimations of catastrophe were fulfilled by the irresponsible manœuvrings of a politician who should, by rights, do his utmost to protect the Serpentine rather than threaten it with unwarranted destruction.

THE GREAT WAR: BERLIN AND LONDON

14 June 1994

I never dared to hope, when planning a large exhibition about art and the Great War, that Berlin and London would both play host to the show. After all, the Germans' attitude to that harrowing conflict differs sharply from ours. For them, the carnage of 1914–18 led to military defeat, a humiliating peace settlement and, ultimately, the national unrest which let Hitler unleash yet another war on a grievously battered Europe. Germany is still trying to come to terms with the guilt of Fascism and the Holocaust, so it might not have wanted to seize the chance of examining images of the First World War as well.

All honour, then, to Professor Christoph Stölzl, director of the Deutsches Historisches Museum in Berlin. When the Barbican Art Gallery approached him, wondering whether he would collaborate on just such an exhibition, his response was enthusiastic. He invited me to Berlin last year, along with the Barbican's enterprising gallery director John Hoole, to discuss the venture. The German public, he explained in his office on the Unter den Linden, knows far less about the Great War than we do. In Britain, the outstanding poetry spawned by the conflict is as familiar as the finest paintings by Paul Nash and Stanley Spencer. We have an excellent collection in the Imperial War Museum, whereas Berlin possesses no equivalent institution. Hitler hated any German artist brave enough to depict the horror of the First World War. He made sure that many of them, including Max Beckmann, Otto Dix, George Grosz and Ernst Ludwig Kirchner, were ruthlessly pilloried as 'Degenerate Artists'.

Rather than shying away from such a troubled subject, Stölzl relished the opportunity to shed fresh light on it. Two years ago, he was responsible for bringing to Berlin a major reconstruction of Hitler's infamous *Degenerate Art* exhibition. And now he committed himself to joining forces with the Barbican, on a show for which I have selected over 200 works by some eighty artists, from Europe, Russia, Canada and the USA. The building he secured for the exhibition is probably the most admired architectural masterpiece in Berlin: the celebrated Altes Museum, designed in the 1820s by Karl Friedrich Schinkel and recently restored to its original neo-classical grandeur. I cannot think of a more inspiring location for a survey that brings together two great cities who fought on opposite sides. The symbolic value of such an alliance, eighty years after the outbreak of the war, hardly needs to be stressed.

The heart of this exhibition, which has just opened in Berlin and travels on to the Barbican in September, is concerned with avant-garde artists determined to convey their experiences as powerfully as possible. Many of them were exposed to harsh conditions at the Front. And their growing awareness of the horror prompted them to question the widespread initial view that the war was a heroic adventure, certain to be 'over by Christmas'. They began to realise that the annihilation around them, and the prolonged military deadlock, were difficult either to understand or justify.

Their scepticism came to be shared by an increasing number of artists who, through infirmity, age or pacifist principles, stayed at home. As the casualties reached ever more sickening proportions, nobody remained immune to the losses involved. Doubt turned to pessimism, anger and even passionate opposition. Censorship occurred when artists working on state-funded commissions, like Christopher Nevinson in England and Max Slevogt in Germany, produced images which flouted government edicts about how the struggle should be depicted. Although some painters lapsed into anodyne banality when they became official war artists, others used the patronage as an opportunity to reveal the full, desolating reality of the killing fields. More, perhaps, than any other major international strife, the First World War had such a powerful effect on its participating artists that they produced an extraordinary range of eloquent work from the event. The primary emphasis in this show is on painters, sculptors and print-makers of stature, who forced themselves to forge a language capable of conveying their response to the suffering. A number of lesser-known artists are included as well, for the battle generated within them work far more intense than anything they would produce later in their careers.

Surprisingly enough, no attempt has previously been made to bring together and examine the international array of images elicited by the First World War. Studies exist of the art made in single countries, usually concentrating on official commissions; and monographs on leading individuals, like Chagall, Kokoschka, Léger, Malevich and Schiele, inevitably take their war periods into account. But nobody has devoted either a book or an exhibition to an assessment of the war art produced on both sides of the Atlantic. So the Berlin survey, coinciding with the publication of my book *A Bitter Truth: Avant-Garde Art and the Great War*, aims to make a start at redressing the balance.

Why do so many images of the Great War carry such a potent charge? One answer surely lies in the unprecedented ferocity of the struggle. The full, battering force of twentieth-century weaponry was unleashed during the conflict's protracted course, and the result made everyone revise their

THE AVANTGARDE AND

BILDER
DES
ERSTEN
WELTKRIEGES
A BITTER
TRUTH

DIE LETZTEN TAGE
DER MENSCHHEIT

THE GREAT WAR

DEUTSCHES HISTORISCHES MUSEUM

146. Poster for *Die Letzten Tage der Menschheit: A Bitter Truth: The Avant-Garde and the Great War*, Deutsches Historisches Museum, Berlin, 1994 (detail of Félix Vallotton's *Verdun. Tableau de guerre*, 1917, Musée de l'Armée, Paris)

preconceptions about the nature of modern warfare. Machine-age armaments produced in immense quantities by highly organised industrial nations were capable of annihilation, on a hitherto unimaginable scale. The spiralling human cost, amounting in the end to around twelve million deaths, soon came to seem out of all proportion to the infinitesimal military gains made on either side. The obscenity of what Ezra Pound condemned as 'the war waste', when he grieved over the death of his friend Gaudier-Brzeska, created a deep-seated sense of incredulity, anger and revulsion. Anyone with a potent imagination was bound to be affected, and the generation embroiled in the fighting contained an unusually high number of outstanding young artists.

For the outbreak of the First World War coincided with an exceptional period of ferment and vitality in Western painting and sculpture. The proliferation of avant-garde movements in the pre-war years had led to a quickening pace, with noisy and often highly competitive groups committing themselves to extreme renewal. Although their energy was bound to be partially swallowed up in military enlistment, training and active service, an impressive number of artists refused to let the war prevent them from working altogether. Even when ensnared in front-line engagements, they often showed great resourcefulness in using whatever materials came to hand. While Léger made a collaged painting on a fragment of wooden shell-crate, Beckmann produced a mural in a soldiers' delousing house. Gaudier-Brzeska stole an enemy's Mauser rifle and countered its 'powerful image of brutality' by breaking off the butt, carving in it a design which 'tried to express a gentler order of feeling'. Derain was equally adaptable, using discarded shell cases to make a series of mask-like metal sculptures. As for Klee, he regularly used his scissors to cut off the linen covering crashed planes and paint on it during his limited amount of spare time.

All the same, this ingenious harnessing of military materials could not solve the central problem of conveying war's reality. The title of my book comes from a phrase coined by Paul Nash, whose paintings and drawings of 1918 are definitive images of the battlefield at its most desolate. Nash had earlier been lucky to survive his spell as a second lieutenant in the trenches of St Eloi. Only three days after he was sent home with a broken rib, many of his fellow officers were decimated in a futile attack on Hill 60. His first watercolours of the Front were oddly lyrical affairs, with names as inconsequential as *Chaos Decoratif*. After his return as an official war artist in November 1917, though, Nash's privileged position led to a profound sense of moral disgust. Despite the comforts provided by a manservant and chauffeur-driven car, he insisted on travelling across

the most devastated and dangerous areas of winter terrain where the Passchendaele campaign had just been fought. Appalled by the mud-clogged landscape, Nash reported that 'it is unspeakable, godless, hopeless. I am no longer an artist interested and curious, I am a messenger who will bring back word from the men who are fighting to those who want the war to go on for ever. Feeble, inarticulate, will be my message, but it will have a bitter truth, and may it burn their lousy souls.'

DEAN CLOUGH AND WOLFGANG LAIB
5 July 1994

While London's art scene keeps reeling from the after-shocks of recession, Halifax continues to flourish and expand. Just over a decade ago Sir Ernest Hall, the irrepressible concert pianist turned businessman, bought the cluster of sixteen major buildings at Dean Clough. Once the home of Crossley's mill, one of the largest carpet factories in the world, these magnificent yet moribund structures looked doomed. Hall, however, was convinced that he could create 'a practical Utopia' there. And his vision has been realised to the full. Dean Clough now houses a prodigious total of 200 companies and organizations, ranging from the Halifax Building Society to the Henry Moore Sculpture Trust Studio. Business and the arts alike find the location immensely congenial, and the rest of post-industrial Halifax is boosted by their presence.

The town's architecture seemed resplendent when, under a blazing summer sky last week, a substantial new network of galleries was unveiled at Dean Clough. The recently cleaned stone buildings offered a prospect very far removed from the blackened, smoke-beset streets of the past. When the painter Edward Wadsworth gazed down on Halifax in the 1920s, he turned to his friend Wyndham Lewis and said with relish: 'It's like Hell, isn't it?' But the spruced-up architecture appeared far from diabolic as Lord Gowrie formally opened the Design House Gallery and the Crossley Gallery. Not long ago, Sir Ernest was Gowrie's chief rival for the chairmanship of the Arts Council of England. But the two men looked affable enough as they stood together here, celebrating the advent of a substantial new space for temporary exhibitions.

The designers, Wolff Olins consultancy, might have been tempted to smarten up the old mill beyond recognition. Mercifully, though, they

opted for a strategy that respects the building's original character. It would be disastrous to hide the elegant iron columns and the horizontal wooden beams stretching across the full width of the gallery. Wolff Olins have preserved and displayed them with pride, even ensuring that the big rivets still protrude brazenly from the beams.

There is also a satisfying contrast between the two main spaces. The Design House Gallery comes first, discreetly lit to protect the rare nineteenth-century quilts on show. Then, from this womb-like antechamber, we move through to the larger and far more brilliantly illuminated Crossley Gallery. Natural light pours in from the sloping glass roof, where every effort has again been made to proclaim the industrial origins of the architecture. And the intense brightness certainly enhances the paintings by the Royal Academician Norman Adams, whose visionary work fills the entire space with uninhibited colour.

There are, however, too many pictures on view. The gallery looks overcrowded, and Adams's art suffers as a result. Many of his canvases have the impact of stained-glass windows. They need room to breathe in, and their profusion here means that the paintings often cancel each other out. Their individual meanings, based on Adams's obsession with the crucifixion, the *pietà* and the stations of the cross, become blurred. References to angels, soldiers and snarling hounds are obscured by his fondness for abstract patterns. He gives his religious subjects a contemporary pertinence by allying them with recent events, like the flight of the Kurdish refugees and Rajiv Gandhi's funeral pyre. But the anguished content often seems at war with Adams's leanings towards a more lyrical abandon, liberating colour from a representational role.

If his show had been restricted to half the number of exhibits, its power would increase. Over at the Henry Moore Sculpture Trust Studio, the virtues of spare, lucid display are obvious at once. The vastness of this handsome white arena is devoted to a single installation, by the German artist Wolfgang Laib. Even before his work becomes visible, it assaults our senses. Laib has used six tons of melted beeswax in this arresting exhibit, and its sweet, potent smell penetrates our nostrils immediately we enter the gallery. Seen from the top of the stairs, Laib's installation resembles a white, minimal box. Its outer walls are blank, apart from a tall, narrow aperture at the front. The opening excites curiosity, and once we descend the stairs a long, tunnel-like space invites exploration.

By this time, the odour of concentrated beeswax has almost become overpowering. It counters the eeriness of the corridor, which looks uncannily like the entrance to a tomb. Memories of Egyptian pyramids are stirred, and we half-expect to find a mummy laid out in state at the

147. Wolfgang Laib, *Interior*, at Dean Clough, Halifax, 1994

end. Here, the tunnel branches out to left and right. But both arms terminate in walls, and a sense of claustrophobia sets in when we realise that escape is only possible by retracing our steps. Naked light bulbs dangle from the ceiling, accentuating the air of oppression. And some of the beeswax slabs project slightly from the walls, suggesting that they might become dislodged and bring the whole monument tumbling down on our heads.

In reality, though, Laib is not an apocalyptic artist. For his most celebrated works, he gathers pollen from the fields and woods around his house in southern Germany and spreads it in simple, glowing rectangles on gallery floors. Whether culled from pine trees, moss or dandelions, these luminous yellow expanses are at once restrained and softly sensuous. The

purity and warmth of their colours sing out from the spaces they emblazon. Laib uses natural materials to generate a feeling of beneficence, and the same aura finally comes to dominate his installation at Dean Clough.

For beeswax has a protective, reassuring presence. The narrowness and secrecy of this dimly lit labyrinth evokes the interior of a hive. We can imagine bees at work, accumulating the honey clearly detectable in the smell surrounding us. Before he devoted all his energies to art, Laib studied medicine at Tübingen university and became a doctor. A healing spirit still pervades everything he makes, and this new installation counters intimations of death with the hope of renewal. There is comfort to be found in the slabs of beeswax, each one melted *in situ* according to an ancient process. Their colour and texture are reminiscent of toffee or fudge, prompting an instinctive desire to lick. But Laib has never been a saccharine artist. His work is very disciplined, taut and refined. The beeswax blocks are built up with great austerity, ensuring that the sweetness does not cloy.

London will have a chance to savour this impressive installation later in the year, when it moves to the Camden Arts Centre. But, bees apart, Halifax is humming with sculptural activity at the moment. The distinguished French artist Christian Boltanski is creating an installation at Dean Clough called *The Lost Workers*, commemorating the men and women made redundant when the Crossley Carpet Factory closed in 1982. And next week, in the splendid eighteenth-century Piece Hall at the centre of Halifax, the young Turner Prize-winner Grenville Davey will exhibit a large new sculpture. Judging by a preview of the unfinished work, already positioned in the shop unit where it will be displayed, Davey is producing a complex and mysterious object. The stone top, quarried locally and evoking the broken surface of a natural arena, honours the material used in the Piece Hall visible through the windows. But the galvanised steel container beneath looks functional, and refers to the mass-produced objects of our own age.

I came away from Dean Clough enormously heartened by my visit. Along with the new Henry Moore Institute in Leeds, and the Yorkshire Sculpture Park nearby, Halifax is playing a vital part in extending support for contemporary art outside London's centralised confines. Much still remains to be done, but the cultural stranglehold of the metropolis is beginning to loosen at last.

CONTEMPORARY ART AT KETTLE'S YARD
18 April 1995

Jim Ede, whose centenary is being celebrated at Kettle's Yard in Cambridge, was a godsend to many of the students visiting his unique collection. Anyone was welcome at the house he had created. Jim delighted in showing them round, and sharing his enthusiasm for the idiosyncratic blend of objects assembled there. One moment, viewers found themselves face to face with a Brancusi bronze head, casually perched on a piano-top. The next, they passed on to a cluster of purged white pebbles nestling near a window-seat filled with well-nurtured plants.

I first rang the ancient doorbell at Kettle's Yard in 1965. As an undergraduate hungry for contact with art of all kinds, I was appalled by Cambridge's lack of interest in the twentieth century. The Fitzwilliam Museum was at that stage locked in the past, so Ede's involvement with modern work came as a tonic. Here was a man who had visited Brancusi's studio on many occasions, and clearly learned a great deal there about how to display art in sympathetic, light-saturated surroundings. He would pause beside Miró's quirky little *Tic Tic*, and recall how he had been given the painting in a Paris café by the artist himself. Above all, Jim talked about his friendship with Ben Nicholson and Barbara Hepworth, his neighbours in Hampstead during the inter-war years. He met them at a time when they were struggling, both for critical recognition and for patrons who would collect their work. Ede was able to acquire their paintings and sculpture very cheaply. I remember how refreshing it was to meet someone who had supported, at its inception, the best British modernism of the period. And Jim was eager to share his good fortune with us, freely allowing students to borrow superb pictures from his collection and hang them in our rooms.

While Ede remained at Kettle's Yard, the main focus always rested on the unique interplay between art works and all the other objects which he displayed with such deftness. Now that he is dead, though, the challenge is to preserve the spirit of Kettle's Yard without letting it ossify. Luckily, the resourceful Director, Michael Harrison, is just the man to strike the necessary balance between conservation and renewal. Armed with a handsome new extension to his temporary exhibition space, he has marked Ede's centenary by moving many of the major paintings and sculpture away from their customary places. Displayed for the moment in a sequence of plain white rooms, they can be viewed afresh. Eyes accustomed to seeing them in their familiar locations, next to light-

switches with their inner workings exposed, will find plenty of surprises here. Even Nicholson's earliest and most tentative oils of the 1920s look unexpectedly magisterial in their new setting. David Jones's visionary watercolours, fortified by felicitous loans, have never looked more ecstatic.

By no means all the important items in the collection have been transplanted. Most of the drawings and sculpture by Gaudier-Brzeska, whose reputation Jim did so much to nurture, remain in their customary places. But Harrison has made sure that nothing remains unchanged. His most exciting idea is to invite nine artists to respond to Kettle's Yard and make work specially for the spaces they found there. Some of the results are spectacularly disruptive, and they have upset some long-standing devotees of Ede's house. But I do not believe that Jim would himself have been dismayed. Far from it: his puckish sense of humour, and love of innovation, are likely to have relished the series of visual ambushes mounted by the guest artists.

The invaders appear where you least expect them. Open the lid of an antique desk, and you discover a pile of crushed white painkillers deposited inside. Tim Head, who placed them there, is the most subversive exhibitor. He clearly wanted to challenge the tranquillity which Ede cherished. Elsewhere, Head has pushed a pile of broken plastic beakers under an old table. They lie there in mock disgrace, typifying the kind of found objects that Ede would never have wanted to display. But he always recognised the artist's right to experiment, and none of the guests has felt inhibited about disturbing the mood of bleached refinement at Kettle's Yard.

Sit down on one of the sofas, and the chances are that you will find yourself recoiling from a serpent-like sculpture placed on the cushion by Richard Deacon. Made of felt and horse-hair, this eerie creature reappears in front of a fireplace and on the attic bed. It follows us round the house like a stealthy intruder on the move, and several other artists do their best to upset the equilibrium as well. The top of the grand piano in the recital area is normally a haven of impeccable serenity. But the impish Richard Wentworth, whose one-person show at the Lisson Gallery rejoices in the same desire to surprise, has covered the entire surface with broken crockery. Unlike Ede, who obtained much of his cracked-plate collection from Cambridge colleges, Wentworth bought them at an East End street market. He broke and glued every one, as a tongue-in-cheek tribute to Jim's habit of mending the Kettle's Yard plates with fastidious care.

Michael Craig-Martin focused on furniture. In a space occupied by some of Gaudier-Brzeska's finest bronzes and carvings, he has painted

the whole of one sloping wall a shameless pink. It clashes head-on with Ede's partiality for white surfaces, and on this provocative puce sea Craig-Martin has floated the image of a wooden chair. By highlighting one of the more modest objects in the house, the painting invites us to look at everything rather than concentrating on the art-works alone. Ian Hamilton Finlay performs a similar service. On a nearby table, where orderly rings of stones normally lie undisturbed, he has incised one of the largest with a typically pithy observation: 'Kettle's Yard Cambridge England Is The *Louvre* Of The Pebble'.

As for Judith Goddard, she directs attention towards the room once inhabited by Jim's wife, Helen. I remember her as a retiring, rarely seen figure, content to let her gregarious husband perform the hospitable role with aplomb. But Goddard opens up Helen's sanctum. A perspex sheet installed in the doorway enables us to peer into the room. Here a video monitor has been installed, and it transmits the images received from a camera perpetually surveying the room. Sometimes the screen is dominated by a bed or a chest-of-drawers which Helen herself once used. At other moments, though, we find ourselves gazing at the view through the window, or contemplating the calm luminosity of the ceiling.

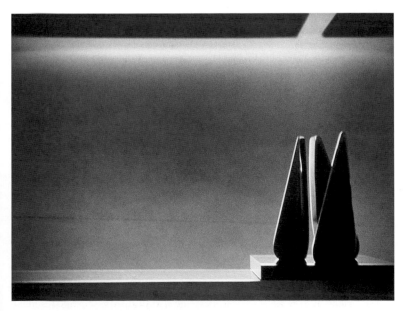

148. Catherine Yass, *Portrait: Sculpture*, at Kettle's Yard, Cambridge, 1995

Goddard seems to be inviting us to look at the room as Helen might have done, and the device brings us closer to a woman whose presence at Kettle's Yard was often overlooked by visitors.

Ultimately, though, Ede's domain is memorable because of the art it contains. The surroundings are important, of course, and they offer a delightful corrective to the notion that paintings and sculpture can only be placed in the severe context of a museum. But at the heart of what Jim described as 'a way of life' lie the works themselves. And Catherine Yass implicitly recognises their central importance by choosing Hepworth's *Three Personages* as the subject of her contribution. Yass has taken two photographs of the sculpture, and displays them in light-boxes positioned at some distance from the work. Rather than diminishing the Hepworth, they enhance it. Yass's hallucinatory colours and grasp of the revealing vantage celebrate the sculpture, forming a tribute from a young woman artist to a forerunner.

Ede would surely have loved the reciprocity between them, and immediately set about explaining, in his quiet yet excited voice, how Yass's images encourage us to see Hepworth's sculpture as if for the very first time.

BACKING BANKSIDE
18 July 1995

Down at Millbank, they must be crossing their fingers and struggling to stay calm. In a matter of weeks, the Tate Gallery will learn whether its £50 million application to the Millennium Commission has been successful. So far, so good: the director and his staff have presented their case for a new Gallery of Modern Art with exemplary skill and care. The proposal was placed on a shortlist last month, selected from an overwhelming shoal of 550 applications jostling for the £350 million available this year. But the tough fact remains that the Tate's bid is still only one among eighty-three millennium projects on the shortlist, and nobody involved in the gallery's development is complacent enough to take success for granted.

That is why anyone who cares about modern art should seize this crucial moment, and emphasise how desperately we need to bring this venture to fruition. London has, after all, waited a shamefully long time to

furnish itself with a fully fledged Museum of Modern Art. New York, Paris and a host of continental cities acquired similar institutions decades ago. The people who visit them in such impressive numbers rejoice in the buildings' presence, and regard them with understandable pride. But London, hampered by an instinctive national mistrust of modern art, has dithered, compromised and clung to the folly of cramming twentieth-century work into a modest edifice also expected to trace the entire history of home-grown produce, from Tudor portraits to Damien Hirst.

It is a preposterous state of affairs. I can scarcely believe that we have moved so slowly towards ending the absurdity of housing our modern collection in a Victorian building originally intended as the National Gallery of British Art alone. Back in 1969, writing as a student for the *Cambridge Review*, I devoted one of my first articles to an angry polemic called 'The State of the Tate'. After deploring the 'schizophrenia' inherent in the gallery's dual role, and the trustees' feeble plan to erect a few more rooms on the existing site, I argued that 'for 20th-century art, there is only one conceivable solution and it has been obvious for years: select a central site and build. An architectural competition should be held for the design of the new gallery, and one chosen which is both individual in itself and as flexible as possible. No one can tell what form the art of the future will take, what size it will be, how it will have to be displayed. On this count alone the trustees are crazy to think that their few extra galleries could possibly do justice to the rapidly changing character of contemporary art.' In those days, of course, few believed that the money for such an ambitious building would be raised. But my article ended by insisting that 'an appeal fund could be launched in the press and on television, industries and foundations approached . . . and a nationwide lottery instituted'.

Over a quarter of a century has passed since those words were written, but only now does the advent of a national lottery place the Tate Gallery of Modern Art in our grasp. This time, we must not let it drop. I feel, if anything, even more passionately than I did at university about the desirability of such a project. True, the current proposal is for a converted power station rather than a custom-built showpiece of new architecture. But I am convinced that the Bankside building could become a marvellous way of celebrating the art of our century.

Why should this redundant colossus, designed by Sir Giles Gilbert Scott in 1947 and completed sixteen years later, be capable of undergoing such an unlikely rebirth? Since 1981, when Bankside was decommissioned, it has sat sulking and unloved by the edge of the Thames. But its air of shabby obsolescence, blighting the area all around, should not prevent us from realizing the location's potential magnificence. Next

149. The old Turbine Hall at Bankside Power Station, London, pre-demolition

door to Shakespeare's fast-growing Globe Theatre, and directly across the water from St Paul's, it inhabits a prominent and culturally rich context. Public access will be transformed with the advent of the Jubilee Line in 1998, while the plan to fling a foot and cycle bridge over the river will make the gallery easily available to anyone visiting Wren's masterpiece on the north bank.

Even so, the main reason for applauding the Bankside scheme lies in the winning proposal for its conversion. The Swiss duo Jacques Herzog and Pierre de Meuron may not be the most well-known or glamorous architects in the world. But their approach to Scott's brooding hulk strikes precisely the right note. They respect the building's muscular integrity, refraining from alterations as drastic as David Chipperfield's rejected plan to remove the chimney altogether. Alongside their appreciation of Bankside's existing strength, though, Herzog and de Meuron envisage a subtle metamorphosis.

Responding to the multiple ways visitors will approach the building, they plan entrances on all four sides. And this spirit of openness extends to the interior. Scott's awesome turbine hall, running the width of the south side and surging to a cathedral-like loftiness, will be retained and hugely enhanced as a great public concourse capable of housing even titanically sized art works with aplomb. But on its north side, the hall will be given a new screen wall which replaces Scott's dourness with crisp, luminous transparency. People walking along the hall, either at floor-level or across an elegant bridge higher up, will see through the screen to light-saturated galleries beyond.

Here, in the top three storeys of the northern block, the main exhibition spaces will be placed. Versatile in terms of size and illumination, they will at last enable the Tate to show off its modern holdings at full strength. The Millbank building is far too small to offer anything more than tantalizing fragments of this collection – especially in its remarkable post-war amplitude. At Bankside, the art produced in recent decades will come into its own, and offer plenty of surprises among the space-hungry works currently condemned to spend most of the time in storerooms.

Herzog and de Meuron also ensure that a tour of the galleries will be enlivened by panoramic views of the Thames. They want to open up the recessed spaces on either side of the central chimney, replacing Scott's brick panels with vast sheets of glass. Natural light will invade the building, while the glass will give the heart of Bankside's river façade a welcome and unexpected delicacy.

The most spectacular addition occurs at the top, however. On an expansive roof already providing a superb prospect of St Paul's, Herzog

and de Meuron will construct what they describe as a 'luminous glass beam' right along the northern block. It promises to give the new Tate a roof-top restaurant with panoramas among the most dramatic in London. At night, this glowing rendezvous will turn Bankside into an enticing metropolitan landmark. Even in daytime it should round off the building with quiet, streamlined stylishness, giving Scott's elemental monolith the airiness and radiance it lacks.

I have no doubt that the finished Bankside will prove irresistible. Already, according to a new survey by the British Tourist Authority, public interest in modern art has mushroomed to the point where the Tate's annual tally of 2,226,399 visitors now outstrips even Westminster Abbey in popularity. Armed with an edifice far larger and more exciting than the Millbank building, our new Gallery of Modern Art is bound to attract still greater throngs. The economic benefits to London as a whole, and to beleaguered Southwark in particular, will swiftly justify the initial £50 million investment. And a derelict stretch of the South Bank can look forward to the regeneration it so urgently needs.

Above all, though, Britain's attitude towards and understanding of modern art will be transformed. The advent of Bankside is a symbol of our willingness to shed weary prejudices, and acknowledge that the work of our own era deserves its own independent showcase. The twentieth century will be over by the time opening day arrives. But at least our inexcusable tardiness can be redeemed, on that memorable occasion, in the grandest way possible. So I urge the Millennium Commission's members to decide in the Tate's favour. If you give this invigorating venture the go-ahead, your vote of confidence will be repaid countless times over by all those visitors who find enlightenment at Bankside in the twenty-first century and beyond.

THE FUTURE OF THE HAYWARD GALLERY
16 April 1996

When the Greater London Council opened the Hayward Gallery on the South Bank in 1968, it was an exciting event thoroughly attuned to the optimistic spirit of the period. Matisse was chosen as the apt subject of the Arts Council's inaugural exhibition, and his work filled the uncompromising interior with a radiant affirmation of vitality. I remember visiting that inspirational show as an awed student, and spending hours there drawing the paintings and sculpture with a feeling of intoxicated admiration.

Since that heady occasion, the Hayward has mounted an abundance of major exhibitions ranging over the entire history of art. But the building itself, which must have seemed the last word in Brutalist modernity when it was designed, gradually became more and more inadequate. By 1985, when the GLC commissioned an independent Report called *Art on the South Bank*, the gallery's shortcomings were criticised in detail. As co-author of that report, with Balraj Khanna and Shirley Read, I naturally hoped that it would provide a springboard for swift action. But soon after its publication the following year, the GLC was abolished by a vengeful Thatcher government. And although the newly created South Bank Board promised to transform the Hayward, woefully little has been done to the building over the last decade. Looking over our report today, I am appalled to realise that most of its recommendations are still waiting to be implemented.

For the sake of the Hayward, and the future of the visual arts in this country, urgent action must be taken now. Occupying a site on the largest arts complex in the world, this is a major gallery with an important international role. But it has become hamstrung by the deficiencies of a building planned and erected with a painfully limited notion of what such an institution should offer visitors. The gallery's bunker-like front is redolent of a time when architects shied away from making their façades inviting to the eye. And inside the Hayward, scant provision is made for the public's needs. The foyer is ridiculously mean and cramped, leading to congestion whenever a well-attended show is held. True, the tiny bookshop's removal and expansion has made the foyer a little less restricting. But it still fails to reflect the importance of the Hayward as whole, and the bookshop now occupies a room which originally formed a vital part of the exhibition space.

Inside, the sequence of galleries is handsome enough to make the

150. Hayward Gallery, London

Hayward a building well worth cherishing. Sculpture looks particularly impressive: Rodin has thrived here in two magnificent surveys, and contemporary sculptors from Anthony Caro to Tony Cragg have benefited hugely from their exposure. As for Richard Long, his show was a revelation for anyone who doubted the Hayward's ability to enhance the art on display. By relying on the inherent strength of the spaces at his disposal, Long proved that the building's unmodified interior provides a

powerful setting for modern art at its most elemental. And I am sure that the 40,000 figures in Antony Gormley's *Field for the British Isles*, recently acquired for the Arts Council Collection, will look marvellous when it makes its London début there later this year.

I disagree, however, with those who claim that the Hayward provides a poor backdrop for painting. The triumphant Matisse retrospective scotched that notion at the outset, and I still relish the memory of discovering how well Morris Louis and Frank Stella interacted with the spaces they were given. Abstract painters look especially convincing at the Hayward, as Yves Klein's work demonstrated only last year. But figurative painting can thrive, too. Edward Hopper seemed completely at home there – and so, more recently, did the mesmerizing Magritte. No wonder Howard Hodgkin responded with such enthusiasm when the Hayward invited him to exhibit there next winter. I am confident that he will provide London with the most beautiful show of the season.

Artists admire the split-level toughness of the Hayward's interior, and would rightly resist any attempt to change its fundamental character as a showcase for their work. But if we consider the rest of the building, its deficiencies quickly become glaring. Where are the lecture hall, workshop spaces and other educational facilities, without which the Hayward is severely hamstrung in its efforts to elucidate the art on display? Where is the well-designed, light-filled café, providing a rendezvous far more inviting than the gloomy structure temporarily erected on an outdoor sculpture court? And where, above all, is the additional but separate gallery, which would enable the Hayward to open all the year round? At the moment, it is only open for nine months in any given year: the rest of the time, its doors are closed while exhibitions are taken down and assembled.

The appeal of any major centre would be seriously undermined by such a policy. The ever-booming Tate Gallery is closed for only a few days each year, and the Royal Festival Hall is open all year apart from Christmas Day – a fact that accounts for much of its popularity. Part of the Hayward should always be open to the public, and the obvious place for its additional gallery is on the ground level – at present occupied by a grim, unsafe parking area and loading bay. If this desolate underbelly were incorporated into the Hayward, and provided with an entrance of its own, the gallery's appeal would be enormously increased. For the first time, the Hayward could announce its existence to the South Bank Centre's visitors at street level. And the exhibition space constructed there would encourage the much-needed development of a more adventurous policy with younger artists, who only make rare appearances in the Hayward's current programme.

All these proposals, and many more besides, were recommended in our Report to the GLC exactly a decade ago. The fact that nothing has happened in the intervening years is a cause for dismay. If the stalemate continues any longer, the Hayward's reputation will be gravely damaged. We expect a great deal of our flagship art galleries nowadays, and any building that remains locked in the limited thinking of thirty years ago is bound to suffer. By the end of the century, if all goes well, the Tate Gallery of Modern Art will open with splendid facilities not very far from the South Bank Centre. If the Hayward remains unaltered, it will look even more shabby and obsolescent compared with the spectacular, state-of-the-art spaces on offer inside the converted power station at Bankside.

That is why the outcome of the South Bank Centre's current lottery bid is so important. Until now, attention has inevitably focused on the overall cost of implementing the plan for the entire site. Richard Rogers's ambitious and seductive design, with its wave of glass undulating beside the Thames, has dominated public discussion. But within his Crystal Palace, and the total lottery bid of £127 million, the distinct needs of the Hayward are too easily overlooked. Extract them for a moment, and you find that the gallery's future can be secured for the relatively modest amount of £11 million. That is the cost of implementing the changes I have already outlined, as well as enhancing the neglected sculpture terraces, introducing a relocated and expanded Hayward shop, enlarging the foyer, overhauling and upgrading environment controls within the gallery, improving the facilities for staff, storage and loading, restoring the decayed concrete on the building's façade, and redesigning the gallery ceilings and lighting.

Much remains to be clarified in the detail design phase, and the contribution made by the Hayward's new Director (who should be appointed this summer) will clearly be vital. But enough has already been proposed in the Rogers Masterplan to ensure that it attains the right balance between preservation and transformation. While honouring the identity of the existing architecture, and seeing that its merits as a showcase for art are protected, the scheme will also give us a revitalised Hayward fit for its dramatically expanded role in the twenty-first century. If these changes are not implemented soon, the gallery will ossify and perish. That would be a national disgrace, and the £11 million required to secure the Hayward's viability is a price well worth paying.

BERLIN: A NEW MODERN MUSEUM
12 November 1996

Outside the entrance to Berlin's new Museum of Contemporary Art, trains used to turn around on tracks now hidden by a formal garden. For the building itself was once the Hamburger Bahnhof, the city's oldest railway station. Designed by Friedrich Neumann in 1847 but abandoned many years ago, this neo-classical landmark has undergone a dramatic rebirth. And its opening proclaims Berlin's eagerness to possess, at long last, a contemporary collection of international stature.

The location could hardly be more symbolic. On the other side of the nearby River Spree, the Federal Parliament's new political centre is developing fast. So is the city's grand new station, intended as a focal point for the European express rail network. They ensure that the museum's building, once marooned in a waste-land border area of East Berlin, is placed at the heart of the city's post-unification plans for expansion. And the renewal of the Hamburger Bahnhof also demonstrates a strong civic desire to preserve the past amidst the spate of new construction. But there would be no point in remaining pedantically faithful to the original building in every respect. As you approach the façade, its fresh identity is announced with commendable restraint. Without altering the existing structure, Dan Flavin's specially designed row of seven vertical neon tubes has been added to the central row of arches. Their light blue fluorescence, combined with another installation by Flavin illuminating the open loggia behind with cool green tubes, gives the frontage a discreet yet festive glow. It looks welcoming, and prepares visitors for the greater theatrical impact of the main hall within.

Compared with the interior of the Musée d'Orsay, the Parisian railway station transformed into an overwhelming museum of nineteenth-century art, the Hamburger hall may look modest. But its muscular cast-iron vaulting is superbly energetic. Dark against the pale grey ceiling, its lean geometry seems appropriate for a twentieth-century gallery. Moreover, the hall has not been cluttered with the cumbersome, obtrusively designed structures that mar the Musée d'Orsay's interior. Everything is kept simple, creating a purged, brilliantly lucid arena where the museum's most spectacular exhibits are given the space they deserve.

Most of the major works displayed here are on permanent loan from the extraordinary collection formed by Dr Erich Marx. Without his generosity the museum would lack the clusters of key images that give its principal spaces their identity. Anselm Kiefer is the first artist to assert his

overblown canvases, as well as rather more impressive work from Enzo Cucchi and Mimmo Paladino, Anish Kapoor's red-pigment floor sculpture appears embattled. His five-piece *1000 Names* glows with sensuousness and spirituality alike. But Kapoor's work needs a room of its own in order to thrive, like the modest yet effective white chamber where Flavin displays three of his spare yet lustrous neon pieces.

Most of the potent moments in the labyrinth of upstairs rooms, which become confusing to explore as we wander from one level to another, occur when a single artist is given space to breathe. Rachel Whiteread's two sculptures look impressive, even though they are bordered on one side by Maria Eichhorn's deeply folded grey curtain. So does Bill Viola, whose 1976 video installation *He Weeps For You* manages to be funny and mournful at the same time. Another video work, Gary Hill's *Crux*, performs a similar tragi-comic feat as the cameras follow his stumbling, martyred movements through a wood.

Both these video works were purchased by the Berlin National Gallery, and a number of its other acquisitions can be found throughout the building. Nevertheless, the overall character of the museum is dictated by Marx's holdings. He owns many of the major pieces in the wing where Joseph Beuys is given a reverential place of honour. The full range of his work, from blackboards and felt to steel, fat and stone, confirms the shaman-like position he occupies in post-war German art. His achievement is lauded here, while so many other artists who deserve inclusion are given no place at all. This is an unashamedly partial collection, and must expand to do justice to the vitality of current art, not just in Western Europe and the USA but elsewhere. A memorable start has been made, though, and the strengths of the inaugural display are potent enough to make it a welcome addition to Europe's foremost showcases of contemporary work.

THE GUGGENHEIM MUSEUM BILBAO
21 October 1997

Glimpsed at the end of a street leading to the waterfront, the new
Guggenheim Museum Bilbao looks at once shimmering and convulsive.
It erupts from the river's edge with astounding force, and yet the titanium-
clad surfaces gleam seductively in the Spanish sun. Frank Gehry, the
California-based architect of this revelatory building, manipulates
writhing forms at their most restless. They explode outwards, and flow
along the embankment like unstoppable white lava. But just as they
threaten to envelop the nearby bridge, their undulations are held as if in
a freeze-frame. Each glittering component is arrested at the peak of its
volcanic energy.

As a result, the museum provides rundown Bilbao with even more of
a landmark monument than its commissioners, the Basque government,
can ever have dared to hope. The centrepiece of the city's ambitious $1.5
billion redevelopment, which includes a coolly refined Norman Foster
tube system and an elegant footbridge by Santiago Calatrava, this swag-
gering *tour de force* deserves to be ranked among the supreme buildings
of the twentieth century. Anyone who cares about architecture must visit
it forthwith. As the millennium approaches, Gehry has produced a mas-
terpiece even more provocative, original, bloody-minded and unforget-
table than Frank Lloyd Wright's Guggenheim Museum in New York.

Because the turbulent exterior is so spellbinding, we are tempted to
linger outside and marvel at its perpetually shifting complexities. Viewed
from the river, the building seems to relax and expand, unfurling like a
sequence of overlapping waves or fish thrashing their ecstatic tails against
the sky. Metaphors proliferate in the mind, ensuring that Gehry's
imagery thwarts any attempt to confine it within a single interpretation.
We notice the dialogue he sets up between materials, juxtaposing the
reflective lightness of titanium with limestone's warmer solidity and the
bristling linear intricacy of ribbed windows. We realise, too, how coura-
geously he has made his building a part of the urban fabric. Far from
avoiding the vehicular bridge, an undistinguished post-war structure
shaken by incessant traffic, Gehry embraces it. One of his twisted titan-
ium curves comes to a halt just above the road, hanging there with
jagged, exclamatory drama to startle the motorists beneath. And the
longest gallery in the museum stretches under the bridge before termi-
nating on the other side. There, as a final obstinate flourish, Gehry has
erected a vertical, splintered structure in metal and stone. Shamelessly

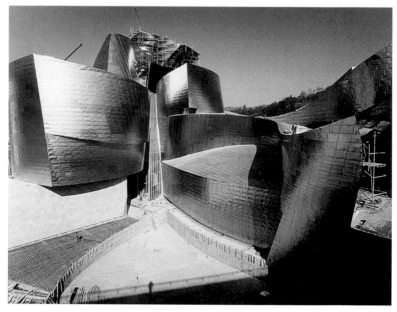

152. Frank Gehry, Guggenheim Museum, Bilbao

unfunctional, it looks more like a freestanding sculpture than an integral part of the building.

Gehry has always been justifiably proud of his friendships with artists. They have nourished his work for decades, helping him to approach architecture with the expressive freedom he seeks. The Guggenheim Museum Bilbao is far and away his most flamboyant attempt to put this unfettered approach into action on the grandest scale imaginable. It suggests the influence of earlier artists as well, ranging from Boccioni's whirling bottle sculpture and Schwitters's proliferating *Merzbau* to late Matisse cut-outs and David Smith's stainless-steel *Cubi* series. But as I traversed its shell and marvelled at Gehry's ceaselessly inventive panache, questions about the interior multiplied in my head. Would it turn out to be nothing more than an ebullient display of architectural high spirits, ignoring the exhibits it was supposed to enhance? Were they all overwhelmed by the uncontrollable exuberance of an architect unable to set artists' work in an uncluttered, sympathetic context?

There is nothing remotely reticent about the titanic atrium confronting everyone soon after they enter. It surges to a vertiginous 165 feet, more

than double the height of Lloyd Wright's spiralling rotunda in New York. And as if to vouchsafe that nobody remains unaffected by its giddiness, Gehry turns this prodigious space into a battlefield of contrasts. He alternates between billowing white plaster and angular girders, sets the smoothness of stone against jagged, buckling expanses of glass, and challenges purged simplicity with wilful complication. Narrow serpentine walkways are suspended in space, daring us to negotiate them without reeling. And as we clamber higher on tortuous Piranesian staircases, approaching the flower-like apex of an atrium saturated with light, severity is continually interrupted by headlong, baroque elaboration. I found myself looking downwards, sideways and upwards in a hydra-headed attempt to absorb everything this inexhaustible building offers. I relished Gehry's determination to provide, time and again, views of sky, river and city, insisting that his museum never becomes sealed off from the life outside. And, conversely, I was ambushed by his willingness to let some of the titanium cladding burst in from outside, invading the space with a flourish and warning us that he is prepared to flout architectural civilities at every turn.

During a press conference held inside the delirious atrium, Gehry declared that 'I've spent much of my life talking to artists about what a museum should be'. His conclusion was unexpected, flouting conventional wisdom by stressing that 'artists are tired of being in a neutral building – they want to be in an important place'. To my relief, though, what Gehry described as his 'give it hell' approach to architecture is countered by an innate respect for the needs of the art work itself. Claes Oldenburg and Coosje van Bruggen, who collaborated with Gehry on a Californian office incorporating a giant pair of binoculars, have been given a place of honour for their *Soft Shuttlecock*. Expanded to a monstrous size and filled with canvas-covered foam, it is transformed into a collapsing science-fiction insect. Beached on a platform high in the atrium, the shuttlecock's feathers flop over the edge and dangle in the void like limp feelers. They are a colossal intrusion, and yet Gehry seems to welcome their presence in the heart of his building.

For all its idiosyncratic bravura, this architecture is generous to the art housed here. Nothing could be more overwhelming than Richard Serra's *Snake*, one of the specially commissioned works now a part of the museum's infant collection. Its three undulating expanses of rusted cor-ten steel wriggle through the largest gallery, inviting us to walk inside the sculpture like travellers exploring a dark, narrow canyon. In common with much of Serra's finest work, it exudes a sense of danger. The boat-shaped room enclosing *Snake* is 450 feet in length, so the sculpture cannot dominate its surroundings. Many of the exhibits beyond, though,

suffer from the immensity of the space. Big minimalist pieces by Carl Andre and Don Judd look diminished, and even the billboard-size paintings by Robert Rauschenberg, James Rosenquist and Andy Warhol are dwarfed on the eighty-feet-high white walls.

If Gehry had his way, this gargantuan gallery would be split up. But Thomas Krens, Director of the Guggenheim Foundation and mastermind of the Bilbao venture, insisted that it remain undivided. In this respect, Krens was clearly wrong. But he deserves huge credit for backing Gehry's $100 million building and pushing it through to triumphant completion. Krens will continue to control the exhibition programme, feeding it with many of the best twentieth-century works from the New York collection. The Guggenheim's role here has been the butt of some sniping articles, deploring its growing influence across Europe. Without doubt, the Basques should eventually make sure that they take entire command of the project. But however many charges of cultural colonialism may be bandied about, the truth is that the Guggenheim has provided Bilbao with a miraculous showcase.

Both Gehry and Krens were clearly aware of the need to accommodate art with diverse requirements. So for every full-blown operatic space inside, like the immense arena where Sol LeWitt has painted an heraldic wall-work, there are also more sober galleries for older, modest-size exhibits. One small, rounded chamber proves ideal for drawings and watercolours by Giacometti, Gorky and Ellsworth Kelly. As for the sequence of rooms containing the Guggenheim's historic modernist collection, from Picasso's Cubism to the Abstract Expressionists and beyond, they could scarcely be more well-behaved. Gehry knows when to restrain himself, and the ability to do so makes his sudden *coups de théâtre* all the more exhilarating. The tall, uneasily angled space devoted to Anselm Kiefer matches his troubled, furrowed art with disconcerting power.

The failures in the opening exhibition are curatorial rather than architectural, and can easily be remedied. Jim Dine's garish trio of crude, red-painted *Spanish Venuses* do not deserve their prominence, blocking a spectacular window behind them. And the gallery beyond is marred by the indigestible variety of work installed there. Richard Long's sublime *Madrid Circle* on the floor needs isolation, and does not deserve to be surrounded, on the walls, by artists as disparate as Georg Baselitz, Daniel Buren and Gerhard Richter. But these mistakes can be rectified, and the successful rooms easily outnumber them. For this is an inspirational museum, both inside and out. Its irrepressible dynamism seems guaranteed to give every visitor an adrenalin rush. Spain, where the equally freewheeling and audacious Gaudí flourished a century ago, is an appro-

priate home for Gehry's pyrotechnic display. Surging, shuddering, swooping and soaring, it shows just how pedestrian most other modern architecture has become.

THE SERPENTINE REBORN
26 February 1998

Just over four years ago, Iain Sproat, the junior minister at the National Heritage Department, threatened to raze the Serpentine Gallery and replace it with facilities for horse-riding. It was a dark moment for the Serpentine's enterprising Director Julia Peyton-Jones, struggling to raise funds for a major renovation of her increasingly decrepit domain. But the former Kensington Gardens teahouse has lasted longer than the Tory government. After raising £1 million itself, the Serpentine was granted £3 million from the National Lottery. And on Saturday, the pristine premises designed by John Miller + Partners will reopen its doors.

The outcome is a delight. Anyone worried that this state-of-the-art gallery might lose its special identity will feel instantly reassured. The character of J. G. West's original 1934 building has been preserved, and the exterior looks virtually unchanged. The entrance is new, a cool white chamber on the south side where a ramshackle lumber room once lurked. But Miller has ensured that its light, airy minimalism is thoroughly in tune with the exhibition rooms beyond. And they retain the luminosity that made the Serpentine such a captivating experience. Space flows more freely between the rooms, allowing us to move with far greater ease from one to another. The South Gallery, always the least satisfactory for display purposes, has become more coherent. Like the other rooms, it boasts a splendid grey slate floor close in tone and texture to the original. At east and west, it leads through ample, unfussy rectangular doorways to long galleries where the old window ranges have been retained. So the delectable views outwards, on to limpid parkland, play just as refreshing a role as ever in our enjoyment of the work on show.

Nowhere else in London does an art gallery offer such a miraculous restorative, banishing metropolitan mayhem and inducing a more meditative mood. Careful scrutiny reveals that the old window-panes have been replaced by double-glazed alternatives, ideal for the sophisticated air-conditioning system which maintains the Serpentine's temperature at

an equable level. It used to be a glacial place in winter, and sometimes so bitter that visitors were discouraged from lingering for long. The roofs leaked, staining the ceilings and threatening the safety of the exhibits. Now the white-painted surfaces are all immaculate, and they contain lighting far more discreet and flexible than before. At night, metal grids stretch across the windows to offer, at last, the kind of security that this isolated, vulnerable building lacked. Lenders and insurers alike can feel confident that art-works now bask in the highest level of protection.

The major loss, in terms of window light, occurs on the north side. Here the central gallery has been blocked off from the glass-paned doors which used to be the Serpentine's main entrance. But this remodelled room is superbly proportioned, and the extra wall enables it to display a significantly greater amount of work. Looking up, we can appreciate here just how much the old premises have gained from their facelift. For the clean geometry of the great circular dome in the centre now emerges with astonishing, streamlined clarity, further enhanced by a sparkling ring of new lights set like stars into the curved ceiling.

Better still, the space between the new gallery wall and the north windows has undergone a transformation. Now renamed The Sackler Centre for Arts Education, it provides a wonderfully welcoming space for visitors who want to study, discuss or make images of their own in response to the exhibitions. Schoolchildren in particular will relish the unique appeal of a room overlooking such an enticing landscape. In warmer months, the north doors can be opened, allowing activities to spread on to the grass beyond. Always lively, the Serpentine's education initiatives will receive a much-deserved boost in this new space. Whether housing the Saturday art club run by artists for young people, or the Summer School for sixth-form students, the Sackler Centre is bound to play a vital role in encouraging people to explore the work on display. Educational departments are too often tucked away in basements, as if the gallery somehow felt embarrassed by their existence. Here, by contrast, it occupies an integral part of the main Serpentine building, fully able to proclaim its existence to anyone walking past.

Set back from the road in such a verdant setting, the gallery could easily be a remote and dozy institution frequented only by devotees. But Peyton-Jones and her lively team have ensured that it attracts an extraordinary following, especially among young viewers in search of the excitement energizing the current British art scene. For her opening show, she has decided to mount a retrospective of an Italian artist who died, far too young, thirty-five years ago. The provocative and prescient nature of Piero Manzoni's work means, however, that this is no pious historical exercise.

Throughout all the diverse experiments made during his brief yet prolific career, he maintained an open attitude bracingly similar to the approach favoured by so many young artists today.

That is why his work still looks fresh and contemporary in Germano Celant's lucid selection. Far from feeling shackled by the awesome legacy of Italian art from the past, Manzoni broke down barriers with impish zest. He saw the fascination in materials which most artists of the period would have regarded as too lowly or banal. In this respect, he was indebted to the challenge posed before the Great War by the arch-heretic Marcel Duchamp, who purchased ready-made objects and displayed them as legitimate art works. Manzoni saw the promise inherent in everyday bread rolls, cotton wadding, rabbit skin and straw. He did not exhibit them raw and untouched, like Duchamp. But he had no desire to disguise them. With the help of kaolin, a white clay used in porcelain manufacture, he turned the bread rolls into lumps mysteriously suggestive of organic life or even grotesque human faces. The rabbit skin becomes a hallucinatory white ball, poised on a black cubic base of burnt wood. As for the straw, it ends up a compressed oblong of stiffened particles, coated in kaolin so that they take on a strangely refrigerated identity.

Manzoni thrived on provocation, and earned lasting notoriety by placing his own shit in small metal cans labelled 'merda d'artista'. Since they

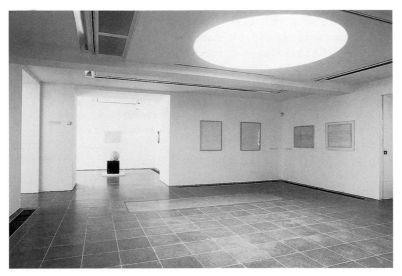

153. Piero Manzoni exhibition at the remodelled Serpentine Gallery, London

are impossible to open, nobody knows for certain what these round, brown objects really do harbour. Displayed at the Serpentine in clusters on a large white plinth, they look from afar like sober scientific specimens. Only by peering at their labels do we realise their purpose, sometimes with the help of information in neatly printed English explaining that they were 'freshly preserved, produced and tinned in May 1961'.

An instinctive showman, Manzoni played the part of artistic insurgent with relish. He even posed for a photograph, canned shit in hand, next to a lavatory bowl. A puckish grin animates his plump face, and his eyes gleam in brazen defiance of all those who dismissed him as a charlatan. It would be a pity, though, if the most scatological side of his work drew too much attention away from the rest of his output. The truth is that most of the Serpentine exhibits possess an unexpected sense of quiet, contemplative purity. Manzoni often impregnated canvases with kaolin, cutting them into squares or folding them in horizontal creases that stretch across the full width of a picture. Obsessively white, they have a melancholy aura and resemble expanses of cold, wind-ruffled sea. Manzoni called them *Achromes*, and they are the most seductive works he ever produced. They have a purged lyricism, prophetic of later developments in art and clearly the product of an artist who knew how to deploy the most rigorous restraint.

How would this prodigy have continued, if he had not died at the untimely age of twenty-nine? We can never know, but there is a curious and satisfying sense of completeness about the work he left behind. Despite his premature end, Manzoni fully succeeded in defining a singular outlook. Operating in a region half-way between painting and sculpture, he insisted on blurring the distinction between art and life so adroitly that his work has been influential ever since. Long before Gilbert & George turned themselves into 'living sculptures', he invited members of the public to become live art works by standing on footprints lodged in a sturdy wooden plinth called *Magic Base*. He signed the bodies of seventy-three people as '*sculture viventi*', giving them numbered certificates of authenticity. They included the young Umberto Eco, who thereby found that he had been designated a 'work of art for life'.

It is easy to mock such manœuvres, and nobody laughed more cheekily than Manzoni himself. But behind the levity lay a wholly serious desire to extend the frontiers of modern art as far as they would stretch. His third *Magic Base*, turned upside-down and made of iron only a year before he died, can be seen as a final testament. Inscribed 'Homage to Galileo' in inverted letters, it appears this time to support the earth and propose that the entire planet should be seen as potential territory for

the art of the future. Called *Base of the World*, it still seems a hugely stimulating proposition today. The reborn Serpentine is right to ally itself with such a generous, all-encompassing vision.

THE IKON RENEWED
17 March 1998

'Let the priests tremble' cry the crimson words in Nancy Spero's installation, dancing across the whiteness of the Ikon Gallery's lofty new space. She unleashes a cavalcade of super-charged women in this exhilarating upper room. They leap, hurtle, gyrate and fly over the luminous walls, revelling in lithe, emancipated energy. And their festive mood chimes with the excitement of discovering that Birmingham, at long last, has the world-class contemporary art showcase it so desperately needed.

When this hugely inviting building opens on Saturday, visitors will find it equipped with all the facilities a modern gallery requires. Originally designed as Oozell's Street School in 1877, by the talented local firm of Chamberlain and Martin, it was saved from demolition only a few years ago. A vigorous exercise in Victorian Gothic, richly embellished with ornamental tiles and stone carvings of acorns and bullrushes, the redoubtable brick edifice occupies a prime location just across the canal from the city's concert hall. So the Ikon's feisty Director, Elizabeth A. Macgregor, was delighted when the site's developers offered her the school at a peppercorn rent. The lease on her existing premises in John Bright Street was about to expire. Eager to make the Ikon larger and more prominent, she realised that the Oozell's building provided an ideal opportunity. But its conversion would be expensive. Quite apart from the restoration of an elaborate Victorian tower, the school's interior needed wholesale conversion. Eventually, with the aid of an Arts Council Lottery grant of £3.7 million and £991,000 from the European Regional Development Fund, the work was undertaken by Levitt Bernstein Associates. They approached the task with the right combination of boldness and respect for the past. The character of the original premises has been honoured and celebrated, so that the Victorian tower once again soars like a rocket towards the sky while the brickwork glows with its former freshness.

The architects have not, however, been afraid to make necessary additions in an uncompromisingly modern style. No urge to indulge in

gothic pastiche mars the public staircase and glazed lift, built on to the side of the old school. They are light, minimalist structures, unashamedly announcing the new function of the building. And they lead up from the ground floor, where a café and shop now provide a welcome, to the galleries above. The dramatic contrast between the lean, metallic stairs and the neighbouring façade of the original premises is reminiscent of Norman Foster's Sackler Wing at the Royal Academy. He made no attempt to hide the difference between his high-tech addition and the existing architecture. Nor does Axel Burrough, the Levitt Bernstein partner mainly responsible for the Ikon scheme. He allows us, as we walk up the stairs, to savour the Ruskinian relief sculpture still carefully preserved on the wall beside us.

The Ikon's former home, a converted warehouse near the station, boasted no such architectural magnificence. Its unheated galleries, glacial in winter, were adequate and yet far from special. But the new Ikon rejoices in the robust dignity of an edifice enhanced by tall windows, spectacular vaulting and sudden, unexpected flourishes of stone-carving and stained glass. The only original building to survive in the ambitious Brindleyplace development, the Ikon now has a proud, free-standing civic presence. Tania Kovats, the artist member of the design team, was responsible for suggesting that the wedge-shaped wall around the school's perimeter should be clad in black slate. It succeeds in setting off the building and marking out the territory inhabited by the Ikon, which never enjoyed such a singular identity in its previous back-street location.

Nor did it have the generous space for educational activities available in the Oozells building. They will play a vital role in helping the gallery to expand its audience, and become a more familiar part of Birmingham's cultural life. Already, aided by an award through the Arts For Everyone scheme, Macgregor has been forging valuable links with local communities through travelling exhibitions in the region. And the new Ikon now looks like a place people will enjoy visiting for its own sake. The café looks enticing enough to compete with the eye-shaped Bar Rouge Café nearby, designed with theatrical brio by Piers Gough as the centrepiece of a new pedestrianised square in Brindleyplace. But when the entire development is complete, there should be plenty of customers for both venues. During the summer in particular, Brindleyplace is bound to become a popular meeting-point, and the Ikon will benefit incalculably from its setting.

As a result, contemporary exhibitions could turn into a major city attraction. Compared with its counterparts in France or Germany, Birmingham has shown shamefully little interest in the art of our own

time. But Simon Rattle stimulated audiences at the concert hall into experiencing twentieth-century music at its most challenging, and Macgregor now has the facilities to perform a similar feat for painting, sculpture and all the alternative media artists are exploring. She is certainly committed to the task, and energetic enough to ensure that a healthy proportion of Birmingham's population becomes aware of the new Ikon's existence. Seeking out audiences should be a central priority for a modern gallery, not an optional extra labelled 'outreach'.

The two opening shows proclaim her involvement with contemporary art at its liveliest. Rather than ignoring senior practitioners in favour of the young, she has given the upper rooms to the seventy-two-year-old Nancy Spero. But the work on display in these high, almost ecclesiastical chambers explains why Spero is widely admired by artists who emerged during the 1990s. Taking nimble advantage of the panoramic surfaces at her disposal, she uses them as an arena where her female figures can become as uninhibited as they wish. They dance, dive and somersault across the walls. Undaunted by a tall end window, they float over its pointed arch with acrobatic *élan*.

But their delight is laced with defiance as well. Having 'let the priests tremble', the militant red words shoot across the wall and yell:'too bad for them if they fall apart, on discovering that women aren't men'. Treating the gallery as a cross between a gymnasium and a swimming-pool, these gravity-flouting bodies could hardly be more headlong. Whether lurking near the floor or hovering above an archway, they prove that Spero knows how to enliven a space with economy, wit and aplomb. Her eclectic range of images roams through the entire history of art, from cave paintings and Celtic carvings to news photographs of Hollywood stars today. Her female types are equally diverse, encompassing sex-hungry libertines as well as ethereal winged spirits. Somehow, she manages to impose her own, immediately identifiable style on all these disparate sources.

Georgina Starr, the young British artist whose specially commissioned work is also displayed at the Ikon, achieves a similar balancing-act. One of the most unpredictable and multi-talented members of the new generation, she brings together music, animation, model-making and painted wooden figures in a hallucinatory work called *Tuberama*. Gesticulating passengers and guards beckon us into her installation, where Old Street Station is transformed into a bizarre fun-fair ride. Tube carriages, with commuters visible inside, clatter round the floor on a circular track. Violently coloured cubicles invite us to sit inside, and listen on headphones to CD tracks like *Horror Street, Sweaty Armpits, Tummy*

154. Georgina Starr, *Tuberama the Musical*, at the new Ikon Gallery,
Birmingham, 1998

Touch and *Pervert*. Initially playful, the music soon assumes a night-mar-
ish quality. And the breezily drawn cartoon film, screened on a large wall
as well as monitors suspended from the ceiling, takes us on an increas-
ingly feverish, macabre journey.

Georgina, the central character, finds herself trapped on a train with
an array of smelly, lascivious and sinister travellers. They all end up in
Dopplestadt, a deceptively whimsical Disneyish fantasy-land. Facsimiles
of all the passengers appear in overwhelming profusion, and Georgina
eventually confronts a 'love replica' of herself who threatens to take over,
leaving the artist alone in her usual 'melancholic haze'. At once light-
hearted and paranoiac, *Tuberama* has the same instantaneous impact as
Spero's crazily choreographed figures. But beneath their zestful surface,
which should prove irresistible to many entering the Ikon for the first
time, darker layers of meaning can be uncovered as well.

GALLERIES AND GOVERNMENT FUNDING
28 April 1998

Public awareness of the Arts Council of England has been dominated, understandably enough, by alarming headlines about shenanigans at the Royal Opera. Having participated in the Council's deliberations for the last three years, I can testify to opera's nightmarish and ultimately wearisome ability to spring up, like Banquo's ghost, at our debates. But the truth is that the Council's energies are devoted to far more than Hullabaloo at The House. It is a pity that bloodletting on the Royal Opera's plush carpets should overshadow other, less scandalous and more rewarding priorities.

After receiving the invitation to chair the Council's Visual Arts Panel, I hesitated over my response. The main worry centred on time. As well as contributing to the Panel's regular meetings, I would automatically become a member of Council and attend its monthly deliberations. Each of these marathon sessions, accompanied by an avalanche of papers to read beforehand, often swallowed up two days. It all amounted to a daunting commitment. As a freelance writer, I also wondered if I could afford to spend so many working hours on unpaid activities.

In the end, these misgivings were outweighed by more positive considerations. After all, visual arts funding was in crisis. The burgeoning vitality and international success of contemporary British art masked a profound malaise. It centred most urgently on the financial plight of the publicly funded galleries exhibiting their work. Discussions with Marjorie Allthorpe-Guyton, the Council's admirable Director of Visual Arts, convinced me that the problem was even more acute. So a large meeting was held of gallery directors across the country. Both Lord Gowrie and Mary Allen, the Council's Chair and Secretary-General, attended. It was an impassioned discussion, reflecting the deep frustration of energetic and enterprising institutions hamstrung by successive governmental cutbacks. United by the urge to expand, and play a more dynamic role within their towns and cities, they found themselves slashing essential expenditure instead.

Their plight was mirrored within the Arts Council itself. The Treasury's miserly grant had forced Marjorie and her talented staff to spend too much time shoring up or axing existing commitments. My predecessor as Visual Arts Panel chair, Richard Rogers, had been instrumental in ensuring that architecture became one of Council's priorities. I was delighted when architecture was brought under the

umbrella of the Visual Arts Department, which further expanded to embrace artists' film and video. But the ever-shrinking grant-in-aid, from Tory governments who seemed to care little about the arts, made it difficult to develop these initiatives beyond modest beginnings.

Then the Lottery arrived, suddenly transforming the Council's grant-giving powers. Everyone's workload multiplied to cope with its advent, but I did not resent the extra time involved in dispensing funds. The amounts pouring in from the nation's love of gambling exceeded all expectation, and they have benefited galleries of every size throughout the country. I am sorry that the Hayward Gallery, caught in protracted negotiations over the renewal of the South Bank Centre, still awaits funds for its excellent plans to enlarge the existing building. But earlier this year, I was enormously gratified when two major galleries reopened to great acclaim. The Serpentine Gallery in Kensington Gardens, threatened with closure by a Heritage minister only four years ago, has now re-emerged with its unique luminosity and airiness enhanced. Aided by a Council lottery grant of £3 million, the Director Julia Peyton-Jones and her architect John Miller have triumphantly modernised the building while retaining its delectable identity. Only a month later, in Birmingham, a quite different yet no less exemplary gallery opened. This time, it involved moving the Ikon from inadequate premises to a splendidly restored Victorian building, the former Oozell's Street School. Adapting its neo-Gothic architecture to the needs of contemporary artists posed a formidable challenge. But it was seized with aplomb by director Elizabeth Macgregor and her architect Axel Burrough. The Arts Council's lottery grant of £3.7 million ensured that Birmingham now boasts a world-class showcase for modern art.

Not all these new galleries are multi-million-pound, big-city affairs. Nothing could be more rural than ArtSway, sequestered in the silence of the New Forest. With £306,000 of Council lottery money, Director Linda Fredericks has created a captivating space for art in the village of Sway. The invitation to open this converted coach-house, now combined with a lucid, minimal new building designed by Tony Fretton, provided me with one of my most enjoyable experiences at the Council. So did the reopening speech I gave at the Spacex Gallery, housed in a nineteenth-century warehouse in the centre of Exeter. To celebrate the handsome restoration of its exhibition spaces, designed by Nicholas Gilbert Scott and funded by a lottery grant, Richard Long mounted a powerful show devoted to his exploration of Dartmoor. The West Country has few galleries capable of staging such an ambitious event, and Alex Farquharson's current exhibition programme is full of vitality.

155. Tony Fretton's converted coach-house at ArtSway in the New Forest, 1998

Some of the most exciting gallery projects have yet to be completed. By far the grandest is the Baltic Flour Mills, a disused and hugely impressive building at Gateshead Quays on Tyneside. Awarded £33.4 million of Council lottery money last year, it will metamorphose into an international centre for modern art under the directorship of Sune Nordgren. The resurgence of the Gateshead region has already been demonstrated by the dramatic unveiling of Antony Gormley's *Angel of the North*, a magnificent and stirring sculpture granted £584,000 from the lottery fund.

The Arts Council's own collection, which provides invaluable support for contemporary artists by purchasing their work, has found a new home for its sculpture acquisitions at Dean Clough in Halifax, where the Henry Moore Institute already runs an outstanding sculpture gallery in converted factory premises. At Walsall, by contrast, a wholly new gallery is being constructed with the aid of £15.75 million from the Council's lottery money. Home of a distinguished collection donated by Jacob Epstein's widow, Kathleen, this canalside building has been designed by the young architects Caruso St John. Its quality is matched by the drive

of Director Peter Jenkinson, whose enthusiasm will ensure that the gallery plays a dynamic part in Walsall's life.

All these necessarily diverse galleries share the desire to look outwards, placing education at the centre of their everyday activities. The Arts Council has made just such a commitment a prerequisite of lottery grants, and the importance of broadening the audience for art cannot be exaggerated. But the galleries' ability to fulfil their educational ambitions depends on the availability of funding. So far, lottery money has been largely restricted to buildings, and it is vital that new legislation widens the Council's range of lottery spending in the future. Already, with the introduction of the popular Arts for Everyone scheme, the Council has shown how funding can be extended into many hitherto neglected areas of society. Among the examples of innovatory grant-giving by Arts for Everyone, let me single out a £350,000 venture called Young at Art. Initiated by the London Institute, the overall body embracing several leading art colleges, the scheme involves schools throughout the metropolis. Pupils and their teachers will be able, through Saturday classes and summer schools, to benefit from a range of courses organised by the colleges. At a time when the arts are threatened by changes in the school curriculum, the Young at Art project offers a much-needed boost to the nurturing of children's interest in both art and design.

Much remains to be done in this exciting area, and I wish I had the time to stay on. But when invited at Christmas to serve for another three years, I declined in order to concentrate more on my writing commitments. Stepping down from the Council now, I remain concerned above all about the visual arts' ability to gain their rightful share of support. At the moment, they only receive a meagre 7.9 per cent of UK spending on the arts as a whole. The average annual income for visual artists in Britain is only £7,936. These are stark facts to set against the booming public interest in contemporary art and buoyant gallery attendances. Over recent years, Marjorie's team has conducted intensive research to back up the overwhelming case for an increase in visual arts' modest share of funding. That is why, in wishing success to the new Arts Council Chair Gerry Robinson and his Secretary-General Peter Hewitt, I trust that their slimmed-down Council will have room to include expert representatives capable of backing visual arts' interests with the vigour they deserve.

BERLIN'S NEW GEMÄLDEGALERIE
16 June 1998

Brutally sundered by the Second World War, Berlin's great Old Master collection has at last been reunited in a new museum custom-built for the paintings. Not all of them survived Hitler's defeat. When the city surrendered in May, 1945, 434 pictures were still protected by a bunker within Berlin's boundaries. But fire mysteriously destroyed them soon after Stalin's army took over the shelter, and the lost canvases included masterpieces by Caravaggio, Signorelli, Rubens and Van Dyck. Much of the collection, though, was housed in remote Thuringian salt mines. American soldiers ensured their safety, and they eventually found a public home in the West Berlin suburb of Dahlem. But the building proved far from ideal, being cramped, poorly lit and uncomfortably removed from the city centre. Worse still, the paintings displayed there were completely divorced from the rest of the collection. Nearly 1000 other pictures had survived the war in East Berlin air-raid shelters, and they were duly housed in the Soviet-controlled Bode Museum.

Only now, in the wake of German reunification, has the collection been brought together under one roof as the reborn Gemäldegalerie. Its new building stands on a central site in the Tiergarten, near the State library, Mies van der Rohe's modern art gallery and the Berlin Philharmonic's flamboyant concert hall. Designed by Heinz Hilmer and Christoph Sattler, the outside of the new gallery is reticent to a fault. The grey rusticated base looks like a timid homage to Florentine Renaissance palaces, and the terracotta panels above are disappointingly anonymous. Maybe Hilmer and Sattler were overawed by the magnitude of their task. After all, the building they were commissioned to design is a receptacle for some of the finest achievements in European painting. But if the challenge of finding an outward manifestation for this temple to Western art defeated them, the interior is a different matter. Here, the architects' reticence becomes a virtue rather than a failing. The rooms surveying the sweep of painting, from early Renaissance to late eighteenth century, are admirable in their simplicity. Refusing to call attention to themselves, they serve the needs of the pictures instead.

Daylight from above, filtered in order to protect the pictures and ensure uniform luminosity, enables us to see them far more clearly than in Dahlem. The velvet-clad walls absorb any undue brightness, enabling the radiance of the pictures themselves to register with maximum impact. True, the brilliance of newly cleaned exhibits sometimes seems

156. Caravaggio, *Amor Vincit Omnia (Cupid as Victor)*, c. 1601–2,
Gemäldegalerie, Berlin

jarring in the company of other, heavily varnished and discoloured paintings. I was also annoyed by the perverse decision to consign Sienese panels by Sassetta and Giovanni di Paolo to recessed spaces covered by distractingly reflective glass. Nor are there enough seats provided for visitors who want to pause and contemplate individual pictures. Furthermore, where wooden benches are provided, they often rest in corners offering only sidelong glimpses of the paintings.

On the whole, though, the pleasure of viewing is aided at every turn. Captions are placed discreetly below each picture. The walls of the early Renaissance rooms are swathed in pale grey, providing a backdrop as refreshing as the Sainsbury Wing at the National Gallery. Their hue becomes warmer with the advent of Venetian art at its most sumptuous. Smaller paintings are thoughtfully housed in rooms of more modest proportions and inferior pictures have been consigned to basement Study Galleries. So the main galleries on the ground floor boast exhibits with a consistently impressive level of quality.

The collection's foundation was provided by a group of paintings once owned by Frederick the Great and his forebears. Gradually, a comprehensive survey was assembled, with the help of blockbuster purchases as spectacular as the Giustiniani collection of Baroque paintings. Its highlight was Caravaggio's *Cupid as Victor*, a shamelessly provocative celebration of love's ability to vanquish everything from musical and martial prowess to scientific discoveries. Caravaggio was never more brazenly homoerotic than in his outrageous image of lust on the rampage.

Within a few years, the Gemäldegalerie had acquired an even more distinguished and utterly different collection from the English merchant, Edward Solly. Powered by a passion for the Italian Renaissance, he acquired masterpieces by some of the most outstanding quattrocento artists. Filippo Lippi's *Adoration in the Forest* stands out, with the virgin kneeling in a dark, flower-strewn glade encircled by streams flowing through clefts in the rock. But Castagno's *Assumption* and Bellini's *Dead Christ with Mourning Angels* are equally impressive. Solly's collection also provided the Berlin gallery with perhaps its most popular possession: Petrus Christus's exquisite *Portrait of a Young Woman*. Her blanched skin, dramatically offset by a tall, black hood, gives the unknown sitter absolute poise.

This jewel-like little panel now takes its place in a magisterial parade of northern Renaissance masters. At one end, Jan van Eyck's almost miniaturist painting of *The Madonna in the Church* is a miracle of spatial exploration, enhancing virgin and child alike in the light-saturated nave of a Gothic cathedral. At the other, Holbein's superb portrait of the Hanseatic merchant George Gisze presides over a wall-full of the artist's work.

After a while, the richness of the Gemäldegalerie's holdings becomes overwhelming. Rubens is seen in all his protean diversity, as much the master of sensuous figures like the ecstatic Saint Cecilia as he is the pioneer of landscape painting at its most turbulent. Rembrandt is even more prodigious, developing from the precision of a youthful *Samson and Delilah* to the wildly handled vehemence of Moses hurling his stone tablets before a gaunt, near-abstract mountainside.

But if visual surfeit threatens, relief is provided by the large, airy hall running like a spine through the new building. Visible from many of the rooms, it offers a multi-columned arena for rest, meditation and eyesalve. Here, in this lofty white sanctum with its unexpected hints of Moorish architecture, exhausted viewers can recharge their energies by watching the sun drop through circular apertures in the ceiling and form pools of brightness on the floor. No paintings hang on the immense walls. The only work of art is a contemporary commission from Walter de Maria, whose gleaming steel rods rise out of a rectangular waterbasin. This hall is the still and pristine centre of Berlin's latest gallery, an institution where the act of looking becomes a continual, unfettered delight.

BEYOND THE GALLERY

THE TYNE INTERNATIONAL
31 May 1990

As you approach Newcastle's Laing Art Gallery, where the First Tyne International begins, Nigel Rolfe's colossal two-part photo-work looms out from the side wall. In one of the pictures, the artist is shown solemnly pouring honey down on to his own face. In the other, the same figure is assailed by an avalanche of milk. Taken together, the images appear to mock the notion that the city they inhabit is basking in plentiful urban regeneration. Both milk and honey are being wasted rather than put to purposeful use, and the abundance they symbolise is only an illusion. The Tyne International itself, though, turns out to be a substantial reality. Financial constraints have, admittedly, prevented the Japanese artist Kawamata from implementing his ambitious plan to place sixteen giant construction cranes across the city and its river, thereby affirming the link between Newcastle and Gateshead and giving the exhibition a spectacular public profile. Scale models and drawings for the project are, however, on show inside the Laing. They bear out the determination of the curator, Declan McGonagle, to take this triennial event out of the gallery and into different contexts around the area. The International's title, *A New Necessity*, refers to his belief in the need for a more socially interactive art of the 1990s.

Rasheed Araeen's billboard poster *The Golden Verses*, which fuses traditional Islamic design and calligraphy with Urdu and English texts, is positioned in Newcastle city centre. Jefford Horrigan has placed two figure sculptures on a walkway under the Tyne Bridge, while Paul Bradley's installation of 2,000 fencing stakes explodes from an alleyway off Grainger Street. But the most extensive group of works occupies a newly built housing estate on the site of the National Garden Festival at Gateshead. The empty white spaces available in three rows of homes have been taken over temporarily by an array of artists, and the outcome is filled with barbed, affectionate, bizarre, vehement and sardonic reflections on contemporary life.

A questioning mood is established inside the very first house, where the Spanish artist Muntadas has erected a greenhouse structure. While an *ersatz* log fire flares in the grate, slides flash words like 'Gentrification' and 'Homesick' on to wall-screens. Estate agents' advertisements block off light from the windows of the house, giving the entire space a claustrophobic air. It is intensified by projected images of domestic cosiness, while a soundtrack oozes songs as cloying as 'I'll Be Home For

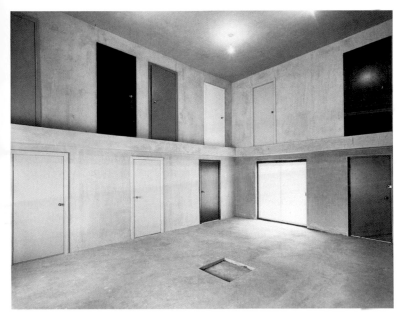

157. Rose Finn-Kelcey, *Openings*, at Tyne International, Gateshead, 1991

Christmas'. By no means all the artists adopt a caustic approach. Keith Alexander, Gateshead's current Artist in Residence, has collaborated with local community groups to produce a cornucopia of decoration and furnishings for his room. Stained-glass windows, painted blinds, ceramic plates, wallpaper, chairs and floor-coverings add up to an overwhelmingly festive interior. It is carried through entirely without irony, as a Morris-like crusade to invest everyday life with ornamental richness. But these houses are so confining that they provoke plenty of other participants into more subversive responses.

Walk into Rose Finn-Kelcey's house and you find yourself confronted by a sequence of doors lining the walls. Although she describes it as 'a centre for exits and entrances', none of these variously coloured doors leads anywhere. They resemble instead a Magritte-like dream, and after a while begin to create an oppressive mood. One visitor suddenly decided she had to escape from the space, announcing: 'this is a nightmare – I can't stand it'. Similar sentiments may have sprung to Jon Bewley's mind when he first surveyed the upstairs room where his contribution is housed. For he has smeared most of the pristine walls with apoplectic

splashes of mud, which defile the meanly proportioned rooms with almost as much forcefulness as a 'dirty protest'.

The tumbledown structure in Lee Jaffe's space implies, all the same, that these houses will be luxurious compared with some alternatives elsewhere in the world. Emptied of its former occupants, this derelict Jamaican shack is redolent of Third World privation. Inside, Jaffe envenoms its meaning by installing a black figure with lamp in hand. His body is riddled with spears containing miniature video monitors, each showing a clip from Griffith's *Birth of a Nation*. As if to insist that similar hardship exists in affluent countries as well, Krzystof Wodiczko fills most of his room with a *Homeless Vehicle*. Part barrow and part makeshift shelter, it is presented as a 'prototype' for the housing of vagrants. Polish-born Wodiczko now lives in New York, where he has plenty of opportunities to study the homeless at first hand. The walls of his space are lined with photographs of a black itinerant pushing the vehicle past locations like Trump Tower, gleaming with indifference in the Manhattan sunlight.

A few of the artists' contributions were made decades ago, and have been borrowed from museums in order to take on a fresh significance in their changed context. Christo's *Wrapped Armchair*, an early work from the mid-1960s, has been loaned from Eindhoven to dominate a small upstairs room with its trussed and weirdly pathetic presence. Gerhard Richter's grey and white painting of a blurred *Kitchen Chair* is lent from Germany, and hangs on its wall like a bleached phantasm from the past.

The future is summoned, in a more optimistic mood, by the elaborate Children's Pavilion attached to the rear of a house. A large-scale model of the structure which Dan Graham and Jeff Wall conceived together, it invites us into a temple-like world far removed from domestic mundanity. Its embracing roundness is echoed by the circular forms of the brilliantly lit colour photographs on the walls, each one containing a beatific child's image. Their multiracial variety intensifies the aura of global harmony, and an aperture in the pavilion's apex allows the building to be illuminated from above by sunlight.

On the whole, though, such expressions of bliss are avoided. At 60 Hanover Street, an old warehouse on Newcastle's Quayside, Edge '90 presents a series of installations within low, dimly lit spaces. Still redolent of the city's heyday as a great port, these sloping, roughly timbered rooms are the antithesis of the sanitised neatness in the housing estate. Under the wry title *All Mod Cons*, Richard Wilson makes dramatic use of his interior by disrupting the floor with a cluster of raw white planks. They rise steeply towards an open window and burst through to terminate outside with powerful abruptness.

The most memorable installation is on the top floor of the warehouse, where Mark Thompson has blocked up all the windows with beeswax. They emit a subdued amber glow, allowing us to make out the forms of stacked barrels and other sawdust-covered lumber. Then, at the far end, the hum of honeybees focuses attention on a gap in the wax. They buzz around it, and make for a hive lodged within the skeleton of a man stretched out on a wooden bed below. He looks like a long-forgotten remnant of Newcastle's past, and again prompts us to ponder whether the city today could ever be truly described as a land of milk and honey.

CHILLIDA OUTDOORS
27 October 1990

In 1977, at the end of Donostia Bay where Spain's northern coast meets the Atlantic, Chillida installed one of the finest public sculptures of the post-war period. He called the three mighty iron works *Combs of the Wind*, and their jutting prongs certainly seem to claw at the air. Each sculpture protrudes from a different clump of rock, positioned either at the water's edge or in the ocean itself. One piece is horizontal, another vertical, and the third explodes from its base in a cluster of crazily tilting curves. So although the sculptures are close enough to form a group, they react in quite distinct ways to the elements around them. They resemble three colossal hands reaching out towards wind, sea and sky, and on a stormy day the waves assail them with spectacular ferocity.

The spray can also splatter people who approach the *Combs of the Wind* on the paved steps built nearby. Chillida collaborated on the project with the architect Luis Peña Ganchegui, and the area has become a favourite haunt for the inhabitants of San Sebastián. They respond to the drama inherent in the conjunction of man-made images and rugged natural setting. They recognise, too, that Chillida's iron tentacles arise from an authentic response to the site. Already well-rusted by their exposure to air and water, each work appears to grow out of the rock it occupies. This sense of rightness and inevitability goes a long way towards accounting for the sculpture's success. Unlike so many recent manifestations of public art, all three *Combs* manage to look like an integral part of the location they inhabit. Chillida, a native of San Sebastián, was undoubtedly helped by his long familiarity with Donostia Bay. As a

schoolboy he would play truant and hide in a hole in the rocks where his sculpture now rests. 'Looking at the waves coming always without stopping, always the same and always different, I was asking myself where the waves were coming from,' he recalled, before adding that 'the sea has always been my master'. Although Chillida had no thought at that stage of becoming a sculptor, the *Combs* were already forming in his mind. 'The place has been the origin of the work', he explained, and the sculpture was conceived as a tribute both to the wind and the coastline which shaped his imagination at a formative stage.

Since he subsequently became a much-admired goalkeeper for San Sebastián's premier-league football club, it is tempting to speculate about a further possible level of meaning in the *Combs*. For each of them might be related to the hands Chillida once stretched out to catch the ball before it entered his net. Poised on their rocks with an athletic assurance which contributes to their appeal, they look vigilant enough to perform such a role. Although it would be unwise to push the connection between sport and art too far, several pencil and ink drawings of hands are included in Chillida's retrospective at the Hayward Gallery. Executed in spidery outlines which show how incisive his draughtsmanship can be, they reveal a fascination with the action of thumb and fingers as they bend over and begin to close on the palm in a clutching or clasping gesture.

Although Chillida's public sculptures could not be transplanted to the Hayward, their importance is acknowledged in a special section of the exhibition containing photographs, drawings and maquettes. In one sense they could hardly be more diverse, ranging from a subterranean work in an urban square at Vitoria-Gasteiz to the ultimate outdoor exposure of a cliff-top at Gijón. But close inspection clarifies their shared preoccupation with the idea of enclosure. If the projecting *Combs* at Donostia Bay suggest the act of reaching out and grasping, the catacomb-like structure embedded in the centre of Vitoria-Gasteiz provides a protective setting for a standing sculpture called *Monumento de los Fueros*. It is sheltered by the sides of a chamber which can only be reached by a steep flight of steps. Since the entire work is entitled *Square of Basque Rights*, the enclosed location possesses a profound symbolic relevance for the city as a whole and, indeed, the proud region surrounding it.

Chillida discovered the importance of his Basque identity at the beginning of his career, after leaving Spain in 1948 to work in Paris. Despite all the advantages of living in the centre of the European art world, as opposed to the provincialism and repression of Franco's Spain, he returned to San Sebastián three years later. 'I had the feeling of a tree that has been transplanted,' he remembered, 'and suddenly he has

returned to his place.' It was a decisive moment for his art, too. Aided by a neighbouring blacksmith, he completed his first abstract sculpture in iron, *Ilarik*. It announced a decisive kinship, not only with the welded metal work of his fellow-countryman González, but with the Basques' traditional mastery of the arts and technique of iron as well.

Not that Chillida became in any sense a parochial or backward-look-ing artist after going home. His resolute commitment to abstraction was a mark of considerable audacity during the Franco regime, and he has always retained a healthy preference for an international rather than a purely local perspective. Links with David Smith and Caro can be detected in his work, and he has recently executed homages to artists as disparate as Calder and Giacometti. Far from revealing tendencies towards eclecticism, these tributes help to define Chillida's individuality. Even the enormous *Homage to Calder*, which abandons his characteristic involvement with bulky form and hangs from the ceiling like a mobile, could not have been made by any other sculptor. Its curving steel sinews remain robust and austere as they arch through space, refusing to indulge in the restless, delicate motion of a Calder mobile.

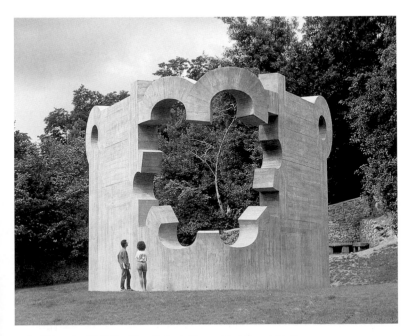

158. Eduardo Chillida, *Our Father's House, Gernika*, 1986–8

This innate feeling for sturdiness often results in work with a strong architectural bias. As a young man, Chillida studied architecture at Madrid University for a few years, and it clearly informs his approach to public commissions. Take *Our Father's House*, commissioned to commemorate the fiftieth anniversary of Franco's ruthless bombing of Gernika during the Spanish Civil War. From the outside, this immense concrete structure resembles the curving wall of a fortress, savagely blown open at its centre. The hole is encircled by jutting fragments, like broken teeth left in a battered mouth. It does not, however, threaten the fundamental stability of the rest of the wall. Moreover, a walk round the monument discloses that it embraces and defends a separate standing form in steel, smaller but notably firm and resilient. Both these elements are orientated towards Gernika's celebrated oak-tree in the green hills outside the town.

Once again, as in Donostia Bay, Chillida has rooted his work in an awareness of, and response to, the locale it enhances. The political resonance of the Gernika site is, of course, very different to the personal significance of the rocks by the ocean's edge. Even so, both of these memorable works are informed by their maker's wholehearted engagement with the spirit of a place, which gives Chillida's outdoor sculpture its alert and nourishing potency.

A DEACON FOR WARWICK
4 February 1991

At a time when so many universities are besieged by incessant demands for financial cuts, the arrival of a hugely invigorating outdoor sculpture on the Warwick campus seems almost miraculous. On a chilly afternoon last Friday, a crowd assembled for the official installation of a forty-five-foot-long *tour de force* in steel by one of Britain's finest young sculptors, Richard Deacon. Since snow threatened, the ceremony was held in a room with an extensive view of the landscaped site where the sculpture stood hidden by darkness. Nyda Prenn, who with her husband Oliver presented the work to Warwick University, threw a switch that transformed the mound into a blaze of light. The excitement was intensified by the flamboyance of the sculpture itself. Deacon, the winner of the Turner Prize in 1987, has produced another arresting image for this, his first public commission.

On the left, an upright form in mild steel undulates gently within a cage. But the sense of confinement is broken at the top, where the form bursts out of its container. In a development that gives the sculpture much of its explosive energy, a horizontal ladder of twisting stainless steel shoots like an electrical discharge to the other side of the sculpture. Here, the voltage seems to surge unchecked through the entire length of the second large form. It threatens to buckle under the impact of the tremor, but it also appears to be exhilarated by its freedom from the cage.

Standing underneath this dynamic structure, which gleamed with the reflection of the spotlights, I immediately felt caught up in the drama Deacon directs with such aplomb. Plenty of monumental works have been weighed down by their ponderous gigantism. Far from succumbing to sloth, however, Deacon has been galvanised by the chance to manipulate form on the grand scale. There is a swashbuckling confidence about the way he engineers the airborne transition from one side over to the other. He treats the mound as an arena, where a titanic encounter is enacted with immense theatrical flair. His instinctive feeling for spectacle is not marred by staginess or rhetorical overkill. The contrast between the two forms remains lean and athletic, purged of all superfluity.

It triggers stimulating questions, too. At first, the sculpture seems to set up a straightforward duality between imprisonment and liberty. An escape is apparently being celebrated, and the gymnastic zest of the connecting ladder crackles with a sense of vitality released from its confines. Deacon may have been thinking about a student's natural desire to leap out of the strait-jacket imposed by institutional authority. The sculpture is, however, too ambiguous to be saddled with such a narrow meaning. Besides, the title Deacon has given it sounds a note of warning: *Let's Not Be Stupid*. While this might apply to imprisonment, it could refer to the dangers of total freedom. The unconfined side of the sculpture is, after all, still connected as if by an umbilical cord to the other half. The tension between them is palpable, and they seem to be engaged in a tug of war. Even as the liberated side rejoices in unshackled space, it still remains dependent on its link with the caged form. They are evenly matched, and the sculpture implies that both sides would suffer if the bridge joining them were severed.

Deacon himself refused to be pinned down on the sculpture's meaning. When I asked him why he had chosen that title, he smiled and said: 'Well, it's a motto for life, really, isn't it?' But he did make clear how much he had responded to the site. While relishing its spaciousness, he said that the minimalism of the nearby Rootes Building had given him a strong context. Eugene Rosenberg, who designed it in the late 1960s and died

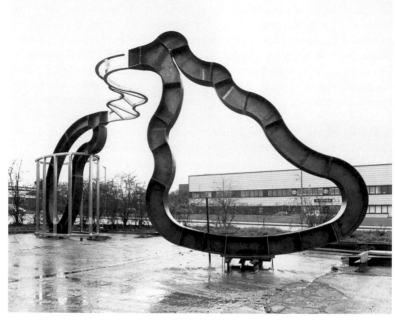

159. Richard Deacon, *Let's Not Be Stupid*, at Warwick University, 1991

last year, would surely have approved of *Let's Not Be Stupid*. A passionate collector, generous enough to lend many paintings to Warwick, he always tried to foster a mutually nourishing alliance between art and architecture. Now, with the additional assistance of the Henry Moore Foundation, Deacon's sculpture vindicates Rosenberg's faith. An outright masterpiece, it is a marvellous achievement, and deserves to be hailed as one of the most outstanding sculptures ever to animate a public space in this country.

STEPHEN COX: CANTERBURY AND LONDON
23 July 1991

Sloping down a green hill towards Canterbury and its cathedral far below, the grounds of Kent University provide a spectacular site for sculpture. Stephen Bann, a professor at Kent, has wanted for years to install a suitably monumental work there. He began by writing to Henry Moore, who produced many of his finest early carvings in rural locations near Canterbury. Although enthusiastic, Moore died soon afterwards. But the Foundation he established in his name offered to help fund an alternative commission for the university. So Bann approached a sculptor of his own generation, Stephen Cox, and asked him to mark Kent's silver jubilee by making a large-scale image for the brow of the hill.

At this stage, the outcome must have been especially difficult to predict. Having begun his career as an abstract sculptor in the minimalist tradition, Cox then discovered Italy and developed a more figurative approach. Subsequent trips to India and Egypt have transformed his work still further, and the multi-cultural strains in Cox's current art give his university carving an absorbing complexity.

It looks, at first sight, simple enough. From the road below, the two-piece granite colossus is reminiscent of a mysterious megalith. Stonehenge came to mind as I walked up towards the sculpture. Although the modernist architecture of Keynes College is visible behind, Cox's *Hymn* seems far more in tune with the antiquity of the distant city. Just as Canterbury cathedral offers sanctuary to anyone in need, so this carving could be used as a rudimentary shelter by people willing to stand underneath it. After a while, though, bodily references become apparent as well. Thrusting into the horizontal slab above, the upright stone carries a phallic charge. The entire carving takes on an erotic, and perhaps even a procreative meaning. Where the two pieces meet, the granite is far more sensuous and smoothly finished. The ease with which both parts fit together contrasts with the otherwise rough-hewn surface of these boulder-like forms.

Walk round to the side of the sculpture, however, and a very different identity asserts itself. The two stones seem to merge in a single mass, its profile reminiscent of the enigmatic figures found at Easter Island. Cox delights in juggling with alternative readings, and from here the top section of the carving looks like a craggy head. But not for long. Viewed from the back, *Hymn* sheds these associations and relies on plain statement. The two ochre stones have been left raw here, as a reminder of

160. Stephen Cox, *Hymn*, at University of Kent, Canterbury, 1991

their primordial state in the quarry at Madras. Flat and almost untouched by the chisel, they made me realise how carefully wrought the rest of the sculpture really was.

Move to the front again, and Cox's manipulation of his material becomes clearer. Even its most rugged areas now appear to be the result of deliberate working, which gives it a far greater forcefulness than the back. The dark oil which he finally applied to the front adds to the sense of *gravitas*. It suggests the idea of anointment, a ritual Cox must often have witnessed during his frequent trips to India. The sculptors who worked on *Hymn* in Madras, before it was shipped over to England for completion, spend most of their time producing temple carvings. Art and religion are closely intertwined throughout Indian culture, and the pouring of oil gives the Kent sculpture a religious aura. Its resemblance to a cross finally becomes inescapable, strengthening its relationship with the cathedral.

All the same, *Hymn* is no more of a Christian than a Hindu image. It refuses to be pinned down to a specific faith, whether of East of West.

Cox acknowledges them both, while retaining the right to make his carving profane as well as sacred. At once sexual and spiritual, it gazes down over Canterbury like a benevolent presence, providing this relatively new university with a reminder of humanity's prehistoric origins.

Hymn occupies its site with an air of inevitability. It already seems to have taken root in the surroundings, like all the most satisfying outdoor sculpture. Cox should be encouraged to produce further public images, for he has an instinctive grasp of the best way to place art in a given setting. Even in the temporary context of his new show at 8 Crinan Street, an architect's office in King's Cross, a fifty-part carving called *Tanmatras* looks tailor-made for the wall it inhabits. Ranged in rows of ten across the white surface, the work contains nothing but granite heads partially or wholly covered in oil. Each face emphasises only one aspect of the features it would normally contain. Eyes, nose, ears and mouth take turns to assume a dominant role, as though determined to celebrate the particular virtues of the senses in question.

They should, by rights, appear bizarre and deformed. But the confidence with which they enliven their space is oddly reassuring. Like *Hymn*, they give out a feeling of serenity, poise and ancient wisdom.

TOWARDS A NEW ALLIANCE
4 May 1992

In 1937, three decades after the young Jacob Epstein had accepted an invitation to carve eighteen figures for the British Medical Association's new London headquarters, a resolute group assembled outside the building. Led by its architect Charles Holden, and the President of the Royal Academy, they mounted the scaffolding and began to inspect the statues, one by one. After Holden had tapped each figure with a hammer and chisel, identifying the portions of stone he believed to be decayed, they were hacked away. Heads, projecting limbs and symbolic attributes were all cut off, without any apparent regard for their sculptural significance. Why was this flagrant act of vandalism allowed to happen? The building's new owner, the Government of Southern Rhodesia, maintained that the carvings were a threat to pedestrians passing below. The statues' supposed frailty was seized on as an excuse to purge the building of unwanted nudity, and despite protests the brutal dismemberment went ahead.

Epstein's noble scheme was reduced to ruin. The sculptor himself made no attempt to hide his mortification when he related how 'anyone passing along the Strand can now see, as on some antique building, a few mutilated fragments of my decoration'.

As well as destroying the most memorable sequence of sculpture ever carved for the façade of a London building, the defacement inadvertently took on a wider symbolic resonance. For it coincided with a widespread readiness, among the most innovatory architects in Britain, to dismiss all thought of embellishing their buildings with art. The growing functionalist aesthetic demanded purity of surface, and the desire to reject ornamental detail resulted in stripped-down, streamlined frontages. Henry Moore, who was so appalled by the Royal Academy's involvement with the destruction of Epstein's figures that he refused to exhibit at Burlington House, nevertheless agreed with the new philosophy. The architects he liked best 'were leaving all unnecessary (even some necessary) details off their buildings and they had no use at all for sculpture. This was a good thing then, both for the sculptor and the architect, for the architect was concentrating on the essentials of his architecture, and it freed the modern sculptor from being just a decorator for the architect.'

Since advanced opinion tended to side with Moore during the inter-war years, the prospect of a fruitful relationship between art and architecture seemed remote. But by 1951, when the Festival of Britain attempted to launch a new era of peace and reconstruction, a cornucopia of artists were invited to provide paintings and sculpture in, on and among the buildings at the South Bank site. Urged on by Sir Gerald Barry, the Festival's Director General, artists and architects found stimulus in the excitement generated by planning an exuberant antidote to 'the national dinge' of austerity-oppressed Britain. Moore produced one of his finest and most disquieting recumbent figures – a bony, elongated presence who lifts her split head towards the sky with an unease still redolent of wartime anxiety. In this instance, Moore's bronze inhabited a plinth some distance from Brian O'Rourke's Country Pavilion. But other artists collaborated more closely with the architects who invited them. Victor Pasmore produced a spectacular 'jazz painting' ceramic mural on the Regatta Restaurant's outer wall, while Lynn Chadwick installed an interlocking metal sculpture within its small, enclosed garden. As for the Riverside Restaurant, Jane Drew commissioned Ben Nicholson, Barbara Hepworth and the young Eduardo Paolozzi to make work for prominent sites outside the building.

The most intriguing of all the images spawned by the Festival was, however, produced by architects. Powell and Moya's cigar-shaped *Skylon*

soared to a height of 300 feet from its angular launching-pad, like the space-rocket which the English could fantasise about but never afford to build. It coincided with the advent of Dan Dare, the Pilot of the Future, whose gung-ho exploits in the cosmos filled the front page of the new comic *Eagle*. The ingenious mounting devised for *Skylon* provoked the wry comment that 'like Britain it has no visible means of support'. But the Festival's visitors took it to their hearts.

The subsequent destruction of *Skylon*, along with every other building on the site apart from the Royal Festival Hall, was deplorable. An acute *rigor mortis* descended on the entire area, and the bunker-like structures erected there during the 1960s showed an arrogant refusal to learn any lessons from the Festival's panache. Commissioned works of art were for a long time rigorously excluded from the chilling cultural complex, with its desolate and disorientating walkways. It is ironic indeed that a locality containing so many buildings dedicated to the nation's artistic vitality should have become such a no-man's-land. The whole site, marooned in unalleviated expanses of decaying concrete, implies that art has no role to play in public spaces today.

The South Bank offers perhaps the most lamentable example of the myriad opportunities missed during the post-war reconstruction of Britain. There were, however, isolated moments when enlightened architects invited artists to make distinguished work for the buildings they produced. One of them was Eugene Rosenberg. After working as a young Czech architect in Le Corbusier's Paris studio, he came to this country in 1939. As a committed exponent of modernism, Rosenberg might have been expected to banish art from his buildings altogether. But Moore's celebrated *Family Group* bronze was installed outside a Stevenage school designed by his partnership, Yorke Rosenberg Mardall, in 1950. An abundance of other commissions followed, most spectacularly at St Thomas's Hospital in London which Rosenberg filled with contemporary art. He also persuaded Alistair McAlpine to fund the superb *Revolving Torsion, Fountain*, Naum Gabo's poised and tensile swansong made for the hospital grounds in 1976.

Rosenberg shared Gabo's passionate belief, announced in the *Realistic Manifesto* of 1920, that 'art should attend us everywhere that life flows and acts'. He planned a pioneering book based on an archive of some 3,000 photographs painstakingly assembled with Patricia Mowbray. They chart the history of art produced for architectural settings throughout Britain since the war. No such survey had been attempted before, and I was delighted when Thames & Hudson invited me to write the text for the book in 1990. Although Rosenberg was in poor health by this time,

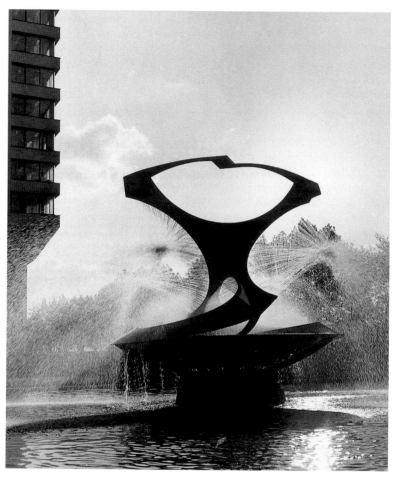

161. Naum Gabo, *Revolving Torsion, Fountain*, 1976, outside St Thomas' Hospital, London

his exclamatory enthusiasm for art was wholly undimmed. Sadly, he died soon after we discussed the project, having seen it through all but the very last stages.

Now that the book is finally about to appear,★ the rare and vital role played by architects as enlightened as Rosenberg in the immediate post-war period is even more clear. Louis Osman commissioned Epstein to produce an eloquent *Madonna and Child* for a bridge he had designed on

the north side of Cavendish Square. Michael Rosenauer, the architect of the *Time-Life* headquarters in Bond Street, invited Moore, Nicholson and Geoffrey Clarke to make memorable work both outside and inside his building. John Weeks asked Mary Martin to produce a waterfall-inspired wall relief for Musgrave Park Hospital in Belfast. And Michael Greenwood, remodelling an interior in the South Hampstead School for Girls, audaciously persuaded Gillian Ayres to paint an exuberant, multi-panelled abstract decoration for the walls. All these adventurous projects were carried out in the 1950s, and by 1962 the consecration of the new Coventry Cathedral disclosed the full extent of Basil Spence's determination to enliven his building with the work of prominent artists. Having won the cathedral competition back in 1951, Spence echoed the collaborative spirit of the Festival of Britain. As well as installing Epstein's *St Michael subduing the Devil* on the exterior, and allowing John Piper to transform the Baptistery window into an ecstatic sunburst, Spence let Graham Sutherland's monumental tapestry of *Christ in Majesty* make the entire nave subordinate to its dominant, hovering presence.

Although plenty of other ventures ended in frustration, especially when last-minute cutbacks forced the cancellation of artists' commissions, the past two decades have also witnessed some spectacular successes. In 1983 Kenneth Martin installed an elaborate yet structurally limpid *Screw Mobile* in the atrium of Victoria Plaza in London. Its steel components chime so felicitously with the real girders above that the sculpture seems like an extension of the architecture. Then, in the same year, Patrick Caulfield painted a colossal picture for the London Life Assurance Headquarters in Bristol. Nobody entering the building can avoid encountering this billboard-size image, placed so provocatively in the foyer and flanked by escalators that provide their users with ever-changing views of the canvas. Peppered with references to local landmarks and Bristol's mercantile history, including the slave trade, Caulfield's painting is an imperious work, boldly articulated by thick contours accentuating the sonorous colours they enclose.

An even more robust appetite for art in architecture is manifested at Broadgate, built by Rosehaugh Stanhope Developments around the splendidly restored Liverpool Street Station. The devotee here was Stuart Lipton, and for the octagonal space at the main entrance he boldly plumped for a monolithic sculpture by Richard Serra. The gamble paid off. Serra's *Fulcrum*, a cluster of rusted cor-ten steel plates, surges upward from the ground with a resounding sense of finality. Scarcely less epic are the works commissioned for interiors at Broadgate. Sol LeWitt's richly coloured drawings preside over the entrance hall of the Bankers Trust

Company with unforced grandeur. And Howard Hodgkin's mosaic for the pool of the Broadgate Club undulates with the rhythms generated by swimmers in the water beneath.

No confining limits should be set on the kind of artist best able to carry out an architectural scheme. Those who regard such work as their special province often resort to formulae, and artists who have never ventured beyond the gallery's boundaries should be warmly encouraged to do so. We need to aim at a far greater freedom of manœuvre, a more extended interplay between public and private realms. Imaginative artists who have spent their whole careers showing in galleries and museums might produce exuberant work when invited to join forces with an architect on a suitably stimulating project. If the collaborative ideal is to flourish, it must attract the energies and resourcefulness of those most likely to spurn hackneyed, glib solutions.

The development of a widespread *rapprochement* between art and architecture cannot be brought about overnight. It will take time to discover the most potent ways of shaping a more humane environment, where artists and architects work in symbiotic union rather than ignoring or antagonizing each other. Much remains to be done, especially if the habit of expecting artists to graft their work on to alien surfaces is ever to be eradicated. But the alternative is unacceptable. For the realization is growing that our surroundings, particularly in the urban areas which suffered most grievously from the barbaric effects of post-war rebuilding, are in need of the imaginative affirmation art can offer. As the new millennium approaches, everyone stands to gain from finding the right way forward.

* *Eugene Rosenberg's* Architect's Choice. Art in Architecture in Great Britain since 1945, *with text by Richard Cork, was published by Thames & Hudson in 1992.*

ANTHONY CARO IN ROME
29 May 1992

The battered Roman grandeur of the Trajan Markets could hardly be more opposed to the spaces where Anthony Caro's sculpture is normally displayed. Pristine white galleries provide his art with a clinical backdrop, often large enough to house several exclamatory works in a single room. But anyone who visits Rome this summer will find, facing the remains of the Forum itself, a context which stimulates an entirely fresh way of assessing Caro's achievement over the last thirty years. Walk down the sloping ramp from the traffic-ridden Via IV Novembre, and the frenetic pace of contemporary Rome gives way to an ancient stillness. Although partially ruined, the brick-built markets still retain the free-flowing fascination of the ingenious, multi-chambered structure erected by the Emperor Trajan around 100 AD. Intended as an extension of the main Forum, the edifice originally housed over 200 rooms which served as shops. But as in Covent Garden during a later era, flagstone-paved thoroughfares running past the spaces promote a sense of interconnectedness. The markets, ending up ranged in a great semicircular sweep of terraces overlooking the Forum, clearly served as a meeting-place as well as a trading centre. Their supple blend of the intimate and the monumental, the enclosed and the outdoor, turns out to salute the differing characteristics of Caro's sculpture with admirable aplomb.

The exhibition, incisively selected by Giovanni Carandente to provide a choice survey of thirty-nine pieces borrowed from America, Europe and Japan, reverses the normal progress of a retrospective. Dominating the entrance is *After Olympia*, a late-1980s *tour de force* of rusted, shot-blasted and varnished steel stretching into the building's shadowy recesses. Like a shell-pummelled battleship resting in dry dock, this sombre and brooding homage to the carved pediment from the Temple of Zeus looks far more at home than it did at the Tate Gallery last autumn. There, squeezed with difficulty into the Duveen Galleries, the sculpture seemed confined by the site. But now, given generous space in a central interior concourse, *After Olympia*'s bulky sobriety is matched by equally dark and measured surroundings. The sculpture's unusual length frustrates any attempt to see it as a whole. All the chambers leading off this space, however, frame varying segments of *After Olympia* in their mighty rectangular doorways. So as we walk through the rooms, our eyes gradually become acquainted with more and more aspects of this epic and demanding showpiece.

After a while, the isolation of other sculptures within cavernous, penumbral settings helps us to look in an extraordinarily concentrated manner. Most of the recent pieces may share deep-toned steel as their material, but they offer a variety of distinct experiences. Look at *The Soldier's Tale*, with a great swollen bell slung so swaggeringly within a structure that chimes with the doorway nearby. Or the enigmatic *Night and Dreams* completed only last year, where a severe altar-like structure carries on its uppermost surface a teasing labyrinth of corridors and sunken spaces fit for sleepwalkers to roam through at will.

Enclosed in their brick-lined rooms, Caro's exhibits gain a taut, compressed energy. Physical separation serves to emphasise how singular and densely considered each piece really is, and how architectural his frames of reference have often been. The aptly named *Roman*, made as long ago as the early 1970s, contains at its heart an open, extended curve redolent of a barrel-vaulted ceiling. The correspondence between this form and the surrounding chamber is so felicitous that *Roman* appears custom-built for the location. So, in a quite different sense, does the even earlier *Ordnance*. One of Caro's leanest and most austere works, it evokes the tables where Trajan's shopkeepers would once have displayed their wares and haggled, with true Latin vigour, over the prices they required. Caro has challenged the status of the sculptural plinth for most of his career, and in a particularly animated recent 'table piece' called *Loose Change* a cluster of waxed steel elements seem to be tumbling from their perch in the wake of a clangorous dispute.

The most provocative encounter between Caro and the classical context occurs upstairs, where Carandente has retained the four Roman carvings which usually occupy a room. White, fragmented and resting on their plinths without even a hint of impatience, they are juxtaposed with a far less serene Caro sculpture called *The Triumph of Caesar*. Bristling with allusions to the spears, banners and trophies borne by the figures in Mantegna's procession, this energetic frieze still adheres to the abstract language Caro favours. But *The Triumph of Caesar* ends up looking unexpectedly compatible with the Roman carvings opposite, and the window behind gives on to the immense thoroughfare where Caesar's triumphant army once carried their spoils through the imperial city.

Like many of Caro's overtly classical works, *The Triumph of Caesar* was executed in recent years. Even when he gives a 1989 sculpture a title as specific as *Medusa*, though, Caro shows no sign of aping an antique language. Among the most agitated and discordant of all his pieces, *Medusa* sends its steel components careering on a wild, unpredictable journey through space. In one part of the piece, pincer-like forms suggest the

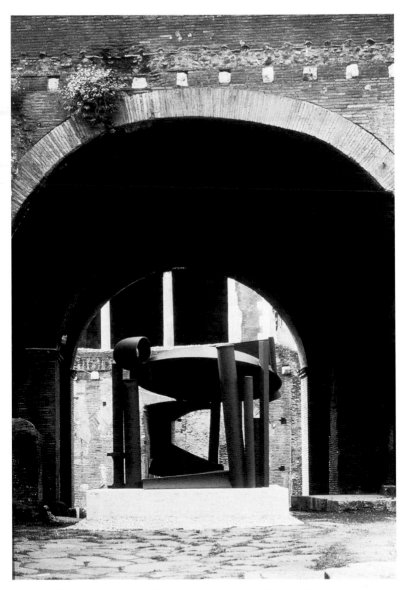

162. Anthony Caro, *North of Rome*, 1989, at Trajan Markets, Rome, 1992

snakes writhing on Medusa's head. But the rest of this flailing sculpture thwarts a clear figurative interpretation, opting instead for a headlong evocation of the tangled, baleful hysteria generated by the vicious Gorgon.

Ever alert to the specific mood of a sculpture, Carandente has devised a dramatically contrasted location for Caro's masterpiece *Early One Morning*. Escaping from the dark interior where *Medusa* continues to contort itself, we reach an open-air landing with a raised wooden platform. At first, the specially built smoothness of the pale planks looks anomalous among the market's weathered surfaces. But by raising the floor-level here, Carandente enables *Early One Morning* to soar above the wall overlooking the Forum. The levitation accords with the spirit of this lean, agile sculpture, where several curving rods stretch upwards as if to greet the advent of day. In Rome, of course, the sun is forceful enough to ensure that Caro's brilliant red paint blazes with unprecedented luminosity against the clear sky.

Early One Morning prepares us for the move away from the building towards the terraces below. A precipitous flight of dilapidated steps leads down into the open, and we find ourselves ambushed at the bottom by the plummeting, jagged vertigo of *Midnight Gap*. But turbulence soon gives way to euphoria. The sweep of the main terrace is punctuated by Caro's earlier works, mostly painted in exuberant colours. They sound a festive note after the restrained hue of the pieces inside, and the welcome flamboyance is announced by *Orangerie*. Placed within four low-lying walls which must have been a shop before the roof was destroyed, this acrobatic sculpture resembles a plant bursting up from the cracks in the paved floor. Forms reminiscent of leaves, stalks and flowers surge towards the sky, bending and twisting in an ecstasy of irrepressible growth.

The open-air sites are more successfully inhabited than the small, cave-like spaces leading on to this terrace. Both *Carriage* and (quite unaccountably) the exhilarating *Month of May* have been snuffed out by cramped, troglodytic rooms, and their plight is in absolute contrast with the liberated exhibits outside. They revel in their expansive surroundings. *Midday*, the earliest piece on view and one of the first to define Caro's sudden breakthrough to a new way of working in 1960, has never looked more celebratory. The glowing yellow paint acts as a sunburst, giving each of the i-beam components a joyful vivacity and poise as they perform their dance on the tilted girder supporting them.

The rigour of *Midday*, and its equally disciplined neighbours, offers an implicit reproach to the grandiose puffery of the monument to Victor Emmanuel II rearing in the distance. But Caro's formal tautness, which

arrives at a peak of pared-down lucidity in his low-slung *Prairie*, is wholly attuned to the refined Roman architecture left on the Forum. The revelation of this ambitious and imaginative survey, jointly organised by the British Council and the Comune of Rome, is the extent of Caro's involvement with the past. Even at his most innovative, when he revolutionised British sculpture almost overnight, his work never lost sight of the oldest traditions in Western art.

BOTTLE OF NOTES
22 September 1993

With admirable enterprise and aplomb, Middlesbrough is about to bestow on its town centre one of the finest public sculptures ever erected in Britain. Soaring nearly thirty-five feet into the northern sky, and leaning at the same tipsy angle as the Tower of Pisa, this eight-ton *Bottle of Notes* monument in tempered steel will be presented to the town on Friday by Lord Palumbo, Chairman of the Arts Council. It amounts to a spectacular *coup*, for Claes Oldenburg and Coosje van Bruggen have never made a sculpture in Britain before. Their large-scale works occupy prominent sites in major cities across the world, from Chicago to Barcelona. And at the height of his early notoriety as a Pop artist in the 1960s, Oldenburg made several provocative proposals for outsize sculptures in the centre of London: a cluster of jumbo lipsticks replacing Eros in Piccadilly Circus, and a movable gearstick instead of Nelson's Column as a tribute to all the cars negotiating their way round Trafalgar Square. But until now, nobody in this country has been audacious enough to commission a sculpture from Oldenburg and van Bruggen, who have worked together on an inventive range of powerful and wittily subversive outdoor projects since their marriage in 1977.

The Middlesbrough venture began as long ago as 1985, when Northern Arts invited them to make a big work for the region. Peter Davies, then Visual Arts Officer at Northern Arts, rightly decided that public sculpture in Britain needed to become more ambitious and less parochial. So Oldenburg visited Middlesbrough, a town he had never seen before, and became fascinated not with its industrial history but with Captain Cook. A local hero, Cook is celebrated there in an elaborate Birthplace Museum devoted to his pioneering voyages. The whole notion

of maritime exploration fired Oldenburg's imagination at once. Both he and van Bruggen realised that it chimed with their longstanding interest in *Gulliver's Travels*, where Swift delights in making the sizes of objects and people undergo astounding transformations. In their Manhattan studio, which Oldenburg likens to a ship at sea, the sculptors aim at a similar form of eye-opening revelation when planning their large-scale ventures. Sometimes, the projects never reach completion – perhaps because, as Oldenburg admits, 'we strayed too far from the reality principle; but we would rather risk rejection than put restraints on our imaginations'.

Captain Cook must have been equally bold. Any explorer has to muster the toughness needed to deal with hazards, and several of Oldenburg's earliest drawings for the Middlesbrough sculpture took the form of a shipwreck. In one study, the vessel has become ominously skeletal, with a shrunken sail and timbers so twisted that they scarcely seem able to withstand the waves. Nemesis arrives on another sheet, where the ship has already keeled over and come to a melancholy rest on rocks or a beach. But then attention shifts from the over-elaborate notion of a galleon, inscribed on one drawing with the symbolic title 'Britiship', to the far simpler image of a bottle lying on its side.

Arising not only from Oldenburg's obsessive involvement with ordinary objects, but also from the convention of a ship in a bottle, the image has further links with van Bruggen's interest in Edgar Allan Poe's *Tales of Mystery and Imagination*. For Poe's macabre 1831 story, 'Ms Found in a Bottle', is written by a sailor who, having been swept by a terrifying storm on board a passing vessel of titanic size, discovers that its eerily aged crew are incapable of registering his existence. He decides to write an account of this nightmarish voyage and, if necessary, cast it into the sea. Before long the vessel is surrounded by ramparts of ice and caught in a terminal vortex. The hapless sailor's manuscript ends with a feverish description of how 'we are whirling dizzily, in immense concentric circles, round and round the borders of a gigantic amphitheatre, the summit of whose walls is lost in the darkness and the distance'.

Although Oldenburg and van Bruggen avoided the melodrama and morbidity of Poe's gothic tale, they incorporated the form of the vortex in their own sculpture. And they ensured that writing played a powerful role, too. But rather than following the example of Poe's sailor, and use ink on paper, they decided to let the words take over. While the cork remained paradoxically intact, the rest of the bottle would be made solely of the writing it contained.

But why does the sculpture incorporate two sets of 'notes', with one sentence wrapped like a lattice around the bottle's circumference while

163. Claes Oldenburg and Coosje van Bruggen, view inside *Bottle of Notes*, in Central Gardens, Middlesbrough, 1993

the other spirals crazily inside? The most visible of the quotations, from a distance at least, was found by van Bruggen in Cook's journals. He describes, with evident satisfaction, how 'we had every advantage we could desire in observing the whole of the passage of the Planet Venus

over the Sun's disc'. The sentence comes from an official log recording a man's professional fascination with studying an eclipse. And this awesome phenomenon lies at the heart of the sculpture.

At first, Cook's words – masculine, matter-of-fact, public prose starting with the pronoun 'we' – appear to obliterate the text on the interior. But if viewers peer through them to the other side, his sentence is itself eclipsed by the Venus-like presence of the writing within. Taken from a poem by van Bruggen, the words are lyrical and celebrate a private memory rather than a collective experience in the present: 'I like to remember sea-gulls in full flight gliding over the ring of canals.' Based on recollections of her childhood in Amsterdam, where the canals testify to Holland's seafaring prowess during the century before Cook's exploits, van Bruggen's sentence takes a quiet delight in the soaring freedom and resilience of the gulls observed from another coast of the sea bordering Middlesbrough.

On a personal level, the two texts surely shed light on the relationship between Oldenburg and van Bruggen themselves. Taking turns to 'eclipse' each other, the male and female passages are nourished by their intertwining. But while celebrating the unusual intimacy which binds them in love and work, the two sets of writing still remain separate. Painted colour helps to mark out their distinctive identities: off-white for the outside, blue for the words within. The rhythms created by the words are also differentiated. Oldenburg's angular handwriting ensures that Cook's sentence seems to be driven by the surge of the sea and the force of the wind. But van Bruggen's rounded handwriting gives the words inside astonishing vivacity. The holes puncturing *Bottle of Notes* encourage us to step inside the sculpture, and there the words spin above our heads with dizzying force. Although the effect is exuberant rather than akin to the terror of Poe's story, the sculpture's tilt conveys a sense of precariousness as well. It suggests that *Bottle of Notes* might have been washed ashore and beached there by a receding wave. The proximity of the newly created lake and rocky cascade in the garden area occupied by the sculpture reinforces this idea, and reminds us that the sea is not far from the centre of town.

In the end, though, vulnerability plays second fiddle to energy and resilience. The daring open structure of *Bottle of Notes*, which cocks a snook at the whole notion of sculptural solidity, pays homage to Middlesbrough's renowned Transporter Bridge. Its tensile strength encouraged Oldenburg and van Bruggen to think in terms of an object defined essentially by line. Drawn in space with flamboyant and rigorously refined assurance, the completed sculpture also testifies to the traditional

fabrication skills of the region. Middlesbrough can be proud of the fact that such a distinguished work was made locally, and that the town has set a challenging new standard to the rest of Britain in its determination to place this provocative, multi-layered and yet crisply accessible monument at the very heart of urban life.

SCULPTURE AT GOODWOOD
13 September 1994

In recent years, the art of displaying sculpture outdoors has made enormous and much-needed advances. We have realized, at last, that hauling lumps of metal and stone into parkland is not enough. Some sculpture should never be exposed to open-air sites: it looks far better in confined, carefully lit interiors. As for the work that does flourish outside, it should only be shown there with care and, above all, generously separated from its neighbours. On my arrival at Hat Hill Copse on the Goodwood Estate, where twenty acres of delectable Sussex countryside have been turned into an ambitious new sculpture park, I had severe initial misgivings. The leaflet, which contains an indispensable map, carries on its cover a full-colour montage of selected sculptures. They have all been ripped out of their locations and herded together, presumably because the designer wanted to enhance their appeal. The outcome is a promotional disaster. The sculptures look unforgivably crowded, jostling for space and warring with each other at every turn.

Mercifully, it bears no relation to the sensitive layout of exhibits on the estate. For every effort is made to install each work in the most appropriate location. The temptation to choke the grounds with an avalanche of bronze and steel has been resisted. Most pieces inhabit their own terrain undisturbed, showing how a marriage between art and nature can best be achieved.

The project is the brainchild of Wilfred and Jeannette Cass, the enterprising art collectors and patrons who own Hat Hill House. They commissioned the redesigning of the grounds specifically to provide areas for sculpture. The planting of 400 extra trees and shrubs has ensured that the setting is richly wooded, helping to give each exhibit an all-important sense of place. As a result, some of the works look far better than they ever did indoors. Take Sir Anthony Caro's *Tower of Discovery*, a behemoth

in rusted steel which made its début at the Tate Gallery three years ago. There, it looked too big for the space, and took on a lumpish, ungainly air. Here, by contrast, the tower sits comfortably within a glade. The sheltering trees are taller than the sculpture, ensuring that it no longer seems monstrously out of proportion with the surroundings. It has room to breathe, so that the twisting staircases and convoluted chambers inside the tower take on a less tortuous rhythm. The new locale also gives anyone scaling Caro's 'sculpitecture' a marvellous view. Looking out from the top, with its echoes of a ship's bridge, visitors can gaze across a captivating expanse of Sussex countryside towards the distant coast. Chichester Cathedral's spire is dominant on one side, but the prospect is expansive enough to take on different meanings when juxtaposed with other sculptures.

Placed near these open fields, Elisabeth Frink's tense, expectant *Horse and Rider* seems to have paused only for a moment. Both man and mount look ready to gallop off across the land, either escaping pursuers or hunting some unseen quarry. And a similar ambiguity informs Bill Woodrow's redoubtable *Cannon*, commandingly positioned so that it thrusts towards the same open terrain. Is it about to bombard the meadows, where cows now graze, or defend the copse against possible siege? Both interpretations are plausible, but there is no mistaking the work's ominous impact. The cannon's barrel resembles a bronze tree-trunk shorn of branches. It recalls the denuded trees left behind on the battlefields of 1914–18. But the cannon, along with the heap of bronze balls nearby, belongs to earlier wars. And the hands beneath the barrel, crazily playing an accordion, add a suggestion of hysteria to this otherwise sombre work.

The tranquillity of *Cannon's* setting might have seemed inappropriate, weakening its baleful identity. But the sculpture ends up gaining in menace when contrasted with such a peaceful scene. Indeed, one of the exhibition's pleasures lies in discovering the different ways in which sculpture's meanings can be enriched by a natural location. Because Paul Neagu's *Starhead 3* is made of highly polished stainless steel, it could easily have looked harsh and jarring among the gentler textures of woodland. This arresting work has, however, been anchored to its space by the presence of a wall. And the action of sunlight on the sculpture's climactic starburst intensifies its ecstatic force.

Light plays a more subliminal role in Shirazeh Houshiary's *The Extended Shadow*. Made principally of lead, her vertical sculpture has a restrained presence. But each of the stacked polygonal elements is painted with gold leaf, and the sun makes them gleam with a lucidity they might not possess in a gallery. These glinting segments animate the

sculpture, lending it a sense of unpredictability. The gold leaf also makes *The Extended Shadow* less solid, helping to explain why Houshiary chose a title that points towards immateriality.

Even so, darkness can play an equally potent role in outdoor spaces. Several sculptures gain a great deal from the decision to position them in the woods, well away from the full impact of daylight. The trio of carvings by Peter Randall-Page lurks in the shadows, waiting to be discovered by anyone negotiating a path through the trees. Two of them are modest in size, and perch on wooden plinths to ensure their visibility. They look like sacrificial offerings prepared by unknown denizens of the forest, but the largest carving lies directly on the ground. It is called *Beneath the Skin*, and forms suggesting human limbs seem to be embedded in the sculpture. They may want to burst out of their confines; but Randall-Page's chisel has ensured that, for the moment at least, they remain trapped within the boulder-like lump of Kilkenny limestone.

If *Beneath the Skin* conducts a dialogue with the earth on which it rests, David Nash's exhibit interacts with the trees. They look etiolated in comparison, for Nash's sculpture is hewn from a doughty trunk of oak. But it looks precarious as well as substantial. Nash has carved the oak into a sequence of chunks, which appear to be balanced on each other like stacked stones. Although the illusion disappears when the work is examined close-to, its blackened surface gives *Charred Column* the air of a scorched survivor.

Not all the sculpture is placed in a felicitous way. Phillip King's *Academy Piece*, an enormous horizontal table-form of steel and painted mesh, filled an entire room when first shown at the Royal Academy in the early 1970s. Here, by contrast, it inhabits part of a far larger expanse of flat, open lawn. Its impact is diminished, especially in comparison with the severe, pared-down assurance of Nigel Hall's *Soglio* nearby. King's deep blue reticence suffers from its proximity to Hall's outspoken orange circle: the two works should have been placed much further apart.

No such problem afflicts Tony Cragg's *Trilobites*, the most memorable work on view. As its title indicates, this two-piece sculpture takes as its starting-point the fossil marine arthropods dating from Palaeozoic times. Occupying a stretch of open ground with a view away to the sea, they resemble at first genuine, outsize molluscs, inexplicably abandoned on the grass. Look at them more closely, though, and they turn out to have cavities lodged inside. Smoothed to a machine finish, unlike the furrowed surface of the fossils, these vessels would be at home in a laboratory. But they do not seem anomalous here. Trilobite and container, from the worlds of prehistory and science, coexist with surprising harmony.

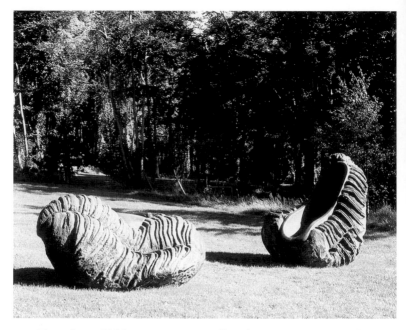

164. Tony Cragg, *Trilobites*, 1989, at Hat Hill Sculpture Trust, Goodwood,

In one of the vessels, I noticed that rainwater had collected and a spider's web stirred in the breeze. Open-air settings have a way of giving sculpture a satisfying sense of natural inevitability. And the fossils' presence here enlarges, in turn, our understanding of the countryside, reminding us of the mysterious antiquity layered far beneath the placid meadows of today.

TESS JARAY AT WAKEFIELD
23 February 1995

While urban centres throughout Britain persist in saddling themselves with predictable pedestrianised areas, Wakefield has come up with an invigorating alternative. Realizing that the tatty and nondescript Cathedral Precinct installed in the 1970s had deteriorated beyond recall, the city's team of architects and engineers decided that they wanted to escape from stale formulae. Andy Kerr, who led the project, felt that all these civic blueprints ended up looking identical. Rejecting off-the-shelf thinking, he persuaded Wakefield to take the highly unusual step of employing an artist.

After interviewing four candidates, Tess Jaray quickly emerged as the favourite. At that time, in 1989, she was immersed in designing Birmingham's Centenary Square. Graham Roberts, Director of Yorkshire's Public Arts agency, was aware of the transformation Jaray had achieved there. But he also appreciated that Wakefield presented a very different challenge. Centenary Square is a colossal piazza, bordered by buildings which offer no hint of Birmingham's ancient origins. At Wakefield, by contrast, the precinct is more intimate and runs beside the gothic bulk of All Saints Cathedral. Both Roberts and Kerr warmly approved of Jaray's determination to give Wakefield the focal point it lacked, treating the cathedral as the centrepiece from which everything else should flow.

Before Jaray got to work, the All Saints building had seemed curiously cut off from the rest of the city. Nothing linked the cathedral with the shopping centre running down the other side of the precinct. Now, however, the metamorphosis is complete. After an intensive three-year remodelling, Jaray has succeeded in honouring All Saints and at the same time bringing the cathedral into a far closer relationship with its surroundings. As in Birmingham, the most delectable part of the scheme is the coloured clay-brick pavement running through the precinct like a quietly seductive carpet. Approaching its outer edges, after walking down a street where the old, shoddy paving still lingers for the time being, is like walking up to one of Jaray's own paintings. Small, angular forms in Harlech Blue float on a sea of buff herringbone patterning. They bring about a change of pace, discouraging automatic trudging and engendering instead a more relaxed, sensuous awareness of the area as a whole.

The cathedral spire asserts its presence above a row of plane trees. And, as you approach the building's west end, the pavement undergoes a dramatic alteration. The first flight of Jaray's wide, inviting steps appears,

acknowledging the fact that the building inhabits a sloping site. Beyond them, the section of pavement opposite the cathedral's entrance suddenly comes alive with the forms of a cross. Without echoing the shape of All Saints in a literal way, the crosses seem to celebrate the building's proximity as they cluster in close-packed ranks. But there is nothing pious about these cruciform units of specially developed Wakefield Buff brick. Although their colour blends uncannily well with the cathedral sandstone above, they take their place in a pavement poised between the sacred and the secular. For the design changes the more you study it, and sometimes the Harlech Blue background takes on an assertive identity of its own. Snakelike elements seem to writhe their way round the forms, threatening to constrict them. A struggle might be under way between good and evil, but Jaray is the last artist to become heavily symbolic. A moment later, the crosses regain their former dominance and placidity prevails. We are left with a design which appears to emanate from All Saints, spreading the building's influence into the city even while registering the impact of other, less beneficent forces outside.

Further down the slope, two more pavements separated by flights of steps reiterate the cruciform motif. On each occasion, though, the crosses become smaller. As the entrance to the cathedral is left behind, so their presence diminishes. The Harlech Blue bricks, which actually resemble a dull purple, grow more prominent. But if the crosses shrink, they also seem increasingly liberated. The clustering effect of the first pavement is replaced by a greater sense of ease, preparing us for the return of the herringbone pattern as we go past the cathedral's east end.

The regeneration of the precinct is not confined to pavements alone. They take their place within a carefully orchestrated ensemble of other elements, this time closer to sculpture than painting. If anyone imagined that Jaray's abilities were limited to image-making on a city's floor, Wakefield would scotch this idea at once. For the brickwork is bounded on one side by grand flights of steps leading up to All Saints, and on the other by York Stone blocks containing a variety of plants as well as slender columns topped by globular lights. They testify to Jaray's eye for refined detail at every turn. And while they chime effortlessly with the forms of the cathedral, she makes no attempt to ape the gothic style in a spirit of pastiche. Serene simplification is the keynote, showing her awareness of post-war shopfronts as much as medieval architecture. Her work becomes a subtle bridge between the two worlds, making sense of the gulf dividing Marks & Spencer or Burger King from the stronghold of High Anglicanism across the way.

Nor does Jaray's passion for the totality of an area stop there. Nothing

165. Tess Jaray's renewed Cathedral Precinct, Wakefield

has been left to chance. Instead of allowing the precinct to be disfigured by banal street furniture, she insisted on designing the benches, handrails and litter-bins herself. They look marvellous. Coated in a colour very close to the dull purple deployed on the pavements, they become an integral part of the space rather than an incongruous afterthought. The litter-bins are particularly handsome, recalling in their confident sturdiness the great age of British pillar-box and phone-kiosk design. Their exteriors are discreetly embellished with a minimal relief reminiscent of the cathedral's gothic window-arches, and the same motif enlivens the stone columns bearing the bulbous street lighting. Gold at the moment, these bronze finials will eventually turn green and streak the stonework below them.

Perhaps the most remarkable manifestations of Jaray's command over the entire design are the bollards. Installed in rows and clusters, to guide heavy vehicles making deliveries to nearby shops, they resemble sentinels standing guard at the precinct's entrances and exits. Like the lighting columns, and the half-mature yews ascending the main steps, their slim, upright presence echoes the pinnacles punctuating the cathedral's roof-line. Just as a neighbouring quarry was used for the mellow York Stone, so local craftspeople were responsible for making all these objects. Although subsidiary in themselves, taken together they help to give the

precinct its unique appeal. The steps and benches will seat over 1,000 people, enabling them to attend events ranging from the Wakefield Mystery Plays and brass-band concerts to outdoor operas. Already, on the day I was there, shoppers were treating it as a natural resting-place and seemed happy to linger.

When the project was first announced, vociferous local opposition centred on the £800,000 cost and the loss of the popular grassy bank which used to slope down from the cathedral. But European regional development funds have met half the bill, and there is now twice as much grass as before in beds once crudely piled with cobbles. More important still, the new precinct looks as if it has been around for ever. The place possesses an air of rightness and inevitability, reflecting Jaray's respect for the context she has enhanced. Her unobtrusive yet radical transformation proves that artists and design engineers can work triumphantly together, giving this once-neglected city an authentic heart at last.

ROBERT WILSON'S H.G.
20 September 1995

Long before you arrive at *H.G.*, the mesmerizing installation Robert Wilson has made with Hans Peter Kuhn, the eeriness of old Southwark takes hold. Wandering down Clink Street is like finding yourself, quite without warning, in a London of disorientating shadows, grimy warehouses and a pervasive smell of ancient Thames-side damp. No wonder the Clink Street Vaults once housed a medieval prison. The aura of desolation is still palpable – as if the spirits of the suffering inmates have refused, even after so many centuries, to go away.

Entering the installation, through a nondescript door marked only with a plate bearing the work's enigmatic title, provides no reassurance. True, the first room is richly stocked with Victorian furnishings; and an elaborate meal, still giving off a seductive, piquant aroma, lies half-eaten on a dining-table where candles still burn in their ornate holders. But the guests who flung the rumpled napkins aside have all vanished. Like the passengers on the *Marie-Celeste*, they departed in a hurry and without explanation. So we are left blinking in the half-light, casting around for possible clues like detectives at the scene of an utterly perplexing crime. Miniature sphinxes, classical columns and an abundance of other cultural

souvenirs suggest a well-educated, much-travelled host. The interior has been assembled with such beguiling realism that we can discover, with the help of clocks and a yellowing copy of *The Times*, that the evacuation occurred on a September evening in 1895. But the precision of these facts only makes the dearth of any larger explanation all the more tantalizing.

Although the rest of the Vaults await exploration, Wilson is not the man to supply an easy solution to the mystery. His hydra-headed activities, as a theatre director, performer, painter and designer, have always thrived on withholding information and confounding every expectation. So we leave the abandoned dining-room, and descend into the greater darkness of the labyrinth beyond, prepared to grapple with enigma at every turn. Subterranean and reeking of the river, Clink Street Vaults turn out to be as cavernous as they are bewildering. Confronted by the Piranesian array of spaces detectable through the gloom, some visitors might succumb to trepidation. The menacing tunnels and vaulted chambers make us feel that we have descended into a Hades-like region. Time seems to collapse as readily as space, and any era, from past or future, can be summoned from the encircling shadows.

In one room, illuminated only by a solitary shaft of intense brightness, a swathed mummy is stretched out on the otherwise deserted floor. The clarity of the lighting is almost painful, picking out the petals scattered across the mummy's bandaged face. But Wilson knows the value of counterpoint, and he ensures that the contrasting space across the passageway barely emerges from inkiness. Gradually, pillars assert their presence there, along with a dull glow beyond the far wall. Then, just when you might have decided that the room is empty, a silhouetted figure becomes faintly visible. Unlike the mummy, it is upright and slowly on the move. By degrees, the figure glides forward, eventually revealing itself as a live performer rather than an effigy fashioned by Wilson himself.

For all his manifest delight in full-blown theatricality, he is a disciplined artist. We are prevented from entering this space, even though Wilson has fired us with curiosity about the figure's identity and predicament. It seems condemned to perpetual isolation, like the inhabitants of the medieval jail. And we wander on, our frustration soon alleviated by Wilson's willingness to let us roam freely around an immense area lined with pale metal beds. Lit by a succession of bare, dangling bulbs, which swing if you brush against them, the beds are stark enough for a military hospital. Freshly laundered and neatly tucked in, the pillows and sheets look expectant. But any likelihood of imminent patients is countered by the steel buckets sunk into the floor. Filled with blood-coloured liquid, they seem to cancel out the hope aroused by the spruceness of the bed-linen.

Wilson and Kuhn's use of sound, hitherto restricted to a distant rat-like scuffling and squeaking in the room with the dark figure, takes on a new eloquence here. A plaintive piano scale echoes through the hospital ward, lending an additional mournfulness to the nearby iron bars set in a prison door. Peer through them, and you find yourself gazing across a nocturnal expanse towards a distant rainforest. Its freshness and verdancy, enlivened by signs of movement among the foliage, is infinitely inviting. But Wilson ensures that the promise of paradise remains achingly beyond reach, so we turn back to encounter a bureaucratic desk heaped with files, lists of names and printed references to an influenza epidemic.

By this time, the idea of escape has an increasing appeal. As if to facilitate the urge, Wilson places a step-ladder by a wall leading up to a trap-door open in the ceiling. As they approach the top, though, the steps become blocked with sheafs of paper. And any thought of exiting through another room vanishes when searchlights rake the space to discover, among the pillars, a predatory animal paralysed by their glare. Feelings of entrapment, however, are outweighed by a gathering fascination. The remaining vaults beckon, irresistibly. And so we move on, negotiating a path through an area where ancestral portraits lie discarded and sodden on a puddle-strewn floor. Having exerted its unseen presence before, water now streams down the walls. We could be standing in a ransacked

166. Robert Wilson, *H.G.*, 1995

castle, long since abandoned and left to rot. Wilson intensifies the sense of ruined civilizations further on, where a gap in a broken wall yields the most astonishing spectacle of all: a cluster of towering classical buildings, dominated overhead by arrows suspended in their flight through a Mediterranean sky.

At this point, after lodging the whole notion of historical journeying ever more firmly in our minds, Wilson provides his most revealing clue – a glimpse, through a doorway, of a white sphinx. The same creature plays a central role in H. G. Wells's *The Time Machine*, where it appears to the dazed traveller as a colossal carving in white stone, winged and so greatly weather-worn that it 'imparted an unpleasant suggestion of disease'. Once the connection has been made, other references fall into place: the title of the installation, the fact that Wells published his story in 1895, and his description both of an opening dinner-party and the menacing animal discovered by the Time Traveller in 'a narrow gallery, whose end and side windows were blocked by fallen masses of stone'.

I do not want to exaggerate the extent of Wilson's debt to Wells. Plenty of episodes in the book receive no acknowledgement down in the Clink Street Vaults, and *H.G.* should properly be seen as a work that parallels *The Time Machine* rather than illustrating it. All the same, the cumulative effect of this brilliantly staged installation, moving with seasoned assurance between darkness and light, epic audacity and minimal restraint, is faithful to the mood of Wells's pioneering story. The roomful of labelled and discarded shoes near the end of *H.G.* cannot be found in *The Time Machine*. But their melancholy summation of loss and endless extermination reinforces the tenor of Wells's concluding page, where the narrator describes how the Time Traveller 'thought but cheerlessly of the Advancement of Mankind, and saw in the growing pile of civilisation only a foolish heaping that must inevitably fall back upon and destroy its makers in the end'.

Working exactly a century after those words were published, Wilson sees no reason to contradict Wells's prescient pessimism. Even so, the virtuoso manipulation of light, sound, space and sculptural form at Clink Street possesses a strange exuberance as well, affirming the power of the unfettered imagination even when it grapples with fear, emptiness and the inescapability of decay.

BILL VIOLA AT DURHAM

24 December 1996

When medieval art was at its height in Britain, churches and cathedrals were the natural home for the finest painting and sculpture of the period. The smashing and burning perpetrated by Henry VIII and his Protestant successors ensured that pitifully little now remains. We are forced to search for vandalised fragments in the shadows of naves, transepts and choirs. They provide only a bruised and abraded hint of the images that once played such an integral part in the architecture they enhanced. And attempts by twentieth-century clergy to commission new religious art have ended, all too often, in excruciating banality. That is why *The Messenger*, Bill Viola's video installation in Durham Cathedral, stays in my mind as one of the most heartening works I encountered in 1996. Initiated by the cathedral's Senior Chaplain, Bill Hall, who invited Viola to make a new work as part of the celebrations of the UK Year of the Visual Arts, it proved against the odds that contemporary art in a hallowed setting can vie with the intensity of its medieval forerunners.

Few of the images which once embellished this sublime building now survive. The great Neville Screen in Caen stone behind the High Altar, given by Lord Neville around 1380, was originally enlivened by 107 richly gilded and painted statues. Only a few of its smallest and most incidental carvings have been spared, and the profusion of empty niches is painful to contemplate. True, a thirteenth-century stone *Crucifixion* can be found in the Chapel of the Nine Altars. But it comes from Nedsham Abbey, and has suffered so much that its surface is severely eroded. Moreover, at the centre of this same chapel an elaborate embroidered Frontal on the altar exemplifies everything wrong with church embellishment today. Designed by Leonard Childs and funded by the Friends of the Cathedral in 1994, it looks frankly garish and unworthy of this austere setting.

Not so Viola's installation, which focuses unapologetically on the full-length figure of a naked man. Medieval art often made eloquent use of bare flesh, especially in the representation of suffering. But Viola's decision to dispense with the statutory loincloth prompted the Dean to consult the police. They considered that nudity might perturb visitors, and took the ludicrous decision to fence off the installation with makeshift screens. Together with a notice warning viewers that 'some may find [the work] offensive and parental discretion is advised', this crude cordoning-off turned Viola's installation into something furtive and shameful. It forced

everyone to approach the work in a grotesquely inappropriate frame of mind, on the look-out for signs of titillation. Such prurient suspicions were wholly misplaced. Pornography played no part in the image of a pale, submerged body projected on to the large screen. Positioned directly below a resplendent stained-glass window at the cathedral's riverside end, and framed by a rounded arch with powerful dog-tooth incisions, the screen was attached to the Great West Door. No architectural location could be more imposing, and the primal simplicity of Viola's image chimed with the monumental severity of its Romanesque surroundings.

When the work commences, it does not strain for grandiose effect. The figure is scarcely discernible at first. He seems little more than a small, wavering blur illuminated by a diagonal shaft of ice-blue light streaming in from the right. Gradually, we realise that the blue-black emptiness around him is a deep body of water. It threatens to extinguish him altogether, and continually breaks up his corporeal solidity in a mass of shimmering, glinting fragments. Slowly, almost imperceptibly, this inert and anonymous man becomes more identifiable as he rises upwards. Bubbles gush from his head like stars spinning out of control in the night sky. He looks more dead than alive. At this stage, we have no way of telling if he is a corpse or a survivor about to take on a miraculous new existence.

As this enigmatic presence approaches the surface, he displays no sign of strain. With both arms hanging down limply at his sides, he submits to the force of the water and allows himself to be pushed towards us on his back. Then, quite suddenly, he breaks through. As his body hits the air and the warmth of a brighter light, the man's gasping relief appears to be mixed with a rush of pleasure. The colour washing over one side of his sun-tanned body is as heady as the brilliantly hued drapery in a Mannerist altarpiece by Pontormo, a painter whom Viola particularly admires. Memories are stirred of the dead Christ in a thousand Deposition scenes, especially when the man's arms float outwards as if in unconscious recollection of his crucified pose.

Although video is Viola's medium, he remains profoundly indebted to the European tradition of figure painting. But he does not seek to impose a religious meaning on *The Messenger*. The floating form is impossible confidently to identify as Christ, even when we watch his bearded face release a long-held breath. Until this instant, the work has been silent. Now, however, the sound of pent-up air rushing from his mouth echoes through the cathedral, from one end down to the other. It animates the space, like an unexpected gift. And for a moment, *The Messenger* seems to be unequivocally concerned with the promise of rebirth.

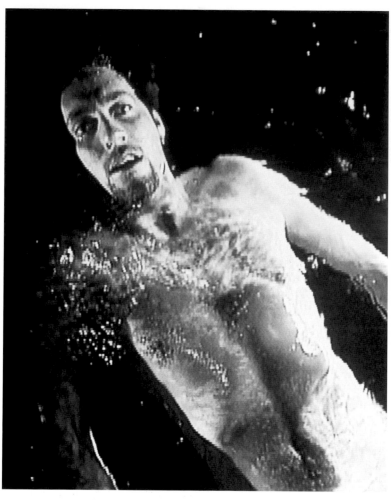

167. Bill Viola, *The Messenger*, 1996 (detail)

A towering seventeenth-century font stands directly opposite the screen, reinforcing the possibility that renewal is Viola's overriding theme. But water's biblical ability to purge sin and generate new life does not dominate the work. When the man sends out his breath, and leaves its unexpectedly loud, urgent and startling sound to resonate in the lofty nave, he does not convey any triumphant resurgence. Although his eyes

open, they fail to focus on their surroundings. He frowns as if in bewilderment or distress, and still seems in thrall to the dreamy state he experienced far below the surface.

Rather than moving towards a Lazarus-like emergence from the void, the figure finally inhales as deeply as possible, closes his eyes and sinks back into the darkness. He recedes as slowly as he once arose. Bubbles streaming from his nose shatter his face with glistening points of light, while the water's undulations invade his body with their ever-increasing distortions. The smaller he becomes, the more he sheds his human identity and lapses into amorphousness. The figure still inhabits the centre of the screen, but breaks up into slivers of glacial light. Once so substantial and fleshy as he lay suspended on the surface, the unknown man now appears to be overwhelmed by the enveloping inkiness.

The cycle begins again, and is repeated without losing any of its trance-like power. On each occasion, the figure's ability to burst through the water and bestow his breath on the air carries the force of a secular benediction. When *The Messenger* eventually ends, though, we find ourselves watching the screen grow completely dark. The diminutive form, now impossible to recognise, is snuffed out. So instead of encouraging us to have faith in a resurrection, Viola's mesmeric work terminates by emphasizing the inevitability of physical obliteration. In this respect, the Durham installation confirms the involvement with mortality explored in many of his earlier video pieces. They often use water as a means of conveying the hope of cleansed renewal and, simultaneously, the inescapable prospect of dissolution. The chilliness of the cathedral in early October certainly added to the feeling that death was close-by. But *The Messenger* did not seem at all morbid. Its prevailing quality lay in an extraordinary sense of graceful lyricism. No struggle was involved in the figure's repeated descents to the depths. He submitted to them without a qualm, as though stoically accepting the disintegration undergone by his body while it sank further into the gloom.

Perhaps he was spiritually buoyed up by the knowledge that a cyclical rhythm controlled his fate, enabling him to ebb and flow like a tide. Above all, he enabled us to take heart from the climactic moment when his mouth sends out an affirmation of life. It is a passionate emission, demonstrating beyond all doubt that contemporary art can still play a potent and illuminating role in the most awesome of ecclesiastical interiors.

home, where he was impressed by his mother's post-war insistence on storing food supplies in case of further emergencies. Memories of the world he experienced as a child feed much of his work. But they are all shaped by the instinctive theatricality of a man equally renowned for his opera designs and spectacular performance works.

Each of the locations in Bath has become his stage set, nowhere more arrestingly than on the first floor of an empty Georgian house in St James's Square. The high, wide room is almost filled with a looming wooden structure called *The House of Flames*. Its doors swing open to disclose an interior as shadowy as a tomb. But no sarcophagus can be found there. Instead, our eyes gradually begin to make out the blue biro lines scrawled all over the walls. They look, at first, like the work of a demented schoolboy who might already have covered his desk with similar marks. But their sheer density becomes strangely luminous. Fabre is fascinated by what his great-grandfather poetically described as the 'Hour Blue' – the moment when night passes into day, light makes its first faint stirring and birds begin to sing. Determined to find its visual equivalent, Fabre has even covered Tivoli Castle in Belgium with blue biro ink. He finds the colour as potent as Yves Klein once did, and it helps to offset the emphasis on mortality which might otherwise make his work intolerably morbid.

No hint of affirmation can be found in a deserted house on Great Bedford Street, where flycatchers hang down from a dilapidated ceiling and wait for their prey. Fabre's self-portrait with protruding red ears is displayed above the fireplace, staring out at the silent room with a vigilant air. But his presence does nothing to alleviate the predatory coldness of an installation where I felt no desire to linger. At times like this, his preoccupation with death alienates my sympathy altogether.

Over at the disused mortuary chapel in Walcot, though, his dramatic transformation of the interior is far from stifling. Seven baths, all resting on claw feet, stretch from one end of the building to the other. They should resemble coffins, and glimpses of a graveyard through the windows intensifies the air of doom. But the baths are empty, and Fabre has enlivened them with his ubiquitous blue ink. It gives their surfaces a dappled, mottled quality, and the depth of the colour is echoed in the reflective blue of the owls perched like sentinels just below the chapel roof. Although their Murano glass bodies have been smothered in ink, they glint in the building's clear light. And they seem benign rather than malevolent, presiding over the baths with protective intent.

The owl reappears in Fabre's exhibition at the Arnolfini in Bristol, where a large blue drawing presents him in the guise of a bird-catcher. As gaunt as Joseph Beuys, his face gazes out at us through the veil of a

beekeeper's hat. This is a portrait of the artist as Lime Twig Man, a legendary German figure who chases birds with his lime branch and, at the same time, attracts clouds of insects. Fabre detects parallels between this mythical, sixteenth-century hunter and the contemporary artist, both of whom attract controversy and misunderstanding as they pursue their single-minded interests.

A fascination with the past is detectable throughout the Arnolfini show. While Fabre's work is unmistakeably modern, it is riddled with references to history as well. In the darkened downstairs space, the most prominent spotlit exhibit consists of three cowled figures, all covered in jewel beetles. Projected from rods high on the wall, they look like hovering angels. As in the beekeeper drawing, Fabre makes an overt reference to images by Bruegel. But the three hoods are empty, and their arms hollow. For all the glinting allure of the insects enriching their robes, they also resemble victims of a public execution left outside to rot.

Death recurs upstairs, where more than 500 wooden crosses lean against a long wall. Although reminiscent of war cemeteries, they are inscribed with insect names conceived by Jean-Henri Fabre. Many of them carry a powerful, sinister charge: I made a special note of spektor, drieland, minotaurus, hoormaar and wolfspin. But the uprooted appearance of these stacked crosses adds to their eeriness. They seem redundant, and Fabre's decision to give them the collective title *The Grave of the Unknown Computer* reinforces the unease. Humanity, he implies, will itself become obsolescent as technological prowess increases. But beetles, who already play a far greater role in his art than people, have the built-in resilience of born survivors.

In another intriguing room at the Arnolfini, devoted to his early drawings and sculpture, the beginnings of Fabre's obsessive world are charted. Small, intense pencil drawings show a dead mouse suspended in a bush, a crab scurrying through the night and butterflies barely discernible through dense layers of graphite. An odd, childish glee animates the strangest images. A witch glowers at an alarmingly enlarged beetle, while in a nearby showcase tarantulas sprout feathers or light bulbs instead of heads. Even at this stage, the young Fabre's imagination was as troubled as his fellow-countryman James Ensor, who shared his infatuation with insects. And like Ensor again, Fabre's sense of zest counters his ever-present awareness of the grave. In his finest work, the two are held in balance. The mouth of *Cocoon*, an earth-coloured sculpture resting half-way up a wall, may reveal a disconcerting void within. But it offers shelter as well, and an unpredictable form of new life might one day be born in its gaping, expectant body.

PHILLIP KING IN FLORENCE
19 August 1997

High on a hillside above Florence, the ancient Forte di Belvedere offers a captivating panorama of Renaissance architecture at its finest. But the Forte, along with its extensive surrounding land, is also used for major surveys of contemporary sculpture. Anyone lucky enough to be displayed there faces an exhilarating yet awesome challenge, pitched against the magisterial finality of Brunelleschi's cathedral dome and Giotto's Tower far below.

Phillip King, whose achievement is celebrated at the Forte this summer, played a key role in revolutionizing British sculpture thirty-five years ago. Abstract, brazenly coloured and often reliant on materials as heretical as plastic, aluminium and steel, King's most flamboyant work of the 1960s was unrepentant in its pursuit of renewal. Never intended to have a Tuscan backdrop, his sculpture might easily have seemed jarring in such a revered context. But it emerges from the risky encounter with enhanced vitality. The Florentine setting reminds us that King's work, even at its most enigmatic, is strongly allied with architecture. Not only did he make a formative trip to Greece in 1960, just before making his own breakthrough as an artist. His reaction to Athens was influenced, in turn, by a childhood spent near Carthage. He never forgot the excitement of seeing how Tunisian light defined the domed forms of Islamic architecture. Those memories have nourished the instinctive feeling for poised monumentality in his mature sculpture, and help to account for the ease with which King's exhibition inhabits its present locale.

There is nothing facile or complacent about his work, though. 'I want people to stand aghast for a second', he once declared, 'and I hope they'll do it again and again with my best work.' In front of the Forte, I found myself stirred all over again by the audacity and brio of King's large sculptures. They erupt on the stepped and sloping terraces overlooking the city. Both the artist and the show's organiser, Peter Murray, have refused to hide the work's exuberance. Admittedly, they had the good sense to place the low-lying and discreet *Academy Piece* directly in front of the cathedral, thereby avoiding an unnecessary clash between King and the quattrocento. But they allow the jerky restlessness of *Cavalcade* to burst in the sky above Florence, and let the scimitar curves of *Quill* slash their painted steel lines against the distant mountains. As for *The Watcher*, where a fat vessel perches precariously on a tall columnar base, it occupies a bold position atop a hillock to vie with the soaring tower of the Palazzo Vecchio beyond.

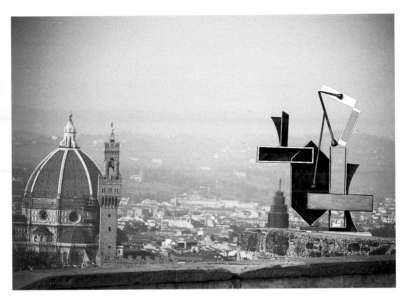

169. Phillip King, *Cavalcade*, 1986, in Florence, 1997

However stimulating these confrontations may be, they have not tempted King and Murray into displaying everything in the open air. The main Forte building provides space for indoor display as well, and some of the most impressive pieces from the early 1960s are shown off here to superb advantage. The room containing three of King's finest early sculptures is far from capacious. But the works themselves seem energised by their confines. Spotlit on a terracotta floor, they complement each other admirably. *Window Piece*, a pale concrete rectangle, shows King at his most austere. But *Drift*, with its breast-like swelling tilted back languorously against a plain wooden support, reveals his sensuality. And these impulses fuse with unforgettable effect in *Rosebud,* a puce plastic pyramid slashed by a thin aperture wriggling from apex to base.

During the first half of the 1960s, King was constantly nourished by his obsession with the cone. *Genghis Khan*, sheltering in the shade of a loggia at the Forte, rears up like a warrior's tent and sprouts exclamatory antler forms from its head. But it opens in the middle as well, allowing a cascade of blue plastic to spill out and rush towards our feet. This willingness to invade the spectator's space enlivened much of King's work at the time. Dispensing with the conventional plinth and resting his work

squarely on the ground, he encouraged it to demolish the invisible barriers separating art work from viewer. In *Twilight*, an effervescent 1963 sculpture where the split cone becomes semi-transparent, a number of propellor-like shafts fan out from the summit and threaten to ensnare us. Two years later, the harsher *Point X* opens outwards and, as hungry as a predatory mouth, seems capable of snapping shut on anyone unwary enough to stretch out a hand.

In the latter half of the 1960s, King expanded his sculpture to an often colossal size. Elements that once formed part of a single object broke free, to assert their own existence in multi-part works. Now the spectator can move through them at will. *Span*, a group of gleaming steel monoliths, looks like a twentieth-century homage to Stonehenge. While some of its pieces are upright, others lean at tipsy angles and have a melancholy, ruined air. They certainly appear mysterious and primordial out on the front terrace, whereas *Call*, set against gentle Tuscan hills rising behind the Forte, has a more dynamic impact. Its two bulkiest components, in scarlet and green, could almost be pitted against each other, in a game marshalled by the pair of slender posts between them.

We never suspect, walking round this inventive and stunningly dramatic exhibition, that King might be tempted to repeat himself. Scorning any reliance on formulae, he has refused to coast along and choose a predictable course. Each new sculpture is for him a fresh adventure, and the show contains plenty of surprises. *Slant* ambushes us, thrusting into the air like a series of scarlet exclamation marks. *Shogun*, by contrast, crouches under a tree like a powerful animal, waiting to pounce. As for the glorious *Dunstable Reel*, its joyful yellow and purple components sing out from a brick terrace baked by blinding sunlight. They dance defiantly in the heat, reflecting King's own euphoria when he awoke to the English countryside in 1969. Until then, his sculpture had possessed a strong urban character, in tune with the industrial, girder-like strength of the work produced by his friend Anthony Caro. But now, installed in a new farmland studio, he responded to his rural surroundings. Hence the mood of Matissean well-being in *Dunstable Reel*, the most relaxed and hedonistic work he has ever produced.

During the 1980s, though, the accidental death of King's son triggered a tragic mood. *Where is Apollo Now?*, cleverly installed in a loggia near pillars and round-arched doorways, contains a doomed figure falling from a sky where impassive clouds hover behind a broken column. It is an openly despairing image, and led on to a series of furrowed, agitated bronzes where King's anguish is still more openly expressed. In their broken, almost feverish modelling, they recall the small figures he made

during the 1950s. One of the finest, *Bird Woman*, is displayed here among later pieces like *Maquette for Peaks and Chimes*. The kinship between them is unmistakable, proving that the change in King's work around 1960 did not cut him off completely from his earlier sculpture.

Even so, the agonised complexity of the bronzes eventually gave way to the calmer, more fulfilled mood of the ceramic vessels he started making in 1995. Benefiting from generous access to a studio in Japan, King returned in these compact and satisfying works to the spirit of his most serene 1960s sculpture. Brancusi's benign influence is detectable throughout the room where the ceramics are shown, above all in the purged *Pitcher and Cup* with its graceful interplay between ripe forms and sudden, sliced cavities. A sense of optimism animates these vessels, even when they sprout startling protuberances. They suggest that, in his sixties, King has cast aside some of his former restlessness in a new search for distillation. But we should beware of imagining that he will ever settle down. The rest of this hugely rewarding survey warns us, time and again, that King's capacity to astound must never be forgotten.

TADASHI KAWAMATA

3 September 1997

Not content with taking its premises apart in an ambitious £4 million renovation, the Serpentine Gallery has now let Tadashi Kawamata loose on materials scavenged from the site. In front of the real building, he has erected a strange, troubling installation of his own. Passers-by might easily mistake this melancholy structure for the shattered remains of the gallery itself, and conclude that the Serpentine had been struck by some terminal, seismic cataclysm.

Viewed from the road, Kawamata's edifice is at its most substantial. He has positioned several of the old glass-panelled windows in a magisterial row, supported by a carpentered surround of new and recycled wood. Combined with white columnar forms, they make an imposing frontage. But anyone intrepid enough to penetrate the façade, and wander through the rickety rooms behind, quickly realises that they amount to nothing more than a shell. Securely nailed sections of wall and ceiling contrast with clusters of loose planks, laid across rafters and seemingly about to fall. Tall doors and windows hang surreally in space, lifted off

the ground as it slopes downwards. The predominantly pale wood gives way, in places, to timber so dark that it might have been scorched by some devastating fire. Broken roof-vaults point to the sky, aspiring yet useless. And at the back, two trees are incorporated in Kawamata's structure. Even they are frail, prevented from collapse by sturdy metal struts grounded in the lawn. But the plentiful leaves sprouting from their branches provide a green canopy for the ruin, implying that it will eventually succumb to natural overgrowth.

Exploring this series of skeletal spaces, I found myself thinking about the fascination exerted by the great medieval abbeys still standing throughout Britain. On one level, the experience offered by Fountains or Rievaulx is mournful: so much of their architectural magnificence was ruthlessly smashed. But substantial pleasure can be gained from them as well. Their sunlit harmony of stone gradually offsets the initial sense of sadness, just as the warmth of Kawamata's bristling geometry in wood militates against morbidity.

It would be a mistake to see his installation solely in British terms, though. Ever since he carried out an initial project in his native Japan eighteen years ago, Kawamata has worked on building sites with very different characters all over the world. He constructed a wooden bridge walkway between the dazzling new Contemporary Art Museum in

170. Tadashi Kawamata's installation outside Serpentine Gallery, London, 1997

Barcelona and the shabbier apartments nearby. He placed an apparently ramshackle shelter in a narrow Roman passage, and erected a sprawling timber structure next to a derelict smallpox hospital on Roosevelt Island, New York. Obsessed with cycles of growth and decay, Kawamata likes to challenge the existing architectural order with subversive additions of his own. On a muddy riverbank in Houston, he built a scattering of huts from scrap material. Juxtaposed ironically with glossy skyscrapers rearing behind, the huts were reminiscent of the slum areas Kawamata had encountered elsewhere in the city. He is not, however, an openly protesting artist. Invited to participate in the 1992 Documenta exhibition at Kassel, he enlisted the aid of immigrant workers to nail together a ghetto of deserted shacks near a canal. Although they stirred thoughts of homelessness, Kawamata avoids polemical outbursts and operates more indirectly and poetically.

Hence the ambiguous, hard-to-pin-down feelings generated by his Serpentine installation. In some places, it seems to celebrate the faded elegance of the old gallery, a former teahouse in Kensington Gardens. Elsewhere, though, visitors picking their way through Kawamata's broken labyrinth are stopped short by brutally boarded-up sections, devoid of grandeur. A desire to evoke the pleasures of the past coexists, here, with a more disturbing determination to ram home the inevitability of decay. Kawamata is a far from sentimental artist, and he does not allow us to indulge in a nostalgic reverie for long.

The complexity of his outlook is even more apparent in another installation at Annely Juda Fine Art. In the back room of the upper gallery, he has organised a small show of maquettes for both the London projects. Consummately executed in balsa wood, acrylic and pencil, they are marvels of precision and intricacy. The deftness Kawamata displays here shows just how much rigorous calculation lies behind the apparent haphazardness of the Serpentine structure. He is clearly a master-manipulator of materials, and the finesse he commands when model-making is formidable.

But the virtuosity of his maquettes is far neater and cleaner than the rough, visceral impact of his installations. The main upper space at Annely Juda's is normally a haven of white, minimal luminosity. Converted by Max Gordon, who also designed the Saatchi Gallery's limpid interior, it gains immensely from the height of the room and the skylight running across its roof. Kawamata, however, shows no hesitation in barging through all this cool, lofty poise. With the help of a crane still visible through the skylight, he hoisted into the gallery a pile of doors and windows salvaged from the Serpentine. Battered and scratched, with

splintered glass and rusty hinges, they could hardly be more opposed to the clinical purity of the Juda space. But Kawamata insisted on joining them together and creating an alternative ceiling, far lower than the original. It surges across the entire room, replacing Gordon's high, clean simplicity with a renegade rush of discoloured, obsolete fragments. This hurtling intrusion has an almost apocalyptic impact. It assails our senses immediately we enter, and implies that nothing – not even a metropolitan sanctum as impeccable as a purged gallery devoted to modern art – can ever be safe from sudden, overwhelming attack.

The mood of inexplicable ambush is intensified by Kawamata's decision to make some of his doors and windows plummet from the ceiling and, apparently, crash through the floor into the showroom below. The Caro sculptures and Hockney paintings displayed down there look disconcerted to find their serene surroundings invaded by this cascade of unruly debris. But just as Kurt Schwitters used rubbish with magical effect in his own house at Hanover, so Kawamata ensures that these plunging shards of glass and painted timber are shaped into a surprisingly coherent, angular tower. Seen from below, they send light down in an unexpected tunnel of brightness to a lower gallery normally reliant on discreet, artificial illumination.

So the startling aggression of Kawamata's work at Annely Juda is countered, finally, by a sense of delight. However low-slung his temporary 'ceiling' may be, it flies across the upper space with effortless *élan*. Its energy is impressive, and when penetrated by the sun it casts a latticework pattern of shadows on to the gallery's walls and floor. The whole room is charged with their boldly striped presence. They transform it into a state of dramatic flux, and the shadows' movement emphasises how Kawamata is preoccupied with the notion of perpetual change. He also manages to turn objects as solid and unwieldy as doors into astonishingly graceful forms. Kawamata has an oriental lightness of touch, and the delicacy so evident in his balsa wood maquettes is carried over to his handling of the far heavier detritus he has transported from Kensington Gardens.

Back at the Serpentine, sounds of shouted commands and intermittent drilling can be heard from the gallery itself. The renovation scheme approaches completion, and only a couple of months after Kawamata's structure is dismantled the modernised and extended premises are scheduled to reopen. It will doubtless be difficult, walking through the calm, pristine interior, to imagine how much gouging and dismemberment was involved in its turbulent creation. But Kawamata's work will remain in my memory as a corrective, with its haunting meditation on transience, survival and loss.

THE KABAKOVS: PALACE OF PROJECTS
31 March 1998

Just over a decade has passed since Ilya Kabakov, along with his wife and collaborator Emilia, finally left Moscow. But memories of the oppressed life he led there still fester in his mind like a persistent, nagging nightmare. As a member of the underground group called Sretensky Boulevard, he was obliged to work in secret for more than thirty years. In order to protect himself from the threat of jail, he became a children's book illustrator. It was a profession that guaranteed Kabakov the obscurity he needed, enabling him to endure Soviet reality by cultivating a world of dreams.

Now based in New York and enjoying an international reputation, he and Emilia at last command the resources to work on a colossal scale. Even when Artangel confronted them with the challenge of The Roundhouse, that awesome North London monument to Victorian industrial prowess, they remained undaunted. The entire central area of this great circular railway building has been enlivened by a spiralling structure called the *Palace of Projects*. Made from wood and white plastic, its taut and pristine walls glow against the griminess of the surrounding iron pillars. It looks oddly innocent, and curves up towards the lofty Roundhouse roof with aspirational zeal. Only at the top is a hesitant note sounded, where wooden prongs jut out from the structure as if unfinished or inexplicably broken.

Once you enter the *Palace*, this uncertainty makes absolute sense. For the Kabakovs have filled their luminous interior with a sequence of chambers where Utopian, and largely unrealizable, proposals are presented. Each one is supposed to have been devised by a Russian fantasist – a chauffeur from Kishinev, a music teacher from Serpukov, or an assembler from Lenino. The obscurity of their addresses echoes Kabakov's own origins, as a Jewish boy who grew up at Dnyepropetrovsk in the Ukraine. And the way they are displayed here likewise bears the hallmark of his other work, quirkily oscillating between extremes of absurdity and pathos, earnestness and farce. A pair of white wings joined by leather straps hangs on one side, near a document headed *How Can One Change Oneself?* The accompanying text, which we are invited to read by sitting at a desk like pupils in a schoolroom, explains how to make the wings and attach them to your back. Then, over a period of weeks, you wear them for a few minutes each day. It is important, stresses the text, to conduct this bizarre experiment alone in your room, thereby 'avoiding

undesirable reactions on the part of other people in the family'. But the effect of the ritual is left unclear, and this haziness applies to the outcome of every drawing, model, diagram and installation within the labyrinthine *Palace*.

Take the section called *Paradise Under The Ceiling*, where a ladder invites us to climb up and view the contents of a high, narrow ledge. The ladder itself is slender and unstable, promoting unease as you mount the rungs. And the Noah's Ark array of toy animals inhabiting the ledge, along with the occasional tree or house, can scarcely be expected to induce a feeling of instantaneous bliss.

Many proposals rely on a naïve belief in the romantic notion of recapturing the outlook of a child. A mattress rests on the floor, encouraging us to lie down and stare at a row of illustrations from books 'we read and loved in childhood'. A wooden box, heaped with an assortment of discarded dolls, teapots, lampshades and clothes, is supposed to bring about a fruitful *Encounter with the Past*. It might equally well be argued that, if all this jumble were thrown away, we could liberate ourselves from burdensome memories. Such scepticism is frowned on in the *Palace*, where one proposal suggests that people addicted to complaining about their lives should dress in 'rags', smear their faces with 'soot or ink', and sit on a street corner with 'a humble request for help' written on cardboard. The text promises that, 'no matter how painful the realisation of this project is, after one or two such "experiences" you will see your life more "positively"'. The optimism seems so quaint and risible that the Kabakovs might be suspected of mocking the fantasies they present. But the attitude informing the *Palace of Projects* is far from simple.

It must, on one level, be fuelled by a lifelong mistrust of the Utopian hunger that led to the barbarity of the Stalinist superstate. One proposal in particular, saddled with the ominous title *Irradiation with Positivity and Optimism*, smacks of the bad old days when Soviet artists were expected to serve up Socialist Realism. Bland paintings celebrating sunshine, health and glorious achievements should, according to this text, be displayed on wooden stands in every public institution where 'the quick and effective establishment of positive energy is necessary'. The gruesomely kitsch example on view in the Palace looks like a caricature of the euphoric pictures Stalin commended. He was ready to persecute anyone who refused to paint them, and Kabakov remembers that tyranny all too well.

Other proposals are still more macabre, like the idea of painting a large piece of plywood with rows of faces depicting *The World As One Big Family*. Ostensibly heart-warming, they alarm in their ruthless

insistence on 'welding together' three generations of relatives in 'a good, "right" kind of family'. The assembled faces in Kabakov's illustration look manic rather than fulfilled, and their crowded ranks tell an oppressive story. Coercion, not liberation, prevails here.

Elsewhere, though, the *Palace* is alive with humour. The proposal for *Open-Air Toilets* is especially diverting. The purgative benefits of a bowel movement would, it seems, be enhanced by building small wooden lavatories 'on tall mountains or on steep cliffs where the process of meditation is not interrupted by anything'. Kabakov's drawings of the sheds and their occupants, stranded on the edge of precipices, are hilarious. But the crankiness of such notions gives way to a poetic, dreamlike intensity in other, even more far-fetched blueprints. What should we make of *A Room Taking Off In Flight*, where the text gravely suggests that 'depressing everyday existence' can be overcome by sawing out some of the boards in your living-room floor? Gazing down into the emptiness below, the lucky occupant will realise that the room has become miraculously reminiscent of 'the inside of a balloon or a rocket rushing upward'. Kabakov appears to give the lie to such a ludicrous fantasy in his accompanying drawing, where a disconsolate figure stares into the jagged, cheerless hole beneath his feet.

171. Ilya and Emilia Kabakov, *Palace of Projects*, 1998, at The Round House, London,

Whether intended or not, the sadness in this picture ends up saying a lot about Kabakov's own former existence. Marooned in a State viciously opposed to the avant-garde, he must have regarded his attic studio in Moscow as a haven. Now it has become a place of pilgrimage for young Russian artists, but for Kabakov himself it would often have seemed like a prison cell. That is surely why so many projects in the Palace are suffused with a sharp sense of longing. However preposterous they might be, these Utopian schemes are never mocked. Kabakov seems to understand, and maybe even sympathise with, the fundamental impulse behind them. They are, on the whole, endearing manifestations of a universal human desire for change, escape and transformation. The more unlikely they appear in practical terms, the more Kabakov warms to them. As a victim of the Soviet Union's perverted vision for mankind, he fears their political implementation. But if they are certain to remain fictions, he favours them – as a means, perhaps, of keeping the imaginative spirit going in times of brutal censorship.

The most disarming and memorable proposal on view here is also the most implausible: *Encounter with an Angel*. Purportedly written by a secretary in Stalinobad, it admits that the very thought of a divine meeting may seem 'insane'. But testimonies by 'eyewitnesses' suggest otherwise. They usually occur in mountainous regions, and always at times of personal crisis. In a watercolour and a touchingly childlike maquette, Kabakov shows how to facilitate the summoning of winged assistance. A light alloy ladder, extending 1,200 metres into the clouds, should be constructed in remote countryside. Secured against storm-buffeting with wires, this dizzying structure is then ascended. The climb might take two days to complete. But once at the top, the combined assault of wind, extreme loneliness and terrifying danger creates the ideal conditions for holy intervention to occur. The angel duly arrives, shooting towards the ladder with the purposefulness of a dive-bomber. In grateful response, the man stretches his arm up. Their hands do not touch, and the outcome is left ambiguous. After all, the man might be blown off his perch and die. For the moment, though, contact has been established between earth and heaven. Hope is generated, and it provides the essential key to survival.

OPEN: THE TIMES/ARTANGEL COMMISSIONS

I The Proposal
23 September 1998

Today *The Times* ventures into the unknown. We are collaborating with the art commissioning company Artangel on a pioneering act of patronage. For the first time, a national newspaper will sponsor an art work that does not yet exist. From the outset, *The Times* will be involved in the creation of two large-scale projects. With support from the National Lottery, the budget is substantial – almost £200,000 in all. We will report on the development of each venture at every stage, from initial idea through to final realization. The whole process should yield fascinating insights into the excitements, pitfalls and rewards of working in uncharted territory.

Artangel has been responsible for initiating and overseeing some of the most memorable and risk-taking art projects of the past decade. Its co-directors, James Lingwood and Michael Morris, savour the adventure involved in seeking out unpredictable locales, far removed from the conventional gallery circuit. But even they admit that *Open: The Times/Artangel Commissions* presents them with a challenge they have never confronted before. Until today, their ventures have all arisen from Artangel decisions to approach particular artists and ask them to embark on projects. Lingwood and Morris have always been clear about who they wanted to work with. But now they are looking forward to the maximum amount of surprise.

As its name suggests, our *Open* is inviting any artist based in Britain to submit a proposal. Whether working individually or as a team, the applicants should ensure that their ideas are ambitious enough to merit serious consideration by a selection panel that includes, apart from Lingwood, Morris and myself, the artists Brian Eno and Rachel Whiteread. No frustrating constraints are set around the proposal. Artists will not have to conform to any pre-existing choice of materials, site or size. Nor will they be restricted to a single art form. They can work in any medium, whether involving sculpture, music, theatre, video, dance, painting, film or installation. Submissions that defy categories altogether, by deploying widely diverse elements, will also be welcomed. But the proposal must be planned with a specific place in mind – a building or an area somewhere in Britain not normally used for the arts.

Why are we doing this? As the new millennium approaches, the public appetite for adventurous new art is burgeoning. The British used to

be notoriously suspicious of experimental work, regarding it with instinctive mistrust. Anything that smacked of innovation attracted knee-jerk hostility, and modern artists often found themselves dismissed as charlatans. It was an ugly atmosphere for everyone who relished the twentieth-century ability to challenge and even overturn expectations about what art can be. But the growth of an eager new audience, especially over the past decade, has put this gruesome reputation to rest. Britain is now seen, across the world, as a country where brave and exciting developments flourish as never before.

Supporting this renaissance, *The Times* has in recent years given an increasing amount of attention to new art initiatives. Newspaper critics can play a vital role in fostering a climate of understanding. If they are prepared to write about contemporary developments in a spirit of openness, much can be done to bring artists into stimulating contact with an ever-wider audience. Conversely, nothing is more depressing than critics who approach innovative work with all their prejudices rigidly intact, refusing to accept that art has the fundamental right to defy even our most hallowed preconceptions. Artists worthy of the name never content themselves with serving up sedatives. They have no desire placidly to reinforce the status quo, failing to question the settled order. While reserving the right to distinguish between the potent and the meretricious, critics should be prepared to engage with even the most provocative and unsettling experiences that contemporary art can provide.

During the past decade, impressive work has increasingly been produced in an unpredictable variety of locations. Galleries still provide the principal arena, and their remarkable expansion in recent years has undoubtedly contributed to the vitality of the current scene. But there is no reason why artists should restrict themselves to galleries alone. The range of alternative spaces is immense, in cities and countryside alike. Art need not automatically be herded into one kind of corral, when the world beyond offers so many settings where different audiences can encounter the work artists make. The possibilities are boundless. Artists stand to gain from the stimulus of different locales, leading them towards new strategies often more daring than anything they have attempted before. And the rest of us benefit as well, by discovering that inventive art can enliven the surroundings we normally take too much for granted.

It would be hard to exaggerate the potential of the *Open*. Even renowned artists need help when they set about wondering how best to implement their most visionary and audacious plans. Once outside the support provided by the gallery system, they often become uncertain about how to raise funds, find a congenial space and establish a fruitful

172. Judging entries for the *Times/Artangel Open*: from left, Brian Eno, Michael Morris, Richard Cork and James Lingwood, 1999. (Rachel Whiteread, the other judge, was away).

relationship with experts capable of bringing the work to fruition. Artangel is experienced, energetic and single-minded enough to ensure that the chosen proposals will be executed with the maximum amount of commitment and flair. *Open* constitutes a rare, exhilarating opportunity for any artist with resourceful and imaginative verve to come up with an exceptional proposal, pushing the boundaries of contemporary practice as far as they can stretch.

II The Judging
30 March 1999

When the *Times/Artangel Open* was launched last September, we hoped that the competition would ignite widespread interest and generate some

astonishing applications. It was, after all, aimed at any British-based artist with an adventurous project in mind, and no restrictions were placed on the form or medium employed. Only one condition was stipulated: that the work should be conceived in response to a particular UK place or building not customarily used for the arts. But in every other respect freedom reigned, and anything seemed possible.

We awaited the proposals with a mixture of excitement, impatience and trepidation. Before the proposals started coming in, Artangel had no inkling of the likely response. The art-commissioning company's co-directors, James Lingwood and Michael Morris, have never organised an open submission. As for the *The Times*, we realised that no national news-paper had hitherto been prepared to sponsor an art-work that did not yet exist. It was a risky enterprise, and suspense grew as the 18 December deadline approached.

We were not disappointed. Hundreds of elaborate submissions, many backed up by batteries of slides, videos and lengthy statements, bombarded Artangel's London office. Then, on the final morning, the staff there were astounded to be given a special Post Office delivery of over 100 registered packages. No sooner had they received them than a stream of artists started ringing the bell in person, handing in parcels too bulky or fragile to be pushed through the letterbox. They continued to arrive all day, and one contender sat on the narrow office staircase for a couple of hours, frantically writing his submission while Artangel staff struggled past him to deal with other last-minute callers at the front door.

Once this cascade of material had been put into coherent order, copies were sent out to the artists Brian Eno and Rachel Whiteread. They, along with Lingwood, Morris and myself, were confronted by the task of assessing the proposals and selecting two winners – one to be implemented this autumn, and the other next year. It was a strenuous experience, at once illuminating, unpredictable, hilarious, baffling and studded with surprises. By the time all five of us met for a day-long discussion on 22 January, we wondered how the deluge of dizzying possibilities could ever be narrowed down to a coherent outcome.

Artangel, however, thrives on seemingly insurmountable challenges. The optimistic company inscription on the wall behind my chair declared: 'I Believe in Miracles'. And further inspiration could be gained from looking across at photographs on the opposite wall of Rachel Whiteread's *House*, a classic example of what can be achieved beyond the institutional boundaries of the art gallery.

Some of the applications confronting us were, however, frankly bizarre. One artist wanted to erect a monumental statue of Baroness

Thatcher called *The Devil of the South*. Equipped with horns, a three-pronged fork and a handbag marked 'Sin', this sixty-metre apparition would be made out of recycled Brown Ale cans and straddle the Hogs Back hillside in Surrey. The artist did admit that 'I envisage some problems with planning legislation', but plenty of the submissions entertained no such misgivings. One visionary proposal wanted to 'seed the oceans of the world' with two thousand 'art pods'. Whether 'towed out to sea from the major UK ports' or 'released by hot air balloons', they would each carry 'an artistic message, comprehensible in any language'.

Other projects, while rooted reassuringly in *terra firma*, were scarcely less headlong. 'I want to build a supermarket', announced one defiant application, while another suggested 'the cutting of a giant chalk pound sign' on a hill in south-east England, as 'a permanent memorial to the impact of the pound on British culture'. A similar gigantism ran riot in many submissions. The hand-knitted tea cosy, large enough to cover a Shetland croft house, sounded grandiose enough. But one artist wanted to saturate an entire town with digitally controlled red light. Stranger still were the colossal ear and nose sculptures, 'facial extrusions' to be built in country locations as 'monuments to the senses'.

But the most daunting of all these mega-projects took London as their target. A team of artists proposed erecting a forty-metre section from a concrete bridge in the middle of Green Park. As for the Thames, it became the focus of a nightmarish scheme to place 'a 737 passenger aeroplane' on the river near Tower Bridge, supported by a submerged barge. 'The sculpture', explained the team, 'is an arbitrary realisation of childlike desires, indulging the desire by achieving an absurd vision.'

Some proposals, inevitably, centred on *The Times* itself. One applicant aimed at staging a retrospective exhibition, in a Fleet Street location, of 100 paintings each made 'by pulping an issue of *The Times* and making the pulp into painting (by bonding it with colourless acrylic)'. A less aggressive scheme entailed asking all *Times* contributors to compose their articles for one edition in longhand, printing the result as an unashamedly handwritten newspaper.

However diverting all these schemes may have been, they proved easier to assess than the ten we singled out for closer scrutiny. During the course of another intense day in February, the artists all came to see us and discuss their ideas in more detail. It was an invaluable exercise. Open submissions always disclose a host of unfamiliar names, and there is no substitute for meeting the most promising candidates face to face. Their projects were fascinating and various, ranging from a filmed exploration of the eerily deserted Victorian hotel at St Pancras station to a robust cel-

ebration of the remote Scottish Islands of St Kilda, intended to mark the 70th anniversary of their final poignant evacuation in August 1930. By dramatic contrast, another scheme involved constructing a magical grotto in an oil tanker, viewable by climbing up inside the glittering, shell-like space 'to find yourself in the middle of a pool'.

After much debate and a further meeting, we finally settled on two other schemes. The proposal scheduled for 2000 will be announced later, but *The Times* plans to reveal this year's winner in early May. The judges agreed that it promises to provide a bold, provocative and above all unforgettable experience.

The first winner of Open was Michael Landy, whose Break Down *is discussed in the fourth volume of this series,* Annus Mirabilis?. *The second winner was Jeremy Deller's* The Battle of Orgreave, *staged in the summer of 2001.*

RICHARD BILLINGHAM'S FISHTANK
10 December 1998

Even today, when so many artists are fascinated by the possibilities of video and film, few are given the chance to show their work properly on television. All the more reason, then, to hail the advent of Richard Billingham's *Fishtank*, an Artangel commission to be broadcast on BBC2 next Sunday. Claustrophobic, unsentimental and focused frankly on even the most distressing aspects of family life in a West Midlands council flat, this fifty-minute film is often painful to watch. But I never felt that Billingham, who keeps his camera closely trained on his father Ray, mother Liz and younger brother Jason, was guilty of sensationalizing his subjects. *Fishtank* moves through a whole gamut of emotions, and its exposure of the tensions in his parents' troubled relationship is impelled, above all, by a desire to tell the truth.

It begins mundanely enough. Ray, shot upside-down, looms on the screen as a train rattles past the window. In a distant room, *News at Ten* sounds its signature tune. But apart from muttering 'ten o'clock', he shows no sign of wanting to watch the programme. Instead, he puffs on his cigarette while the camera zooms in for a disconcerting close-up of his sad, rheumy eye. Aimless yet observant, he seems uncertain how to fill in the time before sleep.

Ray reminded me here of the similarly motionless old man in Edvard Munch's desolate self-portrait *Between Clock and Bed*. Billingham, who started out as a painter, surely owes a debt to the harrowing emotional intensity of Munch. But *Fishtank* makes no overt reference to the artists admired by its maker. The style adopted here is 'video verite', and the camera proves just as adept at defining energy as lassitude. After Ray's gaunt, weary stillness, we encounter the adolescent high spirits of Jason. Stripped to the waist and ready for the chase, he stalks a fly with a post-card in each hand. Semi-dancing to the rock music pounding through the room, he feints a blow before delivering the *coup de grâce*. 'And he gets him – he scores!' says Jason in mock-football-commentator exultation.

His father, marooned in the kitchen, stays silent as he goes about nur-turing life rather than killing it. A blur of colour resolves into a fishtank, and Ray lifts the lid to sprinkle food. A cut-out toy figure of a child stands in the bubbling water, smiling at the gaudily striped fish as they swoop, dart and wheel for their nourishment. As if to draw a parallel between the creatures trapped in the narrow tank and their human owner beyond, the camera now travels slowly over Ray's wizened face, wispy white hair and stubble before coming to rest, startlingly, on a seduc-tive bowl of flowers behind him. He seems equally imprisoned in this high-rise room, its confines accentuated by Billingham's insistence on pressing his lens up against everyone he scrutinises. We are shown a win-dow at night, its sill lined with dolls in elaborate, fairy-tale dresses. Instead of straying outside, though, the camera turns in again before coming to rest on his mother. Her fleshy, monumental face is blue with reflected light from the television set, as she manipulates a boisterous video game with a joystick. But Billingham soon returns us to reverie, and the oppres-sive feeling that there is nothing to do. Jason, still semi-naked, sprawls on a bed wondering out loud why Björk is so 'famous for singing out of tune'. Gift-shop Venetian masks hang mockingly on the wall above him as he gazes towards the window and stops talking altogether.

Words, however, become plentiful when Ray and Liz are in belliger-ent mood. Gulping down mussels with the aid of her fingers, she tells him that 'if you want to bugger off from here, you're going the right way about it. The flat's in my name, not anyone else's.' The camera stays on a tight close-up of her mouth while she rages, and then wanders wildly between them as they discharge verbal broadsides at each other. Billingham cuts to a furry toy animal, chasing a coloured ball across a fiercely patterned rug. He makes the textures in this cluttered flat almost as eloquent as the people, and implies that the toy's manic movements are as irrational as his parents' behaviour.

But then, quite suddenly, a ceasefire is declared. A pet snake curls across Liz's breasts, and comes to rest in the deep declivity between her chest and tattooed arm. She lets the snake play intimately with her face before kissing it, and the camera lingers lyrically on the snake's shadow undulating across a nearby wall. Life seems pleasurable for a moment. Billingham shows a live fly scuttling triumphantly away from the insect squashed by Jason earlier. Ensconced in her bedroom, Liz applies her make-up, accompanied by the distant sound of trains, shouting kids, a barking dog and a car horn.

Before long, though, the true source of the rancour between wife and husband is revealed. Coughing theatrically to disguise the hiss of a beer-can he is opening, Ray takes a defiant swig after growling: 'down the hatch, and bollocks to them all'. Liz, watching television in a neigh-bouring room, is not fooled: 'If you're drinking, Ray, I'm not putting up with you like this.' But she cannot control him. We see Ray later, strug-gling to rise from his armchair, swaying, coughing and then slumping down again with an exhausted, naughty cackle. He plays the part of the mischievous, unrepentant and put-upon child, while she is forced into the stereotype of a scold. They roar at one another, Liz threatening to throw him out, Ray complaining that he had 'more freedom in the forces'. Occasionally, the terrible bitterness is interspersed with a farcical attempt at reconciliation. 'Give me a kiss for your birthday,' says Ray, although he must know that her response will be vituperative. The whole row sounds like a ritual, enacted a thousand times before. But that does not make it any less gruelling to witness. Billingham films it all, closing at one point on Ray's veined hands sunk disconsolately between his thighs. Then we see the two of them: Ray in the foreground, his face a bluish, leaden colour, Liz beyond with her head turned away in dejec-tion. The emotional chasm between them seems as unbridgeable as in Sickert's painting *Ennui*, an equally devastating portrayal of conjugal breakdown. Ray whistles tunelessly as he goes out, muttering: 'I don't like this kind of living, I don't.'

In the most moving sequence of the entire film, Billingham roams through a sequence of family snapshots. Monochrome to begin with, they show a slim young Liz, sometimes with a peroxide rinse, grinning with Ray or her two small boys. As the photo-booth pictures change to colour, with backdrops of garish orange curtains, the melancholy deepens. We sense how much joy the family may once have experienced, and Billingham turns away from the album in order to film trees surging in the wind outside. It is the only moment when he goes beyond the flat; and when the camera returns, the mood has shifted from despondency to rec-

173. Richard Billingham, *Fishtank*, 1998 (detail)

onciliation. Lying on the bed with a bumper sandwich, Liz chats to Ray. He looks stunned beside her, but she rests her head on his chest and burps contentedly. Life seems bearable after all, and Billingham cuts to Jason playing a video game. While flashing war-planes fire venom at each other, a singer croons: ' to know him / is to love him / just to see him smile / makes my life worth while'. Jason joins in raucously, and so does Ray. But then he lapses into a sigh. We return at last to the aimless, repetitive yet oddly expectant fish, as they glide on and on through their liquid prison.

ART AT SADLER'S WELLS
5 May 1999

Most theatres give no sign of bothering about the images displayed on their walls. Faded photographs of half-remembered productions can often be glimpsed, along with occasional posters erupting in the half-light of labyrinthine passageways. But apart from these predictable attempts to boast about their own past, few managements ever mount art exhibitions worth looking at in their foyers, bars and restaurants. That is why Sadler's Wells's new initiative deserves an accolade. From the outset, the building's recent transformation by lottery funds was seen as an opportunity to let artists enliven its spectacularly enlarged public spaces. Under the guidance of Judy Adam, there has been nothing timid about the scheme. Far from resorting to well-worn tactics, and borrowing a few undemanding prints for tasteful decoration, Sadler's Wells has given its chosen artists the chance to stretch themselves. Each show is the outcome of a special commission, and allows the work to have a commanding impact. Visitors entering the theatre, or exploring its multiple levels during the intervals, have encountered an invigorating variety of ambitious, large-scale images since it opened last autumn.

The latest show, by a young artist much-admired in the 1998 Turner Prize exhibition at the Tate Gallery, is particularly exhilarating. Drawing directly on to blackboards sixteen feet wide, Tacita Dean confronts us with panoramic images inspired by *The Tempest*. Shakespeare's stage directions for the play's opening act provided the title for her three works: *The Sea, with a Ship; afterwards an Island*. But those laconic words fail to convey the turbulent power of the drawings themselves. Each occupies a commanding position on a different floor, and the images change dramatically in mood as we ascend the staircase. On the first floor, Dean provides a lyrical scene of waves tumbling on the deserted shore and spreading over the sand like an undulating spillage of milk. One storey above, though, she shows a galleon caught in the full turbulence of the ocean. It is an unashamedly romantic drawing, a *tour de force* in white chalk. But the words Dean here adds to the image have a distancing effect, making it resemble the storyboard for a film. On the top floor, another blackboard looks at first like the calmest of the three, and yet the absence of the ship from these stormy waters ends up giving it a sinister, funereal sadness.

Dean's eloquent drawings show how much can be achieved by an inspired commission. They are bound to win many converts among Sadler's Wells audiences who may not have encountered her work

before. Dance and opera enthusiasts do not automatically go to galleries, but they could find their appetite for contemporary art whetted by the foyer exhibitions here. So far, all three have been outstanding in remarkably diverse ways. Gary Hume, recently selected to represent Britain at the 1999 Venice Biennale, was an excellent choice to start the project last October. Always unpredictable, he initially promised to paint three pictures filled with recognizable images of bird life. Then, at the last minute, his new-found fascination with computer technology resulted in a startling change. Working with gloss paint on aluminium panels, he produced a series of far more abstract images where bird references were difficult to detect. Their visual impact, however, was undeniable. The three multi-panel paintings shouted out their exuberant presence in the Sadler's Wells foyer. They seemed to celebrate the opening of the new theatre with clangorous energy. Nobody visiting the premises could fail to notice them, each one buoyantly asserting the artist's ability to enhance our enjoyment of a revivified institution.

As if to prove that sculpture could be as effective as painting in this location, Sadler's Wells invited Stephan Balkenhol to exhibit there next. Unlike the restless Hume, the German carver is steadfastly committed to the human figure. And he made sure that his sculpture related clearly to the bodily exertions on the theatre's stage. Balkenhol's main carving, in

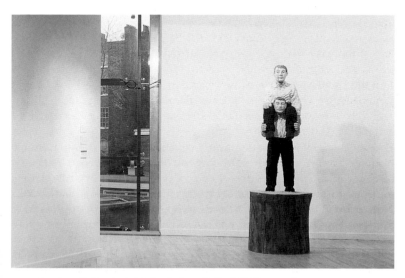

174. Stephan Balkenhol, *Hucke Pack*, at Sadler's Wells, London, 1999

painted poplar wood, showed two young men playing piggy-back on a tree-trunk. Their impassive expressions and stillness gave the sculpture a mysterious sense of expectancy. Further up, Balkenhol made a more explicit reference to dance in a large painted relief, where a multi-limbed male figure threw his female partner into the air. The mood of the work chimed felicitously with the arrival at Sadler's Wells of the Pina Bausch Tanztheater from Wuppertal, performing in London for the first time in seventeen years.

But Balkenhol's exhibits were not confined to dance alone. One of his grandest indoor works was a *Big Head Relief* in painted wood, focusing on the face of a pale young man with a typically deadpan expression. The same mood dominated the carving he placed high on the building's Rosebery Avenue façade. For Balkenhol, who has always been intrigued by the challenge of public sculpture, could not resist the shallow niches he found there. One of them became the temporary home for a painted wood bust of a man in a white shirt, gazing enigmatically down on the street below.

If Sadler's Wells manages to maintain this impressive level of engagement with the visual arts, it will set challenging new standards for theatrical centres elsewhere in the country. Token foyer exhibitions could finally become discredited, as managements realise just how much adventurous artists can contribute to a spirit of innovation, excitement and renewal.

FOURTH WALL
26 May 1999

Ever since the Lyttelton flytower first reared above Denys Lasdun's National Theatre, this cubic colossus has offered a challenge. The very bareness of its concrete surface seemed expectant, as if brazenly daring someone to transform its minimal bulk with light, colour and sound. Now, at last, the gauntlet has been taken up. All this month, an ambitious four-part programme of film and video projections is turning the flytower into a great metropolitan spectacle.

Organised by the Public Art Development Trust, *Fourth Wall* is a bold initiative for the National Theatre to take. Too often, its previous involvement with visual art has been restricted to low-key exhibitions

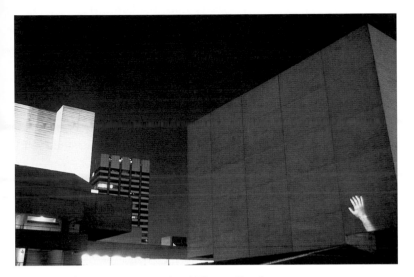

175. Ceal Floyer, *Minute*, at National Theatre, London, 1999

tucked away in cramped, easily overlooked indoor spaces. But nobody
approaching the theatre could ignore *Fourth Wall*'s visceral impact.
Overwhelmingly visible, even from the far side of the Thames, the fly-
tower's giant screen reaches out to a public far beyond theatre-goers
alone. The best vantage is the Baylis Terrace, an ample space on the sec-
ond floor of the theatre. Even on the dampest of chilly May evenings,
substantial and attentive crowds have been gathering there for the free,
twice-weekly viewings. Projections are made from a simple scaffolding
structure, placed opposite the tower's north-facing side. And from the
moment each programme begins, the monumental impact of this ready-
made surface lends the work an arresting power.

Ceal Floyer, a subtle and pared-down artist who thrives on understated
gestures, started off the first programme in a typically wry way. No title
preceded her brief colour film: it simply appeared as an unexplained
intervention, showing a pale hand confined to one corner of the image.
The fingers start drumming in the darkness, as if they belonged to an
audience member impatient for the main show to commence. But noth-
ing happens: the rest of the screen remains black. So the fingers generate
a Beckett-like mood, marking time in a world without any apparent
meaning. Before tedium can set in, Floyer brings the film to a sudden

end. Her conciseness is admirable, and serves as a corrective to the more long-winded contributions elsewhere in the programmes.

Not that Tacita Dean needs any lessons in cutting. Her black and white film, *Delft Hydraulics*, only lasts three minutes. By looking from various angles and distances at the undulating motion of a wave machine in a Dutch ocean laboratory, she manages to set up a dreamlike rhythm that becomes oddly mesmerizing. In certain lights the water looks metallic, as if transformed into a highly polished kinetic steel sculpture. But the tidal flow running through the entire container remains paramount, and exerts by the end a seductive calm.

By no means all the projections have such a soothing effect. Roddy Buchanan offers an aerial view of two young men in a gym, trying to head a basketball between each other 1,000 times. They fail laughably at first, but after the false starts a regular momentum is established. Buchanan adds a jazz soundtrack at this point, and yet the more successful the headers become, the less interesting they are to watch. Doubtless aware of the problem, he fades them out before they become too boring. Melanie Counsell, by contrast, inflicts her *Coronet Cinema* on us for an interminable thirty minutes. A tall glass occupying the centre of the grainy image is drained, very slowly, of its dark contents. The gradual emptying-out is stupefying to watch, and I wanted this mournful film to end long before Counsell eventually terminated it.

Without exception, the most successful works know how to avoid the besetting pitfall of time-based art. Mark Wallinger would not dream of imposing his *Angel* on us for half an hour. In just over seven minutes, he builds up an eerie mood filled with sinister frustration and millennial foreboding. Wallinger himself, bearing an inescapable resemblance to Roy Orbison, stands at the base of a tube station escalator wearing sunshades. Although he carries a blind man's white stick, Wallinger has no hesitation in uttering the Old Testament's classic account of the world's creation with the confidence of an all-seeing prophet. At the outset, his words sound familiar enough. But after he intones 'In the beginning . . .', they become strangely distorted. By speaking them backwards, in a film itself played in reverse, Wallinger makes the Creation myth sound far less reassuring. The unease is compounded by the sight of the passengers behind him, all silently travelling up and down the escalator backwards. They show no sign that anything is amiss, and classical music accentuates the sense of serenity. But this subterranean locale looks increasingly like an infernal madhouse. And when the sightless angel walks in reverse up the escalator, accompanied by the voice of a jubilant choir, lunacy takes over altogether.

More disturbing still was the second week's contribution by Ian Breakwell, the only artist whose work refers throughout to *Fourth Wall*'s theatrical context. In *Auditorium*, an audience assembles for an unidentified production. They sit down facing in our direction, as though we inhabited the stage's space. But they remain oblivious of our presence, and once the lights dim all their faces are focused on the performance. Invisible to us, the activities on stage enthral them. When sounds of hammering, chainsawing and the lowing of cows lead to a sudden crash, the audience ducks in fear, recovers and then applauds. Later they scream, cower and groan as lions growl and whips are cracked. By this stage, in proceedings now as macabre as Buñuel at his most nightmarish, I felt glad to be on the Baylis Terrace rather than locked inside Breakwell's hellish theatre. After a final burst of gunshots and yelling, though, the audience cheered and gave the performance a standing ovation. Catharsis had been achieved, and the evening's programme was rounded off with a lyrical study of the sky at nightfall by Stephen Murphy. Hovering in a starlit void, a substantial white cloud dominates the image. It looks convincing enough, but Murphy is a master of digital manipulation. His entire eight-minute video turns out to be computer-generated, allowing him to orchestrate the slightest shift and tumble in the cloud's trailing wisps. It is a beguiling spectacle, hugely enhanced by its teasing interplay with the real nocturnal sky spreading far above the flytower.

Sam Taylor-Wood, whose *Hysteria* was premièred the following week, did not rely on digital deception of any kind. Instead, she confronted us with the single image of a young woman. Although the film is silent throughout, the face initially appears to be laughing. Head thrown back, eyes open and mouth parted wide enough to show the fillings in her back teeth, she gives vent to an orgy of supposed mirth. Her inability to stop, however, gradually makes the laughing look painful. Frowning now, with eyes frequently closed, she raises both hands to the sides of her face. They seem bent either on blocking out the noise or comforting her. The hands soon drop away, though, and the woman submits to an extended bout of crying.

At times, her mouth opens in a howl reminiscent of Bacon's screaming pope. But there is nothing melodramatic about her anguish. It looks all too real: she appears helplessly in thrall to its wrenching momentum. Engulfed by an infinity of pain, her plight seems unendurable. I felt increasingly like a voyeur witnessing private torment. Although the film only lasts eight minutes, its remorseless intensity made me long for it to finish. But I could not turn away, any more than the woman was able to check her outpouring. Eventually, she passes a blurred, upraised hand

over her face, as if to signal the end. When the film finishes, however, there is no hint that she has purged herself of the distress.

If *Hysteria* was the most impressive work I saw, the programme as a whole deserves applause for its rich, resourceful variety. Nothing could be more removed from Taylor-Wood's work than the digital video that followed it: Joao Penalva's *Wallenda*. On the soundtrack, he whistles a faithful, note-for-note version of Stravinsky's *The Rite of Spring*. And on the screen, this bizarre music is given visual form on the vertical bars of a graphic equaliser. At first, it seems light-hearted. After a while, though, Penalva succeeds in making the most ecstatic passages in Stravinsky's score seem forlorn, vulnerable and even plaintive. While the rest of the screen is enveloped in blackness, the equaliser's bars light up in response to the music. They resemble illuminated minarets flaring at night, while Penalva sounds like a melancholic loner trying to cheer himself up by whistling in the dark.

The last programme in the series, to be projected this week, will undoubtedly repay a twilit expedition to the South Bank. And I hope *Fourth Wall*'s brave enterprise will prompt other experiments on buildings across the land, bringing adventurous new art into billboard-size contact with the widest conceivable audience.

TARATANTARA
1 September 1999

Down on the River Tyne, in the final summer of a dying century, a bold proclamation of faith in contemporary art took dramatic shape. The old Baltic Flour Mills, derelict for so long, were held in scaffolding's rigid grip. Its conversion into a new gallery was suspended for a moment, so that the gutted interior could become the arena for an audacious experiment. It was something of a gamble: the building's outer walls would have collapsed without sufficient support. But Sune Nordgren was enterprising enough to realise that the immense, hollowed-out shell presented a unique opportunity. With great daring, he commissioned Anish Kapoor to make a titanic installation inside. Plenty of artists would have been unnerved by such a high-risk challenge, and produced something fussy, ponderous or pitifully underwhelming. After all, the building itself could well have overpowered anything placed within its daunting structure.

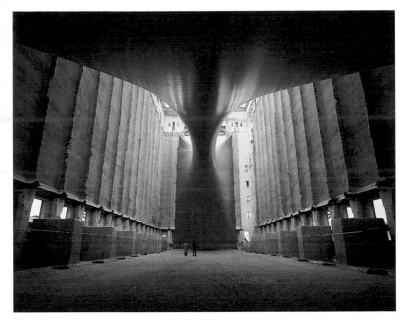

176. Anish Kapoor, *Taratantara*, at Baltic, Gateshead, 1999

Kapoor, however, responded to the invitation with superb, seemingly effortless aplomb. The jubilant title he chose, *Taratantara*, hinted at the work's appeal. But nothing could have prepared me for its impact *in situ*, on a hot and radiant day at the end of August.

Unlike Antony Gormley's equally colossal *Angel of the North*, rising from its exposed hillside only a short car journey away, Kapoor's installation depended on stealth. I approached it from the east, and discovered that a blaze of rich redness had been inserted in the Baltic's open end wall. Seen from a distance, it looked as flat as a gigantic abstract painting. Close-to, though, I realised that Kapoor's lightweight PVC membrane curved inwards. As organic as an open mouth, it terminated in a throat. The cloudless sky could, however, clearly be seen at the far end. It made the building look surprisingly shallow, and I went inside imagining that a compact work would fill this limited space to bursting-point.

With theatrical yet unforced flair, Kapoor utterly confounded my expectations. The Baltic's lofty interior, now open to the air, turned out to be far longer than he had made me believe. And the wine-red membrane

suddenly sprouted into the form of a double trumpet as it travelled right across the 170-foot emptiness. It delivered a flamboyant visual blow, more akin to architecture than sculpture. As I walked underneath it, wondering at Kapoor's tenacious appetite for adventure, the glowing form began to resemble a vast archway rising far above my head. It echoed the curve of the great Tyne Bridge nearby, and celebrated the invigorating immensity of the Baltic's shell.

But *Taratantara* was also a stunning feat in its own right. The membrane, its forty-six long strips welded together by radio waves alone, retained an extraordinary tensile strength as it surged, without any apparent support, from one end of the Flour Mills to the other. At once taut and swollen, rigorous and exuberant, this vaulting apparition could not fail to astound.

In my mind, it still survives as one of the most outstanding works Kapoor has yet produced. I could hardly believe that, only a few days later, his sublime achievement would be dismantled for ever, in order to let the next phase of the Baltic's reconstruction commence. It was a landmark in late twentieth-century art, and its imminent loss seemed as unthinkable as the crass demolition of Rachel Whiteread's *House* five years before. I found myself wondering if, even at that late stage, someone might be able to give Kapoor's *coup de théâtre* an extended life. After all, the membrane was robust and easily transportable. So why not find out whether another empty warehouse would be available to house it, perhaps in London's Docklands? If the installation were recreated with Kapoor's blessing, far more people would have the chance to savour the boldness of a contemporary artist working on the grandest scale imaginable.

I was, of course, indulging in a misplaced fantasy. Kapoor made his monumental masterwork specifically in response to a particular building. It belonged to that site, and nowhere else. It was only meant to be temporary, seizing the moment when the battered Baltic enclosed a tempting void. The beauty of *Taratantara* lay partly in its fleeting quality, and in our melancholy awareness that Kapoor's exhilarating summer intervention could not last.

THE FIRST LIVERPOOL BIENNIAL
29 September 1999

Until now, Britain has shied away from staging spectacular and regularly held surveys of international art. While ambitious Biennales flourish in Venice, Sao Paolo, Sydney and Istanbul, we confine ourselves to home-grown produce as limited in scope as the Royal Academy summer show. But this insular timidity has come to an end at last. Our first-ever Biennial of Contemporary Art has just opened in Liverpool, where 280 exhibitors from across the world are invading the city at every turn. Their presence is inescapable. As well as galvanizing the Tate Gallery at Albert Dock, they occupy a host of other locations from the Anglican Cathedral and Bluecoat Arts Centre to Lewis's Department Store and Princes Jetty on Merseyside. Other substantial exhibitions also come under the Biennial umbrella. *Newcontemporaries*, the annual round-up of sparky British art by students and recent graduates, has mounted an exception-ally lively show at the Exchange Flags. *Tracey*, an artist-led series of anar-chic fringe initiatives, injects a welcome irreverence into explosive street events. And up at the Walker Art Gallery, the twenty-first John Moores exhibition allows everyone to take the pulse of current British painting.

As a judge of this year's Moores show, I am in no position to assess its merits. But the response from a capacity crowd at the prize-giving cer-emony last week, when Lady Grantchester presented cheques to the eleven winners, was overwhelmingly positive. Many of the fifty artists on view here, chosen from an unusually large open submission of 2,100 entries, are young and little-known. Their zest and commitment ensure that painting, far from being dead, will enter the next century in an ener-getic state. The John Moores exhibition plays a salutary role in the con-text of the Biennial as a whole. For painting is hard to find in the main international show. Selected by Anthony Bond, Curator of the Art Gallery of New South Wales in Australia, it brings together sixty-one artists from twenty-four countries. The overall title chosen by Bond is *Trace* – a theme that, in his words, 'suggests materials or objects that allow us to reconstruct histories through our personal memories or associa-tions'. In practice, Bond's sympathies are generous enough to embrace a stimulating variety of work, and many of his artists are refreshingly unfa-miliar to British viewers.

Take the Brazilian Ernesto Neto, whose installation in the Tate's big ground-floor room is superbly arresting. Among the cast-iron columns of the original building, Neto has slung a cluster of dangling, tube-like

forms made from a stretch material called poliamid. They hang down like weirdly elongated pods in an *Aliens* movie. I wandered among them, half expecting a vengeful Sigourney Weaver to appear, intent on destroying them with a flame-gun. But Neto's other-worldly containers are not hatching malevolent eggs. A strong, beneficent aroma is given out by the cloves and spices lodged inside them. Stained with powders ranging from deep orange to chocolate, their sensuous colours and smells are irresistible. In this instance, the heady scent of turmeric reminds us that the Tate inhabits an old dockland warehouse, where similar spices may once have sweetened the air. So Neto responds to the historical character of his location as well, and he is not alone in appealing to senses other than sight. Upstairs at the Tate, the Polish artist Miroslaw Balka has spread a colossal, shallow platform of soap across most of his floor-space. Its sharp tang assails our nostrils as we walk around, past half-charred drawings of frail figures on the surrounding walls. Balka feeds off childhood memories of his grandmother's house near Warsaw. But the pale expanse of pungent soap also resembles water, and we can look down from his installation to the Mersey flowing far below.

Not all the Tate's exhibits are so hushed. Carnival floats move across the end wall of Annelies Strba's installation, where semi-naked figures gyrate to the rhythm of dance music. But the images on the side walls are silent, static and filled with gravestone crosses. The melancholy intensifies in Vik Muniz's photographs and prints of Brazilian street children. They sit, sprawl and slouch among debris from the Rio Carnival, their sadness contrasting with the vitality of Miguel Rio Branco's images of boys kick-boxing in near-silhouette on the opposite wall. As for Pierrick Sorin's video installation, *It's Very Nice*, the mood switches from bizarre comedy to outright disquiet. Confronted by thirty-three monitors in a small room, we find ourselves puzzling over the faces framed there. Each is an eerie composite of different features, so that wrinkled eyes blink below youthful foreheads while full-lipped mouths seem far too large for the noses above. They all seem to look sideways at each other, wary and dazed. 'I really like this work,' insists a repetitive voice, but the faces all appear trapped in a science-fiction nightmare. Then, just as I was leaving this grotesque chamber, another voice confessed: 'It's quite horrible.'

An even more unsettling transformation can be found in Lewis's Department Store, where the Argentinian Nicola Costantino fills a shop window with her *Human Furriery*. Viewed from across the street, the garments draped on her mannequins look dignified and expensive enough. Close-to, though, they turn out to be made of silicone, human skin and

real hair rather than suede or leather. Costantino delivers a visceral shock, intensified by the moulded body parts that she uses to decorate these macabre costumes. Navels and nipples project from their surfaces, making them look like products of genetic sorcery.

In Costantino's case, surreal humour counters the darker side of her work. Up at the Anglican Cathedral, however, Doris Salcedo offers no such relief. The sunken space at the west end of the nave provides an ideal arena for her sculpture. Salcedo, a Colombian, produces memorials to the victims of repression. But no portraits can be detected in her sombre work. Instead, she takes wardrobes and other, equally domestic furniture as her starting-point. They should be reassuringly intimate presences. Salcedo, though, shows a chair half-buried in cement with metal bars thrusting from its raw surface. A large bed, stripped of mattress and springs, is invaded by a cupboard. And a group of small tables rest on legs so fragile that they scarcely seem able to remain upright. Most of the furniture here is old, and looks as if its owners have abandoned it in an emergency. But the cracks are all sealed up, like witnesses whose ability to give evidence has been silenced.

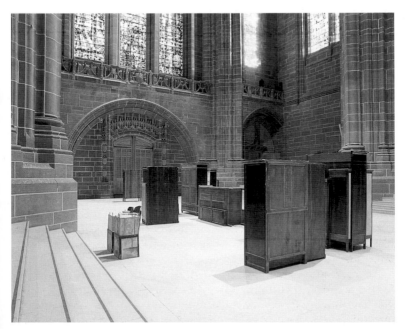

177. Doris Salcedo, *Untitled (series)*, 1989–98, at Liverpool Cathedral, 1999

No other setting in the Biennial can match the soaring solemnity of the Anglican Cathedral. But the top-lit space at John Moores University Art Gallery proves a worthy location for Montien Boonma's *Das Haus der Sternzeichen*. Six cylindrical canopies are ranged round the room, supported on tripods almost as spindly as Salcedo's table-legs. Reminiscent of towers, rotundas and church spires, the steel structures look dark with disuse from the outside. Duck inside them, though, and you may well be seduced by the scent of herbs and spices. Tiny circles of light puncture their ceilings like stars, inducing a contemplative state close to the spiritual traditions of Boonma's native Thailand.

The Biennial does not, however, provide such solace for long. Over at the Exchange Flags, the most powerful installation is Alastair MacLennan's deeply sorrowful *Unseeing Trace*. He confronts us with an immensely elongated trestle table, covered in a white cloth. But in place of disciples gathered there for an updated Last Supper, we find empty chairs and black balloons waiting to burst. Even more disturbing are the real pigs' heads scattered across the table-top, surrounded by printed names on heaps of white tape. They commemorate all the people who have died in the Northern Ireland Troubles since 1969, and the sound of recorded voices quietly reading out these names adds to the elegiac mood. MacLennan himself, a hooded figure dressed in black, sits nearby supporting a branch festooned with fishes and shoes. His feat of physical endurance, remaining there motionless for days on end, seems to symbolise the resilience of those who survive.

The other outstanding room at the Exchange Flags also reflects Ireland's traumatic history. In a surprisingly confined space, we find a video shot by Dorothy Cross as she travelled in a wave-buffeted dinghy round a redundant light ship. Years ago, the vessel acted as a marker, warning other ships to avoid perilous reefs and seas. This year, Cross covered it in phosphorescent paint and moored it in Dublin Bay. It looks spectral in the darkness, and even more dreamlike when the video is screened at dusk from Princes Jetty on Pier Head. There, beside the Mersey were so many ships once arrived from Dublin, it transmits both sadness and hope to everyone assembled at the water's edge.

THE NORTH MEADOW ART PROJECT
5 October 1999

Until now, attention has been focused on the Millennium Dome's interior, ignoring the possibilities presented by its spectacular geographical location. But outside the Dome, on the long sweep of land bordering the river, specially commissioned works by leading British artists will soon enjoy prominent settings. The outcome of an ambitious venture called the North Meadow Art Project, these major sculptures and installations benefit from an epic Thames-side location where the curve of the river is at its most impressive. Whether placed near the beach, among meadow grasses, close to the Meridian Line or in the water itself, each work promises to form an arresting part of a visit to the Dome.

As a member of the 'Sculpture Group' appointed to select the artists, I am relieved and delighted that visual art will play such a dramatic role here. After all, the 1951 Festival of Britain displayed a generous array of artists on its South Bank site, from Epstein and Moore to the young Eduardo Paolozzi. So it would have been deplorable if the vitality of British art today had not been celebrated at the Dome. That is why I responded with enthusiasm when invited to join the 'Sculpture Group', along with Lewis Biggs, Director of the Tate Gallery, Liverpool, Richard Calvocoressi, Keeper of the Scottish National Gallery of Modern Art, Edinburgh, Julia Peyton-Jones, Director of the Serpentine Gallery, London, Charles Saatchi and the project's indispensable curator, Andrea Schlieker. Although we only started our deliberations in May last year, the North Meadow Art Project will yield images adventurous enough to have a stimulating impact on everyone who encounters them. And the media they use, ranging from stainless steel and neon to sound, coloured water and rotating words, reflect the rich diversity of possibilities explored by contemporary artists.

By far the largest work is Antony Gormley's *Quantum Cloud*, a colossus soaring twenty-nine metres in height from the pier at the water's edge. Unlike his *Angel of the North* at Gateshead, this new sculpture replaces solidity with a 'cloud' of 3,500 square steel tubes. Bristling with energy and glinting in the light, they will look as if a myriad particles have been thrown in the air and somehow, magically, stayed there. But the denser area inside the 'cloud' takes the shape, from certain viewpoints, of a human figure. He might be seen as a guardian for ships passing on the Thames. And he will certainly provide a compelling, constantly changing landmark for everybody travelling to the Dome by river.

The diaphanous quality of *Quantum Cloud*, treating the figure more as a force field than as a heavy mass, amounts to a breakthrough in Gormley's work. A similar boldness characterises Anish Kapoor's contribution. For the first time, he has decided to make moving water an integral part of his art. On a meadowland site, Kapoor will instal a monumental, stainless-steel drum eight metres in diameter. With a flat base lodged in the ground, it sets coloured water spinning into the shape of a concave mirror. Although moving very fast, the liquid will seem paradoxically still and solid. The water rides up to the edge of the drum, and viewers peering over the protective handrail will be able to see beguiling reflections of sun, sky and clouds in its smooth surface.

In contrast to Kapoor's low-lying work, Tony Cragg's three-part sculpture surges high into the air. Made of carbon kevlar, a green-tinged woven fabric even stronger than steel, *Life Time* relies on a dynamic interplay

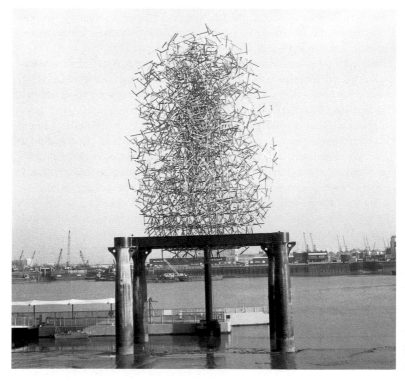

178. Antony Gormley, *Quantum Cloud*, 1999

between geometric and human forms. The unconventional material, usually employed in shipbuilding and the manufacture of rockets, gives Cragg's sculpture a shimmering, sensuous presence. It will entice people to explore all three forms and discover how they evoke the evolution of matter. A strong sense of the earth's primordial mass will develop, with faces emerging in profile at certain vantages. The central piece in *Life Time* rises to a commanding eight metres. But the flanking forms are around three metres in height, and the identity of the sculpture as a whole will continually alter as visitors move around its unpredictable surfaces.

Nobody can get close to Richard Wilson's contribution. Marooned in the Thames, four metres away from the river wall, *Slice of Reality* is as raw and direct as its title implies. For Wilson has taken an abandoned thirty-year-old dredger, built at Appledore in Devon, and cut it through from bridge to hull. The drastic surgery was carried out recently on Teesside, and the dissected ship will travel by barge to the Thames later this month. There it will float, occupying its watery resting-place like a spectral commemoration of the river's long vessel-carrying history. But the decisiveness of the slice is invigorating as well, echoing the action of the Meridian Line as it cuts through the peninsula.

Tacita Dean shares Wilson's fascination with the site's maritime past and shipping's world-wide reliance on Greenwich time. Instead of using a vessel, though, she has taken the Blackwall Tunnel's mushroom-shaped ventilation shaft as her starting-point. Positioned only one metre from the Meridian Line, its octagonal structure will become a sounding-board for the noises Dean wants it to emit, twenty-four hours a day. She is effectively transforming the shaft into a globe, where each side will refer to a different time-zone and give out sounds from ports across the world. At the moment, Dean is travelling with her tape-recorder to Alaska, Bangladesh, Brazil, Fiji, Japan, New Orleans and the Yemen. Along with Greenwich itself, longitude zero, they will make up the eight sources of her highly evocative sound sculpture.

Silence returns with Bill Culbert's contribution, where attention shifts from land and water to the sky. Located near the beach, his four blue neon lines, each thirty metres in length, travel through space with the agility of a hand writing in the air. Drawing on three decades' experience of working directly with the potency of light, Culbert makes eloquent use of his location's outdoor immensity. He will take our attention away from earthbound considerations towards the limitless void beyond – a salutary and poetic move at the millennium's end.

In case anyone needs spiritual reassurance after contemplating infinity, Rose Finn-Kelcey sets out to provide solace. She has turned four choco-

late vending machines into sources of prayer. After putting a twenty-pence coin in the slot, the 'customer' can select a non-denominational prayer from a list of fourteen. The titles use words associated with chocolate bars, including Wispa, Ripple and Milky Way. Then, after the prayer's words flash and whirl round a circular LED screen, the coin is returned. Sprayed a metallic, sparkling blue, the machines will offer a verbal sustenance radically removed from the familiar phrases chanted in church. But Finn-Kelcey's faith in her alternative offerings is summed up by the overall title she has given them: *It Pays to Pray.*

Inside the Dome, all these works would be forced to compete with a formidable battery of other visual distractions. That is why the North Meadow and its riverbank provide such a welcome location. When the 'Sculpture Group' first visited the site in the early summer of 1998, it looked bare and stark. But I remember marvelling, even then, at the sublime curve of the Thames and hoping that it would ignite the imaginations of the artists whose work we commissioned. So indeed it proved. Each of their contributions is charged with a sense of audacity, pushing them in a previously uncharted direction that revitalises their work. If estimates turn out to be correct, and twelve million people encounter these exhibits during their visits to the Dome, then the North Meadow initiative will dramatically widen contemporary art's audience at the very start of the new century.

For a disenchanted account of how the Dome management failed to promote the North Meadow Art Project, see 'Goodbye to All That' in the fourth volume of this series, Annus Mirabilis? Art in the Year 2000.

WRITING ABOUT ART

THE DICTIONARY OF ART
21 October 1996

Anyone with £5,750 to spare, along with a deep and sturdy bookcase, can now acquire by far the most comprehensive reference work on art ever published. Its straightforward title, *The Dictionary of Art*, gives little idea of the epic scope encompassed by the thirty-four volumes. They contain an awesome total of twenty-six million words, written by more than 6,700 scholars from 120 countries. Their entries, including biographies of 3,700 architects, 9,000 painters and 2,500 sculptors, are accompanied by 15,000 illustrations. Taken together, words and images run to 32,600 pages and comprise a remarkably ambitious attempt to sum up current knowledge about everything from prehistoric cave painting to multi-media installations of lesbian erotica by the Canadian group, Kiss and Tell.

The statistics are mind-boggling, and the complete set of books certainly looked awesome when ranged for my inspection in a crescent of dark green and gold at Macmillan's London headquarters. But do the entries themselves, and the subjects they tackle, really live up to editor Jane Shoaf Turner's claim that '*The Dictionary of Art* not only presents the most up-to-date scholarship and research but also accurately reflects recent changes that have dramatically reshaped the political map of the world'? At this point, as the author of twelve entries, I should declare an interest. But my contribution seems puny when set in the context of the whole series, and I played no part in the deliberations of the distinguished Editorial Advisory Board.

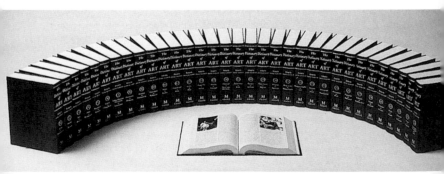

179. *The Dictionary of Art*, published in 1996

My principal fear was that the *Dictionary*, fifteen years in the making, would be incurably Western in its overall perspective. The springboard for the enterprise came, after all, from an idea mooted by Harold Macmillan, Life President of the publishing firm, in 1980. Despite his celebrated 'wind of change' speech, Macmillan's vantage was inevitably shaped by his Euro-American interests, and Ms Turner herself was educated in New York. To her great credit, though, she has ensured that the *Dictionary* is international in the fullest sense. The very first volume makes its breadth impressively clear by devoting well over 200 pages to a magisterial entry on Africa. Starting with its own detailed table of contents, this book-within-a-book offers an admirably wide-ranging guide to African achievements in the visual arts. It will satisfy the appetite aroused by the Royal Academy's recent successful survey of the same subject, and gets away from the reprehensible notion that African art is only interesting because of its powerful influence on early Western modernists like Picasso. The China entry fares even better, spreading across more than 450 pages and two volumes. It inevitably lacks the very latest information about a culture whose finest ancient artefacts continue to be unearthed as I write. But recent spectacular excavations, including the soldiers guarding the First Emperor's tomb, are discussed and illustrated along with a wealth of other information.

One of the dictionary's most heartening qualities lies in its readiness to discuss little-known artists. Lawrence Atkinson, a remarkable pioneer of abstract painting and sculpture in Britain, will be unfamiliar to most readers. But I was invited to contribute an entry on his work, and the rest of the *Dictionary* is replete with similar surprises. Amused by the provocative title on the spine of volume nineteen, Leather to Macho, I looked inside and discovered that Victorio Macho (1887-1966) was a Spanish sculptor who enjoyed considerable esteem in his own country. Such inclusions give the *Dictionary* a constantly refreshing air, and even the entries on major artists manage to escape from predictability. Take the article on the Van Eycks, whose responsibility for the great fifteenth-century altarpiece in Ghent has been a scholarly battleground for centuries. Many historians have claimed that it was, essentially, a collaborative achievement. Here, however, it is argued with considerable authority that Hubert Van Eyck was its principal creator, and that his far more renowned younger brother Jan simply finished some of the panels after Hubert's death. As for the entry on Michelangelo, at thirty pages far more elaborate than the eighteen devoted to Picasso, its author is not afraid to disagree about recent claims concerning two much-disputed panel paintings in the National Gallery. A 1994 exhibition at Trafalgar

Square advanced their claims to be considered Michelangelo's own early work persuasively enough. But the dictionary grudgingly asserts that the *Entombment* 'seems likely to be authentic', and is even more guarded about the other picture.

Any art publication with claims to vitality is likely to reflect and contribute to current debates about the writing of history. Issues relating to gender and sexuality are vigorously debated in many university courses, and the presence on the dictionary's editorial panel of the leading feminist writer Whitney Chadwick has ensured that the topic of Women and Art History receives a substantial airing. So does an entry called Gay and Lesbian Art, illustrated by images ranging from Michelangelo's sensual drawing of *The Rape of Ganymede* to Hockney's classic Californian idyll *Peter Getting Out of Nick's Pool*. Erotic Art in general fares even better. The fifteen pages devoted to its exploration embrace primordial images of the ithyphallic god at one end of the time-scale and Gilbert & George's *Naked Love* at the other.

But it would be wrong to present the dictionary as a self-consciously trendy publication. The overall presentation is sober, based on solid research rather than fashionable speculation. In their design, the thirty-four volumes are similarly matter-of-fact. At a time when art books in general are awash with colour plates, often poorly reproduced, the dictionary relies for the main part on black-and-white reproductions. Occasionally they disappoint: Gaudí's marvellous Casa Mila, recently restored as one of Barcelona's architectural glories, is represented here by a photograph of its old, dingy state. On the whole, though, I prefer a decent monochrome illustration to the wildly distorted colour reproductions so often presented nowadays as a reliable record of the original work.

Above all, however, the dictionary sensibly depends on the quality of its words. And they succeed in performing that most difficult of balancing acts, satisfying specialists while at the same time remaining accessible to the general reader. Unnecessary jargon is avoided, and the bibliographical references at the end of each entry are invaluable for anyone wanting to pursue a subject in greater depth. The prolonged gestation period presumably accounts for the absence of young artists who have come to prominence in the 1990s. Among the new British sculptors, for instance, I searched in vain for Damien Hirst or Rachel Whiteread, and even the older Antony Gormley has been left out. But no enterprise of this size should ever be expected to catch up with the latest wave of artists. Its true strength rests in an ability to span the broadest possible historical sweep with magisterial assurance. I never felt

bored as my eyes scanned the double-column pages. Although many of the texts have been translated from twenty-six different languages, they are lucid to read. And I often found myself delighted by topics as diverting as the Artist's House. Its illustrations commence with Federico Zuccaro's Palazzo Zuccari in Rome, where the garden entrance is transformed into a monster's gaping mouth, and they terminate in Santa Monica with the dramatically splintered home Frank Gehry built for himself seven years ago.

The dictionary teems with similar pleasures, enlivening the scholarship and ensuring that each volume is entertaining as well as instructive. In the end, this astonishing publication deserves to be applauded as an act of faith. It is immensely heartening at a time when too many art books are nothing more than quick, cynical attempts to exploit the growing public appetite for their subject. Like the great *New Grove Dictionary of Music and Musicians*, it will immediately establish itself as the most authoritative and indispensable account of all the visual arts, from one corner of the globe to the other.

THE CRITIC'S ROLE
April 1999

Little more than a year after the First World War ended, the Dada artist Raoul Hausmann pasted together a photomontage portrait called *The Art Critic*. It is a remorseless exposé. The critic's head, balding and creased with censorious frowns, is wedged on a body so small that it blows his features up to a monstrous size, like some grotesque carnival mask towering above the shoulders of its bearer. His face is deliberately brutalised as well. Hausmann has placed a shoe over the critic's brain, daubed clownish white make-up around his partially obliterated eyes, and bared the distended lips bordering the crudely drawn mouth to reveal the fangs of a predator. Towards the centre of his mouth the critic's teeth abruptly disappear, as if they had been broken during a vicious fight. Here, Hausmann's crayon defines the blooded orifice of a vampire hungry for more victims.

As a result, the imagery of a hunt infects everything within sight. Although the elongated pencil lodged in the critic's hand juts out from fly-button level, its role as a surrogate penis gives way, finally, to the

180. Raoul Haussmann, *The Art Critic*, 1919–20

metaphor of a dagger. And the banknote sticking out behind his neck, like a detachable shirt-collar accidentally come undone, signifies the prostitution of a hired killer. Twelve years later, Hausmann's friend John Heartfield would make a similar backhander damn the entire Nazi movement, in a photomontage whose ambiguous title, *Millions Stand Behind Me*, becomes clear as a paunchy capitalist passes a wad of cash into

Hitler's saluting hand. The target Hausmann chose is far less dangerous, and yet the fragment of money that seems to have pinioned its recipient in a venomous paralysis degrades the art critic's status effectively enough. Both he and by extension all other critics, Hausmann appears to be saying, are paid to destroy – regardless of whether they believe in the poisonous distortions their words convey.

It would be tempting to localise Hausmann's disgust by laying it solely at the door of the post-war Berlin he inhabited, a city so riddled with privation and political turmoil that the critical attitudes he was attacking eventually reached a climax in the appalling suppression of so-called Degenerate Art organised by the Fascists. Even the most unscrupulous of today's art critics pales in comparison with such an obscenity, and most of them presumably hope that they are fostering good art rather than impeding it. Criticism today is not on the whole characterised by its gratuitous savagery, and in Britain at least writers on art are not besieged by importunate corrupters offering bribes to promote artists they do not respect. I have only once been approached with a promise of financial reward in exchange for my critical support, and the overture was conducted with such barefaced clumsiness that I merely felt insulted.

All the same, it must be admitted that art critics nowadays still attract a considerable amount of hostility and scorn. The twin accusations that Hausmann hurls at his *Kunstkritiker* – 'assassin' and 'prostitute' – remain among the most prevalent terms of abuse. And they are usually directed at newspaper critics, the regular reviewers whose writings command readerships extending far beyond the narrowness of professional art circles. Precisely because these writers attract such large audiences, they are held to bear a great deal of responsibility for the way art is received and understood by society at large. Their potential ability to further that understanding is therefore considerable, but no more so than their ability to obstruct it. That is why people closely concerned with art can become so incensed by newspaper reviewing that they dismiss the entire activity. Writing in an ill-informed or thoughtless way in full view of a mass readership seems to them unforgiveable, and so they regard the whole notion of writing about art in newspapers as a doomed and destructive enterprise.

Having spent much of my professional life as a newspaper art critic, first at the *Evening Standard* and more recently at *The Times*, I could scarcely be expected to agree. There is a great deal wrong with art reviewing in newspapers, but my belief in its importance remains unshaken. Indeed, as my awareness of the many factors impeding public response to art has grown over the years, I have become steadily more

convinced of the paramount need for serious, knowledgeable, eloquent and above all passionately engaged newspaper criticism. If we despair of establishing a fruitful dialogue between the work artists make and the readers of newspapers, we throw away a crucial opportunity to bring art into contact with an audience wider than the minority who visit galleries regularly and read the specialist literature. In other words, the forums that newspapers can sometimes provide are far too valuable to be spurned or abused. They constitute a challenge which, despite the endemic frustrations newspapers inflict on writers rash enough to work for them, remains well worth taking on.

Critics cannot achieve anything without the aid of editors willing to grant them the necessary space and freedom of manœuvre. In order to do justice to the multi-faceted richness that good art always possesses, it is vital for the writer to make a regular point of concentrating on one exhibition or work of art and trying to disclose something of its full meaning. Space constraints do not often allow such examinations to be conducted at an appropriate length. But they must be attempted if readers are to gain some notion of how well any worthwhile work of art repays close and detailed scrutiny. The range of satisfactions that art affords cannot be grasped if the critic always refuses to go beyond the quick, rather breathless, summarizing comments that journalism too often relies on. Many newspapers favour a writing manner that is relentlessly brisk, jaunty and staccato, whereas it would usually be more appropriate to convey the experience offered by art in a freely searching style, alive to the amount of time it takes to go beyond superficial responses, absorb a work fully and apprehend its wealth of meanings.

Although the use of jargon and needlessly convoluted language should always be avoided, the newspaper critic must not shy away from taxing the reader's intelligence. Running the risk of making too many demands on an audience seems to me infinitely preferable to the betrayal involved in pretending that art is a simple and easy affair, using words that treat people as little more than impatient children unable to comprehend subtleties of any kind. It is patronizing to imagine that readers cannot be expected to grasp complex ideas, or think hard about the layers of meaning embedded in a great work of art. But newspapers often insist on regarding their audience with condescension, and the quality of writing suffers accordingly.

Ultimately, though, I attach the greatest importance of all to openness of response. Critics may be tempted to ignore or censure valuable work simply because it does not fit in with some preconceived idea about the

kind of work an artist ought, according to their grand critical scheme, to be producing. Conversely, there is sometimes a strong temptation to support particular artists merely because they can be identified with the broad direction that a writer hopes to see contemporary art pursuing. While it remains vital for writers to approach art with a cohesive set of beliefs, they must guard against becoming predictable champions of one area at the expense of all others. Narrow partisanship is often the hallmark of poor criticism, which seeks to hide its inner uncertainties behind a façade of rigid, dogmatic decisiveness. Good critics, who are confident of their own robust standpoint, can afford to be generous and enjoy art in all its necessary and inevitable variety.

So the real task confronting critics must be to establish a constantly oscillating interplay between the prescriptive priorities that they bring to an art work, and the specific empirical sustenance which this same art work can provide. If such an oscillation does not exist, or is allowed to falter and lean too heavily on one side or the other, then the critical act is traduced in some way. Either speculative theory is allowed to predominate, so that the precise structure of a work is ignored and the writer becomes damagingly divorced from the responsibility of discovering how a particular artist translates ideas and emotions into coherent form. Or too much emphasis is devoted to isolated experiences, and the writer wanders through an inconsequential haze, appraising conscientiously, describing accurately, giving due credit in all directions but failing to provide the unified vantage-point that justifies the critical performance.

Those who are convinced about the absolute rightness of their maxims quickly decline into repetitive propaganda, cultivating a watertight stance that cuts them off from all genuine readiness to extend or modify their precepts by testing them against the often unclassifiable surprises art affords. While those who nod dutifully at every disparate phenomenon produced by the artist never lay down their own order of importance, or presume to state whether one direction holds out more promise for the future of art than the others.

In both these polarised cases a serious loss is involved, and the full *suppleness* of criticism at its best is betrayed. That suppleness is a vital part of newspaper critics' equipment. Precisely because they occupy a strategic position, between the artist and the broad audience whose needs have been neglected for too long, they are well-placed to build a bridge connecting these two artificially segregated camps. If critics writing for the daily press can help to break down the suspicions bedevelling art's relations with the public, and create instead an awareness of how much each side

has to offer, then Raoul Hausmann's diabolic Dada portrait will eventually turn into a relic of a remote time when nobody could utter the words 'art critic' without prompting sniggers or sneers. Until then, the Hausmann caricature will continue to rankle in the conscience of any writer who knows just how much remains to be done.

FINALE

THE END OF THE TWENTIETH CENTURY
2 August 1990

Entering Joseph Beuys's *The End of the Twentieth Century* installation is like stumbling on the site of an unexplained catastrophe. Once inside the street entrance of the d'Offay Gallery, we find our floor-space invaded by rough-cut lumps of hexagonal-shaped basalt. They crowd around us, thrusting towards the light and heat of high summer outside the plate-glass frontage. The large room is filled with their insistent presence. They seem to be flowing from the corner at the back of the gallery in a desperate bid for the open air beyond.

Their efforts, however, are in vain. Although the thirty-one basalt boulders were once part of molten lava, they have long since cooled in primordial volcanic flues. Beuys selected them from a quarry near Kassel in central Germany, and he did nothing to disguise their ancient, pitted surfaces. Predominantly pale grey, interspersed with darker patches verging on black, they occasionally carry rust-coloured patches like stains on their sides. Chipped and weathered, they contrast absolutely with the immaculate parquet flooring and bare white walls above. They may have been arranged in a loosely organised sequence to imply motion, but none of them is capable of stirring from its allotted position.

After a while, therefore, the impression of onrush is countered by a far more melancholy stasis. The apparent movement, which at first reminded me of the sledges pouring out of a Volkswagen bus in Beuys's earlier *The Pack*, gave way to an overwhelming sense of finality. The boulders, each one approximately as long as a human figure, now seemed to be strewn across the ground like the petrified victims of some far-reaching disaster. A couple of the stones are propped up diagonally against their neighbours, as though left to lie exactly where they were originally felled when the calamity occurred.

At this stage, as I picked my way through the irregular spaces between the basalt lumps, they began to resemble fragments of great tree-trunks hurled down on the forest floor and left to ossify. In this respect, they looked like the pessimistic counterpart of Beuys's celebrated *7,000 Oaks*, an ambitious ecological work carried out for the Documenta exhibition in 1982. Related basalt boulders were placed vertically in the earth next to each of the oaks he planted throughout the severely bombed city of Kassel, and this shaman-like initiative summed up the most healing and affirmative side of Beuys's art. Here, however, the stones are for the most part utterly horizontal, and deprived of any nourishing contact with the

ground. This powerful aura of uprootedness led on to my realization that the boulders also looked like beached creatures from the sea. They reminded me of fish washed ashore after an unidentifiable yet awesome maritime crisis. Deprived of the water which once sustained their existence, they lie in a helpless mass waiting to expire. The holes drilled into one end of each stone undoubtedly reinforce the analogy. They resemble eye-sockets, and within each circular aperture a stone eyeball-form has come to rest.

A closer look discloses, however, that Beuys added his own distinctive mixture of materials to these mysterious cavities. After drilling and extracting the plugs of basalt, he wrapped them in felt before returning them to the holes. Moreover, he embedded each plug in a deposit of clay and fat, thereby ensuring that they rest securely in their womblike shelters. Although the compound where they lie is invariably cracked, and the plugs have sometimes been lodged in it at uneasy angles, there is no likelihood that they will work loose from the mulch and fall out. On the contrary: fat and felt signified for Beuys the quintessence of nurturing substances. According to the story which provided his life and work with

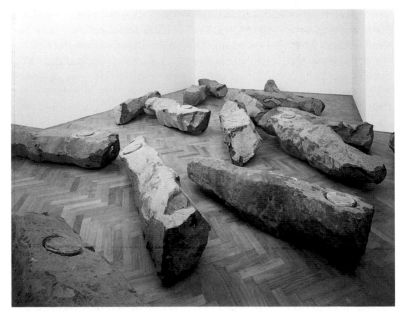

181. Joseph Beuys, *The End of the Twentieth Century*, 1985, installed at Anthony d'Offay Gallery, London, 1990 (detail)

its central symbolism, the artist had himself been nursed back to health with the aid of these sustaining materials. Beuys was a combat pilot in the Second World War, and after crashing in the Crimea the severely injured airman was wrapped in felt and fat by nomadic Tartars who had found him lying in the snow. They appear to have saved his life, and the means they employed thereafter assumed a wider significance in much of the sculpture he produced. In the context of his post-war transformation, from a callow Nazi fighter to a mature artist preoccupied by the safety of a planet threatened with obliteration, both fat and felt took on a redemptive meaning. They summed up the most optimistic side of an artist who had once been embroiled, like so many young Germans of his generation, in an unimaginably evil cause.

By packing his 'eyeballs' with such a highly charged combination of materials, Beuys therefore presented them as an alternative to the intimations of mortality elsewhere in the sculpture. If the stones have been strewn across the floor like corpses, they nevertheless contain within their structure the prospect of renewal. Fresh existence could be germinated inside the apertures, and lead eventually to the resurgence of fragments which appear, at the moment, so stricken and inert.

The fact that Beuys completed this installation only a year before his death in 1986 accentuates its tragic aspect. He never let increasing ill-health impede his mental vigour: I remember interviewing him not long before he died, and his spiritual energy was prodigious throughout a conversation which ended up lasting several hours. He was, however, self-evidently gaunt and frail. When Beuys worked on *The End of the Twentieth Century*, he must have been aware that, for him at least, time was running out. The realization probably made him predisposed to identify with the plight of these boulders, stranded and frustrated in their evident desire to move towards a life-restoring dimension.

It would be a mistake, however, to stress the biographical strain in Beuys's work at the expense of broader considerations. He was the most globally conscious of artists, an instinctive Green who wanted to play his part in saving the world from its likely devastation. By giving his installation such an ambiguous title, he must have intended to pose a question – is the twentieth century about to terminate prematurely in a nuclear apocalypse, or will it be succeeded by an era which asserts a less destructive set of values? Beuys's complex sculpture does not provide a ready-made answer, and that is one reason why it generates such resonance. It benefits enormously from the tension between a mournful aura of extinction and the possibility, however vestigial, that new life might one day emerge from the silent assembly of fallen stones.

INDEX

Page references in *italics* indicate illustrations. Works are listed under artist and subject.

town planning, *see* planning
Traeger, Tessa, 162
Tramway Gallery, Glasgow, 166
Trockel, Rosemarie, 240, 431–5, *433*
Tunga, 175
Turk, Gavin, 100, *101*, 102
Turne, J. M. W., 449, 472
Turner Prize, 4, 25–8
 1991, 25
 1993, 49–52, 318
 1995, 121–5
 1996, 157–62, 232
 1997, 25, 191, 235
 1998, 212–16, 213, 598
 1999, 26–8, 255–9
Tuymans, Luc, 66, *67*, 95–8, *97*
Twombly, Cy, 511
Tyne International, 464, 534–7

Unbound: Possibilities in Painting, 61, 64–8
USA, *see* Aitken; Bourgeois; Chicano art;
 Colescott; diCorcia; Gontarski; Gran
 Fury; Haacke; Hill (Christine);
 Kosuth; Nauman; Rauschenberg;
 Ryman; Sherman; Smith (Kiki)

Valdez, Patssi, 39
Vallotton, Félix, *491*
Velázquez, Diego, 396
in't Veld, Anneke, 265
Venezuela, *see* von Dangel
Venice, 170
 Biennale
 1990, 271–3
 1993, 122, 314–17, *315*
 1995, 355–9
 1997, 170–4
 1999, 239–43, 261
 see also Italy
Venturi, Robert, 11, 465–70, *468*
Victoria & Albert museum
 Nehru Gallery of Indian Art, 452–7, *456*
video, 18, 37, 57–60, 70, 71, 108, 122, 124,
 172–3, 175, 186–90, 203, 224–7, 236,
 237, 239, 245, 250, 266, 314, 358, 373,
 375, 429, 431, 442, 512, 574–3, *572*,
 604, 608, 610
Viola, Bill, 17, 37, 57–60, *59*, 245, 357, 358,
 361, 512, 570–3, *572*
Vorticism, 127, 220, 356

Waddington's Galleries, 376–9
Wadsworth, Edward, 493
Wadu, Sane, 118
Wakefield Cathedral, precinct sculpture,
 563–6
Wales, *see* Nash, David
Walker Art Gallery, *see* Liverpool
Wall, Jeff, 10, 175, 176, 379–83, *382*, 536
Wallinger, Mark, *17*, 44, 106, *107*, 108, 123,
 124, 179, 234, 602
Walsall art gallery, 14, 527
Waplington, Nick, 83
Wappng Pumping Station, 128–31
war, 379–80
 Falklands, 270
 Great War, *see* First World War
 see also museums, Imperial War
 Museum; Second World War
Ward, David, 3
Warde, Caroline, 219
Warhol, Andy, 43, 80, 100, 208, 348, 433,
 510–11, 516
van Warmerdam, Marijke, 142
Warwick University, outdoor sculpture,
 540–2, *542*
Wearing, Gillian, 123, 186–90, *188*
Webb, Boyd, 134, 337–40, *339*
Webb, Gary, 219
Weeks, John, 549
Weight, Angela, 270
Weinberger, Lois, 175
Wells, H. G., 5, 69
Wenda, Gu, 48
Wentworth, Richard, 487–8, *488*, 498
Weschke, Karl, 484
West, Franz, 35
Whitechapel Art Gallery, 57, 124,
 197–200, 259–63, 281–4, 299–302,
 306–9, *307*, 310–13, 326, 329, 344–7,
 351–5, 379–83, 403–6, *406*, 409–13,
 431–5, 443–6, *446*
 renovations, 485
Whiteread, Rachel, 1, *2*, 3, 10, 16, 20, 21,
 25, 30–3, *33*, 49, 50, 52, 56, 150–3,
 153, 170–1, 173, 179, 180, 220, 261,
 428, 486, 512, 589, 591, 592, 593, 606
Wilding, Alison, 385–6
Williams, Val, 80
Williamson, Sandys, 268
Wilson, Jane and Louise, 27, 28, *71*, 72,
 123–4, 224–7, *226*, 257

CREDITS

Courtesy Julian Treuherz, Frontispiece, 19; Frith Street Gallery, London, 2, 4 (Courtesy the artist), 56, 69, 103, 126; Courtesy the artist, 3; The Saatchi Gallery, London, 5 (Courtesy White Cube, London/photo: Stephen White), 23 (Courtesy the artist), 24, 27 (Courtesy White Cube, London), 32 (Courtesy White Cube, London), 39 (Courtesy Jean Pigozzi), 47 (Courtesy Stephen Friedman Gallery, London), 50 (Courtesy White Cube, London), 65 (Courtesy Sadie Coles HQ, London), 75, 76 (Courtesy Hales Gallery, London), 85 (Courtesy White Cube, London/photo: Prudence Cuming Associates, Ltd); Courtesy the artist/Victoria Miro Gallery, London, 6, 7; © FMGB Guggenheim Museum Bilbao Museoa, March 1997/photo: Aitor Ortiz. All rights reserved. Total or partial reproduction is prohibited, 8, 152; Ikon Galley, Birmingham, photo: Adrian Burrows, 9; Baltic, Gateshead/photo: Etienne Clement, 10; Claes Oldenburg and Coosje van Bruggen, 11 (photo: Attilio Maranzano); Courtesy the artist and White Cube London, 12, 36; Courtesy White Cube, London/photo: Edward Woodman, 14; Richard Wilson, 15; Artangel, London, 16 (photo: Cindy Palmano), 30 (Courtesy the artist and Anthony d'Offay Gallery, London), 44 (photo: Michael James O'Brien), 78, 171, 173; Courtesy the artist and Marian Goodman Gallery, Paris, 17; Courtesy Lisson Gallery, London, 18 (photo: Dave Morgan), 34, 41 (photo: John Riddy, London), 52, 61 (photo: Andrew Whittuck), 66 (photo: Stephen White, London), 77, 88, 89 (photo: S. Ormerod and G. Winters, London), 93 (photo: Stephen White, London), 102, 104, 119 (photo: Stephen White, London), 124, 128 (photo: John Riddy), 145, 164 (photo: Stephen White); Photographers' Gallery, London/Courtesy Monika Sprüth, Cologne and Philomene Magers, Munich, 20; Courtesy Illuminations/ Channel 4 Television, 21; Courtesy the artist, Marian Goodman Gallery New York/Paris and Thomas Dane Ltd, London, 22; Courtesy Donald Young Gallery, Chicago, 25; Courtesy Bernice Steinbaum Gallery, Miami, FL, 26; Courtesy the artist, 28; Public Art Development Trust, London, 29 (photo: Colleen Chartier), 175 (Courtesy Lisson Gallery, London/photo: Edward Woodman); Whitechapel Art Gallery, London, 31 (Courtesy Anthony d'Offay Gallery/photo: Kira Perov), 70 (Courtesy the artist/Victoria Miro Gallery, London), 86 (Courtesy White Cube, London/Private Collection), 92 (Courtesy the artist and Metro Pictures, New York), 97 (Courtesy the artist), 99, 100 (Courtesy Michael Hue-Williams Fine Art, London/Private Collection), 109 (Courtesy Timothy Taylor Gallery, London); Courtesy Zeno X Galley, Antwerp, Belgium, 33 (photo: Felix Tirry), 42, 132, 135 (Collection Caterina Boetti, Rome); Serpentine Gallery, London, 35 (Courtesy Gorney Bravin + Lee, New York), 45, 120 (Courtesy the artist/photo: Hugo Glendinning), 133, 134 (Courtesy Goodman Gallery, South Africa), 153 (photo: Hugo Glendinning), 170 (Courtesy Annely Juda Fine Art/Tadashi Kawamata/photo: Hugo Glenndinning); Courtesy the artist and Marian Goodman Gallery, Paris, 37, 55; Courtesy the Photographers' Gallery, London, 38; Courtesy the artist and David Zwirner, New York, 40; Courtesy Jay Jopling/White Cube, London, 43 (photo: Stephen White), 58, 59, 62 (photo: Carl Freedman), 72 (photo:

Stephen White), 112, 113, 178; © Tate, London, 2002, 46 (Courtesy the artist and Thomas Dane Gallery, London), 49 (Courtesy White Cube, London), 53 (Courtesy the artist), 68 (Courtesy Frith Street Gallery, London), 96, 144, 149, 180; Courtesy the artist, 48; Anya Gallaccio, 51; Museum of Modern art, Oxford, 54 (Courtesy Lisson Gallery, London); Anthony d'Offay Gallery, London, 57 (photo: Richard Stoner), 64, 114, 123, 127, 136 (Courtesy the artist and Gagosian Gallery, London), 167, 181; Courtesy Hauser & Wirth Gallery, Zürich and Luhring Augustine, New York, 63; Courtesy Maureen Paley Interim Art, London, 67; Mariko Mori Studio Inc., New York, 71; Courtesy the artist/Victoria Miro Gallery, London, 73; Dominic Berning, 74 (Courtesy the artist); Courtesy Michel Rein Gallery, Paris, 80; Courtesy the artist/Victoria Miro Gallery, London, 81; Courtesy Marian Goodman Gallery, New York, 82; Courtesy the artist, 83; The approach, London, 84; Courtesy Stephen Friedman Gallery, London, 87 (Collection Museum of Contemporary Art, Chicago, restricted gift of Howard and Donna Stone), 174 (photo: Stephen White); Courtesy the artist and Gagosian Gallery, LA/Whitney Museum of American Art, 90; Courtesy the artist, 91; Courtesy Alain Gutharc Gallery, Paris, 94; Camden Arts Centre/Courtesy the artist, 95; Courtesy the artist, 98; Hayward Gallery, London, 105 (Courtesy White Cube, London), 131, 150; Courtesy NB Pictures, 106; Courtesy the artist, 107; Courtesy Daros Collection Switzerland, 110; Courtesy Pace Wildenstein/photo: Ellen Page Wilson/Collection Museum of Fine Arts, Boston, 111; Courtesy the artist, 115, 116, 118, 121; ICA, London/Courtesy McKee Gallery, New York, 122; Courtesy the artist, 125, 129; Goodman Derrick, London, 130; V & A Picture Library © the Board of Trustees of the Victoria & Albert Museum, London, 137; © Royal Academy of Arts, London, 138; Courtesy the Irish Museum of Modern Art, Dublin, 139; © The National Gallery, London, 140; Guzelian/photo: Tim Smith, 142; Courtesy the artist, 143; Courtesy Deutsches Historisches Museum, Berlin, 146; The Henry Moore Institute, Leeds/Courtesy the artist, 147; Courtesy Asprey Jacques Gallery, London, 148; Courtesy Hamburger Bahnhof, Berlin, 151; Courtesy Emily Tsingou Gallery, London, 154; Courtesy Tony Fretton Architects, London, 155; Courtesy the artist/photo: Edward Woodman, 157; South Bank Centre, London/photo: Jesus Uriarte, 158; University of Warwick/Courtesy Lisson Gallery, London, 159; Courtesy the artist, 160; Courtesy Guys and St Thomas's Charitable Foundation, London, 161; Courtesy Barford Sculptures, London, 162; Claes Oldenburg and Coosje van Bruggen/photo: Attilio Maranzano, 163; Tess Jaray, 165; Courtesy the Byrd Hoffman Water Mill Foundation, 166; Jane Connarty/photo: Woodley & Quick, 168; Courtesy the artist, 169; Courtesy The Times, 172; Courtesy Alexander and Bonin, New York, 177 (photo: Nick Hunt/JKA)

COPYRIGHT LINES

© Chris Ofili, 7, 73; © the artist, courtesy Anthony Reynolds Gallery, London, 13, 45, 60, 173; © Gautier Deblonde, 79; © DACS, 2003, 99, 101, 108, 133, 158, 171; © 2002, Kiki Smith, 111; © the Artist, 117; © Courtesy Monika Sprüth Gallery, Germany; © photo Musée de l'Armée, Paris, 146; copyright Angelos, Antwerp, 168